ADOBE® PHOTOSHOP®

LIGHTROOM® CLASSIC

THE MISSING FAQ

3RD EDITION

OCTOBER 2022 RELEASE COVERING VERSION:

Windows / Mac: 12.0

VICTORIA BAMPTON

Adobe Photoshop Lightroom Classic—The Missing FAQ (3rd Edition)

Publication Date 18 October 2022

Copyright © 2022 Victoria Bampton. All rights reserved. Published by The Lightroom Queen, an imprint of LRQ Publishing Ltd.

ISBN 978-1-910381-16-8 (eBook Formats) ISBN 978-1-910381-17-5 (Color Paperback)

No part of this publication may be reproduced in any form without prior written permission of the publisher, with the exception that a single copy of the eBook may be printed for personal use and may not be resold. Permissions may be sought by email to mail@lightroomqueen.com or via the website https://www.lightroomqueen.com/

The publisher/author assumes no responsibility or liability for any errors or inaccuracies that may appear in the informational content contained in this guide.

Adobe, the Adobe logo, Lightroom, and Photoshop are either registered trademarks or trademarks of Adobe Systems Incorporated in the United States and/or other countries. Adobe product screenshot(s) reprinted with permission from Adobe Systems Incorporated.

THIS PRODUCT IS NOT ENDORSED OR SPONSORED BY ADOBE SYSTEMS INCORPORATED, PUBLISHER OF ADOBE PHOTOSHOP LIGHTROOM.

Microsoft and Windows are either registered trademarks or trademarks of Microsoft Corporation in the United States and/or other countries.

Apple, Mac, Macintosh, macOS, iOS, iPadOS, iPad, iPad Air, iPad Mini, iPad Pro and iPhone are trademarks of Apple Inc. registered in the U.S. and/or other countries.

Android and Google Play are trademarks of Google LLC. registered in the U.S. and/or other countries.

All other trademarks are the property of their respective owners.

Adobe product screenshot(s) reprinted with permission from Adobe Systems Incorporated.

TABLE OF CONTENTS

1 - INTRODUCTION	1	File Renaming panel	36
The Book Format	2	Apply During Import panel	40
Talk to Us!	4	Destination panel	42
2 - BEFORE YOU START	5	Saving & Reusing Import Settings	48
What is a Lightroom catalog?	5	The Compact Import Dialog	48
Designing Your Workflow	6	After Pressing Import	49
Shooting Raw, sRAW or JPEG	9	Troubleshooting Import	49
Installing Lightroom	13	Tethered Shooting & Watched Folders	-
Keeping Lightroom Updated	16		54
Upgrading Your Catalog	17	Import Shortcuts	58
Calibrating Your Monitor	19	4 - BACKUP	59
Help Shortcuts	20	Back Up Your Catalog	59
3 - IMPORTING PHOTOS & VIDEOS	21	Back Up Your Photos	62
Import in Detail	27	Back up the Extras	64
Source panel	28	Restoring From Backups	64
Previewing and Selecting Individual		Backup Checklist	67
Photos	30	5 - THE LIGHTROOM WORKSPACE	69
Import Method	33	The Top Bar	69
File Handling panel	34	Panels & Panel Groups	74

	The Filmstrip	76	9 - ADDING METADATA TO YOUR PHOTOS	133
	Workspace Shortcuts	79		4-
6 -	VIEWING YOUR PHOTOS	81	Adding Metadata using the Metada Panel	133
	Viewing Your Photos in Grid View	81	Editing the Capture Time	140
	Selections	86	Keywords	142
	Viewing Your Photos in Loupe View	87	Faces	155
	Viewing Your Photos in Survey	92	Map Locations	166
	View	72	Metadata Shortcuts	179
	Viewing Your Photos in Compare View	93	10 - FINDING & FILTERING YOUR PHOTOS	183
	Secondary Display	95	Sort Order	183
	Viewing Photos Shortcuts	98	Filtering Your Photos	184
7 -	SELECTING THE BEST PHOTOS	101		
	Rating your Photos	101	Using Smart Collections	193
	Quick Develop	106	Filtering Shortcuts	196
	Grouping Similar Photos using	107	11 - DEVELOP INTRODUCTION TO EDITING	197
	Stacks Collections	109	Analyzing the Image—Technical Faults	197
	Selecting Photos Shortcuts	114	Analyzing the Image—Artistic Intent	204
8 -	MANAGING YOUR PHOTOS	117	Learning to Edit	208
	Managing Folders in Lightroom and the Hard Drive	on 117		Photo
	Changing the Folder Structure	123		212
	Managing the Individual Photos	126	Photo Analysis Checklist - Artistic Intent	213
	Managing Photos & Folders	131	Photo Analysis Worksheet Example	214

12	- DEVELOP BASIC EDITING	215	Masking Tools	284
	Adjust from the Top Mostly	215	AI-Based Selections	286
	Simple Editing Examples	219	Brush	290
	Profiles	222	Linear Gradient	293
	White Balance	229	Radial Gradient	294
	Tone & Presence	234	Range Masks	295
	Exposure	235	Combining Mask Types	299
	Global Vs. Local Contrast	237	Copying Masks to Other Photos	302
	Highlights and Shadows	237	Setting Sliders	303
	Whites and Blacks	244	Develop Masking Shortcuts	310
	Texture Vs. Clarity	248 1	5 - DEVELOP ADVANCED EDITING	313
	Dehaze	251	Tone Curves	313
	Vibrance vs. Saturation	252	Black & White	320
	Process Versions	253	Color Grading	325
	Editing Videos	255	HSL & Color	331
	Develop Basic Shortcuts	259	Detail—Sharpening & Noise Reduction	333
13	- DEVELOP SELECTIVE EDITING	261	Reduction	333
	Cropping & Straightening	261	Lens & Perspective (Transform) Corrections	338
	Healing Tool	268	Effects—Post-Crop Vignette &	
	Red Eye & Pet Eye Correction	074	Grain	350
	Tools	274	Enhance Details	354
	Develop Selective Editing Shortcuts	277	Photo Merge	356
11	- DEVELOP MASKING	270	Develop Advanced Shortcuts	
14	- DEVELOP MASKING	279		
	Organizing Masks	282		

367	SERVICES	415
367		using 415
oly to 371	Export To	417
376	Export Location & File Naming	417
378	Video & File Settings	420
380	Image Sizing & Resolution	423
e 201	Output Sharpening	426
381	Metadata & Watermarking	427
382	Post-Processing	431
385	Other Export Questions	432
207	Emailing your Photos	434
	Publish Services	439
	Export Shortcuts	444
R 395	19 - OUTPUT MODULES	445
20/	Book Module	445
	Slideshow Module	448
shop 401	Print Module	450
lity for 405	Web Module	456
407	20 - MULTIPLE COMPUTERS OR CATALOGS	459
409	Managing Catalogs	459
	Moving Lightroom	463
414	Working with Multiple Machines	468
	367 oly to 371 376 378 380 e 381 382 385 386 393 R 395 396 shop 401 lity for 405 407 409 411	SERVICES 367

	Single or Multiple Catalogs	493	23 - CLOUD SYNC	547
	Catalog Shortcuts	498	Lightroom Mobile Basics	548
21	- TROUBLESHOOTING	499	Syncing Lightroom Classic	553
	Missing Files	499	Sync Limitations	558
	The Cat Walked Over the Keyboard	506	Troubleshooting Sync	560
	Catalog Corruption	506	Advanced Workflows	563
	Image & Preview Problems	509	Register your book for additional benefits	566
	Standard Troubleshooting	514	24 - INDEX	567
	Default File & Menu Locations	516	BONUS CHAPTERS IN THE	
	Troubleshooting Shortcuts	520	EBOOK APPENDIX	
22	- IMPROVING PERFORMANCE	521	25 - BOOK MODULE	A1
	Non-Destructive Editing	521	Book Basics	A1
	Debunking Myths	523	Working with Pages & Templates	A4
	Previews in the Library Module	524	Auto Layout	A10
	Previews & Caches in the Develop	F07	Working with Photos	A12
	module	527	Page Styles	A15
	Preferences & Catalog Settings	530	Adding Text to Your Book	A17
	Workflow Tweaks	535	Text Formatting	A21
	Hardware Choices	538	Saving Books	A24
	General System Maintenance	541	Exporting & Printing Books	A26
	What's Slow?	543	Book Module Shortcuts	
	Performance Checklist	546		A30
	Performance Shortcuts	546	26 - SLIDESHOW MODULE	B1
			Slideshow Basics	B1

E19

E23

E25

F1

Slide Layout & Design	B2	Custom Keyboard Shortcuts, Translated Strings and Other Text Hacks E19
Text Captions & Other Overlays	В7	-
Playback Settings	B13	Photoshop Actions via Droplets E23
Saving Slideshows & Templates	B17	Importing From Other Programs E25
Exporting Slideshows for Use Outsi Lightroom	ide of B19	30 - CHANGES F:
Slideshow Module Shortcuts	B23	
27 - PRINT MODULE	C1	
Print Basics	C1	
Print Layout	C7	
Print Design & Overlays	C13	
Printing & Exporting	C16	
Saving Prints & Templates	C23	
Print Keyboard Shortcuts	C26	
28 - WEB MODULE	D1	
Web Gallery Basics	D4	
Web Gallery Layout & Design	D5	
Saving Web Galleries & Templates	D9	
Export for Web	D11	
Web Module Shortcuts	D13	
29 - THE GEEKY BITS	E1	
Proprietary Raw vs. DNG	E1	
Flat Field Correction	E14	
DNG Profile Editor	E15	

ACKNOWLEDGMENTS

A lot of people have contributed to this project, and although I'd love to thank everyone personally, the acknowledgments would fill up the entire book.

There are some people who deserve a special mention though.

First and foremost, my heartfelt thanks go to Paul McFarlane, who has worked closely with me on this book yet again. Without his help, you wouldn't be reading this!

I couldn't go without thanking the whole Lightroom team at Adobe, especially Tom Hogarty, Sharad Mangalick, Lisa Ngo, Ben Warde, Josh Haftel, Jeff Tranberry, Rikk Flohr, Julieanne Kost, Thomas Knoll, Eric Chan, Max Wendt, Josh Bury, Simon Chen, Julie Kmoch, Kelly Castro, Becky Sowada, Smit Keniya, Sreenivas Ramaswamy, Sunil Bhaskaran, Chinoy Gupta and Rahul Agrawal who have willingly answered my endless questions.

I'd like to thank David duChemin for challenging the way I think about photography, and sparking many of the editing ideas in this book. There's always more to learn!

Thanks are also due to the team of Lightroom Gurus, who are always happy to discuss, debate and share their experience, especially Jim Wilde, Johan Elzenga, Laura Shoe, Jeff Schewe, Martin Evening, Peter Krogh, Ian Lyons, John Beardsworth, George Jardine, Rob Sylvan, Jeffrey Friedl, Linwood Ferguson and the rest of the crew!

I'm also grateful to the members of the various Lightroom forums and my social media followers, who constantly challenge us with questions, problems to solve, and give me ideas for this book.

And finally I have to thank you, the Reader. Yet again, many of the changes in the book are based on the suggestions and questions that you've sent in. It's your book. The lovely emails I've received, and the reviews you post online, make all the late nights and early mornings worthwhile—so thank you.

Victoria Bampton — Isle of Wight, England, October 2022

INTRODUCTION

Adobe® Photoshop® Lightroom™ 1.0 was released on February 19th 2007, after a long public beta period, and it rapidly became a hit. Thousands of users flooded the forums looking for answers to their questions. In the years that have followed, Lightroom has continued to gain popularity, becoming the program of choice for amateur and professional photographers alike.

In October 2017, Adobe announced that Lightroom was dividing in two different directions, so that each program can focus on its strengths. Lightroom Classic continues the desktop folder-based workflow we've used for the last 15 years, whereas the Lightroom ecosystem is cloudnative, so all of your photos are stored in the cloud and accessible from any device.

Lightroom Classic and the Lightroom cloud-based ecosystem are like distant cousins, so their communication is limited. We'll discuss their interactions in the Cloud Sync chapter starting on page 547, but the rest of the book will focus on the desktop workflow that is Lightroom Classic's primary focus. To save writing its full name—Adobe Photoshop Lightroom Classic—over and over again, we'll mostly refer to it as Lightroom in this book.

Google now turns up around 120,000,000 web pages when you search for the word Lightroom. So when you have a question or you get stuck with one of Lightroom's less intuitive features, where do you look?

Do you trawl through thousands of web pages looking for the information you need? Perhaps post on a forum, wait hours for anyone to reply, and hope they give you the right information? From now on, you look right here! *Adobe Photoshop Lightroom Classic—The Missing FAQ* is a compilation of the questions most frequently asked—and many not so frequently asked—by real users on forums all over the world.

Unlike many 'how-to' books, this isn't just the theory of how Lightroom is supposed to work, but also the workarounds and solutions for the times when it doesn't behave in the way you'd expect. We're going to concentrate on real-world use, and the information you actually need to know.

I know you're intelligent (after all, you chose to buy this book!), and I'll assume you already have some understanding of computers and digital photography. Unlike the other books, I'm not going to tell you what you 'must' do. I'm going to give you the information you need to make an informed decision about your own workflow so you can get the best out of Lightroom.

Two of my favorite comments about this series of books are "it's like a conversation with a trusted friend" and "it's like having Victoria sit next to you helping." That's my aim—I'm here to help.

THE BOOK FORMAT

Let's just do a quick guided tour so you can get the best out of the book...

The Fast Track for New Lightroom Users

Lightroom's a big program these days, and when you're just getting started, it can be overwhelming. Have you heard of the Pareto principle or 80/20 rule? In short, the idea is that 20% of the effort creates 80% of the results. But when you're just starting out, it's hard to know which information you need to understand, so I've done the work for you.

Starting on page 5, the Fast Track weaves its way through the book, giving you the essential information you need to get started. At the end of each Fast Track section is another red arrow, along with a page reference and clickable link which takes you to the next Fast Track section.

The aim of the Fast Track is to make the information accessible to less experienced users, while retaining all of the advanced geeky detail, so the book's useful to you throughout your whole Lightroom journey.

You can either read the book cover to cover, or you can follow the Fast Track to understand the basics, and then dive into the rest of the book to round out your knowledge, or use it as a reference when you have a question.

Workflow Order

If you read the book from front to back, I'll lead you through a typical workflow. It begins with getting your photos and videos

REGISTER YOUR BOOK FOR ADDITIONAL BENEFITS

If you purchased the paperback from Amazon, Barnes & Noble or another retailer, register your copy of this book to download all the eBook formats and get access to updates, as well as gaining access to other member benefits. To learn more, turn to page 566.

into Lightroom, then viewing them, selecting the best photos, grouping them, adding metadata and filtering the photos. Next, we move on to editing your photos, both in the Develop module and external editors, and then outputting the photos as individual images, emails and publishing them on social media websites. Finally, we discuss how to access your photos on multiple computers or mobile devices.

Index

If you're using the book as a reference, you can find the information you need using the index starting on page 567. In the eBook formats, you can also use the search facility or bookmarks to find the specific words, and you can add your own bookmarks and notes too.

Appendices

In the complimentary eBook formats, there are additional appendices covering the less frequently used Book (page A1), Slideshow (page B1), Print (page C1) and Web (page D1) modules, but you'll also find introductory tutorials for these modules in the Output Modules chapter in the main book (page 445).

In The Geeky Bits appendix starting on page E1 (only available in the eBook formats),

we explore the pros and cons of the DNG format and other geeky topics such as how to use the DNG Profile Editor, how to hack the TranslatedStrings file and how to import from other software.

Keyboard Shortcuts

Many controls can be accessed in multiple different ways—buttons in the user interface, menu commands, context-sensitive menus and keyboard shortcuts. If I listed every single one, you'd be bored stiff, so I've noted the most frequently used (and most easily remembered) commands and shortcuts. They're also listed at the end of each related chapter, and you can download the complete printable keyboard shortcuts list from https://www.Lrq.me/keyboard-shortcuts/

On both platforms, in addition to keyboard shortcuts, the standard modifier keys are used in combination with mouse clicks to perform various tasks.

Ctrl (Windows) / Cmd (Mac) selects or deselects multiple items that are not necessarily consecutive. For example, hold down Ctrl (Windows) / Cmd (Mac) to select multiple photos, select multiple folders, select multiple keywords, etc.

Shift selects or deselects multiple consecutive items. For example, hold down Shift while clicking to select multiple photos, select multiple folders, select multiple keywords etc.

Alt (Windows) / Opt (Mac)—Changes the use of many controls. For example, in Quick Develop, it swaps the 'Clarity' and 'Vibrance' buttons for 'Sharpening' and 'Saturation.' In Develop panels, it changes the panel label to a panel 'Reset' button, and holding it down while moving some sliders shows masks or clipping warnings.

On Windows, standard accelerator keys also work—hold down the Alt key to show the underlined letters

Links

The links in the eBooks are all clickable. In order to keep the website links current, and make them easy for you to access, I've used my own short-url domain https://www.Lrq.me (that's LRQ.ME) to handle the redirections.

Multiple Formats

You can choose how to you wish to read the book—PDF, ePub, Kindle, Paperback, or all four! You might want the PDF version on your computer for searching while you work with Lightroom, the Kindle version for reading cover-to-cover while relaxing in the garden, and the paperback for scribbling extra notes. It's up to you. I would suggest:

PDF—used on computer or large tablets.

ePub—used on smaller mobile devices and most eReaders.

Kindle-used on Kindle eReaders.

Windows or Mac?

It doesn't matter whether you're using the Windows or Mac platform, or even both. Lightroom is cross-platform, and therefore this book will follow the same pattern. The screenshots are mainly of the Mac version because I'm writing on a Mac, but the Windows version is almost identical in functionality, and any significant differences will be explained and illustrated.

Where keyboard shortcuts or other commands differ by platform, both are included. The exception is the shortcut to view a context-sensitive menu, which is

right-click on Windows or Ctrl-click on Mac. I'll keep that simple and just refer to right-clicking. If you use a trackpad on a Mac, right-click is a two-finger tap and dragging two fingers up or down the trackpad is the same as scrolling.

TALK TO US!

This book is based entirely around user feedback, so we'd love to hear the things you like about this book, and anything you feel could be improved. We're always looking for ways to make this book even better, so if you come across a question that we've missed, something that's not clear, or you just want to tell us how much you love the book, you can send us your feedback using the Contact form on the website at https://www.lightroomqueen.com/contact We promise to read every email, even if we can't reply to them all personally.

We've also included a year's Lightroom Classic Premium Email Support with your purchase, via the form in the Premium Members Area, in case you get stuck while you're reading (see page 566).

If you enjoy the book, posting a review on Amazon or your favorite online bookstore would make our day, and would help other Lightroom users find it too. Thank you!

Now, where shall we start ...?

PRINTING PRESS & EREADER LIMITATIONS

The limitations of printing presses and eReaders affects the reproduction of images, so if you're reading this in a paperback book, do check the editing examples in the complimentary PDF version on a calibrated monitor. Better still, if you'd like to try some of these tests for yourself, you can download these files from the Members Area.

BEFORE YOU START

If you're anything like me, the first thing you want to do with a new program is

dive right in. Who wants to read an instruction manual when you can experiment? If you're nodding in agreement, that's fine, but do yourself a favor and just skim through the Fast Track before you jump in head first.

Lightroom's designed around a database, so it doesn't work in the same way as most other image editing software. You'll save yourself a lot of headaches by understanding the basics!

WHAT IS A LIGHTROOM CATALOG?

There are basically two different types of image management software—databases (catalogs) and file browsers. So what's the difference? Let's compare to a physical

library of books to illustrate. (Figure 2.1)

A file browser looks at the files directly on the hard drive and organizes photos by folder. This is like walking straight into the library and looking round the shelves of books. If someone's borrowed a book, you won't even know it exists.

A database is a series of text records. This is like the library's catalog of books. In the old days, it was made up of drawers full of cards, but these days it's all computerized. Each card—or computerized record—contains information about the book, who wrote it, a description, its ISBN number, perhaps a picture of the cover, and most importantly, which shelf the book is stored on. (Figure 2.2)

The books themselves are still on the shelves. They're not IN the catalog. If someone's borrowed a book, you can still

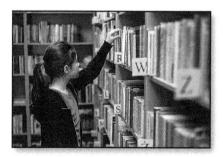

Figure 2.1 The Lightroom catalog is like a library of books.

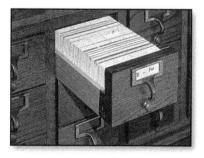

Figure 2.2 There's a text record describing each photo.

see the information describing the book, but you can't read the book until it's returned to its shelf. If someone moves the book to a new shelf, the information on the card is incorrect and you'll be looking in the wrong place until the record is updated.

Lightroom uses a database rather than acting as a file browser. Photos are never IN the catalog. The Lightroom catalog contains text records of information describing the photos, with small previews stored nearby, and most importantly, a note of where each photo is stored on the hard drive. If the hard drive is disconnected or a photo is moved to a new location, you can still see the information describing the photo and a small preview in the catalog, but you can't work with the photo until the original file is found.

Why does understanding the catalog matter?

We're very familiar with working in file browsers. Windows Explorer and Mac Finder are used on every single Windows and Mac computer, so handling files in a browser comes naturally to most computer users.

Catalogs are different. If you move, rename or delete a file outside of Lightroom, the records in the catalog won't get updated to match. Lightroom will still be looking in the old location on the hard drive for the file, and won't be able to find it. When this happens, you may not be able to edit or export the photos (just like you can't read a library book until you find the book itself).

As well as the information about the original image files, the catalog contains a record of all of the work you've done to the photos. This includes flags, stars, keywords, captions, collection membership, and more. Even your Develop edits are stored as a

series of text instructions in the catalog itself. While it's possible to store some of this metadata with the files (in a format called XMP), by default it's only stored in the catalog. If you remove the photos from the catalog, all of your Lightroom edits will be gone. Even if you reimport the photos later, you won't get this information back.

What do I need to remember?

- Always rename photos within Lightroom, using the *Library menu* > *Rename Photos* command. If you don't, you have to fix the links one at a time. BIG job! (See page 127 for more detail.)
- Move photos within Lightroom by dragging and dropping them on another folder—or if you move them using Explorer/ Finder/other software, update Lightroom's records immediately, before you forget where you put them. (See page 129 for more detail.)
- Don't remove photos from the catalog unless you're also intentionally deleting the original photos (e.g. the fuzzy ones). (See page 126 for more detail.)
- Back up your catalog regularly. It contains a lot of essential information! (See page 59 for more detail.)

DESIGNING YOUR WORKFLOW

Finally, before we start using the software itself, let's talk briefly about workflow. It's one of the most popular topics among photographers, but why? What does it actually mean?

The term workflow simply describes a series of steps undertaken in the same order each time. For photographers, this workflow

...continues on page 9

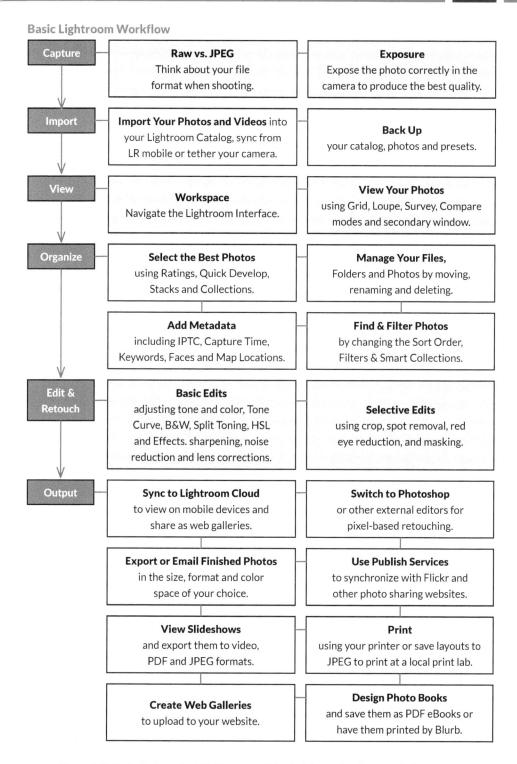

Figure 2.3 Each photographer's Lightroom workflow is different, but there are similar themes.

A Typical Workflow

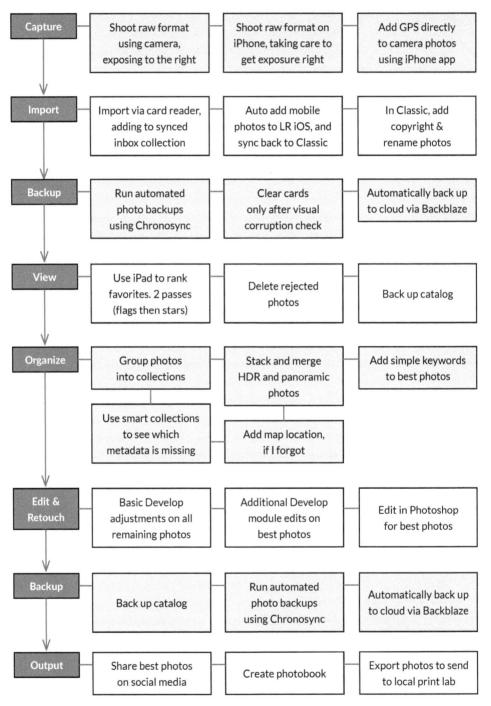

Figure 2.4 This is a typical workflow. Your workflow won't look exactly the same, but it'll share the same principles.

runs from the time of shooting (or even before), through transferring the photos to your computer, sorting and selecting your favorites, editing and retouching them, and then outputting to various formats, whether on screen or in print.

The initial aim for your workflow is consistency. If you do the same thing in the same order every time, you reduce the risk of mistakes. Files won't get lost or accidentally deleted, metadata won't get missed, and you won't end up redoing work that you've already completed (Figure 2.3)

There is no perfect workflow for everyone, as everyone's needs are different. The Fast Track sections of this book guide you through a simple workflow, but outside of the Fast Track, we'll also consider other workflow variations and the thought processes behind them, so you can start to build your own ideal workflow. I've also included a diagram of a typical workflow to help get you started. (Figure 2.4)

Once you've settled on a good workflow, that isn't the end of the story. You'll likely find that you continue to tweak it, finding slightly more efficient ways of doing things. It'll continue to build with time and experience, as well as with the introduction of new technology. The principles, however, remain the same.

SHOOTING RAW, SRAW OR JPEG

Having gained a quick overview of the Lightroom workflow, let's go back and start right at the beginning. Some of the camera settings at the time of capture can affect your options when you later come to edit the photos. These include the file format,

picture style, crop ratio and high dynamic range camera settings. Most other camera settings are ignored by raw editors such as Lightroom.

Should I shoot raw or JPEG?

The most important camera setting is the file format. Shooting in your camera's raw file format offers a lot more flexibility than JPEG, especially if your exposure or white balance aren't perfect, or if you're shooting at high ISO or in a high contrast situation.

Lightroom's Develop tools are primarily designed for raw image processing, giving you the greatest latitude, but Lightroom also works with rendered files (JPEG, HEIC, TIFF, PSD, PNG), giving you an easy way to edit batches of photos. So if you can use Lightroom with JPEGs, which take up less hard drive space, why would you want to consider shooting raw? Well, think of it this way... did you ever play with colored modeling clay when you were a child?

Imagine you have a ready-made model made of a mixture of different colors, and you also have separate pots of the different colors that have never been used. You can push the ready-made model around a bit and make something different, but the colors smudge into each other and it's never quite as good as it would have been if you'd used the individual colors and started from scratch.

A JPEG is like that ready-made model: it's already been made into a photo by the camera before you start editing it. You can change its appearance, but if you try to change it too much, it's going to end up a distorted mess. Your raw file is like having the separate pots of clay—you're starting off with the raw material, and you choose what to make with it. (Figure 2.5)

When you come to edit JPEG photos in the

Develop module, you'll notice that some of Lightroom's controls are more limited when working with rendered files (JPEG, TIFF, PSD, PNG). They include:

Camera Matching Profiles—Some profiles (page 225) are only available for raw files

Figure 2.5 When using modeling clay, you get a better result starting from the raw material than trying to reuse an existing model. In the same way, you'll have more flexibility when working with raw files than you will with ready-made JPEGs.

as they emulate the look of the camera's picture styles.

White Balance—Temperature and Tint sliders (page 229) change from Kelvin values to fixed values, as you're adjusting from a fixed color rather than adjusting white balance. Incorrect white balance is much harder to fix on rendered files.

Exposure Latitude—If photos are under or over exposed (page 235) or very high contrast, there's a lot more information to work with in a raw file. JPEGs start to fall apart a lot more quickly than raw files. (Figure 2.6)

Sharpening and Noise Reduction— Sharpening and noise reduction (page 333) are turned off by default as these may have already been applied by the camera. Lightroom's sharpening and noise reduction controls work better on raw files, as they have more information to work with.

Lens Profiles—Most lens correction profiles (page 338) are built for raw files as the camera may have already applied additional processing (e.g., vignette correction) to JPEGs.

Which file format you choose is your decision. If you shoot raw, there are a couple of additional settings to watch out for...

Figure 2.6 If your file is overexposed or has the wrong white balance (left), the detail is much more recoverable from a raw (center) file than a JPEG (right). The highlight detail on William's nose is missing on the JPEG and it's very difficult to adjust the white balance.

Why doesn't the photo look the same as it did on the camera?

When you shoot in your camera's raw file format, the data isn't fully processed by the camera. The mosaic sensor data is recorded in the raw file, and this sensor data must be converted into an image using raw processing software.

Each raw processor interprets the raw data in a slightly different way. As a result, the photo won't look exactly the same in Lightroom as it did on the back of the camera. There isn't a right or wrong rendering—they're just different.

Adobe could use the camera manufacturer's SDKs (Software Development Kits) to convert the raw data and the rendering would be the same as the camera JPEG, but then they couldn't improve the processing or add additional features to Lightroom, such as masking. It's all or nothing. One of the major benefits of the raw file format is the ability to tweak the photo to your own taste rather than being tied to the manufacturer's rendering.

The initial preview you see in Lightroom is the JPEG preview embedded by the camera, so it has the manufacturer's own processing applied. Lightroom then renders its own preview, ready for you to start editing. This is why it looks like Lightroom is changing the image.

I shot in B&W—why is Lightroom changing the photos back to color?

The same principles apply to the camera's B&W or monotone setting. The sensor data in the raw files from most cameras remains in color, so Lightroom displays the color photo. You can then use Lightroom to convert the photo to B&W, with full control over the color mix used to convert the file.

Can I emulate the camera's own color?

If you prefer the camera's manufacturer's rendering, Lightroom ships with many camera matching profiles which emulate the camera style settings for many popular cameras. These are found in the Profile Browser, accessed from the Basic panel. We'll come back to these in more detail on page 222.

If you can't remember which picture style you had selected on the camera, select the *Camera Settings* preset in the *Develop module > Presets panel > Defaults group*, and Lightroom attempts to select the correct camera matching profile.

If you'd prefer all photos to automatically have the camera matching profile applied as they're imported, you can update Lightroom's default settings. We'll discuss custom defaults on page 376.

Why are my photos so dark?

Certain camera settings can affect the exposure of your raw file directly or indirectly. Most of the settings you can change on your camera only apply to the manufacturer's own JPEG processing. For example, contrast, sharpening, picture styles and color space don't affect the raw data, however these settings do affect the JPEG preview you see on the back of the camera and the resulting histogram and clipping warnings, which can cause you to change your exposure. There are some specific ones to look out for...

Canon's Highlight Tone Priority automatically underexposes the raw data by one stop to ensure you retain the highlights, leaves a tag in the file noting that this setting was applied, and applies its own special processing to the JPEG preview that you see on the back of the

camera. Lightroom also understands this tag and increases the exposure by one stop behind the scenes to compensate, but if you accidentally underexpose the image with HTP turned on too, you can end up with a very noisy file. When shooting raw for use in Lightroom, there's no advantage to using this setting instead of changing the exposure compensation yourself, so you may wish to turn off HTP and set your exposure to retain the highlights manually.

Canon's Auto Lighting Optimizer and Nikon's Active D-Lighting don't affect the raw data itself, but Lightroom has no idea that you've used these settings, and even if it did, the processing applied by the camera is variable. When ALO or ADL are turned on, that special processing is applied to the JPEG preview that you see on the back of the camera, as well as to the resulting histogram. Seeing this false brighter preview could cause you to unknowingly underexpose the image. You'd then be disappointed to find it's underexposed when you view the unedited photo in Lightroom, so it's a good idea to turn these settings off unless you're shooting JPEG or only using the manufacturer's own software.

Other camera manufacturers have similar settings, so check your camera manual for similar highlight priority and high dynamic range settings. They include Dynamic Range Optimization (Sony), Shadow Adjustment Technology (Olympus) and Intelligent Exposure (Panasonic).

Are there any other camera settings that Lightroom understands?

There are a couple of other settings that Lightroom does understand. The White Balance setting is understood by most raw converters. For example, if you set your camera to *Cloudy* and Lightroom is set to *As Shot*, Lightroom uses the white

balance values set by the camera (although it's still an interpretation by the software programmers). The Kelvin numbers may not match as the values are stored in a different format behind the scenes.

Lightroom also respects the in-camera crop ratio, for example, if you have your camera set to a 1:1 (square) crop, it's also 1:1 in Lightroom. For cameras produced since the end of 2012, you can access the full sensor data using the pop-up in the Crop Options panel in Develop, but older cameras must use the DNG Recover Edges plug-in to access the extra data.

If I shoot sRAW format, can Lightroom apply all the usual adjustments?

While we're talking about raw files, there's also a hybrid file type to consider. Canon and Nikon's reduced resolution formats work slightly differently to standard raw formats. Full raw files are demosaiced by the raw processor, whereas sRAW/mRAW files are demosaiced by the camera and some of the data is discarded to create a lower resolution file. (The demosaic is the process of turning the raw sensor data into image data.)

You still have access to all the controls that are available for raw files, however there are a few things which are usually part of the demosaic processing which are not applied to your sRAW files. Artifacts may also be present, for example, Lightroom maps out hot pixels (bright pixels that appear on long exposures) on full raw files, but can't do so on sRAW files. On some cameras, for example, the Canon 7D, the highlight recovery potential is reduced when shooting in sRAW. Other settings may also behave differently, for example, the sharpening and noise reduction may need slightly different settings.

If you convert to DNG (except Lossy DNG), you'll notice that Canon's sRAW files get bigger instead of smaller because the way the sRAW data is stored is specific to the manufacturer and not covered by the DNG specification.

INSTALLING LIGHTROOM

Just in case you haven't installed Lightroom Classic yet, we'll briefly run through the installation and upgrade

processes. If you're already up and running, you can move on to the next chapter starting on page 21.

Minimum System Requirements

The minimum system requirements for installing Lightroom Classic are found at https://www.Lrq.me/classic-sysreq

These are the absolute minimum required in order to actually install Lightroom, but it is likely to 'walk' rather than run on these specs! Lightroom does benefit from higher specification hardware.

Installing Lightroom

To install Lightroom, click on the Creative Cloud icon in the System Tray (Windows) / Menubar (Mac) and select the Apps tab. Scroll down to Lightroom Classic (not Lightroom!) and click Install. (Figure 2.7)

If you don't have the Creative Cloud desktop app (often shortened to CC app) installed, log in to your account at https://www.adobe.com and select the Desktop Apps from the menu. Find Lightroom Classic and click the Download button. It prompts you to install the Creative Cloud desktop app, and then you can follow the previous instructions.

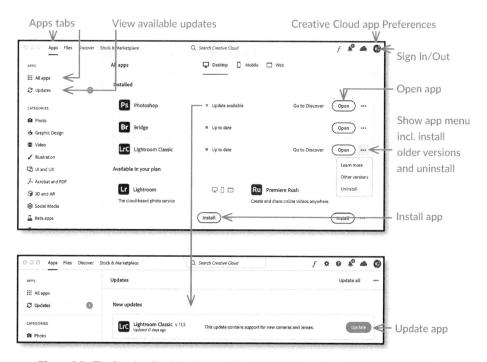

Figure 2.7 The Creative Cloud Desktop app allows you to easily install and update Adobe software.

Opening Lightroom

To open Lightroom again in future, return to the CC app and click Lightroom's **Open** button.

While Lightroom's open, you can set up a shortcut for easier access. On Windows, right-click on the icon in the Taskbar and select *Pin to Taskbar*. On macOS, right-click on the icon in the Dock and select *Options* > *Keep in Dock*.

Splash Screen

As Lightroom loads, it displays a splash screen, but if you'd prefer to display your own photo, create a folder called Splash Screen in the following locations, and put the photo inside:

Windows—C: \ Users \ [your username] \ AppData \ Roaming \ Adobe \ Lightroom \ Splash Screen \

Mac—Macintosh HD / Users / [your username] / Library / Application Support / Adobe / Lightroom / Splash Screen /

If you add multiple photos to this folder, Lightroom cycles through them on startup.

To turn it off completely, go to Lightroom's *Preferences > General tab* and uncheck **Show splash screen during startup** in Lightroom's Preferences dialog.

Setting the Language

Lightroom's not just limited to English—it's also available in Chinese Simplified, Chinese Traditional, Dutch, French, German, Italian, Japanese, Korean, Norwegian, Polish, Portuguese, Russian, Spanish, Swedish or Thai.

By default, it uses the same language as

the operating system. To switch to another language, go to *Edit menu* (Windows) / *Lightroom menu* (Mac) > *Preferences* > *General tab*, select the language you want to use and then restart Lightroom.

Some keyboard shortcuts don't work on international keyboards. In Appendix E on page E19, you'll find instructions for editing the keyboard shortcuts.

Activation

Lightroom Classic requires online activation, and it allows activation on two machines at any time (although you can have it installed on additional computers). The activation process runs automatically while installing Lightroom, and all you need to do is remained signed in with your Adobe ID.

You don't need to remain connected to the

MULTIPLE COMPUTERS

Lightroom's license agreement is cross-platform (both Windows and Mac) and it allows the main user to use Lightroom on two computers, for example, a desktop and a laptop.

Lightroom isn't designed to be used over a network. The Lightroom catalog needs to be stored on a locally attached drive (internal or external), and can only be used by one person at a time. The photos, however, can be stored on a network drive or NAS unit.

There are options for using your catalog on multiple machines, such as between your desktop and laptop. We'll explore the options in the Multiple Computers chapter starting on page 468.

internet after activation, so even traveling to remote areas isn't a problem. Lightroom just needs to be able to 'phone home' at least every 99 days. If you're going to be away from internet, make sure your laptop battery doesn't die, as this can reset the activation.

If you need to switch computers, you can go to *Help menu > Sign Out* to deactivate a computer, but if you forget, don't worry. When you try to activate on a third computer, Lightroom warns that you're already activated on two machines and offers to deactivate them remotely.

Desktop App Usage Information

When you start Lightroom for the first time, it warns you that it'll send some usage information back to Adobe, to help them improve the program. This includes information about your Lightroom usage, but not your photos or other personal information.

If you don't want to share this information with Adobe, go to Help menu > Manage My Account, log in, and select Desktop App Usage Information under Security & Privacy, then uncheck the checkbox.

Creating Your First Catalog

Once Lightroom's installed, there are very few differences between the Windows

and Mac versions, apart from the slightly different appearance. We'll carry on using the Mac version for screenshots, but where there are notable differences, we'll show both. Let's get started...

(If you're upgrading from a previous Lightroom version, skip to page 17.)

If you haven't used Lightroom before, it asks where to store the catalog and how to name it. (Figure 2.8) This is important, because the catalog contains your Lightroom edits. By default, the catalog is called Lightroom Catalog.Ircat and it's stored in a Lightroom folder in your main Pictures folder.

Next to the catalog, Lightroom creates a Previews folder (Windows) / file (Mac) called Lightroom Catalog Previews.Irdata, among other files. The previews folder/file contains a small JPEG preview of all the photos you import so it can grow very large.

If you have plenty of space on your boot drive (usually C:\ on Windows or Macintosh HD on Mac), click *Continue* to select the default location.

If your boot drive's low on space or you'd prefer an alternative location for your catalog, click *Choose a Different Destination* and select your chosen folder and catalog name. (The catalog must be stored on an internal or external hard drive, not network storage.)

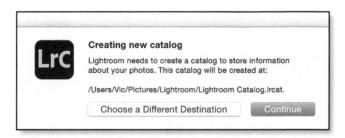

Figure 2.8 Lightroom asks where to store your new Lightroom catalog.

Either way, make a note of the catalog name and location you choose, as you'll need to ensure these files are backed up.

Lightroom may ask whether you want to sync your photos, so you can access them in Lightroom (cloud-based) on your mobile phone, tablet or another computer. We'll come back to these options in more detail in the Cloud Sync chapter starting on page 547. If in doubt, turn it off for now.

Lightroom's main interface opens with some initial tips in the center of the screen. (Figure 2.9) These tips give you a quick guided tour of Lightroom. Press *Next* to view the tips or click anywhere else on the screen to hide them.

KEEPING LIGHTROOM UPDATED

Lightroom's updated every 2-3 months. The updates include support for new cameras and lenses as well as bug fixes, so it's worth staying up to date.

Since Lightroom is now subscription software, it often receives new features in dot releases (e.g., 12.4), rather than having to wait for the next major release number

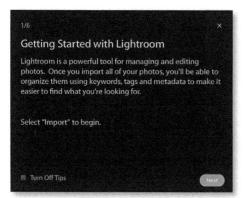

Figure 2.9 Tips appear in the center of the screen.

(e.g., 13.0).

The version numbers are usually increased at the Adobe Max conference in October/ November each year, with dot release numbers in between. The numbers are just used for identification, for example, when asking for support or checking you have the latest book version.

How do I check which version I'm currently running?

To check which version you're running, go to the *Help menu > System Info* and the first line confirms the version and build number. (Figure 2.10)

How do I update to the latest version?

The updates appear in the CC app, which you previously used to install Lightroom. Click the *Update* button to install the update.

Alternatively, you can enable auto update by opening the CC app's *Preferences > Apps tab > Auto Update*.

How do I find out what's changed in an update?

Lightroom displays a simple What's New dialog, but you'll find more extensive release notes on my blog at https://www.Lrq.me/whatsnew/classic/

This book is also updated for each release, describing how to use the new and updated features. If your Lightroom Classic Premium Membership is active, you can download the latest update from the Members Area.

How do I roll back to an earlier version?

Before a new release of Lightroom, extensive testing is done. However, due to the many variations of computer hardware

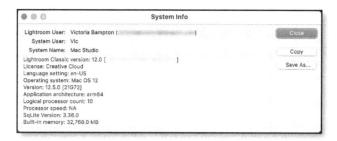

Figure 2.10 The first line of the System Info dialog shows your current build number.

and operating systems, sometimes an issue is found that's serious enough that you'd want to roll back to a previous release.

In the CC App, click Lightroom Classic's ... button, select **Other Versions** and click on the version number you want to install.

How do I uninstall Lightroom?

If you need to uninstall Lightroom, perhaps while troubleshooting, open the CC app and click Lightroom Classic's ... button and select *Uninstall*. (Figure 2.11)

What happens to Lightroom if my subscription expires?

If you cancel your subscription, most of Lightroom carries on working, so you don't lose access to your photos or the work you've done to them. You can still view and export your photos, and even add new ones, but the Develop module, Map module and Sync all stop working.

UPGRADING YOUR CATALOG

Occasionally, Lightroom needs to upgrade your catalog. This updates the database format to enable new features or improve performance.

Figure 2.11 To uninstall, click the ... icon in the Creative Cloud app.

Any catalogs from Lightroom 1-6 or Lightroom Classic can be upgraded to the current Lightroom Classic catalog format.

How do I upgrade my catalog?

If Lightroom needs to upgrade your catalog, it asks for permission. (Figure 2.12) It creates a copy of your Lightroom catalog, adds -v12 to the end of the catalog name (you can choose a different name in the Catalog Upgrade dialog), borrows the previews files from the earlier version, and upgrades the catalog format.

Your original catalog remains untouched, so you may want to move it to your backups folder once the upgrade is complete, to avoid confusion.

If you have Lightroom's *Preferences > General tab > Default catalog* set to open a specific catalog, don't forget to update to the latest catalog version, otherwise it will ask you to upgrade every time you open Lightroom.

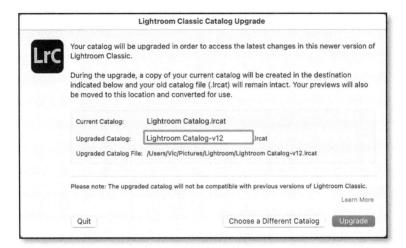

Figure 2.12 When you try to open an older Lightroom catalog, Lightroom asks for permission to upgrade it to the current format.

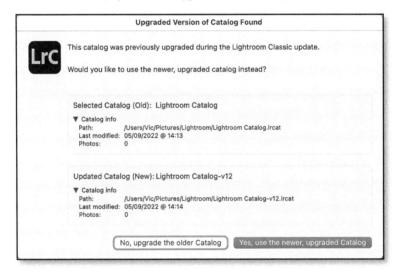

Figure 2.13 If you try to open a catalog that's already been upgraded, Lightroom asks which version to open.

What happens if I try to open the earlier version of my catalog again, after it's been upgraded?

If you accidentally try to open the older catalog again, perhaps by double-clicking on the wrong one, Lightroom asks you whether to open the upgraded catalog or upgrade it again. Yes, use the newer, upgraded catalog is

almost always the right answer, as the older catalog won't include any of the edits you've done since upgrading. You may choose to upgrade again if there was a problem with the first upgrade, for example, missing data, but these issues are very rare. (Figure 2.13)

Once I've upgraded the catalog, can I go back to an earlier Lightroom version?

Once you've upgraded your catalog, you won't be able to open the upgraded catalog in an earlier Lightroom version. You'll still have your older catalog untouched, however if you work on the upgraded copy in Lightroom Classic, for example, using a trial version, and then decide to go back to Lightroom 6 or earlier, the changes you've made to your photos in Lightroom Classic will not show up in your older catalog.

CALIBRATING YOUR MONITOR

Before you start editing seriously, it's worth taking the time to calibrate your monitor.

Why should I calibrate my monitor?

When you walk into a TV store and look around, you'll notice that all of the screens are slightly different. Some are a little brighter, some are a little darker, some are more contrasty, others have less contrast, some are more colorful, some are warm, some are cool... the differences go on.

If you display the same image on all of these screens, they'll all look slightly different. The same applies to computer monitors. The same photo will look different, depending on the screen you're using.

The aim of monitor calibration is to adjust all of these different screens to a standard, so the photo looks similar regardless of the screen you're viewing at the time.

Trying to edit your photos on an uncalibrated monitor is like trying to edit with your eyes closed. You'll be guessing what they look like.

Your surroundings also influence your

perception of brightness and color. Ideally, it's best to edit your photos in dim light, with the light source no brighter than the screen. This may be as simple as closing the curtains and turning on a small desk lamp holding a daylight bulb.

When you put your photos out into the world, you can't control exactly how they'll look, because most people don't calibrate their monitors, but editing your photos on a standardized system gives you the best shot at getting your prints to match the screen.

How do I calibrate my monitor?

Monitor calibration isn't complicated. You simply need a monitor calibration tool and the software that comes with it. The main players are X-Rite's ColorMunki and i1 Display Pro devices, and Datacolor's range of Spyder devices. The software will differ slightly, but the principles remain the same. Let's use the i1 Display Pro to illustrate:

- **1.** Install the software and drivers that come with the calibration device.
- **2.** Follow the instructions in the software. (Figure 2.14) Most ask you to make a few decisions:

Figure 2.14 Calibration software asks you a few basic questions.

Monitor Technology—Newer monitors are probably *White LED*, while older ones are mainly *CCFL*. The software often selects the right one automatically.

White Point-select D65 or 6500.

Luminance—select 120 cd/m2 as a starting point. (You may increase/decrease it later, if your prints are a little darker/lighter than you see on screen.)

Contrast Ratio-select Native.

- **3.** Place the calibration device on the screen, ensuring that it's flat against the screen with no ambient light creeping in the sides, and start measuring. (**Figure 2.15**)
- **4.** The software measures the brightness of the screen, and tells you how bright it is currently. Use the monitor buttons (or *System Preferences > Display* on a Mac with a built-in screen) to increase or decrease the monitor brightness until the line is in the green 'optimum' area. Most monitors are way too bright, so don't be surprised if you have to make a big adjustment.

Some high-end monitors make these adjustments automatically. Other monitors may also ask you to adjust contrast or RGB values to match the target values.

5. The calibration software then flashes a series of colors on the screen, measuring each in turn, so it can build a profile.

6. When the calibration finishes, give the profile a sensible name (perhaps include the date) and click the *Save* button, then close the software. You'll need to recalibrate periodically, as monitors drift over time.

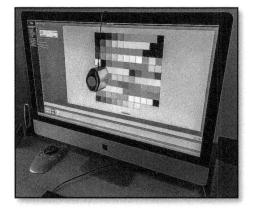

Figure 2.15 The calibration puck is placed on the monitor, where it reads a series of swatches displayed on the screen.

HELP SHORTCUTS

		Windows	Mac
Help Lightroom Help Current Module Help Current Module Shortcuts	Lightroom Help	F1	F1
	Current Module Help	Ctrl Alt /	Cmd Opt /
	Current Module Shortcuts	Ctrl /	Cmd /

IMPORTING PHOTOS & VIDEOS

3

As Lightroom is built around a database, the first thing you need to do is add the information about your

photos and videos to this database. This process is called Importing, but don't let that confuse you. Although it's called Importing, the photos don't go 'into' Lightroom. A better word to describe the process might be reference, link, or register.

Importing the photos simply means that the information describing the photos and videos is added to the database as text records, along with a link to that file on the hard drive and a small JPEG preview. Remember, it's like an index of the books in a library. The library catalog tells you a little about the book and which shelf it's stored on, and maybe even gives you a preview of the cover, but it doesn't contain the book itself. (Figure 3.1)

Where are my photos?

Before you can start adding your photos to Lightroom, you need to know where they're currently stored. I can't answer that question for you, but there are a few common places to look:

- Your phone or tablet.
- Your camera's memory card.
- The Pictures or Photos folder on your

computer.

- Other internal or external hard drives.
- Cloud services, such as Google Photos and Dropbox.
- If you've been using Photoshop Elements to organize your photos, there's an Import tool to transfer your existing photos into Lightroom. See Appendix E in the eBook formats (page E30) for more detail.
- On macOS, Photos app and the legacy iPhoto and Aperture apps default to storing photos in a special kind of folder called a package file, which is not accessible using other software. There's more information on transferring photos from these apps in Appendix E (starting on page E25).

Figure 3.1 Like a manual library card catalog, Lightroom keeps track of where your photos and videos are stored, and information about them, but it doesn't contain the photos/videos themselves.

Once you've found your photos, you then need to decide where you'll store them in future.

Where should I store my photos?

Lightroom doesn't hide your photos away from you. They're kept as normal image files in folders on your hard drive.

The benefit? You have complete control over where your photos are stored, you're not locked in to using Lightroom forever, and you can access the photos using other software.

The downside? That makes you responsible. You need to know where they're stored, how to back them up, and you need to understand how what you do in Lightroom affects these files on the hard drive. Don't worry, we'll learn all the basics you need to know in the Fast Track sections of this book.

When you import your photos, YOU make the decision on where to store the photos (even if that decision is to accept Lightroom's defaults). It's possibly the most important decision you'll make in Lightroom, so it's worth taking the time to pay attention to the choice you make.

At the top of the Import dialog, you're given three main choices: will you copy the photos to a new location, move them to a new location or just add links to the catalog, leaving the image files where they are. (Figure 3.2)

Stop and think about these options for a moment. Your choice will depend on whether you're copying new photos from a camera/memory card or adding existing photos.

If your photos are currently on a memory card, and you tell Lightroom to "add" them at

Copy as DNG Copy Move Add Copy photos to a new location and add to catalog

Figure 3.2 Select Copy at the top of the dialog to copy the photos to your hard drive, or Add to leave them in their current location.

their existing location, Lightroom will record their location as being on the memory card. What will happen when you eject the card? Lightroom will look for the photos on the memory card but won't be able to find them any more, so you won't be able to edit and export them. And when you format the memory card? Gone forever! There won't be a copy on your computer's hard drive, because you didn't tell Lightroom to copy them. So when you're importing photos from a memory card, it's ESSENTIAL that you select *Copy* at the top of the Import dialog.

But what if you're adding photos that are already on your hard drive? Your choice will depend on how organized your photos are:

If your photos are beautifully organized into an existing folder structure, you'll want to select *Add*. This simply adds the information describing the photos to Lightroom's catalog, but the photos remain in their current location. Remember, if you then rename, move or delete the photos outside of Lightroom, Lightroom will no longer be able to find them.

If your photos aren't quite so organized—or if they're spread haphazardly across your computer's hard drives—then you might want to consolidate them in a single location. While importing, Lightroom can copy them to a new location, leaving the originals scattered across your computer (and therefore taking up twice the hard drive space), or it can move them to a new location.

If you're copying or moving photos, you pick the location in the Import dialog's Destination panel. You have to make a one-time decision... where will you store your photos?

The default location is the Pictures folder in your user account. This is a perfectly good location, as long as you don't have too many photos and you have a big hard drive. But what if your hard drive is too small?

Lightroom doesn't mind where you choose to store the photos. They can be on an internal drive, an external drive, a network drive, or even a mix of different drives. The important detail is that YOU know where they are so you can back them up.

You can make life easier for yourself by keeping your folders of photos under a single parent folder (or one for each drive), rather than scattering them in random locations. Why?

- If the folders of photos are grouped in a folder called "Lightroom Photos" or another easily identifiable name, it reminds you not to rename, move or delete these photos.
- If you need to move them to another drive or another computer, it's far easier to copy/ move a single folder with its subfolders than it is to hunt around 300 different folders on your computer.
- It's easier to back them up when they're all stored under a single parent folder.

As your collection of photos grows, you may need to expand onto additional hard drives, which isn't a problem for Lightroom.

So where will you store your photos? Made your decision? Then let's start importing your photos...

How do I import my photos?

When you initially open the Import dialog (Figure 3.3), it may look a little overwhelming, but don't worry, it's simpler than it looks. There are three main decisions to make: where to find the photos (the source), how to handle the photos (copy/move/add) and if you're copying or moving the photos, where to put them (destination). The rest of the options are, well, optional!

First, we'll step through the basics of getting your photos into Lightroom, and then we'll go back through the individual elements of the Import dialog in more detail. Although we'll mainly refer to importing photos throughout the chapter, the instructions apply to videos too. Let's get started...

- **1.** If you're importing from a memory card, insert your memory card into the card reader or attach the camera to the computer. Card readers usually work more reliably with Lightroom than USB camera connections.
- **2.** If the Import dialog doesn't open automatically, go to *File menu > Import Photos and Videos* or by pressing the *Import* button in the lower left corner of the Library module.
- **3.** On the left of the Import dialog is the Source panel, with memory cards at the top and hard drives listed below.
- **4.** If you're importing from a memory card, click on its name. If you only have a single device (i.e. card reader, camera or phone) attached, it's selected automatically.
- **5.** If you're importing existing photos, navigate to the location of your photos in the lower *Files* section of the Source panel.
- 6. If the photos are stored under a single

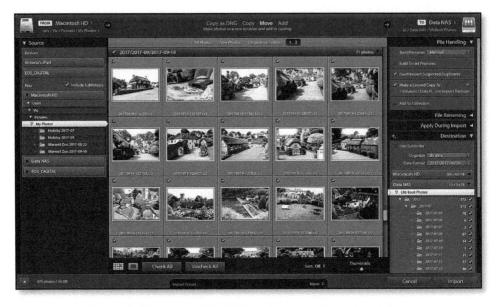

Figure 3.3 Photos are added to Lightroom's catalog using the Import dialog.

folder, such as the My Photos folder in **Figure 3.4**, select that folder and check the *Include Subfolders* checkbox.

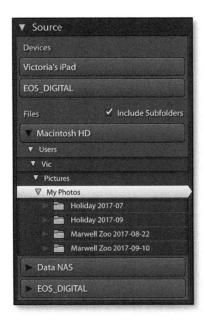

Figure 3.4 Select the memory card or folder of photos in the Source panel.

- **7.** If your photos are spread across multiple folders, hold down Ctrl (Windows) / Cmd (Mac) while clicking on each folder, or hold down Shift while clicking on the first and last folder in a series of consecutive folders.
- **8.** Thumbnails start to appear in the central preview area. They make take a while to appear if you have thousands of photos, but you don't need to wait for them to finish appearing before continuing. It's possible to view and check/uncheck photos in the Import dialog, but it's easier to sort through them in the Library module after import.
- **9.** At the top of the Import dialog (Figure 3.5), decide how to handle the files you're importing.

If you're importing from a memory card, select *Copy*, to copy the photos to your computer's hard drive.

If you're importing from a hard drive, you have a choice: do you want to leave the photos where they are, or copy/move them

Copy as DNG Copy Move Add Copy photos to a new location and add to catalog

Figure 3.5 Select Copy at the top of the dialog to copy the photos to your hard drive, or Add to leave them in their current location.

to a new location? Select...

Add—To reference the photos at their current location, select *Add*. This is a good choice if your photos are already arranged in a tidy folder structure that you'd like to keep.

Move—To let Lightroom move the photos to a new location and automatically reorganize them, select *Move*. This is most useful if your photos are spread across your hard drives in a slightly disorganized fashion.

Copy—To leave the original photos alone and create a copy in the location you choose in the Destination panel, select *Copy*. You'll need twice as much hard drive space if you choose this option, as you'll be duplicating all of your photos, but it leaves your current system intact.

- **10.** On the right-hand side of the Import dialog are a variety of different settings you can apply while importing the photos. We'll use some default settings to get started, and explore the options in more detail later in the chapter.
- **11.** In the File Handling panel (Figure 3.6), set the following:

Build Previews—Standard.

Build Smart Previews—checked.

Don't Import Suspected Duplicates—checked.

Make a Second Copy-If you're importing

existing photos, leave it unchecked. If you're importing from a memory card, check it then click on the file path and choose a location on another hard drive as a temporary backup.

Add to Collection—unchecked.

12. In the File Renaming panel (**Figure 3.7**), if it's available, leave *Rename Files* unchecked or turn to the File Renaming panel section starting on page 36 to learn more.

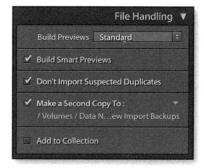

Figure 3.6 In the File Handling panel, choose your preview size and temporary backup location.

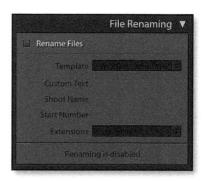

Figure 3.7 In the File Renaming panel, set a new file naming template, or leave it unchecked to retain the camera filename.

13. In the Apply During Import panel (Figure 3.8), set the following:

Develop Settings—None.

Metadata—None or turn to page 41 to learn how to create your copyright metadata preset.

Keywords—leave it blank.

- **14.** If you've set the import type to *Add*, your work is done—press *Import* and allow Lightroom to register all the selected photos in the catalog.
- **15.** If you've chosen *Move* or *Copy*, you need to choose where to put the photos. By default, Lightroom copies your photos into the Pictures folder in your user account, but you can choose another location. In the Destination panel, you'll see a volume bar for each drive that's attached to your computer. When you click on the bar, the drive opens to show the enclosed folders. To see hidden subfolders, click the small triangles.

To select a folder, click on it so it's highlighted in white, like the Lightroom Photos folder shown in **Figure 3.9**. Double check this destination every time you import photos.

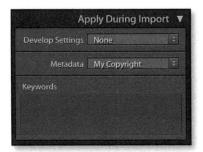

Figure 3.8 In the Apply During Import panel, add your copyright metadata.

16. Then you need to decide how you're going to organize the photos. The options at the top of the Destination panel allow you to set the folder structure. As you try different settings, the folders in the lower half of the Destination panel update, so you can test different options to see what will happen. The folders in italic will be created by your import settings.

We'll go into more detail on the pros and cons of different systems starting on page 42. If you're not sure what to choose, I'd recommend a simple dated folder structure, with one folder per month, grouped by year, but here's a few different options:

To copy/move the photos **directly into the folder** you've selected, select *Into One Folder* in the **Organize** pop-up.

To **create a named subfolder** for the photos, check *Into Subfolder*, enter the name of the new subfolder, and select *Into One Folder* in the *Organize* pop-up. (Figure 3.10) This is useful when copying photos from a memory card into a manually-created folder structure.

To create a date-based folder structure automatically, select *By Date* from the *Organize* pop-up and a folder structure from

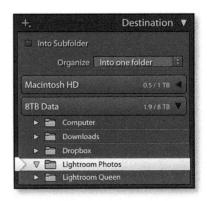

Figure 3.9 Select the Destination folder, highlighted in white.

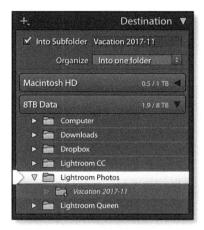

Figure 3.10 You can place the photos into a named subfolder.

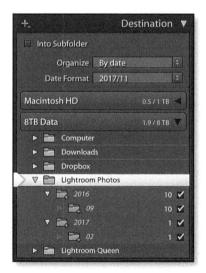

Figure 3.11 Alternatively, you can automatically create a dated folder structure based on the metadata of the selected photos.

Figure 3.12 The recently imported photos are grouped in the Current Import / Previous Import collection.

the *Date Format* pop-up. If you're not sure which to select, the YYYY/MM option is a good default. (**Figure 3.11**) We'll go into more detail in the Destination panel section starting on page 42.

17. Before you start the import, double check the folders in italic, to make sure the folder structure looks correct. The wrong parent folder being selected can cause confusion (see page 46 for more detail), so it's worth checking this italic preview every single time you import new photos.

18. Finally, press Import.

19. The Import dialog closes and the new photos start to appear in the Library module. The photos are grouped in a special collection in the Catalog panel called *Current Import* (which then changes to *Previous Import*) (**Figure 3.12**), and their folders also appear in the Folders panel.

Congratulations, your photos are now cataloged by Lightroom! If you're itching to start using Lightroom, you can now skip on to backing up your photos (page 59) and then viewing them in Lightroom (page 81), and come back to the rest of this chapter later. If you're still with me, let's go back and explore the individual elements of the Import dialog in more detail.

IMPORT IN DETAIL

In Lightroom, there are usually multiple ways to accomplish the same task. For example, to open the Import dialog you can go to File menu > Import Photos, press the Import button at the bottom of the left panel group in the Library module, or use the keyboard shortcut Ctrl-Shift-I (Windows) /

Cmd-Shift-I (Mac).

How do I automatically open the Import dialog?

Lightroom can also open the Import dialog automatically when you insert a memory card. There are two different behaviors involved in the Import dialog opening automatically: whether Lightroom opens the Import dialog when the program is already open, and whether the program launches by itself even though it was closed.

To change this auto-open behavior, go to Lightroom's *Preferences dialog > General tab* and check or uncheck **Show Import dialog when a memory card is detected.** (Figure 3.13)

On Windows, this checkbox controls whether the Import dialog opens automatically when a card is detected, and also whether the program launches from closed (using Windows Auto Play).

On a Mac, the checkbox only controls whether Lightroom opens the Import dialog when the program is already open. To set Lightroom to launch from closed, insert the memory card or plug in the device. Go to the Applications folder, open the Image Capture app, and select the memory card or device on the left-hand side. In the lower left

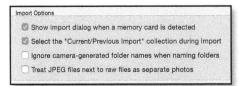

Figure 3.13 The Show import dialog when a memory card is detected checkbox in the Preferences dialog > General tab controls whether the Import dialog automatically opens when a device is connected. On Windows it also launches Lightroom if it's closed.

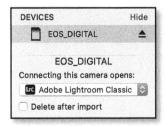

Figure 3.14 On macOS, Image Capture controls whether Lightroom opens.

corner, click the arrow, and select Lightroom as the program to automatically open when that device is detected. (Figure 3.14)

The same logic applies, not just to card readers and cameras, but also to mobile phones and tablets, USB keys, printers with card readers, and various other devices.

SOURCE PANEL

When importing photos into Lightroom, you first need to select the source of the photos using the Source panel. (Figure 3.15) Remember, at the top of the panel are your devices—cameras, card readers, mobile devices, and so forth—and below that are the hard drives attached to your computer, as well as any mounted network drives. To select a source, simply click on the folder or device of your choice.

Why do the folders keep jumping around when I click on them?

When you click on different folders in the Source panel (and later in the Destination panel too), Lightroom can appear to have a mind of its own, with different behavior depending on whether you single-click or double-click, but it's actually a useful feature.

If you navigate around by single-clicking on the folder arrows or folder names, the navigation behaves normally. If you doubleclick, or if you right-click and choose **Dock Folder** from the context-sensitive menu, you can collapse the folder hierarchy to hide unnecessary folders. (**Figure 3.16**) It makes it easier to navigate through a complex folder hierarchy, especially if it's many levels

▼ Source EOS DIGITAL Macintosh HD Applications Library System Users Guest Shared **Applications** Creative Cloud Files Desktop Documents Downloads Library Pictures Public 2TB Data

Figure 3.15 The Source panel on the left of the Import dialog allows you to select the folder or device to import.

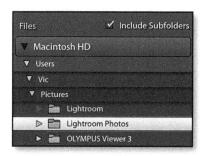

Figure 3.16 With the My Photos folder docked, some non-essential folders are hidden.

deep and the panel is too narrow to read the folder names. If you collapse it down too far, just double-click on the parent folder to show the full hierarchy again. (Figure 3.17)

How do I import from multiple folders or memory cards in one go?

If all the photos you want to import are in subfolders under a single parent folder, for example, within a Photos folder, then you can select that parent folder and check the *Include Subfolders* checkbox. All the photos from the subfolders display in the preview area, ready to be imported.

If your photos are spread around multiple folders, hold down Ctrl (Windows) / Cmd (Mac) while clicking on each folder. (Figure 3.18) The multiple folders don't even have to be on the same drive as long as they appear in the *Files* section of the Source panel. If the folders are consecutive, hold down Shift while clicking on the first and last folder in a series to select them without

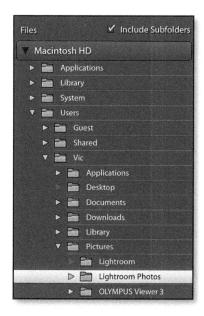

Figure 3.17 When the folders list is undocked, the folder list can become very long.

having to click on each one.

Multiple selections are limited to folders shown in the *Files* section. You can't import from two separate devices in one go, for instance, two card readers. However if the operating system sees the memory cards as two drives in the lower *Files* part of the Source panel, you can Ctrl-click (Windows) / Cmd-click (Mac) on the folders to import both at once.

Can I use the operating system dialog to navigate to a folder instead of using Lightroom's Source panel?

If you're more comfortable using the operating system dialog to select a folder, click on the large button in the top left corner of the Import dialog. (Figure 3.19) (Yes, those corners are large buttons, even though they don't look like it!) The Other Source option in that menu displays the operating system dialog. It also lists

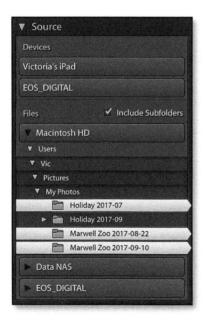

Figure 3.18 You can select multiple folders for import.

shortcuts to popular folders such as *Desktop* and *Pictures*, as well as recent sources. When you select a folder using any of these options, the Source panel automatically updates to display that folder.

The top right corner behaves the same way, except it updates the Destination panel.

PREVIEWING AND SELECTING INDIVIDUAL PHOTOS

Having selected the source of the photos, the photo thumbnails start to populate the central preview area. In this grid, you can view the photos and select the ones you want to import.

A photo count displays in the bottom left corner of the dialog, showing how many photos are checked and how much hard drive space they fill. (Figure 3.20)

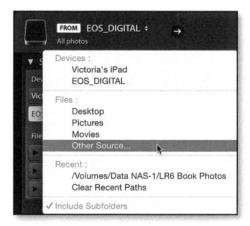

Figure 3.19 Click on the top corners of the Import dialog to view a menu of recent sources and to access the operating system dialog.

Figure 3.20 A photo count displays in the bottom left corner.

How do I select only certain photos to import?

The checkbox in the corner of the thumbnail controls whether the photo is included in the import. They're all checked by default. The **Check All** and **Uncheck All** buttons below the grid check/uncheck all the photos in one go, or you can click the individual checkboxes to select or deselect specific photos.

To check or uncheck a series of photos, hold down Ctrl (Windows) / Cmd (Mac) while clicking on photos to select non-consecutive photos, or Shift-click on the first and last photo to select a group of consecutive photos. Once you have the photos selected, shown by a lighter gray surround, check or uncheck the checkbox on a single photo to apply that same checkmark setting to all of the selected photos.

20140919-130245.cr2
20140919-131955.cr2

Figure 3.21 Dimmed thumbnails without a checkbox (bottom) aren't available for import. Thumbnails with a vignette are unchecked and can be imported by checking the box (top right).

Why are some photos unavailable or dimmed in the Import dialog?

You might notice that some of the photos appear dimmed in the Grid. Photos shown with a vignette are unchecked photos, but they can be selected for import by toggling the checkbox. (Figure 3.21)

Dimmed photos that don't have a checkbox are unavailable for import, either because they're already in your current Lightroom catalog at that location, or they're already in your catalog at a different location and you have *Don't Import Suspected Duplicates* checked in the File Handling panel.

How do I change the preview size?

On the Toolbar below the grid, to the right, the *Thumbnails* slider adjusts the size of the thumbnails. The thumbnails embedded in the files are usually small and low quality, but there's also a larger JPEG preview embedded in most photos. These larger previews aren't used for the Grid view as they're slower to load, but the Loupe view allows you to take advantage of the larger preview.

Can I change the sort order?

Also on the Toolbar is the **Sort** pop-up (**Figure 3.22**), which allows you to sort the thumbnails in the Grid

Figure 3.22 At the bottom of the Import dialog grid, you'll find the sort order pop-up and thumbnail size slider.

The options are:

Capture Time sorts the photos based on their capture time.

Checked State displays the checked photos first, followed by the unchecked photos.

Filename sorts the photos in alpha-numeric filename order.

File Type displays the photos grouped by file type, for example, all of the CR2 files, then the JPEGs, then the TIFFs.

Media Type displays the videos first, followed by the photos.

Off disables sorting.

Can I filter the photos?

As well as changing the sort order, you can filter the photos shown in the Grid using the Filter bar above the thumbnails. (Figure 3.23)

All Photos—displays all the photos in the selected source.

Figure 3.23 Along the top of the Import dialog grid is a Filter bar. Clicking on Destination Folders divides the thumbnails into groups.

New Photos—hides any photos that have already been imported and are recognized as duplicates.

Destination Folders—breaks up the grid into sections based on the folder structure you set in the Destination panel, for example, by date. These grid sections can be collapsed by clicking on the triangle on the left, and whole groups of photos can be checked or unchecked using the checkbox on the dividing row.

How do I select specific file types?

Select the *File Type* sort order in the *Sort* pop-up in the toolbar. This groups the photos by their file type. Click *Uncheck All*, then hold down Shift, click on the first photo of your selected file type, then click on the last photo of the same type. Finally, check one of the selected photos to check all of them.

Can I see a larger preview before importing?

To show a larger Loupe view of a photo, select any thumbnail and press the Loupe button on the Toolbar (Figures 3.24 & 3.25) or double-click on the thumbnail. (If it doesn't work, the file may not include a larger preview, or Lightroom may be having trouble reading it, so go ahead and import the photos and view them in the Library module instead).

Below that Loupe preview is the checkbox to include or exclude the photo from the Import. Be careful marking photos in the Import dialog, because if you accidentally close the Import dialog before importing, you can lose all the work you've done selecting files, whereas marking photos in the Library module saves as you go along.

Press the Grid button on the Toolbar or

Figure 3.24 Below the thumbnails or preview are Grid and Loupe buttons for switching between these views.

Figure 3.25 The Loupe view allows you to see a larger preview of the photo before importing.

double-click on the photo to return to Grid view again.

IMPORT METHOD

Having selected the photos, you need to decide how to handle them. While importing, you can copy them, move them, or leave them where they are. (Figure 3.26) These options are found at the top of the Import dialog.

Copy as DNG copies the photos to a folder of your choice, and converts the copies of any raw files to DNG format, leaving the originals untouched. DNG, or Digital Negative, is an openly documented raw file format. Some cameras create DNG files

Copy as DNG Copy Move Add Copy photos to a new location and add to catalog

Figure 3.26 At the top of the Import dialog, choose how to handle the files.

natively, and other raw files can also be converted to the DNG format. It's worth understanding the pros and cons so you can make an informed decision. In the Geeky Bits Appendix starting on page E1, we explore all the benefits and disadvantages, as well as how DNG can be integrated into your workflow.

Copy also copies the photos to a folder structure of your choice but it doesn't convert them to DNG format. As it's duplicating the photos, it takes up additional hard drive space, so it's primarily used when copying photos from a memory card or other device, rather than importing existing photos from the hard drive.

Move copies the photos to the folder structure of your choice but it also removes the files from their original location. The *Move* option is particularly useful if you want Lightroom to reorganize your existing photos while importing, as it doesn't take up additional hard drive space.

Add leaves the files in their current folder structure with their existing filenames, and references them, or links to them, in that original location. This is a great option for importing existing photos if you already have an organized filing system. You'll note that the File Renaming and Destination panels on the right are missing, since they don't apply when adding photos without moving them.

Why can't I select Move or Add?

When you're importing from a device such as a camera or card reader, Lightroom disables the *Move* and *Add* options to protect you from accidental loss. Most file corruption happens during file transfer, and if you moved the files instead of copying them, you would no longer have an uncorrupted copy on the card. Also, if you use *Add* to reference

the photos directly on the card, you could format the card believing that the files are safely imported into Lightroom, only to discover that Lightroom can no longer find the files.

For that same reason, there's no delete photos from memory card once uploaded option, because it's good practice to verify that the data is safe before you delete the files. Formatting the cards in your camera, rather than the computer, also minimizes the risk of corruption.

FILE HANDLING PANEL

Further file handling options appear in the File Handling panel on the right. (Figure 3.27) Using this panel, you choose the size of the previews to be created after

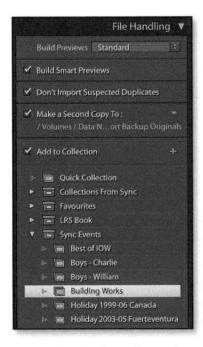

Figure 3.27 The File Handling panel on the right of the Import dialog allows you to set initial preview size, duplicate handling, temporary backups and collection membership.

importing, how to handle duplicate photos, and whether to copy the photos to a temporary backup location.

Why do I have to create previews? Why can't I just look at the photos?

The first option in the File Handling panel is **Build Previews**. All raw processors create their own previews because raw data has to be converted in order to be viewed as an image. Lightroom creates previews of all file types, so that non-destructive edits can be previewed without damaging the original image data. These previews also allow you to view the photos when the original files are offline, for example, when your external drive is disconnected.

What size previews should I build?

There are four preview size options:

Minimal—extracts the thumbnail preview embedded in the file. It's a quick option initially, but it's a very small low quality preview, usually with a black edging and about 160px along the long edge, so you then have to wait to for previews to build as you browse. They're useful if you're in a hurry to import, but don't need to look at the photos until later. Minimal previews aren't color managed.

Embedded & Sidecar—extracts the JPEG preview embedded in a raw file or the sidecar JPEG for viewing in the Library module. This is quicker than building standard or 1:1 previews, so they're useful for initially viewing the photos and selecting your favorites. They don't have any Lightroom adjustments applied, so they look like the camera JPEGs. We'll discuss embedded previews in more detail on page 89.

Standard—builds Lightroom's own previews

Import Preview Decision Tree

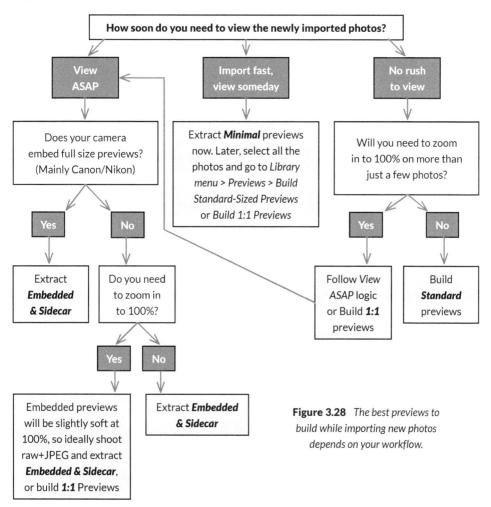

immediately after import, so the photos look the same as they do in the Develop module. Lightroom will have to build standard previews at some point, so if you're not in a hurry to start viewing the photos, this is a good choice.

1:1—builds full size versions of standard previews. They're slower to build, and take up more space on the hard drive, but if you need to zoom in when viewing the photos, and your camera doesn't embed a full size embedded preview, they're a good choice.

Still confused? Try following the decision tree. (Figure 3.28)

There's also a **Build Smart Previews** checkbox. Smart Previews are proxy files that can be used in place of the original files when the original files are offline. They're partially processed raw data (lower resolution Lossy DNG), so they behave like the original raw files when editing in the Develop module. They also help to speed up indexing the image content and mobile sync. We'll come back to Smart Previews in more

detail in the Multiple Computers chapter on page 484 and in the Performance chapter on page 529 and page 533.

What does Don't Import Suspected Duplicates do?

Next in that panel is **Don't Import Suspected Duplicates**. If it's checked, Lightroom matches the photos that you're importing against those that are already in the catalog, to see whether you're trying to import duplicates.

For example, if you forget to reformat the card in the camera before shooting more photos, it recognizes the photos that are already in the catalog and skips them rather than duplicating the files. It's worth leaving checked unless you're intentionally importing duplicate photos.

To be classed as a suspected duplicate, the files must match on the original filename (as it was when imported into Lightroom), the EXIF capture date and time, and the file length (size).

If it doesn't recognize the duplicates, make sure you've inserted the card before opening the Import dialog, as it can be more temperamental if you open the Import dialog first. It also only works if the photos are still in the catalog, so if you've deleted some, they will be reimported from the card. It also won't recognize photos that you've re-saved as an alternative format—only exact duplicates.

What does the Make a Second Copy option do?

When using one of the *Copy* or *Move* options, the *Make a Second Copy To* checkbox becomes available in the File Handling panel. This backs up your original files to the location of your choice, in a dated folder

called "Imported on [date]". If you choose to rename your files while importing, these backups are renamed to match, but they always remain in their original file format, even if you're converting the working files to DNG while importing.

The Second Copy option is useful as a temporary backup, while the photos make their way into your primary backup system, but it's not a replacement for good primary backups as it doesn't replicate your working folder structure. We'll consider backup systems in the next chapter starting on page 59.

How do I add imported photos to a collection while importing?

While you're importing the photos, you can also add them to a collection. This is particularly useful if you use sync photos to the cloud to access on your mobile devices, your workflow is designed around collections, or you're importing photos from an event that spans multiple days, such as a vacation.

Enable the **Add to Collection** checkbox to display and select your existing collections and collection sets, or click on the + button to create a new collection. You can only add the photos to a single collection while importing, although you can add them to additional collections once the import completes.

FILE RENAMING PANEL

Most cameras use fairly non-descriptive file names such as IMG_5968. The problem with these names is, over the course of time, you'll end up with multiple photos with the same name.

Using the options in the File Renaming panel

(Figure 3.29), you can rename your photos while you're importing them. (If your Import dialog is set to *Add*, you won't be able to rename while importing. Either change to one of the *Copy* or *Move* options, or wait until the photos are imported and rename in the Library module.)

How will you name your photos?

The main thing to consider when naming your files is how you'll make the names unique. If a file doesn't have a unique name, and it's accidentally moved to another folder, other photos could be overwritten.

The date and time works well as a unique file name, for example, YYYYMMDD-HHMMSS (year month day—hour minute second). If you regularly shoot in sub-second bursts or you prefer to keep to the camera file name, YYYYMMDD-original file number (and a camera code if you're shooting with more than one camera) can work well with a low risk of duplication.

Others prefer a sequence number combined with some custom text, for example, *Vacation2017_003.jpg*. Don't add the words *Vacation2017* into the template itself, otherwise you'll have to go back to the

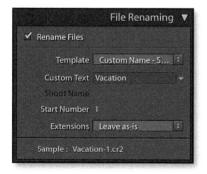

Figure 3.29 The File Renaming panel allows you to rename the photos at the time of import, which means that all versions and backups of the photos will have the same name.

Filename Template Editor each time you need to change it. Instead, use the *Custom Text* and *SequenceNumber(001)* tokens, so you can enter *Vacation2017* directly in the Import dialog.

You can rename the files at any time, as long as you do it within Lightroom, but doing so while importing means your initial backups will have the same names as the working files. This can be invaluable if you have to restore from import backups.

Which characters can I use in my filenames?

It's sensible to only use standard characters, such as plain letters and numbers, and use underscores (_) or hyphens (-) instead of spaces when you're setting up your filenames, so your filenames will be fully compatible with web browsers and other operating systems without having to be renamed again. Some characters, such as / \:!@#\$% < > ,[]{}&*()+= may have specific uses in the operating system or Lightroom's database, causing all sorts of trouble, so these are best avoided.

For more information on recommended filename limitations, check https://www.Lrq.me/cv-filenames

How do I rename the files while importing?

To rename the files, check the **Rename Files** checkbox and select a template from the pop-up to the right. There's a selection of templates built in to Lightroom, but if you select *Edit* in the **Template** pop-up, you can create your own template using tokens in the Filename Template Editor. (Figures 3.30, 3.31 & 3.32)

How do I build a filename template?

1. In the Filename Template Editor, click

	Filename Templ	ate Edito	r	
Preset:	Custom Name - Sequence			
Example: u	intitled-1.cr2			
Custom	Text - Sequence # (1) >			
Image Name				
	Filename number suffix	٥	Insert	
Numbering				
	Import # (1)	0	Insert	
	Image # (1)	0	Insert	
	Sequence # (1)		Insert	
Additional				
	Date (YYYYMMDD)	0	Insert	
	Dimensions	0	Insert	
Custom				
	Shoot Name		Insert	
	Custom Text		Insert	
		0-		333
		Ca	ncel Done	

Figure 3.31 The Windows version displays the tokens as curly brackets rather than blue lozenges.

Figure 3.30 Use the Filename Template Editor to build a filename structure of your choice.

Date (YYYYMMDD)	Haur	Minute	Cocond
Date (FFFFMMDD) V -	Hour 4	Minute ~	Second V
ample: 20150124-001.raw	1		
Date (YYYYMMDD)	Filename	number suffix	~
Date (TTTTIMINES)	- Homanio	namber same	
ample: untitled-0001.raw			

Figure 3.32 These are a few example filename templates:

The first one becomes 20150124-092816.jpg. The second one becomes 20150124-001.jpg. The last one becomes London2015-0001.jpg.

in the white field and delete the existing tokens. The tokens appear as text in curly brackets on Windows, or blue lozenges on Mac.

2. Below the white field is a selection of

pop-ups, each containing different types of tokens. There's a huge selection to choose from! The tokens are grouped into popups. The first contains filename tokens (i.e. current filename), then there are 3 popups for numbering tokens (i.e. sequence numbers) with 1 to 5 digits, then date-based tokens (i.e. YYYYMMDD, and metadatabased tokens (i.e. camera model, star ratings, etc.). Finally there are *Insert* buttons for two custom text fields—*Shoot Name* and *Custom Text*.

- **3.** To add a token, click the Insert button next to one of the pop-ups or select a different option from a pop-up.
- **4.** Repeat to add additional tokens.
- **5.** You can type directly into the white field to add punctuation such as hyphens and

underscores between tokens. You can also add text such as your initials. Add a custom text field for text that changes regularly, such as the name of the shoot or other descriptive text.

- **6.** Finally, save it as a preset by selecting the Preset pop-up at the top of the dialog and choosing *Save Current Settings as New Preset* and giving it a name.
- **7.** Press *Done* to close the dialog, and check that your new preset is selected in the File Renaming panel.

How do I add additional padding zeros to sequence numbers?

In the *Numbering* pop-ups, such as Sequence #, you'll note that there are options from (1) to (00001). Some programs can have problems sorting in intelligent numerical order, so they sort files as 1, 10, 11... 19, 2, 20, 21. The solution is to add extra padding zeros to set the filenames to 001, 002, and so forth.

To use a padded 3-digit sequence number, select Sequence # (001) instead of Sequence # (1) from the pop-up menu. (Figure 3.33)

Figure 3.33 Lightroom offers a range of numbering systems, including a standard Sequence number which you set in the Import dialog.

What's the difference between Import#, Image#, Sequence# and Total#?

While you're looking at the *Numbering* popups, you'll notice that there are a number of different types of sequence number available.

Sequence # is the most useful, and the most familiar type of numbering. It's an automatically-increasing number which starts at the number you set in the File Naming panel in the Import dialog or in the Rename Photos dialog in the Library module.

Import # increases with each batch of photos you import. The first time you use the token during import, it's set to 1, then the next time it's 2, etc. It's only available while importing photos.

Image # increases with each individual photo you import. The first photo is set to 0, then the next is 1, etc.

Both Import # and Image # have starting numbers set in Catalog Settings > File Handling tab, with Import Number used for Import # and Photos Imported used for Image #. (Figure 3.34) If you don't use these tokens, the count doesn't increase. Later, when renaming in the Library module, Image # always starts at 1 regardless of the Catalog Settings.

Total # refers to the number of photos it's renaming in one go, so if you're renaming 8

Import Number:	1	Photos Imported:	0

Figure 3.34 In Catalog Settings > File Handling tab, you can set the Import Sequence Numbers which are used for the Import # and Image # tokens.

photos, the *Total #* token is replaced with 8. It's only available in Library module Rename Photos dialog.

Lightroom can't automatically restart the numbering for each day (i.e. day3-001.jpg) or remember the last number used in a folder (i.e. start at London-253.jpg). To use that type of numbering system, rename the photos in chunks in the Library module, using the *Sequence #* token and setting a start number manually for each batch.

Where do I enter custom text and start numbers?

After creating your filename template, the availability of the additional fields in the File Renaming panel (Figure 3.35) depends on which tokens are used in the selected template.

There are two custom text fields—**Custom Text** and **Shoot Name**—which allow you to add custom text into your filename without returning to the Filename Template Editor each time you want to change the text. The arrow to the right of each field displays recent entries.

Start Number is used with the *Sequence #* token, allowing you to set a starting number

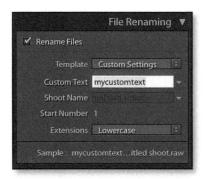

Figure 3.35 If a template includes Custom Text or Shoot Name tokens, they can be updated in the File Renaming panel.

of your choice. For example, you may want your numbering to start at 1, or you may want to carry on from a specific number such as 253.

The **Extensions** pop-up sets the case of the file extension (i.e. .jpg, .JPG, etc.). The default is *Leave as-is*, but you can change it to *uppercase* or *lowercase* if you prefer. That choice is personal preference.

At the bottom of the File Renaming panel is the *Sample* filename, which allows you to double check you have the correct template selected.

APPLY DURING IMPORT PANEL

Next in line is the Apply During Import panel (Figure 3.36). These options allow you to apply settings to the photos as they're imported—Develop Settings, Metadata or Keywords. The settings apply to all the photos in the current import.

You can't apply different settings to different photos in the same import. You could start the first import with selected photos, however doing so runs the risk of missing a photo or two. It's easier to import

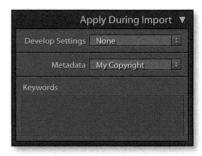

Figure 3.36 The Apply During Import panel allows you to apply initial Develop settings to your photos at import, as well as adding any Metadata or Keywords that will apply to all of the selected photos.

all the photos in a single process and then add the different settings, or move photos into different folders in the Library module once they've all finished importing. All the settings that are available in the Import dialog, such as Metadata and Develop presets, can also be applied in the Library module.

What Develop settings should I apply in the Import dialog?

The **Develop Settings** pop-up allows you to apply a Develop preset to the photos while importing, for example, you may always apply a specific preset to all studio portraits as a starting point. *None* just applies the default settings to new photos but preserves any existing Develop settings stored with the files, so it's the option to choose if you're ever uncertain. Be careful not to confuse *None* with *Lightroom General Presets > Zeroed* which sets every slider back to zero even if there were existing settings.

How do I add copyright metadata to my photos?

Import is the ideal time to apply copyright metadata to ensure that all of your photos include this vital information. To create a metadata preset:

- **1.** Select *New* in the *Metadata* pop-up and the New Metadata Preset dialog appears. (Figure 3.37) At the top, enter a name for the preset such as "Copyright Preset".
- **2.** Enter your copyright information below. Only checked fields are saved in the preset.
- **3.** In many countries, the copyright notice requires the copyright symbol ©, the year of first publication and then the name of the copyright owner, for example, © 2020 Victoria Bampton. Copyright laws vary by country, so please check your local laws for exact specifications. You may also want to include personal details such as your name, address, website and other contact details.
- **4.** To add a © symbol in the Copyright field, hold down Alt while typing 0 1 6 9 on the numberpad (Windows) or type Ctrl-Alt-C (Windows) / Opt-G (Mac).
- **5.** Press the *Create* button to return to the Import dialog, where your new preset is automatically selected.

Should I apply keywords in the Import dialog?

Keywords can also be applied while importing the photos by typing them in

Preset Name:	My Copyrigh	t	
Preset:	Custom		
▼ 🖺 IPTC Cop	pyright		
	Copyright	© 2015 Victoria Bampton	0
Copyright Status Rights Usage Terms Copyright Info URL		Copyrighted	
			0
▼ ☐ IPTC Cre	ator		
	Creator	Victoria Bampton	0
С	reator Address		
	Creator City	Southampton	8

Figure 3.37 Create a Metadata preset to automatically embed your copyright data in every photo.

the *Keywords* field, however remember that they're applied to all the photos in the current import, so it's only useful for keywords that apply to everything. Specific keywords are better applied individually in the Library module.

Can I remove existing metadata?

To remove metadata while importing the photos, perhaps because you've entered metadata in other software and want a fresh start, check the applicable fields in a Metadata preset but leave the fields blank. This prevents the metadata being added to Lightroom's catalog. Simply leaving the Apply During Import panel *Keywords* field blank without checking the checkbox retains any existing keywords.

DESTINATION PANEL

Finally, you need to decide where to put the photos (unless you're using Add to leave them in their current location) and that's where the Destination panel comes into play. It's worth taking the time to get this right before you start importing, as moving the photos after import is a manual process. We decided where to store the photos in the Fast Track at the beginning of the chapter (starting on page 23), but now let's look at how you'll organize them into folders.

What's the best way to organize my photos into folders?

Once you've decided where to store the photos on the hard drive, you then need to decide how to organize them. There's no right or wrong way of organizing photos on your hard drive, but there are some basic principles that can help you avoid problems. It's worth spending the time to set up a logical folder structure before you start importing photos into Lightroom.

As far as Lightroom's concerned, your choice of folder structure doesn't make a lot of difference. Folders are just a place to store the photos, and you can use metadata and keywords to organize them. You could just dump them all into a single folder, but that would become unwieldy in time, so some kind of organization helps. You may also want to find the photos outside of Lightroom, which may influence your choice of folder structure.

We'll come back to some sample folder structures in a moment, but first, let's consider the basic principles behind the widely accepted best practices of digital asset management:

Scalable—You may only have a few thousand photos at the moment, but your filing system needs to be capable of growing with you, without having to go back and change it. Can you go back and add new photos to your system without disturbing existing folders, especially if some of the folders are archived offline?.

Easy Backup & Restore—Your folder structure needs to be easy to back up, otherwise you may miss some photos, and it needs to be easy to restore if you ever have a disaster. This is particularly important as your library grows and becomes split over multiple hard drives.

Storing photos in a single parent folder (per drive), rather than scattering photos around your hard drives, makes it much easier to back up the photos, or move them onto another drive when you outgrow your current drive.

No Duplication—Each photo should be stored in a single location (in addition to your backups).

Besides taking up additional hard drive

space, having the same photo in multiple folders can create chaos when you start trying to add metadata or edit them.

Standard Characters—When naming your folders, stick to standard characters—A-Z, 0-9, hyphens (-) and underscores (_)—to prevent problems in the future.

Consistent—You should always know where a photo should go without having to think about it. If you have to debate each time, there's a higher chance of making a mistake.

We could write a whole book on Digital Asset Management, and the pros and cons of various systems, but fortunately, the world-renowned DAM expert Peter Krogh has already done so. If it's a subject that you would like to learn more about, I recommend The DAM Book https://www.Lrq.me/dambook

Why not organize the photos by topic?

Before you used photo management software, such as Lightroom, you may have organized your photos by subject, so why not carry on doing that? The main reason... a file can only be in one folder at a time, so if you divide your photos up by topic, how do you decide where a photo should go?

For example, if you have a photo of John and Susan, should it go in the John folder or the Susan folder? Perhaps you duplicate in both folders, but then, what happens when you have a larger group of people? Do you duplicate the photo in all of their folders too, rapidly filling your hard drive and making it difficult to track? And if you duplicate the photo in multiple folders, when you come to edit that photo, do you have to update all of the copies too?

Folders work best as storage buckets rather than organizing tools. If you keep

a single copy of each photo (plus backups elsewhere, of course!) in a folder, you can then use keywords, collections and other metadata to group and find photos easily. Using metadata as your organizational tool, the photo of John and Susan may be stored in a single 2017/12 folder, but it would show up when you searched for photos of John, Susan, or even photos shot at a wedding.

Why use a date-based folder structure?

The simplest option for most people is to use a date-based folder structure. It ticks all of the boxes, and more:

- It's scalable, because you just keep adding new dates to the end.
- It's easy to back up the original photos, even to write-once media like DVD/Bluray, because you're adding new photos to the latest folders. (Note that if you save derivative files with the original files, such as those edited in other software, you might still be adding photos to older folders too.)
- It's easy to restore from a good backup. In the event of a disaster, it's even possible to rebuild from files rescued by recovery software, because the capture dates are stored in the file metadata.
- It uses standard characters which are accepted by all operating systems.
- The folders can be nested with days inside of months inside of years, so you don't have a long unwieldy list of folders.
- Lightroom can create the folder structure for you automatically on import, so you don't even have to organize it manually. Photos synced from the Lightroom (cloudbased) family of apps can also drop photos into the same folder structure.

• It's easy to go back and move older photos into the same folder structure, especially if you're only using one folder per month.

Can I adapt a dated folder structure to suit me?

That's not to say you shouldn't adapt the folder structure to suit your needs.

As long as you follow the basic principles above, you can adapt the folder structure to suit your needs without causing unnecessary headaches. It just requires a little more thought initially. Here are a few examples to consider, and I'm sure you can think of a few more:

- Unless you're shooting thousands of photos a day, you probably don't need a full folder hierarchy with one folder per day. A folder for each month, nested inside a folder for each year is a very popular choice, and it's the system I use personally.
- If you want to be able to find photos outside of Lightroom, you might want to use a named folder per shoot, nested inside a year folder. The "random" photos that don't fit inside a full shoot folder can go directly into the year parent folder, and it still follows the basic principles.
- If you're grouping photos by day, you may want to add a descriptive word to the folder name to describe the overall subject, for example, 2017-04-21 Zoo. This makes it possible to find the photos in a file browser, however the folder list can get quite long, so it's worth nesting them in month folders and showing the folder hierarchy so you can collapse them down.
- An event photographer may prefer to use a folder for each event within a parent year folder, sorted by name rather than date, for example, 2017/

John_Kate_wedding_20170421.

• If you shoot for work as well as pleasure, you may want to have separate dated folder structures for Work vs. Personal. But if you decide to split your system, make sure there are no overlaps where a photo may fit into more than one category.

Alternative filing systems aren't 'wrong' but you'll save yourself a lot of headaches if you follow the basic principles. If you're not using a basic dated structure, make sure you think it through properly, and perhaps discuss it with other experienced digital photographers, in case they can see a pitfall that you've missed.

Also, consider how you're going to manage derivatives—retouched masters, and copies exported for other purposes. Are you going to manage these alongside your originals, and if so, how are they going to be backed up and archived?

How do I select a Destination folder?

The Destination panel works just like the Source panel (page 28), including single-clicking for standard navigation, double-clicking to dock folders, and the large button in the top right corner which shows recent destination folders and the operating system dialog.

Select your Destination folder by clicking to highlight it. Any folders that Lightroom creates are placed inside your selected folder. (Figure 3.38)

If the Destination panel is empty, click on the + button and select *View : All Folders*. The other option—*Affected folders only*—only displays folders that are receiving new photos, so they only appear when you have photos selected for import.

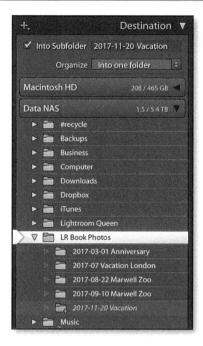

Figure 3.38 Select the Destination folder and preview the results before starting the import.

How do I create a new folder?

There are two main ways of creating a new folder. If you click the + button on the Destination panel header, you can use the operating system dialog to create a new folder in the location of your choice.

Alternatively, select a folder in the Destination panel and check the **Into Subfolder** checkbox at the top of the Destination panel. Enter the name of your new subfolder in the field to the right. The new subfolder appears in italic below your selected folder, showing that it will be created by the import process.

I've chosen Copy or Move—how do I organize the photos into a folder structure that suits me?

How the photos are organized within your selected folder depends on your **Organize**

pop-up selection. You have three choices:

By date gives you a choice of date-based folder structures. It automatically organizes your photos into a tidy folder structure.

Into one folder places the photos in the single folder that you select. It allows you to create your own folder structure manually. For example, a portrait photographer may create a folder for each shoot, or you may choose to create a folder for each family event you attend.

By original folders imports in the same nested hierarchy as their existing structure, but at a new location. This is useful if you're importing existing folders of photos and you wish to keep the existing organization.

Any of these folder structures can also be placed into an existing folder on your hard drive or a new folder.

How do I pick a date structure?

If you select *By date*, the **Date Format** pop-up appears, giving you a choice of difference dated folder structures, based on the capture date stored in each file. (Figure 3.39)

Figure 3.39 A selection of dated folder structures are available in the Date Format pop-up menu.

The slash (/) creates nested folders so 2014/10/07 creates a folder 07 inside of a folder 10 inside of a folder 2014, not a single folder called 2014/10/07.

If you want a single folder, you need to use a format with hyphens (-) or underscores (_), such as the 2014-10-07 format.

For most amateur photographers, the best of these options is YYYY/MM, which creates month folders inside year folders.

I'd suggest ignoring the ones with the month spelled alphabetically, as the Folders panel sorts in alpha-numeric order and isn't quite smart enough to know that May should come before August. (Figure 3.40)

Why are some of the Destination folders in italic?

As you test the different *Organize* and *Date Format* options, watch the folder hierarchy below. The folders shown in italic are folders

 ▼ Folders
 +

 I Data NAS
 1.5 / 5.4 TB
 ▼

 ▼ Numeric and Text
 4

 ► □ 05-May
 1

 ► □ 06-June
 1

 ► □ 07-July
 1

 ► □ 08-August
 1

 ► □ 05
 1

 ► □ 06
 1

 ► □ 07
 1

 ► □ 08
 1

 ▼ □ Text Months
 4

 ► □ August
 1

 ► □ July
 1

 ► □ June
 1

 ► □ May
 1

Figure 3.40 The Folders panel sorts in alphanumeric order and isn't quite smart enough to know that May should come before August.

that don't currently exist, but will be created by the import. It's an easy way to check that the folder organization setting that you've chosen is the one that you want.

To the right of the folder names are numbers and checkmarks. The numbers show how many photos in the current import will be placed in that folder. Two numbers divided by a slash are checked (left) and unchecked (right) photos.

The checkmarks next to the italicized folders select and deselect photos from those folders. They're particularly useful when you're using a dated folder structure, allowing you to select or deselect a whole day or month's photos in one go.

How do I avoid incorrectly nesting dated folders?

There's one particular thing to look out for when selecting the folder: nested year folders. For example, notice in Figure 3.41,

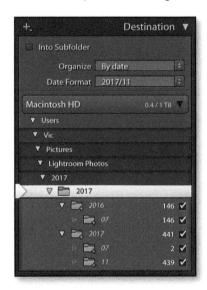

Figure 3.41 In this case, we've selected the wrong folder, resulting in nested 2017 folders. We should have selected the Lightroom Photos folder.

there's a new italic 2017 folder being created inside the existing 2017 folder, which is inside yet another 2017 folder. This happens when you select an existing year folder, and tell Lightroom to create dated folders inside it. But look how easy it is to spot in the Destination preview!

To fix it, if you click on the parent folder— Lightroom Photos, in this case—the dated folders slip back into the correct place in the hierarchy, shown in **Figure 3.42**.

Something as simple as double-checking the preview in the Destination panel each time you import new photos can save hours of work tidying up later. You just need to know where to look.

How do I create a manual shoot-based folder structure?

If you need to find photos outside of Lightroom, you may want to store your photos in a year/shoot-named hierarchy instead of purely date-based folder structure.

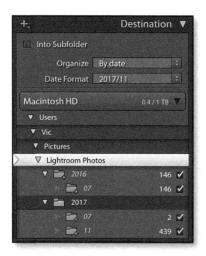

Figure 3.42 Your selected folder structure is previewed in italic. Make sure you check the folder structure is correct before importing the photos.

First, in the Destination panel, look for the parent folder that contains all of your photos. Earlier in the chapter, we suggested calling it something like *Lightroom Photos* (page 22).

Inside that *Lightroom Photos* folder, I'd recommend you have a folder per year. This makes it easy to split your photo archive over multiple drives, or archive some photos offline, as you outgrow your hard drives. For most of the year, this folder will already exist, but if it's January and you don't have a 2018 folder yet, right-click on your *Lightroom Photos* folder and select *Create New Folder* (or create it in Windows Explorer/Finder and then select it in the Destination panel, if that's more comfortable for you).

Select this year's folder so that it's highlighted in white. In the *Organize* pop-up at the top of the Destination panel, select Into one folder. This places the photos into the selected/highlighted year folder. This is a great choice for random photos that don't need their own shoot subfolder.

But let's go one stage further. Let's create a new subfolder to hold the photos you're importing, because they're from a specific shoot. At the top of the Destination panel, check the *Into Subfolder* checkbox, and then enter a name for the shoot. In this example, we'll call it *Marwell Zoo*, but you can add the date if you prefer. (Figure 3.43)

Before you click Import, remember to double check that the photos are landing in the right place. Remember we said that Lightroom previews any new folders in italic? This is a useful double check to ensure that you have the right folder selected.

Can Lightroom manage my photos, like iTunes moves my music files?

Lightroom doesn't automatically manage

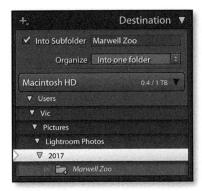

Figure 3.43 Check Into Subfolder to create a folder for the photos.

or rearrange your photos once they've been imported. You can move the photos manually by dragging and dropping them into other folders within the Library module, but that could be a big job, so it's better to decide on a sensible filing system at the outset.

Once you've imported the photos, don't tidy up or rename them using Explorer (Windows) / Finder (Mac) or other software, because Lightroom would no longer know where to find them, leaving you the labor-intensive job of relinking the files individually. We'll investigate how do to that in the Missing Files section starting on page 499, but it's easier to prevent than to fix.

SAVING & REUSING IMPORT SETTINGS

Don't worry, having made all these decisions the first time, you can save them to reuse again later. Lightroom remembers your last used settings, but you might need different settings for different uses. For example, you may use different settings when copying from a memory card than you do when importing existing photos. You can save these sets of settings as Import presets.

Figure 3.44 Import Presets save the combinations of settings you use regularly.

How do I create Import presets, and what do they include?

The *Import Preset* pop-up is tucked away at the bottom of the Import dialog in both the compact and expanded Import dialog views. (Figure 3.44) Select your import settings and then choose *Save Current Setting as New Preset* from the pop-up menu and give it a name.

All of the settings in the right-hand panels are included in the presets, along with the Copy as DNG/Copy/Move/Add choice. Source panel selections and checked/unchecked thumbnails aren't included in the preset, as these change each time you import.

To use these settings again later, simply select the preset from the *Import Presets* pop-up. You can also update or delete existing presets by selecting the preset, editing it and then selecting *Update* (or *Delete*) from the same pop-up.

THE COMPACT IMPORT DIALOG

If you click the arrow in the lower left corner of the Import dialog, it toggles between compact and expanded dialog views. The compact Import dialog allows you to change a few of the settings, such as the Source or Destination folders, and add basic metadata. (Figure 3.45) It doesn't read thumbnails of the photos so it's usually quicker, especially on a slow machine or when importing large numbers of photos. The compact Import dialog also displays a quick summary of your

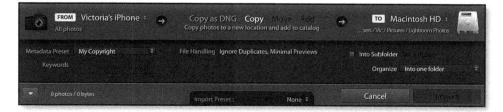

Figure 3.45 The compact Import dialog only offers a summary of settings. Click the triangle in the lower left corner to switch to the expanded Import dialog

other settings, but if you want to change these settings, you need to switch to the expanded Import dialog.

AFTER PRESSING IMPORT

Having set up your import preferences, click the *Import* button in the lower right corner of the dialog to start the import. The *Cancel* button closes the dialog without importing any photos. The *Done* button does the same, but saves the settings you selected in the Import dialog.

The import runs as a background task, allowing you to start (or continue) working in Lightroom while it adds the new photos to the catalog. The progress bar displays in the Activity Center in the top left corner of the screen.

Lightroom selects the *Current Import* collection in the Library module's Catalog panel while importing the photos. If you switch to another folder or collection, it then flips back to the same collection (now called *Previous Import*) automatically when the import completes. This can be frustrating if you're trying to work on other photos while the import runs in the background, so there's a *Select the 'Current/ Previous Import' collection during import* checkbox in the *Preferences dialog > General tab*. (Figure 3.46) It's checked by default, but unchecking it prevents Lightroom from

Figure 3.46 Unchecking the Select 'Current/ Previous Import' collection during import checkbox stops Lightroom automatically switching views when an import completes.

automatically switching view.

Once the import completes and you've built standard-sized or 1:1 previews, visually check the files to ensure that they're not corrupted and your backups are safe before wiping your memory cards.

Some photographers like to delete the files from the memory card using Explorer (Windows) / Finder (Mac), as a reminder that the card's ok to reuse, but it's worth then reformatting the card in the camera. This reduces the risk of corruption.

TROUBLESHOOTING IMPORT

We've covered all the controls you need to know about, but there are a few issues that could prevent you importing your photos. To avoid you tripping at the first hurdle, we'll run through the most frequent of these problems and error messages now, and

FILE FORMATS

Lightroom can import photos and videos in the following formats:

- Camera raw file formats for supported cameras. You can check whether your camera is supported by the latest version of Lightroom by visiting Adobe's website: https://www.Lrq.me/camerasupport
- · Digital Negative (DNG) format
- PSD files set to Maximize Compatibility (8-bit & 16-bit only)
- PSB Large Document Format (as long as they're under the pixel limits noted below)
- TIFF (8-bit, 16-bit & 32-bit)
- JPEG
- HEIF/HEIC
- PNG
- Some video formats from digital still cameras. See https://www.Lrg.me/video-support

There are a few limitations to be aware of:

- Photos can be no larger than 65,000 pixels along the longest edge, and no more than 512 megapixels (not megabytes)—whichever is smaller. A photo that is $60,000 \times 60,000$ is under the 65,000 pixel limit, but it still won't import as it's over the 512 megapixel limit. As most cameras range between 8-36 megapixels, that's only likely to become an issue for huge panoramic or poster shots created in Photoshop.
- CMYK, Lab and Grayscale photos can be imported and managed, but editing and exporting them converts them to RGB. This could result in unexpected shifts in files with other color modes, so you may prefer to control the conversion to RGB yourself using Photoshop, and then import the RGB file into Lightroom for further editing.
- 32-bit HDR files can only be DNG or TIFF format.
- AVCHD format has limited support—Lightroom imports the MTS video clips but not the whole AVCHD folder structure. You'll need to manually copy the AVCHD folder structure from the memory card to your hard drive if you want to retain the additional metadata. Other video formats are also limited on some operating systems.
- Sound files (i.e., WAV and MP3) with the same names as imported photos are copied and marked as sidecar files. This means that they're listed in the Metadata panel, and if you move or rename the original file, the sidecar is also updated.
- Files that aren't created by digital cameras, for example, text files that you may have placed alongside the photos, are not copied to the new location, so always check before formatting the card or drive if you've added extra files.

translate them into more helpful terms.

How do I stop the Import dialog hanging?

If the Import dialog simply hangs before displaying any or all of the thumbnails, it's usually caused by having a mobile phone or tablet attached to the computer. It can also be caused by a drive that's slow to respond (perhaps a network drive), or cloud drives that appear as network drives (e.g. JungleDrive). Try detaching all peripherals from your computer and ejecting network drives before attempting to open the Import dialog again, to narrow down the cause of the problem.

Why can't I see my photos in the Import dialog?

Assuming you've correctly selected a source, there are a few reasons why the thumbnails of the photos might not be visible.

If the photo cells are visible, but the thumbnails are gray and say *Preview unavailable for this file* (Figure 3.47), there are a few likely reasons:

• The raw file format isn't supported by your Lightroom version.

Figure 3.47 If a preview is unavailable, Lightroom displays a gray thumbnail in the Import dialog.

- The file is corrupt or has the wrong file extension.
- The file doesn't have an embedded preview.
- Lightroom is unable to get the previews from the images. If your camera's connected directly to the computer, a lack of previews can be a result of problems with the camera driver at the operating system level. You may consider purchasing a card reader, as they're usually quicker, reduce the wear and tear on your camera, and can show previews more reliably.
- Lightroom simply hasn't finished retrieving all the embedded previews yet.

Regardless of the cause, you can go ahead and press *Import* as normal. Lightroom displays a more descriptive error message if it can't import the photos. We'll discuss some of these errors shortly.

If the photos are completely missing from the Import dialog, there are three main possibilities:

- The photos are in a subfolder inside the selected source, but you've forgotten to check the *Include Subfolders* checkbox.
- The file type isn't supported, for example, Lightroom won't display Word documents. See the File Formats sidebar (page 50) for a list of supported file types.
- In Lightroom's Preferences > General tab is an option to Treat JPEG files next to raw files as separate photos. With this option checked, Lightroom displays the JPEG files alongside the raw files, ready for import. If the checkbox is unchecked, the JPEGs are added as sidecars when you import the matching raw file but they're not visible in the Import dialog. (Figure 3.48)

How does Lightroom handle Raw+JPEG pairs?

If you shoot raw+JPEG, there's a couple of ways to handle them, controlled by the Preferences > General tab > Treat JPEG files next to raw files as separate photos checkbox.

To keep them both visible in Lightroom as separate photos, tick the checkbox. They'll be treated as entirely different photos.

To keep them as a pair, with only the raw file visible in Lightroom, uncheck the checkbox. The JPEGs are handled as sidecar files. Sidecar files aren't treated like photos, so you can't view them separately. If you move

Import Options

Show Import dialog when a memory card is detected

Select the "Current/Previous Import" collection during import

Ignore camera-generated folder names when naming folders

Treat JPEG files next to raw files as separate photos

Replace embedded previews with standard previews during idle time

Figure 3.48 In Preferences dialog > General tab, the Treat JPEG files next to raw files as separate photos checkbox controls the handling of Raw+JPEG pairs.

or rename the visible file, the sidecar file is moved or renamed too.

(Other file types can also be sidecar files, for example, XMP files or audio annotations. They're listed in the Metadata panel.)

If you've imported the raw files already, and you now want to import the JPEGs as separate photos, you can turn off the checkbox and re-import that folder—the raw files are skipped as they already exist in the catalog, and the JPEGs are imported as separate photos. The raw files remain marked as Raw+JPEG, and there isn't an easy way of changing that. Removing them from the catalog and reimporting them resets that label, but if you've made any changes since import, these changes may be lost, so the best solution currently is to close your eyes and ignore them.

What does this error message mean?

If Lightroom can't import the selected files, it displays an error message (Figure 3.49) starting with **Some import operations were not performed** followed by the reason:

"Could not copy a file to the requested

	▶ The files are not recognized by the raw format support in Lightroom. (6)
	▶ The file is too big. (1)
	The file could not be read. Please re-open the file inh the 'Maximize Compatibility' preference enabled. (1)
	▶ The file uses an unsupported bit depth. (1)
0	▶ The following files were imported successfully but have invalid capture times. (6)
	▶ The file uses an unsupported color mode. (1)
	▶ The files appear to be unsupported or damaged. (33)

Figure 3.49 If Lightroom can't import your photos, it lists the photos in the Import Results dialog, along with an error message explaining the reason for the failure. Many of these issues can easily be overcome.

location."

If Lightroom can't copy or move the photos to their new location, it's usually because the Destination folder is readonly. Try another location with standard folder permissions, such as the desktop, to confirm that permissions are the problem. If it works correctly on the desktop, use the operating system to correct the permissions for that folder. If the permissions appear to be correct already, it may be a parent folder that has the incorrect permissions. (You'll need to Google for instructions on correcting file/folder permissions, as it's an operating system function rather than Lightroom.)

Other possibilities include the drive being nearly full or the drive being formatted using an incompatible format, such as a Mac computer trying to write to an NTFS formatted drive.

"The files could not be read."

When Lightroom says "The files could not be read," it more frequently means that they couldn't be written. Yes, I know that's not very helpful! As with the "Could not copy a file to the requested location" error, check the folder permissions for the Destination folder and its parent folders.

Lightroom also shows "The files could not be read" error if the memory card or camera is removed while the photos are still copying, or if the photos are deleted from the source folder before the import completes.

"The files already exist in the catalog."

If you're importing a large number of photos and you press the Import button before Lightroom's finished checking the new photos against the catalog, it may get to the end of the import and say "The

files already exist in the catalog." It simply means that Lightroom didn't need to import them as they're already registered in your catalog at that location. If you search the *All Photographs* collection or look in the folder in the Folders panel, you'll be able to find them.

"The file is from a camera which isn't recognized by the raw format support in Lightroom."

Each time a new camera is released, Adobe has to update Lightroom (and ACR plug-in for Photoshop) to be able to read and convert the raw files. The list of supported cameras can be found at: https://www.Lrg.me/camerasupport

The Lightroom updates are released about every 2 months. Visit the CC app to make sure you're running the latest version. If your brand new camera doesn't appear on the list yet, you may need to wait for Adobe to add support.

There's one other possibility if Lightroom says "The file is from a camera which isn't recognized by the raw format support in Lightroom." If a raw file is corrupted, it may show this error instead of the "unsupported or damaged" error.

"The file uses an unsupported color mode."

Lightroom supports RGB, CMYK, Lab and Grayscale color modes. If you try to import a photo in another color mode, for example, Duotone, Lightroom shows the "unsupported color mode" error. In this case, you'll need to convert the photo to a supported color mode, or import an RGB copy as a placeholder instead.

"The file is too big."

Lightroom has a file size limit of 65,000

pixels along the longest edge, and up to 512 megapixels, whichever is the smaller. If it tells you that the file is too big, then you're trying to import a photo that's larger than that—perhaps a panoramic photo. If you have any such files that you can't import, create a small version of the photo (i.e. using Photoshop) to import into Lightroom to act as a placeholder.

"The files could not be read. Please reopen the file and save with 'Maximize Compatibility' preference enabled."

Lightroom doesn't understand layers, so if there isn't a composite preview embedded in a layered PSD file, it can't import it and Lightroom displays an error asking you to save the file with *Maximize Compatibility* enabled.

To do so, you'll need to open the PSD files in Photoshop and re-save them. You'll find Photoshop's Preferences dialog under the Edit menu (Windows) / Photoshop menu (Mac), and in the File Handling > File Compatibility section, there's an option to Maximize Compatibility with other programs by embedding a composite preview in the file. (Figure 3.50) The preference only applies to PSD and PSB format files, as other formats (such as TIFF) embed the composite by default.

Figure 3.50 Maximize Compatibility in Photoshop saves a composite layer.

Maximize Compatibility does increase file size, but it ensures that other programs—not just Lightroom—can read the embedded preview even if they can't read the layers. It's safest to set your Photoshop Preferences to Always, or simply use TIFF format, which is generally a better choice now anyway.

"The file appears to be unsupported or damaged."

Files that have the wrong file extension, or 32-bit PSD files, can trigger the "unsupported or damaged" error message. 32-bit HDR floating point TIFF or DNG files are supported, but not 32-bit PSD's. Most unsupported file formats aren't even shown in the Import dialog, but those are the exceptions.

More frequently, severe file corruption triggers the "unsupported or damaged" error message, although files with less significant corruption may import without warning.

TETHERED SHOOTING & WATCHED FOLDERS

Before we move on to backing up your photos, we should mention one final way of getting photos into Lightroom. Tethered shooting involves connecting your camera directly to the computer. As you shoot, the photos appear on the computer's monitor, rather than having to download them later. Lightroom offers two different options, depending on your requirements.

If you're using one of the supported cameras, you can use the Tethered Capture tool, which allows you to connect your camera to the computer, view your camera settings and trigger the shutter using Lightroom's interface.

If you're shooting wirelessly, for example,

using an Eye-Fi card, or other remote capture software, you can use Auto Import to monitor a watched folder instead. Auto Import collects photos from a folder of your choice as they appear and automatically imports them into Lightroom, moving them to a new location in the process.

Which cameras are supported by the built-in Tethered Capture?

Adobe supports a wide range of Canon and Nikon cameras for tethering. The current list of supported cameras can be found at https://www.Lrq.me/tethersupport Fuji, Leica and Pentax offer their own Lightroom tethering plug-ins, but the features may be slightly different to the built-in plug-ins.

Lightroom the manufacturer's uses own SDKs to control the camera, which results in some slight differences between manufacturers. For example, if there's a memory card in the camera. Canon cameras can write to the memory card in addition to the computer hard drive, whereas Nikon cameras only write to the computer hard drive. Waiting for the manufacturer to release an updated SDK can also lead to delays in tethering support for new cameras. Nikon cameras are limited to the list linked above, but due a difference in the SDK's. some unlisted Canon cameras may work.

How do I set Lightroom up to use Tethered Capture?

To set Lightroom up for tethering:

- **1.** Connect your camera to the computer using your USB or Firewire cable. A few cameras need to be in PC Connection mode, but most need to be in PTP Mode.
- **2.** Go to File menu > Tethered Capture > Start Tethered Capture. (Note, if you're using an M1/M2 Mac, tethering still requires Rosetta

- 2 emulation at this time. When you start Tethered Capture, Lightroom automatically offers to relaunch in Rosetta emulation mode. When you next restart Lightroom, it automatically reverts to native code.)
- **3.** Choose your settings in the Tethered Capture Settings dialog: (Figure 3.51)

Enter a name into the *Session Name* field. This becomes the folder name for the photos.

(Optional) Check the Segment Photos by Shot checkbox. This subdivides the photos into further subfolders, inside the Session Name subfolder. The Shot Name can be changed from the main Tethered Capture window while you're shooting.

Tethered Capture	Settings
Session	
Session Name: Studio Session	
Segment Photos By Shots	
Naming	
Sample: Studio Session-001.DNG	
Template: Session Name - Sequence	6
Custom Text:	Start Number: 1
Destination	
Location: /Users/Vic/Pictures	Choose
Add to Collection	Create Collection
Quick Collection	
> IWorking Collections	
> 🖀 @GeneralTheme	
> Bodies of Work	
> Film Scans	
Information	
Metadata: My Copyright	
Keywords:	
Other Options	
Disable Auto Advance	
	Cancel OK
	Cancel

Figure 3.51 The Tethered Capture Settings dialog sets initial import settings including the Destination folder, file renaming and metadata.

Select a file naming template. The default Session Name—Sequence template uses the Session Name you've entered at the top of the dialog, followed by a 3 digit sequence number.

- **4.** Select a *Destination* folder. The *Session Name/Shot Name* folder hierarchy is placed inside your selected folder.
- **5.** (Optional) Like the normal Import dialog, you can also choose to add the photos to a new or existing collection by checking the *Add to Collection* checkbox and selecting your chosen collection.
- **6.** For performance reasons, Tethered Shooting doesn't offer the option to convert to DNG while importing. If you prefer the DNG format, once you've completed the shoot, select the files and go to *Library menu* > *Convert Photos to DNG* to automatically convert the files.
- **7.** (Optional) Select your *Metadata Preset* and any keywords to apply to the photos as they're imported.
- **8.** By default, Lightroom displays each photo on screen immediately after it's capture, but if you have someone else editing the photos while you shoot, check the *Disable Auto Advance* checkbox.
- **9.** Press OK to display the Tethered Capture window.

How do I capture photos using Tethered Capture?

Once you've set the Tethered Capture settings, you're ready to start shooting.

Many camera settings can be controlled using the Tethered Capture window (Figure 3.52), including:

- Session Name (which becomes the folder name, and may be used in the filename)
- Shot Name (if Segment Photos by Shot was checked in Settings)
- The *Live* button opens an additional window showing a live preview. The green dot simply means that the Live View is enabled. The icon in the top right corner rotates the preview. (Figure 3.53)
- The Focus buttons allow you to manually adjust the focus by large or small amounts, as long as the camera is set to Auto Focus mode and Live View is enabled. The AF button reverts to the automatic focus.
- Shutter Speed, Aperture, ISO and WB
- Develop Settings allows you to select a Develop preset to apply to each photo on import. Certain settings, such as Crop, can't

Figure 3.53 The Live View window shows a live preview.

Figure 3.52 The Tethered Capture window allows you to set the camera settings and trigger the capture.

be included in Develop presets, however that doesn't prevent you from applying them automatically. Simply shoot the first photo, apply your crop along with any other Develop settings, and then select the *Same as Previous* option in the Develop presets pop-up menu. Any further tethered shots automatically have these previous settings applied, including the crop.

• The cog icon opens the Tethered Capture Settings dialog again.

You can drag the dialog or Live View window to another location if they're getting in your way. They float over the top of Lightroom's standard window so you can carry on working without closing the Tethered Capture window.

Press the shutter button on the camera, the silver button on the dialog or the keyboard shortcut F12 to trigger the shutter.

When you're finished, close the Tethered Capture window by clicking the X in the top right corner.

How do I set Lightroom up to use a watched folder?

If Lightroom's tethering doesn't support your camera, you need to change the camera settings remotely, or you're shooting wirelessly, you can use other tethering tools such as EOS Utility, Camera Control Pro or Eyefi to capture the photos and drop them into Lightroom's watched folder. Lightroom then collects the files from that watched folder, and moves them to another folder of your choice, importing them into your Lightroom catalog, renaming if you wish, and applying other settings automatically.

To set it up:

1. Go to File menu > Auto Import Settings.

- **2.** In the *Watched Folder* section, select an empty folder, perhaps on your desktop. (Figure 3.54)
- **3.** Select a destination folder and subfolder to store the photos.
- **4.** Select your filename template in the *File Naming* pop-up.
- **5.** Choose any other import options in Auto Import Settings dialog—Collection, Develop Settings, Metadata Preset, Keywords and Preview Size. These are the same as the choices in the main Import dialog.
- **6.** Enable the Auto Import checkbox at the top of the dialog or go to File menu > Auto Import > Enable Auto Import. The watched

	Auto Import Settings	
	Enable Auto Import	
Watched Folder:	/Users/Vic/Desktop/LR Auto Import	Choose
Destination		
Move to:	/Users/Vic/Pictures	Choose
Subfolder Name:	Auto Imported Photos	
Add to Co	lection	Create Collection
Quick Col	lection	
> 📷 !Working	Collections	
> @General	Theme	
File Naming: IMG_000	11.DNG	
File Naming:	Filename	Е
Information		
Develop Settings:	None	
Metadata:	My Copyright	
Keywords:		
Initial Previews:	Embedded & Sidecar	E
Other Options		
Disable Auto Ad	vance	
	Can	cel OK
	Can	- Committee

Figure 3.54 You can use alternative tethered capture software to capture your photos, and automatically import the photos into Lightroom using Auto Import.

folder needs to be empty when you enable Auto Import, and Lightroom needs to remain open.

- 7. To check you've set it up correctly, copy a file from your hard drive into the watched folder. As soon as the file lands in the folder, it should start the import, and you should see the file vanish from the watched folder. It should then appear in the destination folder and in Lightroom's catalog. If that works, then you've set up Lightroom properly.
- **8.** Switch to your camera's remote capture software and set it to drop the photos into that folder. Make sure the remote capture software doesn't create a dated subfolder as Lightroom won't look in any subfolders in the watched folder.
- **9.** Finally, connect the camera to the capture software, and ensure it's saving to the right folder. Release the shutter. The file appears in the watched folder, and then Lightroom moves to your destination folder and imports it into your catalog.

IMPORT SHORTCUTS

		Windows	Mac
Import Dialog	Open Import Dialog	Ctrl Shift I	Cmd Shift I
	Grid View	G	G
	Loupe View	E	E
	Move between photos	Left/Right Arrows	Left/Right Arrows
	Zoom	Spacebar	Spacebar
	Check Selected Photos	Р	Р
	Uncheck Selected Photos	X	x
	Toggle Checkbox	`	
	Auto Advance	Caps Lock	Caps Lock
	Add Copyright Symbol	Ctrl Alt C	Opt G
	Begin Import	Enter	Enter
	Cancel / Close Import Dialog	Escape	Escape
Tethered Capture	Hide Tethered Capture Window	Ctrl T	Cmd T
	Shrink Tethered Capture Window	Alt-click on close button	Opt-click on close button
	New Shot	Ctrl Shift T	Cmd Shift T
	Trigger Capture	F12	F12

4

BACKUP

Before we move on to viewing your photos, it's essential to know how to back up your work. This is one of the shortest chapters in this book, but by far the most important.

There are three main categories of files that you'll want to include in your backups:

- The catalog(s)
- The photos
- The extras, such as presets and templates

We'll work through each in turn. If you already have a reliable backup system, you can skip to the checklist on page 67.

BACK UP YOUR CATALOG

All the work you do in Lightroom is stored as text metadata in your Lightroom catalog. There are four main things that could go wrong with the catalog:

User error—you may accidentally remove photos from the catalog or unintentionally change settings.

Hard drive failure—if your hard drive dies, you'll need to restore your catalog from a backup on another drive.

Catalog corruption—although rare, the database can become corrupted, usually due to hardware errors.

Software bugs—all software has bugs even though it's tested carefully. It's best to err on the safe side!

Most backup software just backs up the latest version, overwriting the previous backup. That's fine if your hard drive dies, but what if you make a mistake and don't spot it for a few days? That's where versioned backups come into their own.

Versioned backups keep multiple copies of a file so you can 'step back in time' to an earlier version. Lightroom's catalog backup tool does this automatically by zipping up a copy of the catalog and using the current date/time as the folder name so you can identify it later.

How do I back up Lightroom's catalog?

By default, Lightroom prompts you to back up the catalog weekly when you quit Lightroom, and it's as simple as pressing the *Back Up* button in this dialog.

Let's dive a little deeper into the settings, however, to make sure your catalog backups are safe.

PHOTOS NOT INCLUDED

Lightroom's catalog backup doesn't include your original image files. It only backs up the catalog containing metadata about the photos. I regularly hear from people who have deleted their original photos, thinking that Lightroom has them backed up, and I don't want to hear that you've fallen into the same trap. We'll investigate photo backup in the next section starting on page 62.

Where are the backups stored?

Unless you change the location, Lightroom saves the catalog backups in a *Backups* subfolder next to the original catalog. This is a fairly logical place, as long as these folders are also backed up to another drive by your primary backup system. However, it won't help if they're your only catalog backups and your hard drive dies.

To change the backup folder:

1. Go to Edit menu > Catalog Settings (Windows) / Lightroom menu > Catalog Settings (Mac) and select the General tab.

- **2.** In the *Back up catalog* pop-up, change the backup frequency to *When Lightroom next exits*.
- **3.** Quit Lightroom so that the Back Up Catalog dialog appears (Figure 4.1)
- **4.** Press *Choose* and navigate to the folder of your choice.
- **5.** Press *Backup* to confirm your choice and run your first backup at the new location.

The backup catalog is compressed into a zip file and placed in a dated subfolder at your chosen location.

Should I turn on Test integrity and Optimize catalog each time I back up?

Also in the Back Up Catalog dialog, there are two important checkboxes which are worth leaving permanently checked.

Test integrity before backing up checks that the catalog hasn't become corrupted and attempts to repair any problems.

Optimize catalog after backing up tidies up and helps to keep your catalog running smoothly and quickly.

Note: This only backs up	the catalog file, not your photos	
	en part (in en l'houne in house miller kontant (il king more en leet un seen).	encennes en en en en en en en
Back up catalog: Once a week, when	exiting Lightroom	(3
Backup Folder: /Users/Vic/Dropbox/Lightroom Catalog/Backups		Choose
Also: Test integrity before	e backing up	
Optimize catalog af	ter backing up	
Skip until next week	Skip this time	Back up

Figure 4.1 When the backup runs, you can change the backup location or frequency.

How often should I back up the catalog?

We said that Lightroom prompts you to back up weekly, however if you're working on a large number of photos every day, a week's worth of work is a lot to potentially lose. You can change the backup frequency to prompt you daily, weekly, monthly, or every time Lightroom exits.

To change the backup frequency:

- **1.** Go to Edit menu > Catalog Settings (Windows) / Lightroom menu > Catalog Settings (Mac) and select the General tab. (Figure 4.2)
- **2.** Using the *Back up catalog* pop-up, select the frequency of your choice.

You can also change the frequency in the Backup dialog itself, when a backup runs.

How much work can you afford to lose if the worst happened?

I haven't got time to back up now—can I postpone the backup?

If, on occasion, you don't have time to wait for the backup to run, you can skip the backup. There are two buttons in the Back Up Catalog dialog. **Skip this time** postpones the backup until the next time you close the catalog. **Skip until tomorrow/next week/next month** offers a longer postponement, depending on your selected backup frequency. Don't be tempted to skip it too often, or you could find yourself without a recent backup.

How do I run an extra backup on demand?

If you've done a large amount of work (or moved/renamed files) and your backup isn't scheduled to run for a few days, or you hit skip because you were in a hurry last time you closed Lightroom, you can run an unscheduled backup. Go to Catalog Settings > General tab and change the backup frequency to When Lightroom next exits and then quit Lightroom so that the backup can run. When you reopen that catalog, it automatically reverts to your normal backup schedule.

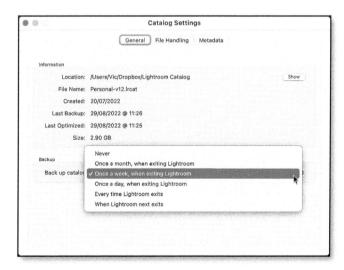

Figure 4.2 Set your backup frequency in the Catalog Settings dialog.

Can I delete the oldest backups?

Lightroom compresses the backups using ZIP compression so they don't take up too much space on your hard drive, but if you're backing up every day, they can start to add up. The backups aren't automatically deleted, but you can go to the Backups folder using Explorer (Windows) / Finder (Mac) and delete older backups yourself.

I'd recommend keeping a couple of older backups in addition to the current ones, for example, 1 year old, 6 months old, 3 months old, 1 month old, plus the most recent 4 or 5 backups. You never know when you might discover a mistake you made a few months ago, and want to retrieve settings for some photos from a much older backup.

Why does Lightroom say it's unable to backup?

If Lightroom says it can't back up your catalog, there are a few possibilities to check:

- Check the backup location—is the drive accessible and does the folder still exist?
- Check the folder permissions for the backup location—do you have read/write permissions?
- Is there enough space on the drive?

If everything looks correct, try changing the backup location to a different folder. If this works, try changing it back to your normal backup location.

Should I also write the metadata to the files as an extra backup?

As long as you're sensible about backups, then you have nothing to fear from keeping your data in a single catalog. However if you like a belt-and-braces approach to backup, you can also save the metadata to the files in a format called XMP which is stored in the header of JPEG/TIFF/PSD/DNG files and in sidecar files for proprietary raw files. XMP doesn't hold all the information that's stored in the catalog, but as the XMP is stored with the image files, it has been known to save the day on occasion. We'll come back to XMP, starting on page 411.

BACK UP YOUR PHOTOS

Lightroom's Catalog Backup is just that—a backup of your catalog. Your photos are not stored 'in' Lightroom and Lightroom's Catalog Backup doesn't back up the photos, so we need to consider how you're going to protect your photos from disaster.

There are a few questions to ask yourself when planning your photo backup system:

1. How many backups do I need?

Backups can fail. For important files such as your original photos, consider keeping 3 copies (1 working plus 2 backups) on 2 different kinds of media (e.g. hard drive and online), with at least 1 copy at a different location.

When considering your backup system, don't limit the backups to internal/external hard drives or network attached storage (NAS), because viruses, theft, computer malfunctions, lightning strikes, floods, and other similar disasters could wipe out all of your backups along with the working files.

Online backups, such as Crashplan (Small Business Edition), Backblaze or Carbonite, are an excellent choice if you have a fast internet connection, or there's always the lower-tech solution of leaving an external hard drive with a friend or family member.

It's possible to back up to Adobe's cloud, but not through Lightroom Classic (see page 558).

2. Are my backups reliable?

Is the backup media (e.g. external hard drive) free from errors? Avoid using old hard drives for your primary backups.

Are they easily checked to make sure they don't develop errors over time? If your backup system is a mountain of DVD's, checking whether they still read correctly is a long job!

Think about what could go wrong and whether your backups would be protected. This includes hardware errors, software bugs, transfer errors, viruses, hacking, theft, fire, water damage, lightning strike and human error.

Is the file transfer validated? Byte-forbyte verification ensures that the files are copied to the backups without introducing corruption.

3. Are the backups protected from user error?

If you accidentally delete a file, could you easily recover it from your backups? For example, RAID1 is not a sufficient backup system as the file is immediately deleted from both drives.

Is the backup system automated, or does it rely on you remembering which files you've already copied?

4. Could I easily restore the photos to their working folder structure with the correct filenames?

If the backups are stored in a different folder structure, or you've renamed the

working photos after backing up, you'll have a nightmare trying to restore them.

How will you keep your primary backups updated with any changes?

5. Will my derivative files (e.g. photos edited in Photoshop) be included?

If you back up to write-once media such as DVD or Blu-Ray, how will you back up the files you've edited in other software or added to the photo folders?

How do I back up my photos?

Every computer system is different, so I can't give you step-by-step instructions on how to back up your photos. Your choices will depend on your workflow, where your photos are stored, how they're organized, and the available backup media, among other things.

If you're not currently backing up your photos, anything is better than nothing. The simplest way to back up your photos is to include them in your main system backups. Windows comes with its own Backup and Restore tool, and macOS includes Time Machine, both of which can back up your computer files to an external drive. For a little more control, you can run dedicated backup software. Ensure that all of your photos are included in the backups, especially if you store them on external drives, as these may be excluded from the default backup settings.

If you're looking for a slightly more flexible option, file synchronization software makes it very easy to keep a mirrored backup on another drive without wrapping your photos up in a proprietary backup format. These can also verify your data during the transfer, as most file corruption happens while copying or moving files between hard

drives. Vice Versa and Chronosync are my personal favorites.

FreeFileSync (Windows/Mac) https://www.Lrq.me/freefilesync

Vice Versa (Windows) https://www.Lrg.me/viceversa

Chronosync (Mac) https://www.Lrg.me/chronosync

I back up photos using the Import dialog—isn't that enough?

We mentioned in the Import chapter (page 36) that the *Second Copy* backup in the Import dialog isn't a replacement for a backup system. It simply copies the imported photos into folders called 'Imported on [date]' so it's great as a temporary backup while you ensure the photos have been safely added to your main backups, or even as a write-once backup stored on DVD/Blu-ray. It won't, however, replicate your working folder structure, back up any additional photos such as those edited in Photoshop, update photos you've moved or renamed, or remove any photos you've deleted.

Should you ever have to try to restore from these backups, you'd have a very time-consuming job reorganizing all the photos.

BACK UP THE EXTRAS

Over the course of time, you'll also gather presets and templates that you've created or downloaded from other websites, so you'll want to back these up too. You can manually copy them from their various locations listed in the checklist on page 67, or set file synchronization software to do it for you.

RESTORING FROM BACKUPS

Now you can relax in the knowledge that your data is protected, but while we're on the subject of backups, let's talk about restoring them. After all, what good is a backup if you don't know how to recover from a disaster?

We'll step through restoring individual backups in this chapter, and restoring everything (after an OS reinstall or moving to a new computer) in the Multiple Computers chapter starting on page 463.

How do I restore a backup of my catalog?

If you're restoring your whole catalog, for example, due to corruption, find your current catalog (*.Ircat file) and rename it, move it or zip it up temporarily. To restore your backup catalog:

- **1.** Find your most recent backup in your Backups folder. The backups are stored in dated subfolders, with the zip file named to match your catalog name, to make them easy to identify.
- **2.** Double-click on the zip file to open the backup. The *.lrcat file displays next to the zip file.
- **3.** If you're on a Mac and your catalog is large, double-click might not correctly unzip the file. In this case, download Stufflt Expander from the App Store (it's free). Open the app and drag the backup zip file onto the icon to unzip it.
- **4.** COPY the backup *.lrcat file to your normal catalog location, replacing (or alongside) the existing damaged catalog. Don't be tempted to open your backup catalog without copying it first.
- 5. Double-click on the *.lrcat file to open it.

6. If everything's now working correctly, you can delete the previous (corrupted) catalog and you should be ready to continue working. If the catalog opens but is behaving strangely, for example, showing the wrong previews or running slowly, you may also need to rebuild the preview cache. We'll discuss this in the Troubleshooting chapter starting on page 513.

How do I restore part of my backup catalog?

But what if you only want to restore part of the backup catalog? Perhaps you accidentally synchronized Develop settings across a folder of photos, or you accidentally removed specific photos from your catalog. If you've worked on other photos since the backup was created, you probably won't want to restore the entire backup catalog, as you'd lose the other work you've done. Instead, you can restore just the settings for specific photos. There are a few additional steps:

- 1. Find your most recent backup in your Backups folder that includes the missing photos. The backups are stored in dated subfolders, with the zip file named to match your catalog name, to make them easy to identify.
- **2.** Double-click on the zip file to open the backup. The *.lrcat file displays next to the zip file.
- **3.** If you're on a Mac and your catalog is large, double-click might not correctly unzip the file. In this case, download Stufflt Expander from the App Store (it's free). Open the app and drag the backup zip file onto the icon to unzip it.
- **4.** Move the backup *.lrcat file to a temporary location, such as the desktop.

- **5.** Double-click on the *.lrcat file to open it into Lightroom.
- **6.** Find the photos you'd like to transfer to the working catalog.
- **7.** Select the photos and go to *File menu* > *Export as Catalog.* Select a temporary location, such as the desktop, and give the exported catalog a name such as "Transfer. Ircat". Check *Export Selected Photos only* and leave the other checkboxes unchecked.
- **8.** Go to *File menu > Open Recent* and open your normal working catalog.
- **9.** In your main working catalog, go to File menu > Import from Another Catalog and direct it to the temporary Transfer.Ircat you created in step 6.
- **10.** At the top of the Import from Catalog dialog, check the *All Folders* checkbox. (Figure 4.3)
- **11.** The availability of the options below depends on your reason for restoring the data from the backup catalog. We'll discuss the options in more detail in the Multi-Computer chapter starting on page 487,

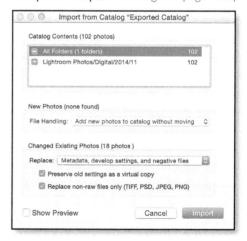

Figure 4.3 Use Import from Catalog to recover part of a backup catalog.

but these are the most likely options:

If you're restoring photos you accidentally removed from the catalog, select *Add new photos to catalog without moving* in the *New Photos* section

If you're restoring metadata for photos that still exist in the catalog, select *Metadata and develop settings only* from the *Replace* pop-up in the *Changed Existing Photos* section. (To keep the current settings as a virtual copy, check the checkbox below too.)

- **12.** Press *Import* to transfer the metadata into your working catalog.
- **13.** Once you've confirmed everything's working well, delete the temporary catalog from the desktop.

There is one limitation worth mentioning. When importing from other catalogs, Lightroom imports all of the data about your chosen photo. For example, you can't import just the Develop settings for a photo without also importing its keywords. There is, however, a workaround. If you check the Preserve old settings as a virtual copy checkbox, your current settings are retained as a virtual copy. You can then John Beardsworth's Syncomatic plug-in to sync specific metadata (e.g. keywords) from the virtual copies to the masters. https://www.Lrg.me/ updated beardsworth-syncomatic

How do I restore a backup of photos?

If you have good backups, restoring photos is as simple as copying the backup photos to their correct locations.

- **1.** Open your photo backups in an Explorer (Windows) / Finder (Mac) window.
- 2. Open another Explorer (Windows) /

Finder (Mac) window and navigate to your normal working folder structure.

- **3.** Copy the photo backups (whether specific photos or whole folders) back to their correct location in your working folders.
- **4.** Open Lightroom and check that none of the photos are marked as missing. To double-check, go to *Library menu > Find All Missing Photos*. If any photos are missing, copy them from the backups.

That's the simple option, but let's consider a couple of variations that might arise:

What happens if I'm restoring to a new hard drive.

- **1.** Open your photo backups in an Explorer (Windows) / Finder (Mac) window.
- **2.** Open another Explorer (Windows) / Finder (Mac) window and navigate to your new drive.
- **3.** Copy the photo backups to the new drive, being careful to retain the same folder structure.
- **4.** Open Lightroom. The folders and photos are marked as missing unless you've given the new drive the same drive letter (Windows) / drive name (Mac) as the old one.
- **5.** Turn to the Missing Files instructions starting on page 499 to reconnect Lightroom's records to the new location.

Test it!

The true test of a backup system is how easily you can restore from these backups and continue working in the event of a disaster. If you're reading this before your

hard drive dies, prevention is better than cure, so now is an excellent time to make sure you know how to restore your backups in the event of a disaster.

BACKUP CHECKLIST

Ideally you'll be running a full system backup, but as far as Lightroom is concerned, there are a few essentials to ensure you've included. I've listed the default locations, but you may have chosen alternative locations for some items such as the catalog.

- □ The catalog(s)—holds all the information about your photos, including all the work you've done on the photos within Lightroom.
- $\\ \circ \ \ \, \text{Windows Default-C: } \ \ \, \text{Users } \ \ \, \text{Incat} \\$
- $^{\circ}$ Mac Default—Macintosh HD / Users / [your username] / Pictures / Lightroom / Lightroom Catalog.lrcat

Go to Edit menu (Windows) / Lightroom menu (Mac) > Catalog Settings to confirm the location of your catalog. Your catalog may have a different name, but they all have *.Ircat as the extension. You may have created more than one catalog.

- ☐ The other catalog files—other files associated with the catalog. These are stored next to the main catalog file. (Some of these files may not exist, for example, if you've never enabled Sync.)
- o *.lrcat-shm
- o *.lrcat-wal
- o *.lrcat-data
- *Helper.Irdata
- *Sync.Irdata
- ☐ The catalog backups—just in case your working catalog gets corrupted.
- By default, they're stored in a Backups folder next to the catalog.
- ☐ The previews—standard and smart previews.

These would be rebuilt on demand as long as you have the original photos. If you have available backup space, backing them up would save time rebuilding them, and if you deleted your original photos accidentally, they may be the only copy left.

If you run a versioned backup system, which keeps additional copies each time a file changes, you may want to exclude the previews as they change constantly and will rapidly fill your backup hard drives.

Previews are stored next to the catalog as folders (Windows) or files (Mac) with a *.Irdata extension.

☐ **The photos**—in their current folder structure, in case you ever have to restore a backup. You'll want to include your edited files too.

These are stored in the location of your choice. To locate a specific folder, go to the Folders panel,

right-click and select Show in Explorer (Windows) / Show in Finder (Mac).

mobile phone or tablet.

 Windows—C: \ Users \ [your username] \ My Pictures \ Lightroom \ Mobile Downloads.Irdata o Mac-Macintosh HD / Users / [your username] / Pictures / Lightroom / Mobile Downloads. Irdata The Mobile Downloads.Irdata file is always stored in your Pictures folder, regardless of where your catalog and other photos are stored, but you can select an alternative location for downloaded photos in Preferences > Lightroom Sync. □ Lightroom-Specific Presets & Templates—includes Slideshow, Print and Web templates, Metadata presets, Export presets, etc. Windows—C: \ Users \ [your username] \ AppData \ Roaming \ Adobe \ Lightroom \ Mac—Macintosh HD / Users / [your username] / Library / Application Support / Adobe / Lightroom / If Preferences > Presets tab > Store presets with this catalog is checked, most (but not all) Lightroomspecific presets and templates are stored in a Lightroom Settings folder next to your catalog. However, presets shared with Camera Raw remain in the following location... ☐ Shared Camera Raw Settings—includes Develop profiles and presets (xmp format), Develop default settings, Lens Profile defaults and camera-specific profiles (dcp format), etc. Windows—C: \ Users \ [your username] \ AppData \ Roaming \ Adobe \ CameraRaw \ Mac—Macintosh HD / Users / [your username] / Library / Application Support / Adobe / CameraRaw / □ Plug-ins—includes export plug-ins, web galleries and any other extensions that you may have downloaded for Lightroom. Don't forget to keep their serial numbers safe too. These are stored in your choice of location. Check File menu > Plug-in Manager for the location of each plug-in. □ Preferences—includes last used settings, view options, FTP settings for uploading web galleries, some plug-in settings, etc. The preferences could be rebuilt if necessary, but you may save yourself a little time by backing them up and restoring them.

□ Mobile Uploads—photos uploaded using the Lightroom (cloud-based) app, perhaps using your

but you may save yourself a little time by backing them up and restoring them.

• Windows—C:\Users\[your username]\AppData\Roaming\Adobe\Lightroom\Preferences\Lightroom Classic CC 7 Startup Preferences.agprefs

Windows-C:\Users\[your username]\AppData\Roaming\Adobe\Lightroom\Preferences

Mac—Macintosh HD / Users / [your username] / Library / Preferences / com.adobe.

☐ Startup Preferences—includes the last used catalog path, the recent catalog list, which catalog to load on startup and the catalog upgrade history. The preferences could be rebuilt if necessary,

\Lightroom Classic CC 7 Preferences.agprefs

LightroomClassicCC7.plist

 Mac—Macintosh HD / Users / [your username] / Library / Application Support / Adobe / Lightroom / Preferences / Lightroom Classic CC 7 Startup Preferences.agprefs

THE LIGHTROOM WORKSPACE

5

It's worth becoming familiar with the whole Lightroom interface as you'll be using different areas in all future

tasks, so on the following double page spread, there's a quick guided tour. Flip over to get an overview (Figure 5.2 overleaf), and then we'll do a deeper dive into the Lightroom workspace, and then come back here to continue...

The highlights are shown on the diagram overleaf are for quick reference, but if they're too small (e.g., on your eReader or tablet), don't worry, as we'll discuss them in detail in the text too.

THE TOP BAR

Let's work our way round the different elements of the screen in more detail, starting at the top.

Module Picker

Lightroom is divided up into modules. Library is where you manage your photos, Develop is where you edit them, Map allows you to add location metadata, and then Book, Slideshow, Print and Web are for displaying your photos in different formats.

In the top-right corner of the Lightroom workspace is the Module Picker where you click to switch modules. (Figure 5.1) When you open Lightroom for the first time, the Library module is selected and its name is highlighted in the Module Picker. To switch to a different module, click on its name.

As you'll likely spend most of your time switching between the Library and Develop modules, it's worth learning those keyboard shortcuts—G for Grid view, E for Loupe view, and D to switch to the Develop module. We'll come back to the Library view modes a little later in the Viewing Your Photos chapter starting on page 81.

If the Module Picker won't fit because you're working on too small a screen, an arrow appears on the right, allowing access to the other modules. If you don't use a specific module often, for example, you don't print from your netbook, you can right-click on the module name and uncheck to hide it. The hidden module is still accessible from the *Window menu*, and you can show it again at any time by right-clicking on the Module Picker and reselecting the module name in the context-sensitive menu.

...continues on page 72

Figure 5.1 If modules become hidden, right-click on one of the other module names or click on the double arrows at the right hand end of the Module Picker.

The Lightroom Interface Overview

Title Bar

The Title Bar shows the name of the — current catalog, along with the standard window buttons. If it goes missing, along with the minimize/maximize/close buttons, press Shift-F once or twice to cancel the Full Screen modes. If the whole interface goes missing, leaving just the photo on screen, press Escape.

Identity Plate & Activity Center

The Identity Plate allows you to add your own branding to your catalogs. When a background task is active, such as building previews, it's replaced by the Activity Center status bars.

Panels

Panels can be opened and closed by clicking on the panel header. If you right-click on the panel header, you can show/hide specific panels.

In that right-click menu, you'll also find Solo Mode, which automatically closes a panel when you open another panel in the same panel group. It's particularly useful when working on a small screen.

Show/Hide Panel Groups

The left and right-hand sides are called panel groups. If you click on the black bars along the outer edges of the screen, you can show/hide the left/right panel groups, as well as the Module Picker and the Filmstrip. Right-clicking on the black bars gives additional options.

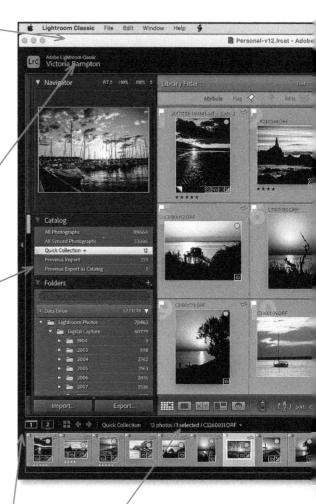

Breadcrumb Bar

The breadcrumb bar at the top of the Filmstrip has controls for the secondary window, as well as information about the selected source folder or collection, the number of photos in the current view and the number of selected photos. If you click on it, there's a list of recent sources for easy access.

Figure 5.2 The sections of the workspace for quick reference.

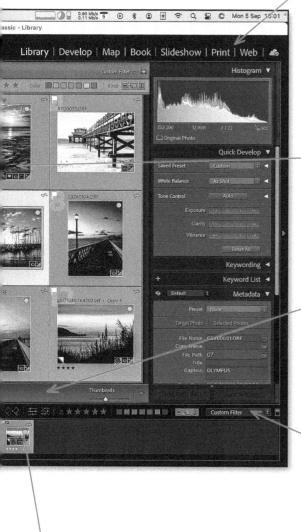

Module Picker

The Module Picker gives you access to the Library, Develop, Map, Book, Slideshow, Print and Web modules. The selected module is highlighted, and you can click on another module name to switch modules. If you right-click on a module name, you can hide modules from view.

Preview Area

The central area of the screen is the Preview Area or main work area.

Toolbar

The Toolbar gives easy access to often used tools. Press T on your keyboard if it goes missing, and click on the arrow at the right-hand end to choose which tools show in the Toolbar.

Filter Bar

When viewing Grid view, the Filter Bar appears above the thumbnails. It allows you to filter the current view to only show photos meeting your chosen criteria. If it goes missing, press the \key on your keyboard. You can also access frequently used filters by clicking the word Filter on the Filmstrip.

Filmstrip

The Filmstrip is available in all modules and shows the set of photos you're currently viewing. When you select a different photo in the Filmstrip, the main Preview Area is updated too.

If you select a custom Identity Plate, you can also change the font used for the Module Picker to a smaller size or narrower font, allowing them to fit on small screens without hiding any modules.

Identity Plate

To the left of the Module Picker is the Identity Plate, which allows you to add your own branding to your catalogs. (Figure 5.3)

To change the Identity Plate, go to *Edit menu* (Windows) / *Lightroom menu* (Mac) > *Identity Plate Setup*. (Figure 5.4) In the *Identity Plate* pop-up, there are three options:

Adobe ID displays your name.

Lightroom simply says "Adobe Lightroom Classic".

Personalized allows you to create your own custom Identity Plate.

Figure 5.3 The Identity Plate is to the left of the Module Picker.

To add your logo, select *Use a graphical identity plate.* Use the *Locate File* button to navigate to your logo, or drag it from Explorer (Windows) / Finder (Mac) into the preview field below. PNG format is a good choice, as it retains any transparency.

To create a text Identity Plate, perhaps using the catalog name, select *Use a styled text identity plate* and type the text of your choice. Select the text and change the font, size and color using the pop-ups below. Different sections of text can have different styling.

These Identity Plates can also later be used in the Slideshow, Print and Web modules, so you may keep a selection of Identity Plate presets for different uses. To save your settings as a preset, select *Save As* in the second pop-up menu at the top of the dialog and give your Identity Plate a name. The Identity Plates settings are stored in the catalog, so if you have multiple catalogs, you'll need to set them up in each catalog.

Activity Center

When there's an active process running in the background, for example, a large import or previews building, the Identity Plate is temporarily replaced by the Activity Center.

Figure 5.4 You can design your own Identity Plate to brand your catalog.

(Figure 5.5) It shows the progress of any current tasks, and clicking on the X at the end cancels the task.

Lightroom is multi-threaded, which means it can do lots of tasks at once, so you don't need to wait for it to finish before doing something else.

If you click on the Activity Center, it expands to show more detail on the current tasks, including the name of the file that Lightroom's working on, and in some cases, a gray progress bar. (Figure 5.6)

In the Activity Center you can also control the ongoing tasks that run silently in the background, such as **Address Lookup** and **Face Detection**. If these tasks are running in the background and slowing down the computer, you can temporarily pause them using the toggle play/pause button to the right, enabling them again at a time when you don't need to use the computer.

Figure 5.5 The Activity Center shows the progress of active tasks.

Figure 5.6 Click on the Identity Plate to show the expanded Activity Center which includes additional information and background processes.

If you right-click on the Identity Plate, you can show these background tasks above the main Identity Plate when they're running. (Figure 5.7)

Title Bar & Full Screen Modes

Above the Identity Plate and Module Picker is the standard window title bar and menu. (Figure 5.8) If you find these distracting when working with Lightroom, they can be hidden using Lightroom's Full Screen modes. They're all listed under *Window menu > Screen Mode*.

Normal window mode allows you to resize or move the window. The title bar along the top of the window shows the name of the current catalog, along with the standard minimize/maximize/close window buttons.

Full Screen with Menu Bar fills the screen but leaves the menu bar showing.

Full Screen hides the menu bar, as well as filling the screen. Floating the mouse right to the top of the screen briefly displays the menu bar.

Full Screen Preview mode hides everything

Figure 5.7 Right-click on the Identity Plate to always show background activity for selected tasks.

Figure 5.8 The Menu bar, Title bar and catalog name.

except the photo, allowing you to view it without any distractions. Even the cursor hides if the mouse is stationary. Press the F key to switch to and from the Full Screen Preview mode.

PANELS & PANEL GROUPS

Down the left and right-hand sides of the screen are panel groups, each holding individual panels. The panel group on the left always holds the Navigator or Preview panel and other sources of information—folders, collections, templates, presets, etc. The panels on the right allow you to work with the photos themselves, adding metadata, changing Develop settings, and adjusting settings for books, slideshows, prints and web galleries.

The black bar along the outer edges of the panels controls whether that panel group is showing or hidden. Click on that bar to open or close the panel group. There are matching black bars at the top and bottom of the screen to hide the Module Picker and Filmstrip too. (Figure 5.9)

Figure 5.9 A solid arrow indicates that the panel is locked into position, and an opaque arrow indicates that the panel group is set to automatically show or hide when you float the mouse over that black bar.

The panel groups are set to **Auto Hide & Auto Show** by default, which means that if you click on the black bar to hide the panel, every time you float the mouse close to the edge, the panels will pop into view. If you right-click on the black bars, you can change the behavior for each panel group, setting it to **Auto Hide** or **Manual**. **Sync with Opposite Panel** opens or closes the panel group at the same time as the panel group on the opposite side. (**Figure 5.10**)

Within the panel groups are individual panels, and they can be opened and closed by clicking on the panel header. If there's a panel you never use, right-click on the panel header (excluding Develop panels) and uncheck the panel name in the context-sensitive menu. To bring it back, just check it again or select the panel name under *Window menu > Panels*.

Solo Mode

In that right-click menu, you'll also find Solo Mode, which automatically closes a panel when you open another panel in the same panel group, so you just have one panel

Figure 5.10 Change the panel show and hide settings by right-clicking on the black bars.

open at a time. It's especially useful when working on a small screen, to save scrolling up and down. To open another panel without closing the first one, hold down the Shift key while clicking on the panel header.

Develop Module Panel Order

In the Develop module, you can rearrange the order of the Develop module panels to suit your own workflow. For example, perhaps you always leave Detail panel (noise reduction/sharpening) adjustments until last to improve performance (page 536), so you might move the Detail panel to the end.

To do so, right-click on the header of a right-hand Develop panel and select *Customize Develop Panel*. Drag the panels into the order of your choice, then restart Lightroom to apply the change. You can also show/hide

Figure 5.11 You can customize the order of the Develop panels to suit your workflow.

Develop panels using the checkboxes. (Figure 5.11)

The keyboard shortcuts to open/close the Develop panels, which are Ctrl 1-9 (Windows) / Cmd 1-9 (Mac) still apply from top to bottom. For example, if you move the Detail panel from position 5 to position 9, the shortcut changes from the number 5 to the number 9, even if some of the panels in between are hidden.

Panel Preferences

As well as showing/hiding panels, you can adjust the way they're displayed. Dragging the inner edge of the panel groups (or top edge of the Filmstrip), you can make them wider or narrower. This also changes the width of the sliders, making them easier to adjust. (On Mac, hold down the Opt key while dragging the inner edge to stretch beyond their normal limits.) (Figure 5.12)

There are additional controls in the *Preferences dialog > Interface tab*, where you can adjust the *Font Size* slightly and add panel *End Marks* to the bottom of each panel group. (Figure 5.13) You can create your own panel end marks, for example, you can display your logo or notes such as

Figure 5.12 Panel groups can be resized by dragging the inner edge. The Panel End Marks show below the panels.

Figure 5.13 Change the Panel End Marks in the Interface tab of the Preferences dialog.

the meanings of your star ratings and color labels.

To create your own panel end mark, you'll need a pixel editor such as Photoshop or Photoshop Elements. Create a transparent file of up to 250px wide (140px wide generally looks good), type your chosen text or add your logo, and save it as PNG, TIF, PSD or GIF. If you're creating a Panel End Mark for a retina display, make it double the size and end the name in @2x (e.g. mypanelendmark@2x.png).

In the Preferences dialog > End Marks pop-up, select Go to Panel End Marks Folder and copy your file to that folder. Finally, select your panel end mark name from the pop-up and close the dialog.

THE FILMSTRIP

The bottom panel is called the Filmstrip. It displays thumbnails of the photos in your current view, making them accessible in the other modules. When you select a different photo in the Filmstrip, the main Preview Area is updated too.

To change the size of the thumbnails, drag the top of the Filmstrip to enlarge it or rightclick on that edge to view a menu of preset thumbnail sizes.

If you find that the Filmstrip thumbnails become too cluttered with icons, or you like them there for information but don't want them to do anything if you accidentally click, you can select which ones to view using the *Preferences dialog > Interface tab* in the *Filmstrip* section, or by right-clicking and selecting *View Options*. The square badges automatically disappear when the thumbnails become too small.

Breadcrumb Bar

Along the top of the Filmstrip are other useful tools, including breadcrumb navigation that allows you to retrace your steps. (Figure 5.14)

From left to right, they are:

Secondary Display controls allow you to display a second Lightroom window.

Grid button gives you quick access to the Grid view from any module.

Forward and Back buttons step backwards and forwards through recent sources, like your web browser buttons. For example, it remembers each time you switch between different folders.

The Breadcrumb shows additional information about your current view. It shows whether you're viewing a folder or a collection, the folder or collection name, the number of photos that are currently visible and aren't hidden by a filter or collapsed stack, the total number of photos in that folder/collection, the number of photos selected, and finally the name of the

currently selected photo.

Even wondered why it's called a breadcrumb bar? It comes from the story of Hansel & Gretel, where they left a trail of breadcrumbs to retrace their steps. When you click on Lightroom's breadcrumb bar, it shows all of your recent sources.

Recent & Favorite Folders are displayed when you click on the breadcrumb, so you can easily skip back to a recent view. It also allows you to add favorite folders/collections that you visit regularly, using the *Add to Favorites* option at the bottom of the menu.

Quick Filters display on the right hand side. They give easy access to basic filtering without having to switch back to Grid view. We'll come back to filtering in the Finding & Filtering chapter starting on page 183, but to toggle between the compact and expanded views, click the word *Filter*, and to disable the filters temporarily, toggle the switch on the right. (**Figure 5.15**)

Preview Area

In the center of the window is the preview area, or main work area, which shows the photo(s) that you're currently working on. In the Library module, this can be Grid, Compare, Survey or People view with multiple photos, or a large Loupe view of the whole photo. We'll come back to these view options in the next chapter starting on page 81. In the Develop module it displays a high quality preview of your photo, and

in the other modules the main preview area displays the output layout you're working on, such as book pages, slides, print packages or web gallery previews.

By default, the background surrounding the photo is mid-gray, however you can change it to white, black, or other shades of gray. To change it, go to Lightroom's *Preferences dialog > Interface tab*, or right-click on that gray surround and select an alternative shade from the context-sensitive menu.

Filter Bar

When viewing Grid view, the Filter Bar appears above the thumbnails. It allows you to filter the current view to show only photos meeting your chosen criteria. We'll come back to the different filter options and their icons in the Finding & Filtering chapter starting on page 183. If it goes missing, press the \ key on your keyboard. You can also access frequently used filters by clicking the word **Filter** on the Filmstrip.

Toolbar

Beneath the preview area you'll see the Toolbar. If it goes missing, press the T key on your keyboard or select *View menu > Show Toolbar*. (Figure 5.16) The options that are available on this Toolbar change depending on your current module or view, and if you click the arrow at the right-hand end, you can choose to show different tools.

Now let's move on to the fun part... viewing your photos!

Figure 5.15 The Quick Filters are displayed on the Filmstrip, and if you click the word Filter (above), it opens up to show additional filter options (below).

Figure 5.16 The Toolbar appears below the grid or preview area, and gives you easy access to frequently used tools. This is the Loupe view toolbar.

WORKSPACE SHORTCUTS

		Windows	Mac
Moving between Modules	Library Module	G/E/C/N or Ctrl Alt 1	G/E/C/N or Cmd Opt 1
	Library Module—Grid view	G	G
	Library Module—Loupe view	E	Е
	Library Module—Compare view	С	С
	Library Module—Survey View	N	N
	Library Module—Faces View	0	0
	Develop Module	D or Ctrl Alt 2	D or Cmd Opt 2
	Map Module	Ctrl Alt 3	Cmd Opt 3
	Book Module	Ctrl Alt 4	Cmd Opt 4
	Slideshow Module	Ctrl Alt 5	Cmd Opt 5
	Print Module	Ctrl Alt 6	Cmd Opt 6
	Web Module	Ctrl Alt 7	Cmd Opt 7
	Go Back to Previous Module	Ctrl Alt up	Cmd Opt up
	Go Back	Ctrl Alt left arrow	Cmd Opt left arrow
	Go Forward	Ctrl Alt right arrow	Cmd Opt right arrow
Panels	Show / Hide Side Panels	Tab	Tab
	Show / Hide All Panels	Shift Tab	Shift Tab
	Show / Hide Module Picker	F5	F5
	Show / Hide Filmstrip	F6	F6
	Show / Hide Toolbar	Т	Т
	Show / Hide Filter Bar in Grid view	\	\
	Show Left Panels	F7	F7
	Show Right Panels	F8	F8

		Windows	Mac
	Expand / Collapse Left Panels	Ctrl Shift 0-9 panel number	Cmd Ctrl 0-9 panel number
	Expand / Collapse Right Panels	Ctrl 0-9 panel number	Cmd 0-9 panel number
	Open/Close All Panels	Ctrl-click on panel header	Cmd-click on panel header
	Toggle Solo Mode	Alt-click on panel header	Opt-click on panel header
	Open Additional Panel in Solo Mode	Shift-click on panel header	Shift-click on panel header
Screen Mode	Normal	Ctrl Alt F	Cmd Opt F
	Full Screen and Hide Panels	Ctrl Shift F	Cmd Shift F
	Full Screen Preview	F	F
	Next Screen Mode	Shift F	Shift F
Hide Lightroom			Cmd H
Hide Others			Cmd Opt H
	Close Window		Cmd W
	Close All		Cmd Opt W
	Minimize		Cmd M
	Minimize All		Cmd Opt M
Quit Lightroom		Ctrl Q	Cmd Q

VIEWING YOUR PHOTOS

6

You'll browse and manage your photos in the Library module, where there are a number of different view modes.

If you've been exploring, select the Library module in the Module Picker, then go to the Catalog panel in the left panel group and select the *Previous Import* or *All Photographs* collection, or select a folder in the Folders panel, and we'll use these photos to explore the different view modes. (Figure 6.1)

VIEWING YOUR PHOTOS IN GRID VIEW

Much of the work you'll do in Lightroom will be in the Grid view, which can be accessed using the Grid icon on the Toolbar, by pressing the G key on your keyboard, or via the *View menu*. (Figure 6.2)

Figure 6.1 The view modes buttons are on the Toolbar. From left to right, they are Grid, Loupe, Compare, Survey and People modes.

Figure 6.2 Enter Grid mode by clicking this button in the Toolbar or by pressing G.

Grid view is a scrolling page of thumbnails (Figure 6.3), and you can change the size of the thumbnails using the slider on the Toolbar. You can drag and drop these thumbnails into a different sort order in the Grid, or drag them onto other folders, collections or keywords to move or copy them. When dragging thumbnails, note that you have to pick them up by the thumbnail itself and not the border surrounding it, otherwise they'll become deselected.

On the right of the Grid view is a scrollbar which allows you to scroll through the thumbnails. My favorite trick is to Ctrl-click (Windows) / Opt-click (Mac) anywhere on that scrollbar to scroll directly to that point. It's much quicker than having to scroll a

Figure 6.3 Grid view

line at a time and get dizzy watching the thumbnails pass before you!

Normally when you scroll, the top and bottom thumbnails are cut off, only showing part of the image. If you prefer to show as many complete thumbnails as possible, enable *View menu* > **Scroll by Row**. If you then hold down the Shift key while scrolling, Lightroom scrolls a whole page at a time, instead of a row at a time.

If you swipe through photos on a Mac using a Magic Mouse, Trackpad or similar peripheral device, Lightroom scrolls very fast. To disable this "speed swiping", uncheck the *Preferences > Interface > Swipe between images using mouse/trackpad* checkbox.

In the Grid View, the thumbnails of the photos are contained within gray cells which hold additional information about the photos. There are three varieties of cell, which you cycle through using the J key or View menu > Grid View Style. First is a minimal view showing the thumbnail without any other distractions, then a compact cell view showing the icons and some file information, and finally an expanded cell view showing additional lines of information. (Figure 6.4)

Thumbnail Options

If you go to *View menu > View Options*, you can choose the information you want to show on the thumbnail cells. (Figure 6.5)

The view of the thumbnails updates in the background as you test various combinations of settings, to help you decide which you like best. (Figure 6.6) Let's take a more detailed look at the thumbnail and its icons...

Thumbnail

In the center, of course, is a thumbnail preview of the photo. When you need to drag a photo, perhaps to another folder or collection, remember to click on the thumbnail itself rather than the cell border surrounding it, otherwise it won't move.

Cell Border

The cell border (or matte) surrounds the thumbnails and holds the extra metadata.

The color of the cell border changes through three different shades of gray, depending on the level of selection, and we'll come back to that in more detail on page 86. Clicking in

Figure 6.4 The simplest cell style (left) just shows the thumbnail photo. The compact cell (center) and extended cell (right) show additional information of your choice.

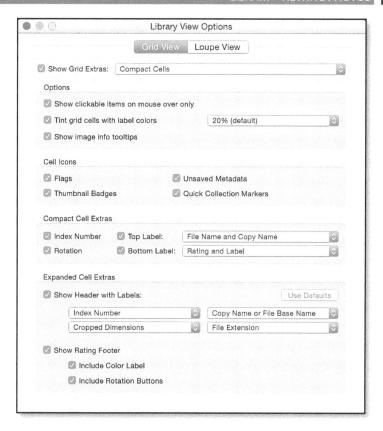

Figure 6.5 Set the thumbnail options in the View Options dialog.

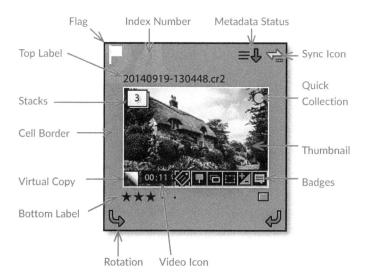

Figure 6.6 A wide variety of information can be shown on the thumbnails.

the cell border deselects all other photos.

If you use color labels (which we'll come to in the Selecting the Best Photos chapter starting on page 101), the cell border can be tinted with the label color using *View Options > Tint grid cells with label color*.

Top & Bottom Label

Metadata, such as the filename or capture date, can also be displayed within the cell border, above and below the thumbnail. By default, the top label is turned off and the bottom label displays the star ratings and color labels, but you can select which metadata to display on each cell using the View Options dialog. Right-clicking on the labels also displays a menu of available options. The Expanded Cells view has additional lines for file information.

Metadata Status

In the top right corner, the metadata status icons keep you informed of the status of the external files, for example, if the original file is missing or corrupted, or the file's metadata doesn't match the catalog records.

Lightroom primarily stores your image metadata in your catalog, but it's possible to store it with the files too. We'll discuss the XMP metadata in more detail starting on page 411. If you choose to write the metadata to the files, enable the *Unsaved Metadata* checkbox in the View Options dialog to display additional status icons. This is what all the different metadata status icons mean:

Lightroom is checking the previews are current, building new previews, or waiting for a better quality thumbnail to load.

The file is missing or is not where

Lightroom is expecting, so click the icon to locate the missing file. More on that in the Missing Files section starting on page 499.

The file is missing but a Smart Preview is available.

The file is damaged or cannot be read, likely as a result of file corruption.

Lightroom's catalog has updated metadata which hasn't been written to XMP.

The file has updated metadata which hasn't been read into Lightroom's catalog.

Metadata conflict—both the XMP data in the file and Lightroom's catalog have been changed. Click the icon to choose whether to accept Lightroom's version or the XMP version.

This photo is included in a Sync collection.

Lightroom is waiting to sync this photo.

Quick Collection Marker

In the top right corner of the thumbnail is a small circle, which you click to check (gray) or uncheck (transparent). The marker displays as a gray circle when the photo is in the Target Collection (usually the Quick Collection). The Quick Collection is a way of temporarily grouping photos, which we'll discuss in more detail in Selecting & Grouping the Best Photos. If you frequently accidentally hit the circular Quick Collection marker, you can disable it in the View Options dialog.

Badges

The square badges at the bottom of the thumbnails give you additional information about the settings applied to the selected photo, and clicking on them takes you to the related module or panel. They are Keywords, Map Location, Collection Membership (only when not viewing the collection), Crop, Develop Adjustments and Comments (only when viewing a shared collection). (Figure 6.7)

Rotation

The rotation icons rotate your photo when you click on them. If **Show clickable items on mouse over only** is checked in View Options, the arrows disappear until you float over the photo.

Virtual Copy

A photo can have multiple versions of settings, whether that's metadata or Develop settings. These virtual copies are marked with a turned corner on the thumbnail. We'll come back to virtual copies in the Develop Module Tools chapter on page 382.

Stack

The Stack indicator shows how many photos are grouped together and the double lines on the left and right show the beginning and end of the visible stack. We'll discuss stacking in the Grouping Similar Photos section on page 107.

Figure 6.7 On the thumbnails themselves, there are badges with additional information. From left to right, they are keywords, map locations, collection membership, crop, Develop settings and social comments.

Flag

The flag state can be unflagged (invisible until you float over it), picked (white flag) or rejected (black flag). Clicking on it toggles between picked and unflagged, and Alt-click (Windows) / Opt-click (Mac) switches to a rejected flag. We'll come back to flagging in the next chapter, starting on page 101. (Figure 6.8)

Index Number

The index number counts the number of photos in the current view. For example, if you have 230 photos in your current folder or collection, the first is marked as 1 and the last as 230.

Video Icon

A video thumbnail icon displays the length of the video, and as you move your cursor horizontally across the thumbnail, it scrubs through the video, showing you the content. (Figure 6.9)

Figure 6.8 Photos can be flagged (left), unflagged (center) or rejected (right).

Figure 6.9 Videos have an additional badge showing the length of the clip.

SELECTIONS

When you select multiple photos in Lightroom's Grid view or in the Filmstrip, you'll notice that the cell border displays in three different shades of gray.

Because Lightroom allows you to synchronize settings across multiple photos, there needs to be a way of choosing the source of the settings as well as the target photos, so Lightroom has three different levels of selection (or two levels of selection plus a deselected state, depending on how you look at it). (Figure 6.10)

Active—The lightest shade of gray is the active photo. That's the single photo that would be shown in Loupe view or Develop module.

Selected—The mid gray is also selected, but it isn't the active photo.

Not Selected—The darkest shade of gray isn't selected.

Figure 6.10 There are three levels of selection—active (top left), selected (top right) and not selected (bottom).

Anything you do in Grid view on the primary monitor, such as adding star ratings or keywords, applies to all the selected photos, whereas other views only affect the active or most-selected photo.

When applying settings, or especially when deleting photos, double check how many photos are selected, otherwise you could accidentally apply a command to all of them.

If you're synchronizing settings across multiple photos, Lightroom takes the settings from the active photo and applies it to the other selected photos.

To select a single photo, you simply click on it. To select non-contiguous photos—ones that aren't grouped together—click the first photo and then hold down the Ctrl key (Windows) / Cmd key (Mac) while clicking on the other photos. To select sequential photos, click on the first photo, but this time hold down the Shift key while you click on the last photo, and the photos in between will also be selected.

There's also a trick to deselecting photos. Clicking on the thumbnail itself retains your current selection and makes that the active photo, leaving the others selected too. But if you click on the cell border surrounding the thumbnail, the other photos are deselected, leaving just that single photo selected.

The thumbnails give you a good overview, but they're a little too small to see the detail in your photos, so Lightroom offers three further view modes—Loupe, Compare and Survey—each with different strengths.

Why aren't my actions applying to all of the selected photos?

Most of your actions only apply to the active photo, for example, pressing Delete only usually removes the active photo. To apply a setting to multiple photos, you must select Grid view on the primary window.

This protects you from applying a setting to multiple photos without realizing they're selected (perhaps because the Filmstrip is hidden) and accidentally undoing many hours of work.

With every rule, there are always exceptions. These are the main ones:

- If you right-click on the Filmstrip or Secondary Display Grid view, the menu command applies to all selected photos (because you're obviously looking at them at the time!).
- A few commands, such as Export and Build Previews, always apply to all selected photos, but they won't do any harm.
- You can change the default behavior by enabling *Metadata menu > Auto Sync*. This causes any metadata actions to apply to all selected photos, regardless of the current view mode.

Can I see a list view?

There isn't a list view built into Lightroom, but there is an excellent plug-in by John Beardsworth called List View, available from https://www.Lrg.me/beardsworth-listview

VIEWING YOUR PHOTOS IN LOUPE VIEW

The Loupe view (Figure 6.11) displays a larger view of one photo at a time. To access Loupe view, click the Loupe button on the Toolbar (Figure 6.12), press the E key, or select Loupe in the *View menu*.

You can move from one photo to the next using the left and right arrows on the

keyboard, by selecting another photo from the Filmstrip, or by turning on the arrows in the Toolbar.

Zooming In on Photos

To zoom in to check details, press the Z key or Spacebar, or click on the photo. By default, it zooms into 100% view (previously called 1:1 view). Repeat to zoom out again.

There's a selection of additional zoom options at the top of the Navigator panel. (Figure 6.13)

The standard view is the **Fit** view which fits the whole photo within the preview area. If you click on *Fit* in the Navigator panel, you can switch to **Fill** view, which fills the entire width or height, hiding some of the photo.

The final pop-up allows you to switch through other zoom percentages, from 6% right up to 1600%. Previous Lightroom versions used ratios instead of percentages.

Figure 6.11 Loupe view gives a detailed view on a single photo, allowing you to zoom in to check the detail.

Figure 6.12 Enter Loupe view by clicking this button in the Toolbar or by pressing E.

Figure 6.13 The zoom ratios are on top of the Navigator panel. The last option is a pop-up of additional zoom ratios.

If you had favorite ratios, here's how they translate:

1:16 = 6.25%	2:1 = 200%
1:8 = 12.5%	3:1 = 300%
1:4 = 25%	4:1 = 400%
1:3 = 33%	8:1 = 800%
1:2 = 50%	11:1 = 1100%
1:1 = 100%	

Lightroom remembers your two most recent zoom settings and toggles between them, so to switch between Fit and 200% views, you'd click on Fit on the Navigator panel and then select 200% from the pop-up.

Once you've zoomed in on the photo, the cursor becomes a hand tool and you can click and drag the photo around to view different areas, which is called panning. If you're using an editing tool such as the brush, you'll need to hold down the Spacebar key while clicking and dragging. Alternatively, you can move the selection box on the Navigator preview.

When you want to zoom in on a specific area of the photo, Box Zoom and Scrubby Zoom may be useful.

Hold the Ctrl (Windows) / Cmd (Mac) key to show the Box Zoom cursor and click and drag on the image to draw a rectangular marquee. Lightroom zooms in to fill the preview area with the selected area of the photo.

Hold the Shift key to show the Scrubby Zoom cursor (currently only available in the Develop module with GPU enabled) and then drag left<>right to zoom in/out continuously. When using the TAT tool, Healing Brush, Red Eye tool or Masking, hold Ctrl-Shift (Windows) / Cmd-Shift (Mac) while dragging.

Lightroom remembers the last-used zoom/pan position for each individual photo, and returns to that same position next time you zoom in. If you check *View menu > Lock Zoom Position*, it ignores this saved position and uses the same image area for each photo. This is particularly useful if you're trying to compare the same spot on multiple photos, and you've previously zoomed into different areas on each photo.

Info Overlay

In the top left corner of the Loupe view (and Develop preview) is the Info Overlay, which displays information about the selected photo such as the filename or camera settings used. (Figure 6.14)

The Library module and Develop module can each store two different combinations of information to show in the Info Overlay. For example, in the Library module, you may be most interested in the Filename and Capture Date/Time, but in the Develop module you may want to see the Shutter Speed, Aperture and ISO.

To set up the Info Overlays for each module, select the module and go to *View menu > View Options*. (In the Library module, you'll also need to select the *Loupe view* tab, as the Grid view options are set using the same dialog.)

Once set, repeatedly pressing the I key cycles through the two Info Overlays and then hides it, or you can select a specific overlay under *View menu > Loupe Info*.

Status Overlay

Whenever you use a keyboard shortcut to apply a setting, a status overlay message appears in the preview area, for example, *Set Rating to 3*.

A similar type of overlay is used in the Loupe or Develop preview when Lightroom is loading or building previews. (Figure 6.15) If you find the Loading Overlay distracting, you can turn it off by unchecking **Show** message when loading or rendering photos in

Figure 6.14 The Info Overlay (top left) and Status Overlay (bottom center) appear in Loupe view.

Figure 6.15 The Status Overlay keeps you informed about any changes being applied to the selected photo.

the View Options dialog. Personally, I leave it disabled in the Develop module, as you can start working on the photo long before it's finished loading.

If you're seeing the Loading overlay in the Library module, it's probably because you haven't built the previews you need in advance, or they need to be updated as you've made Develop changes. To solve this, select all (or none) of the photos in Grid view, choose Library menu > Previews > Build Standard-Sized Previews or 1:1 Previews, then go and make a drink while it works. (Figure 6.16)

We'll come back to previews in more detail in the Performance chapter starting on page 524.

Using Embedded Previews to Avoid the Loading Overlay

Building previews takes time, although it can be done when you're not using the computer. Most cameras embed a JPEG preview inside a raw file at the time of capture, and you can take advantage of these ready-made previews by selecting *Embedded & Sidecar* in the *Build Previews* pop-up in the File Handling panel of the Import dialog (page 34).

When you come to view the photos in the Library module, the thumbnails have a small icon in the corner, and an overlay shown in the Loupe view, to remind you that you're

Figure 6.16 When one photo is selected, Lightroom asks whether to build previews for all the photos or just the selected photo.

viewing an embedded preview rather than one built by Lightroom. (Figure 6.17)

Embedded previews look like the camera JPEGs, with your in-camera settings applied. Develop presets selected in the Import dialog's *Apply During Import* panel are not applied to the embedded previews, so they won't show until you switch to the Develop module.

Lightroom still needs to build its own previews from the raw data eventually, so you can see your edits applied to the image. When you edit a photo using the Quick Develop panel or Develop module, Lightroom builds its own preview, replacing the embedded preview.

You can click on the Embedded Preview thumbnail icon or overlay to build a proper Lightroom preview at any time, or select the photos and go to Library menu > Previews > Build Standard-Sized Previews or Build 1:1 Previews when you're ready to convert them.

In Preferences > General tab, there's also a Replace embedded previews with standard previews during idle time checkbox, which does exactly as it suggests—it builds

Figure 6.17 Embedded previews are marked with an icon (top left of thumbnail) and loupe overlay.

the previews when you're not using the computer. You're probably best to leave this unchecked because it only builds standard-sized previews, and if you needed to zoom in, you'd then have to wait for Lightroom to build a 1:1 size preview.

Once a Lightroom preview is rendered, you can't go back to the embedded preview, and you can't access embedded previews for photos that have already been imported into Lightroom. They're just designed as a fast import preview.

The size of the embedded previews varies, for example, most current Canon and Nikon DSLRs embed full size previews, whereas Fuji, Olympus and Sony embed smaller previews. To check the size of embedded preview that your camera creates, upload a raw file to http://exif.regex.info/exif.cgi and compare the pixel dimensions of the extracted preview on the right against the full resolution on the left. (Figure 6.18)

If you try to zoom in to 100% view on a photo that has a smaller embedded preview, it may look a little fuzzy. If an embedded preview is less than 50% of the full resolution original, Lightroom ignores it and renders a standard preview instead. In either of these cases, you can shoot raw+jpeg in camera and Lightroom will use the full-size sidecar JPEGs instead of the embedded previews.

Distraction Free Viewing—Lights Out and Full Screen Preview

While we're on the subject of distractions, let's talk about Lightroom's distraction free view modes. Lights Dimmed and Lights Out dim or black out the interface around the photo, allowing you to focus solely on the selected photos in the preview area. The photos are surrounded by a single white line. To cycle through the Lights Dimmed and Lights Out modes, and then return to

Jeffre	leffrey's Image Metadata Viewer			Jeffrey Friedl's Image Metadata Viewer (How to use)	
or	of image on the web	I'm not a robot	reCAPTCHA	View Image Data	Some of my other stuff · My Blog · Lightroom plugins · Pretty Photos · "Photo Tech"
File: Choo	ise rile ino lile selected		Privacy - Terms		
					rtainly not required. Send a gift via PayPal , or perhaps an
	ertificate (to: jfriedl@yahoo.com), or perhap		mething kind	or a stranger.	
If you have o	questions about this tool, please see the F	AQ.			
Basic Ima	ge Information			Emb	edded Preview Size
Target file:	20171101-161818.orf		© ⊝ Displa	© 1:1 Extracted 3200 × 24 yed here at 14% width (1/1)	00 1.0-megabyte "Composite:PreviewImage" JPG
Artist:	Victoria Bampton		Note:	thumbnail size does not ma	atch image size —
Camera:	Olympus E-M1MarkII		image	crop not reflected in thum	onail?
Lens:	OLYMPUS M.12-100mm F4 Shot at 100 mm				
Exposure:	Manual exposure, Aperture-priority AE Compensation: +1	, ¹ /200 sec, f/7.1, ISO 640,			
Flash:	On, Did not fire		N.		
Focus:	Single AF; S-AF, Imager AF, Left (or n about <u>59m</u> to infinity, Warning: Olympus camera focus-distance data is	,,,	om		
Date:	November 1, 2017 4:18:18PM (timezoni (1 month, 17 days, 9 hours, 38 minutes, 17 secon Pacific)				
File:	5,240 × 3,912 ORF (20.5 megapixels) 18,766,006 bytes (17.9 megabytes)	Full Resolution			
Color Encoding:	WARNING: Color space tagged as sR profile. Windows and Mac browsers randomly.		Click in	nage to isolate; click this text to s	how histogram

Figure 6.18 *Jeffrey's Image Metadata Viewer shows the size of the embedded preview.*

normal Lights On mode, press the L key on your keyboard three times. You can adjust the color and dim level in the *Preferences dialog > Interface tab*.

To view a single larger photo in Full Screen Preview mode, press the F key to turn it on and off. Like Lights Out view, Full Screen Preview mode hides everything, displaying just the photo with a plain black background.

Loupe Overlay

If you're searching for a photo for a particular purpose—perhaps for a magazine cover or product shots for a catalog—then you may need to preview how the photo will look in its final layout. The Loupe Overlay allows you to preview your photo with an overlaid Grid, movable Guides, and a transparent layout image. (Figure 6.19)

The Loupe Overlay can be used on any photo in the Library or Develop module,

Figure 6.19 The Loupe Overlay Layout Image allows you to preview how your photo will look in the final design, for example, for a book or magazine cover.

but it's most useful when shooting tethered, allowing you to check that you're keeping the subject positioned correctly within the final frame. To activate the overlay, go to *View menu > Loupe Overlay* and add a checkmark to the *Grid*, *Guides* and/or the *Layout Image*.

If you select Layout Image, it asks you to choose a transparent PNG file. (You can change the overlay file again later by selecting View menu > Loupe Overlay > Choose Image.)

To adjust any of the overlays, hold down the Ctrl key (Windows) / Cmd key (Mac) to show the controls. When *Grid* is selected, the available options are size and opacity. When *Guides* is selected, holding down the Ctrl key (Windows) / Cmd key (Mac) allows you to drag the crosshairs to move the guides, and double-clicking on the crosshairs resets them to center.

When you have a **Layout Image** selected, there are a few additional options. When the hand tool is showing, dragging the overlay moves it around on the photo. Dragging the corners resizes the overlay. The **Opacity** option affects the opacity of the overlay itself, and **Matte** affects the opacity of the black area surrounding the overlay. The matte works like Lights Out mode, hiding excess picture under a black matte.

Playing Videos in Loupe View

There's one final Loupe view overlay, which only appears when a video is selected. The playback controller overlay has a play/pause button, timeline, timestamp, thumbnail button and editing button. Press the triangular button to play the video. (Figure 6.20) (Some older video formats may play in a separate window.) We'll come back to basic editing in the Video Editing section starting on page 255.

There are additional view options under View menu > View Options > Loupe View tab. Show frame number when displaying video time adds the frame number to the minutes:seconds display when the playback controller is expanded. Play HD video at draft quality uses a lower resolution for smoother playback on slower machines.

VIEWING YOUR PHOTOS IN SURVEY VIEW

Lightroom's Survey mode (Figure 6.21) allows you to view multiple photos at the same time, so it's particularly

useful when you have a series of similar photos to narrow down to your favorites.

Figure 6.20 The video controls appear when you float the cursor over the video in Loupe view.

Select the photos in Grid or Filmstrip. If they're consecutive photos, click on the first photo, then hold down the Shift key and click on the last one. If the photos are scattered, hold down the Ctrl (Windows) / Cmd (Mac) while clicking on their thumbnails. Once the photos are selected, press the Survey button on the Toolbar (Figure 6.22), the N key on your keyboard, or go to View menu > Survey.

Most of the shortcuts use quite logical letters, but there isn't even an N in the word 'survey.' As an interesting piece of trivia, and easier way of remembering the N shortcut, this view was initially called N-Up while it was being developed, which is where the shortcut originated.

When you hover over a photo, the rating/flag/label icons appear, along with an X icon which removes the photo from the selection and from the Survey view. When you return to Grid view, only the leftover photos are still selected, so you can mark them using the ranking system of your choice.

Figure 6.21 Survey mode allows you to view multiple photos at the same time.

Figure 6.22 Enter Survey mode by clicking this button in the Toolbar or by pressing N.

VIEWING YOUR PHOTOS IN COMPARE VIEW

Compare view (Figure 6.23) is used to compare two similar photos, and unlike Survey view, it allows you to zoom in too. Select two photos and press the Compare button on the Toolbar (Figure 6.24), the C key, or go to *View menu* > *Compare* to enter Compare mode.

The active photo becomes the Select, shown on the left and marked with a white

Figure 6.23 Enter Compare mode by clicking this button in the Toolbar or by pressing C.

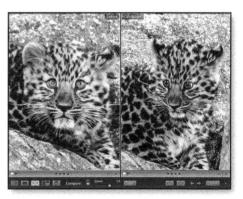

Figure 6.24 Compare mode compares two photos in great detail, so you can choose your favorite before moving onto the next pair.

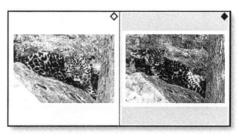

Figure 6.25 In the Filmstrip, when using Compare view, the white diamond is the Select and the black diamond is the Candidate.

diamond icon. The other photo becomes the Candidate, shown on the right and marked with a black diamond icon. (Figure 6.25)

The Select on the left is fixed in place, and as you use the left/right arrow keys on your keyboard to step through the photos, the Candidate on the right changes. When you find a photo you like better than the current

Select, you can press the XY buttons on the Toolbar to switch them round, making your new favorite photo your new Select. (Figure 6.26)

As you upgrade a photo from a Candidate to a Select, the next photo becomes the new Candidate. Imagine you have a series of 5 similar photos, and you want to pick

Figure 6.26 The buttons on the Toolbar switch the Select and Candidate photos.

Figure 6.27 Imagine you start with images 1 and 2. You decide you don't like number 2, so you move to the next photo by pressing the right arrow key.

Figure 6.29 You compare that against number 4, but you still like 3 better, so you press the right arrow key to compare 3 and 5.

Figure 6.28 You're now comparing photos 1 and 3, and you decide you like 3 better, so you press the X<Y button to make number 3 the new Select.

Figure 6.30 In the end, number 3 is your favorite, so you mark it with a star rating.

the best one. You start with number 1 as the Select and number 2 as the Candidate. (Figures 6.27-6.30)

The *Link Focus* icon (which looks like a lock) is particularly useful when checking that all the people in a group photo have their eyes open. If both photos are identically aligned, you can click the lock before zooming, and as you pan around the photo, both photos will pan. If they're not aligned, press the *Sync* button and then lock the position, so that the positioning follows you as you pan around both photos. With the lock unlocked (or while holding down the Shift key), the photos pan and zoom independently.

SECONDARY DISPLAY

When many users think of using dual monitors, they think of Photoshop and tear off panels. Lightroom's Secondary Display options don't allow you to tear off panels, but they do allow you to display the photos on a secondary display, whether that's on a second screen or just another floating window on the same screen.

The Display controls are on the top left of the Filmstrip. (Figure 6.31) A single click on the Secondary Display icon turns that display on or off, and a long click or right-click on each icon shows a context-sensitive menu with the View Options for that display.

Figure 6.31 The Secondary Display buttons change depending on whether they're set to full screen mode or window mode.

The Secondary Display offers a few different view options: (Figure 6.32)

Grid is particularly useful for selecting photos for use in the Map module or one of the output modules.

Loupe displays a large view of the photo currently selected on the main screen.

Live Loupe shows the photo currently under the cursor, and updates live as you float the mouse across different photos on the main screen.

Locked Loupe fixes your chosen photo to the Loupe view, which is useful as a point of comparison or reference photo. (You may also like to use Reference View for this purpose—see page 381 for more detail.)

Compare is the usual Compare view, but allows you to select and rearrange the photos in Grid view on the main screen while viewing Compare view on the secondary display.

Survey is the usual Survey view, but allows you to select and rearrange the photos in

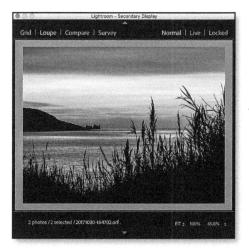

Figure 6.32 The Secondary Display Main Window.

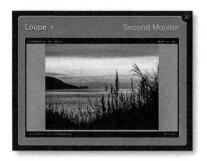

Figure 6.33 The Second Monitor
Preview is available when the Secondary
Display is set to full screen view.

Grid view on the main screen while viewing Survey view on the secondary display. It's useful for checking consistency when editing a set of photos in Develop.

Slideshow is only available when the Secondary Display is in Full Screen mode, where it runs a slideshow of the current folder or collection, while you carry on working on the main screen. Just be aware that if you switch folder/collection on the main screen, the secondary slideshow will also follow that change.

Second Monitor Preview is useful if your second monitor is facing away from you, for example, facing a client on the opposite side of the table. **(Figure 6.33)** Using the

pop-up in the corner of the preview, you can view and control what they see without repeatedly running round to the other side of the table. It only works when the Secondary Display is in full screen mode.

How do I choose which screen displays the primary and secondary windows?

If the windows aren't in full screen mode, you can simply drag them to the screen of your choice, and resize them to suit you, just as you would with any other window.

However, if you have more than two monitors, your chosen window position may not be retained between sessions. Instead, go to *Preferences > Display tab* and select which monitor you would like to display the secondary window. (Figure 6.34)

Why do shortcuts and menu commands only apply to a single photo even though I have multiple photos selected on the Secondary Display Grid?

Lightroom doesn't know which screen you're looking at when you press a keyboard shortcut or menu command. For that reason, it always assumes that you're looking at the Primary Display (the main Lightroom window). Any shortcuts or menu commands

Figure 6.34 A default monitor for the secondary window can now be set in Preferences.

will apply to the photo(s) shown on the Primary Display, unless you have *Metadata menu* > *Auto Sync* turned on, in which case it will apply to all selected photos.

The main exception is the context-sensitive menu command on Grid on the Secondary Display, because if you've just clicked on the Secondary Display, you're obviously looking at it and realize that multiple photos are selected.

VIEWING PHOTOS SHORTCUTS

		Windows	Mac
Grid View	Go to Grid view	G	G
	Increase Grid Size	= or +	= or +
	Decrease Grid Size	-	-
	Show/Hide Extras	Ctrl Shift H	Cmd Shift H
	Show/Hide Badges	Ctrl Alt Shift H	Cmd Opt Shift H
10	Cycle Grid View Style	J	J
	Show / Hide Toolbar	Т	Т
	Show / Hide Filter Bar	\	\
Grid/Loupe View	View Options	Ctrl J	Cmd J
Loupe View	Go to Loupe view	E	E
	Show Info Overlay	Ctrl I	Cmd I
	Cycle Info Display	ı	I
	Show Loupe Overlay	Ctrl Alt O	Cmd Opt O
	Choose Layout Overlay Image	Ctrl Alt Shift O	Cmd Opt Shift O
	Loupe Overlay Options	Hold Ctrl key	Hold Cmd key
	Video Play / Pause	Spacebar	Spacebar
Zoom	Toggle Zoom View	Z	Z
	Zoom In	Ctrl = or +	Cmd = or +
	Zoom to 100%	Ctrl Alt 0	Cmd Opt 0
	Zoom Out	Ctrl -	Cmd -
	Box Zoom	Hold Ctrl and draw marquee on photo	Hold Cmd and draw marquee on photo
	Scrubby Zoom (Develop module only)	Hold Shift and drag left<>right on photo	Hold Shift and drag left<>right on photo

		Windows	Mac
	Scrubby Zoom (when using a tool such as TAT, Healing, Masking etc.)	Hold Ctrl Shift and drag left<>right on photo	Hold Cmd Shift and drag left<>right on photo
	Lock Zoom Position	Ctrl Shift =	Cmd Shift =
	Open in Loupe	Enter	Return
Compare View	Go to Compare view	С	С
	Switch Select and Candidate	Down arrow	Down arrow
	Mark next photos Select and Candidate	Up arrow	Up arrow
	Swap most-selected/active photo	\	\
Survey View	Go to Survey view	N	N
Selections	Select All	Ctrl A	Cmd A
	Select None	Ctrl D or Ctrl Shift A	Cmd D or Cmd Shift A
	Select Only Active Photo	Ctrl Shift D	Cmd Shift D
	Deselect Active Photo	/	/
	Select Multiple Contiguous Photos	Shift-click on photos	Shift-click on photos
	Select Multiple Non-Contiguous Photos	Ctrl-click on photos	Cmd-click on photos
	Add previous/next photo to selection	Shift left/right arrow	Shift left/right arrow
	Select Flagged Photos	Ctrl Alt A	Cmd Opt A
	Deselect Unflagged Photos	Ctrl Alt Shift D	Cmd Opt Shift D
	Select Rated/Labeled Photos	Ctrl-click on symbol in Filter bar	Cmd-click on symbol in Filter bar
Moving between photos	Previous Selected Photo	Ctrl left arrow	Cmd left arrow
	Next Selected Photo	Ctrl right arrow	Cmd right arrow
Lights Out	Lights Dim	Ctrl Shift L	Cmd Shift L

		Windows	Mac
	Next Light Mode	L	L
	Previous Light Mode	Shift L	Shift L
Secondary Display	Show Secondary Display	Ctrl F11	Cmd F11
	Full Screen	Shift F11	Cmd Shift F11
	Show Second Monitor Preview	Ctrl Shift F11	Cmd Shift Opt F11
	Grid	Shift G	Shift G
	Increase Thumbnail Size	Shift = or +	Shift = or +
	Decrease Thumbnail Size	Shift -	Shift -
	Show Filter View	Shift \	Shift \
	Loupe—Normal	Shift E	Shift E
	Loupe—Locked	Ctrl Shift Enter	Cmd Shift Return
	Zoom In	Ctrl Shift = or +	Cmd Shift = or +
	Zoom In Some	Ctrl Shift Alt = or +	Cmd Shift Opt = or +
	Zoom Out	Ctrl Shift -	Cmd Shift -
	Zoom Out Some	Ctrl Shift Alt -	Cmd Shift Opt -
	Compare	Shift C	Shift C
	Survey	Shift N	Shift N
	Slideshow	Ctrl Alt Shift Enter	Cmd Opt Shift Return

SELECTING THE BEST PHOTOS

7

Having imported and viewed your photos, you're ready to start managing them—sorting through them and

choosing your favorites, organizing them into groups, adding metadata to describe the photos, and then later going back to find specific photos using various filtering options.

RATING YOUR PHOTOS

Lightroom offers three different ways of ranking your photos.

Flags have three different states—flagged (picked), unflagged and rejected. It's a popular ranking system among Lightroom users. Note that flags can't be written to the files or shared with other software, so you may prefer to use them as a temporary ranking system, for example, when you're initially sorting through the photos and deciding which to keep. **(Figure 7.1)**

Star Ratings are used by photographers worldwide, with 5 stars being the best photos. Stars are standardized metadata so they can be understood by other software. Many photographers limit themselves to

Figure 7.1 Flags (flagged, unflagged, rejected).

using 1-3 stars when initially ranking their photos, and leave 4 and 5 stars for the best photos they've ever taken. (Figure 7.2)

Color Labels have no specific meaning, so you can decide how to use them. Many use them to mark photos that need further work in other editors, for example, photos that need retouching in Photoshop, sets of photos for merging into HDR, photos to be built into a panorama, etc. (**Figure 7.3**)

There are numerous ways to apply or remove star ratings, color labels and flags including clicking the icons on the thumbnails (or on the Toolbar if stars are enabled), selecting them from the *Photo menu* or right-click menu, or using their keyboard shortcuts.

On the keyboard, the 0-5 keys apply star ratings, with 1-5 obviously setting 1-5 stars, and 0 clearing your rating. The 6-9 keys apply or remove red, yellow, green and blue color labels. Flags use the P key for

Figure 7.2 Star Ratings.

Figure 7.3 Color Labels.

Picked or Flagged, U for Unflagged, and X for rejected. The `key (near the X) toggles between Flagged and Unflagged. If you change your mind, just tap a different key to assign a different rating.

If you're in a decisive mood, turn on Caps Lock, hold down Shift while using these keyboard shortcuts, or enable *Photo menu > Auto Advance*. When you press the keyboard shortcut, Lightroom applies the ranking and automatically advances to the next photo.

These keyboard shortcuts work in all view modes, but viewing photos in the Library module (Grid, Loupe, Compare & Survey views) is faster than the Develop module. Don't forget to build the correct size previews before you start (see page 524), otherwise you'll have to wait for Lightroom to load each photo.

How do I rank my photos?

Let's try ranking the photos you've just imported. If you haven't decided which system you prefer yet, keep it really simple and just use flags for now.

- **1.** Select the first photo and switch to the Loupe mode using the E key or the Loupe button on the Toolbar.
- **2.** Decide whether you like the photo on screen. Press the X key to mark it for deletion or P to mark it as a keeper. If you want to use stars, press the 1-5 keys to assign a star rating (but still use X to mark for deletion). If you prefer to use the mouse, click the triangle at the end of the Toolbar and select Flagging and Rating from the menu to display the icons, then click the icons on the Toolbar to apply your chosen ranking.
- 3. Use the left/right arrows on the keyboard

to move between photos. Keep going until you get to the last photo. Remember, you can change your mind later!

4. If you find a group of similar photos, switch to Compare mode (C key) or Survey mode (N key) to view them together and then mark the best ones from the group.

Applying flags and star ratings to your photos is easy, but when you're faced with thousands of photos, where do you start? How do you decide which photos deserve which ratings... and how do you keep the meaning of the ratings consistent over time?

Which photos are worth keeping?

How you decide which photos are deserving of a specific ranking is a personal decision, but there are a few questions that may help:

- Does the photo immediately grab you?
- Does the photo trigger a strong emotion or a memory?
- Does the photo tell a story or capture a special moment?
- Do you have a similar photo that's better?
- Is the subject (person/animal) making eye contact? Does it capture their personality?
- Are there significant technical issues, for example, is it in focus?

Move fast and don't agonize over decisions. Your gut instinct is often right.

There are lots of different ways of sorting through photos. Some photographers use Grid view and others prefer Loupe. Some like to rate their photos in a single pass, and others like multiple passes. Some like flags

...continues on page 105

Filter: 🌵 🗆 🔾

Rating Workflow

STEP 1

Start in Grid view with large thumbnails. It's easier to make decisions when you're not bogged down in the details. Just flag or reject the ones you really like or don't like. Leave the rest unflagged.

STEP 3

Use the Attribute Filters to show only Flagged photos. Go back through the Flagged photos again, occasionally switching to

Detail view to check focus.

STEP 2

Go to Photo menu > Delete Rejected Photos to delete the really bad photos from the hard drive. Then use the Attribute Filters to show only Unflagged photos, then give them 1 star.

STEP 4

Some months later, go back through the 3 and 4 star photos and see if any need to be upgraded or downgraded. It's easier to make an objective decision when time has passed.

RESULT	Meaning	What's Next
×	Really bad photo worthy of deletion.	Nothing (deleted)
X	Should be deleted really, but I'm a packrat. Never to be seen again!	Nothing (ignored)
**	Triggers a memory, but not great as a photo. The hotel room, a meal out with friends, etc.	A fast edit and a few keywords. They might end up in a photo book
***	Decent photo I'd be willing to show someone.	or slideshow, but they'll never be great photos in their own right.
***	Good photo, might end up on the wall or social media.	A careful edit, possibly some Photoshop work, titles/captions and more extensive
***	Best photos ever taken. Rare!	keywords. These are the photos that will end up on the wall or on social media.

Figure 7.4 Need a tried & tested workflow for selecting your best photos? This is my personal workflow.

More Rating Workflows

Figure 7.5 Here's a few more popular workflows for selecting your best photos.

rescue photos from the rejects before deleting them.

and some prefer stars. Some only use 1-3 stars and some use all 5. Some pick out their favorite photos and others just reject the bad ones. It really is up to you.

Flexibility is a wonderful thing, but so much choice can be confusing, so here's my tried and tested rating workflow, which you're welcome to use. (Figure 7.4) A few more alternatives are shown in the following diagram (Figure 7.5)

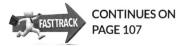

What does Refine Photos do?

If you use Flags, you can select *Library menu* > *Refine Photos* to downgrade all of the flags at once. This command downgrades the unflagged photos to rejects and flagged photos to unflagged.

It's little-used tool, but it works surprisingly well in a multi-pass workflow. Flag all of the photos you like, then select Refine Photos, so that the photo you didn't flag initially are marked as rejects. Go through the newly unflagged photos again, marking the ones you still like with a flag, and repeat. In the end, only the best photos remain.

How do Luse color labels?

Color labels are more flexible than star ratings and flags, because they're simple text metadata represented by a color. Add a red label to a photo using the 6 key, then look in the Metadata panel on the right-hand side of the Library module. You'll see the text "Red" listed next to the word Label, because the red label is associated with the word "Red" by default.

You can decide which color is used to represent which text using *Metadata menu* >

Color Label Set > Images tab. (Figure 7.6) Preset groups of color assignments are listed, for example, if you select Bridge Default, the red label represents the word "Select", the yellow label represents the word "Second", and so forth. If you select Edit, you can create your own sets. (Figure 7.7)

Color labels can also be used for Collections and Folders, but we'll come back to these later on page 112 and page 122.

I've heard some interesting ideas for using color labels. These are a few of my favorites:

What needs to be done to the photos— HDR/panorama sets, LR/PS retouching needed, finished photos

Output options—Facebook, Flickr, web

Figure 7.6 Sets of color assignments can be saved as Color Label Sets.

Figure 7.7 You can decide which color is used to represent which text at any one time.

galleries, email, print

Multiple cameras at the same shoot each camera gets its own color, which helps identify them at a glance when developing

Who took the photo—particularly useful in a family environment

Workflow—to flag/star, to be keyworded, to be developed, to output.

Rating photos—some people skip flags and stars, and just use color labels

But how do you remember what each color represents? You could repeatedly go back to Metadata menu > Color Label Set > Edit to check. You could write them on a post-it note and stick it to the side of your computer. Or you could borrow my trick, and create a transparent PNG file in Photoshop and then add them as a panel end mark in Lightroom (page 75). (Figure 7.8)

You can even create lots of different sets, although that can get a bit confusing as a photo can only have a single color label at a time. If the label text doesn't match a color in the selected label set, it appears as a white label instead.

Figure 7.8 Panel end marks are great for reminding you what your color labels mean.

OUICK DEVELOP

While you're sorting through your photos and rating them, you may need to check whether some are worth keeping, for example, under-exposed photos. You could switch to the Develop module to make adjustments, but the Quick Develop panel (on the right in the Library module) offers easy access to the basic adjustments.

At first glance, the panel looks quite limited (Figure 7.9), but if you click the disclosure triangles on the right, it expands to show a wider range of settings. (Figure 7.10) Two further adjustments are hiding—if you hold down the Alt (Win) / Opt (Mac) key, the Clarity buttons temporarily change to Sharpening and the Vibrance buttons temporarily change to Saturation.

To apply the adjustments to your photos, simply press the buttons. Single arrows make small adjustments and double arrows make larger adjustments. If you hold down the Shift key, the single arrows move in even smaller increments.

If you're viewing in Grid view, it applies to all the selected photos. If you're viewing Loupe, Compare or Survey, it only applies to the

Figure 7.9 Quick Develop is collapsed by default.

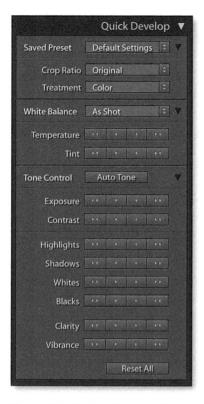

Figure 7.10 Click the Disclosure Triangles to expand the full Quick Develop panel.

selected photo (unless Auto Sync is enabled and multiple photos are selected).

It's also handy for applying Develop corrections to photos you've already edited, as the adjustments are relative to the current settings, but we'll come back to that in the Editing chapters starting on page 197.

GROUPING SIMILAR PHOTOS USING STACKS

As you're sorting through the photos, you may also come across groups of photos that don't mean a lot on their own. For example, groups of photos

taken for a panorama or HDR often look awful as individual photos!

Lightroom offers stacking as a way to group photos. You can put your favorite photo on top of the stack and collapse the stack. hiding the other photos to clear some of the visual clutter. They also help to speed up HDR/panorama merging, as you can select the stacks and leave Lightroom to convert each stack in turn.

To create a stack, select the photos and go to Photo menu > Stacking > Group into Stack. or press Ctrl-G (Windows) / Cmd-G (Mac). The photos automatically collapse into a stack, marked with double lines at the beginning and end. (Figure 7.11)

To open the stack, click the white number in the corner. The border surrounding the thumbnails is slightly different when the photos are in an open stack, but it's not always obvious as the thumbnail divide lines don't disappear until the photos are deselected. (Figure 7.12)

The photo on the left is the photo that shows when you view a collapsed stack. If the photo that best represents the stackperhaps the finished panorama or the finished HDR photo-isn't currently at the top of the stack, click on its number to move it to the top of the stack. You can also go to Photo menu > Stacking > Move to Top of Stack.

Figure 7.11 Collapsed stacks show as a single photo.

Figure 7.12 When you click on the white rectangle, the stack opens to show the group of photos.

To break up a stack, you can ungroup the whole stack using *Photo menu > Stacking > Unstack*, or you can remove a single photo using *Photo menu > Stack > Remove from Stack*, leaving the rest of the stack intact.

There are a few 'quirks' with Lightroom's stacking that you need to be aware of.

Stacks only work when all the stacked photos are stored in a single folder or collection, so if the stacking options in the *Photo menu* are disabled, you're probably viewing a composite folder view and trying to stack photos which are in different folders, or you're viewing a smart collection. To solve it, either select a folder which doesn't have subfolders, deselect *Show Photos in Subfolders* in the *Library menu*, or group the photos in a collection.

Stacks are local to the folder or collection used to create them, so if you stack photos in a folder, they'll still appear as separate photos in their collections, and vice versa.

Also, if a stack is closed, adding metadata (such as keywords) to the stack only applies the metadata to the top photo. There's a trick, however, to make it a little quicker. If

you double-click or Shift-click on the stack number, it opens the stack with the stacked photos already selected, so you can go ahead and add the metadata without having to pause to select them.

Finally, filtering doesn't search inside collapsed stacks, but you don't have to open all of the stacks individually. Instead, use the *Photo menu > Expand All Stacks* command to open them all in one go. *Collapse All Stacks*, of course, does the opposite!

Can I automatically stack sets of photos?

Stacking similar photos manually takes a long time, but Lightroom can automatically stack the photos based on their capture time. For example, you can automatically stack retouched files with their originals or group HDR/panorama sets.

Select the photos and choose Photo menu > Stacking > Auto-Stack by Capture Time and choose a 0 second time difference (0:00:00). or a little longer for panorama stacks. The number of stacks at the bottom of the dialog updates as you move the slider, showing stacks will be created many automatically. (Figure 7.13) Once completes, you may need to tidy up where you've shot in quick succession, but it does most of the work for you.

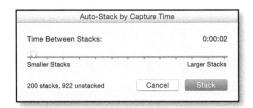

Figure 7.13 Auto-Stack by Capture Time can automatically stack photos shot in quick succession.

COLLECTIONS

Collections are designed to group photos and videos for a specific purpose. Unlike folders, a single photo can be in multiple collections

without taking up extra space on your hard drive, and these grouped photos can come from any number of different folders on the hard drive. Because they're virtual, they can only be viewed inside Lightroom.

So when might you want to create a collection?

- You're organizing your folders by date, but you prefer to view photos grouped by topic or genre. Perhaps you regularly view all of the photos of your grandchildren, or you want to group the photos from your vacations.
- You're gathering your best photos for your portfolio.
- You're working on a creative photo project over a long period of time.
- You want to share a collection of photos with friends and family using Lightroom Web.
- You want to sync photos to your phone or tablet.
- You're gathering photos for output perhaps as prints, books, slideshows or web galleries.

Collections are stored in the Collections panel, which is found in the left panel group in all modules. To view a collection, simply click on its name. (Figure 7.14)

Collections aren't limited to containing photos—they store your chosen sort order,

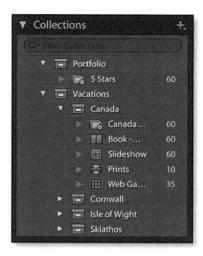

Figure 7.14 Collections can be nested in Collection Sets to keep them organized.

and they can also remember your filtering (depending on your preference setting). Special types of collections store Book, Slideshow, Print or Web module settings too.

Smart Collections are saved search criteria.

smart folders or rules. We'll come back to these later with the filtering tools on page 193.

All of the different types of collections can be grouped into Collection Sets for better organization.

How do I create a collection?

To create a collection, scroll down to the Collections panel, which you'll find in the left panel group in all modules, click the + button at the top and select *Create Collection*. (Figure 7.15)

Once you've named the collection, there's a few additional options you may decide to use:

Inside a Collection Set allows you to group the collection with other collections in a set. We'll come back to organizing photos into Collection Sets on page 111.

Include selected photos adds the selected photos to the new collection, or you can go back add photos manually once the collection has been created. We'll come

back to the benefits of virtual copies on page 382, but *Make new virtual copies* is handy if you want the photos in this collection to have different edits than the originals, for example, if the collection is going to all be B&W.

Set as target collection allows you to use a keyboard shortcut to add photos to the collection. We'll come back to the target collection on page 113.

Sync with Lightroom syncs the collection to the cloud so it can be viewed on mobile devices and at https://lightroom.adobe.com. Turn to the Cloud Sync chapter starting on page 547 for more information.

How do I add photos to an existing collection?

From the Grid view, select your chosen photos and drag them from the preview area onto the collection. Don't forget to grab the photos by their thumbnails, not the border surrounding them. If you don't like dragging, right-click on the collection and select *Add Selected Photos to this Collection* from the context-sensitive menu instead.

	Create C	ollection	
Name:	Holiday 2014-09		
Locatio	on		
☐ In	nside a Collection Set		
Option In	nclude selected photos		
	Make new virtual copies et as target collection		
Ø S	ync with Lightroom		
		Cancel Create	

Figure 7.15 To create a Collection, click the + button on the Collections panel and enter the name in the Create Collection dialog.

How do I remove photos from a collection?

Removing photos from a collection is as simple as hitting the Delete key. When you're viewing a collection, the Delete key only removes the photo from the collection, rather than from the catalog or hard drive, and if the photo's synced, it remains in the All Synced Photographs collection too.

How do I delete photos from the hard drive while viewing a collection?

If you want to delete the photos from the hard drive while viewing a collection, you can use the wonderfully nicknamed 'splatdelete' or Ctrl-Alt-Shift-Delete (Windows) / Cmd-Opt-Shift-Delete (Mac). It deletes from the hard drive whether you're viewing a folder, collection or even a smart collection, but beware, it also bypasses the warning dialog, so use it with care!

How do I rename, duplicate or delete a collection or collection set?

If you right-click on a collection, there's a few management options, including **Rename**, **Duplicate / Duplicate Collection Set** and **Delete**. You can also delete a collection by selecting it and pressing the - button at the top of the Collections panel.

Figure 7.16 When you click on the Collections badge on the thumbnail, the menu lists all of the standard collections which include that photo.

How do I see which collections a photo belongs to?

If you need to check which collections a photo belongs to, right-click on the photo and choose *Go to Collection*, or click on the Collection badge in the corner of the thumbnail. Lightroom displays a list of collections containing that photo, and clicking on the collection name switches to the collection. **(Figure 7.16)**

If you're checking a large number of photos, switch to Grid view and hover the cursor over the collections in the Collections panel. All photos belonging to the collection under the cursor temporarily display a thin white border around the thumbnail, making them quick to identify.

How do I organize my collections into sets?

Collection Sets allow you to build a hierarchy of collections, just like you would with folders. For example, you may have a collection set called *Vacations*, and within that set, sets for each of your vacation destinations. These vacation destinations might divide down further into sets for each year that you visited, and then individual collections for the long slideshow of all of your photos from each vacation, the web galleries or sync collections you created to show your friends, the book you created, and the individual pictures you printed.

You can also include smart collections inside your collection sets too, so you might have additional smart collections for all the 5 star photos, all the photos of beaches, and so on. We'll come back to smart collections on page 193.

To create a Collection Set, press the + button on the Collections panel and select **New Collection Set**. Name it, and then drag

existing collections onto the set to group them. When you're creating new collections, you can select which set to put them in using the pop-up in the New Collection dialog.

There's a notable difference between collections and collection sets. Collections can only usually contain photos and videos, whereas collection sets can contain collections or other collection sets but not the photos or videos themselves.

standard (Although collections can't usually contain other collections, there's one exception. If you start with a standard collection, and then create a book. slideshow, print or web gallery, you can store it inside the first collection. This parent collection becomes a composite view of its children, showing all the photos you've used in those books, slideshows, prints and web galleries. If you add a photo to one of its children, it appears in the parent collection. If you remove a photo from the parent collection, it's also removed from any books/ slideshows/prints/web galleries nested within.)

How do I search for a specific collection?

As you start to nest the collections into sets, it can become harder to remember where you stored a specific collection. Type the collection name into the search field at the top of the Collections panel to filter the list. If you don't know the entire collection name, simply enter the part you do know, for example, searching for scan will find 1975

Figure 7.17 Type in the Search bar at the top of the Collections panel to filter the collections.

scans and scanned photos. Click the X to clear the search. (Figure 7.17)

Using the + button on the Collections panel, you can choose whether to sort the Collections panel by name or collection type. (Figure 7.18)

Changing the sort order works well until you have a large number of collections, at which point collection sets come into their own.

How I use color labels with collections?

You can also apply color labels to make the collections easier to identify, for example, they can also be useful for marking different workflow stages, such as red = to rate, yellow = to keyword, blue = to edit and green = done. To give your labels useful names, go to Metadata menu > Color Label Set > Edit > Collection tab. To apply a label to a collection, right-click on it and select it from the menu. Repeat to remove the label.

You can filter the Collections panel to show only the collections tagged with a specific color by clicking on the magnifying glass in the search field. If the collections are hidden inside collection sets, the sets are displayed too.

Can I convert folders into collections?

If you've been using a topic-based folder

Figure 7.18 You can change the collections sort order by clicking the + button on the Collections panel.

structure and want to change to organizing using collections, you can convert an entire folder hierarchy into a collection set/collection hierarchy. This is useful before changing your topic-based folder structure into a date-based folder structure, or when getting ready to migrate to the cloud-based version of Lightroom. Right-click on the parent folder and choose *Create Collection Set*.

To create a collection from a single folder, drag the folder from the Folders panel to the Collections panel or right-click on the folder and choose *Create Collection*. A collection of the same name is created, containing all the photos in the folder.

Note that the collection sets and collections aren't updated when you make further changes to the folders, so I'd recommend either using folders or collections for topic-based organization, not both.

What are the Quick Collection and Target Collection?

The Catalog panel holds a few more special and temporary collections, for example, *All Photographs* shows all of the photographs in your catalog, *All Synced Photographs* show all of the photos synced to the cloud, and *Previous Import* shows the last set of photos imported into your catalog. Other collections are added temporarily, for example, *Previous Export as Catalog*, *Added by*

Figure 7.19 The Quick Collection is a temporary collection which is always shown in the Catalog panel. The + next to the name indicates that it's also the Target Collection.

Previous Export, Quick Collection and more.

The **Quick Collection** is a special collection for temporarily holding photos of your choice. If you've added a group of photos to the Quick Collection and then you decide you would like to convert it into a permanent collection, you can right-click on it and select *Save Quick Collection* from the context-sensitive menu. **(Figure 7.19)**

The **Target Collection** isn't a collection in its own right—it's just a shortcut linking to another collection. It's marked by a + symbol next to the collection name. Pressing the shortcut key B or clicking the little circle icon on the thumbnail adds to (or removes the photo from) that Target Collection. By default, the Quick Collection is the Target Collection, but you can change the shortcut to the collection of your choice by right-clicking on your chosen collection and selecting *Set as Target Collection*.

SELECTING PHOTOS SHORTCUTS

		Windows	Mac
Flags	Flagged	P	Р
	Unflagged	U	U
	Rejected	×	X
	Toggle Flag	,	
	Increase Flag Status	Ctrl up arrow	Cmd up arrow
	Decrease Flag Status	Ctrl down arrow	Cmd down arrow
	Auto Advance	Hold Shift while using P, U, X or turn on Caps	Hold Shift while using P, U, X or turn on Caps Lock
	Refine Photos	Ctrl Alt R	Cmd Opt R
Star Ratings	0-5 stars	0, 1, 2, 3, 4, 5	0, 1, 2, 3, 4, 5
	Decrease Rating	[[
	Increase Rating]]
	Auto Advance	Hold Shift while using 0-5 or turn on Caps Lock	Hold Shift while using 0-5 or turn on Caps Lock
Color Labels	Toggle Red	6	6-9
	Toggle Yellow	7	7
	Toggle Green	8	8
	Toggle Blue	9	9
	Auto Advance	Hold Shift while using 6-9 or turn on Caps Lock	Hold Shift while using 6-9 or turn on Caps Lock
Stacking	Group into Stack	Ctrl G	Cmd G
	Unstack	Ctrl Shift G	Cmd Shift G
	Collapse/Expand Stack	S	S
	Move to Top of Stack	Shift S	Shift S

		Windows	Mac
	Move Up in Stack	Shift [Shift [
	Move Down in Stack	Shift]	Shift]
Collections	New Collection	Ctrl N	Cmd N
	Expand All SubCollections	Alt-Click on collection set disclosure triangle	Opt-Click on collection set disclosure triangle
Quick / Target Collection	Add to Quick / Target Collection	В	В
	Add to Quick Collection / Target and Next	Shift B	Shift B
	Show Quick / Target Collection	Ctrl B	Cmd B
	Save Quick Collection	Ctrl Alt B	Cmd Opt B
	Clear Quick Collection	Ctrl Shift B	Cmd Shift B
	Set Quick Collection as Target	Ctrl Alt Shift B	Cmd Opt Shift B

MANAGING YOUR PHOTOS

8

As we've mentioned in earlier chapters, using a database to catalog photos is a new concept to many

Lightroom users, so it's important to understand how the photos in Lightroom relate to the files on your hard drive.

So why have we waited until now to start discussing folders? Folders are primarily storage buckets. Lightroom offers other tools, such as collections and metadata, that are better suited to organizing your photos. (Remember we discussed that on page 42.)

You may, however, need to manage files at times, particularly if you start to run out of space on your hard drive. This is primarily done using the Folders panel (on the left in the Library module) and the Grid view.

MANAGING FOLDERS IN LIGHTROOM AND ON THE HARD DRIVE

The folders listed in the Folders panel are references to folders on your hard drive or optical discs. When you import photos into Lightroom, the folders containing these photos are automatically added to the Folders panel.

Anything you do in Lightroom's Folders panel is reflected on the hard drive. For example, creating or renaming folders in Lightroom does the same on your hard drive. You can drag photos and folders into other folders to reorganize them, just like you would in your file browser.

The reverse doesn't work in the same way—when you rename or move a file or folder on your hard drive using your file browser, Lightroom simply marks it as missing and leaves you to manually link it back up again. You'll save yourself a lot of time and frustration by only using Lightroom to manage your files once you've imported them.

We'll come back to moving, renaming and deleting the photos themselves in the following pages, but for the moment, let's concentrate on the Folders panel.

How do I set up a folder hierarchy?

If you've imported some photos, one or more folders will be listed in the Folders panel, but it probably won't match your hierarchical folder structure in Explorer (Windows) or Finder (Mac). Only folders that hold imported photos show in the Folders panel, or if you have *Show parent folder at import* checked in *Preferences > General tab*, it might show a single parent folder too.

To make it easier to visualize where the photos are stored on your hard drive, we can display the same hierarchy. This also makes

it easier to fix if you run into problems later.

We're going to talk about three levels of folders—top-level folders, parent folders and child folders—so it will help to define these first.

Child folders are folders that are inside another folder.

Parent folders are folders that have other folders inside them.

Top-level folders, otherwise known as root folders, are folders displayed without a parent folder.

Let's start tidying up...

- **1.** Find a top-level folder. In **Figure 8.1**, this is one of the folders starting with 2013.
- **2.** Right-click on this folder and choose **Show Parent Folder**. (Figure 8.2) (If this option doesn't appear in the menu, you've right-clicked on the wrong folder.) This doesn't import new photos. It just adds an

Figure 8.1 The initial view of the Folders panel may not be easy to relate to the folders on the hard drive.

- additional hierarchy level to your Folders panel, and does a lot more behind the scenes.
- **3.** In some cases, you'll only need to add a single parent folder, but if you have a deep nested hierarchy, you may want to repeat on the new top-level folders until you can visualize the whole tree.
- **4.** In **Figure 8.3**, we're still missing some parent folders, so we right-click on the 2013-07 folder and choose *Show Parent Folder* and then right-click on the 2013 or

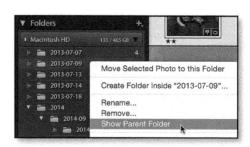

Figure 8.2 Using Show Parent Folder to add additional parent folders to the Folders panel view makes it easier to visualize how Lightroom relates to the hard drive.

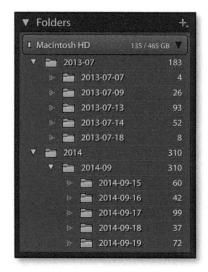

Figure 8.3 In some cases, you'll need to use Show Parent Folder on multiple folders.

2014 folder to show the My Photos folder that contains all of the Lightroom photos.

5. We could go one step further and *Show Parent Folder* on the My Photos folder to show the main Pictures folder too. (**Figure 8.4**)

Once you've finished, you can see a hierarchy of folders that looks much more

like the Explorer (Windows) / Finder (Mac) view. (Figure 8.5)

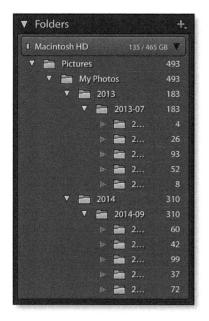

Figure 8.4 The end result of the process is a familiar folder hierarchy.

Figure 8.5 The same folder hierarchy shown in Windows Explorer and Finder. There are more folders here than those showing in Lightroom's folder panel, as some of the folders haven't been imported into Lightroom.

How do I hide parent folders?

If you go too far (perhaps showing your username or beyond), you can hide the top-level folder using **Hide This Parent**.

- **1.** First, check whether there are any photos stored directly in the folders you're going to hide, as these photos would be removed from the catalog. To do so, uncheck *Library menu > Show Photos in Subfolders*.
- **2.** In Figure 8.6, we see that the / folder, Users folder and Vic folder are empty, but the Pictures folder includes a photo, so we won't remove that one. (If you hide a folder containing imported photos, the photos are removed from the catalog, but it warns you first.)
- **3.** Right-click on the top-level folder (shown as / in **Figure 8.6**) and choose *Hide This Parent*.
- **4.** Select *Hide This Parent* on the Users folder, and then on the Vic folder (your folder will have another name, of course!).

Figure 8.6 If you show too many parent folders, it can be difficult to see the folder names.

Once you've finished, your Folders panel should look like **Figure 8.4** again.

5. Once you've finished, you can check Show Photos in Subfolders again to put the folder counts back to normal.

That's the basics, but there are more Folder panel tricks and customizations to play with.

How do I switch between a composite folder view and a single folder view?

Now you have a folder hierarchy, Lightroom can show either the photos directly inside the selected folder, or it can show a composite view of all the photos in the selected folder and its subfolders. The folder counts are also affected by that setting, showing either the composite count, or the number of photos directly in each folder.

By default, **Show Photos in Subfolders** is enabled, showing a composite view. In many situations, it's useful to see a composite view of the subfolder contents, but there are a couple of restrictions. You can't apply a custom sort (user order) or stack photos across multiple folders in a composite view.

You can toggle this setting by going to Library menu > Show Photos in Subfolders and checking or unchecking it. You'll find the same option in the Folders panel menu, accessed via the + button.

Can I change the way the folders are displayed?

The Folders panel is divided into Volume Bars for each volume (drive) attached to your computer, whether they're internal or external hard drives, network attached storage, or optical discs.

Each of these Volume Bars can provide additional information about the

drive—how many imported photos are on each volume, whether it's online or offline, and how much space is used or available. (Figure 8.7) You can choose which information to show by right-clicking on the Volume Bar. (Figure 8.8)

Click anywhere on a Volume Bar to expand it to show the folders contained in that drive, or to collapse it to hide the folders.

While you're exploring the Folders panel

Figure 8.7 The colored rectangle on the left of the Folders panel shows the amount of space available on the drive.

Figure 8.8 You can choose the information shown on a Volume Bar by right-clicking on it.

Figure 8.9 Choose the Folder Path display format by clicking the + button in the Folders panel.

view options, clicking on the Folders panel + button also gives additional path view options for the root folders. (Figure 8.9)

The options are Folder Name Only, Path From Volume, and Folder And Path. They simply display the path of the top level folders in different ways, as you can see from the screenshots in Figure 8.10.

If you're still confused about where to find a folder on your hard drive, just right-click on the folder and select *Show in Explorer* (Windows) / *Show in Finder* (Mac).

What are disclosure triangles?

Next to each folder name is a small triangle, which is officially called a disclosure triangle. You'll also find these triangles used throughout Lightroom's interface. When

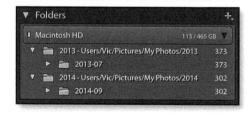

Figure 8.10 The Folder Path can be shown in multiple formats. Folder Name Only, (top) Path From Volume (center), Folder And Path (bottom).

Figure 8.11 Disclosure triangles hide part of the interface.

you click on these triangles, they toggle to show or hide parts of the interface, such as sliders or buttons, or a hierarchy of folders, collections or keywords.

In the case of folders, collections, or keywords, a solid arrow indicates that it's a parent with subfolders/collections/ keywords inside. Those marked with dotted arrows don't have any subfolders etc. inside. (Figure 8.11)

To expand or collapse the full hierarchy in one click, Alt-click (Windows) / Opt-click (Mac) on the parent folder's disclosure triangle.

How do I search for a specific folder?

If you're using topic-based folders, rather than dates, it can become hard to find the right one. Type the folder name into the search field at the top of the Folders panel to filter the list of folders. If you don't know the entire folder name, simply enter the part you do know, for example, searching for scan will find 1975 scans and scanned photos.

How do Luse color labels with folders?

You can also apply color labels to make the folders easier to spot or to mark different workflow stages, such as red = to rate, yellow = to keyword, blue = to edit and green = done. To give your labels useful names, go to Metadata menu > Color Label Set > Edit > Folder tab. To apply a label to a folder, right-click on it and select the label from the menu. Repeat to remove the label.

You can filter the Folders panel to show only the collections tagged with a specific color by clicking on the magnifying glass in the search field.

How do I mark folders as favorites for easy access?

If there are folders you use frequently, you can mark them as favorites by right-clicking and selecting *Mark Favorite*. The folder icon adds a small star as a reminder.

To only show favorite folders (and their parent folders), click on the magnifying glass icon to the left of the search field and select Favorite Folders. (Figure 8.12)

You can also quickly access your favorite folders by clicking on the Breadcrumb bar (page 76) on top of the Filmstrip. (Figure 8.13)

To remove a folder from your favorites, right-click again and select *Unmark Favorite*. However, there's a small catch here. If multiple folders were selected when marking a folder as a favorite, they become a favorite group. These are shown in the Breadcrumb bar pop-up as *Folders: A, B, C*. You can't just unmark a single folder if it's part of a group. To remove these groups of

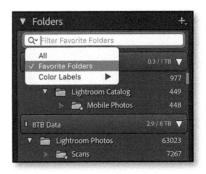

Figure 8.12 Using the Search field pop-up, you can show only your Favorite Folders or folders with color labels.

Figure 8.13 Click on the Breadcrumb bar to display favorite groups of folders.

folders from your favorites, select the group in the Breadcrumb bar pop-up, right-click on one of the folders in the Folders panel and select *Unmark Favorites*.

CHANGING THE FOLDER STRUCTURE

Although Lightroom doesn't care how the photos are stored, you may want to reorganize folder structures or move photos to another drive.

Remember, if you start moving folders around in Explorer (Windows) / Finder (Mac) or other file browser software, Lightroom will complain that your folders have gone missing, and leave you to manually relink them. This can be a huge job if you've "tidied up", so it's usually simpler to manage the folders within Lightroom.

How do I create a new folder or subfolder?

To create a brand new folder, go to *Library menu > New Folder*, or press the + button on the Folders panel and select **Add Folder**. Navigate to the location of your choice.

On Windows, right-click and select *New* then *Folder* and type the name of the folder, then press Enter and select the new folder, then press *Select Folder*.

On a Mac, press the *New Folder* button in the operating system dialog. Give it a name and

press *Create*. Your new folder is created on the hard drive and automatically selected in the operating system dialog, so press *Choose* to add it to Lightroom.

If the new folder already exists on the hard drive, but you want to add it to Lightroom, go to Library menu > New Folder and navigate to the folder, then press Select Folder (Windows) / Choose (Mac). If the folder is empty, it's added to the Folders panel. If there are already photos in the folder, Lightroom opens the Import dialog. In this case, you'll need to import at least one photo to add the folder to the Folders panel.

If you're creating a new subfolder, and the parent folder already exists in the Folders panel, it's even easier. Right-click on the parent folder and select **Create Folder Inside***. Enter the subfolder name and press **Create**. If you have photos selected at the time, you can automatically move them to the new subfolder by checking the *Include Selected Photos* checkbox.

How do I move folders into other folders or drives?

Moving folders into other folders is simply a drag-and-drop operation, just like Explorer (Windows) / Finder (Mac). Select the folders in the Folders panel and drag them onto another folder in the Folders panel. The destination folder is highlighted in blue, showing where the folders will land when

you release the mouse. (Figure 8.14)

Selecting a parent folder automatically moves all of its subfolders too. To move multiple separate folders, Ctrl-click (Windows) / Cmd-click (Mac) to select individual folders or Shift-click to select a series of folders, then drag and drop as normal.

If you're moving a large number of photos to a new drive, there's another option which is safer:

- **1.** Follow the instructions on page 117 to show the folder hierarchy so you just have one or a few parent folders. This makes it easy to relink the folders/files that are marked as missing in this process.
- **2.** Close Lightroom and use Explorer (Windows) / Finder (Mac) or file synchronization software to copy the folders/files to the new drive.
- 3. When the copy completes, rename the original folder (the one on the old hard drive) using Explorer (Windows) / Finder (Mac), or disconnect the old hard drive. This allows you to check everything is working correctly before deleting the files from the

Figure 8.14 Drag and drop folders onto other folders to move them on the hard drive as well as in Lightroom.

original location.

- **4.** Open Lightroom and right-click on the parent folder. Select *Find Missing Folder* or *Update Folder Location* from the context-sensitive menu, depending on which option is available. Navigate to the new location of the folder and press *Select Folder* (Windows) / *Choose* (Mac). The folder disappears from the old volume (drive) in the Folders panel and reappears under the new volume bar.
- **5.** If you have more than one parent folder, repeat the process for any other parent folders until the question marks have disappeared from all the folders.
- **6.** Once you've confirmed that all the photos are available for editing within Lightroom, you can safely detach the old hard drive or delete the files from their original location using Explorer (Windows) / Finder (Mac).

How do I rename folders?

To rename a folder, simply right-click on the folder in the Folders panel and select **Rename**. When you enter the new folder name and press *Save*, it's not only updated in Lightroom but also on the hard drive.

How do I delete folders?

To delete a folder, right-click on the folder in the Folders panel and select **Remove**.

PHOTOS ARE NOT 'IN' LIGHTROOM

Remember, photos are never IN Lightroom. Don't move, rename or delete files or folders using Explorer/Finder or other software after import, as Lightroom won't be able to find them. If the folder is empty in Lightroom, it's immediately removed.

If there are photos in the folder, Lightroom requests confirmation because removing the folder will also remove these photos from Lightroom's catalog.

If there are no other files (e.g. text files) left inside the folder, the folder is also deleted from the hard drive.

I've added new photos to one of Lightroom's folders—why don't they show in my catalog?

If you import a folder into Lightroom's catalog and then later add additional photos to that folder using other software, Lightroom won't know about those additional photos until you choose to import them.

If you go back to the Import dialog and import that folder again, Lightroom just imports the new photos, skipping the existing ones. You can also use *Synchronize Folder* to automate the process.

How does the Synchronize Folder command work?

The main purpose of **Synchronize Folder** (found in the folders right-click menu) is to update Lightroom's catalog with changes made to the folder by other programs, for example, adding or deleting photos or updating the metadata. (**Figure 8.15**)

Synchronize Folder is one of the most misunderstood tools in Lightroom, and can cause all sorts of trouble if you don't read the dialog carefully, so let's run through the options...

Import new photos searches the folder and subfolders for any new photos not currently in this catalog and imports them. If you've dropped photos into the folder using other software, it saves you navigating to the folder in the Import dialog.

Show Import dialog before importing displays the photos in the Import dialog, to allow you to view the new photos and adjust the import options prior to import.

Remove missing photos from the catalog

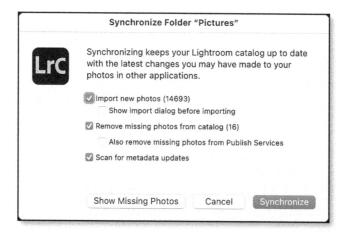

Figure 8.15 Synchronize Folders is powerful, but can cause trouble if you've moved photos outside of Lightroom. Take care to make sure you understand exactly what will happen.

checks for photos that have been moved. renamed or deleted from the folder and removes the missing photos from the catalog.

Be very careful using this option because any metadata for those missing photos, such as Develop settings and ratings would be lost, even if the photos have simply been moved to another location. It doesn't intelligently relink the files. If in doubt, leave this option unchecked.

Scan for metadata updates checks the metadata in the catalog against the file, to see whether you've edited the file in any other programs, such as Bridge.

If you've only changed the metadata in Lightroom, it doesn't do anything.

If the metadata has changed in another program, but not in Lightroom, Lightroom reads the metadata from the file, overwriting Lightroom's settings.

If both Lightroom's catalog and the external file have changed, you'll see a Metadata Conflict badge on a thumbnail, and you'll have to click on that icon to choose which set of data to keep—the metadata in your catalog or the metadata in the file.

We'll come back to XMP metadata in more detail on page 411, including the use of the Metadata Conflict dialog.

The Show Missing Photos button searches for photos missing from the folder and creates a temporary collection in the Catalog panel. You can then decide whether to track them down and relink them, or whether to remove these photos from the catalog. If you want to check your entire catalog for missing photos, it's quicker to use the Library menu > Find Missing Photos command instead. Once you've finished with the temporary collection, you can right-click on it to remove it.

But stop! Before you press the Synchronize button, stop and think. If Remove missing photos from the catalog has a number next to it and you synchronize that folder, you may lose the work you've done in Lightroom. It doesn't intelligently relink missing files. Instead, you need to cancel out of the Synchronize Folder dialog and manually relink the missing files, using the instructions on page 499.

Synchronize Folder is also the wrong tool to use when moving photos to a new hard drive, or moving to entirely new computer. See page 463 for the instructions.

So when is it useful? If you've dropped photos into a folder using other software (including Windows Explorer/Finder), or you've edited a photo in an external editor (e.g. Photoshop or OnOne) and it hasn't been automatically added to the catalog, then Synchronize Folder saves you navigating to the folder in the Import dialog.

Next time you need to use Synchronize Folder, don't forget to stop and read the options carefully before pressing OK.

MANAGING THE INDIVIDUAL **PHOTOS**

There are one or two more file management tasks you might need, such as deleting, renaming or moving individual photos, rather than whole folders.

How do I delete fuzzy photos?

Even the best photographers sometimes end up with photos that aren't worth keeping.

It's possible to delete individual photos while you're sorting through them, simply by pressing the Delete key on your keyboard, but it's quicker to mark them with a Reject flag (X key) and then delete them all in one go.

Photos marked as rejects show in the Grid view as dimmed photos, so it's easy to check that you've marked the right ones. When you're ready to delete all the rejected photos, go to *Photo menu > Delete Rejected Photos*.

Before Lightroom deletes the photos, it asks whether to *Remove* or *Delete* them. (Figure 8.16) Note the difference. *Remove* just removes the reference to the photo from Lightroom's catalog, but the photo remains on the hard drive. *Delete* deletes the photo from your hard drive too (or sends it to the Recycle Bin/Trash if possible).

Before you select either option, double check the number of photos that it says will be deleted, just in case you've accidentally selected photos you want to keep. If you make a mistake with *Remove*, you can immediately use Ctrl-Z (Windows) / Cmd-Z (Mac) to undo it, but that won't work with *Delete*.

How do I rename one or more photos?

We've already learned how to rename photos while Importing them, but you can also rename photos later in the Library module.

To do so, select the photos in Grid view, and then select *Library menu* > *Rename*. The Rename dialog options are almost identical to the Import dialog File Renaming panel, which we used in the Import chapter. (Figure 8.17) Select your chosen file naming template or select *Edit* to create your own template using tokens in the Filename Template Editor. Turn back to the File Renaming section of the Import chapter on page 36 if you need a refresher on the file renaming options.

That's great if you want to rename multiple photos, but to rename just a single photo,

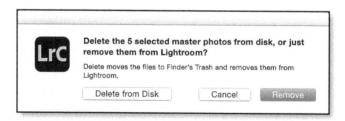

Figure 8.16 In the Delete dialog, note the difference between Remove and Delete, and don't forget to check the number of photos that will be deleted.

<u> </u>	Rename 5 Photos	1
File Naming:	Custom Name - Sequence	
Custom Text:	untitled	Start Number: 1
Example:	untitled-1.jpg	Cancel

Figure 8.17 You can rename photos in the Library Module using the same templates used in the Import dialog.

it's often quicker to open the Metadata panel on the right hand side of the Library module. If you click in the *Filename* field, you can edit the existing filename rather than having to use a template in the full Rename dialog. If you do decide to use a template after all, clicking the little icon at the end of the Filename field takes you directly to the full Rename dialog.

Why are some of the tokens missing?

The available tokens differ slightly between the Import dialog and the Library module. Import has a *Shoot Name* token, which isn't available in the Library module, but the Library module gains tokens such as *Folder Name, Original Filename, Copy Name,* slightly different sequence number options and additional IPTC metadata. The basic principles remain the same.

How do I rename photos back to their original filename?

There's another couple of useful rename options which weren't available in the Import dialog: *Original Filename* and *Preserved Filename*. These allow you to revert back to the original names.

Original Filename field would actually be better named *Import Filename*, as it's the name at the time of import, not necessarily the original name at the time of capture.

Figure 8.18 If the original filename is stored in the catalog, you can view it by changing the Metadata panel to EXIF and IPTC view.

Preserved Filename is the filename of the photo before it was imported into Lightroom, so it's generally the more useful option.

If you want to check whether you have a preserved or original filename to revert to, select the Metadata panel's *Default* view to see the *Preserved Filename*, or switch to the *EXIF & IPTC* view to see the *Original Filename*. (Figure 8.18)

If one of the original filenames is present in the database, you can go to the Rename dialog and select *Edit* in the pop-up to show the Filename Template Editor. You'll find these filename tokens in the *Image Name* section. (Figure 8.19)

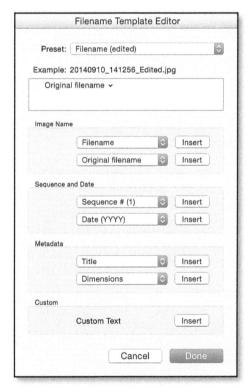

Figure 8.19 Original Filename is one of the tokens in the Filename Template Editor.

Can I search and replace in filenames?

Lightroom's file naming allows for the creations of complex new filenames, but reusing part of the existing filename is not quite so simple. There's no way, for example, to remove –2 from the end of filenames, unless you can recreate the filename using metadata. It's one reason using a date/time filename is a particularly good choice!

There is a workaround, however, using John Beardsworth's Search Replace Transfer plug-in (https://www.Lrg.me/ beardsworth-searchreplace). Taking the -2 scenario as an example, you'd use Search Replace Transfer to copy the filename to any unused IPTC field that Lightroom's renaming dialog can use-perhaps the Headline field. Then you use the plug-in again, this time to remove -2 from the Headline field. and repeat to remove the file extension too. Finally, you'd use Lightroom's main Rename dialog, set to use the Headline token for the new filename. It's not for the faint-hearted, but it does come with excellent instructions.

How do I find out where a photo is stored on my hard drive?

If you ever need to find a photo on the hard drive, for example, to open in another program, you can right-click on a single photo and the context-sensitive menu gives you the choice of **Go to Folder in Library**, which selects the folder in the Folders panel, or **Show in Explorer** (Windows) / **Show in Finder** (Mac).

How do I move or copy photos between folders?

Although folders are primarily storage buckets, you may need to move individual photos at times. (Remember, we moved whole folders a little earlier in the chapter on page 123.) It's a simple drag-and-drop.

Figure 8.20 Drag photos from the Grid view onto the Folders panel, then drop them when the folder turns blue.

Select the photos you want to move, then click on the thumbnail of one of the photos (not the surrounding border) and drag it to the new folder location in the Folders panel, before releasing them. (Figure 8.20)

If you don't like to drag and drop, you can select the photos, then right-click on your chosen folder in the Folders panel and select Move Selected Photos to this Folder to get the same result.

Duplicating photos isn't quite so simple, because Lightroom's designed to use collections and virtual copies, rather than having multiple copies of the same physical file.

If you only need a copy of the photo to try out some different Develop settings, or you want to apply different metadata, consider virtual copies instead. They don't create an additional copy on the hard drive, but they behave like separate photos within Lightroom. We'll come back to virtual copies in the Develop module chapter on page 382.

If you do need to create a physical copy

on the hard drive, use *File menu* > *Export*, select the *Export Location* to the folder of your choice, check *Add to This Catalog* if you want to edit the duplicate in Lightroom, and select the *Original* file format setting.

How do I reorganize photos into dated folders?

Lightroom only automatically organizes photos (e.g. into dated folders) while importing. Any reorganization after import has to be done manually by creating, moving, renaming and deleting folders and photos, so it's best to get your folder structure right when importing. However, if you do want to move to a dated folder structure after import, you can still do it manually.

- **1.** If you wish to preserve your existing topic-based folders, convert them to collections using the instructions on page 112.
- 2. Create your new dated folder structure in the Folders panel. Month folders inside of year folders is usually plenty—creating day folders inside each month takes a long time with minimal benefit. (You could create these as you need them, if you prefer.) (Figure 8.21)

Figure 8.21 Manually create a dated folder structure. Year/month folders work well.

Figure 8.22 Using the Metadata filters, select a month's photos at a time.

- **3.** Select *All Photographs* in the Catalog panel.
- **4.** At the top of the Grid, select the Metadata Filters (discussed in more detail on page 187).
- **5.** In the *Date* column, click an arrow to open a year and show the months of that year. Highlight a single month of photos, hiding photos/videos shot at other times. (Figure 8.22)
- **6.** Select all of the photos in the Grid below and drag them to their month folder. As long as they're not marked as missing, they'll all be moved to the new month folder.
- **7.** Repeat steps 4 and 5 until all of the photos are in the new dated folder structure.
- **8.** There may be many leftover empty folders in the Folders panel—these can now be deleted.

MANAGING PHOTOS & FOLDERS SHORTCUTS

		Windows	Mac
Folders / Collections	New Folder	Ctrl Shift N	Cmd Shift N
	Expand all subfolders	Alt-click on folder disclosure triangle	Opt-click on folder disclosure triangle
	Show in Explorer/Finder	Ctrl R	Cmd R
Rename	Rename Photo	F2	F2
Delete	Delete Photo	Delete	Delete
	Delete Multiple Photos from Loupe/ Develop	Shift Delete	Shift Delete
	Delete Rejected Photos	Ctrl Delete	Cmd Delete
	Remove Photo from Catalog	Alt Delete	Opt Delete
	Remove and Trash Photo	Ctrl Alt Shift Delete	Cmd Opt Shift Delete

ADDING METADATA TO YOUR PHOTOS

9

Once you've finished selecting your favorite photos, it's time to add metadata to help you find

them again later. Sorting through your photos first means you can focus your efforts on the best ones, which are the ones you're likely to want to find again.

First, we'll focus on the Metadata panel, then keywords, tagging people, and finally adding GPS location metadata using the Map module.

What is metadata?

Metadata is often defined as 'data describing data'.

As far as photos are concerned, metadata describes how the photo was taken (camera, shutter speed, aperture, lens, etc.), who took the photo (copyright) and descriptive data about the content of the photo (keywords, caption).

Lightroom also stores all of your Develop edits as metadata, which means that it records your changes as a set of text instructions (i.e. Exposure +0.33, Highlights -30, Shadows +25, etc.) instead of applying them directly to the image data. This means you can edit the photo again later without degrading the image quality.

EXIF data is technical information added

by the camera at the time of capture. It includes camera and lens information such as the make and model, and image information such as the capture date/time, shutter speed, aperture, ISO, and pixel dimensions. Apart from the capture date/time, Lightroom doesn't allow you to edit this EXIF data.

IPTC data is added by the photographer to describe the photo, for example, title, caption, keywords and the photographer's name and copyright. There are official definitions for the IPTC fields, and you can view the full IPTC specification at the IPTC website at http://www.iptc.org/ You can add IPTC data to your photos using Lightroom's Metadata panel.

ADDING METADATA USING THE METADATA PANEL

The Metadata panel, on the right-hand side of the Library module, allows you to view EXIF metadata added by the camera and add your own IPTC metadata. (Figure 9.1)

Near the top of the Metadata panel are two text buttons that are only accessible when multiple photos are selected. These control which metadata is displayed:

Target Photo shows and edits only the metadata of the active (most-selected) photo, which is much faster than reading

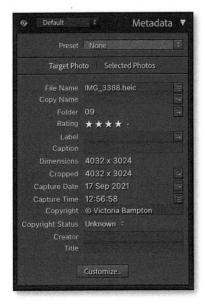

Figure 9.1 View and enter metadata using the Metadata panel.

all of the selected photos. (It can also be toggled on/off using Metadata menu > Show Metadata for Target Photo Only.)

Selected Photos shows the metadata for all of the selected photos, or <mixed> where the metadata differs. Editing the metadata applies to all selected photos if you're in Grid view on the primary monitor.

Where's the rest of my metadata?

Most of the available metadata fields are hidden by the default panel view, because reading large amounts of metadata can affect performance. You can change the fields that are included in the Default preset by clicking the Customize button at the bottom of the panel. By selecting the Arrange button at the bottom of the dialog, you can also change the sort order of the Metadata fields. (Figure 9.2)

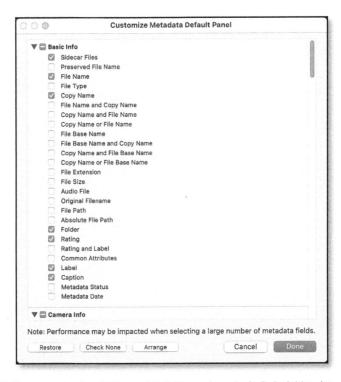

Figure 9.2 You can customize which metadata fields are shown in the Default Metadata panel view.

In the pop-up on the Metadata panel header, there are additional Metadata View presets that ship with Lightroom. For example, *EXIF* and *IPTC* displays most of the available fields. You can't create additional Metadata View presets using Lightroom, but you can do so using Jeffrey Friedl's Metadata Editor Preset Builder: https://www.Lrq.me/friedl-metadatapresets

If all of the metadata fields are blank, you may be in *Edit Only* mode. We'll come back to this shortly, but toggle the button in the top left corner of the Metadata panel to show the metadata again. (Figure 9.3)

How do I enter metadata for my photos?

Entering metadata in the Metadata panel is as simple as typing in the text fields. For example, some photographers like to add descriptive text to the photos, perhaps for use as captions when posting to Flickr or Facebook, or in a slideshow or book.

The **Title** and **Caption** fields do have official IPTC definitions, but many photographers simply use *Title* for a short image title (e.g., Blue Eyes) and *Caption* for a more descriptive paragraph (e.g., Kanika, the Amur Leopard cub, has piercing blue eyes).

You'll also want to add your copyright information and contact details, if you didn't apply them using a preset while importing.

How do I add or change metadata for multiple photos at once?

Adding repetitive metadata would quickly become boring if you had to type that

Figure 9.3 Toggle Edit Only mode using the button on the left of the Metadata panel header.

information into the Metadata panel one photo at a time, but there are a number of ways to apply it to multiple photos in one go.

We said earlier that actions apply to all selected photos when in Grid view on the primary window, but usually only the selected photo in all other views. That applies in this case too, so the simplest option is to select multiple photos in Grid view (on the primary window) and type your metadata into the Metadata panel. If it doesn't work, make sure that the panel is set to Selected Photos rather than Target Photo.

Can I prepend text before or append text after the existing metadata?

If you're adding text to a single photo's metadata, it's as simple as putting the cursor at the beginning or end of the existing metadata and typing.

If multiple photos are selected, you need to be editing in the normal Metadata dialog (as we've learned so far) and have Selected Photos selected at the top of the dialog, so that the metadata shows as <mixed>. Click the field with <mixed> and then click again before the < or after the > to add text before or after the existing data in the fields. The <mixed> is just a token for the existing data, which is different on each photo.

How does Auto Sync break all the usual rules?

If you prefer to select the photos in the Filmstrip with Compare, Survey or Loupe view on the primary window, or you have Grid on the secondary window, your metadata usually only applies to the active photo (with the lightest gray border). You

can override this by enabling *Metadata menu* > Auto Sync.

When Auto Sync is enabled, your actions apply to all selected photos, so you can type in the Metadata panel and that metadata is applied to all the selected photos. Use it with caution if you work with the Filmstrip hidden, as you may not realize you have multiple photos selected.

There are two separate Auto Sync toggle switches—one under the Library module > Metadata menu and one under Develop module > Settings menu, and they both appear as switches on the Sync buttons at the bottom of the right-hand panel groups when multiple photos are selected. The Library switch applies to most metadata actions—assigning keywords, flags, labels, etc.—regardless of which module you're viewing, whereas the Develop switch only applies to Develop changes made in the Develop module.

In summary, if Auto Sync is enabled, metadata changes sync to all selected photos, regardless of which metadata is showing.

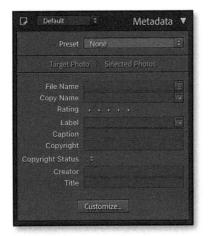

Figure 9.4 The Edit Only Metadata view shows blank fields.

Why would I use the Edit Only view? I can't see the existing metadata!

If you click the icon in the top left corner of the Metadata panel, you switch to *Edit Only* view. It only shows fields that can be edited, and it doesn't show any of the existing metadata, so it's faster. It's great if you're applying metadata to lots of photos, such as updating your contact details after moving house. **(Figure 9.4)**

How do I sync metadata to multiple photos?

Typing directly in the Metadata panel can be slow when working with a large selection of photos, as it updates all of the records each time you move between fields. In these cases, it's quicker to select the photos and press the *Sync Metadata* button (not the *Sync Settings* button) at the bottom of the right panel group. (Figure 9.5)

In the Synchronize Metadata dialog (Figure 9.6), enter the details for any fields you want to update. Put a checkmark next to these fields or press the Check Filled button at the bottom of the dialog, as only checked fields are updated. Press Synchronize when you're finished to apply the metadata to all the selected photos.

Sync Metadata changes all selected photos, regardless of which metadata is showing.

Figure 9.5 The Sync Metadata button, at the bottom of the right panel group in Library module, allows you to copy metadata to all the selected photos.

© 2015 Victoria Bampton	2
Copyrighted	2
Victoria Bampton	0
Southampton	8
UK	0
Type to add, leave blank to clear	E
mail@lightroomqueen.com	C
http://www.lightroomqueen.com/	0
	Copyrighted Victoria Bampton Southampton UK Type to add, leave blank to clear mail@lightroomqueen.com

Figure 9.6 The Synchronize Metadata and Edit Metadata Preset dialogs are very similar. Only checked fields will be changed.

How do I replace or even remove metadata?

Replacing existing metadata, perhaps because you've moved house and need to update the address on your photos, works in exactly the same way. To remove metadata from the selected photos, check the checkboxes in the Synchronize Metadata dialog, but don't type any replacement text.

Which photos are updated if I select...?

There are so many different ways of viewing and updating metadata, it's hard to keep track of whether your changes will affect only one or multiple photos, so overleaf there's a summary table for easy reference. (Figure 9.7)

When would I use each Metadata mode for best performance?

The main reason for all these different modes is to improve performance, so some

modes are more useful depending on the number of photos you're updating. Here's an easy rule of thumb to get you started:

To edit metadata on a single photo, just type directly into the Metadata panel, with the panel set to *Target Photo*. (Why? The metadata's already loaded, and it'll take you longer to switch to a different mode.)

To edit metadata on a small number of photos, select them in Grid view and type directly in the Metadata panel, either with the panel set to *Selected Photos*, or set to *Target Photo* with *Auto Sync* enabled. (Why? Lightroom will load a small amount of metadata quite quickly, and you can see the existing metadata.)

To edit a single metadata field on a large number of photos, select them in Grid view, switch the Metadata panel to *Edit Only* view and *Selected Photos*, then type the metadata directly in the Metadata panel. (Why? It can take a while to load metadata for a large

View Mode	Target/ Selected Mode	Auto Sync Off/On	Edit Only View	Shows	Applies
Grid on primary window	Target	Off	Off	One photo	One Photo
	Target	On	Off	One photo	All selected photos
	Selected	Off	Off	All selected photos	All selected photos
	Selected	On	Off	All selected photos	
	Target				
	Target				
	Selected				
	Selected				
Any other view (e.g. Loupe view or Grid on secondary window)	Target or Selected	Off	Off	One photo	One photo
	Target or Selected	On	Off	One photo	All selected photos
	Target or Selected	Off	On	None	One photo
	Target or Selected	On	On	None	All selected photos

Figure 9.7 Will your current settings display and/or edit the metadata on a single photo or multiple photos?

number of photos, so the *Edit Only* view's blank fields save that time and let you get straight to entering your data.)

To edit multiple metadata fields on a large number of photos select them in Grid view and then use the Sync dialog to enter the metadata. (Why? Because Sync writes the metadata to all of the photos in one go when you've finished entering the metadata, rather than making you wait between entering each field's metadata.) How many photos are considered a small or large number depends on your computer specification, so you might need to experiment a little to find out the best number for your photos.

How do I create and edit a Metadata preset?

If you find you're regularly applying the same metadata, you can save it as a Metadata preset. We used a Metadata Preset to add copyright information while importing the photos (page 41), so we'll quickly recap. At the top of the Metadata panel, choose *Edit Presets* from the *Presets* pop-up. (Figure 9.8)

The Edit Metadata Presets dialog automatically fills with the metadata from the selected photo, and then you can edit the information that you want to save in the preset. At the top of the dialog, select *Save Current Settings as New Preset* and name the preset before pressing *Done*. Remember, only checked fields are saved in the preset. Leaving fields blank but checked would clear any existing metadata saved in these fields.

If you've created a Metadata preset and want to update it, select *Edit Presets* to open the Edit Metadata Presets dialog. At the top of the dialog, select the preset you want to change, and then edit the metadata below. Finally, select *Update Preset* from the popup menu at the top of the dialog. To rename or delete a preset, select it at the top of the same dialog and then return to the popup and select *Rename Preset* or *Delete Preset*.

It's easy to accidentally save keywords in a Metadata preset, and then have these keywords mysteriously appear on all imported photos because you're applying the Metadata preset while importing, so it's usually worth excluding keywords from the preset.

Figure 9.8 Create a Metadata preset for metadata you add regularly, for example, your copyright information.

How do I correct the information Lightroom's trying to autofill?

When you start typing metadata in the Metadata panel, Lightroom offers suggestions based on your recent entries. Click on a suggestion to accept it, or press the up/down arrow keys to select one of the suggestions and then press Enter to confirm.

To view all the available suggestions for a specific metadata field, click on the field label. That context-sensitive menu also allows you to clear the suggestions for that particular field or all fields.

To turn the Auto Fill feature off altogether, go to Catalog Settings > Metadata tab and uncheck **Offer suggestions from recently entered values**. There's a Clear All Suggestion Lists button in the same location.

How do I change the date format and units of measurement?

The metadata uses units and formats set by the operating system's regional settings. For example, the *Altitude* may display in feet or meters, and dates may display as day/month/year or month/day/year, depending on your locality. To change these settings go to *Control Panel > Region & Language > Additional Settings* (Windows) / *System Preferences > Language & Region > Advanced* (Mac).

What are the symbols at the ends of the fields?

At the end of some metadata fields are action buttons. For example, the button at the end of the filename opens the Rename Photo dialog, the button on the *Capture Date* field filters the photos taken on that date. Float over the button to display the action as a tooltip. (Figure 9.9)

Figure 9.9 At the end of some metadata fields are buttons. Float the cursor over the button to see what they do.

Can I add notes to my photos?

Some photographers like to add notes to their photos, perhaps noting additional work that they need to do to the photo. Lightroom doesn't offer a notes field for this purpose, but you can use other metadata fields such as the Workflow Instructions field. (under the EXIF & IPTC view). These fields expand to fit larger quantities of text, and are included when you write to XMP or export the files.

Alternatively, for temporary notes that you don't want to write back to the files, the Big Note plug-in works as a handy scratch pad. https://www.Lrg.me/beardsworth-bignote

EDITING THE CAPTURE TIME

We've all done it... you go on vacation abroad, or Daylight FASTTRAC Savings Time starts, and you forget to change the time stamp on the camera. It's not a problem though, as Lightroom makes it easy to correct the time stamp.

How do I fix the capture time?

- 1. Find a photo for which you know the correct time and note the time down-we'll call this the 'known time' photo for the moment.
- 2. Select all the photos that need the time stamp changed by the same amount, for example, all those shot on the same vacation with the same camera.
- 3. Click on the thumbnail (not the border) of the 'known time' photo that we identified in step 1, making that photo the active (lightest gray) photo without deselecting the other photos.

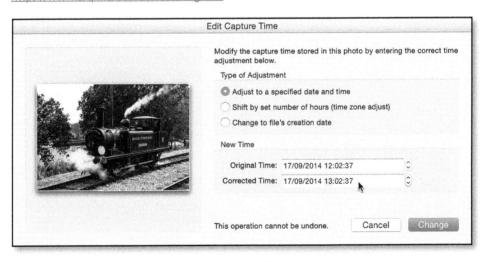

Figure 9.10 The Edit Capture Time dialog allows you to correct the capture time on a group of photos in one go.

- **4.** Go to *Metadata menu* > **Edit Capture Time** to show the Edit Capture Time dialog. If you've selected the photos correctly, the preview photo on the left is your 'known time' photo. (**Figure 9.10**)
- **5.** If you need to change the time by full hours, you can select *Shift by set number of hours* and enter the time difference, but otherwise, choose the first option, *Adjust to a specified date and time*, as this allows you to change by years, months, days, hours, minutes or seconds.

If you've selected the Adjust to a specified date and time option, enter the correct time—the time you noted down earlier for the 'known-time' photo. You can select each number (hours, minutes, etc.) individually, and change the value either using the arrows or by typing the time of your choice.

6. Click *Change All* to update all the selected photos.

If you make a mistake, don't panic, the original time stamp is stored in the catalog unless the photo is deleted, and you can return to the original time stamp by selecting the photos and going to Metadata menu > Revert Capture Time to Original.

Which Edit Capture Time option should I use?

There are three different options in the Edit Capture Time dialog:

Adjust to a specified date and time adjusts the active (lightest gray) photo to the time you choose, and adjusts all other photos by the same increment. It doesn't set them all to the same date and time. (**Figure 9.11**) This

is the most useful option as you can use it to fix incorrect dates, correct capture times that are out by as little as a few seconds, or make half hour time zone adjustments.

	Original Time	New Time
Photo 1	08:57:38	09:57:38
Photo 2	12:02:37	13:02:37
Photo 3	16:20:46	17:20:46

Figure 9.11 Capture Times all move incrementally, rather than setting all the photos to the same time.

Shift by set number of hours (time zone adjust) adjusts by full hours, which is useful when you've only forgotten to adjust the time zone on vacation.

Change to file creation date for each image sets the capture time to the file creation date. This is only usually used on scans that have no capture date, and even then, the file creation date is rarely the date the film photograph was captured.

How do I sync the times on two or more cameras?

If you're shooting with two cameras, matching the capture times can be even more important, as the *Capture Time* sort order would also be incorrect, muddling up your photos. Of course, synchronizing the time stamps on the cameras before shooting would save you a job, but if you forget, all is not lost.

The principle remains the same as adjusting the time on a single camera, but you need to repeat the process for each camera with the wrong time stamp. It's easiest if you have a fixed point in the day for which you know the correct time and were shooting on all the cameras involved, for example, signing

the register at a wedding.

First, separate each camera, so that you're working with one camera's photos at a time. You can do this easily using the Metadata filters, which we'll cover in more detail in the next chapter, starting on page 183. (In short, select Metadata from the Filter bar above the grid, select Camera Model or Camera Serial from the pop-up at the top of a column and then select the model or serial number of the first camera.) Then, using the instructions in the earlier question, change the capture time for these photos. Repeat the process on each additional camera until they all match, then disable the Metadata filter by clicking None in the Filter bar.

How do I change timestamps on scanned photos?

Lightroom's Edit Capture Time is designed for digital capture rather than scans, so it won't set all photos to a fixed date and time. John Beardsworth's CaptureTime to Exif plug-in, however, uses Exiftool to add your chosen date to TIFF, PSD, JPEG or DNG files. You can download it from https://www.Lrq.me/beardsworth-capturetimetoexif

KEYWORDS

It's worth spending a little time adding keywords to help you find specific photos again later, without having to

scroll through your whole catalog. Keyword tags are text metadata used to describe the content of the photo, and they can be stored in the metadata of the files and understood by a wide range of software, so your efforts are not wasted, even if you later move to other software.

Image recognition software is already able to identify many subjects, reducing the need

for keywords. However, it's likely to be some time before software can correctly name your friends and family, or tell the difference between a lesser spotted and great spotted woodpecker, so some keywords are still important.

What kind of keywords should I assign to my photos?

If you've never keyworded photos before, you may be wondering where to start. There are no hard and fast rules for keywording unless you're shooting for Stock Photography. Assuming you're shooting primarily for yourself, the main rule is simple—use keywords that will help you find the photos again later! For example, they can include:

Who is in the photo (people—we'll come back to Face Recognition in the next section starting on page 155)

What is in the photo (other subjects or objects)

Where the photo was taken (names of locations)

Why the photo was taken (what's happening)

When the photo was taken (sunrise/sunset, season, event)

How the photo was taken (HDR, tilt-shift, panoramic)

Before you start applying keywords to photos, think about the kinds of words you would use to search for your photos. Also think about consistency within your keyword list, otherwise you'll spend a lot of time tidying up your keyword list later, for example:

Grouping—as with folders and collections, you can use a hierarchical list of keywords instead of a long flat list. We'll consider the pros and cons shortly.

Capitalization-stick to lower case for

Figure 9.12 This is a subset of the current keyword list from my personal catalog.

everything except names of people and places.

Quantity—either use singular or plural, but avoid mixing them. Either have bird, cat and dog or birds, cats and dogs. Where the plural spelling is different, for example, puppy vs. puppies, you can put the other spelling in the *Synonyms* field.

Verbs—stick to a single form, for example, running, playing, jumping rather than run, jumping, play.

Name formats—consider how you'll handle nicknames or last names for married women. Many use the married name followed by the maiden name (e.g., Mary Married née Maiden), while others choose to put previous names and nicknames in the *Synonyms* field.

Need some ideas? While controlled vocabularies are overkill for most amateur photographers, they can be a great place to get ideas for your own keywords and list structure. (Figure 9.12) It's possible to download these lists, covering just about every possible keyword you can imagine, and for Stock Photographers these lists are ideal. Many of the keywords you'll use may not appear on the downloadable lists, as they'll be names of friends, family and local places, but even if you decide to create your own keyword list, you may pick up some good ideas on how to structure your own list.

Should I use a flat or hierarchical keyword list?

On the left, we have a single long flat list of keywords, and on the right, a hierarchy of keywords nested inside other keywords. So which should you choose? (Figure 9.13)

There are a number of factors that might

Figure 9.13 Keyword List showing flat list (left) vs hierarchical list (right).

influence your decision. They include:

Simplicity—Adding new keywords to a hierarchy requires a little more forethought and logic, whereas adding random keywords to a flat list can be done on-the-fly.

Universally Understood—Flat keywords are understood by most photographic software. If you create a hierarchy in Lightroom, it writes out the keywords as both flat and hierarchical, so if you move to other software, your keywords will still go along for the ride, but probably as a flat list.

Editing in Other Programs—In addition to moving to other software in the future, you can also run into issues with keyword hierarchies when exporting photos to edit in other software and then adding them back into the catalog. If some keywords are set to *Don't Export* (often used for parent keywords like who, what, when), when the photos come back into Lightroom's catalog, their keywords will be listed as new root

level keywords.

Scrolling—If you start adding a lot of keywords to your photos, a flat keyword list can become very long very quickly. If you're on Windows, you may even run into a bug/limitation, which prevents the Keyword List showing more than around 1600 keywords at one time. A keyword hierarchy allows you to collapse the list, so you're seeing fewer keywords at any time.

Automatic Entry—One of the major advantages to a hierarchy of keywords is that parent keywords are automatically added to the photos. For example, if I tagged a photo with *my house*, the parent keywords *Southampton*, *Hampshire*, *England*, *UK*, *Europe* would automatically be added to the photo too. This can save a lot of time.

Time Spent Reorganizing—If you don't start out with a clear idea of how you'll organize your keyword hierarchy, you can spend a lot of time organizing and reorganizing the

keywords into a list you like.

Multiple Catalogs—If you use more than one catalog (pros and cons on page 493), and you reorganize a hierarchical keyword list in one catalog, you'll end up with a massive mess and duplicate keywords when you try to merge that back into another catalog. This can even apply to travel catalogs.

Your final decision will probably depend on how many keywords you think you're going to add. If you're shooting for stock photography, a hierarchy is the obvious choice. If you're shooting for your own use, a flat list may be a simpler choice.

There is, of course, a compromise. You could have a very simple hierarchy, with a few parent keywords and all of the other keywords nested directly inside, for example, your parent keywords might be who, what, where, when, why, how. These can also act as a prompt, to remind you to add at least one keyword for each.

If you decide on a hierarchical keyword list, draft your list in a text editor or spreadsheet, or even on a piece of paper. By doing so, you'll save yourself a lot of time rearranging your keyword list later. One more tip... when adding People keywords, don't try to create a family tree. Since most of us have more than one parent, it becomes messy fast!

Having decided how you'll keyword, you can either start by building your keyword list in the Keyword List panel and then apply these keywords to your photos, or you can start keywording the photos and allow your keyword list to build gradually.

How do I add my first keywords?

There are multiple ways to add and delete keywords, so we'll just describe one option

using the Keywording panel to get you started and then we'll go into more detail.

- **1.** Select the first photo, perhaps in Loupe view so you can see the contents clearly, and go to the Keywording panel in the right panel group in Library module.
- **2.** Click in the keywords field that says Click here to add keywords.
- **3.** Type your keywords, separating them with a comma (,). As you start to reuse keywords, Lightroom suggests existing keywords as you type, which helps to avoid creating additional keywords with different spellings.
- **4.** When you've finished, press the Enter key. Your keywords then appear in the *Keywords* field above. If you make a mistake, click in that field and use the Delete/ Backspace key to delete the incorrect keyword.

Don't go overboard, especially to start with. If you try to add 30 keywords to every photo you've ever taken, it can become an overwhelming job, so just start with a few significant keywords on your best photos.

That's the basics, but now let's do a deeper dive into keywording.

What's the difference between the Keywording panel and the Keyword List panel?

You'll note that there are two panels for keywording photos—the Keywording panel and the Keyword List panel. The Keywording panel focuses on the keywords applied to the selected photos (Figure 9.14), whereas

the Keyword List panel focuses on managing the keywords themselves, organizing them and controlling how they're recorded in exported files. (Figure 9.15) There's overlap in basic functionality, for example, you can create and apply keywords using either panel.

How do I apply keywords to photos?

We said in the Fast Track that there are multiple ways to apply keywords to photos.

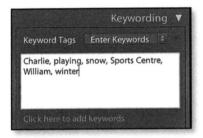

Figure 9.14 You can add keyword tags to your photos by typing them directly into the Keywording panel.

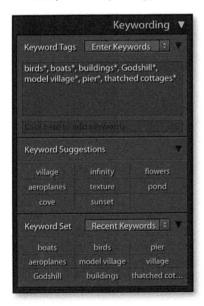

Figure 9.15 You can type keywords directly into the main keyword field in the Keywording panel, or in the small keyword field below.

The main options are:

Keywording panel—In the Keywording panel, type the keywords directly into the main *Keywords* field, divided by commas (as long as the *Keyword Tags* pop-up above is set to *Enter Keywords*), or into the *Click here to add keywords* field below.

As you start to type, Lightroom offers autofill suggestions from your existing keywords. To select the keyword you want to apply, click on one of these suggestions or use the up/down arrow keys followed by tab, or ignore the suggestion and continue to type.

You can place a new keyword inside a new or existing keyword by separating them with a pipe character (|) or greater than character (>), for example, Places|UK|London|Buckingham Palace. If you think better in the opposite direction, use the less than character (<), for example, Buckingham Palace < London < UK < Places.

If you're adding a keyword buried deep inside the hierarchy, for example, *pets* > *cats*, just type *cats*. If *cats* appears in your keyword list more than once, Lightroom displays the options with a less than character (*cats* < *pets*) so you can select the right one.

Keyword Suggestions—The *Keyword Suggestion* buttons intelligently suggest keywords based on your previous keyword combinations and the keywords already assigned to photos nearby. It's smarter than it looks! Clicking on any of those buttons assigns the selected keyword to the photo.

Keyword Sets—Using the pop-up menu in the *Keyword Sets* section, you can create multiple sets of keywords that you tend to apply to a single shoot. For example, you may have sets containing the names of your family members or kinds of animals that are usually found together. To apply the keywords, you can either click on them or use a keyboard shortcut. Hold down Alt (Windows) / Opt (Mac) to see which numerical keys are assigned to each word. (That's why there are only 9 keywords in each set.)

Assign an existing keyword in the Keyword List panel—Click the square to the left of the keyword in the Keyword List panel to add a checkmark.

Click and drag to/from the Keyword List panel—Drag the keyword from the Keyword List panel to the photo or drag the photo to the keyword.

Create a new keyword in the Keyword List panel—If the keyword is new, and therefore doesn't appear in the Keyword List, press the + button on the Keyword List panel. Enter the keyword into the Create Keyword Tag dialog and ensure that Add to selected photos is checked, then press Create. We'll come back to the other options in this dialog a little later.

Painter Tool—Use the Painter tool to spray the keywords onto the photos. (See the next question.)

Keyword Shortcut—To assign a keyword to the keyboard shortcut, right-click on a keyword and choose *Set Keyword Shortcut* then press Shift-K to apply that keyword to selected photos.

Face Recognition—There's also Face Recognition for people keywords, but we'll come back to this in the next section, starting on page 155.

Stock Photography—To add a large number of keywords for stock agencies, try Tim Armes' Keyword Master plug-in from

https://www.Lrg.me/armes-keywordmaster

Note that some stock agencies require keywords in a specific order, however Lightroom always sorts in alphabetical order.

If you need to check how many keywords are applied, hover over the *Keywords* field in *Enter Keywords* view to view the Keyword Count in the tooltip.

How do I use the Painter tool to add metadata such as keywords?

If you like working in Grid view with the mouse (or touchpad, etc.), the Painter tool is a quick way to apply various settings to your photos without having to be too careful about where you click.

The Painter tool (Figure 9.16) can be used to assign color labels, ratings, flags, keywords, Metadata presets, settings (Develop presets), rotate photos or add to the Target Collection. It's particularly useful when you have a large number of interspersed photos that need the same settings, for example, a keyword for a particular animal while on safari.

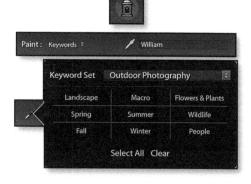

Figure 9.16 The Painter tool (top) is stored on the Toolbar, and the options appear when the tool is selected (center). Hold down Shift to access the Keyword selector (bottom).

To use it, click the spray can icon in the Grid view Toolbar (press T if you've hidden the Toolbar) to select the Painter tool and pick the setting you want to apply from the popup. In this case, you'd select *Keywords* from the pop-up, and enter the keyword(s) in the text field to the right. Multiple keywords can be entered using a comma between each keyword.

Simply click on a thumbnail to apply the setting, or click-and-drag across a series of photos to apply the setting to all the photos the cursor touches.

Any photos that already have that setting applied display a thin white border around the thumbnail, making them easy to spot.

To use the Painter tool to remove a setting, hold down the Alt (Windows) / Opt (Mac) key. The cursor changes to an eraser, then you can click or click-and-drag across the photos to remove the selected setting.

There's also a Painter Tool Keyword Set pop-up. If you hold down the Shift key while the Painter tool is set to Keywords, a pop-up appears under the cursor. You can then click on any of the keywords to add them to the Painter tool (or remove them) without having to type them into the Keyword field. You can even add an entire Keyword Set in one go by clicking on the *Select All* button. It's a well-hidden feature, but it's useful if you regularly use the Painter tool to apply keywords.

How do I edit a keyword?

If you want to edit a keyword, perhaps to correct the spelling, simply right-click on the keyword in the Keyword List panel and select *Edit Keyword Tag*, type the correct name and press *Save*. When you rename a keyword, it's automatically updated on all of the tagged photos too.

How do I delete a keyword from a single photo or all photos?

If you add a keyword to a photo by mistake, you can remove it using either the Keywording or Keyword List panel. With the photo(s) selected, select the keyword in the *Keywords* field in the Keywording panel and press Delete/Backspace to delete the keyword, or remove the checkmark against the keyword in the Keyword List panel.

To delete the keyword from the keyword list as well as the tagged photos, select it and press the - button at the top of the Keyword List panel, or right-click and select *Delete*.

How do I merge keywords?

At some stage, you're sure to end up with duplicate keywords. Perhaps, before you decided on consistent capitalization, you added dog to some photos and Dog to others. Or perhaps you edited photos in another program and the photo came back into your catalog with new flat keywords. Merging them isn't as easy as it should be, but it is possible:

- **1.** In the Keyword List, click the arrow to the right of the "wrong" keyword to show the photos tagged with that keyword. This filters the catalog to show only the photos tagged with the selected keyword.
- **2.** Select all of the resulting photos in the Grid view and drag them onto the "right" keyword, or check the checkbox next to the "right" keyword. This assigns the "right" keyword to the photos.
- **3.** Finally, go back and delete the "wrong" keyword.

Why aren't all of my keywords showing in the Keyword List?

Flat lists of keywords can run into a Windows limitation. There isn't a known limit to the number of keywords you can use, but part of a long flat list may be hidden (or showing but not accessible) in the Keyword List panel. It's possible to work around using the Filter Keywords field at the top of the Keywords panel, but it's far easier to avoid by using a hierarchy instead.

How do I create or change the keyword hierarchy?

By default, new keywords are added as a flat list, but you can change them into a hierarchy. You can have multiple levels of parent/child keywords, for example, your *Animal* keyword may be broken down into *Mammal*, *Reptile*, *Fish*, etc., with individual species within the sub-categories. Turn back to page 143 to consider the pros and cons.

As you drag a keyword onto another keyword, that new parent keyword is

highlighted. (Figure 9.17) When you release the mouse, the keyword moves inside the new parent keyword, just as you would drag folders onto other folders to make them into subfolders.

If you want to do the opposite and change a child keyword into a top-level keyword, drag and drop the keyword between existing top-level level keywords instead. (Figure 9.18) As you drag, a thin blue line appears. Don't worry about dropping it in the right place in the list, as the Keyword List is automatically set to alpha-numeric sort.

Once your hierarchy is underway, you can place new keywords directly into the parent keyword of your choice. You can right-click on the parent keyword and select *Create Keyword Tag inside* [keyword].

If you want to add a series of child keywords inside the same parent, select **Put New Keywords Inside this Keyword** from the right-click menu. Any new keywords are then added to that keyword as child keywords, unless you specifically choose otherwise.

Figure 9.17 To make an existing keyword into the child of another keyword, drag and drop it onto the new parent.

Figure 9.18 To move a child keyword to root level, perhaps to turn a hierarchy into a flat keyword list, drag it to the top of the keyword list and wait for a line to appear.

The keyword is marked with a small dot next to the keyword name to remind you. To remove it again, right-click on the keyword and uncheck *Put New Keywords Inside this Keyword*.

If you prefer to create keywords by typing in the Keywording panel, you can create a hierarchical keywords using the |, > or < characters.

How do I clean up existing keywords?

If you've created a tangle of existing keywords in other software, and want to start from scratch, you can clear them automatically at the time of import. Create a Metadata preset with only the *Keywords* field checked, but leave the field empty. This clears any keywords as you import the photos.

Alternatively, once the photos are imported, select them all and delete the contents of the keyword field in the Keywording panel,

Cre	eate Keyword Tag
Keyword Name:	West Highland White Terrier
Synonyms:	westie
	Keyword Tag Options
	Include on Export
	Export Containing Keywords
	Export Synonyms
	Person
	Creation Options
	Put inside "dogs"
	Add to selected photos
	Cancel

Figure 9.19 You can enter synonyms in the Create Keyword Tag or Edit Keyword Tag dialogs.

and then go to *Metadata menu > Purge Unused Keywords* to remove the empty keywords from your Keyword List panel.

To avoid wasting all of the work you've already done, create a keyword called "To Sort" and drag the existing keywords into it. (We'll come back to creating keyword hierarchies shortly.) Then you can build your new keyword list and drag existing keywords into it or filter the photos using their old keywords and assign a new keyword.

Which options should I select when creating or editing a keyword?

In the Create Keyword Tag dialog (Figure 9.19), there are additional options which create a fair amount of confusion. They are Synonyms, Include on Export, Export Containing Keywords and Export Synonyms. You can also access these options for existing keywords by right-clicking on the keyword in the Keyword List panel and selecting Edit Keyword Tag.

The **Synonyms** field allows you to add other words with a similar meaning. For example, you may add the latin name of a plant, or nicknames of family members. Don't go overboard—you don't have to copy the whole thesaurus! These synonyms can be searched using Smart Collections and Text Filters without adding them as separate keywords. The **Export Synonyms** checkbox controls whether these synonyms are included in exported photos.

You might not want all of your keywords included with exported photos, particularly if they include private information, or they're just category heading keywords such as 'Places' or 'People.' They can be excluded by unchecking the *Include on Export* checkbox in the Create/Edit Keyword Tag dialogs. There's no indicator on the keyword list to show which keywords won't export,

Keywords (synonyms in brackets)	PLACES			0.0000000000000000000000000000000000000	UK (United Kingdom, Great Britain)			uthamp (Soton		
Checkboxes	Include on Export	Export Containing Keywords	Export Synonyms	Include on Export	Export Containing Keywords	Export Synonyms	Include on Export	Export Containing Keywords	Export Synonyms	Results
Let's start with everything checked.	Yes	N/A	N/A	Yes	Yes	Yes	Yes	Yes	Yes	PLACES, UK, United Kingdom, Great Britain, Southampton, Soton
We don't want the PLACES category header to export, so we uncheck Include on Export for that keyword.	No	N/A	N/A	Yes	Yes	Yes	Yes	Yes	Yes	UK, United Kingdom, Great Britain, Southampton, Soton
The Export Synonyms checkbox controls whether that keyword's synonyms are included, so if you uncheck Export Synonyms for UK, UK's synonyms are excluded.	No	N/A	N/A	Yes	Yes	No	Yes	Yes	Yes	UK, Southampton, Soton
Export Containing Keywords controls whether the parent keywords are exported or not, but it won't override an unchecked Include on Export.	No	N/A	N/A	Yes	N/A	No	Yes	Yes	Yes	Southampton, Soton

The PLACES checkboxes marked N/A have no effect as the PLACES keyword has no parent keywords or synonyms.

This doesn't do anything as *Include on Export* is unchecked for PLACES.

Unchecking Export Containg Keywords for Southampton prevents UK and its synonyms from being included.

Figure 9.20 The interaction between the different Keyword checkboxes.

but using uppercase characters (PLACES, PEOPLE, etc.) can to help identify them.

When you assign a keyword to a photo, the parent keywords aren't directly applied, but they can be written to the file when you export the photos. For example, you may have a keyword 'dogs' and inside it you have 'Charlie'. The 'dogs' keyword isn't directly applied to the photo, but leaving **Export Containing Keywords** checked will include it at export. For simplicity, I'd suggest leaving it checked for all keywords, and then excluding specific parent keywords (i.e. PLACES) by unchecking the *Include on Export* checkbox on the parent keyword.

The interaction between these checkboxes is not as straight forward as you might hope, so I've illustrated it in the table below with a hierarchy of PLACES > UK > Southampton.

Figure 9.21 This is the keyword hierarchy shown in **Figure 9.18**.

Figure 9.22 The Keywording panel allows you to view the keywords directly assigned to the photo, the keywords that will be exported including synonyms, or the keywords including their parent keywords, as well as entering new keywords.

I've added synonyms too. Southampton has Soton as a synonym, and UK has United Kingdom and Great Britain as synonyms. On Figures 9.20 (previous page) & 9.21, you can see the results of different checkbox combinations.

How do I see which keywords are applied to my photo?

Still confused about which keywords are applied to your photo? At the top of the Keywording panel is the **Keyword Tags** pop-up.

Enter Keywords is the normal view. It only displays keywords that are directly applied to the photo. In our example, it simply says Southampton.

Keywords & Containing Keywords shows the keywords directly applied to the photo and its parent keywords. In our example, it says PLACES, UK, Southampton.

Will Export shows all the keywords that will be included in an exported photo. In our example, it displays the results shown in the last column of the table, depending on which checkboxes are checked. (Figure 9.22)

If you have multiple photos selected, you may see an asterisk next to some of the keywords in that field. The asterisk indicates that the keyword is applied to some of the selected photos, but not all of them. If you delete the asterisk, the keyword's applied to all of the selected photos.

What do the symbols in the Keyword List panels mean?

There are a number of symbols displayed in the Keyword List to provide additional information. (Figure 9.23) They include:

A check mark indicates that all the selected

photos have that keyword assigned.

An **empty square** indicates that the keyword isn't currently assigned to the selected photos. It only appears when you hover over the keyword.

A **minus symbol** means that some of the photos you've selected have that keyword assigned, or a child of that keyword. If it's a parent keyword, it can also show that all of your selected photos have some, but not all, of its child keywords assigned.

A **plus sign** to the right of the keyword means that keyword is currently assigned to the Keyword shortcut or Painter tool.

A **dot** to the right of the keyword means that new keywords will be placed inside the selected keyword.

An **arrow** appears to the right of each keyword when you float over the keyword. It's a shortcut to filter the photos tagged with the selected keyword. We'll come back to filtering on page 183.

You'll notice that some of the keywords in the list are all capital letters. I do this to remind myself that *Include on Export* is unchecked, as these are just organizational

Figure 9.23 Keyword symbols give additional information about the keyword.

keywords.

How can I keep certain keywords at the top of the list?

The list of keywords is displayed in standard alpha-numeric order, so adding a symbol to the beginning of the name, for example, the @ symbol, keeps these specific keywords at the top of the keywords list. It's particularly useful for workflow keywords, for example, I always add an @NotKeyworded keyword to all photos as they're imported, and remove it when I've finished keywording. If I get interrupted while applying keywords, any half-done photos might not show in the Without Keywords smart collection, but still appear in my @NotKeyworded filter.

Can I create my keyword list using a text editor?

Lightroom can import and export keywords from/to a text file. (Figure 9.24) This means that you can create your keyword list using a plain text editor or spreadsheet and then import it into Lightroom, but be warned, any formatting mistakes may block the import, and it can be a time-consuming job to figure out what's wrong.

If you want to try it, you'll need to save your list as a Tab Delimited .txt file rather than a Comma Separated .csv file. When creating the text file, only use a tab to show a parent-child hierarchy, and avoid other characters. Square brackets around a keyword unchecks the *Include on Export* checkbox, and curly brackets denote *Synonyms*. Back in Lightroom, go to *Metadata menu > Import Keywords* and navigate to the file. If it won't import, you've probably got some blank lines, extraneous spaces, return feeds, etc., or perhaps a child keyword without a parent.

You can also export the keywords to the text

file using Metadata menu > Export Keywords. This allows you to view your keywords in a text editor to look for mistakes, and also transfer keyword lists between catalogs. Again, be warned, importing a keyword list from a text file won't remove or edit existing keywords, so you can't use it to tidy up your hierarchy externally.

```
[ACTIVITY]
    eating
    jumping
    playing
    running
    sleeping
[ANIMALS]
    birds
        birds of prey
            buzzards
        ducks
        herons
        seagulls
        swans
    cats
    dogs
        {puppy}
        {puppies}
        Barney
        Charlie
        Maddie
        Nellie
        Rosie
        Tilly
        William
    donkeys
    dragonflies
        {dragonfly}
    fish
    goats
    guinea pigs
    hamsters
        Hercules
    horses
    kangaroos
    lions
    meercats
    pigs
    rabbits
        Rosie
        Smudge
        Wilbur
    seals
    squirrels
    tigers
    wallabies
         {wallaby}
    whales
    wildlife (unknown)
```

Figure 9.24 Keyword Text File

Is there a quick way of finding a particular keyword in my long list?

If your keyword list becomes lengthy, or keywords are hidden under collapsed parent keywords, it can be difficult to find a specific keyword quickly. Fortunately Adobe thought of this too, and there's a Keywords Filter at the top of the Keyword List panel, which instantly filters the keyword list to show matching keywords. (Figure 9.25) It's useful if you drop a keyword in the wrong place while making it a parent or child keyword, and then can't find it again. If you click on the magnifying glass to the left, you can choose to search All keywords, People keywords or Other keywords. If you select Show All Keywords Inside Matches, Lightroom also displays the sub keywords.

If you click the disclosure triangle to the right, Lightroom displays further filtering options to show **All** keywords, **People** keywords or **Other** keywords, but this time without searching for a specific keyword.

Is it possible to display all the photos in a catalog that aren't already keyworded?

If you want to find photos that haven't yet been keyworded, look in the Collections panel. There's a default smart collection called Without Keywords, or you can use

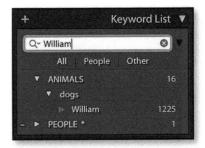

Figure 9.25 Search for a keyword in the list by clicking in the Search field at the top of the Keyword List panel.

Figure 9.26 A text search for Keywords Are Empty is a quick way to find all the photos you haven't keyworded yet. Add them to the Quick Collection rather than keywording them in the filtered view, otherwise they'll disappear when you add the first keyword.

a Text filter set to Keywords > Are Empty. (Figure 9.26)

We'll come back to filteri6ng and smart collections in the next chapter (page 183). If you don't always complete your keywording in one session, you could also use my @NotKeyworded trick mentioned previously.

FACES

Face Recognition searches your photos for things that look like faces, and displays these faces as a grid, ready

for you to identify the people. As you start naming people, Lightroom starts recognizing their facial features and suggesting their names for other faces that look similar, so it's ideal for tagging family and friends.

It gets smarter as you use it. Obviously it's not as smart as you are, and occasionally it identifies trees as people, suggests wrong names (Figure 9.27), and misses incomplete or small faces, but the technology is

Figure 9.27 No, that's definitely not me!

improving, and even in its current state, it can save many hours of work.

The names are stored as a special type of keyword, so you can search and filter just like normal keywords, but there are a couple of differences. Whereas keywords apply to the whole photo, face recognition tags a specific region of the photo, like Facebook's face tagging. If there are multiple people in a photo, you may remember who's who now, but future generations are sure to appreciate the assistance!

Besides being quicker than keywording, confirming name suggestions can be quite funny, when you see some of the ridiculous suggestions. As the faces are all displayed at a similar size in the grid, it's also much quicker to find a specific expression on someone's face when searching.

So if you photograph family and friends, let's take it for a spin.

How do I face tag people?

- **1.** Select a recent folder or collection containing people you can identify.
- **2.** Open People view using the icon on the Toolbar (**Figure 9.28**) or by pressing the O key (O being round like a face).

Figure 9.28 Select the People icon in the Toolbar.

3. Lightroom asks for permission to index your catalog. The indexing process scans your photos looking for faces and builds thumbnails to display in the People view. (Figure 9.29) Select Only Find Faces As-Needed for now, and leave the rest for later. If you select Start Finding Faces in Entire Catalog, it searches the entire catalog in the background.

Depending on the number of photos in the folder or collection, it may take quite some time and slow down your computer while it works. You can start exploring, but it's less frustrating to wait for this indexing stage to

Figure 9.29 Lightroom asks for permission to index your photos.

Figure 9.30 If you previously used keywords to identify people, convert them to person keywords.

complete before you start tagging. You can check its progress in the Activity Center by clicking on the Identity Plate.

4. While you're waiting for the indexing to complete, think about how you'll name people. The names need to be unique, so *First Name Last Name* (e.g. Victoria Bampton) is an obvious choice.

If you've previously created keywords for names, select them in the Keyword List panel, right-click and choose *Convert Keywords to Person Keywords*. This makes the names available for use in the People view. (Figure 9.30)

- 5. Finished indexing? Good!
- **6.** If it's your first time face tagging, click under a face and type the person's name. (Figure 9.31) When you add a new name, the person is added to the *Named People* section at the top of the People view. (Figure 9.32) Press the Tab key to move to the next photo, or click under the next face, and type the name of the next person and repeat.

When Lightroom's pretty sure multiple faces are the same person, it stacks them so you can name the entire stack in one go.

Figure 9.31 Click below the thumbnail to add the person's name.

- **7.** Try to name one photo of each person who appears regularly in your photos. This gives Lightroom initial information to start suggesting names for the other photos.
- **8.** Once you've given Lightroom a kick start, it's often quicker to switch to confirming Lightroom's guesses.

If Lightroom suggests a correct name, click the checkmark in the corner of the photo to confirm it, or hit Shift-Enter.

If you Ctrl-click (Windows) / Cmd-click (Mac) or Shift-click to select multiple faces, you can confirm them with a single checkmark click. It's quicker than clicking them all individually.

9. Select any photos that aren't people's faces (e.g., trees or animals), or faces that you'll never be able to name (e.g., unknown people in a crowd) and press the Delete key to delete the face region. This doesn't delete the photo itself—just the record of the face region.

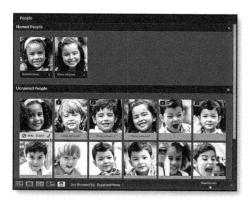

Figure 9.32 As you add names, they're added to the Named People section.

Figure 9.33 Select the Draw Faces tool in the Toolbar.

- **10.** Clicking the icon to reject a name suggestion just removes the suggestion. If Lightroom suggests an incorrect name or displays a question mark, type the correct name. It's quickest to confirm the most correct guessed names first and then fix the rest.
- **11.** Once the *Unnamed People* section is empty, check the photos for any faces that Lightroom missed, perhaps because they were incomplete.

Switch to Loupe view and enable the Draw Faces tool in the Toolbar, if it's not already selected. (Figure 9.33)

Start on the first photo and use the right arrow to move through the photos to check for any missed faces.

If you find a face that Lightroom missed, click and drag a square around the face and type the name in the label above. (Figure 9.34)

That's the basics... now let's learn some extra tips and tricks.

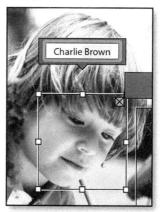

Figure 9.34 Draw around the face and add a name.

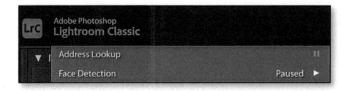

Figure 9.35 In the Activity Center, you can pause or continue background detection of faces.

How do I index my whole catalog?

If you've experimented with face tagging and decided that you're going to use it, it's worth asking Lightroom to index your entire catalog at a time when you don't need to use the computer (e.g., overnight).

There are pros and cons to indexing the whole catalog. The biggest advantage is it saves you waiting for the indexing process each time you switch to People view for a new folder or collection. The downside is it takes a long time if you have a large number of photos and it may slow your computer down while it's indexing. It also takes up a little extra space in your catalog and previews, but it's only about 2 KB metadata per photo, plus a thumbnail of the face.

To start indexing the whole catalog, show the Activity Center by clicking the Identity Plate and click the triangle next to Face Detection—Paused label. (Figure 9.35) You can also go to Edit menu (Windows) / Lightroom menu (Mac) > Catalog Settings > Metadata tab and check the Automatically detect faces in all photos checkbox. (Figure 9.36)

Lightroom uses a couple of tricks to speed

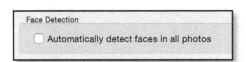

Figure 9.36 You can also enable/disable indexing in Catalog Settings > Metadata.

up the indexing process. If indexing is enabled for the entire catalog when you import new photos, Lightroom uses the embedded preview in the file (1024px or greater) rather than the full resolution data. For photos already in the catalog, Lightroom makes use of any existing Smart Previews as these are quicker to load and provide all the information Lightroom needs.

If neither of these shortcuts are available, then Lightroom uses the original files to build the index. This can be a little slower, depending on the size of the originals and the drive speed. If the originals are offline, they're skipped until the photos are next available.

How do I stop indexing?

If you need to quit Lightroom, the indexing just carries on when you next open Lightroom.

If you need to pause the indexing process, perhaps because the computer's running too slowly and you need to do some other work, click the *Face Detection* pause button in the Activity Center to temporarily pause it, and click again to enable it later.

There isn't a way to disable it completely, but if you leave the indexing turned off for the catalog, never open People view and never select the Draw Face tool in Loupe view, Lightroom won't index the photos.

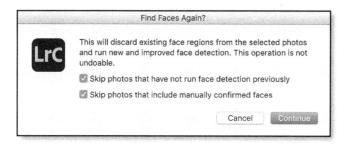

Figure 9.37 The Find Faces Again dialog offers options to avoid wiping out your existing face records.

How do I re-index a folder or collection?

If you accidentally remove many of the automatic face regions, or you simply want to start over, you can select the photos you wish to re-index and choose the *Library menu* > *Find Faces Again* command. (Figure 9.37)

Skip photos that have not run face detection previously is checked by default, because you may have previously intentionally excluded folders or collections containing lots of random people, for example, street scenes or football crowds.

If you've already confirmed faces or you've manually drawn faces on some photos, you won't want to lose that work, so **Skip photos that include manually confirmed faces** ignores photos that you've already named.

Unchecking both checkboxes wipes all of the existing face regions and starts again but any confirmed names are still retained as normal keywords.

How should I organize my people keywords?

In the Keywording section (page 142), we discussed different organizational methods for keywords, so we'll just summarize the main points to consider for your People keywords.

Unique Names—The names must be unique, even if they fall under different parent keywords in your keyword hierarchy.

Parent Keyword—If you decide to keep all of your People keywords together under a parent keyword (such as *PEOPLE*) right-click on the parent keyword and select **Put New Person Keywords Inside This Keyword** to automatically add new people to the group.

There are some occasions when you might want to leave people keywords in other locations, for example, if you visit a waxworks museum, you might want to nest these people's names under the name of the museum.

Family Hierarchies—You might choose to nest people keywords within a family/surname keyword. This works well for grouping, but you'll still need to use the person's whole name (e.g. Victoria Bampton rather than a Victoria keyword inside a Bampton keyword) as there may be more than one person with the same first name.

Consistency—Like other keywords, keep the formatting consistent. For example, you could use *First Name Last Name* or *Last Name*—*First Name*. (Note that you can't use a comma to separate *Last Name*, *First Name* as commas are used to separate keywords.)

Previous Names-Think about how you'll

handle maiden names for married women, for example, First Name Last Name née Maiden Name.

If you already have keywords for people's names, you can convert them to people keywords. Right-click on the keywords and choose *Convert Keywords to Person Keywords* in the right-click menu. You can convert multiple photos in one go, and it also applies to any child keywords. Be careful, because there isn't a way to batch-convert them back to normal keywords if you select the wrong ones. If you do make a mistake, you must right-click on the keyword, select *Edit Keyword Tag* and uncheck the *Person* checkbox.

This is worth doing at the outset to avoid confusion. For example, if you have a keyword for Victoria (the State) in Australia, and then you type the name Victoria under a face, that Victoria keyword would be converted to a person keyword. That's not much help!

While you're converting the keywords, remember to make sure they're full names and unique, renaming them if necessary. If you have the name Victoria multiple times under different family surname keywords, all of the Victoria faces will end up tagged with the first keyword.

Can I convert existing keywords to People keywords?

Converting existing keywords doesn't automatically name all of the faces in the tagged photos because there may be more than one person in each photo. For example, if you have a photo tagged with John and Mary, Lightroom may automatically find their faces but it doesn't know who's who. All is not lost. This information can still help.

If you click the arrow to the right of the

keyword, Lightroom filters the photos to only show the photos tagged with that keyword. When you switch back to People view, the *Unnamed People* section will still contain a number of different people (as the photos likely contain other people too), but the percentage of photos of the selected person will be much higher than the unfiltered view, making it easier to tag them all.

How do I navigate the People view?

The **People** view shows all of the people in the current selected source (e.g. folder, collection, *All Photographs*) and it's split into *Named People* at the top and *Unnamed People* at the bottom. (**Figure 9.38**) When you name a face, it moves from the *Unnamed People* to the *Named People* section.

In the *Named People* section, the name of the person shows below the thumbnail, and the number to the right shows how photos you have tagged with that name. When you hold down the Alt key (Windows) / Opt key (Mac) and float the cursor from left to right (or right to left) over the person's thumbnail, Lightroom scrubs through all of the thumbnails of that person. Unfortunately you can't select which photo to display for each person, because your chosen photo might not be in the current folder or collection. If you double-click on one of the faces, Lightroom switches to *Person View*, which we'll come back to shortly.

In the **Unnamed People** section at the bottom are all of the photos that haven't been identified yet. The label shows Lightroom's best guess, or if it can't guess the name, it just displays a question mark.

As you scroll through the photos, the dividers move to the top or bottom of the screen. If you click on one of the dividers, it immediately scrolls back to the beginning

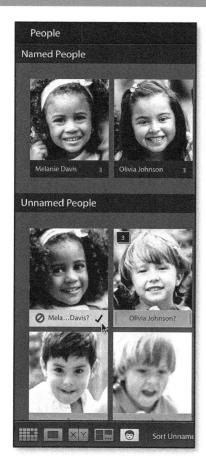

Figure 9.38 When you confirm a face, it moves to the Named People section.

Figure 9.39 When Lightroom's pretty sure the photos are all the same person, it stacks them.

of the selected section. They also show the number of faces in each section.

Some of the thumbnails may be stacked, shown by a number in the top left corner. (Figure 9.39) This means that Lightroom's pretty sure the photos are all the same person.

Clicking on the stack number opens and closes the stack. If the face stack's closed, your actions apply to the entire stack (unlike normal stacks) so confirming or typing a name applies to all of the photos in the stack. When a stack's open, your actions only apply to the selected face.

You can quickly look inside the selected stack by holding down the S key (when the text field is inactive) but it's easier just to go ahead and name the stack and check the individual Person view for mistakes later.

Why are the thumbnails unavailable or too dark?

The thumbnails are based on the unedited file, so some may be too dark or light, but there's no way of fixing this at the moment.

They're automatically built at the same time as the indexing process, however if you quit Lightroom before it's finished, it might not have time to build all of the thumbnails. In this case, they'll build as you scroll through the photos (as long as the originals or smart previews are available).

The **Thumbnails** slider on the Toolbar changes the size of the face thumbnails. This makes it much easier to see who's in the photo.

How do I change the sort order?

Also on the Toolbar you'll see the **Sort Unnamed By** pop-up, which changes the sort

order in the Unnamed People section.

Suggested Names is the default. It sorts all of the suggested names into alphabetical order and puts the ones without guesses at the end.

Filmstrip Order puts them faces in the same order as the photos. It's most useful when naming people in photos taken over a long period of time, as the people progressively age!

Stack Size puts all of the stacks at the beginning, with the largest stacks first. This is handy for getting through the bulk of the photos in one go.

Popular Names puts your most frequently photographed people first. This is useful if you're most concerned with tagging close family and friends and you're not too concerned about people you see less frequently.

How do I add a name to a face?

Like keywording, there are multiple ways to assign a name to a face. They include:

Type under Face thumbnail—The obvious choice is typing the name directly under the photo in the *Unnamed People* section. The pop-up offers auto complete suggestions from the available People keywords.

Confirm suggestion—If Lightroom suggests the correct name, you can confirm it by clicking the checkmark or using the keyboard shortcut Shift-Enter. (Figure 9.40)

Drag to Named People—If the person already appears in the *Named People* section, you can drag the thumbnail and drop it on the correct person.

Drag to Keyword List—If the person's name

already exists as a Person keyword, you can drag the thumbnail to the name in the Keyword List panel. This is easiest if you click the disclosure triangle to the right of the Filter Keywords field and then select *People* to only show the People keywords. (Figure 9.41)

Type on label in Loupe view—In Loupe view, with the Draw 41Face tool enabled, you can click in the name label and type the name.

You can also apply your changes to multiple faces in one go, which speeds the process

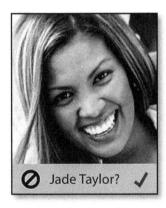

Figure 9.40 You can reject an incorrect suggestion, but it's quicker just to correct it.

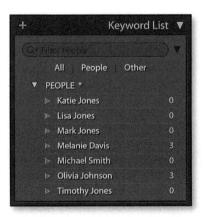

Figure 9.41 You can filter the Keyword List to only show People keywords.

up considerably. Hold down the Ctrl key (Windows) / Cmd key (Mac) while clicking on multiple faces to select them, then name, confirm, reject or delete the faces all in one go. If the faces you want to select are contiguous (not interrupted), click on the first, hold down the Shift key and click on the last to select them

I made a spelling mistake—how do I fix it?

If you make a spelling mistake, find the person in the *Named People* section and click on the name to correct it. You can also right-click on the name in the Keyword List panel and select *Edit Keyword Tag*.

Does rejecting a name suggestion take another guess?

If Lightroom suggests an incorrect name, you can press the icon to reject it, but it's quicker just to replace it with the correct name. Rejecting a name doesn't take another guess, and Lightroom doesn't learn from the photos you reject.

What do I do with people I don't recognize?

If you don't recognize the faces, look in Navigator panel in the top left corner to see whole picture or switch to Loupe view. The context can help to prompt your memory.

If there are children in the photos, use the Metadata Filters to face tag a year's photos at a time. Although the Filter Bar is hidden in People view, the photos remain filtered. Siblings often look very similar when they're little, so knowing that little Freddie was 6 months old and Johnny was 3 years old in the selected year can make them much easier to identify.

If you're still not sure who it is, but you expect to be able to find out (perhaps by

asking another friend or family member), either leave them in the *Unnamed People* section, or give them a temporary name. For example, you might call them *Unknown Bampton* or *Victoria Unknown* or even *Unknown Red Jacket Canada*. Using the word Unknown (or something similar) makes it easy to filter to find and name these people later. Be careful to uncheck *Include on Export* in the Edit Keyword Tag dialog for these keywords, as someone marked as *Unknown Big Nose* might be offended!

If don't think you're ever going to name the person, delete the face region by selecting the thumbnail and pressing the Delete key. (Figure 9.42) If you change your mind, you can draw it back later using the Draw Face tool, but there isn't a way to ask Lightroom to automatically reindex the photo once the regions have been deleted.

How do I access the photos of a single person?

When you double-click on a face in the Named People section (or right-click and select Find Similar Faces), it takes you to **Person View** and displays only the photos of the selected person in the **Confirmed** section. (Figure 9.43)

Figure 9.42 Delete regions that aren't people you want to name.

If you find a face in the *Confirmed* section that has the wrong name, perhaps because it was hidden in a collapsed stack, float over the face to show the label and type the correct name.

In the **Similar** section below, it displays additional photos that may or may not be the same person. The *Similar* section isn't as strict about suggesting faces, so there are a lot more incorrect guesses, but the best guesses are sorted to the top of the section, ready for confirmation. You can't reject suggestions in this section. It's particularly useful to select multiple thumbnails before clicking the checkmark, as the entire *Similar* section refreshes every time you confirm faces.

To switch back to People view, click on the People icon in the Toolbar or on the People link in the top left corner of the preview area. If you double-click on a face in Person view (or in the Unnamed Person section

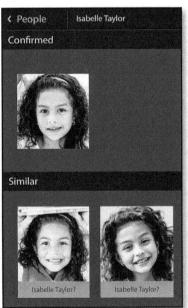

Figure 9.43 In the Person view, you can see all of the confirmed faces of a single person and other similar faces.

of the *People* view), Lightroom switches to Loupe view with the Draw Face tool enabled.

Why didn't the indexing find all of the faces?

Once you've cleared all of Lightroom's suggestions, you may want to check through the photos to find any extra faces that it missed. Face-on is relatively easy for Lightroom to find, but if it's the side of someone's head, Lightroom needs to be able to see both eyes to recognize it as a face. The faces also need to be big enough, so in a crowd of thousands, you'll be pleased to know it won't ask you to name every face!

How do I draw missing faces on the photo?

If Lightroom has missed some faces, you can use the Draw Face tool to add a face region to the photo. It's automatically selected when you switch to the Loupe view from a People view, or you can click on the icon in the Loupe view Toolbar to enable it. Simply drag a square around the face to add a face region. If you want to be really tidy, hold down the Shift key while dragging to constrain the bounding box to a square shape. If you draw a rectangle, Lightroom still creates a square thumbnail for the People views. (Figure 9.44)

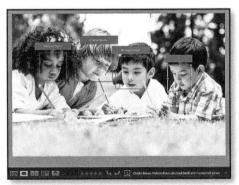

Figure 9.44 Use the Draw Face tool to add any missing faces.

Should I draw round the backs of people's heads?

While you're drawing face regions, you may come across photos of the back of a person's head. You could draw a face region around it. Lightroom won't recognize it as a face if it's missing eyes, so you won't harm the face recognition artificial intelligence, but the back of the head would appear in the Person view, which isn't very helpful. Instead, I'd recommend using the standard keyword tools (e.g., add a checkmark in the Keyword List panel or type the name in the Keywording panel) to tag using a standard keyword. You'll still be able to search and filter on the person's keyword to show all of the photos that include them.

How do I name people in Loupe view?

When you're in Loupe view with the Draw Face tool enabled, the face regions and labels show on the photo. Click on the label to enter or change the name. You can also confirm and reject name suggestions by clicking on the checkmark and reject icon that appear when you float over the label, and delete face regions by clicking the black X in the top right corner of the bounding box.

As a general rule, it's more efficient to do the bulk of the naming in the main People view, but the Loupe is useful for mopping up the ones it misses.

Can I add additional information about people, such as their birthday?

To take your People information to the next level, try Jeffrey's People Support plug-in. It allows you to enter the date of birth for each of your tagged people, and even tells you how old they were in a particular photo. https://www.Lrg.me/friedl-people

How do I delete face regions?

To remove all of the face regions from a single photo, open it in Loupe view, right-click on the photo and select *People* > *Remove All Face Regions*.

To remove all of the face regions from a larger number of photos—perhaps a series of crowd shots where you don't know anyone—select the photos and add them to the Quick Collection. Switch to the Quick Collection and then open People view. All of the faces will be from the photos in the Quick Collection, so you can easily select all of the faces and press the Delete key to remove them.

How do I keep my people keywords private?

When you come to export the photos, the names are included in the keywords and are also copied to the *Person Shown* IPTC field.

If you want the names to remain private, there's a **Remove Person Info** checkbox in the Metadata section of the Export dialog, however this only removes names attached to face regions, not those added as normal keywords.

You can also selectively excludes names by right-clicking on the keyword in the Keyword List panel, choosing *Edit Keyword Tag* and then unchecking *Include on Export*. (Figure 9.45)

Figure 9.45 To keep people keywords private when exporting photos, check the Remove Person Info checkbox.

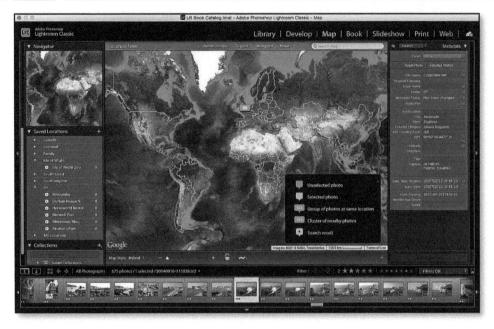

Figure 9.46 The Map module adds location metadata to your photos.

MAP LOCATIONS

Lightroom's Map module allows you to sort and manage your photos by location. Some photos, for

example, those shot on mobile phones, automatically appear on the map as they include GPS (Global Positioning System) data. If you have a GPS device or smart phone app, Lightroom assists you in linking the tracklog with the photos. But you don't need any high-tech equipment to use the Map module, as Lightroom allows you to assign locations by dragging and dropping the photo directly onto the map.

How do I add my photos to the map?

First, we'll add location metadata to some of your photos using the map, and then we'll go into more detail on the other options.

1. Switch to the Map module by selecting *Map* in the Module Picker at the top of

the screen, and make sure the Filmstrip is showing at the bottom of the screen. (If it's hidden, click the black bar at the bottom of the screen to unhide it.)

2. Initially the map displays whole world (Figure 9.46), so you'll need to zoom in to the location your photos were shot. The

Figure 9.47 Hold down Alt (Windows) / Opt (Mac) while dragging a rectangle to quickly zoom.

quickest way to zoom in is to hold down the Alt (Windows) / Opt (Mac) key and drag a rectangle on the map, enclosing the area you want to view. (Figure 9.47) Once you've zoomed in most of the way, use the slider on the Toolbar to zoom in or out, and click and drag the map to pan around.

- **3.** Using the Filmstrip, select photos shot in the same place and drag them onto the map, releasing them at that location. Lightroom displays a yellow marker where you drop the photos and adds the coordinates to the GPS field in the Metadata panel. If you make a mistake, drag them from the Filmstrip to the correct location. (**Figure 9.48**)
- **4.** At the top of the Map, select *Untagged* to dim the photos you've already tagged and repeat the process until all of the photos are dimmed.
- **5.** To view the photos at a specific location, click on the light or dark orange marker. The photos displayed are limited to those in current folder/collection.

Why is the map offline?

The Map module requires a current subscription and internet access to be able

Figure 9.48 Drag photos from the Filmstrip onto the map.

to view the maps, and Google's terms of service don't allow Adobe to cache this information. If your internet is offline or a firewall is blocking access to Google, it says We have no imagery here and then Map is Offline. When you reconnect to the internet, the Map module automatically reconnects.

That's the basics, but there's more to learn. Let's start with navigating the map and viewing the photos you've just tagged.

What do the different icons mean?

The color and style of marker depends on how many photos are tagged at a location, and whether they're selected or not. (Figure 9.49)

Photos are shown with a dark orange marker if they're not selected.

Selected Photos are shown with a light orange marker.

Groups of photos shot at the same location are shown using dark orange markers with numbers.

Figure 9.49 The Marker Key explains the meaning of each marker. Close the key by clicking the X in the corner. To bring it back, select View menu > Show Map Key.

Clusters are shown using dark orange markers with no arrow. Cluster are groups of photos taken near to each other but not actually at the same location. The photos merge into clusters as you zoom out, and split into their individual markers again as you zoom in.

Search Results are marked using a light orange marker with a black spot. We'll come back to searching shortly.

When you roll over or select a single tagged photo in the Filmstrip, the marker bounces up and down to help you spot its location on the map, but it doesn't work for groups or clusters.

How do I view the photos attached to each location marker?

When you hover over a marker, a pop-up displays the photos under that pin. (Figure 9.50) If it's a group or cluster of photos, click on the left and right arrows or scroll the mouse wheel to scroll through the photos.

When you move away from the marker,

Figure 9.50 When you click on a marker, you can scroll through thumbnails of all the photos taken at that location.

the pop-up is automatically dismissed. If you'd like to fix the pop-up so that it remains on screen, click on the selected marker (a yellow one) or double-click on the unselected marker (an orange one). It then stays on screen until you click elsewhere.

How do I avoid accidentally moving a marker?

If you accidentally move a marker, you also change the location data for the photo, so there's a lock icon on the Toolbar to lock the markers in place. (Figure 9.51) Assuming you dropped the photos in the right place initially, you'll likely want to leave the markers locked most of the time.

With the markers locked, you can still add new photos to the map, and also change the location of existing photos by dragging them from the Filmstrip to their correct location.

How do I select the map style?

The maps are powered by Google Maps because they offer detailed mapping of most of the planet. By default, Lightroom displays the *Hybrid* style, which is a combination of the *Road Map* and *Satellite* views, but you can select different map styles using the *Map Style* pop-up on the Toolbar. (Figure 9.52)

The maximum zoom depth is dependent on the map style—the *Hybrid, Road Map* and *Satellite* views offer more detail than the *Terrain* view. It also varies by location, with big cities showing more detail than less built-up areas. This is dependent on the information available from Google.

Figure 9.51 The Marker Lock prevents you accidentally moving a location marker.

Figure 9.52 There are six different map styles.

How do I search for a specific location?

You can zoom in and out and pan around the map until you find the location you're looking for, but it's quicker to search for a specific location. To do so, type the location name or a zip/postal code in the Search Box at the top of the map and hit Enter. (Figure 9.53)

If there are multiple locations that meet your search criteria, Lightroom offers a choice if you search for the same term a second time. (Figure 9.54) The search results are weighted using your current map view, so if it doesn't offer the location you're expecting, zoom in to the general geographic region and try again. For example, if you are

Q Windsor 🕙

Figure 9.53 Use the Search box at the top of the map to search for coordinates or place names.

viewing the whole world when searching for *Windsor*, the search results offer a number of places in the United States and Canada. If, however, you zoom into the United Kingdom, the search results change to show Windsor in the UK first.

How do I show or hide the overlays?

In the top right corner of the Map, you'll see an overlay with the name of the current location or search results. (Figure 9.55) Like

Figure 9.54 If multiple locations match your search, Lightroom gives you a choice.

the Info overlay elsewhere, you can press the I key to show and hide it.

How do I use the Map Filter bar?

To the left of the search box is the Map Filter bar, offering three ways of filtering photos in the Filmstrip based on their location data (Figure 9.56). Like the Filter bar in the Library module, press the \ key to show or hide it.

Visible On Map hides photos in the Filmstrip that aren't tagged with the current map location.

Tagged dims the untagged photos, making it easy to spot the tagged ones.

Untagged dims the tagged photos making it easy to spot the ones who haven't been tagged yet.

None clears the filtering.

You can also use the Library module Metadata Filter bar to filter for photos by

Shanklin, England, United Kingdom

Figure 9.55 Press the I key to show and hide the Location Name overlay.

location, using the Location, City, State/ Province and Country IPTC fields or Saved Locations. (Figure 9.57) We'll come back to filtering in the Filtering Photos chapter starting on page 183.

Why use saved locations?

Many of the photos you take are likely at the same locations—perhaps at home, other places close to home, and favorite vacation destinations. You can save these locations for easy access.

Saved locations are like presets for maps, offering a number of benefits:

Shortcuts—They're shortcuts straight to a location, to save you having to search for it.

Photo Count—The count shows how many photos in the current folder or collection are tagged with this location.

Filtering—You can filter to find photos at saved locations using filters and smart collections.

Privacy—If you mark a saved location as private, you can selectively remove the location information when exporting photos, while retaining location information

Location Filter:	Visible On Map	Tagged	Untagged	None	Q Search Map	١
						N.

Figure 9.56 The Map Filter bar allows you to hide photos based on their geocoding status.

GPS Data	Map Location		Country		State / Province		
All (3 GPS S 26600	Cowes Ferr	45.	All (8 Coun.	26600	All (12 Stat	26600	
Coordinates 16592	Current Ma	0.1	Canada	604	British Colu	604	
No Coordi 10006	Downtown	161	France	4461	Canarias	18	
Unknown 0	Durban Ho	25	Greece	329	Cornwall	41	
	Exbury Gar	116	Libya	10	Dorset	27	
	Foundry Lane	25	Nepal	2	England	7028	
	Freshwater	62	Spain	18.	Isle of Wight	36	

Figure 9.57 The Metadata Filter columns in the Library module allow you to search the location data.

000	New Location		
Location Name:	Shanklin		
Folder:	Isle of Wight		\$
Options			
Radius :		6.7	Kilometers 🔾
Priva	ate Photos inside private locations removed from their metadata w		
		Cancel	Create

Figure 9.58 Set the options for a saved location in the New Location dialog.

on other exported photos.

How do I create a saved location?

- **1.** Navigate to the location on the map.
- **2.** Click the + button on the Saved Locations panel.
- **3.** In the New Location dialog (Figure 9.58), give the location a name and set the radius in *Kilometers*, *Meters*, *Miles* or *Feet*. You can adjust the radius and location once the saved location is created.
- **4.** Decide whether to make the location private. If *Private* is checked, any photos taken within the saved location have their location data automatically stripped on export. For example, you may want to mark the area surrounding your home as private, so that photos uploaded to the web are stripped of your home address.
- **5.** Press *Create* to confirm the saved location.
- **6.** The Saved Location appears on the map as a circle—black if it's private, white if it's not. **(Figure 9.59)** If it doesn't show, make sure your location is selected in the Saved Locations panel and press the O key to

toggle the overlay (or go to View menu > Show Saved Location Overlay).

- **7.** Move the circle to fine tune the location by dragging the dot in the center. The lock icon also indicates that it's a private location.
- **8.** Change the radius of the saved location by dragging the dot on the outer circle to resize the circle.

To rename the location or change the privacy settings, right-click on the saved location in the Saved Locations panel and select *Location Options* to access the Edit Location dialog.

Figure 9.59 Saved Locations show as circles on the map.

To quickly return to a saved location, click the arrow at the end of the saved location name in the Saved Locations panel, or double-click on its name. (Figure 9.60) As you explore the map, you'll also notice that the names of saved locations within the current view light up.

You can have saved locations within other saved locations, for example, you may have a saved location which covers a whole country, and another saved location for a specific town or address.

We've already covered the basics of adding metadata using the map, but now let's learn some extra tricks.

How do I mark photos on the map?

There are numerous ways to add photos to

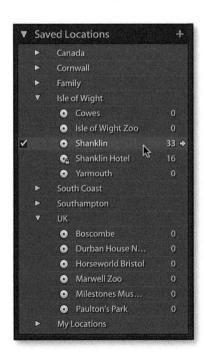

Figure 9.60 The checkmark on the left shows that the selected photo was taken at the Saved Location, and the arrow on the right will take you to that area.

the map and location metadata to the photo.

Drag onto the map—Simply dragging the photo from the Filmstrip or secondary window and dropping it on the map so a marker appears. This works equally well with multiple selected photos.

Right-click on the map—You can select the photos, right-click on the correct location on the map and select *Add GPS Coordinates* to *Selected Photos* from the context-sensitive menu.

Drag to/from a Saved Location—Select the photos and drag them onto a location in the Saved Locations panel, or drag the saved location onto the photos in the Filmstrip.

If you have a second screen or a large monitor, use the Grid view on the secondary window and drag the photos onto the map from the grid instead of the Filmstrip. It allows you to see and select more photos.

Check the Saved Location—Select the photos and go to the Saved Locations panel. As you float over the locations in that panel, a checkbox appears for each saved location. Click the checkbox to tag the selected photos with the central point of that saved location.

Manual Entry—Select the photos and type (or copy/paste from another photo) the GPS coordinates in the GPS field in the Metadata panel.

Sync from another photo—Select a group of untagged photos, plus a photo that already has coordinates. Click the thumbnail of the tagged photo to make that the active photo, then press the *Sync Metadata* button at the bottom of the right panel group. Check the *GPS* field, leaving the others unchecked, and press *Synchronize* to copy that location to the other photos.

How do I find photos I haven't tagged yet?

If you're working through your entire back catalog and tagging photos with locations, it helps to narrow the photos down to the ones you haven't tagged yet.

The *Untagged* filter at the top of the map is useful, as it helps to identify photos that you haven't geocoded, but it can involve a lot of scrolling as the photos are only dimmed, rather than removed from view.

To hide the tagged photos, switch to the Grid view and select the Metadata Filter bar at the top of the grid. Using a pop-up at the top of a column, select *GPS Data* and then click on *No Coordinates* below. The tagged photos disappear from view. (We'll come back to filtering in more detail on page 183). Switch back to the Map module. As you drag additional photos onto the map, they also disappear from view. It works well as long as you drop them in the right place! If you drop them in the wrong place, press Ctrl-Z (Windows) / Cmd-Z (Mac) to undo and try again.

How do I move a photo or group of photos to a different location?

If you make a mistake when adding location metadata, you can easily move the photos to a new location.

To move photos that you've already added to the map, select them in the Filmstrip and drag them onto a different location, as if you were adding a location for the first time.

If a single marker is in the wrong place, you can also unlock the *Marker Lock* on the Toolbar and drag the single marker to a new location.

You can't drag group markers—it's a Google Maps API limitation. You can, however, click on the group marker to automatically select the photos, and then drag them from the Filmstrip to the new location, which moves the marker automatically.

How do I delete location information?

To completely remove location information from photos in the Map module, select the photos and go to the *Photo menu*, where you'll find two delete options. *Delete GPS Coordinates* removes the GPS data, removes the photo from the map, and removes any unconfirmed IPTC location data that was automatically added using address lookup. *Delete All Location Metadata* does the same, but also removes any IPTC Location data that you've added yourself. If you have multiple photos selected, a dialog checks whether you want to remove the data from all the photos or only the active photo.

How do I create a tracklog?

Once you start geocoding your photos, you may want to use a more automated solution, such as a dedicated GPS device. Some GPS devices attach directly to the camera, tagging the photos themselves at the time of shooting, so the photos automatically appear on the map. Other GPS devices create a tracklog, which is a series of GPS locations and timestamps, showing where you were at a specific time. Lightroom then helps you match the tracklog with the photos, showing where the photos were taken.

If you don't have a dedicated GPS device, but you want to use a tracklog rather than adding locations manually, you can use a smart phone app. For example, *Geotag Photos Pro* is an iPhone and Android app which can create a GPX tracklog. Learn more at their website: https://www.Lrq.me/geotagphotosapp Note that GPS tracking using a smart phone can drain your battery quickly, depending on

your logging interval.

Which tracklog formats can Lightroom understand?

Lightroom imports GPX files, which is a standard format for the interchange of GPS data, used by many devices. Many devices, or the desktop applications that come with them, can create GPX files. If your device doesn't offer that facility, you can use GPSBabel (https://www.Lrq.me/gpsbabel) to convert the tracklog to a compatible GPX format. Simply select the correct format for the input file, and GPX XML as the output format.

How do I import my tracklog and match it with the photos?

Having a created a tracklog, upload it onto your computer (your device instructions will tell you how to do that) and switch to the Map module.

- **1.** Click the *Tracklog* button on the Toolbar and select *Load Tracklog*. **(Figure 9.61)** (All of those options are also found under *Map menu* > *Tracklog*.)
- **2.** Navigate to your tracklog on the hard drive and click *Choose*.
- **3.** The tracklog is broken up into its individual sections, which are listed in the **Track** pop-up on the Toolbar.

Figure 9.61 The tracklog menu options are found on the Toolbar.

(Figure 9.62) Select *All Tracks* to see your entire route. The track displays as a blue line on your map. (Figure 9.63)

- **4.** Select all the applicable photos in the Filmstrip and click the Tracklog button on the Toolbar, then select **Auto-Tag Photos**. Lightroom checks the photo timestamps against the tracklog timestamps and automatically drop the photos on the map. You may need to apply a timezone offset, which we'll come to shortly.
- **5.** When you're finished, hide the tracks by selecting **Turn Off Tracklog** under the Tracklog button in the Toolbar. To view it again, select *Recent Tracks* from the menu.

Track: 2 January 2012 🕏

Figure 9.62 Tracks may have multiple sections, which can be selected from the Track pop-up.

Figure 9.63 The tracklog shows in Lightroom as a blue line, and the photos can be automatically added based on their timestamps.

Figure 9.64 Match photos tagged in local time with a UTC tracklog using the Offset Time Zone dialog.

How do I apply a timezone offset?

GPX logs, by definition, are time stamped in UTC (Coordinated Universal Time), whereas photos are usually stamped in local time. Rather than changing the photos to match the UTC time, you can apply a timezone offset to the tracklog.

- **1.** Import the tracklog as before, and select the related photos as if you're going to apply the tracklog.
- **2.** Under the *Tracklog* button on the Toolbar, you'll find **Set Time Zone Offset**.
- **3.** Move the slider in the dialog to match the photo times to the tracklog times. (Figure 9.64) You don't even need to know what the time difference was, as the times for both the selected photos and tracklog are shown in the dialog, allowing you to match them. The text in the dialog turns black when a likely match is found based on the selected photos, and turns red when the offset is wrong.
- **4.** Press OK to confirm the time offset. You can then auto-tag the photos.

Why won't my tracklog import?

If your tracklog won't import, check that it's a supported file type. Lightroom only currently supports GPX files natively. If you used GPSBabel to convert the

file, try reconverting from the original format, double checking your settings. There's a 10 MB tracklog file size limit on Mac, which could prevent the file from importing, but no equivalent limit on Windows. It may be possible to open the tracklog in a text editor and split it into multiple files, or Jeffrey Friedl's Geocoding plug-in can handle larger tracklogs. https://www.Lrq.me/friedl-geocoding

My camera time doesn't quite match the tracklog—how do I fix it?

If the photos don't land on quite the right spot because your camera timestamp was a few minutes off, there are two ways to fix it.

Fix the photo time stamps—Lightroom allows you to correct the camera timestamp using *Edit Capture Time*. Turn back to the Edit the Capture Time section (page 140) to learn more (and don't forget to correct the time on your camera for future shoots).

Shuffle the photos along the track—Lightroom allows you to manually move the photos along the track. Select all the photos you want to adjust, either in the Filmstrip or secondary window. Choose a photo for which you know the correct location, and click on its thumbnail to make it the active photo, shown by the lightest gray thumbnail border. Drag this photo from the Filmstrip to the correct position on the blue track line. Lightroom asks whether to adjust all the

Figure 9.65 If the timestamps are a few minutes off, you can drop a single photo in the right place on the track and Lightroom will use the relative times to place the other photos.

photos or just that photo. When you allow it to adjust all the photos, it shifts all the photos along the track using their relative timestamps to calculate their correct locations. (Figure 9.65)

What is Address Lookup?

Address lookup, previously called reverse geocoding, is the process of converting your GPS latitude/longitude data—your map location—into a readable address, which is then entered automatically into the IPTC Location fields. For example, if you drop a photo on Adobe's Headquarters, it would be entered as GPS coordinates of 37°19'52" N 121°53'36" W. From these coordinates

Enable address lookup?

Lightroom can automatically determine the city, state, and country of any photo tagged with a location. To do this, Lightroom needs to send GPS coordinates to Google Maps. No other data will be sent and Adobe does not have access to the information exchanged between Lightroom and Google.

Allow Lightroom to send GPS coordinates to Google Maps to look up addresses?

Disable

Enable

Figure 9.67 As address lookup requires sending the coordinates to Google, Lightroom asks for permission.

Lightroom, in conjunction with Google Map's API, works out the San Jose address details.

It doesn't automatically calculate the altitude, since you may not have your feet on the ground at the time of shooting, but if you do want to add Google Maps altitude data to a photo, click the Altitude icon in the Metadata panel.

Should I turn on address lookup in Catalog Settings?

When you import your first photo with GPS coordinates or drag your first photo onto the map in a new catalog, Lightroom asks for permission to enable address lookup. (Figure 9.66) If you decline, you can later enable it (or disable it) using the Look up city, state and country of GPS coordinates to provide address suggestions checkbox in Catalog Settings > Metadata tab, or by clicking the play button next to Address Lookup in the Activity Center. (Figure 9.67)

This permission is stored for each catalog individually, so you can have different settings for each catalog, and you can disable it again by going to *Catalog Settings*

Figure 9.68 You can disable address lookup in the Catalog Settings dialog.

> Metadata tab and unchecking the Address Lookup checkboxes.

With address lookup enabled, Lightroom sends the GPS coordinates to Google, so that they can return the address. Only the coordinates are sent, without any personal information, but you must decide whether you're comfortable with this.

You can pause it at any time, perhaps because your bandwidth is limited or costly, by clicking the pause button in the Activity Center.

Will address lookup overwrite my existing location data?

Lightroom only calculates location data if the Location fields (Sublocation, City, State/ Province, Country or Country Code) are all empty. If you've already entered data in any of these fields, the address lookup is skipped.

Figure 9.68 To clear manually entered location metadata, check these fields in the Synchronize Metadata dialog but leave the fields blank.

If you want to replace manually entered data with reverse geocoded locations, you'll first need to clear the manual data. It's easiest to do as a batch process.

Select the photos in Grid view and press the *Sync Metadata* button at the bottom of the right panel group. Press *Check None* and then check the *Sublocation*, *City*, *State/Province*, *Country* and *ISO Country Code* fields in the IPTC Image section. When you check these fields, the field names go red and the fields say *Type to add*, *leave blank to clear*. Leave them blank, then press *Synchronize* to remove the data. (Figure 9.68)

Why are the Location fields dimmed or italic?

You can view your reverse geocoded location metadata in the Metadata panel. The Location fields are dimmed and italicized to signify that the location metadata was generated using Google's maps, and may or may not be correct. (Figure 9.69) It's not permanent, so if you move the map marker to a new location, this data also updates.

Whether this metadata is included in exported photos depends on the status of the **Export address suggestions whenever**

Figure 9.69 Lightroom shows the reverse geocoded data in the Metadata panel.

address fields are empty checkbox in Catalog Settings > Metadata tab. If it's unchecked, only confirmed (white) metadata is included in exported photos. (Note that it only applies to exported files, not writing metadata to XMP in the originals.) Why might you choose not to include Google's guesses? They have been known to be wrong on occasion!

How do I make the lookup data permanent?

If the location metadata is correct, you can commit it by clicking on the field label and then clicking on the menu that appears, or you can edit it manually. (Figure 9.70) Once you've done so, the metadata becomes white and no longer updates if you move the photo to a different map location. There isn't a way of committing the location data as a batch process, however.

If it's incorrect, you can type something different in the Location fields. Once you've done so, the metadata becomes white. It's then included when writing to XMP, as if you'd entered it all manually.

Why is address lookup not working?

If you're dropping photos on the map and nothing's appearing in the Metadata panel Location fields, there are a few possibilities to check:

Figure 9.70 The dark grey geocoded locations can be committed by clicking on the field label and clicking on the location in the pop-up menu.

- Go to Catalog Settings > Metadata tab and ensure that Look up city, state and country of GPS coordinates to provide address suggestions is checked, or click on the Identity Plate to show the Activity Center to check it's not paused. If you've only just turned it on, leave it for a while to catch up or restart Lightroom to trigger the lookups.
- Check that you have internet access and there isn't a firewall preventing Lightroom from accessing Google Maps. If you can navigate around the map in the Map module, that's probably fine.
- Check that you don't already have some user-entered location metadata. If any of the Location fields contain data, the address lookup for that photo is skipped.
- If Google sees the same IP address hit it for more than 100,000 requests per day, it stops sending responses until the next day.

Can I view the location in my web browser?

Alt-clicking (Windows) / Opt-clicking (Mac) on the GPS arrow in the Metadata panel opens Google Maps in your default web browser instead of Lightroom's Map module. Ctrl-Alt-clicking (Windows) / Cmd-Opt-clicking (Mac) goes to Yahoo Maps.

Can I use more advanced geocoding facilities?

If the Map module has whetted your appetite for geocoding, you may be interested in Jeffrey Friedl's Geocoding plug-in, which offers further options and features including altitude, enhancing Lightroom's own facilities. You can download it from https://www.Lrq.me/friedl-geocoding

METADATA SHORTCUTS

		Windows	Mac
Metadata	Copy Metadata	Ctrl Alt Shift C	Cmd Opt Shift C
	Paste Metadata	Ctrl Alt Shift V	Cmd Opt Shift V
	Enable Metadata Auto Sync	Ctrl Alt Shift A	Cmd Opt Shift A
	Save Metadata to File	Ctrl S	Cmd S
	Show Spelling and Grammar	Mac only	Cmd:
	Check Spelling	Mac only	Cmd;
OS Copy/Paste within text fields	Cut	Ctrl X	Cmd X
	Сору	Ctrl C	Cmd C
	Paste	Ctrl V	Cmd V
Keywording	Go to Add Keywords field	Ctrl K	Cmd K
	Change Keywords	Ctrl Shift K	Cmd Shift K
	Set Keyword Shortcut	Ctrl Alt Shift K	Cmd Opt Shift K
	Toggle Keyword Shortcut	Shift K	Shift K
	Next Keyword Set	Alt 0	Opt 0
	Previous Keyword Set	Alt Shift 0	Opt Shift 0
	Apply Keyword from Set	Alt numberpad for 1 9	Opt numberpad for 19
Painter Tool	Enable Painter Tool	Ctrl Alt K	Cmd Opt K
	Show Keyword Painter Sets	Hold down Shift	Hold down Shift
	Add Keyword to Painter Tool	Hold Alt Shift and press 0-9	Hold Opt Shift and press 0-9
Face Recognition	Faces view	0	0
	Confirm Suggestion	Shift Enter	Shift Enter
	With text field inactive		
	Delete Face Region	Delete (when text field inactive)	Delete (when text field inactive)

		Windows	Mac
	Expand/collapse stack	S	S
	Temporarily expand stack	Hold S	Hold S
	Show thumbnails inside stack	Hold Alt while mousing over stack	Hold Opt while mousing over stack
	Activate the text field	Shift O	Shift O
	With text field active		
	Select Next Face text field	Tab	Tab
	Select Previous Face text field	Shift-Tab	Shift-Tab
	Confirm and select Next Photo	Enter	Enter
	Delete Name	Delete	Delete
	Cancel editing name	Escape	Escape
Map Module	Previous Photo	Ctrl left arrow	Cmd left arrow
	Next Photo	Ctrl right arrow	Cmd right arrow
	Search	Ctrl F	Cmd F
	Tracklog—Previous Track	Ctrl Alt Shift T	Cmd Opt Shift T
	Tracklog—Next Track	Ctrl Alt T	Cmd Opt T
	Delete GPS Coordinates	Backspace	Delete
	Delete All Location Metadata	Ctrl Backspace	Cmd Delete
	Show Filter Bar	1	\
	Show Map Info	ı	I
	Show Saved Location Overlay	0	0
	Lock Markers	Ctrl K	Cmd K
	Map Style—Hybrid	Ctrl 1	Cmd 1
	Map Style—Road Map	Ctrl 2	Cmd 2
	Map Style—Satellite	Ctrl 3	Cmd 3
	Map Style—Terrain	Ctrl 4	Cmd 4
	Map Style—Light	Ctrl 5	Cmd 5

	Windows	Mac
Map Style—Dark	Ctrl 6	Cmd 6
Zoom In	= or +	= or +
Zoom Out	-	-
Zoom to Selection	Alt-drag rectangle on map	Opt-drag rectangle on map

FINDING & FILTERING 1 () YOUR PHOTOS

Being able to add metadata to your photos is great, but the purpose of all this work is to be able to easily locate

these photos again at a later date. Using the metadata automatically embedded by the camera, as well as the metadata you've added manually, you can search the database to easily find specific photos.

SORT ORDER

The most basic way of finding your photos is scrolling through the Grid view until you reach the photo you're looking for. If you know the approximate capture date or filename, you can sort the photos into a specific order.

How do I change the sort order?

The **Sort** options are on the Toolbar in Grid view (**Figure 10.1**) or under *View menu > Sort*.

The options are:

Capture Time sorts the photos from oldest to newest.

Added Order sorts the photos according to their import time, with the most recent imports first. It's the default for the *Previous/Current Import* collection.

Edit Time sorts the photos according to how recently they were edited, including both Develop and metadata edits.

Edit Count sorts the photos according to how frequently you've edited that photo.

Rating groups the photos by their star ratings, with the 5 star photos first.

Pick groups the photos by their flags, with the flagged/picked photos first, then unflagged, then rejected.

Label Text groups the photos alphabetically based on their label text (e.g. Blue, Green, Purple, Red, Yellow)

Label Color groups the photos by their label color (i.e. Red, Yellow, Green, Blue, Purple) regardless of the label text

Figure 10.1 The Sort Order controls are in the Toolbar below the Grid.

File Name sorts the photos in alpha-numeric order from A to Z.

File Extension groups the photos by their extension (e.g. *.cr2, *.dng, *.jpg, *.nef, *.psd, *.tiff)

File Type groups the photos by their file type (e.g. Digital Negative Lossless, JPEG, PSD, Raw, TIFF, Video)

Aspect Ratio groups the portrait/vertical photos, then the square photos, then the landscape/horizontal photos, and finally the panoramic photos.

User Order allows you to drag and drop photos into a custom order as long as you're viewing a single folder or collection.

You can reverse the sort order using the **A-Z** button.

You can't change the default sort order, but when you change the sort order for a specific folder, that sort order is automatically selected again the next time you view that folder.

How do I drag and drop into a custom sort order?

To drag and drop photos into a custom sort order, or user order, pick up a photo by the thumbnail (not the gray border surrounding

Figure 10.2 When you drag and drop photos to change the sort order, a black line shows where the photo's going to drop.

it), and drag it to its new location. As you drag the photo, a black line appears between two photos, showing where the photo will drop. (Figure 10.2) The sort order popup automatically changes to *User Order*.

Why can't I select User Order?

User Order isn't available when you're viewing a composite view (a folder with subfolders or a collection set with subcollections) or a smart collection. To solve that, either select a folder with no subfolders, or turn off Library menu > Show Photos in Subfolders, so you're only seeing photos directly in the selected folder or collection. If you need a custom sort across multiple folders, group the photos into a collection.

FILTERING YOUR PHOTOS

Scrolling through the photos works well if you only have a small number, but it becomes impractical as your photo library grows. That's where filtering comes in—it hides the photos that don't meet the criteria you choose. For example, you may only want to view the photos with 3 or more stars, or those taken with a specific camera, or even a combination of criteria, such as photos with two specific keywords shot on a particular date.

How do I filter my photos to show photos fitting certain criteria?

To search your whole catalog, switch to the Library module and select *All Photographs* in the Catalog panel on the left. (Figure 10.3) Filters apply to the photos or videos in the current source, so you can limit the search by selecting specific folders or collections in the Folders panel or Collections panel.

The Filter bar is a gray bar at the top of the Grid view. If it's missing, press the \ key or go to View menu > Show Filter Bar.

There are three types of filter that can be used separately or together: *Text*, *Attribute* and *Metadata*. (Figure 10.4)

Text filters search the metadata of each photo for the text of your choice. For example, you can search *All Photographs* for a filename (e.g. IMG_5493) to find that photo in your catalog.

Attribute filters search by flag status, star rating, color label, master/virtual copy status and file type (photo vs. video). For example, you can search for the videos with 3 or more stars.

The main Attribute filters can also be found on the Filmstrip for easy access. If your Filmstrip Filters are collapsed, click on the word Filter to show the full range of options.

Metadata filters allow you to drill down

Figure 10.3 To search the whole catalog, select All Photographs in the Catalog panel.

through a series of criteria to find exactly the photos you're looking for, for example, photos taken of William last Thursday at home using a Sony RX100.

None temporarily disables the filters. If you want to clear them completely, select the *Filters Off* preset on the right of the Filter bar. You can save your own filters using that pop-up menu too.

To view the search options for each filter type, click on the filter label in the Filter bar. To open multiple filter types at the same time, hold down Shift while clicking on the filter labels or set the filter options in the first filter before clicking on another.

Let's try some simple filters before going into more detail.

- **1.** Click on the word *Attribute* and then click on the 3rd star, highlighting it. All the 0, 1 and 2 star photos disappear from view, leaving only the 3, 4 or 5 star photos showing.
- **2.** Click on the 3rd star again, and the other photos reappear.
- **3.** Click on the red square, and only the red labeled photos show.
- **4.** Click the 2nd star, while leaving the red square highlighted. Now the photos with 2 stars or greater and a red label are showing.

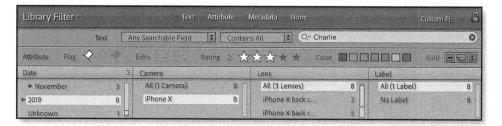

Figure 10.4 The Text Filters (top), Attribute Filters (center) and Metadata Filters (bottom) can all be combined to drill down through a set of criteria and find the photo you need.

- **5.** Click on the word *None* to close to Attribute filters, and then on *Metadata* to open the Metadata filters.
- **6.** In the *Keyword* column, select a keyword of your choice. The other photos disappear from view, leaving only the photos tagged with that keyword.
- **7.** Finally, click on the word *None* to disable the filters, so you're back where you started.

Now let's do a deeper dive to learn more filtering tips and tricks. We'll first look at Attribute filters, as those are most frequently used, then Metadata filters, then Text filters.

How do I use Attribute filters?

We've already used Attribute filters in this simple example, but there are a couple more tricks to learn.

The options in the Attribute filter bar or on the Filmstrip Filters are toggle switches (Figure 10.5), so they're highlighted when they're selected, and dim when they're deselected.

The flags from left to right are flagged, unflagged and rejected. You can combine these, so to hide the rejected photos, click on the flagged and unflagged icons.

The next two buttons show only photos that have been edited or those that remain at their default settings.

Next come the star ratings. The symbol to the left of the stars allow greater control, so you can filter based on:

- ≥ rating is greater than or equal to
- ≤ rating is less than or equal to
- = rating is equal to ()

For example, to display only photos with 0 stars, click on the symbol to the left of the stars and select the = icon, and leave the stars themselves deselected.

To show only photos with selected color labels, click on the colored icons, then click on them again to remove the filer. For example, to show the red and yellow labelled photos, click on the red and yellow boxes.

Figure 10.5 The Attribute Filters on the Filmstrip are collapsed by default (top), but if you click on the word Filter, the other options will appear (bottom).

Figure 10.6 You can combine the various attribute filters, for example, show red and yellow labeled master photos with exactly three stars and a flag.

There are two additional color labels in the filters. The gray square displays photos that don't have a color label. White displays photos with a custom label, where the label name doesn't match a label color in the current Color Label Set.

The final icons are harder to differentiate, but if you float your cursor over the icons, the tooltip shows the button names. The first button shows all normal Master photos, the second button filters for virtual copies and the final button finds videos. (Figure 10.6)

If you Ctrl-click (Windows) / Cmd-click (Mac) on the flag, edit status, color label or star rating on the main Filter bar or on the Filmstrip, the cursor changes to show that you're selecting rather than filtering, and it selects all the photos in the current view with that flag, label or rating without changing the filtering. (Figure 10.7)

How do I use the Metadata filters?

We briefly used the Metadata filters in the Fast Track to search for a specific keyword,

Figure 10.7 Ctrl/Cmd clicking on the filters selects the photos without filtering.

Figure 10.8 Change the Metadata Filter columns by clicking on the popup at the top of the column.

but the tool is far more powerful than that simple search.

The Metadata Filter bar has 4 columns by default, but you can have up to 8. To add and remove columns, click on the button which appears on the right as you float over the column header.

Using the pop-up at the top of each column, you can control which criteria you want to search. (Figure 10.8) By default, they're set to *Date*, *Camera*, *Lens* and *Label*, but there's a wide range of options.

Certain columns, such as the date and keyword columns, offer additional options, such as a *Flat* or *Hierarchical* view or *Ascending* or *Descending* sort order. Click on the button at the top right of the column to access these options. (Figure 10.9)

If you need a bit more vertical space to see a longer list of metadata, drag the bottom edge of the Filter bar to resize it.

How do I view only the photos with the parent keyword directly applied, without seeing the child keywords?

Let's expand the keyword example we used earlier. Imagine you've temporarily applied the parent keyword *Animals* to a group of

Figure 10.9 Click on the icon at the top right of the column to view the menu.

photos, and now you want to go back and assign the individual child keywords such as dogs, cats or mice instead.

Click the arrow that appears at the righthand end of the keyword in the Keyword List panel, which is a shortcut to the Metadata filters, or manually select *Animals* in the Keyword column.

By default, the keyword filter is set to **Hierarchical**, so it'll show all of the photos you've already assigned to *dogs*, *cats* and *mice*, as well as the photos you need to work on. That's not much help!

Click the button at the right-hand end of the column header and select the **Flat** view instead. Now the parents keywords are separated from the child keywords, as a long alphabetical list, so you can filter for photos with only the parent keyword *Animals* applied. (**Figure 10.10**)

Can I select multiple options from a single column, creating an OR filter?

But what if you need to find photos that have either a cat or a dog or a mouse? Then you need an OR filter. To do so, hold down Ctrl (Windows) / Cmd (Mac) while clicking on multiple criteria in the same column. (Figure 10.11)

For example, to search for all photos with either a cat, a dog or a mouse, select a single keyword filter column, click on *cats*, then hold down the Ctrl (Windows) / Cmd (Mac) key while clicking on *dogs*, so that they're both selected.

To select a series of keywords, hold down Shift while clicking on the first and last in the series. For example, if your keyword column shows cats, caterpillars, chipmunks, dogs, click on cats and then shift-click on dogs to include caterpillars and chipmunks in

your selection too.

How do I select multiple options within the Metadata filter columns, creating an AND filter?

Perhaps you need to do a complex search, drilling down through the catalog to find photos that match multiple criteria, such as photos with both a cat and a dog, taken at a specific location. That's where multiple columns come into their own.

Selecting across multiple columns gives an AND filter, so to search for all photos with both a cat and a dog, select *Keywords* at the top of two filter columns and select *cats* in one column, and *dogs* in the other. (Figure 10.12)

When you select *cats* in the first column, the second column updates to show only the keywords that are also assigned to cat photos, so if *dogs* doesn't appear in the

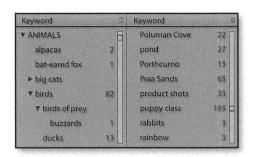

Figure 10.10 Hierarchical (left) and Flat (right) column view.

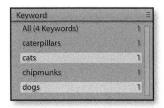

Figure 10.11 Select multiple criteria in the same column to create an OR filter.

second column, you don't have any photos with both keywords applied.

These multi-column AND filters aren't limited to keywords. You can add additional columns of criteria, for example, the *Map Location* option displays all of your Saved Locations. *Date, File Type* and *Camera* are

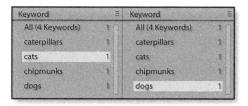

Figure 10.12 Select criteria in multiple columns to create a complex AND filter.

Figure 10.13 The Metadata Column pop-up offers a wide range of searchable criteria.

other popular options, but there's a wide range to suit most scenarios. (Figure 10.13)

Let's try a complex search. We'll search for all the photos shot in 2014 at the Sports Center, using an iPhone, and containing the keyword *Charlie*. (Figure 10.14)

- **1.** In the first column, which is set to *Date—Hierarchical*, click on 2014 to highlight it. The photos from other years disappear from the grid below.
- **2.** In the second column, which is set to *Camera*, click on *iPhone*. Photos shot on other cameras also disappear from the grid view.
- **3.** Select *Map Location* in the third column pop-up, and select *Sports Center* below. At this point it only shows photos shot in 2014 at the Sports Centre on an iPhone. Just Charlie left to find!
- **4.** Select *Keyword* from the fourth column pop-up, and then select *Charlie* from the list below.

How do I add additional columns?

If you need more than the four Metadata filter columns that are shown by default, float over a column header to show the menu button on the right. Click the menu button and select **Left** or **Right** to add a column to the left or right of the selected column. You can also remove a spare column

Library Filter :		Text At	tribute	Metadata None		Custom.	🕰
Date	3	Camera		Map Location		Keyword	
► 2011	786	iPhone	23 🗍	Shanklin Chine	ОП	All (3 Keywords)	135
▶ 2012	2568	iPhone 4S	598	Southampton	0	\$_Copyrighted	135
► 2013	4082	iPhone 6	134	Sports Centre	135	Charlie	1
► 2014	4787	iPhone 6 Plus	41	The Caledon B&B	0	William	2
≥ 2015	56 🗆	Nexus 4	1 📙	The Lizard	o ∏		

Figure 10.14 Multiple types of criteria can be combined to narrow the photos down further.

by selecting **Remove this Column** in the same menu.

How do I use Text filters?

There are certain types of metadata that you can't search using the Metadata filters, for example, the filename or the caption. The Text filter option allows you to search based on the text contents of these fields.

The first pop-up determines which metadata fields are searched. You can leave it set to All Searchable Field, or narrow it down to Filename, Copy Name, Title, Caption, Keywords, Searchable Metadata, Searchable IPTC, Searchable EXIF or Any Searchable Plugin Field.

The next pop-up determines whether it has be an exact or partial match, and of course the text field contains the text you're looking for.

How can I use the Text filters to do AND or OR filters?

By default, the second pop-up (Figure 10.15) is set to *Contains All*, which means that only photos matching all the words (or part words) you type are included, but there are a few other options:

Contains runs an OR filter, such as photos with either *dogs* or *cats* keywords, including partial matches such as *hotdogs* or *tomcats*.

Contains All runs an AND filter, such as photos with both *dogs* and *cats* keywords, including partial matches such as *hotdogs* and *tomcats*.

Contains Words runs an AND filter, such as photos with both *dogs* and *cats* keywords, but only including whole matching words.

Doesn't Contain runs a NOT filter, such as photos without the keyword *dogs* or partial matches such as *hotdogs*.

Starts With runs an OR filter with photos starting with your chosen letters, for example, dogs would show photos with dogs or dogsledding, but not hotdogs.

Ends With runs an OR filter with photos ending with your chosen letters, for example, dogs would show photos with dogs or hotdogs, but not dogsledding.

To combine search types, you can add some special characters. A space is AND, ! is NOT, a leading + means Starts With, and a trailing + means Ends With. They only affect the adjacent word, so you can use dogs !cats !mice to find images with dogs but not cats or mice. (Figure 10.16)

Quotation marks don't work, so you can't search for "John Jack" to exclude photos of another man called "Jack John."

Figure 10.15 The pop-up in the Text Filters controls whether it runs an AND, OR or NOT filter.

How do I search for a specific filename?

Let's try an example: you know the filename (e.g. IMG_2938.dng) but you don't know where the photo's stored.

- **1.** Select *All Photographs* in the Catalog panel to search the whole catalog.
- **2.** Select Any Searchable Field or Filename options in the pop-up menu.
- **3.** Leave the next pop-up on *Contains All* to include partial matches, or *Contains Words* to match the entire filename.
- **4.** Type the filename into the text field and press Enter to leave the field. If you've selected *Contains All*, you can just enter part of the filename (e.g. 2938) but if you've selected *Contains Words*, you'll need the entire filename including the extension (e.g. IMG 2938.dng). (**Figure 10.17**)

If you want to search for a series of filenames, enter them all into the search field with spaces or commas between the filenames, and change *Contains All* to *Contains*.

For longer lists of filenames—perhaps an order from a client, Tim Armes' LR/ Transporter plug-in (https://www.Lrq.me/armes-Irtransporter) reads a text file and marks the related photos in your catalog automatically.

Can I combine Text filters, Attribute filters, and Metadata filters?

As with most tasks in Lightroom, there are multiple ways of combining features, and the filters are no exception. For example, if you want to find all the photos with the word 'Charlie' somewhere in the metadata, with a flag and at least 3 stars, shot in 2019, on a iPhone X, you could combine all 3 filter types. (Figure 10.18)

To open multiple filter bars, simply enter your criteria in one filter before clicking on the next filter name. If you want to open all of the empty filters in one go, hold the Shift key while clicking on the filter names.

The criteria filters down in order, from top to bottom and from left to right, and it can be narrowed down further by first selecting a specific folder or collection view.

Figure 10.16 Special characters can be used to create complex Text Filters.

Figure 10.17 Text Filters allow you to choose which metadata fields to search.

Figure 10.18 Combining multiple filters allows you to drill down to specific photos.

More complex filtering is available via smart collections, which we'll cover in the next section, starting on page 193.

If you need even more complex search criteria, there are a few plug-ins that delve even deeper:

Lightroom Statistics https://www.Lrq.me/Irstats

Jeffrey Friedl's Data Explorer https://www.Lrg.me/friedl-dataexplorer

Jeffrey Friedl's Extended Search https://www.Lrg.me/friedl-extendedsearch

John Ellis' Any Filter https://www.Lrq.me/ellis-anyfilter

How do I lock filters, so they don't disappear when I switch to another folder?

When you switch to another folder or collection, any filters are automatically disabled.

In most cases, that's useful behavior, but there may be occasions when you want your filter to remain enabled, for example, browsing all of the 5 star photos across different folders.

To the right of the Filter bar is a small **Filter Lock** icon. **(Figure 10.19)** By default, it's unlocked but if you click to lock it, the current filter remains enabled as you browse different folders or collections.

Figure 10.19 The Filter Lock keeps the filter enabled when you switch folders.

The pop-up contains Filter Presets.

If the Filter Lock remains unlocked, you can enable the previous filter by pressing Ctrl-L (Windows) / Cmd-L (Mac), or using the switch at the end of the Filmstrip Filters.

This only turns back on the last filter that you used, not the last filter used on that specific folder. If you prefer to remember the filter settings used on each individual folder/collection, rather than a single global filter, go to File menu > Library Filters and select Lock Filters, and then return to that same menu and select Remember Each Source's Filters Separately.

Can I save the filters I use regularly as presets?

The pop-up on the right of the Filter bar holds filter presets with different combinations of criteria. The same pop-up appears in the Quick Filters on the Filmstrip, which makes your presets accessible from any module. (Figure 10.20)

There are a few presets built in, but you can also save your own frequently used filters for easy access. Select your filter options and then select *Save Current Settings as New*

Figure 10.20 Select your filter criteria and then select Save Current Settings as New Preset to save them for quick access in future.

Preset from the preset pop-up.

USING SMART COLLECTIONS

As well as filter presets, you can use Smart Collections to save filter criteria. They're like saved searches, smart

folders or rules in other programs, and they live in the Collections panel. (Figure 10.21)

Unlike standard collections (page 109), where you manually add or remove photos from the collection, smart collections update themselves without any user-intervention Photos automatically appear in the Smart Collection when they meet the criteria you choose, and they disappear again when they stop meeting that criteria. For example, you can create a Smart Collection to show your 3+ star photos, so you can quickly view your best work without having to go to All Photographs and set up a filter. Smart Collections automatically search your entire catalog unless you specify a folder or collection as part of the criteria.

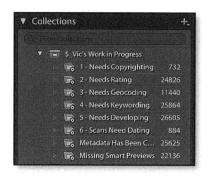

Figure 10.21 Smart Collections are stored in the Collections panel.

Smart Collections also allow you to do more extensive filtering than the Filter bar, as some criteria is only available for Smart Collections.

Let's try a simple example.

- **1.** Press the + button on the Collections panel and select *Create Smart Collection*.
- **2.** Enter a name for your Smart Collection at the top of the dialog.

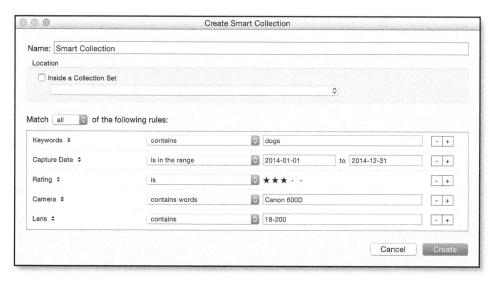

Figure 10.22 Smart Collections are like Saved Searches, automatically updating as photos meet, or stop meeting, the criteria you choose.

- **3.** Enter one or more rows, selecting the metadata type in the pop-up and the criteria to the right. The + button at the end of the row creates an additional row. Our earlier example of photos with the keyword 'dog', shot in 2014, on a Canon 600D, with 18-200mm lens, and rated above 3 stars, is shown in **Figure 10.22**.
- **4.** Press *Create* to finalize your Smart Collection. Your new Smart Collection appears in the Collections panel and you can click to view it again at any time, or double-click to edit the criteria.

Smart Collections are far more powerful than they look at first glance though, so let's learn some power-user tricks...

How do I create complex smart collections?

There are additional conditions you can apply to your smart collections to make them even smarter.

Above the rows of search criteria, you can choose whether to include photos that

Match All of the criteria (AND query), **Any** of the criteria (OR query) or **None** of the criteria (NOT query).

If you hold down Alt (Windows) / Opt (Mac) while clicking on the + button at the end of a row, you can fine tune your criteria further with conditional rules, which show as indented rows. Each of those conditional rules has its own *All/Any/None* pop-up, so the combinations are endless.

Smart collections, particularly with conditional rules, are ideal for workflow collections. For example, I have an 'Unfinished' smart collection (Figure 10.23), in case I don't get to finish adding metadata when selecting my favorite photos. It contains any photos that are either rated, labelled or flagged, but are either missing keywords or are missing my copyright information.

As an excellent example of the workflow benefits of Smart Collections, download John Beardworth's complete set of workflow smart collections from https://www.Lrq.me/beardsworth-workflowsc

How do I duplicate a smart collection?

If you're creating a set of smart collections

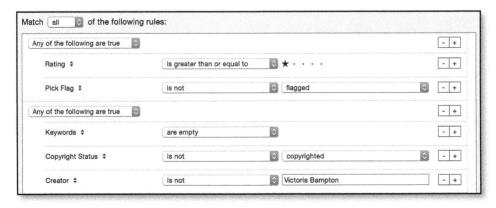

Figure 10.23 Criteria can be nested to create complex searches.

with similar criteria, for example, 5 star photos taken in 2012 and tagged with names of family members, you may want to set up the first person's smart collection, duplicate it and edit the duplicates. To do so, hold down the Ctrl key (Windows) / Opt key (Mac) and drag the smart collection to a new location in the Collections panel. You can either drag onto a collection set, in which case a + icon appears, or you can drag between existing root-level collections, so that a line appears.

How do I transfer smart collection criteria between catalogs?

Smart collections, like other collections, are stored within the catalog, so if you want to use them in other catalogs, you need to create them in each catalog. If they use complicated criteria, that could take a while. Instead, right-click on the smart collection and select *Export Smart Collection Settings* to export them to individual template files.

If you have many smart collections, even importing and exporting them individually can take a long time. The quickest solution is to select a single photo, go to *File menu* > *Export as Catalog* to create a catalog of the single photo, switch to the target catalog, go to *File menu* > *Import from Another Catalog* to pull that tiny catalog into your open catalog. All of your smart collections are automatically imported at the same time, and then you can remove the temporary photo. We'll go into importing and exporting catalogs in more detail in the Multi-Catalog chapter starting on page 483.

FILTERING SHORTCUTS

		Windows	Mac
Filtering	Enable/Disable Filters	Ctrl L	Cmd L
	Show Filter Bar	\	\
Text Filters	Select Text Filter	Ctrl F	Cmd F
	Starts with	+ at beginning of word	+ at beginning of word
	Ends with	+ at end of word	+ at end of word
	Doesn't Contain	! at beginning of word	! at beginning of word
Smart Collections	Add nested smart collection line	Alt-click on + button	Opt-click on + button

DEVELOP INTRODUCTION TO EDITING

11

Most photographers want to get on to the fun bit—editing their photos! Editing photos is not about making them

look fake or photoshopped, nor is it a new phenomenon. Photographers were editing their photos in the darkroom long before computers existed. Even the Masters, such as Ansel Adams, edited their photos, not to fix mistakes, but because a print can't match the dynamic range of the human eye.

Why analyze photos before starting to edit them?

When you watch a professional photo editor editing a series of photos, it looks like they "just know" what to change. They don't start randomly moving sliders, hoping to hit on the right combination of adjustments. Instead, they first analyze the photo.

Due to years of experience, that analysis may only take a few seconds, and may be a subconscious process, but it happens every time. Without necessarily realizing they're doing so, they're essentially running through a series of questions in their head—and you can ask yourself the same questions.

Starting to edit a photo without first taking the time to analyze it is like setting off on a road trip without first looking at a map. You'll end up somewhere, and the trip might still be fun, but you're unlikely to get to the best destination.

You don't have to plan every detail, but having a rough idea of where you want to end up means you can make good decisions along the way, and avoid going in circles.

If you're an experienced photo editor, you can simply skip this chapter, but in case you're just getting started or you want to improve your skills, I've included a checklist and worksheet to help guide you through the process. Printable copies and some start-to-finish editing examples can be downloaded from the Lightroom Classic Premium Members Area of the website (see page 566).

Analyzing your photos may look like a lot of work, but once you understand what you're looking for, you'll be able to analyze your photo in a matter of seconds, like you do when shooting a photo.

You don't have to complete a written worksheet every time you sit down to edit a photo, but your editing will improve if you run through the process a few times on paper before switching to doing it in your head. As you gain experience, it'll become second nature.

ANALYZING THE IMAGE— TECHNICAL FAULTS

One of the aims of the editing process is to get the best possible result from whatever

data you captured, so there are some technical issues to look out for. You may not be familiar with all of the terminology, so we'll explain a few new terms as we go along.

How's the exposure?

In the real world, our eyes don't care whether something is light or dark, as they automatically adjust to see detail in both the highlights and shadows, even in high contrast situations such as midday sun.

A photo (and especially a print) is unable to hold that wide a range of tones while still looking natural. Something has to give. Editing photos is a balancing act, determining which range of tones are most important and where you're willing to sacrifice detail.

There is no such thing as "correct" exposure, but the human visual system (the combination of our eyes and brain) expects

Figure 11.1 Our eyes are most sensitive in the midtones.

Figure 11.2 Note which areas of the photo are considered highlights, midtones and shadows.

to see an image in a specific way. This means there's room for creative expression, but there's a narrow band of exposure most people prefer.

Our eyes are most comfortable when the main focus of interest is around middle gray (called the midtones). Therefore, the optimum exposure setting may lighten or darken the highlights or shadows to move the most important tones towards the midtones. (Figures 11.1 & 11.2)

What can I learn from the histogram?

A Histogram is a bar graph showing the distribution of tonal values. You'll find the Histogram panel in the top right corner of the Library and Develop modules. If you can't see it, go to Window menu > Panels > Histogram.

The brightness of each pixel is measured from 0% (black) to 100% (white), so a histogram runs from the blackest shadow on the left to the brightest highlight on the right. Each vertical bar shows the number of pixels with that specific tonal value. (Figure 11.3)

A color photo is made up of three channels—red, green and blue—so the histogram has a

Figure 11.3 The histogram shows the number of pixels with each brightness value.

series for each channel (all overlapping each other) as well as a white series showing the overall luminance (or brightness).

There's no such thing as a 'correct' histogram. When analyzing your photo, a histogram can provide some really useful information on the exposure values of your photo, but don't get too hung up on it. We're trying to make great photos, not great histograms! However there are a few useful things we can learn from the histogram...

How's the dynamic range?

The difference between the brightest and

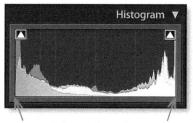

Spikes at the ends = dynamic range too wide

Figure 11.4 The histogram of a photo with a high dynamic range may spike at the ends.

Missing detail in the highlights and shadows

Figure 11.5 A photo with too a high dynamic range loses detail in the brightest highlights and darkest shadows.

darkest tones in the photo is called the dynamic range.

The histogram of a scene that has a much wider dynamic range than the camera could capture shows spikes at both ends. (Figures 11.4 & 11.5) These are pixels that are currently pure white or pure black, but if it's a raw file, there may be detail that can be recovered with careful editing. This is called a **high dynamic range**, and these photos usually have too much contrast.

A histogram stuck in the middle of the range, without reaching the ends is a narrow or **low dynamic range**. In most cases, these photos benefit from stretching to create a real white and black point because they lack contrast. **(Figures 11.6 & 11.7)** However some photos, such as those shot in thick fog, may not have any true white or black details.

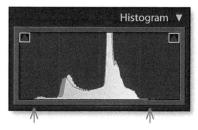

Data doesn't reach ends = low dynamic range

Figure 11.6 A histogram of a photo with a low dynamic range doesn't stretch to the ends.

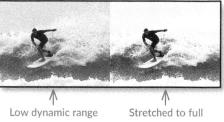

ow dynamic range Stretched to full dynamic range

Figure 11.7 A photo with low dynamic range lacks contrast (left), but the tones can be stretched to give a true white and black (right).

Are the highlights and/or shadows clipping?

If the last pixel on the left or the right of the histogram spikes, it means that some of pixels in your photo are solid white or solid black without any detail. These are called clipped highlights or shadows, or you may hear them referred to as blown highlights and blocked shadows.

Clipping on skin looks unnatural and is worth avoiding at all costs. (Figure 11.8)

Clipping isn't always bad though, as long as there's a smooth transition to image detail and you haven't lost important detail.

In some areas of the photo, such as bright spots on shiny objects, clipping is expected. Small areas of clipping on a light source, (such as a light bulb or the sun) can also look

Figure 11.8 Avoid clipping skin tones.

Figure 11.9 Some clipping is expected, like the bright areas of shiny objects.

fine, but ideally you don't want large clipped areas, such as a window with no detail. (Figure 11.9)

Some studio or product photographers like to clip their backgrounds to pure white or black. Intentionally compressing the shadow detail to gain contrast elsewhere can be a creative choice.

To check whether the clipped pixels are in areas of important image detail, hold down the Alt key (Windows) / Opt key (Mac) while dragging the Exposure, Highlights, Shadows, Whites or Blacks sliders to view the clipping warnings. Clipped blacks show as black on a white background when you hold down the Alt/Opt key and move the sliders. Pixels only clipped in one or two channels show in color. (Figure 11.10)

Figure 11.10 Clipping warnings help you to identify which areas of the photo have clipped pixels, so you can see whether you're losing important detail.

You can also show/hide the clipping warnings by clicking the triangles in the corners of the histogram or by pressing the J key. Clipped highlights are red and clipped shadows are blue

We'll adjust the tones using the Basic panel (page 234) and Tone Curve (page 313).

How's the color?

Unless you're doing reproduction work, the main aim is visually pleasing color, which may not be the same as perfectly accurate color, due to the way the camera captures

Figure 11.11 A color cast (left) makes the photo look muddy.

Figure 11.12 What's wrong with this image? Memory colors need to be accurate!

the scene. While you can make artistic choices, there are a couple of things to look out for...

A color cast is an unwanted tint in the image, often caused by an incorrect White Balance setting. It makes the photo look muddy and hazy, like you're viewing it through a colored film. We're most sensitive to color casts in lighter tones. When you remove the tint, the other colors usually fall into place. (Figure 11.11)

Some colors are burned forever into our memory. Think about skin tones. We recognize when someone looks jaundiced or ashen, or when they've applied fake tan, because the color of their skin doesn't match the color we expect to see. In the same way, we expect the sky to be blue, grass to be green, and bananas to be yellow. (Figure 11.12)

As long as the memory colors remain natural, you can take liberties with other colors for artistic effect, without the photo looking "wrong".

We'll fix the color cast using the White Balance sliders (page 229) and then go on to make further adjustments using HSL (page 331) and possibly Color Grading (page 325).

How sharp are the details?

If we have 20/20 vision, everything we look at is perfectly sharp. Whether it's softness caused by imperfect optics or focusing, there's usually room for improvement in the detail of our photos.

We all grab photos that aren't perfectly in focus and most will be removed when ranking the photos, but occasionally there's just "something" about them that's worth keeping. You can't fix out of focus

photos in Lightroom, but you can certainly improve them. (Figure 11.13) We'll improve sharpness using Texture (page 248) and Sharpening (page 333).

Is there noise?

Our eyes automatically adjust to see detail in the shadows without any noise. Cameras have come on leaps and bounds over the last few years, but they're no match. If you shot in low light, used a high ISO, your camera has a very small sensor, or you need to significantly brighten the photo, then there's likely to be noise in the photo, making it look

very grainy. **(Figure 11.14)** We'll reduce noise using the Noise Reduction sliders (page 333).

Is there moiré patterning?

Moiré (pronounced mwa-ray) is a rainbow-like pattern which is often seen when photographing fabrics. It's caused by two patterns combining—in this case, the weave in fabric and the grid of the camera sensor—which creates a new pattern. (Figure 11.15) We'll fix moiré using a Brush mask (page 308).

Figure 11.13 This was a grab shot, and the camera focused on the grass instead of his eyes, so it's not perfectly sharp but it sums up Charlie too well to throw away.

Figure 11.14 High noise levels are usually found on high ISO photos.

Figure 11.15 Moiré creates colored rings.

Figure 11.16 Lens vignetting darkens the corners.

Are there any optical distortions?

The way the light passes through the camera's lens can result in distortions that can distract from the content of the photo, so it's worth taking a moment to correct them.

Vignetting is a darkening around the edges of the photo, especially in the corners. (Figure 11.16)

Pincushion distortion causes straight lines to curve inward, while barrel distortion causes straight lines to curve outward. It's particularly noticeable when there are straight lines in the photo. (Figure 11.17)

We'll fix lens distortions using the Lens Corrections and Transform panels (page 338).

Figure 11.17 Pincushion (left) and barrel (right) distortion cause straight lines to curve.

Figure 11.18 Halos of opposing colors (green and magenta here) are caused by chromatic aberration.

Is there chromatic aberration or other fringing?

Chromatic aberration (often shortened to CA) is the little fringes of color that can appear along high contrast edges, where the red, green and blue light wavelengths are unable to focus at the same point. It's most noticeable around the corners of photos taken with a lower quality wide angle lens, and doesn't appear in the center of the image. (Figure 11.18) We'll fix Chromatic Aberration using Defringe (page 342).

Is the horizon straight?

Most of us have trouble getting horizons perfectly straight at the time of shooting, and since the edge of the photo acts as a point of comparison, they stand out like a sore thumb. (Figure 11.19) We'll straighten the photo using Crop (page 261).

Are the lines straight?

When you look around in real life, horizontal lines look horizontal and vertical lines look vertical, and even if you tilt your head, your brain compensates. However, if your camera sensor isn't perfectly aligned with those horizontal and vertical lines, the resulting photo looks wonky.

Figure 11.19 Horizons should be horizontal!

Figure 11.20 Due to the camera angle, the building appears to be leaning backwards.

If you're shooting buildings, have you noticed that they sometimes seem to lean backwards? This is called keystoning and it's caused by tilting the camera to get the whole building into the frame. Some keystoning can look natural, as we're used to looking up at buildings, but you may want to reduce excessive keystoning. (Figure 11.20) We'll improve keystoning using Upright (page 345).

Are there any sensor dust spots?

Removing distractions from the photo allows your viewer to focus on the content. Some unnatural distractions, such as sensor dust spots, stand out more than the litter we see around us every day.

Small spots that are most noticeable in the sky are caused by dust on the sensor. If you have a camera with interchangeable lenses, it's worth keeping your camera's sensor clean. Spots on blank areas on the sky are easy to clean up in Lightroom, but when they fall on more detailed areas, they can be tricky to remove. We'll retouch these using the Healing tool (page 268). (Figure 11.21)

Output

Finally, the intended output will affect some of your editing choices, such as...

Does the photo need to fit a specific aspect ratio, for example, a frame?

If a photo will be placed in a specific frame, the aspect ratio used when cropping will be important. You'll need to bear in mind the shape of the frame when cropping the photo (page 261).

Does it need to match the color of another photo?

If the photo is part of a collection that will displayed together on the wall, consistency across the group will be a high priority.

How big is the photo going to be?

If it's a quick snap to email to Granny, you may decide to spend less time editing than you would for a poster-sized print.

ANALYZING THE IMAGE— ARTISTIC INTENT

Photography is a form of visual communication. It's not "just a pretty

Figure 11.21 Dust spots on the sensor can be distracting.

picture." It's up to you to decide what you're trying to communicate through your photo, and ensure that the viewer gets the right message.

The composition, the lighting and the subject of the photo are essential, of course. You can't make a bad photo great through editing, but thoughtful editing can enhance a good photo and turn it into a great photo.

It's easy to look at a photo and say "I like it" but ask yourself WHY you like it. Once you've answered that question, you're well on the way to knowing what needs to be enhanced, to ensure that your viewer sees it the same way. Not sure how to answer? Let's break it down into a series of questions about the purpose of the photo, the story you want to tell, the mood you want to convey, and where you want the viewer's eye to go.

The Purpose

Why did you capture the photo? Or why did you keep the photo? What was it you wanted to show the viewer? For example:

- To capture a specific moment in time.
- · To tell a story.
- A specific subject caught your eye.
- The way the light was falling caught your eve.
- Someone commissioned you to shoot it. (What was their purpose?)
- · Something else?

What's important in the photo? What's interesting about it? For example, in a photo of a thunderstorm the clouds are most important, or in a portrait, it's the eyes.

The Story

They say a picture speaks a thousand words, so what are you trying to communicate through this photo? What kind of story are you trying to tell? What do you want the viewer to think of when they see it? If it's a portrait, does it show the subject's personality?

For example, a portrait of an older man can be edited as a gritty B&W to accentuate the weathered wrinkles on his face, showing that he's worked hard outdoors all his life, or as a soft low contrast color image, showing his softer side.

The Mood/Emotion

How did you feel when shooting the photo, and how do you want the viewer to feel? What emotion are you trying communicate? And then, how can you communicate that mood through your editing?

For example, a high contrast B&W shot of stormy seas may communicate drama, power and a feeling of awe, whereas the colorful blue sky and yellow sand on a paradisaic beach makes us think of relaxation. (Figure 11.22)

Or a country village looks better in peaceful calm tones, whereas edgy architecture looks great with a strong, contrasty look, and a factory can look great with a gritty grainy look.

Think of words you'd use to describe the photo, and the brightness, contrast and colors you associate with those words. (Figure 11.23)

Simplifying the Scene

So far we've been talking about the overall feel of the image, but now, let's think about

the content.

In a confused scene, your eyes don't know

Was it a bright sunny day at the beach?

Or would you prefer a more moody look?

Or do you want to emphasize the drama of the crashing waves and rocky cliffs?

Figure 11.22 Editing can be used to communicate mood.

where to look, so it's important to simplify the scene.

What caught your eye, making you take the photo—and is that the first thing that will catch your viewer's eye? Or will their eye wander off to distractions?

If the eye doesn't go straight there, careful cropping and selective editing can draw the viewer's eye away from the distractions to the right spot.

Drawing the Eye Using Visual Mass

Once you've removed everything that isn't necessary, think about how your eyes move around the photo. Consider:

• Where does the eye go currently, and in what order?

Words to Describe the Feel of a Photo

Light	airy, bright, clear, dainty, fluffy, glowing, hopeful, radiant, shining, sunny	dark, dull, gloomy, heavy, hopeless, mysterious, sinister, somber
Contrast	dramatic, energetic, gritty, hard, stormy, turbulent, wild	calm, delicate, gentle, mellow, mild, peaceful, smooth, soft
Color	cozy, fresh, happy, summery, rosy, upbeat, warm, yellow	bleak, blue, cold, frosty, icy, miserable, wet, wintry
Saturation	bright, cheerful, colorful, excited, gaudy, lively, loud, rich, vibrant, vivid	calm, dull, delicate, faded, mellow, muted, pale, pastel, sober, subdued

Figure 11.23 Think of words you'd use to describe the photo, and the brightness, contrast and colors you associate with those words.

Figure 11.24 Visual Mass can be used to draw the viewer's eye around the photo.

- Where do you want the viewer's eye to go?
- How can you use editing to draw your viewer's eye along that same path?

In the world of photography and art, there's a concept called Visual Mass. It simply means that some elements attract the eye more than others, and you can use this to draw your viewer's eye around the photo. (Figure 11.24) For example, we're drawn to:

- **People** (especially faces, particularly eyes). Even in landscapes, having a person in the scene creates a sense of scale or draws your eye to a specific spot. This also applies to animals, to a lesser extent.
- **Size**—We look at large objects before small.
- Contrasts of Brightness—We're drawn to light things in a mainly dark image, or dark things in a mainly light image.
- **Color**—We drift towards warm colors before cool colors (unless the scene is primarily warm, then we're drawn to the contrasting cool color), and saturated colors before dull colors.
- **Recognizable Objects**—We look at recognizable objects before those that are less recognizable.
- **Sharpness**—We see sharp objects before soft ones (which is why out of focus backgrounds work so well).
- **Lines**—We follow diagonal or curved lines before straight lines. Diagonal lines are more dynamic, whereas our eyes meander along curved lines.
- Text—We always try to read it!

This is massively over-simplified, and these elements are often combined, but you can use this concept to your advantage when editing, as well as when shooting.

Starting on page 261, we'll learn to use the selective adjustment tools to enhance these contrasts, but for now, just start noticing where your eye goes in photos, and where you want the viewer's eye to go to tell your story.

LEARNING TO EDIT

Most new photographers edit photos using profiles, presets and filters. So why bother learning to use the sliders?

Why should I learn to edit using sliders?

Photo editing is a skill, just like any other. If you're trying to learn a language, repeating phrases from a phrase book is only going to get you so far. To become fluent in a language, you have to learn its structure and vocabulary, so you can start to build your own sentences that can apply in any situation.

Editing photos is the same. Profiles and presets are like those pre-built phrases. They'll work okay in some situations, but they'll never be a perfect fit.

Skilled editing can enhance photos in a way that presets simply can't match. Learning which sliders to tweak is also much faster than hunting through hundreds of presets trying to find one that works.

When might I use profiles and presets?

Don't misunderstand me... profiles (page 222) and presets (page 371) have their place. Benefits include:

- Selecting a base profile can be a good starting point for your editing.
- Profiles and presets (especially those you've created yourself) can help to ensure consistency over a group of photos, or over your entire portfolio.
- Presets can be really helpful in learning the kind of styles of editing you prefer, and looking at which sliders are adjusted by presets is a great way of learning how to create a specific look.

How fast will I perfect my editing?

Any new skill takes time to develop, and you'll improve with practice. When you first start trying to edit photos with sliders, rather than relying on presets, you won't always be happy with the result initially. But that's ok! That's the benefit of non-destructive editing—you can go back and change them later, as your skills continue to develop. If you've saved a "classic" edit (as opposed to a fashionable look), your future changes will be tweaks, not a complete overhaul.

Why are you editing your photos?

Before you starting editing, ask yourself why you're editing your photos. Are you editing...

- To fix mistakes? (Yes, even pros make mistakes!)
- To compensate for intentional overexposure (ETTR), done to retain the largest amount of data?
- To adjust the dynamic range of the photo to match the scene you remember?
- To draw the eye to specific areas of the photo?

- To match your artistic vision for the photo?
- For consistency, perhaps across your portfolio or in an album or on the wall?
- To crop in closer, because you didn't have a long enough lens?

The reason you're editing the photos will affect the editing choices you make, for example:

- If you're figuring out the kind of style you like, you might experiment with lots of different presets.
- If you're aiming for consistency, you'll view the images as a group rather than just individually.
- If you're editing an image to put on the wall, you'll probably spend more time on it than a photo to put on social media.

Which photos should you edit?

If you spend hours editing every photo you capture, you'll soon get frustrated. Consider these time-saving tips:

- Don't try to edit everything. Editing won't fix bad photos. They can be improved, but you can't make a silk purse from a sow's ear. Flag/star the photos first, and just edit the best ones.
- Just do a "quick" edit on most of the photos you decide to keep, and focus most of your editing time on the photos you'll be proud to share with the world.

How do you use Lightroom to edit your photos?

You can get the gist of how Lightroom's sliders work simply through

experimentation. It doesn't take a rocket scientist to work out that the Exposure slider brightens or darkens the photos.

However, many of Lightroom's sliders do all sorts of clever calculations behind the scenes. Understanding how the sliders work—and how they work together—means you can get the best result.

What should I avoid when editing my photos?

There are some weird and wonderful photo effects that are popular with new photographers. Play with them and get them out of your system. But then, if you want to be respected as a photographer. your photos should usually look like photos.

There are a few red flags that make it easy to identify new photographers, and of course, you don't want to look like a newbie. so here are a few things to avoid:

- You don't need to use every single slider on each photo, just as you don't need to use every word in the dictionary in each conversation.
- Less is more. Unless you're intentionally aiming for a surreal look, keep it natural. Sliders rarely need pushing to the ends.
- Be especially careful with photos of people. Glowing eyes, bright white teeth and plastic skin rarely look good.
- Watch your white and black clipping. Most photos benefit from a few pure white and pure black pixels, but you don't usually want large areas of white or black without detail.
- Reduce digital noise, but don't make it so smooth it looks like plastic.

- Avoid using too many different presets. because your photos won't look like "yours".
- Don't crop too far, as you'll cause visible pixelation (obvious square pixels).
- Watch out for halos either side of edges in the photo, whether they're wide halos caused by overzealous use of the Highlights. Shadows or Clarity sliders, or narrow halos caused by too much sharpening or chromatic aberration (a lens defect).
- Limit your use of the latest fad and fake film presets that go out of fashion again just as quickly as they arrived. Likewise, limit your use of special effects such as selective color (B&W photos with one element in color), as these effects date quickly.
- Don't go out and buy every software program on the market. Master the ones you already have first. "The grass is always greener on the other side of the fence" doesn't always hold true. Often you just need to learn which slider to adjust to make it greener on this side!
- Finally, don't spend hours on every photo. If you get stuck, consider printing it, sticking it on the wall and "living with it" for a while. This makes it easier to see what needs changing.

DEVELOPING YOUR OWN STYLE

One of the biggest differences between photographers seasoned and photographers is consistency in editing. Would all of your pictures look good hung on the wall together, or are they "all over the place"? Could someone identify a photo as yours, just by looking at it?

Why is having my own style important?

If you look at the work of any famous photographer, you may know who the photographer is, long before you see their name. As you scroll through their website or Instagram feed, all of their photos work together as a consistent set.

This is partly due to their choice of subject, lighting, posing, lens, composition and so forth, but their editing style can make or break the consistency. If they applied a different preset to every photo, the photos would no longer be identifiable as theirs.

Professional photographers gradually develop a style and they stick to it. It may change over time, but it's a gradual shift.

If you're an amateur photographer, you don't have to go that far, but any improvement in consistency will make your photos look better together.

How do I start to develop my own style?

To start to define your own preferences, look at lots of people's photos. Notice what you consistently like, and what you consistently don't like, but don't just copy them, because you're unique.

Experiment with different presets to help you learn too, but remember that they're someone else's style.

Start to analyze what it is you like or don't like about a photo. Look out for things like:

- Do you love high contrast, or do you prefer photos that look soft and dreamy?
- Do you like highly saturated colors, or softer muted shades?
- How important are creamy skin tones?

- Do you prefer specific color palettes, such as muted greens and blues?
- Do you prefer the darkest tones blocked to pure black, or do you prefer more shadow detail?

When you edit a photo and love the result, add it to a "my style" album. Over time, a theme will start to become apparent. The style you prefer for landscapes may not be identical to the style you prefer for portraits, but there will be similarities.

It won't happen overnight, and as you start to improve your editing, you might find your photos even become a little inconsistent for a while, as you're experimenting. That's part of the learning process. I've edited more than a million photos for professional photographers in their own styles, but I'm still figuring out my own preferences too. That's part of the fun of editing!

PHOTO ANALYSIS CHECKLIST - TECHNICAL		
Light & Contrast	Sensor Dust	
☐ Is the overall exposure about right?	☐ Are there any sensor dust spots?	
☐ Is there enough detail in the highlights and shadows?	Output	
■ Does the photo fill the entire dynamic range?	■ Does the photo need to fit a specific aspect ratio, for example, a frame?	
☐ Are the highlights and/or shadows clipping?	■ Does it need to match the color of another photo?	
Color	☐ How big is the photo going to be?	
☐ Is there a color cast?		
☐ Do the memory colors look natural?		
Detail		
□ Is it sharp?		
☐ Is there noise?		
☐ Is there moiré patterning?		
Optical Distortion		
☐ Is there vignetting?		
☐ Is there barrel/pincushion distortion?		
☐ Is there chromatic aberration or other fringing?		
Geometric Distortion		
☐ Is the horizon straight?		
☐ Are the vertical lines straight, or do they converge?		

PHOTO ANALYSIS CHECKLIST - ARTISTIC INTENT		
Purpose	Simplify	
☐ Why did I capture the photo?	☐ Are there any distractions I can exclude from the scene by cropping, darkening, blurring, etc?	
☐ What's important in the photo?		
☐ What did I want to show the viewer?	Draw the Eye	
Story	☐ Can I guide the viewer's eye around the	
☐ What's the story I'm trying to tell?	photo by highlighting or diminishing:	
■ How can I use light, contrast, color and saturation to help tell the story?	□ People	
	□ Contrasts in Size	
Mood/Emotion	☐ Contrasts in Brightness	
☐ How do I want the viewer to feel?	☐ Contrasts in Color & Saturation	
☐ How can I use light, contrast, color and saturation to influence the viewer's	□ Contrasts in Sharpness	
response?	□ Lines	
	□ Something else?	

PHOTO ANALYSIS WORKSHEET EXAMPLE

TECHNICAL

Exposure

Needs a little more detail in his clothes. No pure white expected in the photo.

Color

Color doesn't add to the photo. The strong lines and stone texture would work well in B&W.

Detail

Shot at low ISO in good light, so no notable noise. Texture of stone can take some crunchy sharpening.

Optical & Geometric Distortion

Horizon needs straightening (use bricks in background).

Sensor Dust

None found.

Output

Nothing specific planned.

Good dynamic range, no notable clipping

ARTISTIC INTENT

Purpose

The guy looked small and insignificant against the huge pillars of the government building.

Story

Is he homeless? Or just waiting for a friend? He looks cold and lonely.

Mood/Emotion

Very cold day (hat). Feeling lonely? High contrast B&W with lots of local contrast for a gritty urban look?

Simplify the Scene & Draw the Eye

Notes scribbled on photo.

Remove the sign from the door on the left.

Even up lighting on the pillars, front step and bricks in the background to reduce background contrast.

Increase contrast on face/clothing of man to draw the eve in that direction even more.

DEVELOP BASIC EDITING

12

Most photographers choose Lightroom for its industrystandard photo editing tools. Most of your image

adjustments will be performed using the Basic panel on the right side of the Develop module. Just because there are a lot of sliders in the Develop module doesn't mean you have to adjust every single one!

Lightroom's editing tools are nondestructive. This means you can move the sliders as many times as you like. It doesn't degrade the image quality because the adjustments are saved as text instructions and only applied to the on-screen preview until you export the finished photo.

First, we'll consider basic tutorials to help you get started, then we'll investigate the Basic panel in more detail. (Figure 12.1) In the following chapters, we'll explore selective or local edits, more advanced adjustments and finally Develop module tools that make your life easier.

ADJUST FROM THE TOP... MOSTLY

Once you've roughly analyzed the photo, then you can start editing.

You may have read articles and watched videos by numerous Lightroom users on editing photos, and they all have different opinions.

Some will tell you to start at the top and always work down. Others will tell you to always set *Whites* and *Blacks* first. Some will tell you skip the Basic panel and use a Tone Curve instead. So who is right?

They're all right—and they're all wrong. It's impossible to set hard and fast rules because Lightroom's Basic panel Tone sliders are image-adaptive (intelligent). The range and effect of the sliders changes based on the

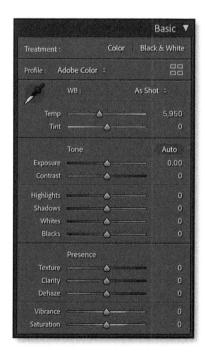

Figure 12.1 You'll make most of your image adjustments using the Basic panel in the Develop module.

content of the photo and the values of the other Basic panel sliders.

In this book, we'll discuss how the sliders were *designed* to work, as explained by the engineers who created them, because they know the tools better than anyone.

Work Top Down... Sort Of

The Basic panel's Tone sliders (Exposure, Highlights, Shadows, Whites, Blacks) were designed to be used top down, because the first few Tone sliders affect the range of the lower Tone sliders. For example, if you change Highlights and Shadows before Exposure, the sliders won't move far enough. It'll be ok for little tweaks, but you'll want to get them in the right ballpark first.

The Contrast slider is the exception to the top-down rule. It can be used at any time as it doesn't affect slider range, and it's usually easiest to set it after you've set the other Tone sliders.

However, the top-down rule doesn't mean you have to adjust every slider. For example, a photo with a low dynamic range (one that doesn't stretch to pure white/black but should do so) is still best adjusted from top to bottom, but goes straight from Exposure to Whites/Blacks, bypassing the Highlights/ Shadows sliders. (Figure 12.2)

We're going to look at the principles behind the "normal" use of each slider, as well as examples of when you might want to break the general rules for a specific effect.

Fix the Biggest Problem First

In the Basic panel, you'll also find the White Balance *Temp* & *Tint* sliders, and eyedropper. These compensate for the color of the light, and are used to remove a color cast in the photo.

If the White Balance is way off, roughly fix it before making tonal adjustments. Likewise, if the photo is very under or over exposed, fix the brightness before trying to adjust the white balance.

Auto

If you just need a quick way to improve photos, try the **Auto** button in the Basic panel, or the shortcut Ctrl-U (Windows) / Cmd-U (Mac). Like your camera's exposure meter, it's not as intelligent as you, so it doesn't know what's in the photo or how you want it to look, but it's often a reasonable starting point.

Auto uses artificial intelligence trained by professional editors editing of tens of thousands of photos, so it works a lot better than earlier Lightroom versions.

It adjusts the Exposure, Contrast, Highlights, Shadows, Whites, Blacks, Vibrance and Saturation sliders. If the photo is cropped, it calculates the auto values based on the cropped area, so it can be useful to crop the photo first (page 261).

Auto is also available in the Grid view's Quick Develop panel and right-click menu. The Auto values may vary slightly, depending on how Auto is selected, because the button in the Develop module uses the full resolution data for accuracy, whereas other modes use lower resolution cached data for speed.

If you hold down the Shift key and double-click on a slider label, Lightroom automatically adjusts that single slider. This is particularly useful for the *Whites* and *Blacks* sliders, where the automatic adjustments are usually quite accurate.

Basic Panel Workflow

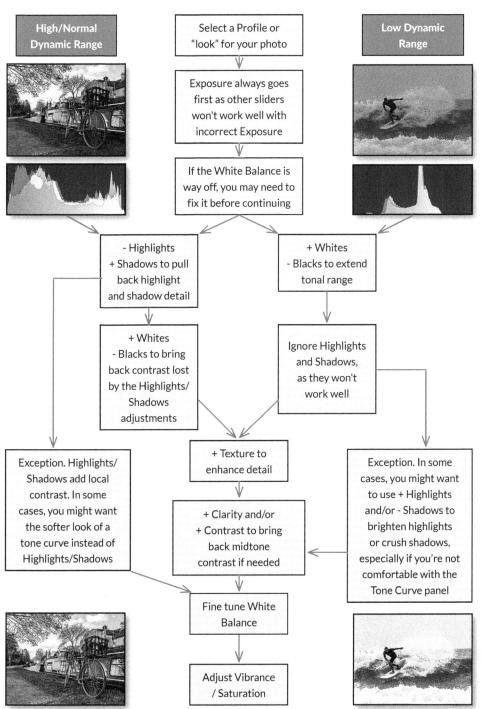

Figure 12.2 Lightroom's Basic panel is designed to be used top-down... mostly.

WORKING WITH SLIDERS

Drag—The obvious thing to do with a slider is to grab the marker and move it, and of course that works, but there are also other options which may suit your workflow better.

Scrubby Slider
Auto

Lengthen—If you like dragging sliders, but find it difficult to make fine adjustments, drag the edge of the panel to make the panel wider. It makes the sliders longer and easier to adjust.

Float—If you hover over the slider without clicking, you can use the up and down keys to move the slider. Adding Shift moves in larger increments or Alt (Windows) / Opt (Mac) decreases the increments.

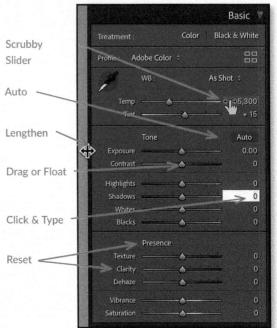

Figure 12.3 There are multiple ways to adjust the sliders.

Scrubby Sliders—Scrubby sliders, such as those used in Photoshop, also work in Lightroom. As you float over the numeric value field at the end of the slider, the

cursor changes to a hand with a double arrow, and clicking and dragging to the left or right moves the slider.

Click & Type—While we're looking at the numeric value fields, you can click directly in one of these fields and either type the number that you're aiming for, or use the up/down arrow keys to move in smaller increments. If you've activated a field to type directly, don't forget to hit Enter or click elsewhere to complete your adjustment.

 $\label{lem:shortcuts-operator} \textbf{Shortcuts-} If you click on a slider label, that slider becomes highlighted, and using the +/- keys on the numberpad adjusts that slider. Adding modifier keys changes the increments, so adding Shift again moves in larger increments, and Opt (Mac only) moves in smaller increments. The ; key resets the selected slider, and the , and . keys move up and down through the sliders, selecting each in turn.$

Reset—To reset a single slider, you can double-click on the slider label. Within many panels, you'll also find a panel label, such as *Presence* in the screenshot, and double-clicking or Alt-clicking (Windows) / Opt-clicking (Mac) on that label resets that whole panel section.

Auto—Holding down Shift and double-clicking on the slider label sets the slider to its Auto position without adjusting the other sliders. Unlike the main Auto button, the slider's Auto setting is based on the existing slider settings.

SIMPLE EDITING EXAMPLES

Let's work on some simple examples before going into more detail on how the sliders interact.

Thatched Cottage

1. Start by analyzing the photo and its histogram. We want to bring out the blue sky, the detail in the bushes and the colors of the flowers. The histogram shows a good

Figure 12.4 Start by analyzing the photo and the histogram.

Figure 12.5 Select the Adobe Landscape profile to enhance the blues and greens.

tonal range. (Figure 12.4)

- **2.** We'll select the *Adobe Landscape* profile, as this enhances the blues and greens. (Figure 12.5)
- 3. You could try pressing the Auto button in

Figure 12.6 Auto hasn't done a bad job with this photo.

Figure 12.7 Exposure and Shadows brighten the building and bushes.

Figure 12.8 Texture and Clarity enhance the detail.

the Basic panel. Sometimes it does a great job and other times it's wildly wrong. If you don't like the result, press Ctrl-Z (Windows) / Cmd-Z (Mac) to undo, or use it as a starting point for further adjustments. It doesn't do a bad job with this photo, setting the photo to Exposure +0.48, Contrast +4, Highlights -65, Shadows +48, Whites +14, Blacks -15, Vibrance +15 and Saturation +1. (Figure 12.6)

- **4.** The building and bushes are a bit dark, so we'll bump the *Exposure* to +0.71 and the *Shadows* to +68. (**Figure 12.7**)
- **5.** We'll enhance the detail using *Texture* (+20) and then add some local contrast or 'punch' using the *Clarity* slider. Since there are no people in this photo, we can afford to push it up to +30. (**Figure 12.8**)

Beach Huts

- **1.** As before, start with analyzing the photo. It's underexposed and we can tell from the histogram that it has no true white because it was shot at dusk. (Figure 12.9)
- 2. It's too dark overall, so we'll increase the *Exposure* to +0.5. We could go further, but we're more interested in the highlights (the white wooden boards) than the shadow tones (the bushes in the background). (Figure 12.10)
- **3.** The photo has a low dynamic range, so we'll skip the *Highlights* and *Shadows* sliders.

TRY IT WITH ME

If you've registered your paperback book or bought this book direct from my website, you can download the following sample photos from the Members Area and follow along using your own copy of Lightroom.

Figure 12.9 Start by analyzing the photo and histogram.

Figure 12.10 Increase the midtone exposure first.

Figure 12.11 The Auto settings for Whites and Blacks stretch the tonal range.

Figure 12.12 Adding Clarity makes it much more punchy.

Figure 12.13 Adding Saturation makes the colors bright and punchy.

- **4.** Shift-double click on the *Whites* and *Blacks* slider labels to automatically set their values. They come out at *Whites* +56 and *Blacks* -11. (Figure 12.11)
- **5.** The overall brightness is better, and there's good shadow and highlight detail, but it just looks flat, so we'll add *Clarity* +40. **(Figure 12.12)**
- **6.** Finally, we want to highlight the bright colors of the beach huts, so we'll bump *Saturation* to +40. (**Figure 12.13**)

Seagulls at Sunset

1. As usual, start by analyzing the photo. The foreground is too dark, but if we just increase *Exposure*, we'll blow out the sky. (Figure 12.14)

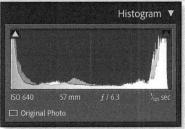

Figure 12.14 Start by analyzing the photo and histogram.

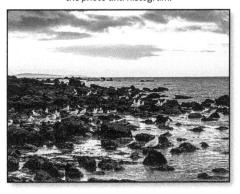

Figure 12.15 The Highlights & Shadows adjustments bring out the detail, but the photo looks very flat.

- **2.** It's a sunset, so the *Adobe Vivid* profile would be a great choice.
- **3.** We'll use *Highlights* -100 to recover and enhance the detail in the sky, and *Shadows* +60 to bring out detail in the rocks. (Figure 12.15)
- 4. We'll increase local contrast in the

Figure 12.16 To bring back some detail in the foreground, we've used Clarity and Texture.

Figure 12.17 Using the White Balance controls to warm the photo enhances the sunset vibe.

foreground using *Texture* +40 and *Clarity* +50. (**Figure 12.16**)

5. It still feels very cold, so we'll increase *Temperature* to 5750 to give it that sunset glow. (Figure 12.17)

Further tweaks

Although the major adjustments are made in the Basic panel, you probably won't stop there. For example, if you want to try the photo in B&W, select B&W at the top of the Basic panel or press the V key.

You might also want to crop/straighten the photo, remove red eye and sensor dust

spots or apply adjustments to specific areas of the photo—we'll come back to these adjustments in the Selective Editing chapter starting on page 261.

You may then want to apply sharpening, noise reduction and lens corrections to your photo—we'll come back to these adjustments in the Advanced Editing chapter starting on page 313.

And finally, you can also copy your settings to other photos and apply special effect presets to your photos—we'll come back to these tools in the Develop Tools starting on page 367.

At the end of the chapter, there's also a diagram demonstrating a typical editing workflow. (Figure 12.72 on page 258)

PROFILES

The idea of starting to build your photo from a base profile isn't a new concept. In the world of film photography, each film has its own characteristics, and a photographer chooses their film stock based on the kind of look they desire.

For example, Kodak's Portra range is popular for portraits, with its natural skin tones, realistic color saturation and fine grain, whereas their Ektar film offers much more vivid and highly saturated colors.

Slide films like Kodak's now-retired Kodachrome and Ektachrome, and Fuji's Provia and Velvia, have long been popular with landscape photographers for their vibrant, punchy colors and high contrast.

For B&W, the iconic Kodak Tri-X has lots of contrast and a distinctive grain, making it popular for street and documentary photography, whereas Kodak's T-Max had a finer grain for a cleaner look.

In the same way, you can build your photo edits from a specific base profile, depending on the look you desire.

How do I select a profile?

Profiles are designed to be selected first, before you start editing, just like choosing a specific film stock for it's unique "look." You can select a different profile at any time, and your slider values will remain untouched, but the look of the photo may change considerably, so it's more efficient to select at the outset.

The **Profile** pop-up is found at the top of the Basic panel, and it lists the available profiles that are currently marked as favorites. (Figure 12.18)

To view the full range of profiles, click the Profile Browser icon (four squares) to open the Profile Browser panel. (Figure 12.19)

The thumbnails in the Profile Browser may be a little small to preview properly, so to preview a profile on the main image preview, simply float over the profile thumbnail or name. Holding down the Alt key (Windows) / Opt key (Mac) while hovering over a profile temporarily disables the large preview, which makes it easy to do a quick before/ after preview.

When you're ready to apply the profile, click on it and then click the *Close* button at the top to return to the normal Develop panels,

Figure 12.18 The Profile pop-up is at the top of the Basic panel.

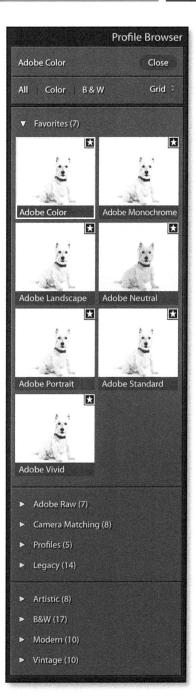

Figure 12.19 The Profile Browser panel displays all of the installed profiles. They're broken up into folders, depending on whether they're camera-specific, creative or third-party profiles.

or double-click on the profile to do both at once.

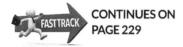

What's the difference between the Adobe Raw profiles?

The Adobe Raw profiles aim to make photos from different cameras look as similar as possible, so if you change your camera or shoot an event with multiple camera brands, they'll blend well. They're available for raw photos from most (but not all) supported cameras. (Figure 12.20)

Adobe Color is Adobe's default profile. The aim is to look great on a wide range of photos, so it adds a little contrast and saturation, while attempting to protect the skin tones.

Adobe Portrait is optimized for a wide range of skin tones, including very pale skin and very dark skin, so it's ideal for portraits and family shots. By default, it has a little less contrast than *Adobe Color*, but you can add contrast if you prefer a bit more punch.

Adobe Landscape removes the skin protection and compresses the tones to give a little more headroom for outdoor photos that often have a wide dynamic range, and the blues and greens are enhanced to benefit many landscape photographs.

Adobe Vivid looks like it's on steroids, with a very punchy and saturated effect. It's great for sunsets and other very colorful photos, but may be a little over the top for portraits.

Adobe Neutral is a very flat starting point, ready for you to edit in your own way. It's ideal for photos with very tricky colors and gradients that just don't quite work with the

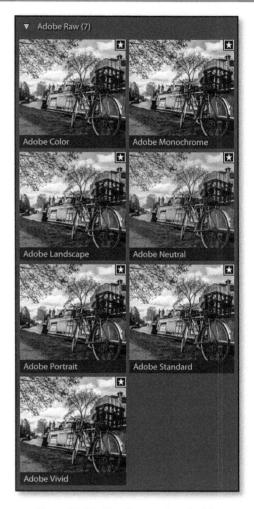

Figure 12.20 There's a selection of Adobe profiles, depending on your content of the photo and your personal preferences.

other profiles.

Adobe Standard is an older profile that all of the other Adobe Raw profiles are based on. It's similar to *Adobe Color*, but it has a little less contrast and saturation.

Adobe Monochrome is designed to be a better starting point for B&W photos, so it's the new default profile for B&W photos. It's automatically assigned when you hit the V key or select *Basic panel* > *Treatment* > *Black*

& White.

How I do emulate the camera settings using the Camera Matching profiles?

The Camera Matching or camera emulation profiles are designed to mimic your camera's picture styles, so they'll more closely match the image you saw on the back of the camera, or on a mirrorless camera, on the viewfinder too. Canon calls them Picture Styles, Nikon named them Picture Control, Fuji has Simulation Modes, Olympus has Picture Modes and Sony calls them Creative Styles.

The names of the profiles themselves vary, depending on the picture styles available for your specific camera model. For example, they may include *Camera Standard* or *Camera Portrait*. (Figure 12.21)

If you'd like Lightroom to automatically select the right profile to match the picture style selected in the camera at the time of shooting, you can change the defaults to use the *Camera Settings* instead of the *Adobe Defaults*. We'll learn how to do this on page 376. For photos that have already been imported, select the *Camera Settings* preset in the *Presets panel > Defaults* set.

What are Creative profiles?

The next section of folders contains a selection of creative profiles. These are primarily designed to apply special effects or a specific "look" to your photo, and they'll work for rendered files (JPEG/TIFF/PSD/PNG) as well as raw photos. (Figure 12.22)

Unlike the camera-specific profiles, they're designed to not need much further tweaking, beyond corrections for exposure, lens distortion, sharpening, etc.

The Modern profiles represent current

Figure 12.21 The available Camera Matching profiles vary depending on the camera.

fashions in photography, while the **Vintage** profiles are designed to look more like film photos. The **Artistic** profiles are designed to be more edgy, with stronger color shifts.

The **B&W** profiles are optimized for high impact black and white work, offering a range of preset color channel mixes and tonal adjustments. In addition to the selection of numbered B&W profiles, there are additional profiles to imitate the effect of adding a red, orange, yellow, green or blue filter that are traditionally used at the time of capture when shooting B&W film.

The effect of the Creative profiles can be faded or exaggerated using the **Amount** slider at the top of the Profile Browser panel or Basic panel. 100 applies the effect as the developer intended, but moving the slider to

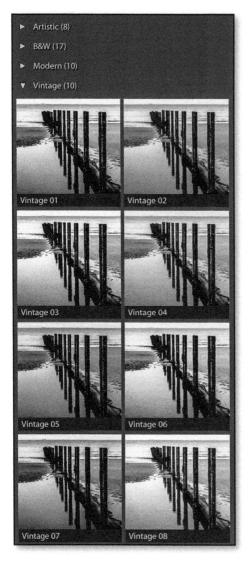

Figure 12.22 The Creative profiles add a specific "look" to your photos. They'll work on rendered images as well as raw files.

Figure 12.23 Creative Profiles have an Amount slider to fade or exaggerate the effect.

the left reduces the effect of the profile, and moving it to the right amplifies the effect. (Figure 12.23)

Where are my custom DNG profiles?

The Profiles folder contains camera-specific DCP format profiles that you created using the DNG Profile Editor (page E15) or X-Rite ColorChecker Passport plug-in, or older camera-specific profiles created by third-parties such as VSCO or RNI Films.

Why are profiles available for some photos but missing on others?

Adobe Raw and Camera Matching profiles only apply to raw photos, so for rendered files (JPEG/TIFF/PSD/PNG), you'll find a Basic folder containing just **Color** and **Monochrome**.

A few cameras don't have an *Adobe Standard* profile (such as Phase One backs), so they don't have any of the *Adobe Raw* variations either.

Camera Matching profiles are available for many current DSLR cameras, but may not be available for older cameras or many compact cameras.

Third-party developers can also specify which cameras and file types their *Creative Profiles* will work with.

How do I mark my favorite profiles?

Over the course of time, you're likely to find you use some profiles more than others. This is a good thing, because the profile becomes part of YOUR look. If you mix and match the different profiles too much, your work may lack consistency.

By clicking the star icon in the corner of the thumbnails, you can mark these profiles

as your favorites. This groups them in the **Favorites** folder, and also adds them to the main *Profile* pop-up, so you don't have to open the Profile Browser every time you want to switch profiles.

How do I filter my profiles?

There are a lot of profiles built into Lightroom, and you're likely to add more third-party profiles. You can't rename or reorganize them, but there are a few view options to make it easier to find the profile you need.

Above the thumbnails are filters to show just the *Color* or *B&W* profiles, which helps to narrow down the choices. (Figure 12.24)

Using the pop-up to the right, you can switch between the default small thumbnails (*Grid*), larger thumbnails (*Large*), or a text (*List*) view. The number of visible thumbnails changes depending on the panel width, so if you want to see more thumbnails, drag the edge of the panel to the left.

How do I hide or delete profiles?

If there are some imported profiles and profile groups you never use, you can delete them by right-clicking on them.

The built-in profiles can't be deleted, but you can hide groups that you don't want to see. In the Profile Browser panel, click the + button and select *Manage Profiles*, then uncheck any groups you want to hide. (Figure 12.25)

To show the hidden profiles/presets again, return to the same dialog and check the groups, or right-click on a profile group and choose Reset Hidden Profiles.

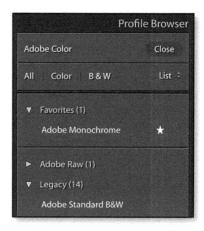

Figure 12.24 Using the filters at the top of the Profile Browser, you can show/ hide the Color or B&W profiles, and swap the thumbnails for a list of profiles.

Figure 12.25 Sets of profiles can be hidden.

How do I install downloaded profiles?

You can download additional profiles from third-party developers. If you only use Lightroom on a single computer, the automatic method for installing profiles is quick and easy.

However, automatically imported profiles are placed in the *Camera Raw / Imported Settings* folders in your user account, which is not helpful if you like to store the presets with the catalog to use Lightroom on multiple computers (page 489). To avoid this issue, you can install the presets manually.

Automatic installation of profiles:

1. Click the + button on the Profile Browser panel and choose *Import Profiles* or go to *File menu > Import Develop Profiles and Presets*.

- **2.** Navigate to the individual profiles or a zip file containing the profiles, select them and press the *Import* button.
- **3.** The profiles appear in the Profile Browser ready for use.

Manual installation of *.xmp profiles:

- 1. Unzip the profiles if they're zipped.
- **2.** Go to Preferences > Presets tab.
- 3. Press the Show Lightroom Develop

Camera-Specific Raw Profiles	Creative Profiles	Presets
.dcp or .xmp file extension	.xmp file extension	.lrtemplate or .xmp file extension
Work on raw files only (usually camera-specific)	Most work for all photo formats	Works on all photo formats, unless they call a raw-only profile
Mostly created by third-party developers using DNG Profile Editor (.dcp format) or Profiles SDK (.xmp format)	Mostly created by third-party developers using Profiles SDK	Create them yourself using Lightroom
Separate layer of adjustments, which doesn't move visible sliders, so they're more difficult to learn from	Separate layer of adjustments, which don't move visible sliders, so they're more difficult to learn from	Moves sliders, so you can see how the adjustments were created
Applies normal Lightroom edits behind the scenes, plus 3D LUT's for more advanced color adjustments	Applies normal Lightroom edits behind the scenes, plus 3D LUT's for more advanced color adjustments	Can only adjust visible Lightroom tools such as sliders
Can't be faded	Amplify/fade effect using Amount slider, then edit from there	Amplify/fade effect using Amount slider, then edit from there
Best as a starting point, like film stock	Best for special effects	Best for your own settings, to improve consistency and efficiency

Figure 12.26 Camera-Specific Raw Profiles, Creative Profiles and Presets all have different strengths and weaknesses.

Presets button to open Explorer/Finder to the correct location.

- **4.** Copy the *.xmp format profiles into the *Settings* subfolder.
- **5.** Restart Lightroom. The profiles appear in the Profile Browser ready for use.

How do I create my own profiles?

Creating profiles is more complex than creating presets (page 371). There's an SDK for preset developers, and they are created using a hidden interface in the Adobe Camera Raw plug-in for Photoshop/Bridge, which can be downloaded from https://www.Lrq.me/profilesdk

What's the difference between profiles in the Profile Browser and presets in the Presets panel?

On page 371, we'll also come across presets, so what's the difference? (Figure 12.26)

Camera-specific profiles (e.g., *Adobe Raw* and *Camera Matching* profiles) only work on raw files and are designed to be a starting point for your own editing.

Creative profiles can be applied to all sorts of photos to add a distinctive look, and they're designed to not need additional editing, beyond corrections for exposure, lens distortion, sharpening, etc. They can also be faded or exaggerated using the *Amount* slider, depending how strong an effect your prefer.

Presets, found in the Presets panel, save sets of slider values to easily apply to other photos. They're ideal for saving your favorite combinations of settings, or the starting edits you apply to every photo. They can also be faded or exaggerated using

the Amount slider, depending how strong an effect your prefer.

Profiles are smarter than presets. They can contain any normal slider adjustments to be applied "behind the scenes", but they can also include LUT's (Look Up Tables) for much more advanced color adjustments. 3D Look Up Tables can, for example, tell Lightroom to make this shade of blue yellower and make this shade of blue more saturated and this shade of blue lighter. The tables allow profile developers to apply specific adjustments in very precise, targeted ways that are not possible through any of the normal sliders.

WHITE BALANCE

Having gained an overview of the Basic panel and learned about profiles, let's take a more detailed look at the individual sliders and understand what's going on behind the scenes. We'll work from the top down for easy reference, starting with White Balance.

The color of light varies depending on its source. It can range from cool (blue sky) to warm (candlelight or tungsten), and the color temperature is measured using the Kelvin scale.

Our eyes and brain automatically compensate for different lighting conditions, which is why a white object looks white to us whether it's viewed in sunlight, shade or indoors using artificial lighting.

Cameras aren't quite so smart. A camera's auto white balance works fairly well in a narrow range of daylight with "average" image content, but it doesn't take much to confuse it. Capture a scene of autumn leaves, and the camera's likely to make the photo a little cold and blue. Capture a snow scene, and the camera will probably try to

warm it up.

Lightroom's White Balance sliders are designed to compensate for the color of the light in which the photo was taken. When you get the white tones right, everything else falls into place. (Figure 12.27)

Most of the time, you'll want the colors in the scene to be rendered as accurately as possible, but sometimes you'll want to warm or cool the scene to suit the mood of the photo.

If you look outside on a cold winters day, the light is cool and blue, but during a beautiful sunset, it may be warm and orange. If you neutralize these colors, you lose the atmosphere.

How do I set the white balance?

White balance adjustments are made using the *Temp* (*Temperature*) and *Tint* sliders in the Basic panel. (Figure 12.28)

There are a few ways of deciding on the best values:

Auto—In the *White Balance* pop-up, select **Auto**. It attempts to neutralize the photo, but like the camera's auto white balance, it's not as intelligent as your eyes, so the results may not be perfect.

Presets—If you're working on a raw file, the **White Balance** pop-up includes presets for standard lighting conditions. They include As Shot, Daylight, Cloudy, Shade, Tungsten, Fluorescent and Flash settings. Select the right preset for the lighting conditions, for

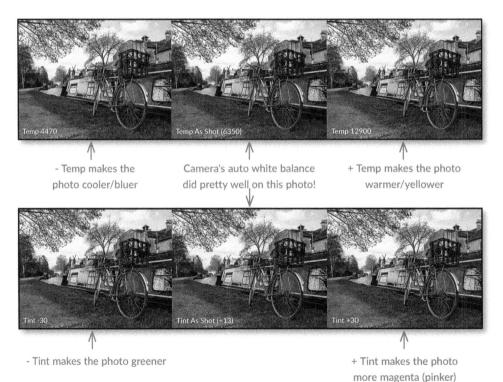

Figure 12.27 The white balance adjustments compensate for the color of the light.

example, if the photo was captured on a cloudy day, select the *Cloudy* preset. (Rendered files—JPEG, TIFF, PSD, PNG—only have *As Shot*, *Auto* and *Custom*.) (Figure 12.29)

Eyedropper—For more control, the White Balance Selector allows you to click in the photo to automatically neutralize any color cast.

Click the eyedropper icon in the Color panel or press the W key, then click on something in the photo that *should* be neutral, for

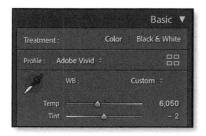

Figure 12.28 The White Balance Eyedropper and sliders are at the top of the Basic panel.

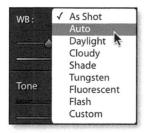

Figure 12.29 White balance presets are available for standard lighting conditions.

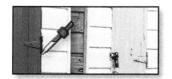

Figure 12.30 Select the White Balance eyedropper and click on something that SHOULD be white or light gray, like this white beach hut.

example, the shadows on a white t-shirt. Using white or light gray subjects gives a more accurate result than darker shades, but avoid whites that are too bright, as some of the color data may be clipped. (Figures 12.30 & 12.31)

When you click with eyedropper, the pop-up changes to *Custom* and the sliders automatically adjust. If it still doesn't look right, click somewhere else to try again or tweak the sliders by eye. The eyedropper's often a good way to get the white balance in the right ballpark before tweaking.

If you regularly shoot in difficult lighting or you struggle to select the right white balance, a WhiBal, ColorChecker or other calibrated neutral light gray card is an easy way to guarantee correct white balance. Simply shoot a photo of the card in the same lighting conditions as the subject and click the eyedropper on that photo to get an accurate white balance setting. You can then copy these values to other photos shot in the same conditions.

Adjust Sliders By Eye—As you gain experience, you can go straight to the *Temp* and *Tint* sliders. If the photo's too yellow or warm, move the *Temp* slider to the left to compensate, and if it's too blue or cold, move the slider to the right. Likewise, the *Tint* slider adjusts from green on the left to magenta on the right.

If you're working on a raw file, the *Temp* slider uses the Kelvin scale to measure the color of the light. For JPEGs and other image formats, the slider runs from -100 to 100, because the white balance compensation has already been applied to the image data (e.g., by the camera), and now you're simply warming or cooling the photo.

How do I adjust for mood?

Once you've made the photo neutral, you can tweak the white balance sliders to enhance the mood. For example, indoor photos often look better with a *Temp* value 200-400K higher than neutral, to bring back a pleasant warmth. Or a sunset shot may need warming up to reflect the lovely warm light usually seen at that time of day. (Figure 12.32)

How do I keep the White Balance eyedropper turned on?

While you have the White Balance eyedropper active, there's an **Auto Dismiss** checkbox in the Toolbar. (Figure 12.33) With

Figure 12.31 The easiest way to correct the white balance is to start with the eyedropper and tweak from there.

Oooops, clicking on the stone path turned the photo too blue

Clicking on the window made it a bit too warm and pink because it's reflecting the surroundings

What else might be neutral in this picture?

Darker areas of clouds may work if they weren't partially clipped (white with no detail), but results can vary depending on where you click

this checkbox unchecked, the Eyedropper remains on screen until you intentionally dismiss it by pressing W, clicking the *Done* button in the Toolbar or returning the Eyedropper to its base. This can be useful if you're trying a number of different areas of the photo to find the best click white balance. If you can't see the Toolbar beneath the photo, press T.

The satellite dish gave the best result, but it's still a bit cold, so try an extra 200K-400K on Temp

Paintwork and white fabrics often yellow over time

 Shiny objects are no good, as they'll reflect surroundings

Stone sometimes works, but it's rarely perfectly neutral

Figure 12.32 Candlelit photos look better warm. Some photos just aren't meant to be perfectly neutral!

Figure 12.33 The White Balance Eyedropper options are on the Toolbar.

Figure 12.34 The White Balance Loupe shows a zoomed view of the area under the Eyedropper, so you can check that you're not polluting your selection with pixels that aren't meant to be neutral, like this red door.

Can I change the eyedropper averaging?

When the Eyedropper is selected, the White Balance Loupe appears next to it. It displays an enlarged view of the area you're sampling, so you can make sure you're selecting the best set of pixels without any other colored areas that might influence the white balance calculation. (Figure 12.34)

The Eyedropper averages the pixel values you can see in its loupe, so there are two ways you can affect the sampling area. When you zoom out, you're sampling a larger area than when you're zoomed in, which is particularly useful for noisy photos. Also, you can change the loupe scale using the **Scale** slider on the Toolbar, to change from a 5x5 pixel area up to a 17x17 pixel area, so it averages over a smaller or larger number of pixels.

If you find the Loupe distracting, you can disable it using the **Show Loupe** checkbox on the Toolbar.

How do I handle mixed lighting?

Sometimes your photos will be shot with light from two or more sources. For example, a photo shot at night may have moonlight and street lighting, a photo shot near a window may have warm tungsten light and cooler daylight, or a photo shot outdoors may have bright sunlight and shade. (Figure 12.35)

In this case, you have three choices:

- Pick a white balance in the middle that looks ok for both.
- Get the lighting right for one light source and don't worry about the other.
- Use Lightroom's Selective Editing tools to apply a different white balance to each area

Figure 12.35 Photos shot in mixed lighting are notoriously difficult to correct.

of the photo (page 306).

How do I adjust white balance for infrared photos?

Lightroom's White Balance sliders only run from 2000K to 50000K *Temp* and -150 to 150 *Tint*. That covers most lighting conditions, but some extreme lighting or infrared shots or photographs of film negatives can fall outside of this range. To solve this issue, you can create custom profiles for these extreme white balances. For example, open an infrared DNG file of a landscape using the DNG Profile Editor

and on the *Color Matrices* tab, move the *Temp* slider to around -75 to -100, making the foliage as neutral as possible. Export the profile, then restart Lightroom and select the new profile in the Camera Calibration panel. Use the white balance eyedropper to click on foliage (or something else that should be white), then edit as usual. You can learn more about the DNG Profile Editor in the Appendix starting on page E15.

TONE & PRESENCE

In the Fast Track, we learned roughly how to use the Basic panel sliders, but now let's take a closer look at how each slider affects the tones of the photo and how they interact.

As everyone learns differently, we're going to demonstrate the effect of the sliders in four ways: (Figure 12.36)

- 1. A raw photo.
- **2.** A gray 21 step wedge, created in Photoshop to illustrate the effect on the full range of tones.

Baseline Photos for Comparison

Figure 12.36 As a baseline for comparison, these are the images with everything set to 0.

- **3.** The histogram showing the effect of the sliders on the 21 step wedge. Each spike on the histogram is one of the gray squares on the step wedge. As the spikes move to the left, the tones are getting darker. As they move to the right, the tones are getting lighter. As the spikes move further apart, there's greater contrast in that range of tones, and as they move closer together, the contrast is reduced.
- **4.** A curve based on sRGB measurements from the 21 step wedge. If you're comfortable reading curves, it makes it easy to see the amount of contrast introduced to different tones. (If you've never used curves, we'll discuss them in more detail in the Advanced Editing chapter starting on page 313).

Bear in mind that the histogram and curve are only guides showing the effect of each slider. The actual measurements and slider values vary depending on the content of each photo, as the processing is image-adaptive. This means that the values you use for each photo will vary. +50 on a slider has a different effect on different photos, depending on the image content and the other settings, so don't focus too much on the numerical values—focus on the photo itself.

EXPOSURE

Near the top of the Basic panel, the **Exposure** slider sets the overall image brightness, and it uses the same f-stop increments as your camera, so +2.0 of *Exposure* is the equivalent of opening the aperture on your camera by 2 stops. The *Exposure* slider attempts to maintain a gentle transition to pure white to avoid harsh digital clipping. (Figures 12.37 & 12.38)

It's important to get the Exposure setting

about right before moving on to the other Basic tone panel sliders, as the range of other sliders are affected and they won't work well if your *Exposure* slider is set incorrectly.

How do I set the Exposure slider?

So how do you know where to set the *Exposure* slider? Try these tips:

Squint Your Eyes—If you screw your eyes up, you won't be able to see the detail in the photo, and you'll be left with the overall impression of how bright it is. You're aiming for a mid-gray.

The Only Slider—Pretend it's the only control you have available. If there weren't any other sliders, how bright would you make the photo?

Confuse Your Brain—Your eyes adjust to the original camera exposure, making it difficult to judge the correct exposure. It can help to confuse your brain by swinging the *Exposure* slider to the left and right like a pendulum and then settle somewhere in the middle, wherever it looks right.

Focus on the Midtones—Don't worry if the highlights are a bit bright or the shadows a bit dark, or if there are clipped highlights or shadows at this stage (white/black areas with no detail), as you'll pull them back using the Highlights and Shadows sliders.

You can hold down the Alt key (Windows) /

Figure 12.37 Harsh clipping (left) vs. gentle transition (right).

Exposure Slider

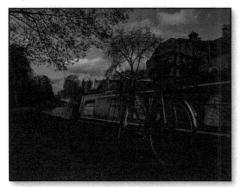

Exposure -2 shows there's loads of detail available even in the brightest clouds, which can be pulled back using the Highlights slider, but the change makes it way too dark overall.

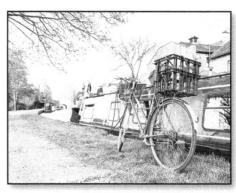

Exposure +2 makes it way too bright and loses all the detail in the clouds, but shows there's loads of detail in the dark areas, which can be pulled back using the Shadows slider.

Figure 12.38 The Exposure slider brightens or darkens the photo overall, and attempts to protect the highlights from clipping.

The stepwedge, histogram and curves are all based on rendered data, however on a raw file, there may be more hidden highlight detail that can be recovered, like the clouds in the photo.

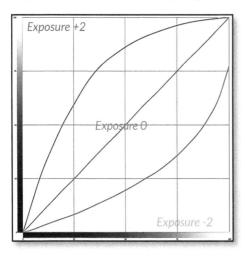

Exposure +2 moves the histogram to the right. The shadows increase in contrast (spikes move apart) but highlights are compressed.

Exposure -2 moves the histogram to the left. The highlights increase in contrast (spikes move apart) but shadows are compressed.

Opt key (Mac) to view the clipping warnings, but don't worry about them at this stage.

GLOBAL VS. LOCAL CONTRAST

The next slider in the Basic panel is the **Contrast** slider. It's a bit of a blunt instrument, so it usually works better when you adjust other sliders first. But why?

Contrast is defined as the difference in tone or color that makes an object distinguishable from its surroundings. In real terms, this means that all of the detail we see in the world around us—or in a photo—depends on contrast.

Contrast also affects the feel of a photo, with high contrast adding drama and excitement, commanding your attention. Since our eyes are drawn to the highest contrast, you can use it to draw the viewers eye away from distractions and toward the subject.

Enhancing these contrasts is, therefore, one of the most important things we can do when editing photos.

How do I increase contrast?

To increase midtone contrast globally, you have to make light pixels lighter and dark pixels darker. That's what the *Contrast* slider does. The problem is, you lose highlight and shadow detail in the process. (Figure 12.39)

Fortunately, our eyes are more interested in local contrast—small contrasts in similar tones—than they are in big global contrast. Local contrast adjustments look for small changes in contrast and enhances them. This adds contrast without sacrificing as much detail in the highlights and shadows. Lightroom mainly adjusts local contrast using the *Clarity* slider, but it's also affected by the *Highlights*, *Shadows* and *Dehaze*

sliders. (Microcontrast, or even smaller local contrast, is added using *Texture* and *Sharpening*, but we'll come back to that later.)

It can sound complicated, so let's illustrate the difference using the stepwedges and photos. The stepwedge's 21 blocks of gray, ranging from pure black to pure white, make it easier to see the differences. (Figure 12.40)

Once you've adjusted all of the other Basic tone sliders and added local contrast where needed using *Clarity*, you can tweak the midtone contrast using the *Contrast* slider or Tone Curve, but in many cases, it won't need adjusting at all.

How do I decrease contrast?

But what if you have the opposite problem? If a photo has too much contrast (too wide a dynamic range), you can darken highlights and lighten the shadows using *-Contrast* to see more detail in those tones, but then you lose midtone contrast, making the photo look really flat. The *Highlights/Shadows* sliders are usually better at reducing dynamic range as they add local contrast at the same time, so it's often best to skip the *Contrast* slider altogether.

There may be exceptions, however. On a soft dreamy image, the extra local contrast may not be desirable, so you might want to use a negative *Contrast* adjustment or Tone Curve in that case. Or if the *Highlights/Shadows* sliders don't go far enough, some negative *Contrast* can be useful to compress the tones. (Figure 12.41)

HIGHLIGHTS AND SHADOWS

We've skipped Contrast, and in many cases, Clarity is best left for later, so after setting

Increasing Contrast or Clarity Sliders

Figure 12.39 The Contrast slider adds global contrast by compressing the highlights and shadows (top), whereas the Clarity slider looks for areas of local contrast and enhances them (second from top).

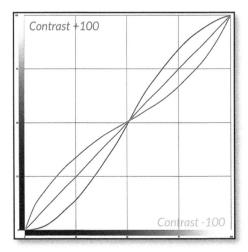

+ Global Contrast (using the Contrast slider)

Lost highlight & shadow detail

- Added midtone contrast

+ Local Contrast (using the Clarity slider)

Still plenty of highlight & shadow detail

Added midtone contrast

Contrast +100 increases contrast in the midtones (spikes move apart) but highlights and shadows are compressed.

Clarity +100 increases local contrast but without changing brightness. Note that the spikes have spread due to the gradients.

Contrast vs. Clarity Sliders

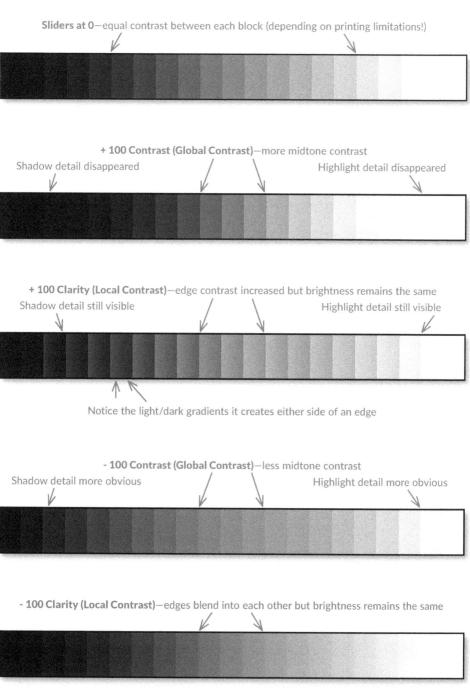

Figure 12.40 The Contrast slider adds global contrast by compressing the highlights and shadows, whereas the Clarity slider looks for areas of local contrast and enhances them.

Decreasing Contrast or Clarity Sliders

Contrast -100 decreases the contrast in the midtones (spikes move closer) but highlights and shadows gain contrast.

- Contrast (Global Contrast)

Reducing contrast recovers the highlight and shadow detail

Whole photo ends up really dull and flat

- Highlights / + Shadows (with Local Contrast)
- Highlight brings back the cloud detail
- + Shadows brings back the shadow details

Photo still retains its punch thanks to the local contrast enhancement

- Clarity (reduces Local Contrast)

The edges in the photo are softened,

but the overall brightness of each
tone remains about the same.

Figure 12.41 If there's too much contrast, the Contrast slider can make the photo flat, whereas Highlights & Shadows darkens the highlights and lightens the shadows while adding local contrast.

Clarity -100 retains the overall contrast between tones but softens the edges.

Exposure, the Highlights and Shadows sliders are next in line for adjustment.

The **Highlights** slider only adjusts the brighter tones in the photo and barely touches the darker tones. It's generally intended to be dragged to the left (-) to recover highlight details, such as fluffy clouds in the sky or detail on a bride's dress. (Figure 12.43)

Shadows does the opposite, mainly affecting the darker tones in the photo. It's generally intended to be moved to the right (+) to lighten shadow details, such as shadowed areas on people's faces or detail in a groom's suit. (Figure 12.44)

How do I set Highlights and Shadows?

Here's a few tips to help you decide where to set the *Highlights* and *Shadows* sliders:

Local Contrast—Brightening shadows and darkening highlights usually comes at the cost of midtone contrast. Unlike a simple highlights or shadows control, *Highlights* and *Shadows* also adds local contrast (like *Clarity*) to help compensate for the loss of global contrast, and it also affects saturation. (Figure 12.42)

Amount—How much highlight and shadow detail you recover will depend on the results of your photo analysis. For example, if the photo is of a stormy beach, the detail in the clouds will be essential, so you'll use more highlight recovery. Likewise, if the photo is a woodland scene, you'll need more shadow detail in the leaves and bark, but you won't need as much if the bushes are unimportant in the background of a wedding photo.

While you're moving the *Highlights* slider, hold down the Alt key (Windows) / Opt key (Mac) to see the clipping warnings, to ensure your adjustment is recovering any clipped highlights.

The effect on local contrast (like Clarity) gets stronger as you move the sliders further. Both sliders look fairly natural up to 50%, but beyond that, the effect becomes more surreal, which can make photos look over-processed if not used carefully.

Symmetrical Sliders—Due to the local contrast and saturation changes included with the *Highlights/Shadows* sliders, they usually work best when they're fairly symmetrical, for example, -50 *Highlights* and +50 *Shadows*. There are always exceptions, for example, you may only want local contrast in the clouds but softer shadows.

- Highlights / + Shadows (adds Local Contrast)
- Highlights brings back the cloud detail
- + Shadows brings back the shadow details

Photo still retains its punch thanks to the local contrast enhancement

Figure 12.42 Highlights and Shadows bring back detail without making the photo too flat, due to their local contrast enhancement.

Highlights Slider

 Highlights brings back cloud detail without darkening the shadows

+ Highlights lightens the highlight tones without affecting the shadows

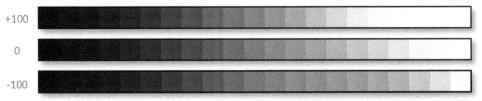

Figure 12.43 The Highlights slider lightens or darkens the highlight tones. The slider is usually pulled to the left, bringing back highlight detail in the clouds.

The stepwedge, histogram and curves are all based on rendered data, however on a raw file, there may be more hidden highlight detail that can be recovered, like the clouds in the photo.

Highlights +100 lightens just the highlight tones. The highlight spikes spread due to the local contrast gradients.

Highlights -100 darkens just the highlight tones. The highlight spikes have spread out due to the local contrast gradients.

Shadows Slider

- Shadows darkens the shadows without affecting the highlights

+ Shadows lightens the shadow tones without lightening the highlights

Figure 12.44 The Shadows slider lightens or darkens the shadow tones. The slider is usually pulled to the right, bringing back detail back into the darkest tones.

Shadows +100 lightens just the shadow tones. The shadow spikes spread out due to the local contrast gradients.

Shadows -100 darkens just the shadow tones. The shadow spikes have spread out due to the local contrast gradients.

Add Global Contrast with Whites/Blacks—Darkening highlights and lightening shadows decreases the midtone (global) contrast, so you'll usually need to adjust the Whites/Blacks sliders after Highlights/Shadows. We'll look at these sliders next.

Opposite Directions—If you need to swing both sliders in the same direction, it's usually (but not always) a sign that the *Exposure* slider needs moving in that direction.

There are some exceptions, when you might choose to break these general rules:

The "Wrong" Way—Occasionally, you may want to swing the sliders in the opposite direction to darken shadows and lighten highlights. This adds global contrast, but with more control than just using the Contrast slider, however it also affects local

contrast. Traditionally you'd use a Tone Curve for this purpose.

Local Contrast Control—You don't have any control over how much local contrast (*Clarity*) is added with *Highlights/Shadows*, and you can't remove the effect using the *Clarity* slider either. For average photos, that's not a problem, but for some photos you may want a softer look, so you might prefer to use the Tone Curve.

WHITES AND BLACKS

The **Whites** and **Blacks** sliders affect the clipping point and roll off at the extreme ends of the tonal range. If you've used other image editing software, they're similar to the black and white points in Levels. (Figures 12.46 & 12.47)

Whites/Blacks After Highlights/Shadows

After -100 Highlights and + 100
Shadows, the full range of detail is back but the photo looks very flat If we use +21 Whites and -61 Blacks (below left), we can add back contrast without losing it anywhere important

Using the Blacks clipping warning (black areas) we can see we're just clipping the blacks in areas where the detail doesn't matter

Figure 12.45 Use Whites and Blacks after Highlights and Shadows to bring back some contrast.

Whites Slider

 Whites darkens the entire photo, but especially the lightest tones.

+ Whites clips light pixels to pure white, but we've pushed it too far and lost detail in the clouds. Try to only clip small specular highlights.

Figure 12.46 The Whites slider lightens or darkens the photo allowing you to clip the whites.

The stepwedge, histogram and curves are all based on rendered data, however on a raw file, there may be more hidden highlight detail that can be recovered, such as the detail in the clouds.

Whites +100 lightens the entire photo, clipping the lightest tones. Note the increase in contrast (spikes slightly further apart) in the midtones.

Whites -100 darkens the entire photo. Note the increase in contrast in the very lightest tones, but other tones lose contrast.

Blacks Slider

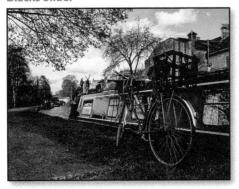

 Blacks clips dark pixels to pure black. It's ok to clip dark pixels to black, but avoid creating large areas of solid black like this.

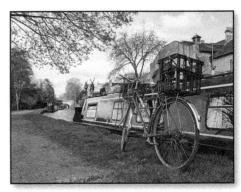

+ Blacks lightens the entire photo, but especially the darkest tones.

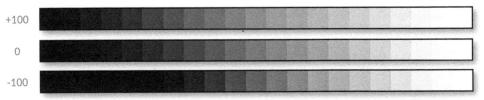

Figure 12.47 The Blacks slider lightens or darkens the photo allowing you to clip the blacks.

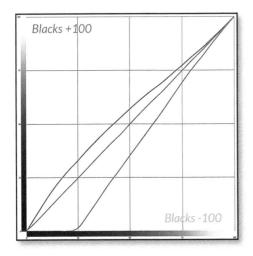

Blacks +100 lightens the entire photo. Note the increase in contrast in the very darkest tones, but other tones lose contrast.

Blacks -100 darkens the entire photo, clipping the darkest tones. Note the increase in contrast (spikes slightly further apart) in the midtones.

In most cases, the *Whites* slider is pulled to the right (+) and *Blacks* is pulled to the left (-) to expand the tonal range.

How do I set Whites and Blacks?

Here's a few tips to help you decide where to set the *Whites* and *Blacks* sliders:

After Highlights / Shadows—If you've used -Highlights and +Shadows, pulling Whites and Blacks in the opposite direction (+Whites and -Blacks) brings back some contrast by clipping a few of the lightest and darkest pixels. (Figure 12.45)

Try Auto—The Auto values for the Whites and Blacks sliders are usually accurate, so try holding down the Shift key while double-clicking on the slider labels.

Low Dynamic Range—If a photo was captured in flat light, and therefore has a

Figure 12.48 A histogram of a photo with a low dynamic range doesn't stretch to the ends, but can be stretched using the +Whites and -Blacks sliders.

Figure 12.49 A photo with a low dynamic range may be dull and flat (left) but expanding the dynamic range using the Whites and Blacks sliders sets a true white and black point (right).

low dynamic range, use +Whites and -Blacks to stretch image data to fill the entire histogram, making a few pixels black and a few pure white. (Figures 12.48 & 12.49)

Adaptive Range—The sliders adapt to the range of the photo, so even a foggy white photo can be stretched to fill the entire tonal range. This becomes even more useful when working with scans of old faded photos, as it allows you to create a bright white and deep black point in even the lowest contrast photos if you need to do so. (Figure 12.50)

Check the Clipping Warnings—Hold down the Alt key (Windows) / Opt key (Mac) while dragging the Whites or Blacks sliders to view the clipping warnings, so you can check

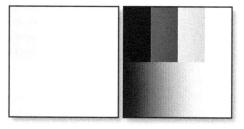

Figure 12.50 The sliders adapt to the range of the photo, so even a foggy white photo (left) can be stretched to fill the entire tonal range (right).

Clipping Warnings on:
Whites slider

Blacks slider

Not clipped

Completely clipped

Colored pixels clipped in 1 or 2 channels

Figure 12.51 The clipping warnings show which areas of the photo have lost detail.

you're not clipping important details (making large areas pure white or pure black). The colored overlay shows whether the clipping only affects one channel, multiple channels, or all channels. (Figure 12.51)

Mind the Skin—Clipping any channel on someone's skin looks really bad and is worth avoiding at all costs.

Specular Highlights—Some areas of the photo, called specular highlights, are meant to be pure white and we don't expect to see detail. These include the sun, reflections on shiny objects and similar. It's fine to clip these areas, but you don't want large areas of pure white (such as a window). (Figure 12.52)

Deep Blacks—Deep blacks, caused by clipping larger numbers of dark pixels, is a popular choice to enhance contrast. Just be careful not clip too far and lose important shadow detail. This is more frequently done with a tone curve, as it compresses the dark tones with gentler transitions.

Clipping Studio Backgrounds—If you're shooting against a white studio background, which you want to keep pure white, the Whites slider allows you to clip highlights that would otherwise be protected by the

Pure white clipped highlights don't look out of place on shiny objects

Figure 12.52 The clipping warnings show which areas of the photo have lost detail.

Exposure slider's gentle roll off. If the photo was correctly exposed, with the whites close to clipping, a small value such as +15-25 is enough to blow the white background without having a noticeable impact on the overall exposure. The same principle applies using the *Blacks* slider with a black studio background.

TEXTURE VS. CLARITY

As we learned on page 237, local or edge contrast helps to lift the photo off the page or screen, adding depth and drawing you into the photo without losing too much highlight or shadow detail. *Texture, Clarity* and *Sharpening* all adjust local contrast, but the size of the halo varies depending on which tool you use.

Sharpening creates the smallest halos. Too much sharpening can make a photo look "crunchy" and it tends to sharpen noise, which isn't ideal. We'll come back to sharpening on page 333, along with noise reduction. (Figure 12.53)

Texture is designed to enhance mid-size details in your photo. You might describe the effect using words like structure, microcontrast, bite, crispness, a 3D look or, of course, texture. *Texture* ignores the noise and focuses on the slightly larger details in the photo, with a much cleaner result than *Sharpening*, and a more subtle effect than *Clarity*. (**Figure 12.54**)

Clarity enhances much larger details, and has a significant effect on overall contrast. You might use words like definition, punch or pop to describe the effect. (**Figure 12.55**)

Each of these tools can be used to good effect alone, but they look even better when used together. By using *Texture* to enhance the mid-size details, you can use

Figure 12.53 Sharpening 150, others at default— While you can experiment with the settings, extreme sharpening just makes the photo look "crunchy" rather than defining structures in the image

Figure 12.54 Texture +100—The archway stones are more defined and the rocks have greater depth, but the overall contrast remains the same and there's no sign of over-sharpening

Figure 12.55 Clarity +100—While it's added punch and definition to the larger objects, notice the strong shift in overall contrast

less Clarity, resulting in a much more natural looking photo that still pops off the screen or page, without needing to apply too much Sharpening.

How do I set Texture?

Positive Texture can be used for a lot of different purposes, but it's particularly good for landscapes, nature photography, architecture and B&W photography. (**Figure 12.56**)

Because the effect is subtle, you may need to zoom into 100% view, especially on very high resolution photos. Artifacts are rare, even when pushed to 100, but watch out for small halos that can occasionally be created. It can make Chromatic Aberration (color fringing) more obvious, but we'll learn how

Figure 12.56 The Texture slider enhances medium sized details without affecting the overall contrast

Figure 12.57 Negative Texture is ideal for smoothing skin without making the person look like a plastic doll

to fix this fringing on page 342.

Be careful adding *Texture* to people's faces, as it will enhance wrinkles, but it can be brushed over the eyes to define the individual eyelashes.

Negative Texture is ideal for softening skin. Because Texture primarily affects mid-size details and ignores the smallest details, it evens out the skin tone while retaining some of the skin's texture, minimizing the smooth plastic appearance that can result from skin smoothing. Rather than applying it globally, use the Masking tools (page 309) to soften only the face. (Figure 12.57)

How do I set Clarity?

Positive *Clarity* is very good at emphasizing large details, so it works well on architecture and landscapes, adding a distinctive crisp feel, and it can also look great on high contrast B&W photos.

Although the slider goes to 100, that's almost always too strong, as it can create wide halos. *Clarity* can quickly make your photos look over-processed, so be conservative with the amount you apply. (Figure 12.58)

Figure 12.58 The Clarity slider helps to add 'pop' to buildings, landscapes and other textured scenes, which naturally have small contrasts between similar tones.

As a general rule, it's best to use a very low setting for portraits, if you use it at all, as it acceptuates lines and wrinkles

Clarity doesn't increase saturation, so if you use high Clarity values, you may find that the colors start to look a little muted. Adding a little Vibrance or Saturation can make the effect look more natural.

Negative *Clarity* creates a diffuse, soft-focus, dreamy effect. It adds a gentle glow to the photo, similar to the well known Orton effect, so it can look good on B&W, vintage style or infrared photos.

In the past, negative *Clarity* has been used for softening faces, but the *Texture* slider gives a more realistic effect.

DEHAZE

The **Dehaze** slider is designed to remove (or add) haze, for example, atmospheric haze over a landscape or city smog. It also works well on photos of the night sky, backlit photos, underwater photos, reflections, scans/photographs of old faded photos, and

more. It's also brilliant for adding a high contrast gritty feel to B&W photos. (Figure 12.59)

It runs complex calculations to adapt to the content of the image to get a good result as quickly as possible.

How do I set Dehaze?

To get the best result, adjust the white balance first (page 229), as it uses the air light color and light transmission in its calculations, then adjust the *Dehaze* slider until your photo looks great.

It's best used in combination with the normal adjustment sliders. Use *Dehaze* to remove the worst of the haze, and then use the other sliders as normal to finish editing the photo.

Dehaze is a magical slider, but it can have negative side effects such as unwanted color shifts, halos, stronger noise, enhanced sensor dust and enhanced lens defects. As a result, you may need to adjust the Light panel sliders, Vibrance or Saturation, Noise Reduction, Vignette and tweak any healing

Figure 12.59 The Dehaze slider quickly removes or adds atmospheric haze.

after applying the Dehaze slider.

Because *Dehaze* adapts to the content of each photo, it's best avoided when doing timelapse photography.

VIBRANCE VS. SATURATION

Saturation describes the intensity or purity of a color. Lightroom offers two different

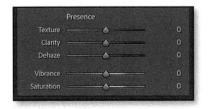

Figure 12.60 The Vibrance and Saturation sliders affect saturation in different ways.

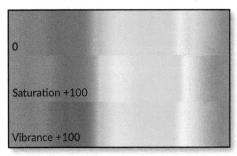

Figure 12.61 Vibrance enhances the blue tones more than Saturation, and keeps the reds/oranges looking more natural.

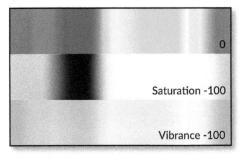

Figure 12.62 Saturation completely desaturates to B&W whereas Vibrance is more gentle.

global saturation controls, with slightly different behaviors. (Figure 12.60)

Saturation is quite a blunt instrument which adjusts the saturation of all colors equally. This can result in some colors clipping as they reach full saturation.

Vibrance is often more useful as it adjusts the saturation on a non-linear scale, increasing the saturation of lower-saturated colors more than highly saturated colors. It also aims to protect skin tones from becoming over-saturated. (Figures 12.61 & 12.62)

Understanding these differences is important, for example, if you want to boost the yellows, oranges and reds in a sunset, *Saturation* may be a better choice than *Vibrance*, but on skin tones, the opposite would be true.

How do I set the saturation?

Our eyes are drawn to vivid saturated colors, but if you go too far, it becomes garish and cartoon-like. This is particularly true on skin tones, which look ridiculous when heavily saturated.

The saturation of colors also affects the mood of the photo. You may want bright, saturated colors for a kid's party, but calm, muted colors may be better suited to a newborn photo.

If you need even more control over the saturation of specific tones, you can use the HSL tools (page 331) or Masking (page 306).

PROCESS VERSIONS

Over Lightroom's lifetime, there have

been significant changes in Lightroom's processing algorithms to improve the image quality that it can produce.

As Lightroom's edits are stored nondestructively as text instructions, simply removing the old sliders or changing the effect of existing sliders would change the appearance of existing photos. All of your photos would need editing again whenever major changes were made to Lightroom.

To avoid this situation of significantly different rendering, Lightroom uses a concept called Process Versions. This tells Lightroom which set of algorithms to use when rendering a photo.

PV1 (2003) is the original rendering from ACR 1. New sliders were added over time, but existing ones remained constant. (**Figure 12.63**)

PV2 (2010) was added in Lightroom 3. It changed *Sharpening*, *Noise Reduction* and *Fill*

Figure 12.63 PV1/PV2 used the original Basic panel Tone sliders.

Figure 12.64 PV3 and later use the newest set of Basic panel Tone sliders.

Light.

PV3 (2012) was added in Lightroom 4. It changed most of the Basic panel sliders, resulting in a completely different rendering, as well as adding RGB point curves and new local adjustment sliders. (Figure 12.64)

PV4 (2017) was added in Lightroom Classic 7, for the new range mask and updated auto mask for local adjustments.

PV5 (2018) is the default at the time of writing. It's virtually the same as PV4, but fixes an issue with negative *Dehaze* and improves neutrality in the shadows of very high ISO photos.

How do I know which process version I'm using?

To check which process version a photo is using, check the Histogram panel. If you're using an older version, a lightning bolt appears, and floating over the icon displays the process version number. (Figure 12.65)

You can also check the **Process** pop-up in the Calibration panel. (**Figure 12.66**)

Figure 12.65 A lightning bolt appears under the Histogram if your photo uses an older process version.

Which process version should I use?

The most recent process version—currently PV5—offers the best image quality and latest technology, so it's generally the best choice.

That said, if you upgrade photos from PV1/2 to PV5, you'll generally need to edit them again, so don't upgrade all of your really old photos.

How do I update the process version?

New photos default to PV5 unless you apply an old Develop preset, or they already have settings stored in their metadata, so for most new imports, you won't need to do anything.

For existing photos, you may want to update the process version.

Photos set to PV3/PV4 are automatically upgraded to PV5 when you start editing, unless you've already used auto mask, in which case they don't update themselves until you use Masking (page 279).

Figure 12.66 The Process Version is found at the top of the Calibration panel.

Photos that use much older process versions can be upgraded by selecting Version 5 (Current) in the Process popup in the Camera Calibration panel or via Settings menu > Process.

To update to the latest process version, you can also click on the lightning bolt in the Histogram panel. In the resulting dialog (Figure 12.67), choose:

Review Changes via Before/After displays the before/after side-by-side so you can decide whether to go ahead. If you decide not to update, use Ctrl-Z (Windows) / Cmd-Z (Mac) or select the previous state in the History panel to revert to the earlier setting.

Update just updates the selected photo. If you're going to select this option, it's quicker to hold down the Alt (Windows) / Opt (Mac) while clicking on the lightning bolt, as this skips the dialog.

Update All Filmstrip Photos updates all of the photos in the current view. Be careful, because if the photos were set to PV1/2, you'll likely have to edit all of the photos again using the new sliders.

How do I update my presets to the new process version?

Some of your Develop presets may include

Figure 12.67 If you click on the lightning bolt in the Histogram panel, Lightroom asks whether you'd like to update just that photo or multiple photos.

an old process version, so when you apply the preset, the photo reverts to PV3 or earlier.

We'll come back to creating and updating presets on page 371. If you have lots of presets to update and you're an advanced user, it's quicker to open the presets in a text editor and remove the entire Process Version line (e.g., *ProcessVersion* = "6.7").

What do the other Calibration panel sliders do?

The **Shadows**, **Red Primary**, **Green Primary** and **Blue Primary** in the Calibration panel are primarily legacy sliders. They were used for adjusting camera calibration before the detailed camera profiles were invented, so they're rarely needed now. That said, they can be useful for creative effects. **(Figure 12.68)**

EDITING VIDEOS

Many digital cameras now produce, not only still photographs, but also video. We've already used the Loupe view to play

Figure 12.68 The Calibration panel contains legacy calibration sliders.

your videos, so before we move on to more advanced stills editing, let's take a quick look at Lightroom's basic video editing tools.

How do I trim videos?

In the Loupe view, click on the cog button on the video overlay to show the individual video frames. If the overlay isn't wide enough to accurately scrub through the video, you can drag both ends to enlarge it.

The trim handles are shown at the left and right ends of the overlay, and dragging these toward the center trims the ends from the video. The easiest way to select the best trim position is to drag the position marker or pause the video in the right spot. When you drag the trim handles, they snap to the selected frame.

The trimmed sections of video aren't removed from the original file, but they're hidden when playing the video in Lightroom, and are excluded when you export the video to a new file.

You can't clip sections out of the middle of the video, as it only allows you to trim the ends, however you could create virtual copies of your video, allowing you to trim a different section from each. (Figure 12.69)

Can I join videos together?

There isn't officially a way of merging video clips together into a single video within Lightroom, but there is a workaround... Add the videos to the Slideshow module, remove the extraneous overlays and background and then go to Slideshow menu > Export Video Slideshow to create a merged video.

What do Capture Frame and Set Poster Frame do?

Under the rectangular thumbnail button

Figure 12.69 Video playback and editing options.

on the video overlay are two additional options:

Capture Frame extracts the current frame as a JPEG and automatically adds it to the folder. If you're viewing a folder or standard collection, the captured frame should appear next to the video, but it may be hidden if you're working in Previous Import, Quick Collection or if you set a filter or smart collection to only show videos.

Set Poster Frame allows you to select which frame is shown as the video thumbnail in the Grid view, and as the preview in other modules.

If you're trying to select a specific frame for the Capture Frame or Poster Frame, it can be difficult to drag the position marker to exactly the right spot. If you drag it to approximately the right spot, you can use the arrow buttons either side of the play button to step through one frame at a time.

Can I view video metadata such as Frame Rate?

If you select the *Video* preset at the top of the Metadata panel, you'll be able to see additional video metadata, such as the *Frame Rate*, *Dimensions* and *Audio Sample Rate*. (Figure 12.70) You will note that there's limited metadata included in most video files. Details that we're used to seeing in digital image EXIF data, such as the camera and lens used, are not usually present. If this data is important to you, consider taking a photo just before recording, so that you have a permanent record.

You can add or edit the capture time for videos, just as you can for photos, which can help if the capture time wasn't initially recorded with the video.

Can I edit the color and exposure of my videos in the Develop module?

Video isn't supported in the Develop module, however you can make Develop

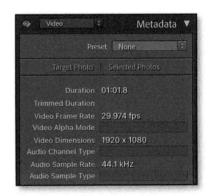

Figure 12.70 The Video preset in the Metadata panel shows additional information such as Frame Rate.

changes using the Quick Develop panel or Develop presets. Any changes you make apply to the whole video, not just the selected frame.

The Quick Develop panel in the Library module gives you quick access to basic Develop controls—Treatment (Color or B&W), White Balance, Auto Tone, Exposure, Contrast, White Clipping, Black Clipping, Vibrance, and also Saturation when holding down the Alt (Windows) / Opt (Mac) key.

Additional adjustments can be made to Tone Curve, Color Grading, Process Version & Camera Calibration by including them in a Develop preset. This enables you to make your videos sepia or apply other effects, in addition to basic exposure and white balance corrections.

The easiest way to make the adjustments is to use *Capture Frame* to create a JPEG from the video. You can edit this JPEG in the Develop module and then save it as a preset or sync the changes to the video. It allows you to preview your adjustments before applying them to the whole video, rather than using trial and error. When syncing the settings, you'll note that only settings that can be applied to videos are available in

the Sync dialog. (Figure 12.71) (We'll come back to creating presets and synchronizing settings in the Develop Tools chapter starting on page 367.)

Can I open my video into specialist video editing software?

Lightroom doesn't make it easy to open your videos into editing software such as Adobe Premiere, but you can right-click and choose Show in Explorer (Windows) / Show in Finder (Mac) and then open into the editor of your choice.

Alternatively, John Beardsworth's Open Directly plug-in allows you to open the original video into the software of your choice, including video editing software: https://www.Lrq.me/beardsworth-opendirectly

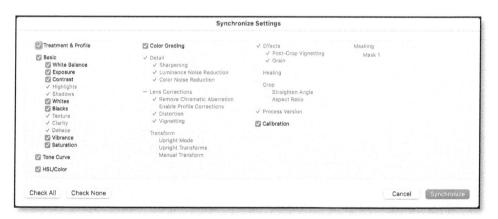

Figure 12.71 Only some Develop settings can be synchronized when working with videos. The other checkboxes are disabled.

Typical Develop Workflow

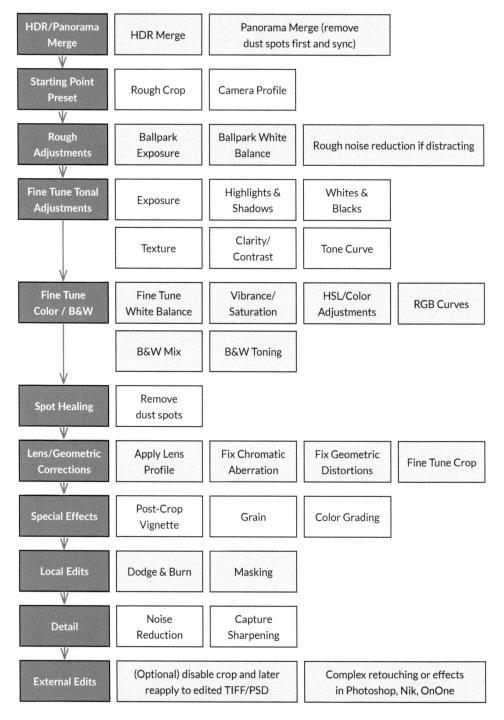

Figure 12.72 A typical editing workflow.

DEVELOP BASIC SHORTCUTS

		Windows	Mac
Go to Develop		D	D
Sliders	Select next Basic panel slider		
	Select previous Basic panel slider	,	,
	Increase slider value	= or +	= or +
	Decrease slider value	-	-
	Move slider value by larger increment	Shift while using = or + or -	Shift while using = or + or -
	Move slider value by smaller increment		Opt while using = or + or -
White Balance	Select White Balance Eyedropper	W	W
Auto	Auto White Balance	Ctrl Shift U	Cmd Shift U
	Auto Settings	Ctrl U	Cmd U
	Auto Slider Value	Shift double- click on slider label	Shift double- click on slider label
Clipping Indicators	Show Clipping	J	J
	Temporarily Show Clipping	Hold Alt while moving slider	Hold Opt while moving slider
Reset	Reset Slider	Double-click on slider label	Double-click on slider label
	Reset Group of Sliders	Double-click on group name	Double-click on group name
	Reset All Settings	Ctrl Shift R	Cmd Shift R
Video	Toggle Play/Pause	Space	Space
Video Trimming	Set In Point	Shift I	Shift I
	Set Out Point	Shift O	Shift O

DEVELOP SFLECTIVE EDITING

13

Once you've made basic tonal adjustments to your photos, you can make more selective adjustments. These

include cropping the photo, removing dust spots and fixing red eye. These tools are found in the Tool Strip directly beneath the Histogram panel. We'll investigate each in turn. (Figure 13.1)

CROPPING & STRAIGHTENING

In an ideal world, you would have the time to make sure a photo was perfectly composed in the camera at the time of shooting. Unfortunately, few of us live in an ideal world, and by the time you've perfected the shot, you've missed the moment.

Most photos benefit from cropping, whether to remove distracting objects, straighten horizons, for artistic effect, or simply to fit your chosen ratio.

When you're cropping in Lightroom, you're deciding which bits of the photo will be cropped, rather than setting a fixed size. When you come to export, you then define the size of the exported photo, either as pixel dimensions or as inches/cm combined

Figure 13.1 The Tool Strip.

with a resolution setting. Let's give it a try...

- **1.** To open the Crop tool, select the second icon in the Develop Tool Strip below the Histogram or press the R key. The Crop Options display below. (Figure 13.2)
- **2.** First, straighten your horizon by pressing the *Auto* button.
- **3.** If Auto doesn't work well, select the **Straighten** tool in the Crop Options panel, and click and drag a line along the horizon. Lightroom automatically rotates the photo to make it horizontal.
- **4.** Select your crop ratio in the *Aspect* pop-up. (You don't choose the size until you export the photo.) To switch the crop orientation, for example, to make a vertical

Figure 13.2 To open the Crop tool, select the second icon in the Tool Strip. The options appear below.

crop from a horizontal photo, press the X key.

- **5.** Adjust the crop by dragging the corners or the edges of the bounding box.
- **6.** Move the photo around under the crop overlay by clicking within the bounding box and dragging the photo into position. Rotate the photo by clicking and dragging around the outside of the bounding box. Think of it as moving the photo underneath the crop overlay, rather than moving the crop.
- **7.** Once you've finished cropping, press the Enter key or select the *Edit* (sliders) button on the Toolbar.

That's the basics, but now let's do a deeper dive into the crop options.

How do I straighten or rotate a photo?

As well as clicking on the *Straighten* tool icon in the Crop Options panel, you can quickly access the tool by holding down the Ctrl key (Windows) / Cmd key (Mac) while you drag

Figure 13.3 The Straighten tool is stored in the Crop Options panel, next to the Angle slider.

Figure 13.4 Straighten the photo by selecting the Straighten tool and dragging a line along the horizon.

along the horizon line on the photo. (Figures 13.3 & 13.4)

If you prefer to straighten by eye, hover outside of the crop boundary, so that the cursor changes to a double-headed arrow (Figure 13.5), then click and drag to rotate the photo up to 45 degrees in either direction. Or you can manually adjust the degree of rotation using the **Angle** slider.

As you rotate the crop, the photo remains level so you don't have to turn your head to see how the photo will look once it's cropped. (Figure 13.6)

To get a better view of the cropped photo as you adjust the crop, try enabling Lights Out mode by pressing the L key twice. Press L again to switch back to the normal view.

Figure 13.5 To rotate a crop, float the mouse around the outside of the crop area until the double-headed arrow appears.

Figure 13.6 Reverse the crop orientation by dragging a corner at a 45 degree angle or pressing the X key.

How do I resize the crop?

To resize the crop, drag the edges of the photo. If you drag the corners, you can adjust two sides in one go.

You can also move the photo around under the crop overlay by dragging the center of the photo.

How do I draw a freeform crop?

For a free form or non-standard crop ratio, unlock the Lock icon and click and drag a rectangle on the photo or drag the edges of the bounding box.

How do I crop a vertical portion from a horizontal photo?

To change the crop orientation, drag the corner of the crop diagonally until the long edge becomes shorter than the short edge and the grid flips over (it gets easier with practice!), or just press the X key to flip the crop overlay.

Alternatively, unlock the ratio lock in the Crop options panel and adjust to the crop of your choice. You can also drag a crop freehand, by dragging a rectangle on the photo, but if you already have a crop applied, you have to press the *Reset* button in the Crop Options panel first.

What is Aspect Ratio?

Images on screen can be any shape you like, but if you're printing or framing a photo, you'll be limited by the aspect ratio of the paper or frame.

The aspect ratio is simply the proportional relationship between width and height of a photo—it's the shape of the photo. You'll often see it written with a colon (2:3) or with an x (2x3).

Some aspect ratios are long and thin, whereas others are closer to square. To illustrate, we'll overlay a few different aspect ratios over each other, all aligned to the left edge, so we can compare them. The white square on top is 1x1—the height and width are equal. At the bottom of the stack, the red 2x3 shape is a long and thin rectangle. (Figure 13.7)

How do I change the crop ratio?

If you're planning on printing the photo, you may want to restrict your crop to a standard aspect ratio. As Lightroom never throws away pixels, it doesn't crop to a specific size—just a ratio. This enables you to reuse the same crop for multiple different sizes, for example, a 4x5 ratio crop can be output as 800x1000 pixels, 4"x5", 8"x10", etc.

By default, the crop ratio is set to *Original* (or As Shot for photos that have an in-camera crop). If you'd prefer a different ratio, select it from the **Aspect** pop-up.

When you change the crop ratio on an existing crop in the Develop module (not Quick Develop), Lightroom applies the new ratio to the existing crop instead of resetting the crop to maximum size. If you'd like it to reset the crop to the largest possible size, hold

Figure 13.7 The shape of standard print ratios varies. For example, 4x5 (blue) is quite square, whereas 2x3 (red) is longer and thinner.

down the Alt (Windows) / Opt (Mac) key while selecting a ratio.

What's the difference between As Shot and Original?

Some cameras allow you to crop the photos to a specific ratio at the time of shooting, or display crop lines on the screen. Some photographers want their in-camera crop (i.e. 3:2, 16:9, 1:1) applied in Lightroom and others want the full raw file.

In cameras added to Lightroom 4.2 or later, the As Shot crop ratio displays the photo with the in-camera crop applied, but changing to Original in the Aspect pop-up displays all the available sensor data.

For older cameras (those released before mid-2012), you'll need to use the free DNG Recover Edges plug-in (see page E13 in the Appendix).

How do I set a custom crop aspect ratio?

The standard ratios are: As Shot, Original, Custom, 1x1, 4x5/8x10, 8.5x11, 5x7, 2x3/4x6, 4x3, 16x9 and 16x10.

As Shot	
Original	
Custom	
1 x 1	
4x5/8x10	
8.5 x 11	1
5 x 7	
2x3/4x6	
4 x 3	1024 x 768
16 x 9	1920 x 1080
16 x 10	1280 x 800
Enter Custom	***
2 x 2.4	
11 x 14	
11 x 17	
6 x 10	
4 x 10	

Figure 13.8 Select the ratio from the list or create a custom one.

(Figure 13.8) If your chosen crop ratio isn't on this list, you can create your own custom crop ratio.

In the *Aspect* pop-up, select *Enter Custom* and type your own crop ratio. **(Figure 13.9)** It'll automatically be added to the bottom of the list. You can't delete custom crop ratios manually, but they work on a rolling list of 5, so only your most recent custom ratios remain in the list. As you add a new one, the oldest one is removed from the list.

How do I lock my crop ratio?

When you select a crop ratio from the popup, the lock icon to the right automatically locks. (Figure 13.10) As you drag the edges of the crop bounding box, the nearest three edges move, retaining your chosen crop ratio. To allow the crop edges to move freely, one at a time, click the crop ratio lock icon to unlock it.

Can I set a default crop ratio?

If you always crop your photos to a specific ratio, for example, 8x10, you may want to apply this ratio automatically instead of selecting 8x10 from the *Aspect* popup on each photo. You can't change the

Figure 13.9 Create your own custom ratios by selecting Enter Custom from the Aspect pop-up.

Figure 13.10 The lock icon fixes your crop to your chosen aspect ratio.

default crop ratio, but there are two easy workarounds.

Return to the Grid view and select all of the photos. In the Quick Develop panel (Figure 13.11), click the disclosure triangle to the right of the *Saved Preset* pop-up to show the *Crop Ratio* pop-up, then select your chosen ratio.

Alternatively, crop the first photo in the normal Crop mode, and synchronize or copy/paste that crop to all the other photos. (We'll come to Synchronize in the Develop Module Tools chapter on page 367.)

Once you've done this, your chosen ratio will already be selected in the Crop options panel and you can go through the photos and adjust the crop to taste.

Either way, it's intelligent enough to rotate the crop for the opposite orientation photos,

Figure 13.11 Crop ratios can also be accessed from the Quick Develop panel in the Library module.

but beware, it also resets any existing crops.

Why do I need to select the right ratio for prints?

Imagine you have a rectangular photo and a square frame. (Figure 13.12)

Clearly it doesn't fit, so what are your options? (Figure 13.13)

- **1.** Squash/squeeze the photo to fit. This never looks good, so Lightroom doesn't let you do it.
- **2.** Keep the rectangular shape, but add white borders along the other edges.
- 3. Crop the top and bottom (or sides), so

Figure 13.12 Imagine you need to make this rectangular photo fit a square frame.

Squash/squeeze it

Add white borders

Crop it

Figure 13.13 To make a rectangular photo fit a square frame, you must squash it, add borders or crop it.

that it will fit.

4. Buy another frame that's closer to the aspect ratio of the photo, so you don't need to crop as much.

The same principle applies to other aspect ratios, not just cropping to square. Imagine trying to fit a panoramic photo into a normal rectangular frame, and you'll have the same choices to make.

How do I change the Crop Overlay?

When you first enter the Crop mode, gray grid lines are overlaid over the photo. This is called the Crop Overlay and it's useful as a composition guide. It's set to *Thirds* by default, named after the Rule of Thirds, but there's a variety of different overlays to choose from: *Grid*, *Thirds*, *Fifths*, *Diagonal*, *Center*, *Triangle*, *Golden Ratio*, *Golden Spiral* and *Aspect Ratio*.

Figure 13.14 You can cycle through a range of different overlays to help decide on the best composition. From top left to bottom right, they are: Grid, Thirds, Fifths, Diagonal, Center, Triangle, Golden Ratio, Golden Spiral and Aspect Ratios.

Press the O key to cycle through a variety of overlays (Figure 13.14), and Shift-O changes the orientation of these overlays. You may only use some of the overlays so you can hide the others by selecting *Tools menu* > Crop Guide Overlay > Choose Overlays to Cycle. (Figure 13.15)

The Aspect Ratio overlay displays a number of different ratio lines to help envisage how

Figure 13.15 You can choose which overlays to display.

Figure 13.16 You can choose which aspect ratios to display in the Aspect Ratio overlay.

it'll look at different ratios. You can choose which ratios to display using the Tools menu > Crop Guide Overlay > Choose Aspect Ratios dialog. (Figure 13.16)

You can't change the Crop Overlay color but if you find the overlays distracting, press the H key to hide them, or select *Never* from the pop-up on the Toolbar. If the pop-up's set to *Auto*, the Grid overlay only displays when you're rotating the photo.

Is there a way to see what the new pixel dimensions will be without interpolation?

If you go to *View menu > View Options*, you can set the Info Overlay to show *Cropped Dimensions*, which is the cropped pixel dimensions without any resampling. Every time you let go of the edge of the bounding box, these dimensions update. You'll also find the original and cropped dimensions in the Metadata panel in the Library module.

Should I check Constrain to Image?

Finally, there's a **Constrain to Image** checkbox in the Crop Options panel. It prevents you from including blank white pixels in your crop, which may be caused by lens corrections. It means that you can crop your photo without having to be too careful to avoid including blank areas, so it's usually worth leaving checked. There's a *Constrain Crop* checkbox in the Transform panel which does the same thing.

How do I flip photos?

Occasionally you may want to flip a photo horizontally or vertically, so they look good as a group on the wall, or to lead the viewer's eye from left to right. To flip the photo, go to *Photo menu > Flip Horizontal* or *Flip Vertical*.

When you're in the Library module, there's

also a temporary flipped view under *View menu* > *Enable Mirror Image Mode.* It affects all of the photos you're viewing, but only while it's enabled. It's useful when viewing photos of yourself (or showing other people photos of themselves), because it's the same view we see in the mirror every day.

How do I reset the crop?

If you change your mind about the crop setting, you can cancel it at any time by pressing the **Reset** button at the bottom of the Crop Options panel.

How do I zoom in while cropping?

You can't zoom while in Crop mode, but if you need a larger preview, select the Crop tool and then press Shift-Tab to hide all the side panels. It's particularly useful when straightening a photo.

If you need even more space, Shift-F hides the window title bar and T hides the Toolbar.

HEALING TOOL

The third icon in the Tool Strip beneath the Histogram is the Healing tool. (Figure 13.17) It's not

intended to replace Photoshop or other pixel editors, but it allows you to quickly

Figure 13.17 Select the Healing tool from the Tool Strip under the histogram.

remove dust spots and other small distractions.

Let's try removing a small spot (Figure 13.18) before we go into more detail.

- **1.** Select the third icon in the Tool Strip beneath the Histogram, or press the Q key.
- **2.** If the distraction is small, you may need to zoom in before brushing over the distraction, so you can see the photo in detail. To pan around the photo without accidentally creating extra spots, hold down the Spacebar while clicking and dragging.
- **3.** Select the *Heal* mode button which looks like a bandaid, then select your brush characteristics using the sliders. A brush size that will cover the object without too many strokes is ideal, and since we're using *Heal* mode, set the *Feather* slider to 0 and

Figure 13.18 Find a spot or distraction in the photo, such as this piece of seaweed on the sand.

Figure 13.19 Click and drag to paint over the distraction.

Figure 13.20 Lightroom finds some new pixels to cover the distraction, but you can click and drag the overlay to choose a different source.

Opacity to 100.

4. If the distraction is circular, such as sensor dust or a pimple, simply click on the distraction to remove it. Unlike brush strokes, these circular spots can be resized later.

For all other distractions, hold down the mouse button and drag the cursor across the photo to brush over the distraction. (Figure 13.19)

- **5.** Lightroom automatically tries to find a good source, but you can click and drag the overlays to fine tune the correction. (**Figure 13.20**)
- **6.** To add more repairs using the same healing mode, continue clicking or brushing over the distractions. If you want to change to a different mode, press the Escape key first or Ctrl-click (Windows) / Cmd-click (Mac) on the mode icon, otherwise the mode of the selected repair gets changed too.
- 7. To delete a repair, hold down the Alt key (Windows) / Opt key (Mac) to change the cursor into a pair of scissors, and then click on the spot again.

Which healing mode should I use?

Lightroom can do three different kinds of repair. (Figure 13.21)

Remove uses Photoshop's Content-Aware technology, so it analyzes the surrounding area to remove entire objects, distractions or blemishes. It works best in areas of

Figure 13.21 The Healing tool has three modes: Remove (left), Heal (center) and Clone (right).

similar texture and tone, whether that's sky, grass, seaweed or stone.

Heal attempts to intelligently match the texture, lighting and shading to blend the repaired pixels seamlessly into the surrounding area. Unlike the Al-based *Remove* mode, you can select the source of the pixels, so it works well in situations that *Remove* can't handle.

Clone simply copies the pixels and pastes them in another location, so it's best for repairing patterns, moving birds to a different location in the sky, or retouching along hard edges.

For most repairs, the *Remove* or *Heal* modes work best. (Figure 13.22) However, if you're trying to retouch a spot along an edge in the photo, like a roof line against the sky, these tools can smudge, in which case the *Clone* option may work better. We'll come back to some tricky retouching examples later in this section.

How do I select the right brush characteristics for each heal mode?

There are two or three brush options, depending on your selected mode:

Size obviously affects the size of the brush stroke. You can also use the [and] keyboard shortcuts or your mouse scroll wheel to adjust the size.

If you're removing a circular spot, make the inner circle big enough to just cover the spot. For a non-circular object, a brush size that will cover the object without too many strokes is ideal. You don't want holes in your repair! (Figure 13.23)

The **Feather** slider only applies to *Heal* and *Clone* modes and adjusts the softness of the brush edge. The Shift-[and Shift-] keys also

Remove works great for these people, who are in fairly simple surroundings, or try Heal mode if you want to pick the source area.

Want a few more seagulls? That's a job for the Clone mode.

Figure 13.22 Not sure which healing mode to use? Here's a few tips...

Remove gets confused by the multitude

of textures, but Heal allows you to pick a

source further along that concrete edge.

Figure 13.23 Select a brush size that will cover the distraction in a minimal number of strokes.

Remove may work if you're careful tracing

along the tyre, but a combination of Clone

along the edge then Heal or Remove for the rest will likely work better.

Figure 13.24 Use Feathering to blend a Clone repair into its surroundings.

adjust the feathering. (Figure 13.24)

A *Clone* repair stands out if it has hard edges, so you'll usually want to select a higher feathering value, such as 90-100. The *Heal* mode works best with *Feather* set to a low value (e.g., 0-15) as it automatically blends the edges into the surroundings.

The current brush size and feathering are previewed on the cursor, with two lines close together for minimal feathering, and further apart for greater feathering. (Figure 13.25)

Most of the time you'll want the *Opacity* slider set to the maximum of 100. However, there are occasions when you might want to reduce it. For example, you may not want to completely remove the lines on a person's face, but just fade them slightly. If you do want to reduce the opacity, it's often easier to adjust the slider after drawing the repair.

Figure 13.25 The brush size and feathering are previewed on the cursor.

Figure 13.26 Drag the overlays to select a new source in Heal or Clone mode.

How do I choose the source of the replacement pixels?

Lightroom automatically searches for a good source of replacement pixels, even if that's outside of the current crop boundary. The result may be perfect from the initial click, but if the suggested source pixels aren't a great match for the surroundings, press the **Refresh** button or / key to make Lightroom try again.

If you'd like a little more control, you can select a custom source. In *Remove* mode, hold down the Ctrl (Windows) / Cmd (Mac) key and drag on the image, or in *Heal/Clone* mode, drag the source pin to a more suitable area. (Figure 13.26)

If you're creating a one-click circular repair, you can also select the source while you're creating it. Hold down the Ctrl (Windows) / Cmd (Mac) key while clicking on the spot and drag to your chosen source without letting go of the mouse button.

Manually changing the source does have implications when copying/synchronizing the repairs to other photos. If Lightroom automatically finds the source, and then you copy the repairs to other photos, Lightroom will check for the best source on each of the photos. If you select a source manually, Lightroom copies from the same location on each of the photos. This is particularly useful when using the Healing tools to remove sensor dust in a clear area of sky, as it's intelligent enough to adjust for orientation.

What's the difference between clicking and dragging?

There are two kinds of repairs—circle spots

and brush strokes (non-circular healing). Circle spots are created by a single click, and they can be moved and resized. Brush strokes, on the other hand, are created by clicking and dragging. They can have an arbitrary shape but they can't be resized later.

How do I draw a straight line?

Holding down the Shift key while you're drawing a brush spot constrains it to a horizontal or vertical line, which is rarely helpful. However the Shift key can be used to create straight lines at other angles, which is particularly use for power or telephone lines. Click at the beginning of the line to create a circle spot, and then hold down the Shift key and click at the end of the line. Lightroom joins the spots using a straight brush spot.

Figure 13.27 The Visualize Spots checkbox shows in the Toolbar when the Healing tool is selected.

Figure 13.28 Visualize Spots makes it easier to spot distractions, such as the stones and seaweed in the sand.

How do I use *Visualize Spots* to quickly find dust spots?

When the Healing tool is selected, there's a checkbox and slider in the Toolbar (below the photo) marked **Visualize Spots**. (Figure 13.27) When you check its checkbox or press the A key, Lightroom displays a black and white mask of your photo. (Figure 13.28)

If you drag the slider to the right, more dust spots are revealed, and dragging it to the left hides them. It's similar to the mask used for the sharpening *Masking* slider, which we'll come to on page 335. You can retouch the spots with the mask active, or you can turn it off again once you've found them.

How do I ensure I don't miss a spot?

If you zoom into 100% view to retouch dust spots, start in the top left corner and then press the Page Down key (Windows) / Fn + down arrow (Mac) to work through the photo. It divides the photo up into an imaginary grid, so when you reach the bottom of the first column, it automatically returns to the top of the photo and starts on the next column. (Figure 13.29) By the time you reach the bottom right corner, you'll have retouched the entire photo without missing any spots. If you prefer to work left to right, hold down the Shift key too.

Figure 13.29 Page Down divides the photo into imaginary sections.

How do I edit an existing repair?

Because Lightroom is a non-destructive editor, you can come back and change your retouching later.

To find existing repairs, you'll need to see the overlays. If they're not showing, set the *Tool Overlay* pop-up in the toolbar (under the preview) to *Auto* or *Always* (or press the H key) and float the cursor over the photo.

To select a repair, click on its pin.

How do I move or resize a repair?

To resize a circle spot, adjust the *Size* slider, or hover over the edge of the outline, so the cursor changes to a double-headed arrow, and then drag the edge to adjust the size. (Figure 13.30) Remember, you can't resize non-circular brush strokes.

To move a repair, drag the source or target pin to a new location. (Figure 13.31)

Figure 13.30 To resize a circle spot, drag the edge of the spot.

Figure 13.31 To move a repair, click and drag the overlay.

How do I delete an existing repair?

To delete a repair, click on it to make it active, and then press the Delete key on your keyboard. Alternatively, if you hold down the Alt key (Windows) / Opt key (Mac), the cursor changes to a pair of scissors, and then clicking on the individual pins or dragging a box around the pins deletes them. (Figure 13.32) To remove all repairs, press the **Reset** button.

Note that Healing is the one tool in Lightroom that's sensitive to the order in which the corrections are applied. The target for one repair can become the source for another repair, and if you then delete the first repair, the latter repair is affected too.

What are the limitations of the Lightroom's Healing tools?

It's possible to do fairly complex retouching using Lightroom's Healing tools, however, as Lightroom is a metadata editor, it has to constantly re-run text instructions, so it gets slower with the more adjustments that you add

The tools are ideal for removing distractions such as sensor dust, power cables in the sky, leaves on the grass, etc., but detailed retouching is still quicker and easier in a pixel editing program, such as Photoshop

Figure 13.32 To delete repairs, hold down the Alt (Windows) / Opt (Mac) key and click on the pins or drag a box around them.

or Photoshop Elements. The point where a pixel editor becomes more efficient than Lightroom depends on your computer hardware, as well as the retouching you're trying to do. When it gets frustrating, stop and switch to Photoshop!

How do I retouch faces?

Faces also need slightly more advanced retouching. For softening skin, brightening eyes, whitening teeth and similar retouching, you'll need to use the Masking

Figure 13.33 Chickenpox spots or acne can be removed using Remove or Heal mode.

Figure 13.34 Use a low opacity repair to soften bags and wrinkles.

tools. The Healing tool, however, can be useful for reducing wrinkles and bags under eyes and removing pimples and scars. (Figure 13.33)

If you remove bags and wrinkles completely, it looks unnatural, so try a brush set to *Clone* mode, and reduce the *Opacity* to around 20-25. Select a source that's similar in tone and texture, such as the skin immediately underneath. (Figure 13.34)

For blemishes, use a *Heal* brush slightly larger than the pimple, set to full *Opacity*. (Severe acne may still need the power of Photoshop.)

How do I handle larger distractions?

Let's try a more complex example combining *Clone* and *Heal* modes... (Figures 13.35-13.39)

RED EYE & PET EYE CORRECTION TOOLS

Red eye in photography or green eye, in the case of pets—is caused by light from a flash bouncing off

the inside of a person's eye. Although many cameras now come with red eye reduction, their pre-flashes tend to warn people that you're about to take a photograph, and can lose any spontaneity. If you turn it off, you can use Lightroom's Red Eye tool to fix red eye in post-processing.

To remove red eye or pet's green eye:

- **1.** Select the fourth icon in the Tool Strip beneath the Histogram.
- **2.** Select **Red Eye** or **Pet Eye** from the Options panel below.

Figure 13.37 (left) Use two thin Clone lines along the edge of the beak and sign. When you then paint a large Heal stroke over the duck's head and body, and slightly overlap the these Clone strokes, you'll get a much cleaner result, as there won't be any adjacent dark pixels to smudge.

Figure 13.39 (right) Additional strokes can be used to heal any leftover artifacts. Repeat the same process for the duck's body and legs to remove him completely.

Figure 13.35 (*left*) The duck photobombed this photo, so we want to remove him.

Figure 13.36 (above) If we just brush up to the edge of the beak and sign using Heal mode, it leaves a dark smudge, but using Clone mode doesn't match the texture and leaves harsh edges. Remove mode creates a really odd effect, as the surroundings are too complex.

What we need is the best of both worlds. To remove the duck, we'll use both the Clone and Heal modes.

Figure 13.38 (left) In this case, there's only one suitable small clone source to the right of the duck's head, which isn't big enough to clone over his whole head and body. To solve this, we divide him up using additional Clone strokes.

Brush over the individual duck sections one at a time using a Heal brush, slightly overlapping the clone dividers.

- **3.** Drag from the center of the eye, to encompass the whole eye. Lightroom automatically searches for the red/green eye within the selected area, and then makes the other options available in the Options panel. (Figure 13.40)
- **4.** Once it locks, you'll see a dark gray spot which replaces the red eye. (**Figure 13.41**)
- 5. Using the **Pupil Size** slider, adjust the size of the spot to cover the pupil, then adjust the **Darken** slider to darken or lighten the pupil. (Figure 13.42)
- **6.** If you're adjusting a pet eye, check the **Add Catchlight** checkbox to add a small

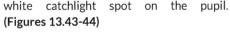

Lightroom's Red Eye Correction tool can't lock on to the red eye—is there anything I can do to help it?

If the Red Eye Correction tool can't lock on to the red eye, scroll down to the HSL panel, select the *Saturation* tab and increase the *Red* slider (or *Green* for Pet Eye), then try again. Once it locks, you can set the HSL panel back to its previous settings (0 by default).

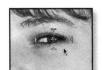

Figure 13.40 Drag from the center of the eye.

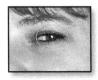

Figure 13.41 Once the pupil has been detected, adjust the size and darkness of the pupil.

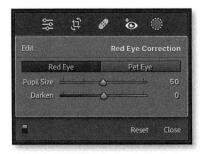

Figure 13.42 Once the circles are in place, edit the Pupil Size and Darken settings.

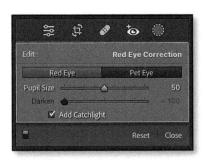

Figure 13.43 Using the Pet Eye Correction, you can add a white catchlight by clicking the Add Catchlight checkbox.

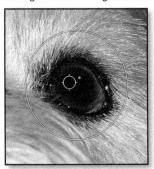

Figure 13.44 Adjust the catchlight position by moving the inner circle.

DEVELOP SELECTIVE EDITING SHORTCUTS

		Windows	Mac
Cropping	Go to Crop Tool	R	R
	Reset Crop	Ctrl Alt R	Cmd Opt R
	Crop As Shot	Ctrl Alt Shift R	Cmd Opt Shift R
	Constrain Aspect Ratio	А	А
	Crop to Same Aspect Ratio	Shift A	Shift A
	Rotate Crop Aspect	Х	Х
	Reset Crop to Maximum for new Aspect Ratio	Alt while changing aspect ratio	Opt while changing aspect ratio
	Crop from Center of Photo	Alt while dragging	Opt while dragging
	Rotate Left 90° CCW	Ctrl [Cmd [
	Rotate Right 90° CW	Ctrl]	Cmd]
	Rotation Angle Ruler	Ctrl-click on start and end points	Cmd-click on start and end points
	Cycle Guide Overlay	0	0
	Cycle Guide Overlay Orientation	Shift O	Shift O
Healing	Go to Healing Tool	Q	Q
	Create New Circle Spot with auto source	Click	Click
	Create New Circle Spot scale from center	Ctrl Alt while clicking	Cmd Opt while clicking
	Create New Circle Spot scale from starting point	Ctrl Shift while clicking	Cmd Shift while clicking
	Create New Circle Spot with manual source	Ctrl while click spot and drag to chosen source	Cmd while click spot and drag to chosen source
	Create New Brush Spot	Click and drag	Click and drag
	Create New Brush Spot constrain to horizontal/vertical axis	Shift and drag	Shift and drag

		Windows	Mac
	Edit Existing connect existing circle spot to new spot, changing to brush spot	Select existing circle spot then Shift and click	Select existing circle spot then Shift and click
	Select new auto source	/	/
	Increase circle spot size]]
	Decrease circle spot size	[[
	Increase feather	Shift [Shift [
	Decrease feather	Shift]	Shift]
	Visualize Spots	Α	Α
	Hide Spot Overlays	Н	Н
	Delete Spot	Select Spot then Delete or hold Alt while clicking	Select Spot then Delete or hold Opt while clicking
When zoomed in, go to top left corner H	Home	Fn Left Arrow	
	When zoomed in, move down	Page Down	Fn Down Arrow
	When zoomed in, move to the right	Page Up	Fn Right Arrow
	Delete Multiple Spots	Hold Alt and drag marquee to surround spots	Hold Opt and drag marquee to surround spots

DEVELOP MASKING

14

Most of Lightroom's sliders apply to the whole photo, but the masking tools allow you to apply settings to

specific areas. This isn't a new concept, photographers have been dodging and burning photos in the darkroom for years.

The Masking tools are very powerful, but with that comes a level of complexity, so we'll take it one step at a time. First, we'll run through a quick tutorial to get you started. We'll then go into more detail on specific tools and selection methods. Then we'll take a look at more complex ways of combining different selections for powerful masking. And finally, we'll consider how you might use some of the different slider adjustments.

Why would I use the Masking tools rather than editing a photo in Photoshop?

There are two main benefits to using Lightroom's Masking tools rather than switching to Photoshop: non-destructive editing and raw data.

When you edit a photo in Photoshop, you have yet another large photo file to store, and if you want to edit it without degrading the original image data, you have to retain multiple layers, which increases the file size further. Lightroom's Masking tools store the edits as metadata in the catalog, so you can go back and change your adjustments again later.

Also, when you're using the Masking tools in Lightroom, you have access to the full raw data, whereas Photoshop uses rendered data (unless you use the raw file as a smart object). For example, if you're using a masked area to lighten shadow areas, there's a much wider range of data available in the raw file, so you can pull back more detail.

The main disadvantage is performance. Because Lightroom is a metadata editor rather than a pixel editor, it can be slower than doing the same kind of edits in Photoshop (see page 521 for further detail).

Photoshop is also a better choice if you need fine control over very detailed masks, such as selecting hair. For most masking needs though, Lightroom can do a very good job.

How do I get started with the Masking tools?

Before we start, let's clarify the terms:

Masks are listed in the Masks panel (page 282). Each mask can have a different set of slider adjustments.

Masks contain one or more **selections**, which are officially called **components**. All of the selections within a mask share the same slider adjustments.

The selections are made using the **masking tools**—the Al-based *Select* tools, the *Brush*, the *Gradients* and the *Range* tools.

To select the Masking tool and show the mask options, click the last icon in the Tool Strip beneath the histogram. Lightroom invites you to add your first mask, so let's give it a try using the Brush tool... I'll use a plain white image so you can see clearly, but you could use a photo.

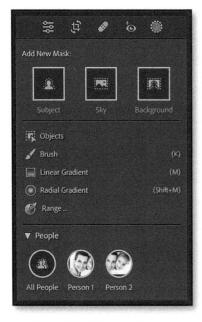

Figure 14.1 When you first open Masking, Lightroom asks which kind of mask you want to create.

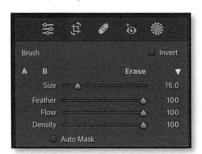

Figure 14.2 The selection tool options are found in the right panel group.

- **1.** Select *Brush* from the list of selection tools. (Figure 14.1)
- 2. Set your brush size and feathering using the options in the right panel, which we'll call the options panel. (Figure 14.2) The cursor changes to two circles, showing the brush size (inner circle) and feathering (outer circle). We'll come back to the other options in more detail on page 290. (Figure 14.3)
- **3.** Click and drag on the photo to paint your brush strokes. If you make a mistake, hold down the Alt key (Windows) / Opt key (Mac) to turn the brush into an eraser, and click and drag over the mistake to remove the brush stroke.
- **4.** By default, Lightroom displays a red overlay to show where you're painting. You can toggle it on and off using the O key. (Figure 14.4)
- **5.** Now let's apply some edits to your selection, using the sliders in the right panel, under the brush settings. For example, increasing the *Exposure* slider lightens the selected area (a.k.a. dodging) or reducing the *Exposure* slider darkens the selected

Figure 14.3 The brush size and feathering is represented using two circles.

Figure 14.4 The red overlay shows the area you've selected.

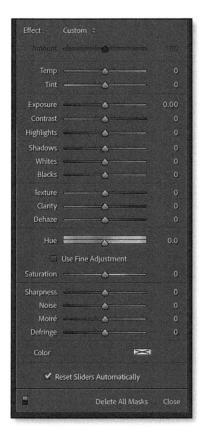

Figure 14.5 Select your slider adjustments in the right group, underneath the selection tool options.

Figure 14.6 The Masks panel lists all of your masks.

area (a.k.a. burning). Settings such as Sharpness, Clarity and Noise Reduction can be used for softening skin on portraits. White Balance or Color are useful when adjusting

for mixed lighting situations. Settings can be combined, so a combination of perhaps - Exposure, - Highlights, + Saturation, + Clarity and a blue tint can make a dull sky much more interesting. (Figure 14.5)

- **6.** You may have noticed an additional panel appeared when you first selected the Brush tool. By default, the Masks panel floats in the top right corner of the preview area, but it can be moved around. **(Figure 14.6)** We'll come back to it in more detail on page 282, but for now, let's create an additional mask.
- **7.** Click the *Create New Mask* button in the Masks panel and select *Linear Gradient*.
- **8.** Click and drag from the bottom of the image to half way up. You can go back and adjust the gradient using the three lines. The outer lines show where the gradient starts (0% of settings applied outside of this line) and stops (100% of settings applied outside of this line). Drag the lines to increase or decrease the range. The center line rotates the gradient. Finally, apply some slider adjustments to the linear gradient. (Figure 14.7)
- **9.** Look at the Masks panel again. Both masks are now listed. You can click on a

Figure 14.7 You can add multiple masks to the same photo. In this case, we've added a linear gradient to our existing brush stroke.

Figure 14.8 Both masks are listed in the Masks panel. Click on the masks to switch between them, or click the ... menu to access additional options.

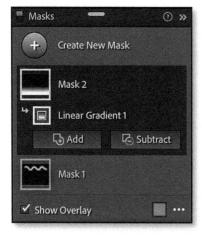

Figure 14.9 The Add and Subtract buttons allow you to combine selections to create complex masks.

mask to reselect and edit it again. (Figure 14.8) If you float over a mask thumbnail in the Masks panel, the overlay displays on the photo to help you identify different masks. If you click the eye icon, you can temporarily disable the mask. Clicking on the ... icon shows a menu, which allows you to rename and delete the mask, among other things.

10. If you click on the mask thumbnail, additional buttons marked *Add* and *Subtract*

appear. These allow you to combine multiple selections in a single mask, so you can create really complex selections, but we'll keep it simple for now. We'll come back to combining selections on page 299. (Figure 14.9)

11. When you're done with Masking, click the *Edit* (sliders) icon in the Toolstrip to return to the normal sliders.

Now let's explore the tools in more detail...

ORGANIZING MASKS

By creating multiple masks, you can apply different edits to different areas of the photo, and they can be overlapped and layered to build up the effect.

The Masks panel lists all of your masks, to make it easy to manage and switch between them. (Figure 14.10)

How do I create new masks?

When you first open the Masking tool, it asks what kind of mask you'd like to create. To create additional masks, simply click the *Create New Mask* button at the top of the Masks panel, or use the keyboard shortcut for your chosen tool.

When I try to create a new mask, why are some of the tools unavailable?

Occasionally, some types of mask are unavailable, so they're dimmed in the Create New Mask panel.

Depth Range is only available if depth information is available in the file. You can

find photos with depth information using the Metadata Filter column (page 187) set to *Depth*.

The AI-based selection and *Range Mask* options are disabled when editing older photos set to process version 1 or 2 (page 252). Updating to the current process version makes them available for selection.

How do I edit an existing mask?

When you float over the thumbnail in the Masks panel, Lightroom displays the overlay on the photos to help you identify which mask you want to edit. Click on the mask to reselect and edit it.

A number of mask management options are available in the menu for each individual mask. To show the mask menu, right-click on the Mask or click its ... button to the right of the Mask name.

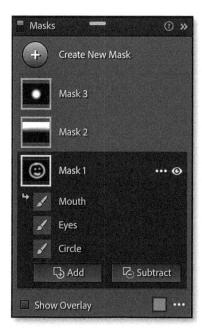

Figure 14.10 The Masks panel lists all of your masks, to make it easy to manage and switch between them.

Is it worth renaming my masks?

If you have a number of masks on an image, you can rename the masks to help identify them. Mask names are particularly useful if you're going to copy the masks to other photos or save them in a preset. To rename a mask or selection, double-click on the mask name or go to the mask's ... menu > **Rename**.

How do I delete masks?

You can delete a single mask by going to the mask's ... menu > **Delete Mask X**. You can also delete all masks from that same context-sensitive menu, or using the **Delete All Masks** button at the bottom of the options panel, below the sliders.

Can I temporarily turn off masks without deleting them?

To hide the effect of a single mask, click its eye icon or select *Hide* from the mask's ... menu. Repeat to show the effect again. Holding the mouse button on the icon temporarily hides the mask and then shows it again when you release the button.

To hide the effect of all masks on the desktop, click the switch at the bottom of the options panel, below the sliders, or at the top of the Masks panel.

You can also fade the effect of a mask, rather than disabling it completely, but we'll come back to that on page 304.

Why might I duplicate a mask?

The **Duplicate and Invert Mask** command in the mask's ... menu is particularly useful if you've created a mask, perhaps of a subject, and then want to apply different settings to an inverted copy. The slider settings are automatically cleared as you'll obviously want to apply different settings.

The **Duplicate** command simply duplicates the mask along with its settings, so it's useful, for example, if you've used a Radial Gradient to spotlight an area of the photo, and then want a second spotlight. You can also drag a selection onto the *Create New Mask* button to create a copy of it in a new mask.

How do I move a mask?

If you have a mask with multiple gradients or brush masks, you can move the whole mask by dragging one of its mask pins. If you only want to move one of the selections/components, make sure that the component is selected in the Masks panel before dragging the pin.

Does the order of the masks matter?

The masks are listed in chronological order, and you can't change the order, but the order of the masks doesn't matter anyway. However, if you've combined multiple selections within a single mask then the order of those selections does matter. We'll come back to that on page 302.

Can I move the Masks panel out of the way?

By default, the Masks panel is pinned in the top right corner of the preview area, but you can move it around by dragging the line at the top. When the panel is floating, you can switch between the full panel and a compact thumbnail view by clicking the arrow in the top right corner. (Figure 14.11)

Figure 14.11 The floating Masks panel can be changed to a compact view by clicking the arrow in the top right corner.

The floating panel automatically hides itself as you draw your selection, so it doesn't get in the way.

If you drag the Masks panel to the right panel group, it docks itself with the other panels, and you can adjust the height using the line at the bottom.

MASKING TOOLS

In addition to the Masks panel, Lightroom has a range of overlays and pins to help you identify and visualize your masks.

How do I show the mask overlay?

The mask overlay shows the location and opacity of your masks. You can temporarily show the mask overlays by floating over the mask thumbnails in the Masks panel. To keep it turned on for the selected mask, check the **Show Overlay** checkbox at the bottom of the Masks panel or press the O key. **(Figure 14.12)**

Why does the overlay show up when I'm creating a new mask, even though Show Overlay was disabled?

If you create a new mask, the overlay is automatically enabled so you can see which

Figure 14.12 The mask overlay shows the area that you've selected.

areas of the photo are being affected. It's automatically disabled again when you make slider adjustments. If you prefer to have full control over the overlay, go to the Mask panel's ... menu and disable **Automatically Toggle Overlay**.

When are the different mask overlays useful?

There's a variety of mask styles available in the Masks panel's ... menu or in the **Overlay Mode** pop-up in the toolbar, or you can cycle through the styles using Alt-O (Windows) / Opt-O (Mac).

Color Overlay, Color Overlay on B&W and Image on B&W are particularly useful when initially creating a mask, as they still allow you to see the photo below.

Image on Black, Image on White, and my personal favorite White on Black, are most useful for refining a mask, especially when filling in gaps in brush strokes. (Figure 14.13)

How do I change the color of the Color Overlay?

By default, the Color Overlay is a red mask, but that's not much help if you're trying to select a red flower! You can change the color by clicking on the swatch at the bottom of the Masks panel or by going to the ... menu > Color Overlay Settings. (The shortcut Shift-O cycles through the colors without opening the dialog.)

The default swatches are red, green, white and black. The fifth swatch changes based on the color you select using the color picker. If you want to save more than one custom color, right-click on a swatch and select *Set this Swatch to Current Color*. To go back to the defaults, there are *Reset* commands in the same right-click menu.

Figure 14.13 The Color Overlay Settings dialog allows you to set your own overlay color.

Figure 14.14 The Color Overlay Settings dialog allows you to set your own overlay color.

In the same dialog, you can also adjust the *Opacity* of the mask, but the default of 50% is generally a good choice. (**Figure 14.14**)

What's the difference between the pin icons?

When you select a mask, each selection is marked with a small icon called a pin. You can float over a pin to show the mask overlay. There's a different pin for each type of selection. (Figure 14.15)

The Group pins (the generic ones that apply to entire masks rather than selections) only show if there isn't a mask selected, and if **Show unselected mask pins** is enabled in the Mask panel's ... menu. You can show them at any time (as long as the Masking tool is open) by holding down the S key.

How do I show or hide the pins?

By default, the pins and the gradient tool lines only show when you float the cursor

Subject

Linear Gradient

Sky

Radial Gradient

Color Range

Color Range

Luminance Range

People

Depth Range

Brush

Group

Figure 14.15 There's a different pin for each selection tool.

Show Edit Pins: Auto : Overlay Mode: Color Overlay :

Figure 14.16 The pop-ups for the pins and overlays are found in the Toolbar.

over the photo. If you want them to show all of the time, change the **Show Edit Pins** popup on the Toolbar from Auto to Always. If they disappear, you've probably selected Never or accidentally pressed the H key, so press H again. You'll also find them under the Tools menu > Tool Overlay or in the Mask panel's ... menu > Show Pins and Tools. (Figure 14.16)

AI-BASED SELECTIONS

The Subject, Sky, Background, Objects and People selection tools are the easiest tools in the Masking toolbox, because they use artificial intelligence to automatically select elements in the photo, with varying results.

What kind of Al-based masks can I create?

Subject selection attempts to select the subject, whether that's a person, an animal, a flower or a bicycle. Perhaps you need to selectively lighten a black dog, or add a little *Texture* to their fur.

A **Sky** selection makes it easy to add *Clarity* to highlight the clouds, or make it the shade of blue that you remember. Inverted, you might apply *Sharpening* or *Texture* to the

Figure 14.17 Select Sky allows you to enhance the clouds, or sharpen the foreground without introducing additional noise in the sky.

foreground without making the sky too noisy. (Figure 14.17)

A **Background** selection isn't actually just the background, it also includes the foreground! It selects everything except the subject. (Figure 14.18)

The **Objects** tool is like *Subject* selection, except you choose the subject. It uses AI to select whatever item you roughly scribble over or draw a box around.

The **People** selection automatically selects entire people or specific body parts. It's a real time saver when retouching portraits!

How do I create a Subject, Sky or Background selection?

To create a Subject, Sky or Background selection as your first mask on an image, select the Masking tool beneath the histogram then Subject, Sky or Background. Lightroom searches the photo for the subject or sky, and creates a selection. To add additional AI masks, select Create New Mask in the Masks panel then Subject, Sky or Background.

Figure 14.18 Background selection affects everything except the subject.

How do I create an Object mask?

To create a user-guided object selection, select the Masking tool beneath the histogram then *Objects* from the list of masking tools. In the right panel, select the brush or box selection mode. (Figure 14.19)

If you're using the brush, simply brush over the object, completely covering it with the red overlay. You don't need to be too careful. You can change the brush size using the slider or the [and] keys.

If you prefer to use the box selection mode, drag a box roughly around the object.

You can continue to brush over or draw boxes around additional objects to add them as additional selections in the same mask, or go to *Create New Mask* in the Masks panel to start a new object mask.

How do I create a People selection?

To create a *People* selection, select the Masking tool beneath the histogram then decide who to select—*All People* or a single person. (Figure 14.20)

If you want to select more than one person, just click on one initially, then click *Add People* at the top of the next screen to check the others. (Figure 14.21)

If you can't identify people's faces, float the

Figure 14.19 The Objects selection tool allows you to select an object using a brush or box.

cursor over the *Person* icons to show the overlay on the main preview.

One detail to note... at the time of writing, selecting one person then adding all of the other people results in a more accurate selection than the *All People* option. I hope this is a bug that will be fixed in a future release, but at least it has a good workaround for now!

Next, decide whether to select the Entire Person or just their Face Skin, Body Skin,

Figure 14.20 Start a People selection by choosing who to include.

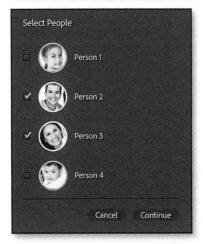

Figure 14.21 To add extra people, click Add People then check their checkboxes before clicking Continue.

Eyebrows, Eye Sclera (the whites of the eyes), Iris and Pupil, Lips, Teeth and/or Hair. (Figure 14.22)

If you check *Create X separate masks*, Lightroom creates multiple masks, rather than placing all of the selections in a single mask. This allows you to apply different adjustments to the different body parts, for example, soften the facial skin, reduce saturation on bloodshot eyes, and whiten the teeth.

Finally, click *Create* to allow Lightroom to create the masks.

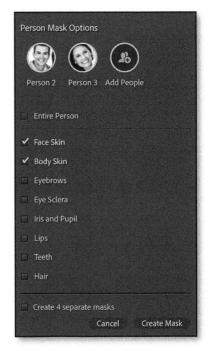

Figure 14.22 Select which parts of the body to include in the masks.

Figure 14.23 The options panels for the Al-based selections all have Invert checkboxes.

How do I invert an AI-based selection?

To invert the selection, for example, to select everything but the sky, enable the *Invert* checkbox in the options panel. (Figure 14.23)

Can I refine an Al-based selection to reduce a halo or to add bits it missed?

At this point in time, there are no other controls to refine the selection, but you can use the other Masking tools to add to or subtract from the selection. We'll come back to combining selections on page 299.

How do I update multiple AI masks after pasting settings?

When you paste or sync masks from other photos, or apply them using a Develop preset, the masks are automatically updated for the new image content. There are occasions, however, when the masks may need to be manually updated. For example, you may have applied a Develop preset

Histogram ▼

ISO 100 85 mm f / 4.0 1/100 Sec

□ Original Photo

■ Masks

■ Create New Mask

Skin

A Some Al masks need to be updated
Update All

Figure 14.24 Masks that need updating show a warning triangle under the Histogram.

during import or as a raw default, and these aren't automatically recomputed.

If a photo has a mask that needs updating, it shows a warning triangle under the Histogram, in addition to a warning triangle on the mask itself. (Figure 14.24)

You can update the masks on a single photo by clicking the warning triangle in the Histogram panel, using the **Update All** button in the Masks panel or the keyboard shortcut Ctrl-Alt-U (Windows) / Cmd-Opt-U (Mac).

Better still, you can select multiple photos (in the Grid view or Filmstrip) and then go to Develop module > Settings menu > Update Al Settings. Any masks that need updating are automatically recomputed, and any photos that don't have outdated masks are simply skipped.

How do I update AI masks after using the Healing tool?

The other reason you may need to manually update a mask is if you've used the Healing tool (page 312) after creating an Al-based mask. For example, imagine there's some seagulls in the photo when you create a Sky mask. If you then use the Healing tool to remove the seagull, the mask doesn't get automatically updated, so you're left with a ghost of the seagull. (Figure 14.25)

Figure 14.25 Using the Healing tool after creating an Al-based mask can result in a ghost image.

At the time of writing, Lightroom doesn't give any warning that you've used the Healing tool in an Al-masked area, other than displaying an **Update** button above the Masking sliders when the mask is selected. The same *Develop module > Settings menu > Update Al Settings* command or its keyboard shortcut also updates the masks. (Figure 14.26)

The easiest way to avoid this issue is to simply do your Healing adjustments before creating Al-based masks, rather than afterwards. Hopefully this workflow will be refined in future updates.

BRUSH

The Brush tool allows you to create a freeform selection by painting on the photo. Unlike the other selection tools, it's not constrained to a specific shape, so it's very flexible.

How do I create a new brush mask?

To create a Brush mask as your first mask on an image, select the Masking tool beneath the histogram then *Brush*. To add additional Brush masks, select *Create New Mask* in the Masks panel then *Brush*. Or, you can press the K key at any time to start a new Brush mask.

When you select the Brush, it's automatically ready for you to start painting.

If you're doing some painting at home, you'll

Figure 14.26 Click the Update button to rebuild an AI mask after using the Healing tool.

pick the right brush for the job. Perhaps a large brush for the wall, and a small brush to paint along the edges. Lightroom offers similar controls in the options panel. (Figure 14.27)

When you're ready to start painting on the photo, hold down the mouse button and drag the cursor across the photo. Holding down the Shift key while you paint draws the stroke in a straight vertical or horizontal line

If you start painting without any slider adjustments, the overlay is turned on by default so you can see where you're painting. If you're dodging and burning (lightening/darkening) with less than 100 Flow or using a pressure sensitive tablet and pen, you may want to adjust the Exposure slider before you start painting, so you can see exactly what you're doing.

How do I erase brush strokes?

If you make a mistake when brushing, it's not a problem. Simply select the *Eraser* in the Brush options panel or hold down the Alt (Windows) / Opt (Mac) key to select it temporarily, and then you can erase all or part of the existing stroke. Of course, if you've just painted a stroke, Ctrl-Z (Windows) / Cmd-Z (Mac) will also undo your last action. You can, of course, also

Figure 14.27 The options panel for the Brush tool includes the brush settings and presets.

delete the entire brush mask using the Masks panel.

How do I choose the size and softness of my brush?

At top of the options panel are the brush settings.

The *Size* slider runs from 0.1, which is a tiny brush, to a maximum size of 100. You can use multiple different brush sizes on the same mask, perhaps using a large brush to cover a large area, then a small brush for detailed edges. As well as the slider, you can also use the [and] keys or scroll the mouse wheel to increase and decrease the size of the brush.

If you can only see the *Size* slider, click the disclosure triangle to show the additional settings.

Feather runs from 0, which is a hard edged brush, to 100 which is soft. A harder edged brush is useful when you're brushing up against the edge of an object in the photo,

Figure 14.28 Feathering set to 0 (top) and 100 (bottom).

Figure 14.29 The brush cursor shows the size and feathering.

whereas a soft brush is better for blending your edits into the rest of the photo. Shift-[and Shift-] shortcuts and Shift/scroll can also be used to increase and decrease the feathering. (Figure 14.28)

The size and feathering are previewed on the cursor, with the two lines close together for minimal feathering, and further apart for greater feathering. (Figure 14.29)

There are two saved brush settings, plus an eraser, all accessed from the options panel. This allows you to quickly switch between a hard and soft brush or a large and small brush, without having to constantly adjust the sliders.

To store the settings for each brush, click on **A**, adjust your brush settings for your A brush, and then click on **B** and adjust your settings for that brush too. You can quickly switch between them by clicking on the A or B button, or by using the / key.

You set the size and softness of the *Erase* brush in the same way, except Lightroom won't allow you to select the eraser brush until you've added a brush stroke to the photo.

What's the difference between Flow & Density?

The **Flow** slider controls the rate at which the stroke is applied.

With *Flow* at 100, the brush behaves like a paintbrush, laying down the maximum effect with each stroke. The effect is applied equally with each stroke. (Figure 14.30)

With Flow at a lower value such as 25, the brush behaves more like an airbrush, building up the effect gradually. Each stroke adds to the effect of the previous strokes. Areas that have multiple brushstrokes are

stronger than those with a single stroke. (Figure 14.31)

Density limits the maximum strength of the stroke. Regardless of how many times you paint using those brush settings, the mask can never be stronger than the maximum density setting. Unless you need the *Density*

Figure 14.30 Flow at 100 creates solid lines.

Figure 14.31 Flow at 25 builds up the effect gradually.

Figure 14.32 Density 0 (top), 25 (center) and 100 (bottom). The Density slider prevents the brush strokes getting any stronger than the maximum setting, regardless of how many times you paint over it.

control for a specific purpose, I would suggest leaving it set at 100. (Figure 14.32)

How do I move brush strokes?

You can move brush strokes by dragging the pin. If you can't see the pins when you float over the photo, press the H key or select *Auto* or *Always* from the *Show Edit Pins* popup in the toolbar.

Can I invert a brush mask?

To invert the brush selection, for example, to make everything B&W except for the small area you've selected, check the *Invert* checkbox.

What does Auto Mask do?

The **Auto Mask** checkbox confines your brush strokes to areas of similar color, based on the tones that the center of the brush passes over, helping to prevent your mask spilling over into other areas of the photo. For example, you can paint over a child's shirt to selectively adjust the color, without having to carefully brush around the edges.

It can result in some halos, for example, trying to darken a bright sky with a silhouette of a tree in the foreground may leave a halo around the edge of the tree.

Auto Mask actually works better in reverse—use a large brush without Auto Mask to paint a large area first, and then enable Auto Mask while erasing areas of your mask. As a general rule, the more modern range mask tools do a better job than the older Auto Mask. We'll come back to combining mask types on page 299.

Why are there small dots or speckles on my photo?

If you're editing a noisy photo, you may

find speckles or dots in the brushed area. To avoid this issue, apply noise reduction before painting your mask with *Auto Mask* enabled.

Why is nothing happening when I brush over the photo?

If you're brushing over the photo and nothing seems to be happening, it's usually because either the *Flow* or *Density* sliders are set too low. If they're both set to 100, make sure the mask overlay is enabled by pressing the O key.

LINEAR GRADIENT

The Linear Gradient is particularly useful for darkening the sky in a sunset photo or blurring a distracting foreground. (Figure 14.33) It can also be useful if the lighting on one side of the photo is different

Figure 14.33 The Linear Gradient is ideal for darkening skies.

to the other side.

How do I create a new Linear Gradient?

To create a Linear Gradient as your first mask on an image, select the Masking tool beneath the histogram then *Linear Gradient*. To add additional Linear Gradients, select *Create New Mask* in the Masks panel then *Linear Gradient*. Or, you can press the M key at any time to start a new Linear Gradient.

Click at your gradient starting point, and drag to your gradient end point before releasing the mouse button. If you prefer to work from a central point, rather than selecting your gradient start and end points, hold down the Alt (Windows) / Opt (Mac) key while dragging. The gradient then expands equally from both sides of your starting point. You can hold down the Shift key while creating the gradient to constrain it to a 90 degree angle.

How do I edit an existing Linear Gradient?

The Linear Gradient is controlled by the tool overlay, which allows you to adjust the size, rotation and position of the gradient. (Figure 14.34) If you can't see the tool overlay when you float over the photo, press

Figure 14.34 The Linear Gradient uses three lines for control. The central line and outer handle control rotation and the outer lines show the limits of the gradient.

the H key or select Auto or Always from the Show Edit Pins pop-up in the toolbar.

Feather/stretch the gradient—When you float over the outer lines, the cursor changes to a hand tool, enabling you to adjust how far the gradient stretches. Moving the outside lines further apart increases the feathering, and moving them closer together reduces the feathering.

Rotate the gradient—When you float over the central line, the cursor changes to a double-headed arrow, enabling you to adjust the rotation of the gradient. You'll have more control if you drag the outer ends of the lines. If it's a really narrow gradient, it's easier to rotate using the white handle that sticks out.

Invert the gradient—The red dot on the tool overlay shows which side of the gradient is being affected by your adjustments. If the gradient is the wrong way round, simply press the 'key or check the *Invert* checkbox to invert it. (Figure 14.35)

Move the gradient—If you need to move the whole gradient, click and drag the square central pin.

There used to be a brush and eraser tool in the Linear and Radial Gradients? Where's it gone?

The gradient's brush and eraser tools in Lightroom Classic 10 and earlier have been replaced by the ability to combine multiple

Figure 14.35 The only control in the options panel for the Linear Gradient is the Invert checkbox.

selections in a single mask. We'll come back to combining selections, including subtracting a brush stroke from a gradient, on page 299.

RADIAL GRADIENT

The Radial Gradient is particularly useful for off-center vignettes, to draw the eye to a specific area of the photo. It can also be used to lighten faces in photos or put a "spotlight" on one area of the photo, among other things. (Figure 14.36)

How do I create a new Radial Gradient mask?

To create a Radial Gradient as your first mask on an image, select the Masking tool beneath the histogram then *Radial Gradient*. To add additional Radial Gradients, select *Create New Mask* in the Masks panel then *Radial Gradient*. Or, you can press Shift-M at any time to start a new Radial Gradient.

Click in the center of your new circle/oval,

Figure 14.36 The Radial Gradient is ideal for off-center vignettes or as a spotlight to draw the eye.

and drag out towards the edge of the photo before releasing the mouse button. Holding down the Shift key constrains it to a circle instead of an oval.

How do I edit an existing Radial Gradient?

A **Radial Gradient** is controlled by the circular bounding box and the 4 square markers. **(Figure 14.37)** If you can't see them when you float over the photo, press the H key or select *Auto* or *Always* from the *Show Edit Pins* pop-up in the toolbar.

Resize the gradient—When you float over the handles, the cursor changes to a straight double-headed arrow, enabling you to adjust how far the gradient stretches. To automatically expand the mask to the edges of the photo, double-click inside the oval bounding box.

Figure 14.37 The Radial Gradient uses two lines for control. The central line changes feathering and the outer line adjusts the size, shape and rotation of the gradient.

Figure 14.38 The options panel for the Radial Gradient includes the Invert checkbox and the Feather slider.

Feather the gradient—The feathering on the Radial Gradient is controlled using the **Feather** slider in the options panel or by dragging the red handle on the inner circle. Holding down Shift while turning your mouse scroll wheel works too.

Rotate the gradient—When you float over the line itself, the cursor changes to a curved double-headed arrow, enabling you to click and drag to adjust the rotation of the gradient. You can also use the outer white handle

Invert the gradient—By default, the Radial Gradient affects the area inside the circle. If the gradient is the wrong way round, you can check the *Invert* checkbox in the options panel, but it's quicker to simply press the 'key to invert it. (**Figure 14.38**)

Move the gradient—If you need to move the whole mask, like dragging a spotlight around the photo, click and drag the central pin.

RANGE MASKS

The Range mask tools allow you to build complex masks for local edits:

The *Color Range* mask selects an area based on sampled colors, whether that's a child's t-shirt, a flower, or perhaps skin tones.

The Luminance Range mask selects pixels based on their brightness. This makes it much easier to select detailed objects such as trees, or select just the shadow or highlight tones in an image.

The *Depth Range* mask relies on a depth mask captured using some iPhone models, which can be used for blurring and darkening backgrounds.

How do I create a Color Range selection?

To create a Color Range selection as your first mask on an image, select the Masking tool beneath the histogram then *Color Range*. To add additional Color Range selections, select *Create New Mask* in the Masks panel then *Color Range*. Or, you can press Shift-J at any time to start a new Color Range selection.

The color range selector is automatically selected. Click on your chosen color in the photo, or for greater accuracy, click and drag a rectangle to select a range of colors. By holding down the Shift key, you can add up to five samples. If you make a mistake and need to remove a sample point, hold down the Alt key (Windows) / Opt key (Mac) and click on the sample icons. (Figure 14.39)

Once you've selected the right color

Figure 14.39 Click or drag on the image to select specific colors.

Figure 14.40 The options panel for Color Range includes the Invert checkbox and the Refine slider.

ranges, adjust the **Refine** slider to adjust the threshold. Holding down the Alt (Windows) / Opt (Mac) key while dragging the slider makes it easier to see which pixels are included in the selection. (**Figure 14.40**)

Sometimes it can be easier to choose a color range and then check *Invert* to select everything else.

How do I create a Luminance Range selection?

To create a Luminance Range selection as your first mask on an image, select the Masking tool beneath the histogram then Luminance Range. To add additional Luminance Range selections, select Create New Mask in the Masks panel then Luminance Range. Or you can press Shift-Q at any time to start a new Luminance Range selection.

The luminance range selector is automatically selected. Click and drag a rectangle on the photo to select the brightness values you want to include your selection. (Figure 14.41)

Alternatively, you can manually set the lightest and darkest pixels you want to affect using the **Luminance Range** slider.

The range is selected using the box handles

Figure 14.41 Click or drag on the image to select a specific luminance range.

in the center, and the smoothness of the transition from selected to unselected is controlled by the outer handles. If you've got a handle in just the right spot, hold down the Shift key while moving the other handles, to prevent them moving each other. (Figure 14.42)

The **Show Luminance Map** checkbox makes it easier to see which pixels are included in your selection, or you can hold down the Alt key (Windows) / Opt key (Mac) while moving the sliders. **(Figure 14.43)**

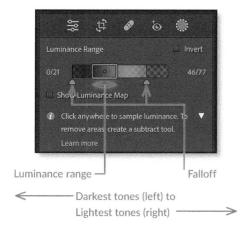

Figure 14.42 The options panel for Luminance Range contains a special slider that sets both the range and the falloff.

Figure 14.43 Hold down the Alt/ Opt key while moving the sliders or enable the checkbox to see the Luminance Map.

To invert the selection, check the *Invert* checkbox.

How do I create a Depth Range selection?

To create a Depth Range selection as your first mask on an image, select the Masking tool beneath the histogram then *Depth Range*. To add additional Depth Range selections, select *Create New Mask* in the Masks panel then *Depth Range*. Or, you can press Shift-Z at any time to start a new Depth Range selection.

If the Depth Range mask option isn't available, the photo doesn't have the needed metadata. To capture a photo with a depth mask, select *Depth Capture* from the pop-up in Lightroom mobile's camera, or use the iOS camera's *Portrait* mode (both limited to specific iPhone models with multiple cameras).

The depth range selector is automatically selected, and you can drag a rectangle on the photo to set the range, then fine tune the selection using the slider. If you prefer, you can skip the eyedropper and just use the slider.

The **Depth Range** slider allows you to choose which range of pixels should be included in the selection. The pixels closest to the camera are to the left of the slider, and the most distant pixels are on the right.

The range is selected using the box handles in the center, and the smoothness of the transition from selected to unselected is controlled by the outer handles. For example, moving the handles to the left selects the pixels closest to you. (Figure 14.44)

To easily see which area is selected, check the **Show Depth Map** checkbox. The grayscale mask shows the depth mask, and

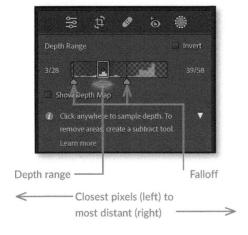

Figure 14.44 The options panel for Depth Range contains a special slider that sets both the range and the falloff.

Figure 14.45 The Depth Range mask is useful for creating complex selections based on the distance from the camera. The Depth Map can help you visualize which areas of the photo are selected.

Figure 14.46 Old Luminance or Depth masks must be updated if you want to change their settings.

the red mask shows the selected area. You can also hold down the Alt (Windows) / Opt (Mac) key while moving the sliders to see a grayscale preview. (Figure 14.45)

I'm trying to edit an old photo but Lightroom wants me to update an existing Luminance or Depth mask. Do I have to?

Luminance or Depth masks created in Lightroom 10 or earlier used a different combination of sliders (Range and Smoothness), so if you try to edit an old mask, Lightroom displays an **Update** button instead of the slider. (Figure 14.46)

Most existing Depth masks don't need to be updated. Lightroom will continue to render the image exactly as it did in older versions, and you can change any of the other sliders without updating.

The only reason to press the *Update* button is if you need to change the range of selected pixels. Updating makes the newer slider available, so you can set a new range. Be warned, the old settings don't translate to the new slider ranges perfectly, so you will likely need to select a new range after updating.

If you're trying to approximately replicate the previous settings, you may want to create a snapshot or virtual copy before updating.

In older Lightroom versions, I used to add a gradient or brush mask before adjusting the range mask settings. How do I restrict the range mask to a specific area of the photo?

As of Lightroom Classic version 11, the range masks are first class citizens, so you no longer have to create a mask before specifying the range. By default, the range masks affect the entire photo but it is

possible to restrict the effect to a specific area by combining multiple masks as an intersection.

If you have trouble remembering it, you could create presets for the combinations you use most frequently (e.g., brush the refine using luminance range), and then just tweak the settings.

Let's investigate the Add, Subtract and Intersect options in the next section...

COMBINING MASK TYPES

The real power of masking comes in the ability to combine multiple types of selection in the same mask. As a reminder:

Masks are listed in the Masks panel (page 282). Each mask can have a different set of slider adjustments.

Masks contain one or more **selections**, which are officially called **components**. All of the selections within a mask share the same slider adjustments.

Figure 14.47 Each mask can be made up of multiple selections, which in turn can each be set to either add to, subtract from or intersect with the other selections.

The selections are made using the **masking tools**—the Al-based *Select* tools, the *Brush*, the *Gradients* and the *Range* tools.

To see the selections (or components) that make up each mask, click on the mask in the Masks panel. If they still don't show, click again.

So far in this chapter, we've only used a single selection per mask, but notice the *Add* and *Subtract* buttons... these allow you to add additional selections to an existing mask. (Figure 14.47)

We'll illustrate the differences in behavior using two overlapping radial gradients, with -2.5 Exposure applied to the mask.

Why might I add to an existing mask?

Add simply adds to the selection. You'd use it when different selections need the same adjustments, for example:

- You want to brighten both eyes by the same amount.
- You're applying the same amount of skin softening to multiple faces.
- Multiple bridesmaids are wearing the same color dress but the hue isn't quite right.
- Select Subject or Select Sky missed a bit so you add to it using a brush or range mask selection.

You could apply these adjustments as separate masks (if they don't overlap), but combining them in a single mask means you only need to move the adjustment sliders once.

There are also situations where you can't get the same result using multiple

Figure 14.48 Add combines the selections in a single mask, applying the same adjustments to the combined area (left) whereas overlapping selections on separate masks builds up the effect (right).

masks because the masks overlap, for example, three overlapping linear gradients surrounding a doorway. (Figure 14.48)

Why would I subtract from an existing mask?

Subtract, as the name suggests, subtracts from the selections below it in the list **(Figure 14.49)**, for example:

- You've used a linear gradient on a sky, but don't want to apply the settings to the person or building in the foreground, so you subtract using a brush or *Select Subject*.
- Select Subject included something that wasn't part of the subject, such as the chair the person was sitting on, so you subtract using a brush.

- You've used a radial gradient to select a person's face, but you want to brush away the skin softening over the eyes, or use a luminance mask to exclude their beard.
- You've applied a linear gradient to create fake depth of field, but want to exclude the subject from the blur.
- You've painted a mask with a large feathered brush and want to erase very detailed areas. You could use the eraser on the same brush selection, but if you make a mistake, it's almost impossible to paint back the right degree of feathering, whereas a separate subtracted brush selection can easily be revised.

Figure 14.49 Subtracting a selection removes it from the mask, like the "bite" that's been taken out of the left gradient.

Figure 14.50 Create a Reverse ND Grad filter effect using two gradients, with the second narrow one set to subtract.

• You want to create a fake reverse graduated neutral density filter effect, so that the gradient is lightest at the top, but stops abruptly at the horizon. (Figure 14.50)

What's the difference between the brush eraser and a subtract brush selection?

The brush eraser can only erase brush strokes made on the current brush selection, whereas a subtract selection can remove any kind of underlying selection.

What does intersect mean?

If you hold down the Alt key (Windows) / Opt key (Mac), the Add and Subtract buttons are replaced with an **Intersect** button. (Figure 14.51)

This gives you the ability to restrict a selection to to a specific area (Figure 14.52), for example:

- You want to select a child's green t-shirt, but not all of the green in the background, so you do a rough brush over the t-shirt and then subtract a color range. This essentially becomes a more accurate *Auto Mask* tool.
- You use *Select Sky* to select the sky area, but then use a luminance range mask to exclude the clouds before changing the hue.

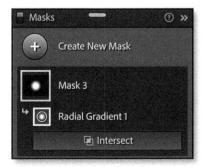

Figure 14.51 Hold down the Alt/Opt key to show the Intersect button.

• You apply a linear gradient to the sky, but the horizon isn't straight, so you use *Select Sky* to restrict the area it affects.

The button is simply a shortcut for these manual steps:

- **1.** Select the limits of the area you want to affect, for example, using a brush.
- **2.** Subtract the type of selection you're using to refine the mask, for example, luminance range.
- 3. Invert the subtracted selection.

I have a mask that's made up of multiple selections. How do I invert the whole mask?

Imagine you've used a subject selection and then painted in the bit it missed. Now you want to invert it to affect the background instead. If you just invert the individual components/selections, you won't get the result you want.

Instead, to invert a whole mask, click on the mask's ... button in the expanded Masks panel, or right-click on the mask thumbnail in the compact Masks panel and select *Invert* Mask.

Likewise, if you want to create an inverted copy of the mask, you can select *Duplicate*

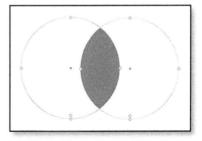

Figure 14.52 Inverting a subtracted selection only applies the edits to the areas that intersect.

Figure 14.53 You can invert an entire mask even if it includes multiple selections.

and Invert Mask. (Figure 14.53)

Does the order of the masks or selections matter? Can I rearrange them?

In the Masks panel, the masks are listed in chronological order and you can't rearrange them, but the order doesn't make any difference.

If you're adding to the selections within a mask, the order still makes no difference, either, because the resulting mask is a composite of all of the selections.

However, if you're subtracting from or intersecting with a selection, there logically has to be a selection below it to subtract from.

To change the order of the selections within a mask, simply drag and drop them.

Can I move or copy selections to other masks?

To move a selection to a different mask, simply drag and drop it on the existing mask. To create a new mask using the existing selection, drag the selection onto the *Create New Mask* button. In both cases, you can copy a selection rather than moving it by holding down the Alt (Windows) / Opt key while you're dragging.

If you click the ... menu on a selection (not the mask itself), there are also *Copy* and *Paste* commands. These can be used to copy paste a selection from one mask to another, or even paste it on a different mask on a different image.

COPYING MASKS TO OTHER PHOTOS

Whether you've created your ideal sunset sky mask, or you keep forgetting how to limit a luminance range mask to a specific area, or you simply need to reuse your masks to other similar photos, there's a few options for copying masks to other photos...

Can I save masks as presets?

Any mask, even if it's made up of multiple selections, can be saved in a Develop preset to use on other photos.

To do so, click on the + button on the Presets panel and check the sliders and masks that you want to include in the preset. (This is where renaming your masks really comes in handy!) Give the preset a name, then press *Create.* Your preset appears in the Presets panel. We discussed Presets in more detail in the Develop Module Tools chapter on page 371.

Each mask has an internal ID, so when you apply the preset to other photos, the masks from the preset are added on top of any existing masks.

One word of warning... if you apply a mask preset and then make changes to the mask, applying the preset again will change the masks back to their preset state rather than adding another copy of the masks. For example, if you've created a "Brush refined with Luminance Range" preset, you can only use it once per photo, even if you edit the brush area or settings, because applying the

preset again will simply reset that mask.

Can I copy masks to other photos?

You can use the *Copy/Paste*, *Previous*, *Sync* and *Auto Sync* tools described on page 367 (**Figure 14.54**), however there are some differences in behavior to look out for:

For *Copy/Paste* or *Sync*, if there are any existing masks, Lightroom asks whether to merge or replace them. (Figure 14.55)

Replace removes the existing masks and replaces them with the ones you're copying.

Merge adds the copied masks on top of any existing masks.

Previous automatically uses the Replace mode, replacing any existing masks with

those from the previous photo.

Auto Sync doesn't ask you what to do, but automatically uses the Merge mode, like Presets. When you add a mask with Auto Sync enabled, it's created on all of the selected photos. If you edit a mask that doesn't exist on the other photos, it's also created on the other photos. Other pre-existing masks are not automatically created on the other photos.

SETTING SLIDERS

Having created your masks, you're ready to apply adjustments using the sliders. (Figure 14.56)

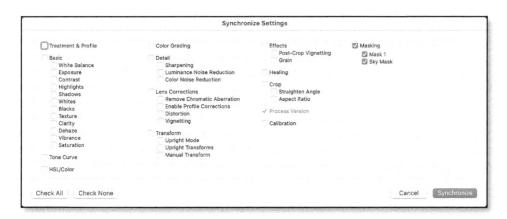

Figure 14.54 In the Create Preset, Copy Settings and Sync Settings dialogs, you can choose which masks to include.

Figure 14.55 When using Copy/Paste or Sync, Lightroom may ask how to handle existing masks.

Figure 14.56 There's a wide range of adjustments available for masks.

How do I set default slider settings?

If you're editing a set of photos that need the same adjustments, it can be irritating to have to reselect the slider values for each new mask, but to save time, you can save the settings as new defaults. To do so, select one of the Masking tools, uncheck *Reset Sliders Automatically* and adjust the sliders to your new chosen defaults BEFORE you draw the mask. Lightroom remembers these settings and uses them for any new masks, until you next repeat the process.

If you'd prefer the sliders reset to 0 for each new mask, check the **Reset Sliders Automatically** checkbox below the sliders.

How do I fade the effect of an existing mask?

When you come to edit a mask, you may want to increase or fade the effect of your edits. You can adjust each of the individual sliders separately, but if you've applied a lot of different adjustments, you may prefer to use the **Amount** slider to adjust them all in one go.

The slider runs from 0-200, with a default of 100. O completely disables the mask, 1-99 fades the effect, 100 applies the adjustments exactly as listed, and 200 amplifies the slider settings. So for example, if a mask is set to *Exposure +1*, changing the *Amount* to 200 actually applies *Exposure +2*.

How do I use the Local Adjustment presets?

There's a selection of presets in the **Effect** pop-up to help you get started. They include basic presets for each of the sliders, plus presets for *Burn* (darken), Dodge (lighten), Iris Enhance, Soften Skin and Teeth Whitening.

The presets just move the sliders to specific values, but they can be helpful if you're not sure which sliders to adjust. For example, the *Teeth Whitening* preset increases the exposure to lighten the teeth and reduces saturation to desaturate the yellow.

If the default presets disappear, select Restore Default Presets from the bottom of the Effect pop-up.

How do I save sets of slider settings as a Local Adjustment preset?

You can save your own sets of settings you use regularly. Unlike Develop presets, Local Adjustment presets only save the slider settings, so you can apply them to any type of mask.

To create a preset, set your chosen slider settings, and then select *Save Current Settings as New Preset* from the *Effect* pop-up menu. Your new preset appears in the pop-up, ready to select. Unfortunately there's no way of organizing them, so don't make too many! Like the other pop-up menus through the program, you have to select the preset in the pop-up to show the *Rename*, *Update* and *Delete* options.

How do I install Local Adjustment presets?

Many preset developers sell Local Adjustment presets, often marketing them as Lightroom Brushes. However, unlike the Develop presets we'll learn about on page 371, they can't be installed automatically. To install them, follow the instructions for manual installation on page 374, but place them in the Local Adjustment Presets subfolder rather than the Develop Presets one.

How do I dodge and burn?

The word 'dodging' comes from the darkroom printing process and refers to lightening areas of the image. Many photos

benefit from a little dodging, for example, lightening faces.

The opposite of dodging is 'burning in' or selectively darkening areas of the photo that are too bright, attracting your attention more than the main subject.

One of the most logical uses for localized edits are these tonal changes using *Exposure*, *Contrast*, *Highlights*, *Shadows*, *Whites & Blacks*. They can use for darkening skies, brightening shadows, reducing bright highlights, darkening edges like an off-center vignette, and many other adjustments. (Figures 14.57 - 14.59)

How do I add local contrast?

The *Clarity* slider allows you to add local midtone contrast, which is particularly useful for the clouds in the sky.

Dehaze is particularly useful when used selectively. When applied globally, it can create halos and color shifts, so either paint Dehaze onto selected areas, or reduce the Dehaze effect if it's too strong. It also works surprisingly well on reflections on glasses!

Figure 14.57 The
Linear Gradient is great
for darkening skies. In
this case we've used
negative Exposure to
reduce the brightness,
positive Clarity to make the
clouds stand out, slightly
increased Saturation plus
a slight blue Color tint.

Figure 14.58 The light falling through the trees is distracting on the kennel walls. A brush set to negative Exposure helps to remove the distraction.

The light on the leopard cub's face is also uneven. A mixture of Exposure, Highlights and Saturation pulls back the light and dark areas to even it out.

Figure 14.59 The Radial Gradient is ideal for off-center vignettes. In this case we've used negative Exposure, negative Highlights and negative Sharpening.

How do I adjust the white balance?

The *Temp* slider makes the selected area warmer or cooler, while *Tint* moves between green and magenta, like the main White Balance sliders. This helps to compensate

for mixed lighting situations, where the white balance is different in specific areas of the photo. The local *Temp* and *Tint* sliders start at 0 rather than using the Kelvin scale, because you're adjusting relative to the main white balance values.

How do I make localized HSL adjustments?

By selecting the color you want to shift using a Color Range mask (page 296), you can make local HSL adjustments. The *Hue* slider adjusts the hue, the *Saturation* slider affects the saturation, and the *Exposure* slider changes the luminance.

On page 331, we'll use the HSL panel sliders to change the color of some beach huts, but we'll only be able to shift the color by a limited amount. With the local *Hue* slider, you can change the color completely.

Unlike the other Masking sliders, the *Hue* slider is a pair of gradients. The bottom gradient shows the color that you started with, and the static top gradient shows the resulting color after the hue adjustment. They're just a guide, and it's often easier to see the result on the photo itself.

The slider offers an additional helping hand by automatically adjusting its starting point based on the masked pixels. For example, when you've selected something red, the color gradients move along to put red under the slider handle. (Figure 14.60)

Checking the *Use Fine Adjustment* checkbox makes it easier to make small adjustments, such as tweaking the color of the sky without affecting the other blue tones in a photo, or reducing ruddy cheeks without changing lip color.

How do I apply a color tint?

The *Colorize* option applies a specific color tint of your choice, without the brightness changes that would happen with *Temp/Tint*. It's a much more subtle shift than *Hue*, but can apply color to neutral areas of the photo, whereas *Hue* can only adjust existing color. You might use it to apply a hand-colored effect to old black & white photos.

In most cases, you can simply select your chosen color from the gradient. To select a color from the photo, click in the Color Picker and while holding the mouse button down, drag the cursor onto the photo. As you drag across the photo, the Color Picker updates live to reflect the color beneath your cursor. When you release the mouse button, the color under the cursor is selected in the Color Picker.

To clear the tint, double-click on the *Color* label and the *Color* box changes to a white box with a cross in it to show it's disabled. (Figure 14.61)

Figure 14.60 Local Hue is a pair of sliders.

Can I adjust Vibrance instead of Saturation?

The Saturation slider acts like the intelligent Vibrance slider when dragged to the right (+), but dragged to the left (-), it behaves like negative Saturation, allowing you to desaturate the selected area to B&W. Adjusting the saturation in limited areas of the photo can help to draw the eye towards the subject or away from a distraction. Some like to use Saturation for a spot color effect, for example, a B&W or partially saturated photo with a small area of the photo in its original color.

How do I sharpen selectively?

Brushing on *Sharpness* or *Texture* can be useful for sharpening eyes and other facial features without over-sharpening the skin, or enhancing fine texture on specific areas of a photo, such as brickwork.

The local sharpening adjustments only affect the *Amount* of sharpening, and the *Radius*, *Detail* and *Masking* settings remain identical across the photo, using the settings selected in the Detail panel.

Can I add a lens blur effect?

If you set the *Sharpening* slider to between -50 and -100, it applies a blur similar to a lens blur, allowing you to blur the background of a photo. It's very processor intensive, so it can be slow. Negative *Clarity*

Figure 14.61 Select a Colorize tint using the Color Picker.

creates a slightly different softening effect.

How do I reduce noise in a smaller area, or only in the shadows?

Contrary to the name, the *Noise* slider doesn't add noise, but decreases or increases any global noise reduction that you've applied, for example, the shadows may benefit from extra noise reduction. If you use a Luminance Range Mask (page 296) to only target the shadow tones, you can limit your noise reduction to the darker areas of the photo. This helps to avoid softening detail in the highlights.

How do I remove local color fringing?

The *Defringe* slider removes color fringes along high contrast edges, or reduces the effect of the Lens Correction panel's Defringe sliders. We'll come back to this is in greater detail on page 345.

How do I reduce Moiré?

Moiré is a rainbow-like pattern which is often seen when photographing fabrics. It's caused by two patterns combining—in

this case, the weave in fabric and the grid of the camera sensor—which creates a new pattern. (Figure 14.62)

The *Moiré* removal slider in the Brush allows you to paint the moiré rainbow away. It can only usually remove the color rainbow, not any luminosity changes, but it works very well. It works on both raw and rendered photos, although the additional data in a raw file means that it is far more effective on raw files.

To use it, select a plus value on the *Moiré* slider, ensure that you've turned off *Auto Mask*, and brush over the pattern. If you cross a boundary of another color in the photo, it can blur or smudge, so it's best to use a hard edged brush (*Feather=0*) and be careful where you brush. This gives the cleanest result without any side effects. It can help to temporarily increase *Saturation* in the Basic panel while brushing, and then reduce it again when you're done. If you set the *Moiré* slider to a negative value, it won't do anything—it's only used to reduce the effect of another brush stroke which already has positive moiré removal applied.

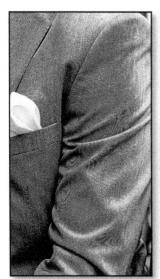

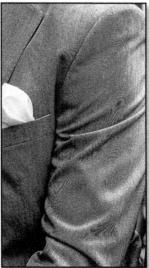

Figure 14.62 Moiré causes a colored pattern on the image (left) but it can be improved using the Moiré slider and the Brush (right).

How do I enhance a portrait?

The Al-based *People* masks make it quick and easy to retouch portraits. Your favorite settings can be saved as a preset for one-click portrait retouching, and sample presets are included in the *Adaptive: Portraits* set to get you started.

When you're ready to try your own settings, turn back to page 287 for a refresher on how to create *People* masks, then here's a few examples of slider adjustments to try.

For natural **skin** softening, try setting *Texture* to around -20 and *Clarity* to -10, or a little further for more extreme softening. (Figure 14.63)

To give the subject's **hair** a little extra texture, play with the *Texture* and *Clarity* sliders.

To darken the **eyebrows**, start with *Shadows* -20 and adjust to taste.

If the subject's **eyes** are blood shot or would benefit from a little brightening, set the *Eye Sclera* mask to around *Saturation* -60 and *Exposure* +0.15. **(Figure 14.63)**

To brighten the **iris** of the eyes (the colored bit!), try settings like *Exposure* +35, *Saturation* +40 and *Clarity* +10. You might also want to adjust the *Hue* slider to change the color slightly.

To whiten yellowing **teeth**, try around +0.20 *Exposure* and *Saturation* of -30 to -60. (Figure 14.64)

To add a little **lipstick**, experiment with adjusting *Tint*, *Hue* or *Colorize*. For a matte effect, try reducing *Texture* and *Clarity*.

Figure 14.63Brighten the iris and reduce redness.

Figure 14.64 Clean up yellowing teeth using the Teeth Whitening preset.

DEVELOP MASKING SHORTCUTS

		Windows	Mac
Organizing Masks	Show / Hide Masks panel	Shift W	Shift W
	Create new mask using currently- selected type of selection tool	N	N
	Invert selection	' (apostrophe)	' (apostrophe)
	Duplicate selection	Ctrl Alt while dragging pin	Cmd Opt while dragging pin
	Move existing selection to a new mask	Drag selection to Create New Mask button	Drag selection to Create New Mask button
	Copy existing selection to a new mask	Hold Ctrl while dragging selection to Create New Mask button	Hold Opt while dragging selection to Create New Mask button
	Delete mask	Select mask then Delete	Select mask then Delete
	Deselect all masks	Ctrl click on Masking panel	Cmd click on Masking panel
	Navigate Masks list	Alt and arrow keys	Opt and arrow keys
Masking Tools	Show Overlay	0	0
	Cycle Overlay Color	Shift O	Shift O
	Cycle Overlay Mode	Alt O	Opt O
	Show/Hide Pins & Tool Overlays	н	Н
	Set Pins & Tool Overlays to Always Show	Ctrl Shift H	Cmd Shift H
	Show Unselected Mask Pins	Hold S	Hold S
Al-Based Selections	Update Al Masks	Ctrl Alt U	Cmd Opt U
Brush	New Brush mask	К	К
	Paint brush stroke	Click and drag	Click and drag
	Switch brush A / B	1	1

		Windows	Mac
	Temporary Eraser	Hold Alt	Hold Opt
	Increase brush size]	1
	Decrease brush size	[]
	Increase brush feathering	Shift]	Shift]
	Decrease brush feathering	Shift [Shift [
	Toggle Auto Mask	А	А
	Set Flow value	0-9	0-9
	Constrain Brush to Straight Line	Shift while clicking or dragging	Shift while clicking or dragging
	Confirm brush stroke	Enter	Return
Linear Gradient	New Linear Gradient mask	М	М
	Draw Linear Gradient	Click and drag	Click and drag
	Resize(extend/contract)	Click and drag	Click and drag
	Resize (rotate)	Click and drag central parallel line or outer handle	Click and drag central parallel line or outer handle
	Move	Click and drag	Click and drag
	Constrain to 90 degrees	Shift while dragging	Shift while dragging
Radial Gradient	New Radial Gradient mask	Shift M	Shift M
	Draw (scaled from center)	Click and drag	Click and drag
	Draw (from starting point)	Alt while dragging	Opt while dragging
	Draw (constrain to circle)	Shift while dragging	Shift while dragging
	Draw (from starting point and constrain to circle)	Alt Shift while dragging	Opt Shift while dragging
	Draw (constrain to crop bounds)	Ctrl double click	Cmd double click

		Windows	Mac
	Resize (opposite sides move)	Click and drag edge	Click and drag
	Resize (selected side moves)	Alt while dragging edge	Opt while dragging edge
	Resize (constrain to existing aspect ratio)	Shift while dragging edge	Shift while dragging edge
	Resize (expands 3 nearest sides)	Alt Shift while dragging edge	Opt Shift while dragging edge
	Resize (maximize to crop bounds)	Ctrl double click within ellipsis	Cmd double click within ellipsis
	Move	Click and drag	Click and drag
Range Mask	New Color Range mask	Shift J	Shift J
	New Luminance Range mask	Shift Q	Shift Q
	New Depth Range mask	Shift Z	Shift Z
	Delete Color Range Mask samples	Hold Alt while clicking on samples	Hold Opt while clicking on samples
Combining Masks	Add to existing mask using Brush	Alt K	Opt K
	Add to existing mask using Linear Gradient	Alt M	Opt M
	Add to existing mask using Radial Gradient	Alt Shift M	Opt Shift M
	Add to existing mask using currently- selected type of selection tool	Shift N	Shift N
	Subtract from existing mask using currently-selected type of selection tool	Alt N	Opt N
	Intersect with	Hold Alt to show button	Hold Opt to show button
	Invert whole mask (with mask selected)	' (apostrophe)	' (apostrophe)
	Invert whole mask (with component selected)	Alt 'apostrophe	Opt ' (apostrophe)

DEVELOP ADVANCED EDITING 15

We've explored the Basic panel and selective adjustments, but there are plenty of extra panels with advanced controls yet to investigate. They include selective color and contrast adjustments, advanced sharpening and noise reduction, lens and perspective corrections, and special effects.

TONE CURVES

Below the Basic panel is the Tone Curve panel. Like the Basic panel, it allows you to lighten or darken the tones in your photo. The sliders even have similar names: *Highlights, Lights, Darks* and *Shadows*. That's where the similarities end, as the behavior can be quite different.

How do I read a tone curve?

The first thing you'll see when you look at the Tone Curve panel is the 4x4 grid which holds the tone curve. You'll spot the histogram showing faintly in the background.

Along each axis are all the possible tones, with pure black (0%) on the left/bottom and pure white (100%) on the right/top. The horizontal (x) axis is the pixel brightness before adjustment, and the vertical (y) axis represents the adjustments you make using the Tone Curve. (Figure 15.1)

The tone curve starts as a straight 45°

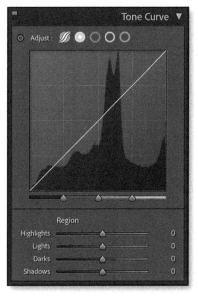

Figure 15.1 Before adjustment, the Tone Curve is a straight line.

diagonal line, with no changes being applied to the photo. Moving the line up/left makes the tones lighter, and moving down/right makes the tones darker. The line getting steeper means contrast is increased, and getting flatter means contrast is reduced. (Figure 15.2)

Why use curves?

Tone Curves are primarily used for controlling brightness and contrast in specific tonal ranges. The steeper the angle of the curve, the higher the contrast becomes. When the curve gets steeper,

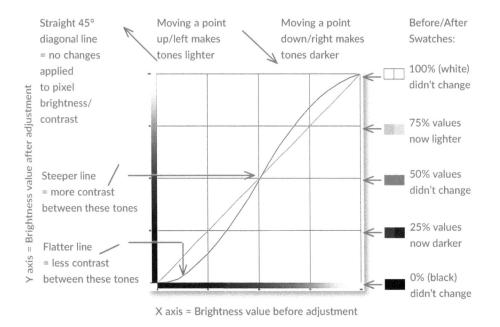

Figure 15.2 A typical S shaped tone curve adds contrast by making the light tones lighter and the dark tones darker.

increasing the contrast in one range of tones (e.g. the shadows), it gets shallower in another range of tones (e.g. the highlights), decreasing the contrast in that range. It allows you to control where you're willing to sacrifice contrast to gain it in other areas.

The most frequently used curve is an S shape, which increases midtone contrast by lightening the highlights and darkening the

shadows. The middle of the curve becomes steeper, giving the midtones greater contrast, while the highlights and shadows become shallower with less contrast. (Figure 15.3)

How are Tone Curves different to the Basic panel?

So you might be wondering how that's different to the Basic panel. After all, you can lighten the highlights using the *Highlights* sliders and darken the shadows using the *Shadows* slider.

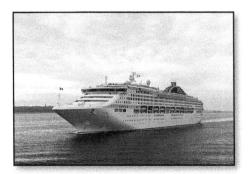

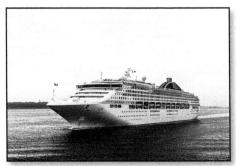

Figure 15.3 Before (left) and after (right) a standard S curve contrast adjustment.

The Basic panel sliders adjust broad ranges of tones, whereas a tone curve allows you to carefully control where you're willing to sacrifice contrast to gain it in other areas. For example, the *Contrast* slider adds contrast using a simple S curve, with almost equal compression in the highlights and shadows. However, you may decide that you're willing to lose more shadow detail in the deepest shadows but you want to keep more contrast in the highlights.

Likewise, if you have a photo with too much contrast, if you lighten the shadows and darken the highlights to see more detail, you lose contrast in the midtones. The *Highlights* and *Shadows* sliders compensate by adding local contrast, but the resulting halos can be

too strong, especially on photos that benefit from a softer look. The tone curve doesn't add local contrast or saturation, leaving you to decide whether to add it yourself. (Figure 15.4)

As a rule of thumb, the Basic panel sliders are designed for the heavy-lifting—the major adjustments—and the Tone Curve is usually used for fine tuning, but rules are made to be broken, so feel free to experiment!

What's the difference between the parametric curve and the point curve?

Lightroom offers two different tone curves: a parametric curve and a point curve.

Figure 15.4 Highlights and Shadows (left) add local contrast, which may not be desirable in a photo shot in lovely soft light, whereas the Tone Curve (right) allows you to reduce excessive contrast without adding local contrast.

The parametric tone curve is the default view, and it allows you to adjust four different regions of the curve called *Highlights*, *Lights*, *Darks* and *Shadows*, rather than individual points. This protects the photo from extreme adjustments, so it's a great way to start experimenting with curves.

The point curve interface, represented by the colored circles, is usually used by more advanced users or those familiar with Photoshop's curves dialog. It gives you full control over the curve, including the individual RGB channels. (Figure 15.5)

Point curves aren't necessarily an alternative to the parametric curves. You may be more comfortable with one or the other, but both curves are active at the same time and the effect is cumulative.

How do I adjust the standard parametric tone curve?

To adjust the parametric tone curve, click and drag up and down on the curve itself or adjust the sliders below. For example, the most frequently used curve is a basic contrast curve which is an S shape. Click on the white line in the *Shadows* or *Darks* regions and drag down to darken the shadow tones, then click on the white line in the *Lights* or *Highlights* section and drag upwards to lighten the highlight tones.

How far you drag away from the center line

Figure 15.5 The point curve is accessed using the colored circles.

controls how much you brighten or darken those tones. As you drag, the highlighted section shows the maximum range of movement for that region of the curve. It's limited in order to maintain smooth transitions between tones and protect your photo from banding/posterization. (Figure 15.6)

To reset the curve, double-click on a slider title to reset a single section, or right-click on the curve to access a range of reset options.

What are the triangles at the bottom of the parametric tone curve?

At the bottom of the parametric tone curve are three triangles called split points. (Figure 15.7)

For example, if you've used the *Shadows* and *Highlights* regions to create strong midtone contrast, you may move the 25% and 75% split points out to restrict the flattened

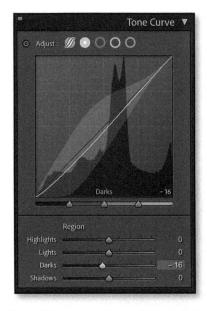

Figure 15.6 The maximum adjustment limits are highlighted on the parametric curve.

contrast to the lightest highlights and the deepest shadows. (Figure 15.8)

They're also useful if you've got the shape of the curve about right, but it's a little light or dark overall. (Figure 15.9)

How do I use the Targeted Adjustment Tool?

Appearing in the Tone Curve, Hue,

Figure 15.7 The split point triangles at the bottom of the curve control how much of the tonal range is affected by each slider.

Saturation, Luminance and B&W panels, the Targeted Adjustment tool, or TAT for short, allows you to directly control the sliders by dragging on the photo itself. It means you can concentrate on the actual photo rather than the sliders, and saves you having to work out which sliders you need to adjust for a specific color or tone. This rather unobtrusive little tool is a real gem! (Figure 15.10)

Figure 15.10 The TAT, or Targeted Adjustment tool, appears in the top left corner of the Tone Curve, HSL, Color & B&W panels.

Figure 15.8 The shape of the curve changes depending on whether the split points are at their defaults (left), far apart (center) or close together (right), so you can use it to fine tune the curve.

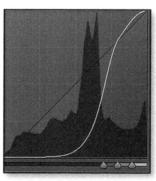

Figure 15.9 Dragging all of the split points to the left or right can change the overall brightness without changing the relative shape of the curve.

- **1.** Click the TAT icon in the top left corner of the panel to select it.
- **2.** Float the cursor over the photo. As you float, a small circle displays on the curve, showing which section of the curve you'll be adjusting, but you don't need to take too much notice of the curve. Just focus on the photo itself.
- **3.** Click on the image and drag up to make the tones lighter or down to make the tones darker. For example, to darken the shadows, click and drag downwards on a shadowy area of the photo until you're happy with the result.

Alternatively, you can hover the TAT cursor over the shadows in the photo and press the Up/Down keys on your keyboard to adjust it.

- **4.** Repeat on other tones in the image, for example, drag upwards on a light area to make the highlights lighter.
- **5.** Once you've finished, just press Escape or return the tool to its base in the corner of

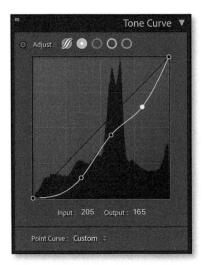

Figure 15.11 The point curve allows you to create a freeform curve.

the panel.

How do I use the point curve?

If you need greater control, click the gray circle to display the RGB point curve. (Figure 15.11)

Click anywhere on the curve line to add a control point, and then drag it up or down to adjust the photo. Control points can make adjustments or lock the curve in position, so you can adjust other tonal ranges without those changing.

Unlike the parametric tone curve, you can also freely move the ends of the curve, creating the flat shadows effect that is popular in many film-effect presets. (Figure 15.12)

Like the parametric curve, the TAT tool makes it easy to work out where on the curve to place your points. Be careful not to place too many points as extreme twists and turns in the curve can create posterization (banding) in the photo.

To fine tune the placement, holding down the Alt (Windows) / Opt (Mac) key while dragging slows the movement, or holding

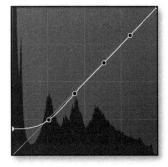

Figure 15.12 Locking most of the curve in place and then lifting the deepest shadows creates the flat shadows effect popular in film-effect presets.

the Shift key constrains the movement to vertical only.

If you prefer to use the keyboard, float the cursor over the active point and use the up and down keys, or type new *Input* and *Output* values in the scrubby fields below.

If you're a little OCD and like everything perfectly lined up, there's also a *Snap to Grid* option in the right-click menu, which locks the control points to the intersections of a 20x20 grid, rather than the standard 4x4 grid.

To remove a single point, right-click on it and choose *Delete Control Point*. Reset Channel and Reset All Channels are also found in the right-click menu.

The red, green and blue circle icons give you access to the red, green and blue channels that make up your photo. These are often

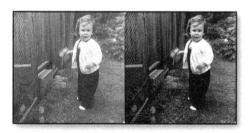

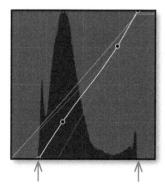

Figure 15.13 To roughly correct color casts in scans, move the ends of the point curve to the ends of the histogram on each color channel.

used for cross processing effects, or for correcting scans or other tricky white balance situations. For example, where color casts differ between the highlights and shadows—perhaps where the overall color is correct but the shadows have a magenta tinge—normal white balance adjustments would be unable to fix it, but RGB curves allow you detailed control over each channel. (Figures 15.13 & 15.14)

The **Point Curve** pop-up holds point curve presets which are shared with Camera Raw (ACR) in Photoshop. *Linear* is the default, but two more legacy presets—*Medium Contrast* and *Strong Contrast*—also add a slight S curve. To save your own point curve as a preset, select *Save* from the pop-up. (You can also save it as a normal Develop preset.)

Unlike most of the preset pop-ups, you can't update, rename or delete the point curve presets from within Lightroom. Instead,

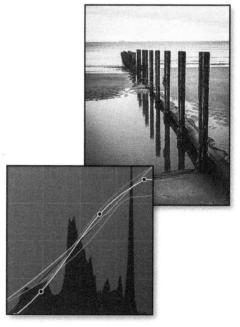

Figure 15.14 RGB point curves are often used for cross-processing effects, creating a different result to the Color Grading wheels.

Figure 15.15 Reversing the tone curve inverts scanned negatives, although it doesn't remove the orange mask of color film, and the Basic panel sliders go "the wrong way"

you must find them in the Camera Raw user folder (page 519) using Explorer (Windows) / Finder (Mac) and delete them manually.

How do I invert a negative photo?

To invert the photo, perhaps because you've scanned a negative, select the point curve and drag the left point to the top left corner and the right point to the bottom right corner. It's handy for negative scans as well as special effects. Don't forget to save it as a preset, as it's tricky to get the points in the right place. (Figure 15.15)

The Negative Lab Pro plug-in is a much more intuitive way to invert negatives. There's a free trial and it can be purchased from https://www.LRQ.me/negativelabpro

BLACK & WHITE

Black and white photography is an art in its own right. Some photographers consider

it more creative than color photography, because it doesn't match the reality we see around us. In the days of film, you generally had to make the decision at the time of capture, and add filters to change the appearance. For example, you'd use a red filter to create a dark dramatic sky. Today, you can make the decisions while editing the photos.

Lightroom offers great control over the contrast between light and dark, and between the different colors that made up the original scene, but first, you need to decide which photos to convert.

How do I decide which photos to convert to B&W?

A good color photo usually also makes a good B&W photo, so how do you decide which photos to convert? Do you have to test a B&W conversion on every single photo?

If you're not sure, think back to the decisions you made when you were analyzing the photo, and ask yourself...

- Is the photo lacking color? For example, the drab colors captured in bad weather may be better removed altogether. (Figure 15.16)
- Does color add anything to the photo? (Hint—if the photo's of a sunset, the answer's probably yes, but in bad weather, the photo may be better without color.)
- Is the color distracting? For example, is the color drawing your eye to the wrong spot?
- How would conversion to B&W affect the story and mood of the photo? The way we respond emotionally to color may conflict with the story we're trying to tell. (Figure 15.17)

You can also look out for elements in the

photos that look great in B&W, for example:

- Contrasts of brightness, especially the beams of light and strong shadows caused by directional light.
- Contrasts of color (light vs. dark, saturated vs. unsaturated, warm vs. cold.)
- Shapes, textures, patterns and compositional features like leading lines. By removing the color, your eye is drawn to these elements.

But remember, these are just a guide—rules are made to be broken!

Why should I correct the color first?

Before you convert a photo to B&W, first adjust the photo in color. This removes any color cast or other problems, so you can accurately judge the best B&W settings. You may even want to create a snapshot or virtual copy (page 382), so you retain your color version as well as the B&W rendition.

How do I convert photos to B&W?

There are numerous ways to convert a photo to B&W, including:

• Shoot using the B&W mode on your camera with the JPEG file format. This isn't a great option as it limits your editing options later. (Shooting in B&W mode in

Figure 15.16 Photos that don't have much color often look more striking in B&W.

Figure 15.17 Color may add to or detract from the story you're trying to tell.

raw, however, can be helpful in visualizing how a photo would look in B&W. As it's raw, it'll be imported into Lightroom as a color photo, ready for you to convert to B&W yourself.)

- Move the *Saturation* slider to -100. It's a very limited way of converting to B&W, because you can't control the ways the color channels are mixed.
- Select a B&W profile from the Profile Browser, or a preset from the Presets panel. These profiles and presets are "pre-mixed," so you can pick one that suits your photo and tweak it from there.
- Click the B&W button in the Basic panel and use the B&W panel to manually mix the color channels.

Let's take a closer look at two of these options that give you control over the look of the photo.

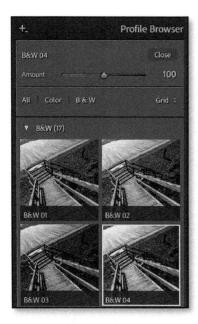

Figure 15.18 Select a B&W profile from the Profile Browser.

How do I convert to B&W using profiles?

On page 222, we introduced the Profile panel. B&W film photographers select a specific film stock and filters, depending on the look they desire. Profiles allow you to do the same when editing your digital photos. Let's give it a try:

To view the B&W profiles, click the four squares at the top of the Basic panel to open the Profile Browser. Click the B&W filter to show just the B&W profiles.

Float over the profile thumbnails to find a profile that suits the photo, then double-click to apply it and close the Profile Browser. (Figure 15.18)

How do I change the B&W Mix?

If you prefer to "blend your own" B&W mix, you can use the B&W panel sliders to control how the color channels are mixed.

Press the V key or select **Treatment: Black & White** at the top of the Basic panel. **(Figure 15.19)** This automatically selects the default *Adobe Monochrome* profile for raw photos, or the default B&W profile for rendered (JPEG/TIFF/PSD/PNG) photos.

You can then fine tune the way the color channels are mixed using the B&W panel.

There is an Auto button, and while the

Figure 15.19 Convert to B&W using the button at the top of the Basic panel.

computer can't evaluate the scene as accurately as your eyes and brain, it can be a good starting point.

Adjust the sliders for each color range, for example, move the blue slider to darken the sky. As you move a slider to the left, the color channel is darkened, and as you move to the right, the color channel is lightened. The colors overlap, for example, adjusting the orange slider also affects red and yellow tones in the photo. (Figure 15.20)

How do I know which color channels to lighten or darken?

Before you switch the photo to B&W (or switch it back to color briefly using the

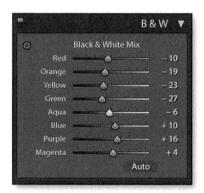

Figure 15.20 Fine tune the B&W channel mix using the B&W panel.

V key), take a close look at the contrasts between the different colors in your photo. These different shades become varying levels of brightness in the B&W photo, and by mixing the colors to make some colors lighter and others darker, you can control the contrast (or tonal separation) in your B&W photo.

Notice in the color wheel in Figure 15.21, the first conversion makes all of the tones a similar brightness, and it lacks contrast as a result. You don't know where to look first. However, when adjusting the brightness of the different colors, we can create some interesting contrasts and start to control how the viewer's eye travels around the photo.

Now let's put this into a simple real world situation. If you look at a landscape on a sunny day, the sky may be vibrant blue and the grass and bushes a vibrant green, so there's an interesting contrast, however the default conversion may make them a similar shade of grey. Using the B&W Mix tools, you can darken the sky to contrast with the white fluffy clouds, and lighten the greens and yellows, enhancing the texture and details. (Figure 15.22)

As you're adjusting the sliders, concentrate on increasing tonal separation (the contrast

Figure 15.21 The default conversion (center) lacks contrast, but adjusting the B&W mix (right) allows you to lighten some colors and darken others.

Figure 15.22 The way you mix the colors can add contrast and draw your eye to different areas of the photo.

between different colors) and don't worry about the overall brightness and contrast initially. Ansel Adams, who is famous for his B&W photos, frequently used a dark sky to contrast with white fluffy clouds, and lightened the greens and yellows. On portraits, lightening the skin (especially red tones) can make it seem smoother, whereas darkening it enhances wrinkles.

As with most things, moderation is key. Pushing the blue tones too far can introduce noise into your photo, and extreme adjustments between contrasting colors can create halos.

How I do use the Targeted Adjustment Tool to adjust the B&W Mix?

Rather than trying to remember the exact shade of each object in your photo, there's a handy tool called the Targeted Adjustment Tool (TAT tool). You'll already be familiar with it, as we used it for the Tone Curve (page 317). When used with the B&W Mix sliders, it allows you to adjust the brightness of different color ranges by dragging directly on the photo.

Click on the TAT tool icon in the top left corner of the panel. (Figure 15.23) The TAT tool allows you to adjust the B&W mix visually by dragging directly on the photo, while it figures out which sliders to move. Find an area of the photo that you'd like to be darker—perhaps the blue sky—and click and drag down on that area. As you drag, the blue tones get darker and the sliders in the B&W panel move. Find another color in the photo that you'd like to be lighter—perhaps the grass—and as you click and drag up the green and yellow tones lighten.

For greater control, float the cursor over the tones you want to change and tap the up/down arrow keys on your keyboard. Holding the Shift key moves in larger increments, or holding the Alt key (Windows) / Opt key (Mac) moves in tiny increments.

How do I create a B&W photo with some areas in color?

There's a technique which is often called B&W with Spot Color. It's a B&W photo with

Figure 15.23 The B&W TAT tool is the easiest way to select the right mix of sliders.

a small area of the photo in its original color. It's possible to reproduce this in Lightroom using the Adjustment Brush, although you have little control over the B&W conversion. First, make Develop adjustments to create a good color version. Then open the Masking tool (page 279), and select a *Brush* or *Objects* mask. Check *Invert* and reduce the *Saturation* slider to -100 to make the entire photo B&W, then paint back the area you'd like in color.

How do I create an infrared effect?

If you don't own an infrared-converted camera, you can create some infrared-style effects using Lightroom. There are many styles of infrared photography, but the most popular has three main traits: blue sky is very dark, green foliage is white, and it has a slight glow.

To create something similar in Lightroom, try this:

- **1.** Switch to *B&W* at the top of the Basic panel.
- **2.** In the B&W panel, increase *Yellow* and *Green* to +100 and reduce *Blue* to -100.
- **3.** In the Basic panel, move the *Temp* and *Tint* sliders to the left. The exact value depends on each individual photo.
- **4.** Set *Clarity* to a negative value to create the glow, for example, -40.
- **5.** Save it as a preset for use on other photos. (But note that they're extreme adjustments, so they work better on raw files than JPEGs).

How do I finish off the B&W photo?

Most B&W photos need a full range of tones, from a deep black with detail to a

bright white with detail, and all the shades in between, so once you've selected your profile or adjusted the B&W mix, you'll likely need to fine tune the overall contrast using the Basic panel sliders or Tone Curve.

The Linear Gradient (page 293) can be useful for darkening the sky in a B&W photo, like an ND Grad filter, and you can add *Clarity* to bring out contrast in the clouds. A Radial Gradient (page 294) can darken the edges of the photo to draw your eye into the center, especially if there are bright areas around the edge that draw the viewer's eye out of the photo.

You may also want to use the Brush (page 290) to dodge and burn to add emphasis, or add local contrast. Be careful not to go overboard, or the changes will stand out. You can also damp down the contrast in some areas to draw the viewer's eye away from distractions.

Many people love the grain inherent in many popular B&W film stocks, so turn to page 353 to learn to add grain to your B&W photos.

You can also try adding a Sepia or Selenium tint to the photo using Color Grading, like many monochrome photos from years ago.

COLOR GRADING

Whereas the White Balance and HSL tools are primarily used for color correction, Color Grading is designed for color effects.

It can be used for toning monochrome photos but it also works well for influencing the mood of the viewer, applying cross-processed color effects, or simply enhancing the lighting.

How do I use the Color Grading panel?

The Color Grading controls are hidden by default, but appear when you click the Color Grading icon in the Color panel. (Figure 15.24)

There are a number of color wheel views, selected using the circle icons at the top of the panel. (Figure 15.25)

The **Global** wheel applies a single tint to the entire photo, for example, adding a golden hour feel to the photo.

Shadows, **Midtones** and **Highlights** wheels apply the tint to individual tonal ranges. The **3 Way** view shows a smaller version of the *Shadows*, *Midtones* and *Highlights* color wheels. It's useful for seeing existing settings, but they're a bit small to make fine adjustments. (**Figure 15.26**)

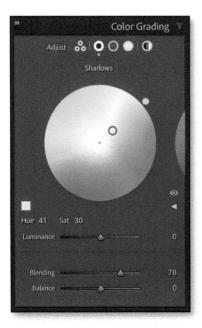

Figure 15.24 The Color Grading panel creates sepia or other toned photos, or even cross-processed effects.

The inner and outer handles are used to adjust the **Hue** and **Saturation**. It's often easiest to pull the inner handle to the edge for maximum **Saturation**, and use the outer handle to select just the right **Hue**. Then hold down the Shift key while using the inner handle to reduce the **Saturation** to taste. The Shift key constrains the movement so the **Hue** doesn't change.

The numeric *Hue* and *Saturation* values show beneath the color wheels (except in 3 Way view), and you can click and type directly in these fields. If you prefer to adjust the *Hue* and *Saturation* using sliders, click the disclosure triangle to show the sliders. (Figure 15.27)

Figure 15.25 The Color Grading panel creates sepia or other toned photos, or even cross-processed effects.

Figure 15.26 The 3 Way view shows the Highlight, Midtone and Shadow tints in one go.

You can also adjust the **Luminance** (or brightness) of the tint using the slider below the color wheel.

The eye icons temporarily disable the effect of a color wheel, to compare with and without a specific adjustment.

If there are specific tints that you use frequently, you can save them as color swatches. Click the small rectangle to view the color swatches, and click on one to apply it. (Figure 15.28) To update a swatch, select the tint of your choice using the color wheel, then right-click on the swatch you want to replace and select *Set this Swatch to Current Color*. Dragging the eyedropper allows you to select a color from the photo, or anywhere else on your screen.

What's the difference between Blending and Balance?

The **Blending** slider controls how much the highlight and shadow tones blend into each other. To illustrate, if we give the shadows a blue tint and the highlights a red tint, you can see that the midtones remain neutral at

Figure 15.27 Click the disclosure triangle to show the Hue and Saturation as sliders.

Figure 15.28 Your most frequently used colors can be saved as swatches.

0 (unless there's a midtone tint, of course), whereas red and blue blend into purple at 100. (Figure 15.29)

If there is a midtone tint applied, such as the green applied here, that tint is also blended into the highlight and shadow tints. (Figure 15.30)

This can be useful, for example, if you only want a tint to apply to the highlights but you don't want it to affect the midtones too much. Imagine you're adding a tint to sunset, but you don't want to significantly affect the building in the foreground. Depending on the range of tones in a photo, the effect may be more or less noticeable.

Holding down the Alt (Windows) / Opt (Mac) key while moving both the *Blending* and *Balance* sliders temporarily sets the *Saturation* of the tints to 100, making it easier to see the effect.

The *Balance* slider defines the range of tones affected by each color wheel. To illustrate, if we set the shadows to blue, the midtones to green and the highlights to red, you can see that at the default of 0, each color wheel affects approximately 1/3 of the tonal range. Moving to -100 results in the

Figure 15.29 Blending controls how much the highlight and shadow tones blend into each other.

Figure 15.30 Midtones also blend into the highlights and shadows.

shadow tone affecting the majority of the tonal range, with just a small amount of midtones, and moving to +100 primarily applies the highlight tint. (Figure 15.31)

What happened to Split Toning?

Color Grading has replaced the older Split Toning controls, but it's fully compatible, and just extends what is possible.

To reproduce older split toning adjustments, simply set the *Blending* slider to 100 and leave the other controls at their defaults. You can then select the tint for the *Shadows* and *Highlights* and adjust the *Balance* slider, as you would have using the old interface.

What color combinations work well for B&W photos?

Traditionally, sepia (a brown tone) or selenium (a blue tone) were used to tone B&W photos to increase the longevity of the prints, and while this is no longer the aim, these tones are still popular choices, adding

Figure 15.31 Fine tune the B&W channel mix using the B&W panel.

a soft warm look or a crisp cool look.

For a Sepia effect, set the *Shadow Hue* to around 40-50 and adjust the Saturation to taste. For a Selenium effect, try a *Shadow Hue* of around 215-225 and adjust the *Saturation* sliders to increase or decrease the strength of the effect. A mix of these tones can also look great, with sepia highlights and selenium shadows, or you can create your own combinations. (Figure 15.32)

What color combinations work well for color photos?

On color photos, it gets a little more tricky, because there are already colors in the image that you don't want to conflict with. So how do you know which colors to use? There are no set rules, but some combinations typically go well together. (Figure 15.33)

Pairs of complementary colors—those opposite each other in the color wheel—look great together. Other traditional color schemes also work well.

While there can be exceptions, you generally want warm tones in the highlights and cool tones in the shadows, as this reflects the way we see the world around us.

Usually the midtones are assigned the same

Figure 15.32 Sepia (left), Selenium (center) and a mix of both (right) are popular toning choices for monochrome photos.

Monochromatic schemes use a single dominant color across the range of tones. These are popular for tinting B&W photos.

Complementary color schemes use colors directly opposite each other on the color wheel, such as warm vs. cool.

Split complementary color schemes use the two colors adjacent to the exact complementary color, for a more subtle effect.

Triadic color schemes use three equally spaced colors.

Analogous color schemes use colors adjacent to each other. It looks much like the monochromatic color scheme but with more colors.

Figure 15.33 Traditional color combinations work well for color grading.

color as the shadows, but you're free to do it differently as long as you keep in mind the Color Theory as a guideline.

Yellow highlights and blue shadows is also flattering to a range of photos if not overdone, or a softer combination of sepia (brown) and selenium (blue) can add a little color contrast without being obvious.

Watch out for memory tones in the images and ensure these remain natural. We're particularly quick at spotting unnatural skin tones.

What is Cinematic Color Grading?

Do you have a specific color palette in mind? You may have heard of cinematic color grading, which is often used by movie editors to convey a specific look or mood. Next time you're watching a movie, especially summer blockbuster movies, look out for the color palette they've used and how it makes you feel, or Google movie color palettes to see some examples.

Orange and teal/blue is popular in Hollywood, because the teal shadows contrast with people's skin tone, making the actors stand out from the background. This is an effect you can replicate on your own photos, but you have to be quite subtle with the orange saturation if there are people in the photos, or you'll make them look seriously ill. (Figure 15.34)

How do I enhance colors using Color Grading?

The Color Grading controls can also be used to enhance the tones in a photo to tell your story.

As a simple example, adding yellow to the highlights and blue to the shadows can give an "golden hour" feel to photos that weren't

shot in ideal lighting. (Figure 15.35)

Slightly warming the highlights on a portrait can make it feel like your person has the sun on their face, without the overall warming of a white balance adjustment.

Likewise, adding blues and purples to the shadows can make your nighttime photos crisp and clean. (Figure 15.36)

You can also use Color Grading to play with the colors of a sunset. (Figure 15.37)

Color Grading can also be helpful when mimicking certain film styles, for example, Kodak Portra has blue shadows and yellow highlights, whereas expired film has red shadows and blue highlights. Film cross-processing effects are also a popular choice. (Figure 15.38)

Be Subtle

Although I've exaggerated the effects in this book so you can see the difference, the key in real life is to be subtle, enhancing the existing colors rather than blowing them away, unless you're aiming for a quirky cross-processed effect.

For the shadows, try a *Saturation* value between 10 and 25, regardless of the *Hue*. This because the darker you go, the more intense and saturated the colors will look.

If you're setting a midtone tint (you often may not need to), try a *Saturation* value of between 15 and 30, and for the highlight tint, aim for between 20 and 35.

The number of combinations are almost endless, although some look better than others! If you're just starting to experiment with cross-processing and toned black & whites, there are many free presets to give you ideas.

Figure 15.34 Orange highlights and teal shadows is a popular combination.

Figure 15.35 Adding yellow to the highlights and blue to the shadows changes the feel of the photo.

Figure 15.36 Adding blues and purples to the shadows makes nighttime photos crisp and clean.

Figure 15.37 Color Grading works well for adjusting the color of sunsets.

Figure 15.38 Color Grading can be used for cross-processing effects.

HSL & COLOR

The HSL and Color panels can look slightly daunting to start with, as there is a multitude of sliders divided into separate tabs. They allow for much finer adjustments of specific colors in your photos. (Figure 15.39)

What are the HSL and Color panels used for?

They allow you to adjust the individual colors in your photo.

H stands for Hue, which is the color.

S stands for *Saturation*, which is the purity or intensity of the color.

L stands for **Luminance**, which is the brightness of the color.

The tabs at the top of the HSL panel change the view, displaying the *Hue* sliders, *Saturation* sliders, *Luminance* sliders or all of the sliders in a single view.

The sliders are tinted to help you remember how the color will change, for example, moving the *Red Saturation* slider to the left reduces the saturation of the reds in the photo.

The Color panel works in exactly the same way. (Figure 15.40) They're the same tools laid out differently. The *Hue*, *Saturation* and *Luminance* sliders are grouped for each color, with the color options along the top.

When would I use HSL and Color?

HSL is particularly useful when your white balance is perfect but you want to change or enhance particular colors. (Figure 15.41) For example, if you have some grass in your photo, moving the *Green* slider

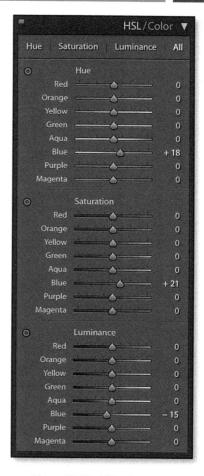

Figure 15.39 HSL adjustments target specific colors.

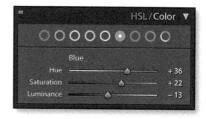

Figure 15.40 The Color panel shows the HSL sliders in a different format.

to the left makes that grass more yellow, without affecting the reds significantly. If someone's skin is too pink, you may need to adjust a few of these sliders, including the *Magenta* and *Red* sliders.

Figure 15.41 HSL Hue adjustments can be used to change colors, such as the blue/purple color in these beach huts.

How do I use the HSL/Color TAT tool?

In the top left corner of the HSL panel is the TAT tool, like the one used in the Tone Curve panel. It's particularly useful when working with HSL, as color in your photo is usually affected by more than one slider. For example, the grass may not be green, but a mix of green and yellow. (Figure 15.42)

The **Target Group** pop-up in the Toolbar controls whether the TAT tool affects the hue, saturation or luminance slider for that color.

My favorite use of the TAT tool and the HSL panel is for a quick blue sky fix. (Figure 15.43) When brightening a photo causes those beautiful blue skies and white fluffy clouds to become too light, select the

TAT tool, set it to *Luminance* in the pop-up (or select the *Luminance* tab in the HSL panel), and click on the blue sky and drag downwards to darken the sky. You may want to switch to *Saturation* and drag upwards to increase the blue too. Don't go too far, as you'll start to introduce noise, but it's a quick fix.

Figure 15.42 The HSL TAT tool is the easiest way to select the right mix of sliders.

Figure 15.43 HSL adjustments are a quick way to create deeper blue skies.

DETAIL—SHARPENING & NOISE REDUCTION

Most digital photographs require some degree of sharpening, and although

camera sensors are improving, most high ISO photos also benefit from noise reduction. Some even say that the quality of the sharpening can make or break an image. Lightroom's Detail panel contains advanced tools to improve your photos. (Figure 15.44)

How do I fix noisy or soft photos?

In the Sharpening section of the Detail panel, the Amount slider controls the amount of sharpening applied. The default settings are an excellent starting point and you may be satisfied with these settings. If you want

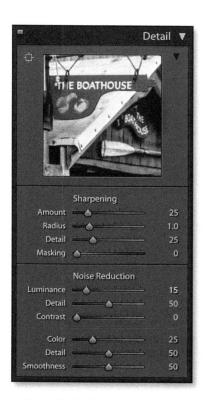

Figure 15.44 Sharpening and Noise Reduction are applied using the Detail panel.

to experiment further, try the sharpening presets found in the Presets panel. We'll come back to the other sliders in more detail shortly.

Noise in your photos can be distracting. You'll particularly notice it in photos shot at high ISO, for example, shot without flash in a darkened room. If you've increased the exposure considerably within Lightroom, it can also increase the appearance of noise. Fortunately, Lightroom's Noise Reduction tools are excellent.

If you're working on raw files, try a setting of around 15-20 *Luminance* as a starting point. This reduces the noise without losing too much image detail. The aim is to reduce the noise, rather than making the subject look like plastic, so don't push it too far. JPEGs may have already had some noise reduction applied by the camera, so you'll need a lower value for these.

When adjusting the sharpening or noise reduction on your photos, it's important to zoom into 100% view by clicking the 100% icon on the top of the Navigator panel. Other zoom ratios aren't as accurate. If you do need to assess noise reduction or sharpening in Fit view, switch to the Library module, zoom into 100% view and then zoom back out. The result is closer than the other non-100% views.

The Detail Preview, which can be hidden using the disclosure triangle to its right, always displays a 100% view. If you select on the square spiky icon to the left of the preview and then click on the photo, you can choose which section of the photo to preview.

What is multiple pass sharpening?

Lightroom's sharpening is based Bruce Fraser's multiple pass sharpening techniques. The sharpening is done in stages:

Capture sharpening is intended to offset the inherent softness caused by digital capture and the demosaicing that's done by the raw converter, and it's done using the sliders in the Detail panel.

Creative sharpening is usually applied to specific parts of the photo, for example, the eyes in a portrait. Clarity and the sharpening in the Masking tools would be classed as creative sharpening.

Output sharpening is the last stage, depending on whether the photos are viewed on screen, inkjet print, photographic print or a variety of other presentation options. The sharpening applied in the Export dialog or Print module would be classed as output sharpening, as it's calculated based on the output size and type.

How do the sharpening sliders interact?

Let's take a closer look at the individual sharpening sliders and how they interact...

Digital image sharpening works in two ways.

USM, or unsharp mask, works by creating small halos along edges to make them appear sharper. On the dark side of an edge it creates a darker halo, and on the light side of an edge it makes a lighter halo. (Figure 15.45)

Deconvolution sharpening attempts to calculate and reverse the cause of the blurring.

Lightroom uses both kinds of sharpening. balanced using the Detail slider.

Amount works like a volume control. It runs from 0-150, with a default of 40 for raw files or 0 for JPEGs, as the JPEGs may have been sharpened in the camera. The higher the value, the more sharpening applied. You won't usually want to use it at 150 unless you're combining it with the masking or detail sliders which suppress the sharpening.

Radius affects the width of the sharpening halo. It runs from 0.5-3, with a default of 1.0. Photos with fine detail need a smaller radius. as do landscapes, but a slightly higher radius can look good on portraits.

Detail and Masking are dampening controls, allowing you to control which areas get the most sharpening applied and which areas are protected, but there's a difference in the way they behave.

Detail is very good at controlling sharpening of textures. Low values use the USM sharpening methods, and as you increase the slider, it gradually switches to deconvolution methods. The default of 25 is a good general sharpening setting. A low setting is ideal for large smooth areas, such as portraits or sky. Try a high setting for landscapes or other shots with lots of fine detail, where you want to sharpen details like the leaves on the trees. As you increase

Figure 15.45 USM sharpening creates halos either side of edges.

Detail, it also starts to amplify the noise in the image, so you may need to reduce the Amount slider and increase the Masking and Luminance noise reduction to compensate.

Masking creates a soft edge mask from the image, protecting pixels from sharpening. It runs from 0-100, with a default of 0 (no masking). Higher values are particularly good for close-up portraits, allowing higher sharpening settings for the eyes, but still protecting the skin from over-sharpening.

Holding down the Alt key (Windows) / Opt key (Mac) while moving the sharpening sliders shows a grayscale mask of the effect, which can help you determine the best value for each slider individually, for example, when using the *Masking* slider, the white areas of the mask are sharpened and the black areas aren't. (Figure 15.46)

So how do you know where to set the sliders to get a crisp result, without over sharpening? Try this:

- **1.** Zoom out to Fit view so you see the entire photo.
- **2.** Hold down the Alt key (Windows) / Opt key (Mac) and drag the *Masking* slider to the right. You're aiming to make areas of low detail, such as the sky, turn black so that that'll be protected from sharpening.
- **3.** Zoom into 100% view to accurately preview your further adjustments.
- **4.** Increase the *Amount* slider to easily preview the effect of your adjustments. Try around 75-100 temporarily.
- **5.** Hold down the Alt key (Windows) / Opt key (Mac) and drag the *Detail* slider slightly to the left for portraits or slightly to the right for detailed shots such as landscapes. The aim is to enhance the detail, shown

Figure 15.46 Holding down the Alt key (Windows) / Opt key (Mac) while moving a slider shows a mask to make it easier to select the right slider value. Amount mask (first), Radius mask (second), Detail mask (third), Masking mask (fourth).

in white, without sharpening the noise, protected in grav.

- **6.** Hold down the Alt key (Windows) / Opt key (Mac) and drag the *Radius* slider slightly to the left for detailed shots such as landscapes or slightly to the right for portraits. Watch the width of the black and white halos you're creating along the edges, and note where these halos are most visible. A value around 1 is usually perfect.
- **7.** Hold down the Alt key (Windows) / Opt key (Mac) and drag the *Amount* slider to the left until the halos almost disappear.
- **8.** Check over the photo for any areas that appear over sharpened. Create a Brush mask, set to *Sharpening* 0 to -50 (no further, as that starts to blur) and brush over the over sharpened areas to reduce the sharpening. Don't remove it entirely, as it may look too smooth in comparison with the rest of the photos.
- **9.** Finally, you may want to go back to the Basic panel and adjust the *Clarity* slider to increase midtone contrast slightly.

Why are my photos softer and noisier in Lightroom than in other software?

When Lightroom's sharpening and noise reduction sliders are at 0, these tools are disabled, whereas many other programs apply additional sharpening and noise reduction behind the scenes, even with their tools set to 0.

How do the noise reduction sliders interact?

There's also an array of noise reduction sliders, but just because they exist doesn't mean you need to use them on every photo. Most photos only require the *Luminance* and *Color* sliders. (Figure 15.47) The other

sliders are there for more extreme cases, and can be left at their default settings most of the time.

The *Luminance* slider controls the amount of luminance noise reduction applied, moving from 0, which doesn't apply any noise reduction, through to 100 where the photo has an almost painted effect. (Figure 15.48)

The *Color* slider tries to suppress single pixels of random noise without losing the edge detail. (Figure 15.49) By default, it's set to 25 for raw files, which is usually plenty. It's set to 0 for JPEGs, but if there's still colored noise in your photo, particularly in the dark shadows, try increasing it slightly.

The other sliders only make a noticeable difference to extremely noisy images, such as those produced by the highest ISO rating that your camera offers, or where a high ISO file is extremely underexposed. You're unlikely to see a difference at lower ISO ratings, for better or for worse, so in most cases you won't need to change these settings from their defaults.

The **Luminance Detail** slider sets the noise threshold, so higher values preserve more detail but some noise may incorrectly be identified as detail.

Figure 15.47 A high ISO photo shows a lot of noise.

Figure 15.48 Luminance
Noise Reduction at
O doesn't apply noise
reduction, but 100 removes
the noise, turning the
detail into a painted or
smooth plastic effect.

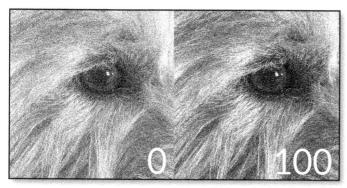

Figure 15.49 Color Noise Reduction set to 0 doesn't apply color noise reduction, but 100 can create color bleed. The default of 25 is often about right.

The *Luminance Contrast* slider at 0 is a much finer grain than 100. Higher values help to preserve texture, but can introduce a mottling effect, so lower values are usually a better choice.

The **Color Detail** slider refines any fine color edges. At low values it reduces the number of color speckles in these edges but may slightly desaturate them, whereas at high values, it tries to retain the color detail but may introduce color speckles in the process.

The *Color Smoothness* slider is similar to the *Color* slider, but it aims to remove larger areas of color mottling or splotchiness. You're most likely to see this on very underexposed images, where you've brightened an area considerably, or extreme contrast images that you're tone-mapping. The default is 50, which works very well on most images. Moving the slider to the

right increases the smoothing at the cost of performance.

Can I apply or remove sharpening or noise reduction selectively?

The sliders in the Detail panel apply to the whole photo, but the Masking tools allow you to apply or remove sharpening and noise reduction in specific areas of the photo. You can 'paint in' increased sharpening over a selected area, such as the eyes in a portrait, or selectively reduce global sharpening on large smooth areas of sky. Local noise reduction allows you to selectively increase or decrease the global noise reduction, perhaps because the noise is more noticeable where you've lightened the shadows. (Turn back to the Masking chapter on starting on page 279 for more information.)

The Masking Sharpening slider is directly tied to the sharpening sliders in the Detail panel, so the Radius, Detail and Masking settings from the Detail panel are combined with the amount set in the Masking sliders. This also gives you the ability to remove sharpening that's been applied by the main sharpening Amount slider in the Detail panel.

O to -50 on the Masking Sharpening slider reduces the amount of sharpening applied by that global sharpening. Beyond -50 starts blurring the photo with an effect similar to a lens blur, but that's very processor intensive, so don't be surprised if Lightroom starts to slow down.

The Masking *Noise* slider applies luminance noise reduction only. You'll need to use the global *Color* noise slider in the Detail panel to reduce color noise.

LENS & PERSPECTIVE (TRANSFORM) CORRECTIONS

You may notice some distortion in your photos, either because of defects in the lens itself or because of

the shooting angle. Fixing these issues is as simple as clicking the checkboxes in the **Profile** tab of the Lens Corrections panel. (Figure 15.50)

These lens and perspective corrections interact, so it's best to work from the top down. Upright, particularly, works much better when a Lens Profile has been applied first.

1. First, check the **Remove Chromatic Aberration** checkbox. It removes specific types of fringing in the photo, particularly around high-contrast edges or in the corners of the photo.

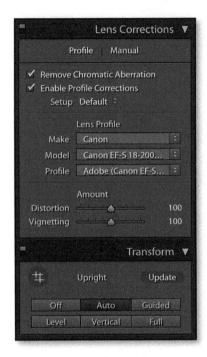

Figure 15.50 The basic lens and perspective corrections are found in the Lens Correction and Transform panels.

2. Next, check the **Enable Profile Corrections** checkbox to apply the default lens profile.

If the profile isn't automatically selected in the pop-ups below, manually select the correct lens profile.

If the file was shot using a compact or mirrorless camera, a lens profile may have already been applied behind the scenes so you don't need to do anything. If so, it'll say Built-in Lens Profile applied at the bottom of the panel.

3. Finally, you can press the *Upright Auto* button in the Transform panel to apply automatic perspective adjustments. Most of the time, *Auto* is the best choice, but you can try the other *Upright* buttons to see if you prefer the result.

There are additional lens and perspective controls, so now let's take a closer look at the options. Since the lens correction controls jump between different panels and tabs, we'll cover them in the order you're likely to need them.

How do I select the correct profile for my lens?

When you check the **Enable Profile Corrections** checkbox, Lightroom checks the EXIF data in the file to identify the lens. If it finds a matching profile, the pop-up menus below automatically populate, and you're done. If Lightroom can't find the correct profile, then you can help by selecting the correct lens profile in the **Make, Model** and **Profile** pop-up menus in the **Profile** tab of the Lens Corrections panel. (If there isn't a suitable profile listed, we'll come back to your options shortly.)

Why is the lens profile not selected automatically?

The EXIF 2.3 official standard for recording lens information in the metadata is only just starting to come into effect, and therefore it isn't always clear which lens was used. Lightroom uses all the information available to make an educated guess, but if it's not sure, it leaves you to select the profile. Once you've chosen the lens, you can set this as a default for that camera/lens combination, so you don't have to select it on every photo in future.

How do I set a default lens profile?

If your lens isn't automatically recognized by Lightroom, you can set a default lens profile to save manually selecting it each time. This default includes the lens details selected in the pop-up menus and the *Amount* sliders below.

- **1.** Open a photo taken with the camera/lens combination.
- **2.** Go to the Lens Correction panel and check the *Enable Profile Corrections* checkbox.
- **3.** Select the lens make, model and profile from the pop-up menus.
- **4.** (Optional) Adjust the *Amount* sliders to increase or decrease the effect of the profile.
- **5.** Go to the *Setup* pop-up menu and select *Save New Lens Profile Defaults*. (Figure 15.51)

In the Setup pop-up menu, what's the difference between Default, Auto & Custom?

In the **Setup** pop-up, you'll note three other options:

Auto leaves Lightroom to search for a matching profile automatically. If it can't find a matching profile, either because the profile doesn't exist yet, or because it doesn't have enough information in the photo's EXIF data, the pop-ups remain blank.

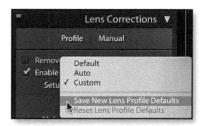

Figure 15.51 If Lightroom doesn't recognize your lens correctly, you can update the default settings.

Default does the same, but also allows you to customize the settings for specific lenses. For example, if *Auto* can't find a lens because it doesn't have enough information, you can select the correct profile from the pop-up menus below and save it as a default for the future. From then on, whenever you select *Default* for a photo with that camera/lens combination, it applies your new default lens setting. It's also useful if you have multiple profiles for a lens—perhaps one provided by Adobe and one you've created yourself—and you want to automatically select one of these profiles.

Custom means that you've manually selected a profile or changed one of the *Amount* sliders and you haven't saved it as a new default setting.

How do I apply lens corrections to new photos by default?

We'll come back to setting defaults in more detail on page 376, but the basic idea is to create a preset that includes the settings you wish to apply on import, and then assign that preset as the default in Preferences.

When creating a preset (page 371) to apply as your default, it's important that the Lens Corrections *Setup* pop-up is set to *Default*, so that Lightroom automatically selects the right profile for your camera/lens combination.

How do the Amount sliders interact with the profile?

There are some situations where you might want to use some of the profiled correction, but not all of it. The **Amount** sliders at the bottom of the *Profile* tab act as a volume control, increasing or decreasing the amount of profiled correction that's being applied. O doesn't apply the correction at all, 100 applies the profile as it was created,

and higher values increase the effect of the correction. For example, with a fisheye lens, you might want to remove the vignette automatically, but keep the fisheye effect. To do so, reduce the **Distortion Amount** slider to 0 but leave the **Vignetting Amount** slider at 100.

Why is the lens profile available for some photos and not others, using the same lens?

Many of the lens profiles are for raw files only, so if a profile is usually available for your lens, check the format of your selected photo. It may be a JPEG or TIFF/PSD.

The processing applied by the camera to non-raw formats can affect the corrections needed, for example, some cameras apply distortion correction and many apply processing that reduces the lens vignetting and chromatic aberration.

If you apply a raw profile to a rendered file (i.e. a JPEG), you may get an unexpected result as it tries to correct for a defect which has already been corrected. There are unofficial ways of making a raw profile available for use with JPEGs by editing the profile with a text editor, but creating your own profile or downloading one created using JPEGs gives a more accurate result.

How do I know whether my lens profile's built in?

Many compact and mirrorless cameras have lens profile information embedded in the raw file. Identical lens corrections are usually applied to JPEGs by the camera.

To check whether your camera manufacturer's lens profile is being applied automatically, look for information at the bottom of the Lens Corrections panel > Profile tab. (Figure 15.52) If it says Built-in

Lens Profile applied, click on the *i* button to view additional information about the automatic fixes. (Figure 15.53) The built-in profile can apply corrections for distortion, chromatic aberration and/or vignetting. For example, the Sony RX100 applies corrections for distortion and chromatic aberration behind the scenes, but you might still want to check *Enable Profile Corrections* to apply a profile that removes the

Figure 15.52 Many recent cameras have the lens profile information built-in and applied automatically.

Figure 15.53 If a built-in profile has been applied, click on the **i** icon to see which corrections are included.

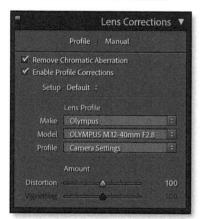

Figure 15.54 When the manufacturer's profile is embedded in a file, enabling Profile Corrections automatically selects the embedded profile.

vignetting.

Some more recent cameras embed the lens profiles, but Lightroom allows you to decide whether to use them or not, so they don't say that the built-in profile is applied. In this case, you'd check *Enable Profile Corrections* to apply the lens profile. The built-in profile is selected by default, and the *Profile* pop-up says *Camera Settings*, to show that it's the manufacturer's own profile rather than one provided by Adobe. (Figure 15.54)

What are my options if my lens profile isn't available?

If your lens doesn't appear in the Lens Profile pop-up menus and isn't built in, you have a number of different options:

- Wait for Adobe to create a profile for that lens. Lens profiles are being added gradually in each dot release. You can check the list of supported lenses at https://www.Lrg.me/lensprofiles
- Switch to the *Manual* tab and adjust the sliders manually.

What's the difference between the Distortion/Vignetting sliders on the Profile tab and the Manual tab?

You'll notice that there are also *Distortion* and *Vignetting* sliders on the *Manual* tab of the Lens Correction panel (Figure 15.55). Although they have the same name, they're not completely interchangeable.

The sliders at the bottom of the *Profile* tab are used in conjunction with a lens profile, increasing or decreasing its effect, whereas the sliders on the *Manual* tab are used when you don't have a profile for the lens and need to make manual corrections for distortion, colored fringing and lens vignetting.

The **Distortion** slider corrects for barrel or pincushion distortion (**Figure 15.56**), and the **Vignetting Amount** and **Midpoint** sliders correct lens vignetting. Unlike the **Post-Crop** Vignette in the Effects panel, these Vignetting sliders are not affected by cropping.

How do I fix Chromatic Aberration or colored fringes?

Chromatic aberration, or CA, refers to the little fringes of color that can appear along high contrast edges, where the red, green and blue light wavelengths are unable to focus at the same point. There are two different kinds of chromatic aberration, which require different treatment.

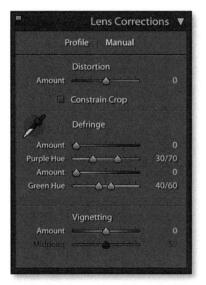

Figure 15.55 The Manual tab of the Lens Corrections panel offers manual distortion, vignetting and chromatic aberration correction.

Figure 15.56 Distortion in the Manual tab +100 (left) and -100 (right).

Type 1—Lateral/Transverse Chromatic Aberration

Lateral or transverse chromatic aberration results from color wavelengths hitting the focal plane next to each other. (Figure 15.57) It's most noticeable around the corners of photos taken with a lower quality wide angle lens, and doesn't appear in the center of the image. You'll recognize the two different colored fringes appearing on opposite sides of your image details.

This type of chromatic aberration is fixed using the *Remove Chromatic Aberration* checkbox in the *Profile* tab of the Lens Corrections panel. It's disabled by default as it can slow Lightroom down slightly, and in rare cases may introduce new fringing.

Type 2—Axial/Longitudinal Chromatic Aberration

The second type of chromatic aberration is called axial or longitudinal chromatic aberration, which results from the color wavelengths focusing at different lengths. (Figure 15.58) Unlike lateral CA, with its pairs of opposing colors, axial CA causes a halo of a single color—purple in front of the focal plane or green behind it—which can be present anywhere on the image.

Figure 15.57 Lateral/Transverse Chromatic Aberration.

Axial CA isn't the only cause of purple fringing. Flare and sensor issues can also cause it, usually along high contrast backlit edges, but the treatment of these purple fringes is the same regardless of the cause.

This type of chromatic aberration is fixed using the *Defringe* sliders and eyedropper in the *Manual* tab. (Figure 15.59) These allow you to target specific hues to remove the fringing.

To demonstrate how to use these tools, let's correct this example image (Figure 15.60), which exhibits both types of chromatic aberration.

- **1.** Develop the image, working from the top down as normal.
- **2.** Correct lens distortion by checking the *Enable Profile Corrections* checkbox in the *Profile* tab of the Lens Corrections panel,

Figure 15.58 Axial/Longitudinal Chromatic Aberration

Figure 15.59 The Defringe controls allow you to fix chromatic aberration and other fringing.

as the distortion corrections can affect the chromatic aberration.

- **3.** The green and magenta fringes caused by lateral chromatic aberration are still visible (Figure 15.61) so enable the **Remove Chromatic Aberration** checkbox in the **Profile** tab.
- **4.** After removing the lateral chromatic aberration, this photo still exhibits purple fringing along the backlit edges. Zoom in to 100% or greater magnification in order to clearly see the fringe pixels. **(Figure 15.62)**

If the leftover chromatic aberration is

Figure 15.60 Chromatic aberration refers to little fringes of color.

Figure 15.61 Even with the lens profile applied, the purple and green fringes are still visible.

limited to a small area, it's quicker and safer to use the local brush or gradient rather than the global lens corrections, so skip the next 2 steps. Otherwise continue to the next step to apply global corrections.

5. Select the eyedropper tool from the *Manual* tab of the Lens Corrections panel and float over the fringes. The end of the eyedropper becomes purple or green, depending on the color of the fringe you're sampling. (**Figure 15.63**) If the end is white, it won't work. Click on the purple fringe to automatically remove it. If there's any green fringing, click to sample the green fringe too.

Figure 15.62 After checking the Remove Chromatic Aberration checkbox, the photo still shows some purple fringing.

Figure 15.63 The tip of the Fringe Color Selector changes color based on the color of the pixels.

For many photos, that's all you need to do. When you sample the fringe using the eyedropper, the *Defringe* sliders in the *Manual* tab of the Lens Corrections panel are automatically adjusted.

6. If you need to fine tune the corrections further, you can adjust the **Defringe** sliders manually.

There are two pairs of sliders for correcting purple and green fringes. The **Amount** sliders affects the strength of the adjustment, and the **Hue** sliders affects the range of colors being corrected. As you move the *Hue* sliders further apart, the fringe removal affects a wider range of colors.

At first glance, it may appear easiest to set the amount to 20 with the widest hue range possible, but doing so would also desaturate the edges of other objects in your image. To avoid this, use the lowest amount and narrowest hue range possible, while still removing the fringing.

The easiest way to check that you've captured all the fringe pixels is to hold down the Alt key (Windows) / Opt key (Mac) while dragging the slider.

For the Amount sliders, only the affected area is shown, with the rest of the image being masked in white. This enables you to check that the fringe pixels have been completely desaturated. (Figure 15.64)

Used with the *Hue* sliders, the affected fringes turn black, allowing you to check that there are no stray colored fringe pixels. (Figure 15.65)

7. Finally, once you've removed the fringing using the global controls, you may want to increase or decrease the fringe removal in some areas.

Figure 15.64 When you hold down the Alt (Windows) / Opt (Mac) key and drag the Amount slider, the photo shows a B&W mask with your fringe highlighted (left). Drag the slider until the fringe disappears (right).

Figure 15.65 The same Alt/Opt mask applies with the Hue slider, with the colored fringes (left) turning black (right) as you move the slider, showing that you've captured all the stray colored pixels.

How do I remove localized fringing?

As long as your photo is set to PV3 or later, you can use the Masking tools to apply defringe to specific areas, or to protect objects from the global fringe removal.

For example, you may find that global defringe adjustments have unavoidably affected the edges of other objects, such as this building. (Figure 15.66)

Create a Brush mask, set the *Defringe* slider to a negative slider value (i.e., -100) and brush over the areas you want to protect from the global adjustment. (Turn back to page 279 for general information on Masking.)

You can also use a positive *Defringe* value (i.e., +100) on a mask to remove any leftover fringing that wasn't removed by the global adjustment, or to apply small amounts of

fringe removal on photos that don't require a global adjustment.

The positive values on the Masking *Defringe* slider are not tied to the global sliders, so it removes fringing of any color, such as the red fringe shown in **Figure 15.67**.

How do I fix the perspective?

Moving on to the Transform panel, the *Upright* tool can fix perspective automatically by analyzing the straight edges in your photo. (Figure 15.68) For example, it attempts to automatically fix tilted horizons and straighten buildings. You can then tweak the results to get the exact correction you desire.

What do the different Upright buttons do? Which one should I use?

The Off button is simple-Upright is

Figure 15.66 The global defringe may affect other edges in the photo (note the gray desaturated areas along the black edges in the left photo) but setting the Adjustment Brush to -100 Defringe and painting over the area brings back the color (right).

Figure 15.67 The Adjustment Brush Defringe slider set to positive values removes fringing of any color, such as the red fringe in this photo.

Figure 15.68 The Upright buttons are found in the Transform panel.

disabled, so no adjustments are made.

The **Auto** button is the most intelligent option. It not only tries to level the photo and correct converging horizontal and vertical lines, but it also takes into account

the amount of distortion that's created by the correction. It aims to get the best visual result, even if that's not perfectly straight. (Figure 15.69)

The *Guided* button allows you to draw lines directly on the image to show Lightroom which lines should be horizontal or vertical. We'll come back to this tool in more detail in a moment.

The **Full** button is the most extreme option. It levels the photos and fixes converging horizontal and vertical lines, even if that means using very strong 3D corrections which distort image features.

The **Level** button only tries to level the photo, fixing tilted horizons and verticals. It's similar to straightening the photo when cropping. It doesn't try to adjust for converging lines.

The **Vertical** button levels the photo, like the *Level* button, but also fixes converging verticals.

There's a little bit of trial and error involved in picking the right one for each photo, but more often than not, the *Auto* button gives the best result.

How do I use Guided Upright?

Upright's Guided mode allows you to draw lines on the image, showing which lines should be vertical or horizontal.

Figure 15.69 Upright corrects perspective distortion, but a full correction may look unnatural. Original (first), Full (second), Auto (third).

Figure 15.70 The Guided Upright tool lives in the corner of the Transform panel.

- **1.** First, enable the lens profile or make manual lens corrections in the Lens Corrections panel.
- **2.** In the Transform panel, click the *Guided* button. This automatically selects the Guided Upright tool, which lives in the corner of the panel. (Figure 15.70)
- **3.** Click at the beginning of your vertical or horizontal line (for example, the wall of a building) and drag to the end of the line. Hold down the Alt (Windows) / Opt (Mac) key to slow down the cursor for greater accuracy. (Figure 15.71)
- **4.** Repeat to add additional lines—up to two horizontal and two vertical. If you add more than two lines in each direction, an error message displays at the bottom of the Transform panel. When you add the second, third and fourth line, Lightroom updates the perspective of the image so you can preview the effect.

As you float over the image, the floating Loupe tool displays a zoomed section of the photo, which aids in making an accurate selection, but if you find it distracting, uncheck *Show Loupe* in the toolbar. (Figure 15.72)

Figure 15.71 Using the Guided
Upright tool, draw up to 4 lines on the image to show which parts of the photo should be vertical or horizontal.

To adjust an existing line, click on the square at the end of the line and move it to a new position. If the lines aren't showing on the image, select the Guided Upright tool in the corner of the Transform panel. By default, the lines show on the image whenever the Guided Upright tool is enabled, but you can set the *Tool Overlay* pop-up in the Toolbar to *Always*, *Auto* (hides the lines when you move the cursor away from the image) or *Never*.

To delete a line, click on it to select it and press the Delete key on the keyboard. To remove all of the lines, double-click on the word *Upright* in the Transform panel.

When do I need to press Update?

The **Update** button is only available when the adjustments need to recalculated, usually because you've checked or unchecked the *Enable Profile Corrections* checkbox in the Lens Corrections panel, or occasionally because Adobe have improved the automated calculations.

How do I reduce the effect of the Upright correction?

You'll notice that the **Transform** sliders below aren't adjusted automatically when using Upright. (Figure 15.73) This is because

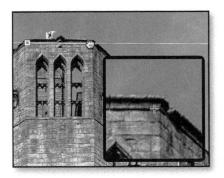

Figure 15.72 The Loupe displays a zoomed section of the photo, which aids in making an accurate selection.

the complex calculations would require numerous extra sliders, so it's all done behind the scenes. These manual sliders are still useful for reducing the effect of the Upright corrections.

We're used to seeing converging verticals in everyday life, so full correction can look unnatural. Using the *Transform* sliders, you can adjust individual axes of rotation, reducing their effect. For example, setting the *Vertical* slider to +10 reintroduces some converging verticals, giving a more natural appearance.

What do each of the *Transform* Lens Corrections sliders do?

As well as reducing the effect of Upright, the *Transform* sliders are particularly useful for slimming people and recovering pixels pushed out of the frame by other lens and perspective corrections. Let's take each in turn...

Figure 15.73 The Transform sliders manually rotate and turn the image.

The **Vertical** and **Horizontal** sliders adjust for perspective. It's most useful for reducing the effect of Upright corrections. (**Figure 15.74**)

The **Rotate** slider adjusts for camera tilt. It's applied at a much earlier stage in the processing than the crop, with a different result. Rotate pivots on the center of the uncropped photo instead of the center of the crop.

If you're using the *Transform* sliders to correct perspective, and your camera wasn't level, it's better to use the *Upright* buttons or the *Rotate* slider in the Transform panel to level the camera, rather than *Angle* in the Crop tool. (Figure 15.75)

The **Aspect** slider squashes or stretches the photo to improve the appearance. Strong keystone corrections can make a photo look unnatural, especially when they include people. The slider direction is sensitive to the image rotation, but in most cases, dragging the slider to the left makes things

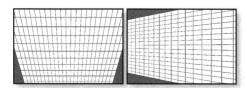

Figure 15.74 Vertical -100 (left) and Horizontal +100 (right).

Figure 15.75 The same grid was rotated using the Crop Angle slider (left) and the Rotate slider (right) followed by an identical -100 Vertical transform. This small crop was taken from the corner of each photo, so you can see there's a difference in the slider behavior.

look wider, and dragging the slider to the right makes them look taller and thinner. (Figure 15.76)

Even if you haven't used the other perspective corrections, moving the *Aspect* slider slightly (usually to the right) slims down the subject, reversing "the camera adds 10lbs!" (Figure 15.77)

The **Scale** slider interpolates the data to recover pixels which have been pushed out of the frame by other lens or perspective corrections, which the Crop tool can't do.

Scale can also remove blank areas of the photo caused by the lens and perspective corrections, but it interpolates the data (creates new pixels) in the process, so

Figure 15.76 Aspect set to +100 (left) and -100 (right).

Figure 15.77 The Aspect slider can make anyone look slimmer!

cropping these blank areas is usually a better choice. (Figure 15.78)

The *X Offset* and *Y Offset* sliders shift the photo left/right/up/down, which is useful when an adjustment has pushed the important section of the photo out of the frame, as it moves it back into range without interpolating the data. (Figure 15.79)

Finally, the **Constrain Crop** checkbox crops the photo to remove any gaps around the edge, which can be caused by lens or perspective corrections. It's identical to the *Constrain to Image* checkbox in the Crop Options panel (page 267).

How do I hide the grid?

By default, the grid overlay appears when you float over the Transform sliders, to help you make adjustments by eye. You can turn

Figure 15.78 With Scale at 0 (left), some of the image is being lost from the corners, whereas Scale -50 (right) shows the extra image data.

Figure 15.79 If some of the data is pushed out of the frame by the lens corrections, the X Offset and Y Offset sliders can shift the data without interpolation.

the overlay off or on permanently using *View menu > Loupe Overlay > Grid* or by selecting the Guided Upright tool (in the corner of the Transform panel) and adjusting the *Grid Overlay* options in the toolbar.

What's the difference between syncing Upright Mode vs. Transforms?

We'll come to synchronizing settings in the Develop Tools chapter on page 367, but it's worth noting that the wording on some of the Upright Sync options isn't entirely clear. Manual Transform refers to the Manual sliders (Vertical, Horizontal, etc). Upright Mode uses the same Upright button (Auto, Level, etc.) but analyzes each photo individually, whereas Upright Transforms uses exactly the same settings behind the scenes, without adjusting for each photo. In most cases, Upright Mode is the option you'll choose. If you're syncing across photos that are almost identical, then Upright Transforms consistent gives result. more (Figure 15.80)

EFFECTS—POST-CROP VIGNETTE & GRAIN

Vignetting is the darkening or lightening of the corners of a photo. (Figure 15.81)

Although traditionally it's caused by

Figure 15.80 Note the difference between Upright Mode and Upright Transforms when syncing settings to other photos.

the camera lens, it's become popular as a photographic effect, so the controls are found in the Effects panel. (Figure 15.82) There's also a grain effect, designed to simulate traditional film grain, which feels more natural than digital noise.

What's the difference between Highlight Priority, Color Priority and Paint Overlay?

The *Style* pop-up in the Effects panel gives a choice of three different post-crop vignettes, which all fit within the crop boundary, rather than the original lens correction vignette which is designed for correcting lens problems.

Highlight Priority is the default and imitates a traditional lens vignette with the colors remaining heavily saturated throughout.

Color Priority retains more natural colors into the vignette, with smoother shadow transitions.

Paint Overlay adds a plain black or white overlay.

How do the Post-Crop Vignette sliders interact?

The **Amount** slider controls how dark or light the vignette should be, with 0 not applying a vignette at all. Most photos look better with a dark vignette, rather than a white one. (Figure 15.83) For many photos, the main *Vignette* slider is the only one you'll need to adjust, but if you want more control, click the arrow to the right to show additional sliders.

The *Midpoint* slider controls how close to the center of the photo the vignette affects. The vignette created by the Effects panel is always centered within the crop boundaries, but if you need an off-center vignette, you can use the Radial Gradient instead (page 294). (Figure 15.84)

The **Roundness** slider controls how round or square the vignette is. -100 is almost rectangular and barely visible whereas +100 is circular. Most vignettes look great with the default of 0, which matches the ratio of the photo. (Figure 15.85)

The **Feather** slider runs from 0 to 100, with 0 showing a hard edge, and 100 being so

Figure 15.82 The Effects panel contains the Post-Crop Vignetting and Grain controls.

Figure 15.81 A vignette can help to draw your eye into a photo and focus on the main subject.

Figure 15.83 The effect of the Vignette Amount slider.

Figure 15.85 The effect of the Vignette Roundness slider.

soft it almost disappears. The default of 50 is a great starting point, with most vignettes ranging from 35 to 65. (Figure 15.86)

The *Highlights* sliders runs from 0, which has no effect, to 100, which makes the highlights under a dark vignette brighter. This allows you to darken the edges without the photo becoming too flat and lacking in contrast. (Figure 15.87)

How do I decide on the best vignette settings?

Ready to give it a try? You can use the sliders in any order, but this works well:

1. Move the Amount slider to -100, so you can easily see the effect of the other sliders.

Figure 15.84 The effect of the Vignette Midpoint slider.

Figure 15.86 The effect of the Vignette Feather slider.

- **2.** Adjust the *Midpoint* slider, so the vignette doesn't cover important areas of the photo.
- **3.** Adjust the *Feather* slider so the edge of the vignette disappears.
- **4.** Move the Amount slider back towards 0, until you're drawn into the photo, but the vignette isn't immediately obvious.
- **5.** Adjust the *Highlights* slider if the corners look too flat and lack contrast.

How do I move the vignette off-center?

The Post-Crop Vignette is always centered within the Crop boundaries, but the Radial Gradient allows you to create your own offcenter vignettes. Turn back to page 294 to learn how.

Figure 15.87 The effect of the Vignette Highlights slider.

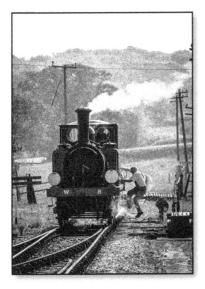

Figure 15.88 Some photos benefit from added grain for effect.

How do the Grain sliders interact?

We spend a lot of time trying to reduce the noise in our photos... and then put grain back! However, some photos look great with a little extra grain, particularly if they're B&W or sepia. (Figure 15.88)

It can also help to hide the plasticky look that results from high noise reduction. Lightroom's **Grain** sliders aim to emulate a traditional film grain, which looks a little different to digital noise.

The **Amount** slider in the Detail panel affects

the amount of grain applied. The noise is applied equally across the photo, giving a much more film-like quality than digital noise, which tends to be heavier in the shadows. (Figure 15.89)

Size affects the size of the grain, just as grain on film came in different sizes, and it gets softer as it gets larger. More expensive film usually had smaller grain. (**Figure 15.90**)

Roughness affects the consistency of the grain, so 0 is uniform across the photo, whereas higher values become rougher.

Figure 15.89 The effect of the Grain Amount slider.

Figure 15.90 The effect of the Grain Size slider.

Figure 15.91 The effect of the Grain Roughness slider.

(Figure 15.91)

Like sharpening and noise reduction, you'll need to zoom into 100% view to get an accurate preview. Grain is very sensitive to resizing, sharpening and compression, so if you're going to downsize the photo when exporting, you'll need stronger grain. It won't reproduce well in this book, so try it on some of your own photos too.

ENHANCE DETAILS

While Lightroom's main tools are ideal for most photos, sometimes you'll come across a special photo that deserves the very best. Using advanced machine learning and millions of photos, the Enhance tool extracts the finest details, reduces artifacts and intelligently increases the resolution of your photos.

It's not a tool you'll need or want to use on every photo, as the resulting DNG files are huge and it takes extra time to run, but it's handy to have in your toolbox for special occasions. The Enhance dialog has two options: Raw Details and Super Resolution.

When would I use Enhance Raw Details?

The *Raw Details* option is designed to extract additional detail from raw files at the initial demosaic stage of processing. Fuji X-Trans photographers, those who create very large prints, and photographers who like to view their photos at 100% view (affectionately known as pixel peepers) will see the greatest benefits.

It's primarily designed to improve the fine detail in Fuji X-Trans photos, reducing the "worm" effect that some photographers have reported. It can also improve some photos shot on Bayer sensors, especially if the camera doesn't have a low pass filter

and you're using a very sharp lens. However, on many other photos, where the standard demosaic is already extracting all of the available detail, you won't be able to see a difference.

To play spot the difference, you'll need to zoom into 100% or greater. You're most likely to see improvements in very fine details, less than 1px wide, especially if they're diagonals or curves, for example, hair or fur. Edges of different colors (especially orange against blue) may also become better defined, such as in a field of flowers or neon signs. Moiré patterns may also be reduced. I'd love to include some examples, but they're impossible to see in small prints.

How do I use Super Resolution to increase the resolution of my photos?

We'll learn about file resolution on page 423, but in short, when you enlarge a photo, it usually becomes more blurry because it's having to create new pixels. **Super Resolution** uses the intelligence gained through analyzing thousands of pairs of photos to preserve greater detail while doubling the size of your photo. **(Figure 15.92)**

It's particularly useful if you're creating very large prints, or you've had to crop heavily. It also works well if your camera has a low megapixel count, for example, a mobile phone camera or most older cameras.

You'll see the greatest benefits when using a raw photo captured with a sharp lens. Lightroom automatically uses the Raw Details demosaic to extract extra detail before increasing the resolution. Super Resolution also works on other image file formats, such as JPEGs, TIFFs and PSDs, but if the original is poor quality or has compression artifacts, these defects may be

enhanced.

The resulting photo has twice as many pixels in each direction, so four times as many pixels overall. For example, a 16MP photo becomes a 64MP photo. Huge!

The enhanced DNG must still fit within Lightroom's maximum file size, so the original can be no more than 32,500 pixels along the longest edge and no more than 128 megapixels before applying Super Resolution. You're unlikely to hit these limits unless you're enhancing a large merged panorama. If you do hit the limit, Lightroom

displays an error message.

How do I apply the Enhance tool to my photos?

To use Enhance, select one or more photos, right-click and choose *Enhance*. You'll also find it under the Photo menu, or the keyboard shortcut is Ctrl-Alt-I (Windows) / Cmd-Opt-I (Mac). (Figure 15.93)

There are checkboxes for *Raw Details* and *Super Resolution*, as you may not always need to use both.

Figure 15.92 Enhance Super Resolution (right) retains much more detail when increasing resolution, compared to the standard Bicubic Sharper algorithm (left).

Figure 15.93 Enhance can extract additional detail at the same time as increasing image resolution.

The Enhance dialog includes a small preview window, so you can check that the extra processing will be beneficial before running the conversion. Click on the preview to show the "before" version or drag on the preview to view a different area of the photo.

If multiple photos are selected, the dialog only shows a preview for the first photo, but still processes them all. If you want to bypass the dialog and use the same settings as last time, add Shift to the keyboard shortcut.

This advanced processing is very processor intensive, so the Enhance tool saves the result as a separate linear DNG file. If you find that you're using it frequently, a fast GPU optimized for machine learning (Windows ML/Core ML) can significantly improve processing times.

The DNG file is stored next to the original. and -Enhanced is added to the file name. If you check Create Stack, the original and enhanced files are automatically stacked too. Lightroom automatically copies all of the metadata and Develop edits already applied from the original to the new enhanced file. You may need to tweak your Sharpening, Noise Reduction and Texture settings, especially if you've used Super Resolution.

The original image data is also stored within the DNG file, so even if you delete the original file, you can run Enhance again in future when the Artificial Intelligence improves further. Other raw processing software won't be able to understand the enhanced portion of the DNG file, but can still access the standard raw data. As a result, other software may still report the original pixel dimensions, even if you used Super Resolution.

Be warned, the resulting file sizes are huge. For example, a 16MP raw file started out at 15.8 MB. With Raw Details applied, it became 76.7 MB and adding Super Resolution made it a whopping 243.6MB!

PHOTO MERGE

The Photo Merge feature allows you to stitch together multiple photos into panorama or create a high dynamic range

(HDR) file from multiple images.

How do I stitch a panorama?

- **1.** Select a series of photos. The order of the photos in the Filmstrip doesn't matter, as Lightroom matches the photos visually. This means you can even stitch multi-row panoramas. (Figure 15.94)
- **2.** Go to *Photo menu > Photo Merge > Panorama*. The Photo Merge options also appear in the right-click menu in the Grid and Filmstrip, which is useful when you're working in the Develop module.
- **3.** Select a projection mode that looks good. The Merge preview is low resolution for speed, so you can resize the dialog or zoom in slightly, but you can't zoom in to a full 100% view.

- **4.** Check the *Auto Crop* checkbox to remove the blank white space, or use *Boundary Warp* or *Fill Edges* to fill the white space.
- **5.** Check *Create Stack* to automatically group the merged photo with its originals.
- 6. Press Merge. (Figure 15.95)
- **7.** The resulting photo is stored in the same folder as the originals and automatically imported into Lightroom, where you can edit it in Develop as a normal photo.

How do I create an HDR file?

When the camera's sensor isn't capable of capturing detail in both the lightest and darkest tones, you can take a series of shots with bracketed exposures and blend them in Lightroom.

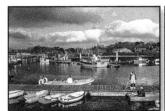

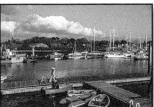

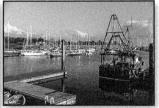

Figure 15.94 Select multiple photos to merge into a panorama.

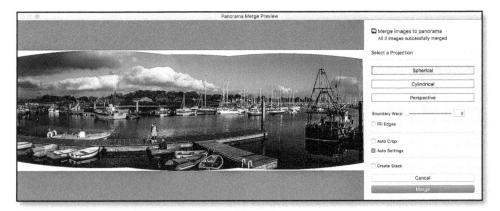

Figure 15.95 Select the merge options in the dialog.

- **1.** Select a series of bracketed photos. In most cases, select just two photos—one for the highlights and one for the shadows. (Figure 15.96)
- **2.** Go to Photo menu > Photo Merge > HDR.
- **3.** Check the Auto Align and Auto Tone checkboxes.
- **4.** If there's movement in the photo (e.g. water), try the *Deghost* options until you find the one that gets the best result. If there's no movement, leave it set to *None*.
- **5.** Check *Create Stack* to automatically group the merged photo with its originals.
- 6. Press Merge. (Figure 15.97)

Figure 15.96 Select two photos to merge into an HDR file.

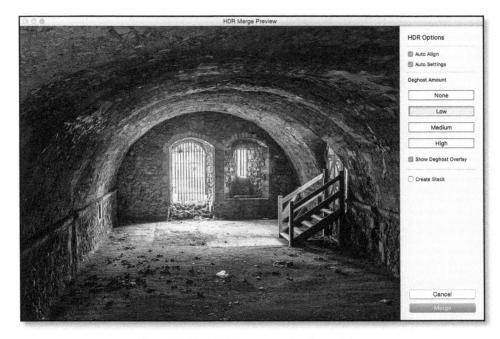

Figure 15.97 Select the merge options in the dialog.

- **7.** The resulting HDR photo is stored in the same folder as the originals and automatically imported into Lightroom, where you can edit it in the Develop module. You'll note that the *Exposure* slider now runs from -10 to +10 instead of -5 to +5.
- **8.** The *Photo Merge > HDR Panorama* option works in the same way as the individual controls, but creates an HDR panorama out of bracketed images.

How do I merge multiple sets of photos at once?

If you have a larger number of photos to merge, you can queue them up and walk away.

- **1.** Stack each set of photos (page 107).
- **2.** Ensure that all of the stacks are collapsed, by going to *Library menu > Stacking > Collapse All Stacks*.
- **3.** Select the first stack and go to *Photo* menu > *Photo Merge* > *Panorama*, HDR or HDR *Panorama*.
- **4.** Set your chosen settings in the HDR or Panorama Merge dialog and merge that first stack.
- **5.** Select all of the other stacks that require merging using the same settings and start the merge. Any loose photos in the selection are automatically ignored when there's at least one collapsed stack selected.
- **6.** Lightroom queues up the merges, showing the progress in the Activity Center.

Why use Lightroom for merging instead of Photoshop or other software?

In External Editors, we'll briefly discuss the Edit In > Merge to HDR Pro and Merge to Panorama using Photoshop, which was Adobe's older merge method. Photoshop's Merge to Panorama is still useful for merging rendered files (e.g. JPEGs) as it gives you greater control over the blending, but Lightroom's new merge has a distinct advantage when working with raw files.

Photoshop and other software have to partially convert the raw data before merging, reducing the possible dynamic range and applying the white balance. This affects the image quality.

When the merge is performed on the raw image data, as Lightroom now offers, the resulting file has all the editing flexibility of the original raw files. It is demosaiced, so it's no longer in the original sensor format, but it's still scene-referred data so you have full control over the white balance as well as a much wider dynamic range.

There are still some cases where you might want to use other software. For example, for tricky panoramas, dedicated software such as Hugin may get a better result. Also, Lightroom creates fairly natural looking HDR files, but you may prefer the surreal HDR style that dedicated HDR software produces.

What type of files do I need for merging?

There are a few requirements for the source files. The files must be:

- All the same file type (raw or rendered). Raw files create significantly better results.
- Smart previews will work, but the resulting merge is smaller, so it's better to

use the originals.

- All shot on the same camera (required for HDR, but best for panoramas too).
- Metadata containing at least the exposure time for HDR.

There are a couple of shooting tips that can help you get the best merge result:

- For the best results, use a tripod to ensure the photos are correctly aligned, especially when shooting HDR sets.
- Overlap panorama sections by around 30% so they blend smoothly, and shoot panoramas with a 20mm-50mm lens in Manual mode to avoid significant lens distortion and exposure differences (although Lightroom does attempt to normalize the exposure for raw files).

What format are the merged files?

The merged files are stored as 16-bit DNG files. Lightroom automatically names the merged file using the name of the active photo and it adds -Pano or -HDR to the end of the filename to help identify them. (Make sure you keep this Pano/HDR ending, as it's currently the only way to filter for these files.)

In the case of HDR images, the files don't need the full 32-bit depth used for Photoshop HDR merges as the pixel data is stored as floating-point data. This makes it possible to store the image values accurately across a huge contrast range without such a huge file size.

Panoramic images have to be no more than 65,000 pixels along the longest edge or 512 megapixels (whichever is smaller) to fit within ACR/Lightroom's maximum, so Lightroom automatically downsizes any

panoramas that would fall outside these limits when creating them.

Should I edit the photos before I merge them?

There's no benefit to editing the photos before you merge them as the data remains scene-referred (assuming it's a raw file in the first place). This means you can edit the file after it's merged without any loss of quality.

There are two exceptions when merging panoramas—lens corrections and sensor dust.

Lightroom applies the default lens profile and chromatic aberration correction to the raw data before merging the panorama to get the best result, whether you've enabled it for the selected files or not. If Lightroom doesn't automatically select the right profile for your lens, turn back to page 339 and save a default profile before merging.

Dust or sensor spots appear in the same place on every image, and retouching them individually can take a long time on a huge panorama. You can fix your dust spots on one photo, sync the corrections to the other photos, and they'll be applied during the merge process.

One thing to note is that these lens corrections and spot corrections are 'baked in' to the resulting merged image data, so you can't go back and edit them in the finished panorama. Spots that only need to be removed on a single image are best left until the finished merged image is available.

If you do choose to edit the photos before merging, Lightroom automatically copies some of the Develop settings from the active photo onto the merged photo. It skips things like the crop, geometric corrections and masks as they may not end up in the right place on the merged photo.

Let's take a closer look at some of the merge options.

What's the difference between the Panorama projection options?

There are three projection options: (Figures 15.98 & 15.99)

Spherical aligns and transforms the photos as if they were mapping the inside of a sphere. If you've taken a 360° panorama, this is usually the best choice.

Cylindrical displays the images as if they're on an unfolded cylinder, using the middle image as the reference point and transforming the photos where they overlap. It reduces the bow-tie type distortion you can get with Perspective. It works well on wide panoramas.

Perspective uses the middle image as the reference point and transforms the other images where they overlap, but it can result in a bow-tie type distortion.

How do I fill in the white areas around the edges?

When you create a panorama, you end up with blank areas around the edges. You have a few options, and each has pros and cons:

- **1.** Crop the photo to remove the white areas. To do so automatically, check the **Auto Crop** checkbox. All of the pixel detail is retained and you can use the Crop tool to reset or edit the crop later in the Develop module. It's the most accurate option, but obviously loses some of the photo.
- **2.** Use **Boundary Warp** to analyze the image and warp it to fill the empty space. It has a slider ranging from 0-100, so you can choose how far to warp the image. **Boundary**

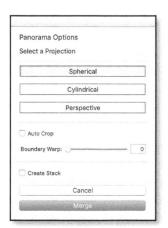

Figure 15.98 Panorama Options.

Figure 15.99 There are three projection options—Spherical (top), Cyclindrical (center) and Perspective (bottom).

Warp doesn't require an additional rendered file and doesn't create artifacts, but straight lines can get a little wobbly as the photo is warped.

3. Fill Edges doesn't warp the photo, so your lines stay straight, and it doesn't require creating an additional file, but its intelligence is limited, so it may create artifacts and blending problems. (Figure 15.100)

The results will vary depending on the content of the photo and the amount of white areas that need filling. Photos merged using *Spherical* or *Cylindrical* usually work better with *Fill Edges* than *Perspective* mode, simply because there are fewer pixels to make up.

In many cases, the best solution is a mix of tools: bend it a little using *Boundary Warp*, fill in what's left with *Fill Edges*, and crop away any distorted areas. If you have a photo that doesn't work well with those solutions, then you'll need to take it to Photoshop and give the technology a helping hand yourself.

Where are the HDR editing options?

Many photographers use the term HDR to describe a specific surreal style of editing, but think about the letters HDR... they stand

for high dynamic range.

There are two stages to the process:

- **1.** Merging multiple source files to create a single image with a much higher dynamic range. The result is an HDR file.
- **2.** Manipulating the high dynamic range data to compress it into a lower dynamic range suitable for viewing on a screen or print. The result is a normal photo with a specific style of editing applied.

Most HDR software combines these two steps, allowing you to merge the files into an HDR image, apply your chosen style and output that photo with a low dynamic range.

Lightroom splits this process into its separate stages, first merging the photos into an HDR image, and then tone-mapping this image in the Develop module before outputting the photo. This allows you to go back and change the look of the photo non-destructively at a later date without having to merge the original images all over again.

How many photos should I select for an HDR file?

Unlike most HDR software, Lightroom works best with as few source images as

Figure 15.100 Fill edges has introduced blending problems in this example.

possible. In most cases, this is only two raw files—one correctly exposed for the highlights and one correctly exposed for the shadows. As Lightroom's working with the raw data, it doesn't need the images in between, and additional images actually increase the risk of misalignment and ghosting.

If the images are more than 3 stops apart, add one or more additional images in between to reduce noise, ideally shot on a tripod to avoid introducing ghosting, for example:

- -1.5 to 1.5 = 2 exposure (-1.5, 1.5)
- -3.0 to 3.0 = 3 exposure (-3, 0, 3)
- -4.5 to 4.5 = 4 exposure (-4.5, -1.5, 1.5, 4.5)
- -6.0 to 6.0 = 5 exposure (-6, -3, 0, 3, 6)

There's no point trying to do a 'fake HDR' using a single file, because you won't gain any additional dynamic range.

Should I check Auto Align and enable Deghost?

There are a couple of options available in the HDR Preview dialog. (Figure 15.101)

Auto Align is worth checking if the photos were shot handheld and may not be perfectly aligned. If the photos were shot using a tripod and remote release, with no risk of movement, you can leave it unchecked.

The **Deghost** options are needed if there's a moving subject in the photo, for example, water or trees, as these can creates ghosts when photos are merged. There are three levels to choose from—Low, Medium or High—and they control how sensitive Lightroom is to movement in the photo. The High setting is much more aggressive, whereas Low just picks up significant ghosting.

Check the **Show Deghost Overlay** checkbox to see which areas are affected by the deghosting, and remember to check them in the finished photo to ensure the deghosting hasn't introduced additional noise or sharp edges. **(Figure 15.102)**

How do I edit the HDR file after merging?

Auto Tone is applied to the preview to give you an idea of the tonal range before merging. Once the photo's merged, you can

HDR Options
Auto Align
, E
Auto Settings
Deghost Amount
None
Low
Medium
High
Show Deghost Overlay
Create Stack
Cancel
Merge

Figure 15.101 HDR options

Figure 15.102 Check the Deghost Overlay to see which areas are being taken from a single photo to minimize ghosting.

edit it in the Develop module. The resulting file has a much greater range of data with more highlight headroom and shadows with less noise. The Exposure slider runs to +10/-10 instead of +5/-5, and the Highlights and Shadows sliders have a greater range. If you need to push the Highlights or Shadows further than +/- 100, you can paint on greater values using masks such as the brush or a gradient.

DEVELOP ADVANCED SHORTCUTS

		Windows	Mac
Tone Curve	Constrain drag to vertical only	Hold Shift while dragging up/down	Hold Shift while dragging up/down
	Slow down movement	Hold Alt while dragging point	Hold Opt while dragging point
Black & White	Toggle Color / Black & White	V	V
Targeted Adjustment Tool	Tone Curve	Ctrl Alt Shift T	Cmd Opt Shift T
	Hue	Ctrl Alt Shift H	Cmd Opt Shift H
	Saturation	Ctrl Alt Shift S	Cmd Opt Shift S
	Luminance	Ctrl Alt Shift L	Cmd Opt Shift L
	Black & White Mix	Ctrl Alt Shift G	Cmd Opt Shift G
	Deselect TAT tool	Ctrl Alt Shift N	Cmd Opt Shift N
Sharpening/Noise Reduction	Show Mask	Hold Alt while moving sliders	Hold Opt while moving sliders
Enhance Details	Create Enhanced Copy	Ctrl Alt I	Ctrl Opt I
Lens Corrections	Apply Upright without clearing Crop/ Manual Transforms	Hold Alt while clicking Upright button	Hold Opt while clicking Upright button
	Cycle Upright options	Ctrl Tab	Ctrl Tab
	Cycle Upright options without clearing Crop/Manual Transforms	Ctrl Alt Tab	Ctrl Opt Tab
Soft Proofing	Show/Hide Soft Proof	S	S
	Destination Gamut Warning	Shift S	Shift S
Merge to HDR	with HDR dialog	Ctrl H	Ctrl H
	without HDR dialog	Ctrl Shift H	Ctrl Shift H
	Show overlay	0	0
	Cycle overlay colors	Shift O	Shift O
Merge to Panorama	with Panorama dialog	Ctrl M	Ctrl M
	without Panorama dialog	Ctrl Shift M	Ctrl Shift M

DEVELOP EDITING TOOLS

16

In the previous chapters, we've covered the types of changes you can make to your photos, but the

Develop module also includes a range of tools to make your editing quicker and easier. For example, you can sync your settings across multiple photos, save settings as presets to apply to other photos, update the default settings that are applied to new imports, undo changes that you've made and compare your edits against other versions of the photo.

COPYING SETTINGS TO SIMILAR PHOTOS

Lightroom is a workflow tool, so it's designed to work with multiple photos. If you shoot a series of photos in similar light, you may want to copy settings from one photo to the other similar photos. There are multiple ways to do this...

Sync

Sync uses the data from the active (lightest gray) photo, and pastes it onto all the other selected (mid-gray) photos. That's why there are three different levels of selection.

- **1.** Adjust the first photo, which is the source of the settings.
- 2. Keeping this photo active, also select

the other photos by holding down Ctrl (Windows) / Cmd (Mac) or Shift key while clicking directly on their thumbnails, rather than the cell borders.

3. Click the **Sync** button in the Develop module (Figure 16.1), or **Sync Settings** in the Library module, to show the Sync Develop Settings dialog.

Holding down the Alt (Windows) / Opt (Mac) button while pressing the *Sync* button synchronizes the settings but bypasses the dialog. It remembers which checkboxes were checked last time you accessed the dialog.

4. Select the checkboxes for the slider settings that you want to copy to the other selected photos, and then press *Synchronize* to transfer the settings.

Copy and Paste

The *Copy* and *Paste* buttons allow you to copy settings into memory, and then paste them onto individual photos.

1. Adjust the first photo, which is the source of your settings.

Figure 16.1 The Sync button is at the bottom of the right panel group.

2. Click the **Copy** button in the Develop module. (**Figure 16.2**)

Figure 16.2 The Copy and Paste buttons are at the bottom of the left panel group.

- **3.** Select the checkboxes for the slider settings that you want to copy.
- **4.** Press the arrow key on your keyboard to move to the next photo, or select a different photo in the Filmstrip.
- **5.** Click the **Paste** button to paste the settings onto the selected photo.

You don't have to copy all the settings. Sync and Copy/Paste both have dialogs allowing you to choose specific settings to transfer, so you may just sync Noise Reduction or White Balance, for example, without copying the Exposure settings. You may want to exclude things like Crop, Red Eye and Healing that are specific to the photo. (Figure 16.3)

Previous

The *Previous* button copies all the settings from the most recently selected photo to the current photo.

- 1. Adjust the first photo.
- **2.** Press the arrow key on your keyboard to move to the next photo, or select a different photo in the Filmstrip. (Don't view any photos in between, as it takes the settings from the previously selected photo).
- **3.** Press the **Previous** button to paste the settings onto the selected photo. (Figure 16.4)

There's one exception—if you're moving from a photo with no crop, to a photo with an existing crop, the crop is not reset.

Figure 16.4 The Previous button only shows at the bottom of the right panel group when a single photo is selected.

	Synchron	ize Settings		
Treatment & Profile Basic White Balance Exposure Contrast Highlights Shadows Whites Blacks Texture Clarity Dehaze Vibrance Saturation Tone Curve HSL/Color Check All Check None	Color Grading Detail Sharpening Luminance Noise Reduction Color Noise Reduction Color Noise Reduction Remove Chromatic Aberration Enable Profile Corrections Distortion Vignetting Transform Upright Mode Upright Transforms Manual Transform	Effects Post-Crop Vignetting Grain Healing Crop Streighten Angle Aspect Ratio Process Version Calibration	☑ Masking ☑ Mask 1 ☑ Sky Mask	onize

Figure 16.3 In the Copy and Sync dialogs, check the settings you want to transfer to the other photos.

Auto Sync

By default, even if multiple photos are selected, your slider adjustments only apply to the active photo. If you want your adjustments to apply all of the selected photos, you can enable *Auto Sync*.

- 1. Select multiple photos.
- **2.** Toggle the switch next to the Sync button so that the label changes to **Auto Sync** and the button is highlighted. (**Figure 16.5**)
- **3.** As you adjust the photos, all the selected photos update with any slider adjustment at the same time. Note that it can be slow for large numbers of photos, particularly when used with the Crop or Masking tools.

Auto Sync is powerful but dangerous, as it's easy to accidentally apply a setting to multiple photos without realizing that they're all selected. It gets particularly confusing if you often switch between standard Sync and Auto Sync, so you may find it easiest to leave it turned on at all times, or at least leave the Filmstrip visible so you can see the number of photos that are selected.

As an extra safeguard, an overlay displays how many photos are affected by each edit, but if you find it distracting, you can disable it in *Preferences > Interface tab > Show Auto Sync notifications*.

When you have *Auto Sync* enabled, you can still use the keyboard shortcuts for the other sync options such as *Previous*, *Paste* or standard *Sync*, but they apply to ALL selected photos, not just active photo.

Figure 16.5 Auto Sync can be enabled by clicking the switch to the left of the Sync button.

Why won't my white balance sync?

There's one quirk that trips everybody up when syncing settings. Your white balance is perfect on photo A, so you sync the settings to photo B... but it doesn't change. So you try it again... and it still doesn't change. Why?

As Shot is the key. If photo A is set to As Shot white balance, photo B is also then set to As Shot, not the same numerical values. To solve it, select Custom from the white balance pop-up, or shift the values slightly, and then sync with photo B, and your numerical values will be copied.

Can I make relative adjustments, for example, brighten all selected photos by 1 stop?

Imagine you've processed a series of photos, each with different settings, and then you decide you would like them all 1 stop brighter than their current settings. The first photo is set to -0.5 exposure, the next is 0 exposure, and the third is +1 exposure.

You could use Synchronize Settings, but that would move the sliders of the selected photos to the same fixed value as the active (most-selected) photo. Instead, you need relative adjustments, relative to their current settings.

You can't make relative adjustments directly within the Develop module, but you can do so using the Quick Develop panel in the Library module.

Select the photos and make sure you're viewing the Grid view, so that your changes apply to all selected photos.

By default, the Quick Develop is collapsed, so only a few of the buttons are available. Click the disclosure triangles to expand the full panel, then press the buttons to adjust

the sliders. (Figures 16.6 & 16.7)

The double-arrow buttons move in large increments, and the single-arrow buttons move in smaller increments. For even smaller adjustments, hold the Shift key while pressing the single-arrow buttons. Sharpening and Saturation don't have buttons of their own, but they appear when you hold down the Alt key (Windows) / Opt key (Mac).

If some of the buttons are unavailable, your selected photos include a video or a mix of process versions.

What does Match Total Exposures in the Settings menu do?

While we're on the subject of synchronizing settings, let me introduce you to Match Total Exposures. It's a little-known command found under the Settings menu in Develop, and it's very useful. It intelligently adjusts the exposure value to compensate for variations in camera settings.

Where photos are shot in the same lighting. but on Aperture Priority/AV, Shutter Priority/TV or Program, it results in varying exposure values. This clever command

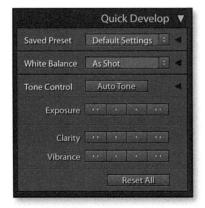

Figure 16.6 The Quick Develop panel is collapsed by default.

calculates and adjusts the exposure on all selected photos to end up with the same overall exposure. It doesn't adjust for the sun going behind a cloud though!

To use it, correct the exposure on a single photo, then select other photos taken at the same time in the same light. In the Develop module, go to Settings menu > Match Total Exposures. The photos are automatically adjusted to match the overall exposure of the active photo, taking into account the variation in camera settings. You'll also find it in the Library module under Photo menu > Develop Settings, so you can apply it from Grid view.

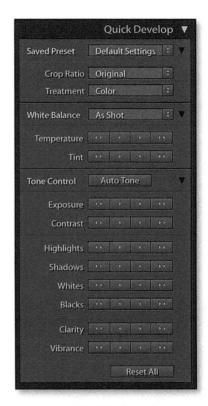

Figure 16.7 Click the disclosure triangles to view additional buttons.

PRESETS—SAVING SETTINGS TO APPLY TO OTHER PHOTOS

Presets save sets of settings to apply to other photos over and over again. They simply move sliders to preset positions.

Some presets ship with Lightroom, so you can experiment with them before creating your own presets.

How do I preview and apply a preset?

To view the Presets, go to the Presets panel on the left in Develop. (Figure 16.8)

As you float the cursor over the preset names, Lightroom displays a preview in the Navigator panel above. If *Preferences > Performance tab > Enable hover previews of presets in Loupe* is checked, it also temporarily updates the main image preview, but some people leave it unchecked to improve performance.

To apply the preset to your photo, simply click on the preset name.

The **Amount** slider at the top of the Presets panel allows you to scale the preset, either fading or amplifying the effect. Not all settings are scalable, for example, it wouldn't make sense to partially apply geometric correction, or checkboxes like *Remove Chromatic Aberration*. Any settings that aren't scalable are applied using whatever value was saved in the preset, regardless of the *Amount* slider value.

To apply a preset to multiple photos, it's easiest to select all the photos in Grid view and choose your preset from the pop-up in the Quick Develop panel. Anything you do in Grid view applies to all the selected photos.

Figure 16.8 Develop presets are stored in the Presets panel.

Why is the Amount slider disabled?

You can go back and adjust the preset's *Amount* slider until you apply another preset or until you override one of the settings set by that preset, for example, by adjusting the *Grain Amount* on a grain preset.

For some presets, however, the Amount slider is never available because Support Amount Slider checkbox was disabled when the preset was created or updated.

How do I create my own preset?

If there are certain combinations of sliders you use over and over again, you can save them as a preset.

- **1.** Adjust a photo to the settings that you want to save as your preset.
- **2.** Press the + button on the Presets panel and select *Create Preset* to show the New

		New Dev	elop Preset	
Preset Name: Group: Auto Settings Auto Set	Untitled Presets User Presets			Θ
☑ Treatmen ☑ Basic	b Balance sure rast lights own ss ss ss ree ry Ze noe attion	✓ Color Grading ✓ Detail ✓ Sharpening ✓ Luminance Noise Reduction ✓ Color Noise Reduction ✓ Color Noise Reduction ✓ Remove Chromatic Aberration Enable Profile Corrections ✓ Instanting Transform Upright Mode Upright Transforms Manual Transform	 ☑ Effects ☑ Post-Crop Vignetting ☑ Grain ✓ Process Version ☑ Calibration 	Masking Mask 1 Sky Mask
Advanced Sett Support Am Create ISO a	ount Slider Lear	n More Learn More		Cancel Create

Figure 16.9 Create a new preset by pressing the + button on the Presets panel and checking the sliders you want to include in the preset.

Develop Preset dialog. (Figure 16.9)

- **3.** Check or uncheck the sliders you want to save in your preset. If a checkbox is unchecked, that slider won't be adjusted when you apply your preset to another photo. For example, if your preset is just for Sharpening settings, uncheck the other checkboxes and only leave the *Sharpening* checkbox checked.
- **4.** Check the **Support Amount Slider** checkbox if it's available, unless you want to prevent the preset from being scaled.
- **5.** Give your new preset a name. If you try to reuse the name of an existing preset, Lightroom asks what to do. *Replace* overwrites the existing preset. *Duplicate* creates a new preset with exactly the same name as the existing preset, however this could rapidly become very confusing! *Rename* takes you back to the Create New

Preset dialog to type a different name for the new preset.

- **6.** Select an existing group to keep similar presets together, or select *New Group* from the *Group* pop-up to create a new one.
- **7.** Press the *Create* button. Your preset now appears in the Presets panel, ready to apply to other photos.

Why can't I check the Support Amount Slider checkbox?

The Support Amount Slider checkbox is only available when Auto Settings and Auto B&W checkboxes are unchecked, and at least one of the other settings is scalable.

For reference, the scalable settings are: White Balance, Exposure, Contrast, Highlights, Shadows, Whites, Blacks, Texture, Clarity, Dehaze, Curves, Sharpening Amount,

Luminance Noise Reduction Amount, Color Noise Reduction Amount, Color Mixer, Color Grading (Hue/Saturation/Luminance but not Blending or Balance), Grain Amount, and Vignette Amount. Don't worry about remembering that list though, as Lightroom automatically disables the checkbox if none of the settings are scalable.

How do I create an ISO adaptive preset?

Most presets contain a single set of settings, however it's possible to create an ISO adaptive preset that applies different settings depending on the ISO of the selected photo. This is particularly useful if you like to apply additional noise reduction to higher ISO photos, and don't want to have to create multiple presets.

The steps are almost identical to creating a standard preset, with a couple of exceptions:

- Rather than selecting a single photo, you select and adjust multiple photos, one per ISO. For example, you might select ISO 200, 1600 and 6400. Settings for the ISO values in between are interpolated automatically.
- Check the **Create ISO adaptive preset** checkbox at the bottom of the New Preset dialog.
- Add ISO to the name of the preset to remind you that it's adaptive. If you update an adaptive preset with only a single photo selected, it reverts to a standard preset.

How do I install downloaded Develop presets?

A whole community has sprung up online, sharing and selling Lightroom Develop presets. They can offer a good starting point for your post-processing, or more often, some weird and wonderful effects.

There's a few different options for installing presets, depending on preset format and your settings.

Automatic installation

If you're installing a small number of presets from a single folder, the automatic method is quick and easy.

- **1.** Click the + button on the Presets panel and choose *Import Presets*. (The *File menu* > *Import Develop Profiles and Presets* command is similar but can't import the older *.lrtemplate format presets.)
- **2.** Navigate to the individual presets or a zip file containing the presets, select them and press the *Import* button.
- **3.** The presets appear in the Presets panel, ready for use.

If you selected a zip file and Lightroom says Unable to import presets. There are no items to be imported in the zip file, the presets are probably the older *.Irtemplate format. Double-click to unzip the zip file and select the individual presets for import.

Manual installation of *.xmp format presets

Automatically imported presets are placed in the *Camera Raw / Imported Settings* folders in your user account, which is not helpful if use your catalog on multiple computers (page 489). To avoid this issue, you can install the presets manually.

- **1.** Unzip the presets if they're zipped.
- **2.** Go to *Preferences > Presets tab* and press the *Show Lightroom Develop Presets* button.
- **3.** Drag (or copy/paste) the presets into the *Settings* subfolder

4. Restart Lightroom.

Manual installation of *.lrtemplate format presets

If you've downloaded a set of presets that are organized into multiple folders, install them manually to retain that folder organization, otherwise they'll all be placed in the User Presets group.

- **1.** Unzip the presets if they're zipped.
- **2.** Go to *Preferences > Presets tab* and press the *Show All Other Lightroom Presets* button.
- **3.** Double-click on the selected *Lightroom* or *Lightroom Settings* folder.
- **4.** Drag (or copy/paste) the presets into the *Develop Presets* subfolder, still in their folders if you'd like to keep them organized in the same way.
- 5. Restart Lightroom.

What's the difference between *.lrtemplate presets and *.xmp presets?

Presets created in Lightroom Classic 7.2 and earlier were written in a language called Lua and stored as *.Irtemplate files. Presets created in newer Lightroom versions are written in a language called XML and stored as *.xmp files, for better compatibility across the ecosystem.

Lightroom automatically converts older *.lrtemplate presets to the newer *.xmp format on opening, and appends a tilde (~) to the beginning of the *.lrtemplate preset filename so it doesn't try to convert them again.

Why are some presets in italic? Or why are some presets missing on some photos?

Some presets may not be fully compatible with the selected photo. For example, by default, a preset that applies the *Adobe Color* profile is hidden when viewing a JPEG image, because the *Adobe Color* profile isn't available for JPEG images. Likewise, presets that apply a Canon camera profile may not be visible when a Fuji photo is selected.

If you check *Preferences > Presets tab > Show* **Partially Compatible Develop Presets**, these partially compatible presets display in the Presets panel as italic/dimmed text. The partially compatible presets can then be applied to any photo, but the resulting look may be different. **(Figure 16.10)**

Can I apply multiple presets to the same photo, layering the effects?

Presets only move a slider to a new position. They don't calculate new settings relative to the current slider settings.

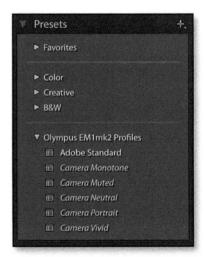

Figure 16.10 Partially compatible presets are shown as dimmed italic when the preference is checked, or they disappear completely when unchecked.

If Preset A only adjusts, for example, the *Exposure* and *Contrast* sliders, and Preset B only adjusts the *Vibrance* slider, all of the settings are applied to the photo.

If the presets change the same sliders, for example, Preset A sets the *Exposure* to -1 and then Preset B sets the *Exposure* to 0, then the changes made by the first preset are overwritten by the second preset.

How do I organize my presets into folders or groups?

Many photographers are now overflowing with presets that they've created or downloaded, and it can be difficult to find the one you're looking for.

You can create a group of presets while creating the preset by selecting *New Group* from the *Group* pop-up. To create a group for existing presets, right-click on the preset and select *Move*, then select *New Group* from the pop-up.

Once you've created your group, you can drag and drop presets onto it. You can only drag one preset at a time, so it's worth getting the organization right at the outset!

You can't rename a preset group, however you can create a new group with the right name and drag the presets into the new folder. The group with the wrong name will automatically disappear once it's empty.

How do I update, rename or delete Develop Presets?

To edit or update a preset, set the photo to the settings of your choice (as you did when creating it) and then right-click on a preset in the Presets panel and choose **Update** with Current Settings. Check or uncheck the sliders you want to save in your updated preset. If a checkbox is unchecked, the slider

value isn't saved with the preset.

To rename a preset or a preset group that you've created or purchased, right-click on it and select **Rename**. Renaming the preset file manually in Explorer (Windows) / Finder (Mac) doesn't work because the preset name is embedded in the file itself.

To delete one of your presets or preset groups, right-click on it and choose **Delete/ Delete Group**. If you think you might want to use the presets again in future, you can just hide the group.

How do I hide presets I don't use very often?

It's easy to end up with too many presets, especially if you like to download presets. To reduce the clutter, you can temporarily hide groups that you don't use frequently.

In the Presets panel, click the + button, select **Manage Presets** and uncheck any groups you want to hide. (Figure 16.11)

To show the hidden presets again, return to the same dialog and check the groups, or right-click on a preset group and choose **Reset Hidden Presets** to show them all.

Legacy Presets that shipped with older Lightroom versions, are now hidden by default, but can be re-enabled the same way.

How do I mark some presets as favorites?

If there are some presets you use frequently, right-click on them and select **Add to Favorites**. A new *Favorites* group appears at the top of the Presets panel, providing easy access. To remove presets, just right-click again and select *Remove from Favorites*.

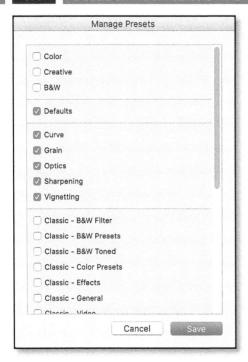

Figure 16.11 Sets of presets can be hidden.

Why won't Lightroom let me rename, move or update a preset?

Some developers use a cluster to keep their presets together. Clusters are separated from other groups of presets using a dividing line.

Clustered presets can't be renamed, moved into other groups or updated using Lightroom's Presets panel, so they're a little more protected than other presets.

If you're a preset developer, open your presets in a text file and enter your brand name in the crs:Cluster="ClusterName" line of each preset to group them in your cluster.

How do I share my presets?

If you've created a really good Develop preset, you may want to share it with other Lightroom users. To do so, right-click on the preset/preset group and select **Export/ Export Group**, then select a folder on your hard drive. Exporting a whole preset group automatically zips the presets for you, ready for you to send.

Alternatively, you can right-click on a preset and select *Show in Explorer* (Windows) / *Show in Finder* (Mac). This takes you directly to the current template location, ready to copy to another computer.

DEFAULTS

Default settings are automatically applied to raw photos when you import them. Adobe sets the original default settings, but you can change them to suit your own taste. The defaults you set in Lightroom are also used by ACR (Camera Raw) in Photoshop/Bridge, and vice versa.

Why would I change the default settings instead of using a preset?

You could apply a Develop preset in the Import dialog instead of changing the defaults, but the defaults have a couple of additional benefits:

- The defaults can automatically select the camera matching profile, to emulate the picture style you selected in the camera at the time of shooting.
- The defaults can be set for specific camera models or even specific camera bodies, whereas presets apply to all of the photos being imported.
- The default settings also apply any time you press the *Reset* button or double-click on a slider label, whereas the resetting a photo imported with a preset resets to Adobe's defaults.

• The default settings only apply to newly imported photos that don't have existing settings stored in XMP, whereas a preset would override these existing settings.

How do I set custom defaults?

To set your own defaults, go to the *Preferences dialog > Presets tab*. Select the default of your choice in the *Global* pop-up. This applies to all newly-imported raw photos, unless they already have settings stored in XMP, or unless you override the *Global* defaults using camera-specific defaults or an import preset. (Figure 16.12)

To set a camera-specific default:

- **1.** Check the **Override global setting for specific cameras** checkbox to show the camera-specific options.
- 2. Select the camera from the *Camera* popup. It automatically lists all of the cameras used to capture raw files found in this catalog. If you check the *Show serial number* checkbox, it also shows the individual camera bodies.
- **3.** Using the **Default** pop-up, select your chosen default, for example, a preset you've

created for this particular camera body.

4. Click *Create Default* to confirm. The table to the right shows all of your cameraspecific defaults. The arrow at the end of each line displays a menu, allowing you to change or delete the custom default.

What's the difference between Adobe Default, Camera Settings and Preset?

There are three options for the defaults:

Adobe Default uses the normal default settings (e.g., Adobe Color profile, Sharpening 40, Color Noise Reduction 25, 0's for everything else). If you're happy with these defaults, you can leave the custom defaults alone.

Camera Settings recognizes the picture style you selected in the camera and applies the matching camera profile, if it's available. This is particularly useful if you use a compact or mirrorless camera, since the picture style is what you see in the viewfinder. In some cases, such as the Nikon Z6/Z7, the camera writes additional Lightroom settings (such as custom sharpening) into the image files, so these settings are also applied.

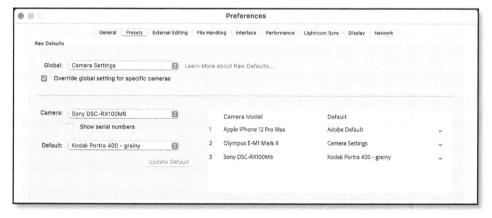

Figure 16.12 Custom defaults are now set in Preferences.

Preset applies the preset of your choice. This is useful if, for example, you apply a little *Texture*, *Clarity* and a gentle *Post-Crop Vignette* to every single photo. It saves you having to remember to select the preset in the Import dialog.

If you're going to use presets for defaults, I'd suggest grouping the presets into a preset group called *My Defaults*. Once you've set the defaults, you can hide the preset group (page 375) so you don't accidentally change or delete the presets. Adobe's created a few presets to get you started, grouped into their own set called *Defaults*.

How do I apply different defaults settings to each ISO?

You may wish to apply different settings, for example, noise reduction, depending on the ISO of the photo. To do so, create an ISO adaptive preset (page 373), and set that preset as the default.

What happens if my preset only applies certain settings?

If you select a preset as your cameraspecific default, but that preset only applies specific edits (for example, it just turns on lens corrections), the other sliders revert to the *Camera Settings* default, not the default selected in the *Master* pop-up.

HISTORY & RESET

Because Lightroom's edits are stored as metadata, you can easily undo any of the adjustments.

As in most programs, Ctrl-Z (Windows) / Cmd-Z (Mac) is the Undo command. When pressed repeatedly, it steps back through your recent actions, whether that's slider

movements, star ratings, or simply switching between modules. There are a few actions that can't be undone using these shortcuts, such as deleting photos from the hard drive, but the dialogs always warn if an action is not undoable using this shortcut.

Lightroom also keeps a record of all the Develop changes made to each photo. You can see this list in the History panel on the left in the Develop module. (Figure 16.13) You can try different settings without worrying, and then return to your earlier state if you don't like the result of your experiment.

To go back to an earlier version, click on an earlier history state in the History panel. If you make further changes, a new history is

History		×
Temperature	-50	5.3K
Black Clipping	+10	-10
Temperature	-200	5.3K
White Balance: Custom		
Tint	+45	4
Tint	-65	-41
Tint	+20	24
Temperature	-1.8K	5.1K
Temperature	+1.8K	6.9K
Post-Crop Vignette Hig	+100	100
Post-Crop Vignette Am	-15	-15
Clarity	-40	10
Contrast	+20	90
Shadows	0	40
Shadows	+20	40
Contrast	+20	70
Exposure	-0.10	0.43
Exposure	+0.40	0.53
Exposure	-0.20	0.13
Shadows	+20	20
Contrast	+20	50
Highlights	-20	-40

Figure 16.13 The History panel keeps track of the Develop changes you make, as well as any exports.

written from that point on, replacing the steps that followed.

Finally, if you don't like the results of your edits and want to start again, press the *Reset* button at the bottom of the right-hand panel group to reset the photo's settings back to their defaults. There are reset options for individual panels and sliders too. Let's explore further...

How long do the adjustments stay in the History panel?

Thanks to its database, Lightroom keep a per-photo list of the Develop steps you've taken to get to the current settings. Unlike Photoshop, the history remains in the catalog indefinitely, even if you close Lightroom. As long as you don't remove the photo from the catalog, you can come back months later and pick up where you left off, or go back to an earlier history state and carry on processing from there.

The **X button** at the top of the History panel clears the list of History states from the list, but it doesn't reset the Develop settings for the photo. It's useful if you've used a large number brush strokes, which are taking up a huge amount of space in the catalog and can increase RAM usage, but it's not usually necessary.

To clear the history states for multiple photos, select the photos and then go to *Develop menu > Clear History*. If more than one photo is selected, Lightroom asks whether to clear the history for the active photo or all of the selected photos.

The Develop History is linear, so you can't remove a single earlier history state. If you look at the numbers to the right, it tells you how far you moved the slider, and you can manually move the slider back by the same amount.

If you've been experimenting and decide to return to an earlier history state, you can leave the unused history states and they'll simply be overwritten when you next make an adjustment, or you can right-click on your earlier history state and choose *Clear History Above This Step* to remove them from the catalog.

How do I reset Develop settings?

To reset a photo back to default, press the **Reset** button at the bottom of the right-hand panel in the Develop module. If you've set custom default settings, you can reset the photo to Adobe's default settings using the **Adobe Default** preset in the *Presets panel* > Defaults group. (Figure 16.14)

To reset multiple photos back to your default settings, it's easier to switch to the Grid view in the Library module and press the *Reset All* button in the Quick Develop panel (or select it in the right-click menu > *Develop Settings*).

To reset a single slider to its default setting, double-click on the slider label. To reset a whole section within a panel, hold down Alt (Windows) / Opt (Mac) and the panel label changes to a *Reset* button for that section (e.g. *Reset Tone*), or double-clicking on that same panel label without holding down the

Figure 16.14 The Reset button sets the sliders back to your current default settings, which may be different to Adobe's default settings.

Alt (Windows) / Opt (Mac) buttons does the same.

BEFORE / AFTER PREVIEW

Once you've edited your photos, you'll want to see the results of your hard work. The Before/After Preview allows you to compare your current Develop settings with an earlier version, using your current crop settings. (Figure 16.15)

Press the \ key to toggle back and forth between before/after, or the Y key to see them side-by-side. The Y button on the Toolbar offers further options.

The Before/After preview excludes the crop settings, as different crops make it difficult to compare the other Develop adjustments.

How do I change the preview options?

By default, the Before/After preview displays side-by-side, but if you click the *Before / After Previews* button in the Toolbar (the one with Y's on it)—you'll see other options, such as side-by-side, top-and-bottom and split-view previews.

When would you use each option? Vertical side by side is useful for vertical photos, but

Figure 16.15 The Before and After views allow you to compare the results of your Develop adjustments.

hopeless for viewing wide panoramas, so click on the arrow to the left of the YY button and select *Before/After Top/Bottom* instead. (Figure 16.16) If you're comparing something like noise reduction or sharpening, one of the split options is more useful, as it splits the photo down the middle.

How do I select a different history state for the Before view?

By default, the *Before* view is the last time you read settings from the file's metadata state which is usually when the photo was imported.

You can choose any history step or snapshot to be the Before view. To do so, right-click on the history step or snapshot, and choose **Copy History Step Settings to Before** or **Copy Snapshot Settings to Before**. (Figure 16.17)

If you have the *Before* view on screen, you can also drag a history state from the History panel directly onto the *Before* preview, rather than going through the right-click menu. The key is dragging, rather than just clicking on the history state, as clicking would change the *After* view instead of the *Before* view. The arrowed buttons on the Toolbar allow you to swap the views

Figure 16.16 The YY button on the Toolbar allows you to change the display layout of the Before/After views.

Figure 16.17 Select a different Before view by right-clicking in the History panel.

currently on screen.

To revert the photo's settings to the *Before* state, because you liked the old settings better, click the first arrow icon.

To update the *Before* state to match the current *After* state, perhaps because you want to make further adjustments to the photo and compare them against the current state, click the second arrow icon.

To swap the *Before* state and the *After* state, click the icon with two arrows.

Can I turn off the effect of a whole panel's settings, to see the preview with and without these settings?

On the end of most panel headers in the Develop module, such as the Tone Curve panel, there's a toggle switch.

Figure 16.18 Use the toggle switch on panel headers to preview the image with and without that panel's adjustments.

(Figure 16.18) This switch temporarily enables or disables the sliders in the section, so you can preview the photo with and without the effect of panel's sliders. It not only affects the preview but also any photos you export. This also applies to the selective editing tools in the Tool Strip, which have a switch at the bottom left of their Options panel.

COMPARING PHOTOS IN REFERENCE VIEW

Like the Library module's Compare view, Reference View allows you to display two photos side-by-side, but it also allows you to edit one of the photos at the same time. (Figure 16.19)

This can be useful for:

- Matching photos shot at the same time using different cameras.
- Trying to match a raw file to its in-camera ipeg.
- Trying to match photos that will be

Figure 16.19 The Reference view makes it easy to compare photos while editing.

displayed together, perhaps on the wall or in an album.

- Replicating a "look" of a different photo.
- A skin tone reference shot (like an old-fashioned Kodak Shirley card).

You can use a Locked Secondary Window (page 95) for the same purpose, but Reference View is more useful if you're on a single monitor.

How do I display a photo in Reference view?

- **1.** Click the *R/A* button in the Develop module toolbar or press Shift-R to open Reference view. If you can't see the toolbar, press the T key to show it. (Clicking the R/A button again switches between side-by-side and top-and-bottom views.)
- **2.** Drag and drop the reference photo onto the left pane from the filmstrip, or right-click on a thumbnail in Grid view or the Filmstrip and select **Set as Reference Photo**.
- **3.** Go ahead and edit the active photo as you normally would.
- **4.** To switch back to normal single image view, click the Loupe icon in the toolbar or press D.

Why does the Reference photo keep disappearing?

The reference photo disappears when you switch modules, but if you lock the lock icon in the toolbar, the reference photo remains selected until you quit Lightroom.

VERSIONS—SNAPSHOTS & VIRTUAL COPIES

The before/after preview is great if you only want to compare two history states, but what do you do when you want to compare

multiple versions of a photo? You could keep switching between history states, but there's an easier option... snapshots and virtual copies.

If you want to experiment with different settings without overwriting your current version, you can create a virtual copy. Virtual copies show up in Lightroom as duplicate photos, and they have their own metadata and settings. They don't take up much more space on your hard drive as Lightroom doesn't need to duplicate the original image file.

To create a virtual copy, right-click and choose *Create Virtual Copy* or use the shortcut Ctrl-' (Windows) / Cmd-' (Mac). An additional copy appears next to the Master (the original file), and it has a small triangle in the corner of the thumbnail indicating that it's a virtual copy. It's automatically stacked with the original in the folder view. (Figure 16.20)

If you no longer want a virtual copy, you can delete it like any other photo. Deleting a virtual copy won't remove the original photo from the hard drive—only a Master can do that. It just removes that version of the metadata.

A snapshot is a special history state, which captures the slider settings at the moment of its creation. You can make changes to your photo, save it as a snapshot, make more adjustments, and then easily go back to the earlier snapshot state, even if you clear the History panel.

To create a snapshot, click the + button on the Snapshots panel, or right-click on a history state and choose *Create Snapshot*. (Figure 16.21) By default, it names the snapshot using the current date/time, but you might prefer to give it a more useful name such as "4x5 crop." To update, rename or delete it, right-click on it. To reselect a snapshot, just click on its name (but remember that any Develop changes will overwrite your history).

Virtual copies and snapshots are particularly useful for keeping different versions of your photos, for example, a color version, a black & white version, a special effect version, and different crops.

Figure 16.20 Virtual Copies can be identified by the triangular page turn icon in the corner of the thumbnail.

Figure 16.21 Snapshots capture the slider settings at the time of creation.

How do I choose whether to use a virtual copy or a snapshot?

There's a crossover in the two concepts, so you can decide which works best for you.

Both options are virtual, so they don't take up additional space on the hard drive, with the exception of the metadata, and also the preview for a virtual copy.

A virtual copy is treated like a separate photo, so they show in Grid view alongside the master and any other virtual copies. This means you can compare the different versions side by side in the Compare or Survey views.

You can do almost anything to a virtual copy that you can do to a master photo. For example, you can give it a different star rating, label, keywords, or other metadata. A new virtual copy starts off with a copy of most of the metadata and Develop settings from the original photo, but the History panel only shows a single History state. (Just remember that if you edit the original image file in other software, such as Photoshop, your edits apply to all versions of the photo.)

A snapshot is more like a bookmarked history state. A photo can only be in a single snapshot state at any one time. A photo with multiple snapshots only appears as one photo in Grid view, and there's no way of telling that there are multiple versions from the Grid view unless you use the Metadata Filters or a Smart Collection.

If you write metadata to the files, as well as the catalog (we'll come back to this in the XMP section on page 411), there's one more deciding factor: information about virtual copies is only stored in the catalog and can't be written to the files, whereas snapshot information can be written back to the files.

Figure 16.22 Set the Copy Name of virtual copies in the Metadata panel.

Can I rename virtual copies?

If you rename a virtual copy, the name of the master photo changes too—after all, it's virtual. When you export the virtual copies, they can have different names from the originals as if they're individual photos, and you have some control over this naming while still in the Library module.

In the Metadata panel of a virtual copy is a *Copy Name* field which defaults to Copy 1. You can change it to an alternative name of your choice, for example, Sepia. (Figure 16.22)

You can display the copy name on the thumbnails or Info Overlay using the View menu > View Options dialog. For example, File Name and Copy Name displays both the master file name and the copy name, whereas Copy Name or File Base Name displays the copy name unless it's blank, in which case it displays the existing filename.

You can also use the copy name to rename the photos when you export them, by selecting the *Copy Name* token in the Filename Template Editor. For example, if you've set the copy name to *Sepia*, you can use *Original Filename_Copy Name* tokens to create IMG_003_Sepia.jpg. (Figures 16.23 & 16.24)

Can I convert snapshots to virtual copies and vice versa?

If you're viewing a snapshot when you create a virtual copy, the virtual copy uses the current settings, and if you're viewing a virtual copy when you create a snapshot, the snapshots use the current settings.

Snapshots are available to all of the virtual copies, which is a really handy feature. It means you can use virtual copies when you're experimenting with different versions, and then save the final state of each virtual copy as a snapshot. You can then delete the virtual copies to clear the clutter when you've finished comparing them, without losing your Develop adjustments.

If you need to create snapshots for lots

Figure 16.24 Rename the photos when exporting, using their Copy Name as part of the new filename.

Figure 16.23 In the View Options dialog, you can set the thumbnail cell options to include the Copy Name.

of photos, Matt Dawson's Snapshotter plug-in can automate the process. https://www.Lrq.me/photogeek-snapshotter

Can I promote virtual copies and delete the master?

If you need to swap a virtual copy for its master, perhaps because you want to keep the virtual copy's settings and delete the other, select the virtual copy and then select **Set Copy as Master** from the *Photo menu*. If you want to do a whole batch of photos, it's not quite so simple. There are two options.

Export the virtual copies to another folder, with the file format set to *Original*, and then import the new files into your catalog. You'd only have data that's stored in XMP, but it may be a good compromise in some circumstances.

Use the Syncomatic plug-in to sync settings from virtual copies to their master photos. It can sync flags, star ratings, labels, keywords and most Develop settings, but the crop is not copied. https://www.Lrq.me/beardsworth-syncomatic

What do Sync Copies and Sync Snapshots do?

Earlier in the chapter (on page 367) we used Sync to copy settings between photos. Under the *Settings menu*, there are two additional sync options which apply to virtual copies and snapshots. *Sync Copies* and *Sync Snapshots* allow you to sync settings from your current rendering to all of that photo's virtual copies or snapshots in one go. For example, if you've created different versions for different crop ratios, and then you brighten the photos or change the sharpening, you might want to update all of your other versions of that photo too.

HISTOGRAM AND RGB VALUES

We introduced the Histogram on page 198, but there's a few extra tricks.

As you hover over the *Exposure*, *Highlights*, *Shadows*, *Whites* or *Blacks* slider in the Basic panel, the approximate range affected by slider is highlighted on the histogram. You can click and drag directly on the Histogram to lighten or darken the affected tones, and the highlighted slider moves. (Figure 16.25)

Can I view the RGB values?

As you hover the cursor over the photo, Lightroom displays the RGB values for these pixels. (Figure 16.26) 0 0 0 % is pure black and 100 100 100 % is pure white. Matching numbers in between are neutral, for example, 50 50 50% is mid gray.

Can I view the RGB values using a 0-255 scale?

If you've used Photoshop or other photographic software, you might be used to seeing the RGB values displayed using a 0-255 scale, for example, 128 128 128. In Lightroom, the RGB values are shown in percentages (0-100%) because 0-255 is an 8-bit scale and Lightroom works in 16-bit. When you turn on Soft Proofing, the RGB

Figure 16.25 You can adjust the Basic tone sliders by dragging left <> right on the histogram.

Figure 16.26 Lightroom displays the RGB values of the selected pixel as you float over the photo.

values switch to the 0-255 scale, as you're simulating an 8-bit output color space. We'll come back to soft proofing in the Develop Tools chapter starting on page 386, and bit depth in the External Editors chapter on page 398.

Can I display L*a*b* values instead of RGB?

You can also display L*a*b* values under the Histogram, as an alternative to the normal RGB values. To switch from RGB to L*a*b*, right-click on the Histogram and select Show Lab Color Values.

L*a*b* values are primarily used in scientific and reproduction environments, but they can also be useful for correcting skintones. For 'average' skintones, if there is any such thing, keep the a* and b* values close, often with the b* value slightly higher.

COLOR MANAGEMENT & SOFT PROOFING

When it comes to color management, there's lots of confusion. Should you choose sRGB because it's commonly used? But you've heard ProPhoto RGB is better because it's bigger, so maybe you should choose this one?

Lightroom is internally color-managed, so as long as your monitor is properly calibrated, the only time you need to worry about color spaces is when you're outputting the photos. This may be passing the data to Photoshop or other software for further editing, passing the data to a printer driver for printing, or exporting the photos for other purposes, such as email or web.

So why are we talking about color management in Develop? There's a tool in Develop called Soft Proofing, which helps you to visualize the limitations of the output color spaces. Before we can dive into that though, we need a basic understanding of color management. Color management is a huge subject that could fill a separate book, so we'll just cover the bits you need to know.

If you'd like to learn more about color management, Jeffrey Friedl wrote an excellent article on color spaces at: https://www.Lrg.me/friedl-colorspace

Which color space should I use?

In the Histogram section on page 198, we said that photos are made up of pixels, and each pixel has a number value for each of the color channels (red, green and blue). For example, 0-0-0 is pure black. 255-255-255 is pure white. The numbers in between are open to interpretation. Who decides exactly which shade of green 10-190-10 equates to? That's where color profiles come into play: they define how these numbers should translate to colors.

There are two main groups of profiles—working profiles and output profiles—and they each cover different ranges of colors. Some color spaces contain a larger number of colors than others, so we refer to the 'size' of the color space.

Working profiles are standardized, so they

can be used in a wide range of situations, whereas output profiles are designed for specific outputs, for example, a particular printer/paper/ink combination.

The most popular working spaces are:

sRGB is a small color space, but fairly universal. It can't contain all the colors that your camera can capture, which results in some clipping, so it's not great as a working space. However, as it's a common color space, it's a good choice for photos that you're outputting for screen use (web, slideshow, digital photo frame), and many non-pro digital print labs expect sRGB files too.

Adobe RGB is a slightly bigger color space, which contains more of the colors that your camera can capture, but still can't contain the full range. Many pro digital print labs accept Adobe RGB files. It's also a good choice for setting on your camera if you choose to shoot JPEG rather than the raw file format, if your camera can't capture in ProPhoto RGB.

ProPhoto RGB is the largest color space that Lightroom offers, and it's designed for digital photographers. It can contain all the colors that today's cameras can capture, with room to spare. The disadvantage is that putting an Adobe RGB or ProPhoto RGB file in a non-color-managed program, such as most web browsers, give a flat desaturated result. This makes it an excellent choice for editing and archiving 16-bit photos, but a poor choice when sending photos to anyone else.

Display P3 is a wide gamut color space used on the latest Apple devices. It's a similar size to Adobe RGB, but it's shifted slightly towards reds/oranges and loses some of the greens/blues. It's primarily useful when exporting photos for display on the latest

Apple devices. (Figure 16.27)

Output profiles are specific to the device, whether they're inkjet printers or huge photo labs.

So the right color space depends on the situation. You don't need to worry while the photo stays in Lightroom, as all the internal editing is done in a large color space which Lightroom manages. When the photo leaves Lightroom, then you need to make a choice. When you edit in an External Editor such as Photoshop, you'll want to stick with a large working space. Once you've finished your editing, and you want to export the finished photo for a specific purpose, then you can choose a smaller color space which defines the characteristics of your output device (i.e. printer).

Whichever color space you choose to use, always embed the profile. A digital photo is just a collection of numbers, and the profile defines how the numbers should be displayed. If there's no profile, the program has to guess—and often guesses incorrectly. Lightroom always embeds the profile, but Photoshop offers a checkbox in the Save As

Figure 16.27 Color spaces cover different color ranges.

dialog, which you must leave checked.

We'll discuss color spaces for editing in the External Editors chapter starting on page 397, and output profiles for editing in the Export and Print chapters (page 422 and page C20), but for now let's focus on soft proofing the finished result.

What is soft proofing?

Soft proofing attempts to simulate, on your calibrated monitor, how the photo will look with your chosen printer/paper/ink combination. You can then adjust the photo for that specific output without creating numerous test prints.

If you don't print to a locally attached printer, such as an inkjet printer, soft proofing can still be useful. If you send prints to an offsite lab, they may be able to provide their printer profile for soft proofing purposes.

Even if you only ever show your photos on a screen—perhaps on the web—soft proofing can show how your photos will look when exported to the smaller sRGB color space. Colors that are within Lightroom's working space may clip when converting to sRGB, for example, highly saturated reds become much less colorful when exported as sRGB. Soft proofing allows you to preview that effect and compensate if needed.

Let's illustrate with these flowers... the saturated colors make it clear to see the difference. We'll look at the histogram and clipping, in addition to the photo.

In the first photo (Figure 16.28), the histogram doesn't spike at either end and the clipping warnings aren't showing, which means that all of of the colors can be contained in Lightroom's working color space.

Figure 16.28 Lightroom's working space can contain the full range of colors that the camera captured.

And then we have the sRGB version (Figure 16.29), with clipping warnings turned on, and it's clear to see, both from the clipping warning and the histogram, that the red channel is clipped in the smaller color space.

How do I enable soft proofing?

To turn on soft proofing, check the **Soft Proofing** checkbox in the Toolbar. (Figure 16.30)

The Histogram panel changes to a Soft Proofing panel with additional options, and the background surrounding the photo changes from mid-gray to paper white. (Figure 16.31)

Select your output profile from the **Profile** pop-up menu. If your profile doesn't appear in the pop-up, select *Other* at the bottom of the *Profile* pop-up and put a checkmark next to your output profile in the Choose Profiles dialog. It then appears in the *Profile* pop-up, ready for selection. (**Figure 16.32**)

Figure 16.29 In sRGB, the highly saturated colors clip (shown as red highlights) because they fall outside of the small sRGB gamut.

Figure 16.30 Soft Proofing is enabled using the checkbox on the Toolbar.

Why is my profile not available for selection?

If your profile is correctly installed in the operating system, but it still doesn't appear in the Choose Profiles dialog, then it may be an unsupported profile. Lightroom's limited to RGB, so it won't work with grayscale profiles, or some other non-standard profiles designed for Printer RIPs (Raster Image Processor).

Some profiles don't conform to the ICC Specification, and they're ignored too. Running *Profile First Aid* in ColorSync Utility on a Mac can often repair these profiles, making them available in Lightroom. I'm not aware of any free Windows software that can run an ICC profile repair.

Figure 16.31 The Histogram panel changes to a Soft Proofing panel.

Figure 16.32 Select the profile you want to use for soft proofing.

Should I select Perceptual or Relative Colorimetric?

When you've selected your profile, the *Intent* options become available. The rendering intent options only apply to output spaces such as printer profiles, not working spaces like sRGB, Adobe RGB and ProPhoto RGB.

Perceptual squeezes all the colors into the smaller color space while trying to retain their relationship to each other. That means that all the color values shift but it should still look natural. Perceptual rendering

intent is good for highly saturated photos with a lot of out-of-gamut colors.

Relative Colorimetric leaves most of the colors alone, and just clips the out-of-gamut colors to the closest reproducible colors. It's usually a better choice if a photo is mostly within gamut, as it only shifts the out-of-gamut colors.

So which should you choose? If you're exporting the photo using the Export dialog, use *Relative Colorimetric*, as the Export dialog doesn't give you a choice of rendering intent. If you're printing through Lightroom, the Print module does give you a choice. In this case, it depends on the photo, so try both and see which looks best.

Should I check Simulate Paper & Ink when viewing my soft proof?

Simulate Paper & Ink simulates the reduction in contrast caused by dull white paper and dark gray black ink, so it's also known as the Make the Photo Look Rubbish checkbox. Your eyes adapt to the color and brightness of the whitest object in your view, making the soft proof look dark and flat.

To solve this, remove all other white/ light reference points from your view and switch to Lights Out mode by pressing the L key. Your eyes then adjust to the soft proof version and you can adjust the photo accordingly.

With Lights Out, however, it's obviously impossible to adjust the photo, so when you're ready to start making adjustments, you'll need to disable Lights Out by pressing the L key again.

The 25% and similar zoom ratios on top of the Navigator panel allow you to zoom out further, surrounding the photo with a larger area of paper white, while still being able to adjust the photo using the Develop controls.

Can I change the background color surrounding the photo while soft proofing?

By default, the background surrounding the photo shows a paper white, but the accuracy of that paper white depends on the quality of the profile. Some profiles show a bright yellow background which looks nothing like the paper. If it's wrong, you can switch to an alternative background by right-clicking in the background area. There's a range of shades of white and gray available, so you can select one which more closely matches the paper. Your chosen color is also used for the background when using Lights Out mode.

What's the difference between the Monitor Gamut and Destination Gamut warnings?

In the top corners of the histogram, the clipping warning buttons are replaced by gamut warning buttons. (Figure 16.33) (The gamut is the complete subset of colors that can be reproduced in your chosen color space or by a specific device.)

When you click to enable them, out of gamut areas of your photo are highlighted in blue, red or purple. If either out of gamut warning is showing, it's simply telling you that you're not seeing an accurate preview of those colors. (Figure 16.34)

Figure 16.33 The Monitor Gamut (left) and Destination Gamut (right) triangles take the place of the clipping warning buttons in the corner of the histogram.

Blue indicates that a color is outside of the monitor gamut, which means that even if the color is printable, you won't get a good print-to-screen match because the monitor can't display that particular color accurately.

Red means that a color is outside of the destination gamut, which means that it's not printable and will be remapped by the output profile.

Purple is out of both gamuts.

What should I do if some colors are out of gamut?

If the colors are showing as out of gamut, it doesn't necessarily mean that you need to do anything about it. It's simply information. It tells you that the final print won't exactly match the screen preview in those areas.

Desaturating the photo, or locally desaturating the out-of-gamut colors, is traditionally suggested as a solution, however a good quality profile usually does a far better job of pulling these colors back into gamut without you having to adjust anything.

Figure 16.34 Colors that are out of gamut are highlighted to warn you that they may not print as expected.

How should I adjust the photo while viewing the soft proof?

So if you're not going to reduce the saturation of the out of gamut colors, what's the point of soft proofing?

The main aim is to compensate for the losses in printing, to make the print look closer to the original. Often that's a difference in contrast and brightness, rather than color.

We discussed the Before/After views earlier in the chapter (starting on page 380), but they become particularly useful when soft proofing, as they allow you to compare your original intended rendering with the soft proofed copy. To turn it on, press the Before/After Preview button (the one with the Y's on it) in the Toolbar. Other views are also available when you click on the arrow next to the Before/After Preview button.

With the original photo on screen next to the soft proof preview, adjust the sliders to make the soft proof more closely match the original. You're simply trying to make the soft proof—and therefore the finished print—look better. (Figure 16.35)

How do I compare my proof adjusted photo with the original?

There's an additional **Before** pop-up in the Toolbar which allows you to select which version of the photo you want to compare against.

Current State shows the current settings for the photo, without the soft proof applied. This allows you to see the effect that the output profile is having on the photo.

Before State shows the normal 'before' state of the photo, without the soft proof applied. You can update this Before State by right-clicking on your chosen History state and

Figure 16.35 The Before/After preview allows you to compare your proofed version with your original rendering.

selecting Copy History Step Settings to Before or by dragging the History state onto the Before view.

Master State shows the current settings of the Master photo, without the soft proof applied. This allows you to see how well your profile-specific adjustments on the virtual copy match the general edits for that photo. You also have the option to compare with other virtual copies of the photo.

How do I save my photo after adjusting it for a specific profile?

Just below the histogram, there's a **Create Proof Copy** button, which creates a virtual copy of your photo for soft proofing. It means that your original settings, which were suitable for any kind of output,

remain untouched, and your profile-specific adjustments are stored separately in a virtual copy.

If you start editing a photo without first creating a proof copy, Lightroom asks if you want to create a virtual copy for the soft proof, or whether you want to edit the original photo. (Figure 16.36)

If you select *Make This a Proof*, your current photo is marked as a proof under the *Settings menu*, and your adjustments apply to the master photo. It's not a bad choice if you're editing for sRGB use, but if you're adjusting for an output profile, it's better to select *Create Proof Copy*.

Figure 16.36 When you edit a photo with soft proofing enabled, Lightroom offers to create a virtual copy.

How can I tell which profile I used for a particular photo?

If you allow Lightroom to create a virtual copy for the soft proof, it enters the name of the profile in the *Copy Name* metadata field, and it updates if you switch to a different profile. You can view the Copy Name in the Metadata panel, the Grid view thumbnails, the Info Overlay or along the top of the Filmstrip. (Figure 16.37)

Any snapshots you create in Soft Proof mode also automatically include the profile in the Snapshot name.

When exporting the file, you can include the *Copy Name* field in the new filename for reference. *Filename-CopyName* tokens will result in a filename such as IMG_003-sRGB.jpg. Remember that Export always uses Relative Colorimetric as the rendering intent.

20140917-185210.dng / U.S. Web Coated (SWOP) v2, Perceptual

Figure 16.37 If you create a virtual copy for the soft proof, the name of the profile appears in the breadcrumb bar.

DEVELOP TOOL SHORTCUTS

		Windows	Mac
Copy, Paste & Sync	Copy Settings	Ctrl Shift C	Cmd Shift C
	Paste Settings	Ctrl Shift V	Cmd Shift V
	Paste Settings from Previous	Ctrl Alt V	Cmd Opt V
	Sync Settings	Ctrl Shift S	Cmd Shift S
	Sync Settings (bypass dialog)	Ctrl Alt S	Cmd Opt S
	Enable Develop Auto Sync	Ctrl Alt Shift A	Cmd Opt Shift A
	Match Total Exposures	Ctrl Alt Shift M	Cmd Opt Shift

		Windows	Mac
Presets	New Preset	Ctrl Shift N	Cmd Shift N
	New Preset Folder	Ctrl Alt N	Cmd Opt N
Undo/Redo	Undo	Ctrl Z	Cmd Z
	Redo	Ctrl Y	Cmd Shift Z
Reset	Reset Slider	Double-click on slider label	Double-click on slider label
	Reset Group of Sliders	Double-click on group name	Double-click on group name
	Reset All Settings	Ctrl Shift R	Cmd Shift R
Before / After View	Toggle Before/After	\	\
	Left / Right	Υ	Υ
	Top / Bottom	Alt Y	Opt Y
	Split Screen	Shift Y	Shift Y
	Copy After's Settings to Before	Ctrl Alt Shift left arrow	Cmd Opt Shift left arrow
	Copy Before's Settings to After	Ctrl Alt Shift right arrow	Cmd Opt Shift right arrow
	Swap Before and After Settings	Ctrl Alt Shift up arrow	Cmd Opt Shift up arrow
Reference View	Open Reference View	Shift R	Shift R
Snapshots & Virtual Copies	Create Snapshot	Ctrl N	Cmd N
	Create Virtual Copy	Ctrl'	Cmd '
Soft Proofing	Show / Hide Soft Proof	S	S
	Destination Gamut Warning	Shift S	Shift S

FURTHER EDITING IN OTHER PROGRAMS

17

Lightroom is a brilliant workflow tool but there are still some tasks, such as detailed retouching, that

require a pixel editor such as Photoshop. Lightroom can pass your edited photo over to your pixel editor and automatically add the resulting photo back into the catalog.

Integration with Photoshop

If a full version of Photoshop is installed on your computer, it appears in *Photo menu > Edit In* or the right-click menu. **(Figure 17.1)** You can also press Ctrl-E (Windows) / Cmd-E (Mac) to open the photo into Photoshop.

If the photo is a raw file and you're using the latest version of Camera Raw, Lightroom opens the photo directly into Photoshop. Older ACR versions ask how to handle the file, so press *Render Using Lightroom* in order

Figure 17.1 Lightroom can pass your photos to Photoshop and other external pixel editors.

to ensure the file renders correctly.

If you're working with a JPEG, TIFF, PSD or PNG file, a dialog asks how to handle the file. Select *Edit a Copy with Lightroom Adjustments* to open your photo with your Develop adjustments applied.

Once you've finished editing the photo in Photoshop, go to *File menu > Save* and then close the photo and switch back to Lightroom. Your edited photo is updated in your catalog automatically.

Integration with Photoshop Elements

Not everyone needs the power of full Photoshop. Elements can do many of the tasks photographers require. Like Photoshop, Lightroom recognizes when a recent version of Elements is installed, and *Photo menu > Edit In > Edit in Photoshop Elements* or Ctrl-E (Windows) / Cmd-E (Mac) opens the photo into Photoshop Elements. Once you've finished editing the photo, save (don't change the filename or file type) and close the file before returning to Lightroom.

Opening Photos in Other Editors

Lightroom can also send files to other external editors, such as On1 software, Nik software, Pixelmator or PaintShop Pro.

Some of these editors come with their own Lightroom plug-ins and presets which

are installed automatically. If your editor doesn't install its own connection, you can set it up manually. We'll come back to that a little later on page 407.

Why might I use an external editor?

But can't you do everything in Lightroom? Lightroom does offer a wide range of tools to cater for most of your editing needs, but that doesn't always make it the best tool for the job.

It's a parametric editor, which means that it runs text instructions rather than directly editing the pixels.

The benefit is it's non-destructive, so you don't need to save multiple versions of the file, taking up masses of hard drive space, and you can go back and change your edits again later.

The downside is that running text instructions over and over again is slower than making a single change to the pixels themselves. For global edits, that's barely noticeable, but Lightroom can start to drag when using multiple masks and retouching multiple spots. For this reason, pixel editors such as Photoshop and Elements are still better suited to more detailed retouching.

There may also be times when you want to do more specialized edits. For example, Lightroom can do great B&W conversions but Nik Silver Efex is designed purely for that purpose.

When in my workflow should I use Edit in Photoshop or other External Editors?

You may be wondering when to use your external editor. Is it better to edit your photo in the Develop module first, or wait until you've finished the retouching in the external editor?

Lightroom's Develop adjustments work best on raw files, because they have the largest amount of data available. For this reason, it's usually best to do most, if not all, of your Lightroom adjustments in Lightroom before using Edit in Photoshop to do your retouching. The same would apply to most other External Editors.

There are a couple of exceptions:

- You may prefer to leave cropping until after your external edits, leaving you the flexibility to non-destructively crop to multiple different ratios without having to repeat your retouching and other edits.
- If the photo is going to be in both B&W and color, you may also want to retouch the color version and then convert the resulting photo to B&W so that you only have to do the retouching once.
- If your photo was shot in JPEG, or it's a scan, the workflow order isn't as important. For example, you may decide to retouch dust on negative scans in Photoshop before editing them in Lightroom.

Having covered the basics, let's do a deeper dive into the settings.

SETTING EXTERNAL EDITOR PREFERENCES

We'll go into more detail on specific programs, but first, let's consider the settings that apply to all external editors. The file type, color space, bit depth, resolution and compression are all set in *Preferences > External Editing*. The top half of the dialog sets the primary editor's settings—the most recent version of

			Preferences	
	General Presets	Extern	File Handling Interface Performance Lightroom Sync Display	Network
Edit in Adobe Photos	shop 2020			
File Format:	TIFF	B	16-bit ProPhoto RGB is the recommended choice for best preserving color details from Lightroom.	
Color Space:	ProPhoto RGB	0	Color detens from Eighta doni.	
Bit Depth:	16 bits/component	0		
Resolution:	240			
Compression:	ZIP	0		
Additional External E	ditor			
Preset:	Topaz Mask Al			5
Application:	Topaz Mask Al.app			
ripplication.	Topaz mask Atapp			Choose Clear
File Format:		0	16-bit ProPhoto RGB is the recommended choice for best preserving	Choose Clear
File Format:		0	16-bit ProPhoto RQB is the recommended choice for best preserving color details from Lightroom. ZIP compressed TIFFs may be incompatible with older applications.	Choose Clear
File Format: Color Space:	TIFF		color details from Lightroom. ZIP compressed TIFFs may be	Choose Clear
File Format: Color Space:	TIFF ProPhoto RGB 16 bits/component		color details from Lightroom. ZIP compressed TIFFs may be	Choose Clear
File Format: Color Space: Bit Depth:	TIFF ProPhoto RGB 16 bits/component		color details from Lightroom. ZIP compressed TIFFs may be	Choose Clear
File Format: Color Space: Bit Depth: Resolution:	TIFF ProPhoto RGB 16 bits/component	0	color details from Lightroom. ZIP compressed TIFFs may be	Choose Clear
File Format: Color Space: Bit Depth: Resolution:	TIFF ProPhoto RGB 16 bits/component	0	color details from Lightroom. ZIP compressed TIFFs may be	Choose Clear
File Format: Color Space: Bit Depth: Resolution: Compression:	TIFF ProPhoto RGB 16 bits/component	0	color details from Lightroom. ZIP compressed TIFFs may be	Choose Clear
File Format: Color Space: Bit Depth: Resolution: Compression:	TIFF ProPhoto RGB 16 bits/component 240 ZIP Stack With Original	0	color details from Lightroom. ZIP compressed TIFFs may be	Choose Clear
File Format: Color Space: Bit Depth: Resolution: Compression: stack With Original	TIFF ProPhoto RGB 16 bits/component 240 ZIP Stack With Original aming: IMG,0002-Edit psd	0	color details from Lightroom. ZIP compressed TIFFs may be	
File Format: Color Space: Bit Depth: Resolution: Compression: stack With Original	TIFF ProPhoto RGB 16 bits/component 240 ZIP Stack With Original	0	color details from Lightroom. ZIP compressed TIFFs may be	Choose Clear

Figure 17.2 Set the default settings for Photoshop and other external editors using the Preferences dialog.

Photoshop or Photoshop Elements—and the lower half creates presets for all other external editors. (Figure 17.2)

Which file format should I use?

The first pop-up, *File Format*, determines the file type that's passed to the external editor.

TIFF is publicly documented, more efficient when updating metadata, compatible with a wide range of software, and can contain almost everything that PSD's do. It's generally considered the best choice for external edits. We'll come back to the various **compression** options in the Export chapter on page 420, but ZIP compression is a good choice for most external editors.

PSD is Adobe's proprietary format. It's well supported by other applications, as long as you check *Maximize Compatibility* but

it's generally considered an older format now, so even Adobe are recommending TIFFs instead of PSD files now. Some plugins, such as OnOne software, prefer PSD format.

JPEG is only available for secondary external editors, as some (rare!) editing programs are unable to work with TIFF or PSD files. It's a lossy format, so it's not a great choice for external edits.

Which color space should I select?

Files are automatically color managed in Lightroom, but when you pass them to another editor, you'll need to choose a working space using the *Color Space* pop-up. We've already discussed color spaces in the previous chapter (starting on page 386), but as a reminder:

ProPhoto RGB is the best choice if your external editor is color managed, as it preserves the widest range of color information. ProPhoto RGB doesn't play well with 8-bit though, because you'd be trying to jam a large gamut into a small bit depth, which can lead to banding, so stick with 16-bit while using ProPhoto RGB.

Adobe RGB is a smaller color space, but it's a good choice if your external editor can only handle 8-bit files (or you're saving as JPEG).

sRGB is the smallest color space available, so it's not ideal for external editors.

Display P3 is a wide gamut color space used on the latest Apple devices. It's a similar size to Adobe RGB, but it's shifted slightly towards reds/oranges and loses some of the greens/blues. It's primarily useful when exporting photos for display on the latest Apple devices.

Why use a big color space when nothing can print that wide a range?

Now it's true, not all of these possible ProPhoto RGB colors can be reproduced on screen or print at this point in time, but that's not a good reason for throwing data away and using a smaller space. Even now, some printers can print some colors that can't currently be displayed on the best screens.

Remember when computer monitors were only B&W or 256 colors? Photographers still created full color images even though they couldn't see the full range of colors. If they'd limited themselves to what they could see, they'd have kicked themselves when the current monitors became available. So in the future, when even more advanced monitors are released, you'll be able to see your full range of image data.

There can be a little bit of guesswork involved when working with extremely saturated colors, but that's where the gamut warnings on the soft proof start to help. These give you information, telling you which colors may not match what you're seeing on screen. Unless you're pushing the saturation/vibrance really high, you won't run into issues on most images, and even when you do, profiles do an excellent job of pulling colors back into gamut without you having to change anything. But it helps to understand what's happening.

Whichever color space you choose, it's important that it's selected in both programs. We'll come back to settings the color space in Photoshop and Photoshop Elements in the next section (starting on page 401).

Should I choose 8-bit or 16-bit?

The next pop-up is **Bit Depth**. To the right, you'll notice a note that says 16-bit ProPhoto RGB is the officially recommended choice for best preserving color details from Lightroom, but what does that actually mean?

Every photo is made up of pixels. In an RGB photo, each pixel has a Red, a Green and a Blue channel, and in an 8-bit photo, each of those channels has a value from 0-255.

If you need to make any significant tonal changes, you only have a maximum of 256 levels per channel to play with. For example, if you've significantly underexposed the photo, all the detail may be in the first 128 levels (on the left of the histogram). As you correct the exposure, you stretch the detail out to fill the full 0-255 range, but you can't create new data. The missing data displays as gaps in the histogram. (Figure 17.3)

The gaps may not be visible on an average

photo, but they display as banding (or steps) on photos with smooth gradients, such as a sky at sunset. (Figure 17.4) A 16-bit photo, on the other hand, has 65,536 levels per channel, so you can manipulate and stretch it without worrying about losing too much data.

The downside to 16-bit is that all that extra data takes up more space on your hard drive, so in the real world, it's not always quite so clear cut. 16-bit files can only be saved as TIFF or PSD, not JPEG, and the file sizes are much bigger than an 8-bit high quality JPEG, often with very little, if any, visible difference to the untrained eye on a small print. A Canon 5D Mk2 file is around 126 MB for a 16-bit TIFF, 63 MB for an 8-bit TIFF, but less than 15 MB for a maximum quality 8-bit JPEG. That's a big difference on a large volume of files!

So the reality is you may want to weigh it up on a case-by-case basis. Everything's a trade-off. If you're producing a fine art print, 16-bit would be an excellent choice

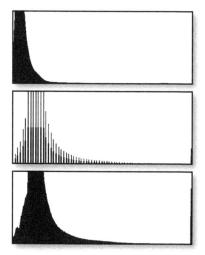

Figure 17.3 If you take an underexposed photo (top) and stretch the 8-bit data, you'll get gaps in the histogram (center) whereas 16-bit has more data to stretch (bottom).

to preserve as much detail as possible. Or if you're going to take a file into Photoshop and make massive tonal changes, 16-bit would be an excellent choice, giving greater latitude for adjustments. But if you're just doing light retouching on a large volume of files, 8-bit JPEG could be a far more efficient choice. You can always re-export from Lightroom as a 16-bit file if you find a photo which would benefit, such as a photo exhibiting banding in the sky, or suchlike.

Which resolution should I select?

We'll come back to the concept of **Resolution** in the Export chapter (page 423). While editing the photos in external editors, your choice of resolution doesn't really matter, as all of the pixels (less any cropped pixels) are passed to the external editor. There are a few cases where you might want to select a specific resolution, for example, when you're running a Photoshop action that uses specific measurements.

Figure 17.4 This 8-bit image shows significant banding in the sky.

How do I change the file name and location?

By default, Lightroom saves the edited file in the same folder as the original, and simply adds -Edit to the end of the filename to show that it's a derivative file. You can change -Edit to another file naming template of your choice at the bottom of the Preferences dialog > External Editing tab.

As long as you simply save the file when you've finished editing it in Photoshop or another editor, the edited file is also returned to your catalog. If you choose to Save As a different filename, file type or location, the behavior changes, depending

on the type of external editor you're using. (Figure 17.5)

Can I create different filenames for different editors?

The single filename template in the External Editor preferences applies to all external editors, so you can't apply a different filename to each editor (e.g. 201503092100-NikSilverEfex.tiff). The edited photos are also saved in the same folder as the original, rather than a folder you specify.

You can work around this limitation by using Export presets instead. We'll come back

	Edit In	Save	Save As	Close (No Save)
	Edit in Photoshop with (matching ACR	Folder: same as original	Folder: your choice	File not saved
dou	version)	File Type: as preferences	File Type: your choice	
File Created by Photoshop	Edit in Photoshop	Filename: as	Filename: your choice	
P.	(outdated ACR version	preferences		
d by	set to Open Anyway)		Catalog: if you select a	
ate		Catalog: adds edited file	new filename, file type	
S.	Open as Smart Object	on save	or location, file is not	
File	in Photoshop or Merge		added to the catalog.	
	to Panorama/HDR using			
	Photoshop or Open as			
	Layers in Photoshop			
	Edit in Additional	Folder: same as original	Folder: your choice	Folder: same as original
Ę	External Editor			
L S		File Type: as preferences	File Type: your choice	File Type: as preferences
igh	Edit in Photoshop			
File Created by Lightroom	(outdated ACR version	Filename: as	Filename: your choice	Filename: as
ted	set to Render Using	preferences		preferences
Leg .	Lightroom)		Catalog: adds unedited	
ie e		Catalog: adds new file	file at time of creation	Catalog: adds new file at
-		at time of creation and	but catalog doesn't know	time of creation
		updates when saving	about the new edited file	

Figure 17.5 The Save / Save As / Close behavior varies depending on whether Photoshop or Lightroom renders the file.

to the options in more detail in the Export chapter (starting on page 415), but in short, go to the Export dialog and select the options of your choice, for example:

Export Location—Set to the location of your choice, for example, *Same folder as original photo* and select *Put in Subfolder* called *Edited*. Check *Add to this Catalog* if you want the resulting photo imported automatically, as it would be with standard External Editors.

Rename to—Set to *Filename-Custom Text* with the custom text set to *NikSilverEfex* (or your editor's name)

Image Format—TIFF 16-bit or another rendered file format of your choice.

Post-Processing—Set it to After Export: Open in Other Application and navigate to the program. Select the exe file (Windows) / application (Mac).

Finally, save your settings as a preset and cancel out of the Export dialog. To use the preset, right-click on a photo, scroll down to *Export* and click on your preset.

Can I automatically stack the files?

The final option in preferences is a **Stack** with **Original** checkbox that stacks the edited photo with the original, putting the edited version on top. Some photographers like to apply a color label to their finished photos to help quickly identify them.

Why does Lightroom keep putting the photos at the end of the current folder/collection?

If your sort order is set to *User Order, Edit Time*, etc., Lightroom puts the edited file at the end of the series of photos, and if you have it set to *Stack with Original* in

Preferences, it also moves the original photo to the end. If you don't want to have to keep scrolling back again, use a sort order such as *Capture Time* or *Filename* that won't automatically be updated.

EDITING IN PHOTOSHOP OR PHOTOSHOP ELEMENTS

As you'd expect, Lightroom has greater interaction with Adobe software than it does with other pixel editors. In the case of Photoshop, this includes the ability to pass the raw data, without first needing to create a TIFF/PSD file. It uses Adobe Camera Raw (ACR) to render the file, which we'll discuss in more detail in the next section, starting on page 405.

Why isn't Lightroom opening my photo as a TIFF or PSD file according to my preferences?

If Photoshop is set as the Primary External Editor (the first choice), the photo is opened directly into Photoshop and rendered using Adobe Camera Raw (ACR), so it's not saved as a TIFF or PSD until you choose to save it.

When you press Ctrl-S (Windows) / Cmd-S (Mac) in Photoshop, or go to *File menu* > *Save*, Photoshop creates the TIFF or PSD file according to your Lightroom preferences. You don't need to use *Save As* to create the TIFF/PSD file (in fact, it causes more complications if you do use *Save As!*)

That's a great feature, as if you're just experimenting and you decide not to keep your edited file, you can just close without saving and don't have to worry about going back to delete the TIFF or PSD. (Note that this only works with matching ACR versions, or when you select *Open Anyway* in the ACR mismatch dialog. We'll come back to ACR mismatches in the next section on page

405.)

What's the difference between Edit Original, Edit a Copy, or Edit a Copy with Lightroom Adjustments?

If you're passing a rendered file to Photoshop or Elements—a TIFF, a PSD, or a JPEG—then Lightroom first asks how you want to handle the file. (Figure 17.6) (It doesn't ask for raw files.)

Edit a Copy with Lightroom Adjustments passes the image data and the settings to ACR to open directly into Photoshop, or creates a TIFF/PSD if you're using Elements. Any layers are flattened in the process. If there's a mismatch in ACR versions, it displays the same ACR Mismatch dialog as a raw file, with the same results.

Edit a Copy creates a copy of the original file, in the same format, and opens this into Photoshop without any of your Lightroom edits. It allows you to edit the photo without overwriting your previous file, and also retains any layers in the file.

Edit Original opens the original file into

Figure 17.6 When you send rendered files to Photoshop, it asks you how to handle the file. This dialog is skipped for raw files.

Photoshop without any of your Lightroom edits. It's useful if you want to continue editing a photo that you've previously edited in Photoshop, as it retains any layers in the file.

If you need to open the photo back into Photoshop to make further adjustments to the layers, perhaps for additional retouching, choose the Edit Original or Edit a Copy options, rather than Edit a Copy with Lightroom Adjustments. This opens the layered file into Photoshop without your Develop adjustments, and when you bring the file back into Lightroom, your Develop adjustments are still laid non-destructively over the top.

What do the other options in the Edit In menu do?

Using Edit in Photoshop as the primary External Editor, you can open the file or multiple files directly into Photoshop without first saving an interim TIFF or PSD file (Figure 17.7), although you may get unexpected results if you're not using a fully compatible version of ACR. The older the Camera Raw version, the more unexpected the results will be.

Open as Smart Object in Photoshop allows you to edit the Develop settings in the ACR dialog while in Photoshop, although these Develop settings won't then be updated on the original file in your Lightroom catalog, but remain with the edited copy.

Open as Smart Object in Photoshop... Merge to Panorama in Photoshop... Merge to HDR Pro in Photoshop... Open as Layers in Photoshop...

Figure 17.7 If you're using a recent full version of Photoshop, additional options will be available, such as Merge to Panorama and Merge to HDR Pro.

Merge to Panorama, Merge to HDR Pro and Open as Layers in Photoshop only become available when you have multiple photos selected.

Merge to Panorama in Photoshop opens the files directly into the Photomerge dialog in Photoshop, allowing you to create panoramic photos with more control over the layout and blending than Lightroom's own *Photo Merge > Panorama* tool.

Merge to HDR Pro in Photoshop opens the files directly into the Merge to HDR Pro dialog in Photoshop to create HDR photos. Lightroom's own *Photo Merge > HDR* is a better choice as it works on the unprocessed raw data.

Using Merge to Panorama or HDR Pro automatically adds the resulting photos to your Lightroom catalog when you save them.

Open as Layers in Photoshop opens the files directly into Photoshop and places the photos into a single document as multiple layers, which is particularly useful if you need to merge multiple photos in Photoshop.

Should I still use Merge to HDR Pro or Merge to Panorama in Photoshop?

Lightroom now has its own HDR and Panorama merge tools, but there are occasions when you might want to use Photoshop's version of these tools.

If Lightroom has trouble with ghosting in an HDR file, Photoshop can occasionally do a better job. To try it, select the files, right-click and choose *Edit In > Merge to HDR Pro in Photoshop*. In the HDR Pro dialog, select 32-bit mode and press *OK*. The White Point Preview slider only affects the preview. When you save the resulting photo as a

32-bit floating-point TIFF, Lightroom allows you to import and edit the photo with an extended slider range.

If you're merging photos into a panorama and you want to control the blending yourself, or you want another perspective that Lightroom doesn't offer, you can use Photoshop instead.

When creating a panoramic photo using Photoshop, first edit your photos in the Develop module. Make sure they match, otherwise you'll find join lines in the finished panorama. Pay particular attention to the exposure, especially if you weren't shooting in Manual mode. It's also a good time to apply lens corrections, noise reduction, etc. The photo that comes back from Photoshop will be a rendered file (TIFF or PSD) with less editing flexibility, unlike Lightroom's own panorama merge.

Select the files, right-click and choose *Edit In* > *Merge to Panorama in Photoshop*. Select the merge options in Photoshop's Photomerge dialog and press *OK*.

Why do my photos look different in Photoshop?

If you open your files into Photoshop and they're a different color, it's usually due to incorrect color space settings. For example, a ProPhoto RGB photo mistakenly rendered as sRGB displays as desaturated and flat. (Figure 17.8)

- **1.** In Lightroom, go to the *Preferences dialog* > External Editing tab.
- **2.** Make a note of the *Color Space* setting for Photoshop. **(Figure 17.9)**
- **3.** Switch to Photoshop or Elements and go to *Edit menu > Color Settings* to view the Color Settings dialog.

4. Set the **RGB Working Space** to the same color space that you selected in Lightroom's External Editor preferences. (Figure 17.10)

Selecting Preserve Embedded Profiles and/or checking the Ask When Opening for Profile Mismatches in that same dialog helps to prevent any profile mismatches.

Preserve Embedded Profiles tells Photoshop to use the profile embedded in the file regardless of whether it matches your usual working space.

Ask When Opening for Profile Mismatches displays a warning dialog when the embedded profile doesn't match your usual working space, and asks you what to do. If *Preserve Embedded Profile* is selected, you can safely leave the profile mismatch checkboxes unchecked. (**Figure 17.11**)

As long as your Photoshop and Lightroom color settings match, or you have Photoshop set to use the embedded profile, your photos should match between both programs. The same principles also apply to opening photos in other software, or when opening photos exported from Lightroom using the Export dialog.

If your color space settings are correct, a color mismatch can also be caused by a

corrupted monitor profile. That's easy to check using the instructions on page 510 of the Troubleshooting chapter.

Lightroom can't find Photoshop to use Edit in Photoshop—how do I fix it?

When Lightroom starts up, it checks to see whether Photoshop or Photoshop Elements are installed, and if it can't find them, then the *Edit in Photoshop* menu command is disabled.

If you install a new version of Photoshop, and then uninstall an earlier version, the link can get broken by the uninstall. Uninstalling and reinstalling Photoshop usually solves it, or you can fix it by editing the registry key (Windows) or deleting Photoshop's plist file (Mac). There's more

Figure 17.9 Lightroom's External Editor Settings need to match Photoshop's Color Settings.

Figure 17.8 A
ProPhoto RGB
photo displays
correctly in
color managed
software (left)
but when
incorrectly
displayed as
sRGB, it's flat
and desaturated
(right).

		Col	or Settings		
Settings:	Custom	V			ОК
Working	Spaces		Conv	ersion Options	
	RGB:	ProPhoto RGB	Engine	: Adobe (ACE) ~	Cancel
	CMYK:	U.S. Web Coated (SWOP) v2	Intent	: Relative Colorimetric ~	Load
	Gray:	Dot Gain 20%	3	☑ Use Black Point Compensation	Save
	Spot:	Dot Gain 20%	3	Use Dither (8-bit/channel images)	P Paradam
Color Ma	anagement	Policies		Compensate for Scene-referred Profiles	☑ Preview
	RGB:	Preserve Embedded Profiles ~	Adva	nced Controls	
	CMYK:	Preserve Embedded Profiles ~	☐ De	saturate Monitor Colors By: 20 %	
	Gray:	Preserve Embedded Profiles ~		nd RGB Colors Using Gamma: 1.00	
Profile Mis	smatches:	☐ Ask When Opening ☑ Ask When Pasting	☑ Ble	nd Text Colors Using Gamma: 1.45	
Missin	g Profiles:	Ask When Opening	ab u	nsynchronized: Your Creative Cloud applications	

Figure 17.10 Photoshop's Color Settings need to match Lightroom's External Editor Settings.

Figure 17.11 Checking the Ask When Opening checkbox in Photoshop's Color Settings dialog displays the Embedded Profile Mismatch dialog when the color spaces don't match.

information on the official Adobe tech note at: https://www.Lrg.me/fixphotoshoplink

Of course, you may be able to take the easy course and add it as an *Additional External Editor*, however you would be missing out on some of the direct integration which comes with matching ACR versions.

ADOBE CAMERA RAW COMPATIBILITY FOR PHOTOSHOP

ACR, or Adobe Camera Raw, is the processing engine which allows Adobe programs to read raw file formats and convert them into image files. The engine is built directly into Lightroom Classic and the Lightroom cloud ecosystem, but it's a separate plug-in for Adobe Bridge, Photoshop and Elements.

Updates for Lightroom and Camera Raw are released approximately every 2 months to add new camera and lens support and bug fixes. It's best to update both at the same time to make sure the Camera Raw versions are fully compatible.

What happens if I'm still using an older version of Camera Raw?

Usually, when you open a photo into Photoshop from Lightroom, Lightroom passes the original raw data and instructions over to the Camera Raw plug-in hosted by Photoshop, and Camera Raw performs the conversion and opens the image into Photoshop. (Figure 17.12)

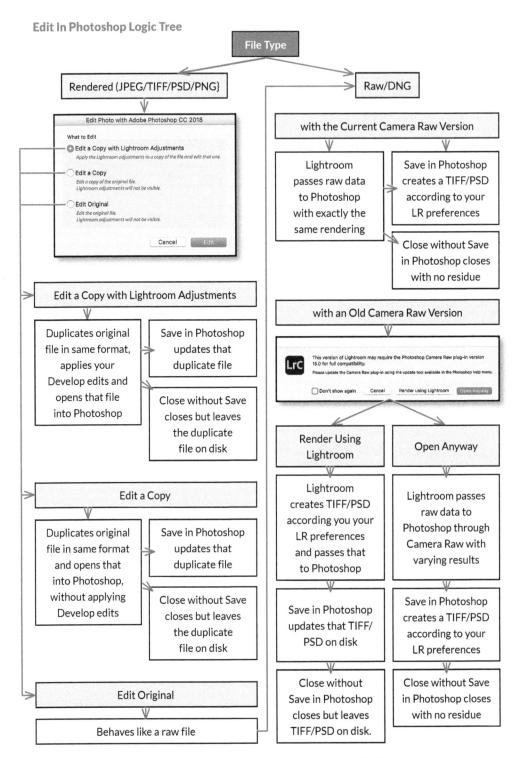

Figure 17.12 The Edit in Photoshop logic, depending on whether they're raw or rendered.

If you've forgotten to update Camera Raw, it may not understand all of Lightroom's instructions, resulting in a completely different rendering, so Lightroom asks you how to handle the file. (Figure 17.13)

What's the difference between Render Using Lightroom and Open Anyway in the Camera Raw mismatch dialog?

The Camera Raw Mismatch dialog gives you three choices:

The simplest choice is to *Cancel*, update Camera Raw and then try again.

Render using Lightroom uses Lightroom's own processing engine to render the TIFF or PSD file, which is then automatically opened into Photoshop. All of your Lightroom adjustments are applied correctly.

Open Anyway ignores the mismatch and passes the image data and settings to Photoshop for Camera Raw to process, which may produce something close to the correct rendering or may be completely different. It doesn't save the TIFF/PSD until you choose to save the changes.

If you try to open a proprietary raw file from a camera that wasn't supported by your old Camera Raw version, the file won't even open as Photoshop won't know what to do with it.

SETTING UP ADDITIONAL EXTERNAL EDITORS

Although Photoshop is the obvious choice for use with Lightroom, as it's included in your Photography Plan subscription, it's not the only choice. Many photographers use Nik Software or OnOne software with Lightroom, among others.

Some programs automatically install plugins, external editor settings or export presets, which you can access from the File menu > Plug-in Extras, Photo menu > Edit in or File menu > Export as Preset respectively. You'll also find those options in the right-click menu. Check with the developer for each individual program.

How do I create my own external editor preset?

If you have a program that doesn't automatically link with Lightroom, you can create your own external editor preset.

- **1.** Go to Lightroom's Preferences dialog, under the *Edit menu* (Windows) / Lightroom menu (Mac) and select the *External Editors tab*.
- **2.** In the bottom half of the dialog, press *Choose* and navigate to the program's exe file (Windows) / app (Mac). (Figure 17.14)

Figure 17.13 If your ACR version isn't fully compatible, Lightroom will ask whether to Render Using Lightroom, creating a TIFF/PSD and passing that to Photoshop, or Open Anyway, taking a chance that the rendering may be different.

- **3.** Select other preferences below—TIFF is a good choice for file format, and 8-bit vs. 16-bit depends on your specific editor. If your software is fully color-managed, select ProPhoto RGB. Otherwise select sRGB.
- **4.** In the Preset pop-up, select *Save Settings* as *New Preset* and give your editor a name.

You can use the same steps to create as many external editors presets as you like.

When you close the dialog, the preset selected in the Preset pop-up becomes the main Additional External Editor shown at the top of the list, and it's assigned the secondary keyboard shortcut, which is Ctrl-Alt-E (Windows) / Cmd-Opt-E (Mac).

5. To open a photo into your external editor, go to *Photo menu > Edit In* or access it from the right-click menu. **(Figure 17.15)**

How do I edit an external editor preset?

If you need to change one of your External Editors, return to the *Preferences dialog > External Editing tab* and select the preset from the pop-up menu. You can then edit the settings, perhaps changing the file format or color space, and go back to the pop-up and select *Update Preset* from the listed options. To rename or delete a preset, select it in the pop-up and then select *Rename preset* or *Delete preset*.

Where have my external editors gone?

If some external editor presets go missing, toggle the *Store presets with this catalog* checkbox in *Lightroom's Preferences > Presets tab* to see if they reappear. To learn more about this checkbox, turn to page 489.

Can I open the raw file into another raw processor?

Lightroom sends TIFF/PSD files to its

Figure 17.15 If you open a file into a secondary external editor, it allows you to change the file preferences on-the-fly.

Preset:	Silver Efex Pro 2		
Application:	Silver Efex Pro 2		Choose Clear
File Format:	TIFF	0	The sRGB color space cannot encompass the full range of colors available within Lightroom.
Color Space:	sRGB		
Bit Depth:	16 bits/component	0	
Resolution:	240		
Compression:	None	0	

Figure 17.14 You can set up multiple additional external editors using the External Editing tab in the Preferences dialog.

Additional External Editors, rather than the raw data, which is ideal for most pixel editing software, but there may be occasions when you want to open a photo into another raw processor (or a video into video editing software). On these occasions, right-click on the photo, choose *Show in Explorer* (Windows) / *Show in Finder* (Mac) and then open into your raw processor.

Alternatively, John Beardsworth's Open Directly plug-in takes the original file and passes it to the software of your choice. https://www.Lrq.me/beardsworth-opendirectly

INSTALLING PLUG-INS

Plug-ins allow third-party developers to add additional functionality to Lightroom, with greater integration than simple External Editors. They're written in Lua, and the SDK (Software Development Kit) is freely available from:

https://www.Lrg.me/sdkdownload

There's a wide variety of plug-ins available, doing everything from adding a List view to the Library module, to adding borders while exporting photos, to automatically uploading photos to various websites. I've mentioned my favorites throughout the book, but you can find a longer list at https://www.Lrg.me/links/plugins

How do I install a plug-in?

Some plug-ins automatically install themselves, but if your downloaded doesn't automatically install:

1. If the plug-in has a .zip extension, doubleclick to unzip it, and store it somewhere safe.

It's a good idea to keep all of your plug-ins in one place, to make them easy to find, update, transfer, back up or delete. Creating a *Plug-ins* folder alongside the other presets

Figure 17.16 Plug-ins are installed and uninstalled using the Plug-in Manager dialog.

folders would be an ideal place, and you can find that folder easily by going to *Preferences* dialog > *Presets tab* and clicking the *Show All* Other Lightroom *Presets* button.

- **2.** Go to File menu > Plug-in Manager to show the Plug-in Manager dialog. (Figure 17.16)
- **3.** Click on the Add button in the lower-left corner.
- **4.** Navigate to the *.lrplugin* or *.lrdevplugin* folder/file for the plug-in you would like to install. On Windows, you need to select the folder, rather than its contents, whereas *.lrplugin* files are a single package file on Mac.
- **5.** Some plug-ins have additional instructions, for example, the LR/Mogrify plug-in also needs you to install the Mogrify

Figure 17.17 Some Export plug-ins appear in the pop-up at the top of the Export dialog. Other plug-ins create their own section in the bottom left corner of the Export dialog.

application. Most developers include full installation instructions.

How do I uninstall a plug-in?

To remove any plug-ins that you've installed by means of the *Add* button, simply select the plug-in in the Plug-in Manager dialog and press the *Remove* button. The *Remove* button isn't available for plug-ins stored in Lightroom's own Modules folder, such as plug-ins that use an installer.

How do I use a plug-in?

Once you've installed the plug-in, it's ready to use. The way you access it depends on the individual plug-in, but each developer should provide instructions.

Some plug-ins that export directly to a different destination, such as LR/TreeExporter, show in the pop-up menu at the top of the Export dialog, where it usually says *Hard Drive*. They may also create their own panels in the Export dialog. (Figure 17.17)

Some plug-ins, such as LR/Mogrify and Metadata Wrangler, appear in the Post-Process Actions section of the Export dialog, below the Export Presets. From there, you can choose which options you want to make available for your current export, for example, on LR/Mogrify, a single border. The plug-in panels that you choose then appear beneath the normal export panels.

Publish Service plug-ins appear in the Publish Services panel, like the built in Facebook and Flickr plug-ins. (Figure 17.18)

Most other Export Plug-ins have a menu listing under the *File menu* or *Library menu* in the Plug-in Extras section instead (yes, there are two different menus with the same name!).

Figure 17.18 Plug-ins for Publish Services appear in the Publish Services panel.

SAVING METADATA TO THE FILES

While we're on the subject of editing photos in other programs, let's also talk about sharing metadata with other programs.

Because Lightroom is designed around a database, any changes you make in Lightroom are stored within Lightroom's catalog. This means that the changes aren't available to other programs such as Bridge. To make the metadata available to other programs, you need to store it in/with the files using a format called XMP.

XMP stands for Extensible Metadata Platform. It's simply a way of storing text metadata, such as Develop settings, star ratings, color labels and keywords, among other things, with the photos themselves. XMP is based on open standards and the SDK is freely available, which means that other companies can also write and understand that same format, making your metadata available to other image management software.

The XMP for most file types (e.g. JPEG, TIFF, PSD, DNG) is written to a section in the header of the file. These changes don't affect the image data, and therefore never degrade the quality of the photo. The metadata's written to a sidecar file for

proprietary raw files because writing back to these file formats can prevent some other software from reading them.

While we're on the topic of sidecar files, if you come across any *.acr sidecar files next to your raw files, it's because you've edited the file using the Adobe Camera Raw plugin for Bridge/Photoshop. It's a settings sidecar file like *.xmp, but it just includes the mask for Al selections such as Select Sky. Lightroom writes this data out to normal *.xmp sidecar files if you choose to write the metadata to the files, but ACR uses separate *.acr sidecars for performance reasons. Lightroom and ACR can understand both sidecar formats. Just treat them like sidecar xmp files.

Should I write to XMP?

Writing the metadata back to the files has pros and cons:

Sharing metadata—To edit or view metadata using other software, it has to be written to the files.

Belt-and-braces backup—Many use XMP data as an additional backup of settings in case their Lightroom catalog and backups become corrupted or they remove photos from the catalog by accident.

Transferring between catalogs—Some use XMP to transfer photos between catalogs (but only some of the metadata can be stored in XMP so Import from Catalog is a better choice... we'll come back to that on page 497).

Corruption—On the downside, writing changes back to the original files does slightly increase the risk of file corruption for JPEG, TIFF, PSD and DNG files, even though it's only updating the header of the file.

Big backups—Updating the metadata in the original JPEG, TIFF, PSD or DNG files means they're seen as changed by your backup software. If you use online backups, that could mean all the adjusted photos being reuploaded each time you make a change.

Lots of little files—If you write metadata to proprietary raw files, it's written to sidecar files. You may like or dislike all those extra little files!

Limited data—Only some of your Lightroom settings can be written to the files, due to limits in the XMP specification. It's not a complete backup.

Sync Bandwidth—When metadata is written back to the file, it's seen as changed and therefore uploaded again. This can use a lot of bandwidth quickly.

Which of Lightroom's data isn't stored in XMP?

Flags, virtual copies, collection membership, uncommitted location data, Develop history, stacks, Develop module panel switches and zoomed image pan positions are currently only stored in the catalog itself, and not the XMP sections of the files.

How do I write settings to XMP?

To write settings to XMP, select the files in Grid view and press Ctrl-S (Windows) /

Cmd-S (Mac) or go to Metadata menu > Save Metadata to Files.

When you're manually writing metadata to DNG files, you'll note that the Metadata menu offers two options:

Save Metadata to File just updates the XMP metadata, as it would with any other kind of file.

Update DNG Preview & Metadata does the same, but it also updates the embedded preview in any DNG files to include your Develop edits.

You can also turn on **Automatically write** changes into XMP in Catalog Settings > Metadata tab (Figure 17.19), which updates the XMP every time a change is made to the photo (although it's smart enough to wait a few seconds for you to stop editing). If you need to temporarily pause it to prioritize other tasks, click on the Identity Plate to show the Activity Center and click the pause button next to **Saving XMP**.

If you're considering enabling automatic writing, there are a few points to be aware of:

• Think about how it will affect your backups—XMP sidecars for proprietary raw files are tiny to back up, but updating XMP embedded in DNG, JPEG, PSD, TIFF or PNG files may trigger your backup system to back

Figure 17.19 Automatically write changes into XMP saves the metadata with the files as well as in the catalog.

up the whole file again. Even something as simple as correcting the spelling of a keyword triggers an update.

- Making changes to large numbers of photos (i.e., thousands) may be noticeably slower with auto-write turned on, due to the sheer volume of individual files that need to be written. This is especially noticeable when reorganizing your keyword list.
- When you first turn auto-write on, performance may drop considerably while it writes to XMP for all the photos in the catalog. Once it's finished doing so, performance improves, so you're best just to leave it to work for a while.
- Avoid turning auto-write off and on again too often, as every time you turn it on, it has to update the files with all the changes.

Should I allow Lightroom to update the capture time in raw files rather than XMP sidecar files?

There's an exception to the sidecar rule for proprietary raw files. If you edit the capture time, the new capture time can be updated in the original file. It's written to a documented portion of the metadata file header, so it's relatively safe. Some people feel that their raw files should never be touched in any way, so there's a **Write date or time changes into proprietary raw files** checkbox in *Catalog Settings > Metadata tab* which allows you to choose whether the updated date/time is stored only in the catalog, exported files and XMP sidecar files, or whether it can be updated in the original raw files too.

Should I check or uncheck Include Develop settings in metadata inside JPEG, TIFF, PNG and PSD files?

There's an extra option in Catalog Settings >

Metadata tab with regard to XMP, marked Include Develop settings in metadata inside JPEG, TIFF, PNG and PSD files. It controls whether Lightroom includes your Develop settings when it writes the other metadata. Personally, I leave it checked to include Develop settings when I write to XMP, but these text instructions can increase the file size if you've used lots of masks or healing.

How do I read the metadata from the files?

Having written the metadata to the files, Lightroom essentially ignores it. The adjustments you make in Lightroom are still stored in the catalog, and that database is always assumed to be correct, whether XMP metadata exists or not.

The external metadata is only read at the time of import, or when you choose to read the metadata using Metadata menu > Read Metadata from Files. If you read the metadata from the files, it overwrites the information stored in the catalog for that photo.

Lightroom uses the metadata icons to show whether Lightroom's metadata or the external metadata was most recently updated (although it can take a few minutes before Lightroom notices an external change).

The metadata in the catalog is newer than the metadata in the file.

The metadata in the file is newer than in Lightroom.

The metadata has changed both in Lightroom and externally, resulting in a conflict.

Clicking on this icon requests confirmation: (Figure 17.20)

Import Settings from Disk-If you've

intentionally changed the metadata using another program, this reads the metadata from the file and replacing the information in the catalog.

Cancel—don't do anything.

Overwrite Settings—If you're comfortable that everything looks correct in Lightroom, this replaces the external XMP metadata with Lightroom's data, clearing the warning icon.

When resolving metadata conflicts, is there a way to preview what will happen?

If Lightroom tells you there's a metadata conflict, you have to decide which set of data to keep. The problem is, it doesn't tell you which data is different in each version, so you have to either remember which you last updated, or take a guess. The good news is there's a workaround, although it would be time-consuming if you have a large number of conflicts.

If you create a virtual copy before reading

the metadata, the virtual copy retains the Lightroom metadata and the master is updated with the external metadata. You can then flick back and forth, comparing metadata and Develop settings, and decide which to keep. If you want to keep the data on the virtual copy, select *Photo menu > Set Copy as Master* before removing the other copy.

If the conflicted file is raw file, you can also open the XMP file using a XML or text editor to manually compare the contents with the information in the catalog.

How do I avoid metadata conflicts?

If you're going to make changes to the metadata in another program, save Lightroom's settings out to the files before editing in the other software. When you read the metadata again later, Lightroom's Develop settings are simply read back again, along with your new metadata edits, rather than being reset to default.

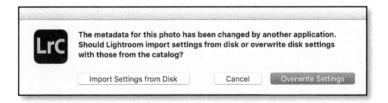

Figure 17.20 If there's a metadata conflict, clicking on the icon will ask how to handle it.

EDIT IN... SHORTCUTS

		Windows	Mac
Edit in	Edit in Photoshop	Ctrl E	Cmd E
	Edit in Other Application	Ctrl Alt E	Cmd Opt E
XMP	Write Metadata to Files	Ctrl S	Cmd S

EXPORT, EMAIL & PUBLISH SERVICES

18

Lightroom is nondestructive, which means that it doesn't save over your original image data. To apply

your settings to your photos, you use *Export*, which is like a *Save As* in other programs.

When you export photos, it's usually for a specific purpose, such as posting on the web, giving them to someone else, or sending them away to be printed. Most exports can be deleted after use, as the photos can be exported again in future using the original image data and the settings saved in the catalog.

You can also email photos from within Lightroom, and publish photos to social media websites, but we'll come back to these a little later in the chapter (page 434 and page 439). First, let's cover the basics of export.

'SAVE AS' A COPY ON THE HARD DRIVE USING EXPORT

To export your finished photos, select them and then go to *File menu > Export* or press the *Export* button at the bottom of the left panel group in Library module.

These are the main settings you'll need to check: (Figure 18.1)

Export Location—decide where on the hard

drive to save the exported photos.

File Name—you can rename on export, for example, creating a template for Sequence #(001)-Filename puts a sequence number before your existing filename to ensure that they sort correctly in other software. It doesn't affect the names of the original files.

File Format—JPEG is an excellent choice for web, email, etc. TIFF is best for pixel editors such as Photoshop.

Color Space—select sRGB for screen/web use or ProPhoto RGB for color managed pixel editors such as Photoshop.

Size—refers to the pixel dimensions of the photo. There are some sample sizes in the sidebar.

Output Sharpening—select *Screen* for screen/web use, and the type of paper for prints.

If you're just starting out, here are some sample export settings for different uses:

Email or small web photo—*Longest Edge* 800px, and you can ignore the resolution as we're specifying the size in pixels. Format JPEG, quality 60. sRGB.

4" x 6" digital print—Dimensions 4" x 6" at 300ppi. Format JPEG, quality 70. sRGB.

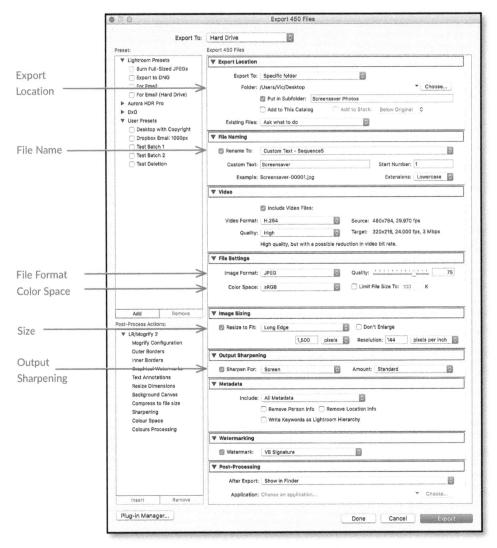

Figure 18.1 Use Export to create copies of your photos with your adjustments applied. We'll look at the individual panels on the following pages.

8" \times **10"** digital print—Dimensions 8" \times 10" at 300ppi. Format JPEG, quality 80. sRGB (unless your lab requests another profile).

Full resolution file—uncheck the *Resize to Fit* checkbox. Format JPEG, quality 90-100. (There's a significant reduction in file size by dropping from 100 to 90, with minimal visible changes). sRGB.

Edit in another color managed program—uncheck the *Resize to Fit* checkbox. Format TIFF, no compression, 16-bit, ProPhoto RGB.

The *Export* button starts exporting the photos using your selected settings. *Cancel* closes the dialog without exporting any photos. *Done* does the same, but saves the settings you selected in the Export dialog.

Now let's start exploring these settings in more detail, starting at the top of the Export dialog and working down.

EXPORT TO

At the top of the Export dialog is the **Export To** menu that's usually set to *Hard Drive* for normal exports. The other options include writing the exported files to *CD/DVD*, creating photos to *Email*, or exporting to specific plug-ins. **(Figure 18.2)**

To burn exported photos to CD/DVD directly from Lightroom (Blu-ray burning not available), change the pop-up menu at the top of the Export dialog to CD/DVD. When you press the Export button, it prompts you to insert a disc. If there's too much data for a single disc, Lightroom calculates how many discs are needed and spans the data without splitting any individual files. Alternatively, you can export to the hard drive and use specialized software to burn instead.

If you're exporting to a USB stick, select *Hard Drive* at the top, and then select the

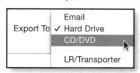

Figure 18.2 Set the export type in the Export To pop-up.

USB stick in the Export Location panel, as if you're selecting another external hard drive.

On the left of the dialog are Export Presets and then space for plug-in options. We'll come back to these later (page 432). The right-hand side of the Export dialog is made up of a series of collapsible sections which hold all the export options, so we'll start exploring these.

EXPORT LOCATION & FILE NAMING

The first pop-up in the **Export Location** section (**Figure 18.3**) determines the destination folder for the exported files. You have three choices:

Specific folder groups all the exported photos in a single folder. Select the location by pressing the *Choose* button and navigating to a folder. The chosen folder path then displays below the pop-up. Clicking on the arrow to the right displays the other folders you've recently used for exports.

Select folder later also groups all the exported photos in a single folder, but it pops up asking for a folder location just before the export begins. It's useful if you're creating a preset that will export to a different location each time you use it.

Same folder as original photo stores the exported photos with their original files, so they may be spread across a variety of

Export To:	Specific folder	0		
Folder:	/Users/Vic/Desktop		-	Choose
	Put in Subfolder: Holid	day IOW		
	Add to This Catalog	Add to Stack:	Below Original	0
Existing Files:	Ask what to do	0		

Figure 18.3 In the Export Location section, select the Destination folder for the exported photos.

different locations. It's particularly useful when combined with the *Put in Subfolder* checkbox

The **Put in Subfolder** checkbox creates a new subfolder inside your chosen destination folder, using the name you enter in the field. For example, you might select an *Exported Photos* folder on your desktop, inside which you create a named subfolder for each export you run, or you might want to create *Finished JPEGs* folders inside the original image folders.

Lightroom can't reproduce the folder hierarchy natively, for example, a wedding that's grouped into folders for each stage of the day, LR/TreeExporter plug-in can save you doing so manually. https://www.Lrg.me/armes-lrtreeexporter

You can do the same using Publish Services (we'll come back to these on page 439) for both folder hierarchies and collection hierarchies, using Jeffrey Friedl's Folder Manager and Collection Manager plugins. https://www.Lrq.me/friedl-folpub and https://www.Lrq.me/friedl-colpub

Can Lightroom automatically re-import the exported files?

In most cases, you won't need to import the exported photos into your catalog, as they're exported for a specific purpose and can then be deleted. If, however, you're exporting photos ready to be retouched in an external editor, you may want these retouched versions to be catalogued along with the originals.

You could use the Import dialog to manually import the exported photos into the catalog, but it's quicker to check the **Add to This Catalog** checkbox to add them automatically.

At the same time, the exported photos can

be automatically stacked above or below the original photos using the **Add to Stack** checkbox. Remember, stacking is a way of grouping photos in the grid so they appear as a single photo. To make this option available, you must have the *Export To* pop-up set to *Same folder as original photo* (because stacked photos have to be in the same folder) and *Put in Subfolder* must be unchecked.

Of course, to add the exported photos to the same folder in order to stack them, they must have different filenames or file formats, otherwise they could overwrite the originals. The simplest solution is to add an additional word such as -Edit to the end of the filename. You can rename the photos while exporting—we'll come to that in a moment (page 419).

How do I handle existing photos with the same names?

If there are already photos with the same names in your destination folder, perhaps because you forgot to rename while exporting, Lightroom needs to know how to handle them. It can skip exporting these photos, overwrite them (only if they're not the original photos you're exporting) or automatically use unique names. Unique names just adds a -2 (or similar) to the end of the filename. You can select the default behavior in the Export dialog, or you can leave the **Existing Files** pop-up set to Ask what to do so it gives you the choice when those circumstances arise. (**Figure 18.4**)

Figure 18.4 If files with the same name exist in the Destination folder, Lightroom asks you what to do. You can pre-empt the decision using the pop-up in the Export dialog.

Can I overwrite the original photos?

Lightroom won't allow you to save over the original file that you're exporting, as it goes against its philosophy of non-destructive editing. Overwriting the originals is like throwing away the negatives once you've made a print that you like!

How do I change the filename while exporting?

Beneath the Export Locations section is **File Naming**. Photos are only renamed if the **Rename To** checkbox is checked. The options should be familiar by now, as they're the same options used in the Import dialog (page 36) and Rename Photo dialog (page 127). To create a filename template, select *Edit* from the pop-up, add your chosen tokens and save it using the pop-up at the top of the Filename Template Editor dialog.

The File Naming section in the Export dialog (Figure 18.5) renames the exported photos, but it doesn't affect the original photos in your catalog, so there are a number of situations where it's helpful.

We've already mentioned the example of adding a word such as -Edit to the end of a filename, to distinguish a retouched photo from the original. To create this template, insert a filename token, then click in the white field and type -Edit (or use a custom text field if you want to change it regularly). (Figure 18.6)

If the photos you're exporting are to be viewed in other software, adding a sequence number with leading zeros to the beginning (i.e. 003-myfile.jpg) forces them to sort in the same order as the Grid view. Remember, in the *Sequence* pop-up, there's a variety of different sequence numbers, with varying numbers of leading zeros. If you're exporting 100 to 999 photos, you'll need 3 digits. (Figure 18.7)

When renaming exported photos, consider whether you'll later need to match them up with their originals. For example, if you export as wedding001.jpg to wedding300. jpg (custom name—sequence template), but your originals in Lightroom are still called IMG_3948 to IMG_8574, how are you going to match them up when the client brings back a list of orders?

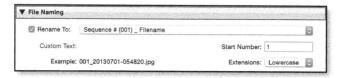

Figure 18.5 Set the filename in the File Naming section. If the Rename checkbox is unchecked, the files retain their existing names.

Figure 18.6 You can automatically add -Edit to the end of filenames.

Figure 18.7 Use a Sequence # (001) token, then a hyphen (-) or underscore (_) and then a Filename token, to ensure that photos sort correctly in other software.

VIDEO & FILE SETTINGS

The next sections in the Export dialog are **Video** and **File Settings**, where you select the file format, quality and color space.

The file format you select depends on the purpose of the photo or video. (Figure 18.8)

We'll come back to video formats in a moment (page 422), but for photos you have four *Image Format* choices:

JPEG is an excellent choice for emailing photos or posting them on the web. It's a lossy format so there is a trade-off between smaller file sizes and artifacts, but these artifacts are often invisible at medium-high quality settings. JPEGs can only hold 8 bits of data per channel, so stick with smaller color spaces such as Adobe RGB and sRGB.

TIFF is a lossless format, so it's great for storing working files and high-value edited photos. TIFFs can hold 16 bits of data (or even 32 bits for HDR photos) as well as Photoshop layers and transparency. Compression usually reduces the file size, although it takes a little longer to save.

PSD is also lossless and allows you to save less frequently used Photoshop color modes such as duotone, but TIFF is more widely supported.

DNG is the digital negative format. It wraps the raw data in a standardized format, along with the metadata. It's a good choice when sending raw data along with your Lightroom settings to another Lightroom or Photoshop

user. You can learn more about DNG in the Geeky Bits Appendix starting on page E1.

PNG is primarily used on the web. It's a lossless format (unlike JPEG) and it supports transparency. However, it doesn't natively support EXIF data, and the files are generally bigger than the equivalent JPEG.

Original exports in the original format, creating a duplicate of the original file but with updated metadata. Your Develop edits are not applied to the image data when selecting *Original* format, but may be visible if the photo's imported into Lightroom or opened in Bridge/Photoshop.

Should I apply compression to the photos?

There are two main kinds of compression: lossless and lossy.

Lossless compression, as the name suggests, compresses the files, but they can be put back together perfectly, without any loss of quality.

Lossy compression works by throwing away some of the data. It can significantly reduce file size but at the expense of image quality and detail.

Because compressed files require more processing to open and close them, they can be a little slower to work with, but the space saving can be substantial.

The PSD format automatically compresses the files using lossless compression.

Figure 18.8 Set the image format and color space in the File Settings section.

The TIFF format gives you a choice of compression, between *None*, *LZW* and *ZIP*.

None applies no compression, so the file sizes are large.

ZIP applies ZIP compression. It's a good allround choice.

LZW is only available for 8-bit files, because LZW compression doesn't work well with 16-bit files and often makes them larger. It's still available for compatibility with some programs that don't understand ZIP compression, although such programs are rare now.

The JPEG format has a *Quality* slider, which controls the amount of compression applied to the photo. The resulting file sizes vary depending on the content of the photo, and therefore how much they can be compressed. Photos with large flat areas of color compress much more than detailed or noisy photos.

As a rule of thumb, Lightroom's default setting of 75 is a good all-round choice. 60 creates smaller for photos for the web/email, without significant loss of quality. For 'master' images that aren't important enough to require lossless compression, try using 90 instead of 100. There's a substantial reduction in file size without visible degradation.

Visit https://www.Lrq.me/friedl-jpegquality for interactive examples showing the effect of different quality settings.

Can I export to a specific file size?

If you're uploading the JPEGs to a website with a specific file size limit (e.g. 70 KB), it can be time-consuming to repeatedly export the photos, changing the quality setting until the file falls inside the limit. If you check

the *Limit File Size To* checkbox and enter a limit, Lightroom does that for you, however the export can take longer than a standard export. It also removes the embedded thumbnail to improve the reliability and reduce the file size.

Lightroom only adjusts the JPEG quality setting automatically, and not the pixel dimensions, so you'll need to select reasonable pixel dimensions for the file size. It's only intended to work for small web-size photos, so if you enter 8000K (i.e. just under 8 MB), it may well fall over.

Which bit depth should I select?

We also discussed the subject of **Bit Depth** in the Edit in External Editors chapter on page 398. As a reminder:

8-bit saves hard drive space but may introduce banding in smooth gradients. It's a reasonable compromise for most finished files.

16-bit retains a larger amount of image data, so it's a better choice for working files (e.g., to send to external editors) and important master images.

JPEGs are always 8-bit. PSD and TIFF files give you the choice.

What is Save Transparency?

There's one final option in the TIFF settings, marked *Save Transparency*. TIFF's the only format that offers the choice as PSD, PNG and DNG include transparency automatically, and JPG can't contain transparency. (Figure 18.9)

A PNG, TIFF or PSD file may have already included transparent areas before the photo was imported, Lightroom's manual lens corrections can create transparent

Figure 18.9 The TIFF format also allows you to select the Bit Depth and Save Transparency.

areas where you've corrected for distortion or rotation, or a panorama may have transparent areas around the edge. In most cases, you'll want to save the transparency.

Which color space should I select?

While you're working in Lightroom, it manages the colors for you, however when you take the photos outside of Lightroom (such as when you're exporting), you're in charge of selecting the best color space using the *Color Space* pop-up. We discussed the pros and cons of different color spaces in the Soft Proofing section starting on page 386, but as a quick reminder, here are your options.

ProPhoto RGB retains the most data, so it's the best choice when transferring photos to Photoshop or other external editors. ProPhoto RGB photos look odd in programs that aren't color managed, such as web browsers. Because the space is so wide, it's not appropriate for 8-bit images.

Adobe RGB is a good all-round choice, as long as you're working in a fully color-managed environment (for example, you're sending the files to a print lab that accepts Adobe RGB files).

sRGB is a smaller color space, but it's the most widely used. It's a great choice for screen output, emailing or uploading to the web. It's also the safest choice if you don't know where the photos will end up.

Display P3 is a wide gamut color space used on the latest Apple devices. It's a similar

size to Adobe RGB, but it's shifted slightly towards reds/oranges and loses some of the greens/blues. It's primarily useful when exporting photos for display on the latest Apple devices.

Other allows you to select other RGB ICC profiles installed on your system. For example, some professional labs may request that you convert the photos to their own custom ICC profile. To do so, select Other from the Color Space pop-up, add a checkmark next to your custom profile and then press OK. Your custom profile is automatically selected in the pop-up.

How do I export or save my edited videos?

If you've edited a video, you likely want to apply the changes before sending it to someone else, just as you would for an image file. Using Export, you can create a duplicate of the original unedited video, or output to DPX or H.264 mp4 format. The options in the **Video Format** pop-up (Figure 18.10) are:

DPX is a lossless format used for editing in some professional video editing programs, such as Adobe Premiere.

H.264 is the best option for compressing your final videos, and it offers multiple quality settings.

Maximum quality uses a bit rate as close to the source file as possible, to prevent any loss of quality.

High quality retains the resolution but may

	Include Video Files:			
Video Format:	H.264	0	Source:	1920x1080, 25.000 fps
Quality:	High	0	Target:	1920x1080, 25.000 fps, 22 Mbps

Figure 18.10 Set the file format and quality in the Video section.

reduce the file size slightly.

Medium quality is useful for sharing on the web, as it's a lower resolution and bit rate.

Low quality is intended for mobile devices such as mobile phones, with a much lower resolution and bit rate resulting in a much smaller file size.

Original, as with photos, is a duplicate of the original file.

As a guide, a 10 second clip from a Canon 600d resulted in the following file sizes:

Original file: 155 MB for 27 seconds, so around 51 MB for 10 seconds

DPX-2.07 GB

H264 Max-29.7 MB, 1920x1080, 22 Mbps approx.

H264 High—29.7 MB, 1920x1080, 22 Mbps approx. (in this case it didn't make a difference)

H264 Medium—11.3 MB, 1280x720, 8 Mbps approx.

H264 Low-1.5 MB, 480x270, 1 Mbps approx.

IMAGE SIZING & RESOLUTION

If you leave the **Resize to Fit** checkbox unchecked in the Image Sizing panel, the photos remain at their native resolution, (less any cropped pixels). If you check it, you can resize the exported copies to the right size for your intended purpose. Remember, Lightroom doesn't resize the original photos while cropping, as this would go against it's non-destructive design. After all, there's nothing more destructive than deleting original pixels! Instead, you crop to a specific ratio in the Develop module and then set the size (or more accurately, the number of pixels) you require in the Export dialog. (Figure 18.11)

Pixels don't have a fixed physical size. They expand or contract to fill the space available. If you expand them too far, the photo appears blurry and pixelated (you can see the squares), so the aim is to keep the pixels smaller than or equal to the monitor pixels or printer dots. (Figure 18.12)

How big can I print my photo without visible pixelation?

Most current cameras capture large files suitable for most purposes, but if you've cropped the photo heavily, you may have

Figure 18.11 Set the new pixel dimensions in the Image Sizing section of the Export dialog.

Figure 18.12 The smiley face looks sharp when it's printed small, but the individual pixels show when it's enlarged too far.

cropped many of the pixels away. You can check the original and cropped dimensions in the Metadata panel. In **Figure 18.13**, the 4608x3456 pixel file has been cropped to 3299x2474.

To check how big a high-quality print you can create, simply take the number of pixels along each edge and divide them by the desired print resolution.

$$1187px$$
 / 300ppi = 4"
 $1008px$ / 300ppi = 3.4"

Why 300ppi? Most printers output high quality prints at 250-360dpi, or dots per inch. You can often get away with a lower value (e.g., 200-240ppi), especially for large

Figure 18.13 Check the pixel dimensions in the Metadata panel.

prints, as you'll view them from a distance, but they won't be quite as sharp. Some printers and papers are also more forgiving than others, for example, a print on canvas doesn't notice if it's a little soft or pixelated.

How do I calculate the number of pixels I need for a specific print size?

To work out how many pixels you need for a specific print size, it's another simple calculation. Let's use a 8" x 10" print. Simply multiply the length of the edge in inches by 300ppi, and you'll end up with the pixel dimensions.

$$|0^n| \times |300ppi| = |3000px|$$
 $|8^n| \times |300ppi| = |3400px|$

The good news is Lightroom can do most of the math for you. You just have to enter the **Size** and **Resolution**.

Print sizes are usually defined in inches or cm, so enter your print size and select *inches* or cm from the pop-up, for example, 4" x 6". We said the *Resolution* setting is only useful when combined with units of measurements. If you enter the PPI required by your print lab (usually between 250ppi and 360ppi), Lightroom automatically calculates the right number of pixels for that size print. This process of creating new pixels or selectively throwing away pixels is called resampling.

Screen sizes are usually defined in pixels, so they're easy. You just enter the pixel dimensions you require and select *pixels* in the pop-up, for example, you may email a file that is 1024px along the longest edge. There's no point sending a huge file when it's only going to be viewed on screen. When you're defining the image size in pixels, the *Resolution* setting is irrelevant.

What's the difference between Width & Height, Dimensions, Longest Edge, Shortest Edge, Megapixels & Percentage?

The differences between the Width & Height, Dimensions, Longest Edge and Shortest Edge options are more easily illustrated using diagrams. The red lines mark the dimensions entered into Lightroom's Export dialog, and the black rectangle shows the resulting photo size and orientation. (Figures 19.14)

Width & Height fits the photos within a bounding box in their current orientation. This setting is width/height sensitive—settings of 400 wide by 600 high produces a 400×600 vertical photo, but only a 400×267 horizontal photo, assuming it's a 4x6 ratio.

Dimensions fits your photo within a

bounding box, but it's a little more intelligent than Width & Height. It takes into account the rotation of the photo, and it makes the photo as big as it can within your bounding box, even if it has to turn the bounding box round to do so. The Dimensions setting isn't width/height sensitive, so settings of 400 wide by 600 high produces a 400×600 or 600x400 photo, if the photo has a 4x6 ratio.

Longest Edge sets the length of the longest edge, as the name suggests. A setting of 10 inches long would give photos of varying sizes such as 3"×10", 5"×10", 7"×10", 8"×10", 10"×10", depending on the ratio of the photo.

Shortest Edge sets the length of the shortest edge, again as the name suggests. A setting of 5 inches along the shortest edge would

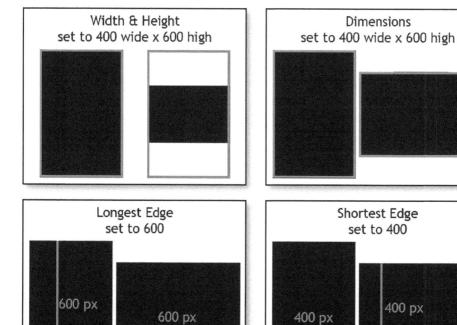

Figure 18.14 The Resize to Fit options in the Export dialog.

give varying sizes such as $5"\times5"$, $5"\times8"$, $5"\times10"$, $5"\times12"$, depending on the ratio of the photo.

Megapixels sets the dimensions automatically, based on your chosen pixel count. For example, selecting 24MP (24,000,000 pixels) would result in files of 4000x6000 and panoramas of 2400x10000, depending on their crop ratio. (Note that megapixels aren't the same as megabytes, so a 24MP file won't be 24 MB when saved.)

These measurements must still fall within the ACR limits of 65,000 pixels along the longest edge and 512MP, so if your photo falls outside of this range according to the measurements you've set, Lightroom simply makes the photo as big as it can.

There's also a **Percentage** option, so you can create files that are 50% of the original pixel dimensions, and so forth.

It's generally easiest to use *Longest Edge* and a pixel dimension for screen/email files and *Dimensions* with inches/cm and PPI for prints.

What's the difference between DPI, PPI, pixels per inch and pixels per cm?

Many people mix up PPI and DPI. DPI refers to Dots Per Inch. It doesn't apply to digital images until they're dots on a piece of paper. While they remain as pixels, the resolution is measured in PPI, or pixels per inch.

Pixels per cm is also available in the Export dialog, but it's rarely used, even if the print dimensions are measured in cm.

What does the Don't Enlarge checkbox do?

The **Don't Enlarge** checkbox prevents small photos from being upsized to meet the dimensions you've set, while still downsizing photos which are too large to fit your chosen dimensions.

Is it better to upsize in Lightroom or in Photoshop?

When Lightroom resizes, you don't have a choice of interpolation method, unlike Photoshop which offers Nearest Neighbor, Bilinear, Bicubic, Bicubic Smoother and Bicubic Sharper. Instead, Lightroom uses an intelligent adaptive bicubic algorithm which automatically adjusts for the increase or decrease in size. In theory, because Lightroom is working with the raw data and isn't limited to one specific resizing algorithm, it should give the best results. Either program can do a good job though.

OUTPUT SHARPENING

Once you've set the sizing, the **Sharpening** option is next in line. The output sharpening may only have two pop-up menus, but it's far more powerful than it looks. (**Figure 18.15**)

The complex output sharpening algorithms were created by the team at Pixel Genius, who also created the well-known Photoshop plug-in PhotoKit Sharpener. Based on the size of the original file, the output size and resolution, the type of paper, and the strength of sharpening you prefer, it automatically adjusts the sharpening to

Figure 18.15 Output Sharpening complements the Capture Sharpening applied in the Develop module.

create the optimal result.

Which Export Sharpening setting applies more sharpening—screen, matte or glossy?

The difference between *Matte* and *Glossy* is barely noticeable on screen, but there is a difference between each of the settings. At a glance, you'll see that the *Screen* setting sharpens the high-frequency details less than the *Matte* or *Glossy* settings, but there are a lot more technicalities behind that.

As a general rule, pick the right paper type, and you'll be about right. Sending matte sharpening to a glossy paper looks worse than sending glossy sharpening to matte paper, because the matte sharpening is compensating for the softer appearance of matte paper. Screen sharpening may look a little soft on old CRT monitors as it's optimized for LCD screens.

The **Amount** pop-up controls the amount of sharpening applied to the photo, and this decision is a question of personal taste. To get the best out of the automated output sharpening, you do need a properly capture-sharpened photo, so the sharpening settings in the Develop module are still essential. Avoid over-sharpening in the Develop module though, as the Export Sharpening makes it look a lot worse.

If you have no idea how the photos will be used, perhaps because you're giving them to a friend or client, *Glossy Standard* is a reasonable default.

METADATA & WATERMARKING

As soon as you release your photos, whether on the web or in printed form, they're at risk of being stolen. While you can't control that, ensuring that you have copyright metadata stored in the files, and possibly adding a watermark, can help to deter would-be thieves. On the other hand, you might want to strip some metadata from your files to protect your privacy.

How do I select which metadata to include in my files?

The *Metadata* section of the Export dialog (Figure 18.16) allows you to decide how much of the photo's metadata to *include* in the exported file. The basic options are self-explanatory. From the most retained metadata to the least, they are: *All, All Except Camera & Camera Raw Info, All Except Camera Raw Info, Copyright & Contact Info Only* or Copyright Only.

If you've added Map locations to your photos, you may want to strip the location data to protect your privacy. The **Remove Location Info** checkbox removes both the GPS coordinates and the IPTC Location data. You can also selectively remove specific locations, for example, your home address, by encircling these locations in a Saved Location using the Map module and marking it as private.

For the same privacy reasons, you may want to check the **Remove Person Info** to automatically exclude people's names from the exported keywords. Like the location

Figure 18.16 You can remove specific metadata from exported photos using the Metadata section.

data, you can right-click on the individual keywords in the Keyword List panel, select Edit Keyword Tag and uncheck Include in Export to only exclude specific people.

There's also a **Write Keywords as Lightroom Hierarchy** checkbox in the *Metadata* section. When it's checked, Lightroom uses the pipe character (|) to show parent/child relationships for your keywords, for example, Animals | Pets | William. It's useful if you'll be importing the photos back into the catalog, or into other software that understands keyword hierarchies. If you uncheck it, the keywords assigned to

the photo are only recorded individually, resulting in separate keywords for *Animals*, *Pets*, and *William*.

If you want to be even more selective, Jeffrey Friedl's Metadata Wrangler Export Plug-in allows you to choose which metadata to remove and which to keep. You can download it from: https://www.lrq.me/friedl-metadatawrangler

How do I add a watermark to my photos?

In the **Watermarking** section (Figure 18.17), you can select a watermark to apply to your

Figure 18.17 Select your watermark in the Watermarking section.

Figure 18.18 In the Watermark Editor dialog, you can design your own watermarks.

photos.

Check the **Watermark** checkbox and then select your watermark from the pop-up.

The most basic form of watermark is a small text watermark in the lower left corner of the photo, aptly named the *Simple Copyright Watermark*. It takes its text from the Copyright metadata field in the Metadata panel, and it's so simple you can't even change the font or size.

If you'd like something a little more decorative, select *Edit Watermarks* to design your own text or graphical watermark using the Watermark Editor dialog. (Figure 18.18)

How do I create a text watermark?

Let's first create a text watermark. Select the *Text Style* option at the top of the dialog, and then enter your text in the text field beneath the preview image. To add a © copyright symbol, hold down Alt while typing 0169 on the number pad (Windows) or type Opt-G (Mac).

Using the options in the **Text Options** section (**Figure 18.19**), choose the **Font**, **Style** and

Font: SF Grunge Sans
Style: Regular 🕏
Align: 🖺 🚆
Color:
Shadow
Opacity:
Offset: 10
Radius:20
Angle:

Figure 18.19 Set the options for your text watermark.

Color of your watermark text. The **alignment** buttons apply to the text alignment within the bounding box and they only come into effect when you have multiple lines of copyright text. You can also add a **Shadow** behind the text.

How do I create a graphical watermark?

If you'd prefer a graphical watermark, press the *Choose* button in the *Image Options* section and navigate to the PNG or JPEG file of your choice.

The PNG format has the advantage of allowing transparency, or semi-transparency—for example, you may want a large © symbol across your photo, but you don't want a large white square showing. (Figure 18.20)

You can download some of my favorite watermarks from: https://www.Lrg.me/resources

How do I set the size and placement on the photo?

The **Watermark Effects** section (Figure 18.21) allows you to set the size and placement of the watermark.

The **Size** is proportional to the size and orientation of the exported photo, and you can decide whether to *Fit* the watermark

Figure 18.20 A graphical watermark without transparency won't work!

▼ Waterma	rk Effects			
Opacity:	1 1 1 1 1 1	1 1 1	6 E	100
Size:	Proportional			
	○ Fit ○ Fill			59
	Inset			
Horizontal:			Nazyee	0
Vertical:		etron valles possessories	T COURS	0
Anchor:	000		Rota	te:
	888		4	4

Figure 18.21 Set the position and size of the watermark using the Watermark Effects section.

within the short edge, Fill the long edge, or keep it Proportional to the current orientation. If it's set to Proportional, you can adjust the size using the slider or the small square in the corner of the bounding box on the preview. (Figure 18.22) Remember to consider how it'll look on horizontal. vertical, square and panoramic photos.

To move the watermark around on the image, you can't drag it, but you can use the 9-way **Anchor** buttons to lock it to the center, a corner, or an edge of the photo.

Once it's anchored, you add additional spacing to distance it from the edge of the photo using the Inset sliders. If, for some reason, you've saved the graphic the wrong way round, you can also use the arrows to rotate the watermark.

If you haven't adjusted the opacity of the graphic, or you're using text, use the Opacity slider to reduce the opacity of the watermark, fading it into the photo.

Can I place the watermark in a different place on each photo?

The Watermark tool's purpose is to apply a watermark to large numbers of photos in the same size and position, so there isn't an interface for moving the watermark on individual photos, unless you want to keep returning to the Edit Watermark dialog every time you export. You could save multiple versions of a watermark preset, with the watermark in different positions, however you'd still have to select the photos to use with each preset. Using the Identity Plate and Print to JPEG, which we'll cover in the Print module, is a partial workaround if you need to carefully position a watermark on each individual photo.

Fill setting.

Proportional setting.

Figure 18.22 The size of the watermark is always relative to the size of the photo.

How do I save my watermarks?

Once you're happy with your watermark, use the pop-up menu at the top of the dialog to Save Current Settings as New Preset ready for use on your photos. (Figure 18.23)

To edit a preset you've already saved, first select the preset in the pop-up, edit it, and then return to the pop-up and select *Update Preset*. To rename or delete, first select the preset in the pop-up and then the *Delete Preset* and *Rename Preset* options become available.

Can I add metadata to my watermark?

Using Lightroom's watermark feature, you can add either a text or a graphical watermark, but not both. If you want greater control over the watermarking and you're willing to experiment to get your ideal result, the LR/Mogrify plug-in offers extensive options for adding multiple lines of text, metadata, multiple graphics and borders. You can download it as donationware from: https://www.Lrq.me/armes-lrmogrify2

Figure 18.23 To overwrite an existing Watermark preset, select it, make your changes, and then Update appears in the pop-up.

POST-PROCESSING

The final **Post-Processing** section (Figure 18.24) of the export dialog focuses on what happens to the photos after they're exported.

The **After Export** pop-up is set to *Do Nothing* by default, but *Show in Explorer* (Windows) / *Show in Finder* (Mac) is a useful alternative, taking you directly to the exported photos.

If you're exporting photos for editing in another program, select the *Open in Other Application* option and press the *Choose* button below to select the program.

If you choose the *Go to Export Actions Folder Now* option, it opens an Explorer (Windows) / Finder (Mac) window. Placing shortcuts/ aliases to applications or even Photoshop Droplets in this folder adds them to the main *After Export* pop-up for easy access.

What are Post-Process Actions?

If you've installed certain plug-ins, such as LR/Mogrify 2, there may be an additional section in the Export dialog marked **Post-Process Actions**. (Figure 18.25) To use one of

Figure 18.25 The Post-Process Actions section may be added by a plug-in.

Figure 18.24 In the Post-Processing section, select the action to take once the export has completed.

these actions, select it and press the *Insert* button. The action options become available as additional panels on the right of the Export dialog.

OTHER EXPORT QUESTIONS

Before we move on to email and Publish Services, there are a few other questions that often arise when exporting photos.

Can I save my Export settings as a preset?

Having chosen all of your settings in the Export dialog, you can save them as a preset for easy access next time. A few Export presets are already included by default, but it's useful to save your own settings too. You might choose to create presets for regular exports, such as email, blog, printing at a lab,

Figure 18.26 Export presets show on the left hand side of the Export dialog, and you can group them into folders to keep them organized.

Figure 18.27 Export presets can be accessed from the photo's right-click menu.

archiving full resolution, and so forth.

To create an Export preset, set your Export options, and then press the *Add* button in the *Presets* panel of the Export dialog. (Figure 18.26)

Your presets are stored in the User Presets folder by default, but you can organize them into folders by right-clicking in the Presets panel and choosing *New Folder*, and then dragging the presets into your folders. To rename, delete or update them when your settings change, right-click on the preset. To share the presets with others, use the *Import* and *Export* options in that same right-click menu.

To export using a preset, click on the preset name so it's highlighted. Like a Develop preset, this just changes the settings on the right. You can edit the settings before exporting, or just go ahead and click **Export**.

You can also easily export using the preset settings using *File menu > Export with Preset*, or through the right-click context-sensitive menu for any photo. (Figure 18.27) This is particularly useful if you're using the Export preset to open the files in an external editor.

What's the difference between a highlighted preset and a checked preset?

A highlighted preset is selected and its settings are shown on the right. You can change the settings for a single export or update the preset.

Checked presets are used for multiple exports, so the preset settings become readonly. Only hard drive exports are supported for bulk exports, so the checkboxes for *Email* and *CD/DVD* presets are disabled. (Figure 18.28)

Figure 18.28 Checkboxes (left) are used to select multiple presets, whereas highlighted presets (right) are used for single exports and the settings can be edited.

Can I export using multiple presets at once?

At times you may want to export multiple sizes/formats of the same photos, without having to return to the export dialog over and over again. For example, a wedding photographer may want a full resolution set of JPEGs to send to the print lab, a medium resolution screen-sharpened set to give to the bride and groom, and a low resolution watermarked set to upload to an online gallery.

To export using multiple presets, check the checkmarks next to the preset names, rather than highlighting the presets themselves,

and then click **Batch Export**.

The Batch Export dialog that follows allows you to override the destination folders and file names (custom text and sequence number) specified in the presets. (Figure 18.29)

Why are my adjustments not being applied to my exported file?

If you choose *Original* as the File Format in the Export dialog, you'll create a duplicate of the original file, without your Develop settings applied. The file size may be slightly different as Lightroom updates the metadata, unlike an operating system

	er: /Users/Vic/Desktop/My Batch Expo der will overwrite any destinations s		
Desktop with Copyr	ight		
Put in Subfolder:	Lightroom Exports		
Custom Text:		Start Number:	
Example:	20140915-182958.jpg	Extensions:	Lowercase 😂
Dropbox Email 1000	рх		
Put in Subfolder:	Lightroom Exports		
Custom Text:	Dropbox	Start Number:	1
Example: I	Dropbox-00001.jpg	Extensions:	Lowercase

Figure 18.29 There's additional control over the destination folder when doing a batch export.

duplication, but it won't re-compress the image data, so the quality won't be reduced.

It gives an error message—Some export operations were not performed. The file could not be written. or The file could not be found. What went wrong?

If Lightroom says it couldn't export the files (Figure 18.30), press the *Show in Library* button to view an *Error Photos* temporary collection, so you can see the photos in question.

If the error says The file could not be found, then some of the selected photos are missing because you've moved or renamed them with other software, or the drive is offline. Click on the exclamation point on the thumbnail and locate the original file, and run the export again. We'll come back to locating missing files in more detail in the Troubleshooting chapter starting on page 499.

If the error says *The file could not be written*, check the permissions on the export folder or parents of that folder, because they're probably read-only, or you're running out of disc space on that drive.

Figure 18.30 If an export fails, Lightroom displays an error dialog listing which photos failed and the reason for the failure.

EMAILING YOUR PHOTOS

You could export your photos to a folder on your hard drive and then attach them to an email, but

Lightroom makes even easier to email the photos direct.

Select the photos (no more than 100) and then go to File menu > Email Photos.

Which mail clients are supported?

On Windows, most email clients are supported, using standard Windows APIs to pass the images. This includes Windows Live Mail, Thunderbird, Eudora, Microsoft Outlook, etc.

On Mac, only Apple Mail, Microsoft Outlook, Microsoft Entourage and Eudora are supported, as each is coded separately.

How do I set up email if my email client is supported?

- **1.** Lightroom displays the Email dialog. (Figure 18.31) Your email software is automatically selected in the *From* pop-up.
- **2.** Select the photo size using the **Preset** pop-up in the bottom left corner.
- **3.** Leave the address and the rest of the email blank and press **Send**. The email message opens into your email software, where you can type your message and access your address book.
- **4.** Alternatively, you can type the recipient's email address and your message into the Email dialog and send it directly.

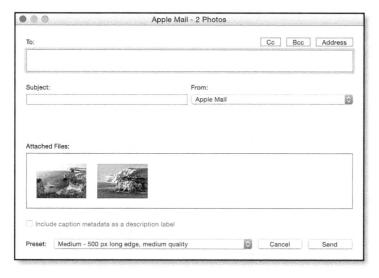

Figure 18.31 If your email client is supported, you can select it in the From pop-up.

How do I set up email if I use webmail or an unsupported email client?

- **1.** Lightroom first asks you for your email account SMTP settings. (**Figure 18.32**) (These are the settings you'd use to set up your email in a desktop email program.) You'll only need to add them once, as they're stored for future emails.
- **2.** In the New Account dialog, select your email Service Provider—AOL, *Gmail*, Windows Live Hotmail or Yahoo Mail. Enter a name for the account to help you identify it, and enter your email address and password,

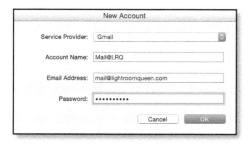

Figure 18.32 If your default email client isn't supported, Lightroom asks for your server details.

and press OK.

Many email providers, such as Google and Yahoo, now have increased security requirements which may block Lightroom from validating. In most cases, you can solve this by creating an App Password. For setup instructions for Gmail, see https://www.Lrq.me/gmailpw or for Yahoo, see https://www.Lrq.me/yahoopw.

3. If you use another email host, select Other from the Service Provider pop-up, enter the basic account details and press OK. In the Email Account Manager dialog (Figure 18.33), enter the rest of your email SMTP server settings. Once you've finished entering the details, press Validate to confirm that you've set up the account correctly, and press Done to confirm.

If you're not sure of your SMTP details, google the name of the provider and SMTP (e.g. "iCloud SMTP") or ask your email provider. When the Port is 465, the Security setting is usually SSL/TLS. When the port is 587, it's usually STARTTLS.

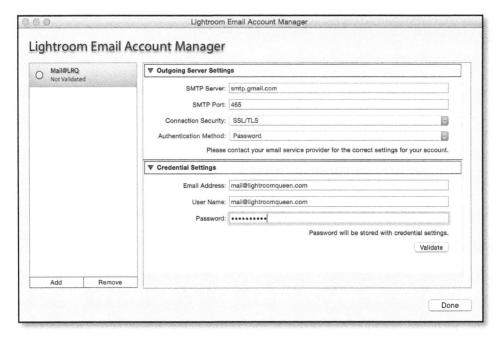

Figure 18.33 If your email client isn't supported, enter your email server SMTP details into the Email Account Manager dialog.

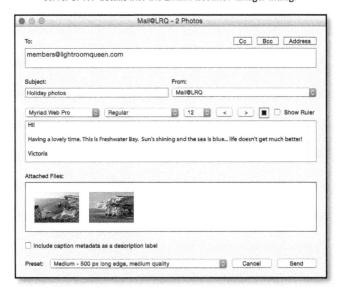

Figure 18.34 Enter the recipient's email address in the To field, the email subject, and your email message below. Set the image size using the pop-up in the bottom left corner.

- **4.** Select your new account in the *From* popup in the Email dialog (Figure 18.34), and you'll be ready to send your first email.
- **5.** Enter the address of the recipient, a subject for your email, and the message to include with your photos. Select the size of

photos from the *Preset* pop-up in the lower left corner of the dialog, and finally press *Send*. To send an email to multiple email addresses, separate them with a; and a space.

Can I have multiple email accounts?

If you're manually setting up email accounts using the Email Account Manager dialog, you can store settings for multiple accounts. To add additional accounts, select *Go to Email Account Manager* in the *From* pop-up, and click the *Add* button to add accounts. The accounts are then listed in the *From* pop-up as presets. (You can also delete accounts using the *Remove* button in the same dialog.)

How do I set the size of the photos I want to email?

In the bottom left corner of the Email dialog is the *Preset* pop-up. **(Figure 18.35)** Lightroom comes with 4 email presets by default, with different sizes and JPEG quality settings. They are: 300px low quality, 500px medium quality, 800px high quality, and full resolution very high quality.

Bear in mind the overall email size if you're

Figure 18.35 There are four image sizes available by default, or you can create a custom one for this email.

sending lots of photos, or you're sending a few full resolution photos. Many email accounts have a 10mb-per-email limit, both for sending and receiving email, although Gmail/Yahoo have increased this to 25mb. A few full resolution photos can quickly reach this limit and cause the email to bounce.

If you need to send many photos to the same person, consider creating a web gallery or uploading them to a photo sharing website instead of attaching them to an email. Lightroom web is ideal for sharing galleries of photos and it's included in any Adobe Creative Cloud subscription. See the Cloud Sync chapter starting on page 547 for more information.

If the recipients need to download a large number of photos, export them to a Dropbox folder (https://www.Lrq.me/dropbox) and email the download link, or use WeTransfer (https://www.Lrq.me/wetransfer) to send the files. It's more efficient for both you and the email recipient, and avoids clogging their email inbox.

If your emailed photos don't match the size you've selected in the Email dialog, check that your email software isn't downsizing the photos further. For example, Apple Mail has an *Image Size* pop-up that must be set to *Original Size*.

Can I save a custom email preset including extra settings, such as a watermark or a different file format?

If you'd like to specify your own export settings for the photos, perhaps to include a watermark, or a different sharpening setting, you can create your own preset using the Export dialog.

If you're viewing the Email dialog, select Create New Preset from the Preset pop-up in the bottom left corner to open the Export dialog. If you're already viewing the Export dialog, select *Email* at the top of the dialog to save an email Export preset. When you've selected your export settings, don't forget to save it as a preset. Turn back to Saving Presets (page 432) for a quick reminder.

How do I use Lightroom's address book?

If you use a supported desktop mail client, Lightroom passes the photos over to the mail client, so you can use your standard email address book.

If you send emails direct from Lightroom, you won't have access to your main address book. Instead, Lightroom allows you to save email addresses in a Lightroom address book. (Figure 18.36) To access Lightroom's address book, press the *Address* button in the Email dialog.

To save a new address, press the *New Address* button and enter the details. The new address is listed in the main Address Book.

If you regularly send emails to the same

group of people—perhaps family members—you may want to create a group of their email addresses for easy access. In the Address Book dialog, press *New Group* and click to put a checkmark against their email addresses in the left column. (Figure 18.37) Press the >> button to send them to the group, shown in the right column. Give your group a name and press *OK*. Your group is then listed in the Address Book dialog.

To use saved addresses in your email, press the *Address* button to return to the Address Book dialog and put a checkmark next to the individual or group, and their email addresses is automatically added to the *To* field. For individuals, rather than returning to the Address Book dialog, you can simply start to type the name of the recipient or the beginning of the email address in the *To*, *CC* or *BCC* fields, and it autofills. The autofill doesn't work for group names.

How do I keep a copy of my sent email?

If you send through your default email client, the sent email storage depends on

Figure 18.36 You can store email addresses in Lightroom's own address book.

Figure 18.37 Add users to a group using the New Group dialog.

the preferences for that software—if it usually saves your sent emails, it continues to do so for emails initiated by Lightroom.

If you send through Lightroom directly, saving the sent email depends on the email host. Some, for example, Gmail/Google Apps, automatically keep all outgoing as well as incoming emails, whether they're sent via SMTP or directly through webmail. Most other hosts do not keep all email, but pressing the *BCC* button in the Email dialog and typing your own email address would send the email to your own inbox, as well as the primary recipient's inbox.

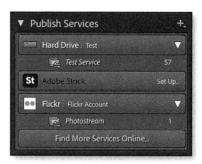

Figure 18.38 Publish Services have their own panel in the left panel group in the Library module.

PUBLISH SERVICES

Publish Services is another way of sharing your photos. You could consider it a 'managed export' as it keeps tracks of the photos exported to specific locations, and when you update the photos within Lightroom, it offers you the opportunity to update them at their exported location too. Depending on the service used, some updates such as comments made on websites can also be transferred back to your catalog.

How do I set up a Publish Services account?

We'll use Flickr for the step-by-step instructions, and then go into more detail. The basic principles of Publish Services setup are the same regardless of which service you're using.

- **1.** Go to the Publish Services panel (Figure 18.38), on the left in the Library module.
- **2.** Click on the *Flickr Set Up* button to show the Lightroom Publishing Manager dialog. (Figure 18.39)

- **3.** At the top of the dialog, give your account a name and then press the **Authorize** button. Lightroom asks for confirmation and then opens Flickr's website.
- **4.** Log in using your normal account details and confirm that you want to allow Lightroom access to your Flickr account. If you've previously authorized Lightroom access, it may skip the authorization page.
- **5.** In the *Flickr Title* section, select the title/caption to display with the photo.
- **6.** Set your normal export preferences below, for example, file name, size, sharpening and watermark. The options should be familiar from the standard Export dialog, which we discussed earlier in the chapter.
- **7.** At the bottom of the dialog, set your privacy settings. These settings control who can view your photos, so they can be set to *Public* to be visible to everyone or limited to your friends and family. *Safety* controls Flickr's own content filters, rating the photos as safe for anyone to view through

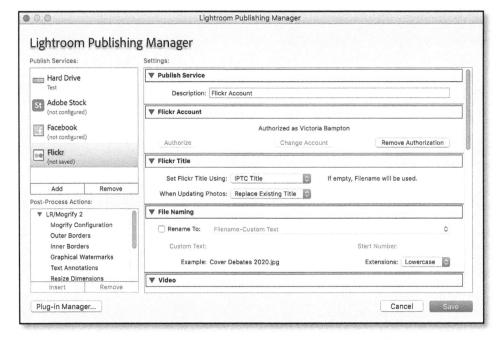

Figure 18.39 Authorize your account in the Publishing Manager dialog.

to restricted which are unsuitable for some age groups, like movie parental guidance ratings. (Figure 18.40)

- **8.** Press *Save* to store the settings. The dialog closes and in the Publish Services panel, you'll see your new Flickr connection, with the default *Photostream* album displayed underneath.
- **9.** Drag photos from the grid to the *Photostream* collection, or right-click on the Flickr Publish Service to create additional collections to store your photos. To add additional photos to an existing Flickr photoset, create a collection with precisely the same name.

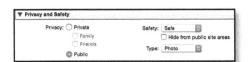

Figure 18.40 Flickr's Privacy and Safety settings control who can view the photos.

- **10.** Click on the collection to display the photos. The grid is divided into sections, showing the current status of the photos.
- **11.** Click on the **Publish** button at the bottom of the left panel group, or right-click on the Flickr album and select **Publish** Now.
- **12.** Go to the Flickr website to view your uploaded photos.

Does it automatically publish changes I make to my photos?

Publish Services tracks the changes you make to the photos, but it doesn't upload the updated photos automatically. Lightroom waits for you to click on the collection and choose *Publish*, otherwise it would be constantly uploading every time you made a change to a photo and you could end up accidentally publishing photos that you're part-way through editing.

How do I publish multiple collections at once?

We've already used the **Publish** button to publish a single collection. To publish multiple collections in one go, Ctrl-click (Windows) / Cmd-click (Mac) or Shift-click on the collections to select them all before pressing *Publish*. The photos start to upload which, depending on the dimensions chosen and your internet connection upload speed, could take a while!

To temporarily limit your upload to specific photos, hold down the Alt (Windows) / Opt (Mac) key. The *Publish* button at the bottom of the left-hand panel changes into a *Publish Selected* button which only uploads the selected photos.

How do I update my service with the changes I've made to my photos?

Lightroom divides the Grid view into different sections—New Photos to Publish, Deleted Photos to Remove, Modified Photos to Republish and Published Photos. (Figure 18.41) To update your service with your changes, right-click on the collection and choose Publish Now or press the Publish button below. To update multiple collections in one go, select them all before pressing the Publish button.

If photos are in the *Deleted Photos to Remove* section, they're removed from most Publish Services, but this is dependent on the API.

How do I mark photos as already published, so they don't upload again?

If you make a change to a photo, such as changing some metadata, it moves to the *Modified Photos to Re-Publish* section. If you don't want to republish it, perhaps because the change was minor or you don't want to upload it as a new photo on Facebook,

right-click on the photo and choose **Mark** as **Up-To-Date** to move it back into the **Published Photos section**

I didn't mean to remove a photo from a collection—how do I restore it?

If you accidentally remove a photo from a collection, just drag it back onto the

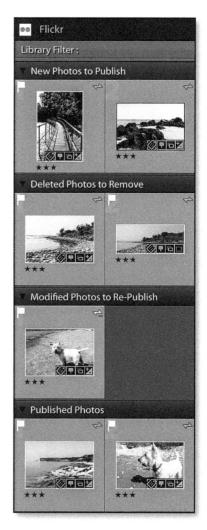

Figure 18.41 Lightroom keeps track of the changes you make and groups the photos into New Photos to Publish, Deleted Photos to Remove, Modified Photos to Re-Publish and Published Photos.

collection in the Publish Services panel again. If you pressed *Publish*, nothing will have changed on the service (e.g., Flickr) and it moves straight back into the *Published Photos* section. If the photo has been deleted from the service, it's uploaded again.

I accidentally revoked the authorization on the website—how do I fix it?

While we're on the subject of accidents, you may accidentally revoke the authorization on the website, preventing Lightroom from publishing your photos. To fix it, right-click on the Publish Service in Lightroom and choose *Edit Settings* to access the Publishing Manager dialog. There you can log in again and re-authorize Lightroom's access.

Can I have the same account connected to multiple catalogs?

The same Flickr account can be connected to multiple catalogs, but there are limitations. You can't easily transfer your collections/photosets between catalogs, even using Export as Catalog, and Lightroom won't know about anything that's already on the website or in your other catalog. Some advanced plug-ins, such as those created by Jeffrey Friedl, attempt to match up photos in your catalog against existing photos on the website, but it's a situation best avoided.

There is a plug-in which can transfer Publish Services information between catalogs, although it does have some limitations. You can find more information about the Lightroom Voyager plug-in at https://www.Lrq.me/alloy-lrvoyager

How do I view people's comments?

Many photo sharing services allow visitors to leave Likes or Comments on your photos.

Lightroom's Comments panel is designed to

work with Publish Services and Lightroom Sync, synchronizing comments with supported photo sharing services, so it's only available when you have a Publish collection or synced collection selected.

If someone comments on one of your photos on the website, their comments are retrieved when you next publish/sync that collection, or when you click the Refresh button in the corner of the panel (where available). (Figure 18.42)

What other third party plug-ins are available?

The built-in plug-ins are just a starting point—a sample to show what can be done with Publish Services. Third-party developers use Adobe's SDK (software development kit) to build Publish Service plug-ins to add additional photo sharing websites.

If you're using the built-in Flickr plugconsider upgrading to Jeffrey's more advanced and more regularly updated version which can be downloaded donationware as from https://www.Lrg.me/friedl-plugins

Third-party developers have also created Publish Service plug-ins for many other popular photo sharing websites, including

Figure 18.42 People's comments show in the Comments panel.

Zenfolio and SmugMug, and online printers such as Snapfish, Costco and Walmart. Each of the services have slightly different limitations, dependent on the website facilities and API, but the basic setup is the same. There's a list of the most popular Publish Service plug-ins at https://www.Lrg.me/links/plugins

What can I use the Hard Drive option for?

One of the most useful Publish Services is the Hard Drive service, as it manages photos exported to a folder on your computer. If you create additional collections, they become subfolders.

Any changes you make to these photos within your catalog after the initial export are tracked, allowing you to selectively export only the photos that have changed or are not yet published, without re-exporting the whole set.

For example, perhaps you like to have your screensaver showing your latest photos, so a smart collection sending your last month's photos to your screensaver folder would be useful.

If you're using album design software, it's also a convenient way of making changes to the individual photos in Lightroom, and then being able to keep the exported versions updated in the album design.

If you need to export different sizes of photos, you'll need to set up two separate Publish Services connections as the settings are per-connection.

There are a couple of things to be aware of. If you move to a new computer, you can't change the location of the folder. Also, if you rename the files in Lightroom after the initial export, the exported photos aren't renamed to match. For a more advanced

plug-in, try Jeffrey's Collection Publisher https://www.Lrq.me/friedl-colpub

Is Lightroom Sync a Publish Service?

Lightroom Sync isn't technically a Publish Service, but there are similarities. It allows you to select collections to sync to the cloud, and these web galleries can then be shared publicly. Any likes or comments that friends or family add to the photos are automatically synced back to your catalog. As you edit the photos in Lightroom, your changes are updated on the web and mobile devices, and when you edit the photos on your mobile device, they're updated in your desktop catalog. See the Cloud Sync chapter starting on page 547 for more detail.

EXPORT SHORTCUTS

		Windows	Mac
Export	Export dialog	Ctrl Shift E	Cmd Shift E
	Export with Previous	Ctrl Alt Shift E	Cmd Opt Shift E
Email Photo		(no shortcut)	Cmd Shift M
Plug in Manager		Ctrl Alt Shift,	Cmd Opt Shift ,

OUTPUT MODULES

19

Lightroom's primary focus is organizing and editing photos, but it also includes tools for creating

basic photobooks, slideshows, prints and web galleries. They're more limited than dedicated software, but they're adequate for most photographers. We'll introduce these less frequently used modules in this chapter, and then go into much greater detail in the bonus chapters at the end of the eBook formats.

BOOK MODULE

The Book module (Figure 19.1), as its name suggests, assists you in creating photo books without the need for external software. Using a template-based system and drag-and-drop interface, you can create a beautiful book complete with text, and then easily upload it to Blurb for printing. Blurb is a well known photobook company who print and ship high quality books to photographers worldwide.

Figure 19.1 The Book module.

We'll go into detail in the Appendix (starting on page A1), but let's just run through the basics so you can start to create your first photo book.

- **1.** In Library module's Grid view, decide which photos you want to include in your book. This might be a folder or a collection of photos. If the photos are spread across multiple folders or collections, use the Quick Collection to group them together.
- **2.** Switch to the Book module by selecting it in the Module Picker.
- **3.** The first time you switch to the Book module, Lightroom takes the photos from your current view and creates a book using Auto Layout. This gives you opportunity to explore before starting on your first book project.

Figure 19.2 The view modes are found on the Toolbar—Multi-Page view (left), Spread view (center) and Single Page view (right).

5. Select each in turn, then return to the Multi-Page view. **(Figure 19.3)**

Multi-Page view is like the Library module Grid view, complete with the thumbnail size slider on the Toolbar.

Spread view fills the preview area with facing pages and the buttons on the Toolbar move from one page to the next. (Figure 19.4)

Single Page view is particularly useful when working with text, as it allows you to zoom in closer. You'll find the zoom options on the top of the Preview panel, just as they'd be on

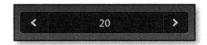

Figure 19.4 In Spread or Single Page view, you can move between photos using the arrows on the Toolbar.

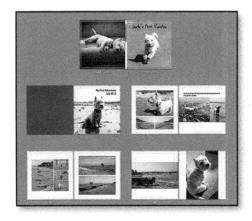

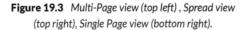

the Navigator panel in Library module.

- **6.** In the Auto Layout panel, press *Clear Layout* to start with a clean slate.
- 7. At the top of the Preview Area, press the Create Saved Book button, uncheck the Include only used photos checkbox and give your empty book a name. (Figure 19.5) Saving the book before you start means you won't accidentally lose your work. The saved book appears in the Collections panel, and it remembers the photos you're using as well as the book layout.
- **8.** Select your book size and orientation using the *Size* pop-up in the Book Settings panel and ignore the other options for now. (Figure 19.6)

Figure 19.5 Save your book before you start on the design.

- **9.** The first pair of pages in the Grid view are the front and back cover. You can change the template and photos and add text, just as you would with a page inside the book. Let's work on the inside of the book first...
- **10.** In the Page panel, click on the template preview to display the Page Template Picker. (Figure 19.7)
- 11. The templates are grouped into sets

Figure 19.6 Select your book size and orientation.

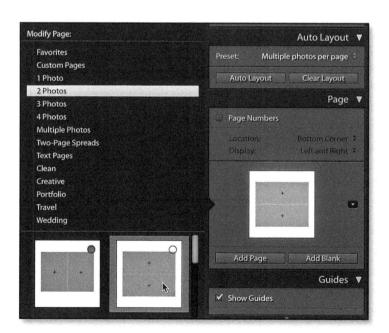

Figure 19.7 Select a template for the page layout.

based on the number of photos or template style. Click on the set names at the top of the Page Template Picker to view the templates below. The gray cells are photo cells and the lines are text cells.

When you find a template you like, click on it to add a new page.

- **12.** Select a photo from the Filmstrip at the bottom of the screen, and drag its thumbnail onto a gray photo cell on the page in the main Preview Area. If you can't see the Filmstrip, click the black bar at the bottom of the screen.
- **13.** Return to the Page panel and repeat the process to add additional pages and photos.
- **14.** To change a page template, click on the page to select it, shown by a large orange border, then click on the template in the Page panel to display the Page Template Picker, and select a different template.
- **15.** To move a photo to a different photo cell, click on it and drag to the new location.
- **16.** Switch to Single Page view by clicking on the third icon in the Toolbar. Press T if the Toolbar is missing.
- **17.** In the Text panel, check the *Page Text* checkbox and start typing in the text field that displays on the page. (**Figure 19.8**)
- **18.** You can adjust the colors and design of the pages, as well as the text overlays, using the panels on the right. We'll come back to these settings in more detail in the following pages.
- **19.** Scroll back to the beginning and click on the words *Front Cover* to highlight the cover pages, then change the template, add photos and text.

Figure 19.8 Select Single Page view before entering text.

20. At the bottom of the left panel group, press the *Export Book to PDF* button to create a PDF preview of your finished book. You can then upload the book to Blurb for printing using the *Send Book to Blurb* button at the bottom of the right panel group.

Having learned the basics, it's time to begin fine-tuning your book. We'll consider how to use the pages and templates first, before going on to add photos, text and decoration.

SLIDESHOW MODULE

Lightroom's Slideshow module (Figure 19.9) isn't designed to replace specialized software, but it's an easy way to create a simple slideshow. You can design the slides yourself, add branding and text overlays to personalize your slideshow, and add audio backing tracks. The finished slideshow can be played in Lightroom, or it can be exported as video, PDF or JPEG format.

We'll go into detail in the Appendix (starting on page B1), but let's just run through the basics so you can start to create your first slideshow.

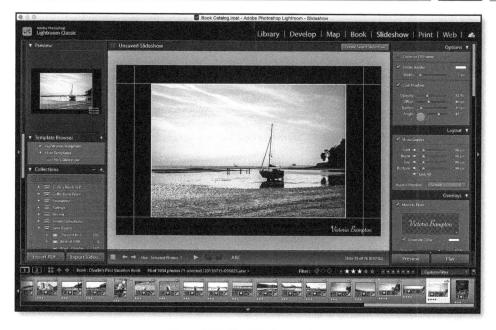

Figure 19.9 The Slideshow module.

- **1.** In Library module's Grid view, decide which photos you want to include in your slideshow. This might be a folder or a collection of photos. If the photos are spread across multiple folders or collections, use the Quick Collection to group them together.
- **2.** Switch to the Slideshow module by selecting it in the Module Picker.
- **3.** At the top of the Preview Area, press the *Create Saved Slideshow* button and give your slideshow a name. Saving the slideshow at the beginning means you won't accidentally lose your work. The saved slideshow appears in the Collections panel, and it remembers the photos you're using as well as the slideshow settings.
- **4.** In the Template Browser panel on the left, click on the different templates to apply them to your slideshow until you find a design that you like.

- **5.** You can adjust the colors and design of the slides, as well as the text overlays, using the panels on the right. We'll come back to these settings in the following pages.
- **6.** (Optional) Add a musical backing track by going to the Music panel and press the + button. Navigate to your music on the hard drive, and choose a DRM-free MP3 or AAC music file.
- **7.** (Optional) Check the *Sync Slides to Music* checkbox in the Playback panel to align the slide timings with the music tracks.
- **8.** Preview your slideshow in the Preview Area by pressing the *Preview* button at the bottom of the right panel group. Press the Escape key or the square stop button on the Toolbar to stop the slideshow and adjust settings, and then preview again until you're happy.
- **9.** Finally, you're ready to play your slideshow full screen. Press the *Play* button,

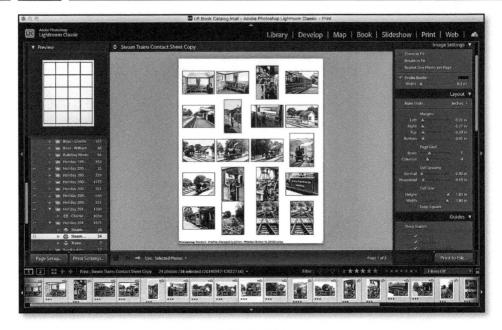

Figure 19.10 The Print module.

which is next to the *Preview* button. It's worth doing a dry run before showing it to someone else, as Lightroom builds slide previews before playing the first time.

PRINT MODULE

Although most photos today start out as digital files, at some stage you may to want to print them. Exporting the photos and sending them to an online lab is an easy option but Lightroom also includes a Print module. (Figure 19.10) You can print single prints on a local printer, or build contact

Layout Style ▼
Single Image / Contact Sheet
Picture Package
Custom Package

Figure 19.11 The Layout Style panel allows you to choose whether to create a print with single or multiple photos.

sheets and lay out multiple photos on a page to print on a local printer or send away.

Lightroom offers three different layout options for printing, which you select in the Layout Style panel. (Figures 19.11 & 19.12)

Single Image/Contact Sheet is a single photo on a page, or different photos all the same size, laid out as a contact sheet grid.

Picture Package is the same photo in different sizes, laid out free-form on the page.

Custom Package is different photos in different sizes, laid out free-form on the page.

We'll cover all of the various options in the Appendix (starting on page C1), but in this chapter, we'll run through the basics of setting up each style of print and how to print your design.

Single Image—one photo per page.

Picture package-same photo, different sizes.

Contact Sheet—different photos in a grid, same size.

Custom Package—different photos, different sizes.

Figure 19.12 There are multiple different layout styles.

How do I create a 4" x 6" borderless print?

First, let's create a simple 4"x6" borderless print (assuming your printer can print borderless!). If you're just sending individual photos to an online or local lab to be printed, it's quicker to turn back to the Export chapter (starting on page 415) and export JPEGs instead

- **1.** Select the photo or photos you want to print, and then switch to the Print module using the Module Picker at the top of the screen.
- **2.** At the bottom of the left panel group, click the *Page Setup* button to display your printer's dialog. (The options vary depending on the operating system and printer.)

- **3.** Select your paper size, for example, if you're using 4x6 borderless paper, you'll need to select the 4" x 6" borderless setting. Close the *Page* Setup dialog. (Figure 19.13)
- **4.** In the Layout Style panel at the top of the right panel group, select *Single Image/ Contact Sheet*.
- **5.** In the Image Settings panel, check *Zoom* to *Fill* and *Rotate* to *Fit*. This fills the cell with the photo.
- **6.** In the Layout panel, set all the margins

Figure 19.13 Set the paper size to 4" x 6" borderless in the Page Setup dialog.

to 0 for borderless printing. If they won't go down to 0, the Page Setup isn't set to borderless or your printer can't print borderless, in which case you'll need to use a larger piece of paper and cut it down after printing.

- 7. Still in the Layout panel, set the Rows and Columns sliders to 1 to place a single photo on the page, and set the Cell Size to 6x4 for a 6" x 4" print. (Figure 19.14)
- **8.** In the Toolbar underneath the preview, choose *Selected Photos* from the *Use* pop-up

Figure 19.14 These are layout settings you'll need to create a 4"x6" borderless print.

to print the selected photo(s) or All Filmstrip Photos to print all of them. Try a single print to double check your settings before printing a large number of photos.

How do I print it?

Once you've finished designing your layout, whether that's a single print or a complex design, it's time to print.

- **1.** Scroll down to the Print Job panel. (Figure 19.15) As a default, set the *Print Resolution* field to 360ppi for Epson or 300ppi for Canon/HP.
- **2.** Enable the *Print Sharpening* checkbox, selecting the amount in the first pop-up (*Low, Standard* or *High*) and the paper type (*Glossy/Matte*) in the second pop-up. If in

Figure 19.15 Select the Resolution, Sharpening and Color Profile for the print in the Print Job panel.

doubt, select Standard Glossy.

- **3.** If you have a profile for your printer, select *Other* from the *Color Management Profile* pop-up and choose the profile. Press *OK* and select the profile in the pop-up. If you don't have a profile, select *Managed by Printer* so that the printer cares for the color management.
- **4.** Press the *Printer* button to view the Print dialog. Like the Page Setup dialog, this dialog varies depending on the operating system and printer driver. If you're using a Mac, you may need to press the *Show Details* button to access the printer driver options. (Figure 19.16)

Select your paper type, quality settings and any other settings specific to your printer driver. (If these options aren't available, ensure that you've installed the printer driver direct from the manufacturer rather than the default driver provided by the operating system.) If you've selected a profile in the Color Management Profile popup, select No Color Adjustment or ColorSync in the printer dialog.

5. Finally, press *Print* and wait with bated breath!

Figure 19.16 After setting up the print layout in Lightroom, press the Printer button and select the correct paper and quality settings.

How do I create a contact sheet?

A contact sheet is a selection of photos laid out as a grid, often with a filename underneath. (Figure 19.17) They're often used by photographers to help clients select their photos or as an index page in an album. Others use contact sheets to check their prints will turn out as expected, without wasting ink on full size test prints.

- **1.** In Library module's Grid view, decide which photos you want to include in your contact sheet. This might be a folder or a collection of photos. If the photos are spread across multiple folders or collections, use the Quick Collection to group them.
- **2.** Switch to the Print module using the Module Picker at the top of the screen.

Figure 19.17 Contact sheets were traditionally used for selecting the best photos, but are still useful for test prints today.

- **3.** In the Toolbar underneath the preview, choose All Filmstrip Photos from the Use pop-up.
- **4.** At the bottom of the left panel group, press the *Page Setup* button and select your paper size (e.g. Letter or A4 size) in the printer dialog before returning to Lightroom.
- **5.** In the Layout Style panel at the top of the right panel group, select *Single Image/Contact Sheet*.
- **6.** In the Layout panel, choose the numbers of rows and columns for your contact sheet using the *Page Grid* sliders, and adjust the spacing between the cells using the *Cell Spacing* sliders. As you adjust the slider, the preview updates live. **(Figure 19.18)**
- **7.** If you have a mixture of horizontal and vertical photos, toggle the *Rotate to Fit* checkbox in the Image Settings panel to enable or disable rotation.
- **8.** To display the filename beneath each photo thumbnail, check *Photo Info* in the Page panel and select *Filename* in the pop-up to the right.
- **9.** Then turn back to page 452 to send it to your printer.

How do I create a picture package?

The Picture Package enables you to print multiple versions of the same photo in varying sizes on the same piece of paper, for example, printing two small copies for your wallet, and a larger copy for a frame.

- **1.** Select the photo, and then switch to the Print module using the Module Picker at the top of the screen.
- **2.** In the Toolbar underneath the preview,

Figure 19.18 Select your page layout settings in the right panel group in the Print module. These are the settings for a contact sheet.

choose Selected Photos from the Use pop-up.

- **3.** At the bottom of the left panel group, press the *Page Setup* button and select your paper size (e.g. Letter or A4 size) in the printer dialog before returning to Lightroom.
- **4.** In the Layout Style panel, select *Picture Package*.
- **5.** In the Ruler, Grid & Guides panel, select cm or inches from the *Ruler Units* pop-up,

depending on your preference.

- **6.** Click a button in the Cells panel to add a cell of that size, for example, press the 4x6 button to add a 4" x 6" cell to the page. Repeat to add additional photo cells. To delete a cell, click on it and then press the Delete key. Press Clear Layout if you want to start again. (Figure 19.19)
- **7.** Once you've added the cells, click the Auto Layout button to automatically arrange the cells on the page or drag and drop them into a layout that you like.
- **8.** In the Image Settings panel, check the Zoom to Fill and Rotate to Fit checkboxes to fill the cells you've created.
- **9.** Turn back to page 452 to send your design to your printer.

How do I create a custom package?

The Custom Package enables you to print any photos in a mixture of sizes to avoid wasting paper, so you have two choices: either you place the cells first and then drop the photos into those cells, or you drop the photos directly onto the page and their cells

Figure 19.19 Add cells to the page using the Cells panel.

are automatically created, ready for you to resize. In this example, we'll drop the photos onto the page.

- **1.** In Library module's Grid view, decide which photos you want to include in your design. This might be a folder or a collection of photos. If the photos are spread across multiple folders or collections, use the Quick Collection to group them for easy access.
- **2.** Switch to the Print module using the Module Picker at the top of the screen.
- **3.** In the Layout Style panel, select *Custom Package*.
- **4.** Select a photo in the Filmstrip, drag it to the page and drop it.
- **5.** Using the squares in the corners of the bounding box, adjust the size of the cell. To move it, click in the center of the cell and drag it. (**Figure 19.20**)
- **6.** To add an additional photo, drag it from the Filmstrip and drop it on a blank area of the page. If you drop a new photo on an existing cell, the photo is replaced. To delete a cell, click to select it (shown by the bounding box) and press the Delete key.

Figure 19.20 Drag the bounding box handles to resize the cells and drag the center of the cell to arrange the cells on the page.

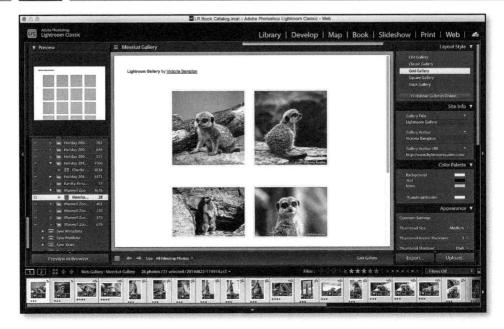

Figure 19.21 The Web module.

7. Turn back to page 452 to send your design to your printer.

WEB MODULE

The Web module (Figure 19.21) makes it easy to create static galleries. Lightroom offers multiple ways of publishing your photos online, and it can be difficult to figure out which is best suited to your needs. There are, of course, a huge number of alternative photo sharing websites, and today, they're generally a better option.

However, if you're looking for a simple static web gallery, let's just run through the basics. We'll cover all of the various options in the Appendix (starting on page D1).

1. In Library module's Grid view, decide which photos you want to include in your web gallery. This might be a folder or a collection of photos. If the photos are spread across multiple folders or collections,

use the Quick Collection to group them together.

- **2.** Switch to the Web module by selecting it in the Module Picker
- **3.** At the top of the Preview Area, press the *Create Saved Web Gallery* button and give your gallery a name. Saving the web gallery at the beginning means you won't accidentally lose your work. The saved web gallery appears in the Collections panel, and it remembers the photos you're using as well as the gallery settings.
- **4.** In the Template Browser panel on the left, click on the different templates to select a design (or float over them to preview in the Preview panel above). Lightroom ships with four different web gallery styles. (Figure 19.22)
- **5.** (Optional) You can adjust the colors and design of the gallery, as well as the text overlays, using the panels on the right. We'll

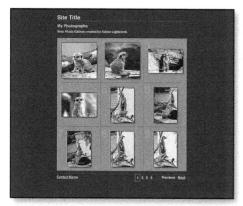

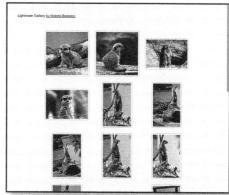

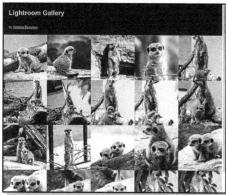

Figure 19.22 There are four default layouts: Classic (top left), Grid (top right), Square (bottom left) and Track (bottom right).

come back to these settings in the following pages.

If you customize any of the settings, click + button on Template Browser to save your design as a new template. This allows you to apply the same settings to other groups of photos.

- **6.** Once you're happy with the preview in the Web module, click *Preview in Browser* at the bottom of the left panel group to open it in your default web browser.
- **7.** Finally, to export your web gallery, click the *Export* button at the bottom of the right panel group. This saves the web gallery on your hard drive, ready to upload to

your website using FTP software (such as FileZilla).

It's also possible to upload the gallery directly from Lightroom by entering the FTP server details in the Upload Settings panel, however the built-in FTP is not as robust as dedicated FTP software.

MULTIPLE COMPUTERS OR CATALOGS

20

At the beginning of the book, we talked about creating a database called a catalog. The catalog contains records of all the photos you've imported, plus metadata and other settings you've applied to these photos in Lightroom.

In this chapter, we'll consider how to look after that catalog, then how to move your Lightroom files, whether that's on the same computer or to a new computer. We'll also explore the options for working on multiple computers, and the pros and cons of using more than one catalog.

Some people ask whether they have to use a catalog. Why not just browse the photos on the hard drive instead? Quite simply, many of Lightroom's features are dependent on its database backbone, and wouldn't be possible using a simple file browser. For example, Lightroom can create virtual copies, store extensive edit history for each image, and track information on settings for books, slideshows, prints and web galleries and their associated photos, all of which depend on the database. Searching image metadata (EXIF, keywords, etc.) is much faster as a result of the database. and Lightroom can also search for photos that are offline, as well as those currently accessible.

MANAGING CATALOGS

Let's start off with some catalog basics—finding, renaming and maintaining your catalog.

How do I find my catalog on the hard drive?

When you opened Lightroom the very first time, using the information in the Before You Start section (page 15), Lightroom created a catalog to store the information about your photos.

By default, Lightroom places the catalog in your user account *Pictures* folder and calls it *Lightroom Catalog.Ircat*, but you may have chosen a different name or location.

If you don't remember where you stored your catalog, go to *Edit menu* (Windows) / *Lightroom menu* (Mac) > *Catalog Settings*. The name and location of your open catalog is displayed on the *General* tab of the Catalog Settings dialog. Press the *Show* button to open an Explorer (Windows) / Finder (Mac) window at that location.

If you can't open Lightroom, perhaps due to catalog corruption, then you'll need to use your operating system's search facility to search for files with a *.Ircat file extension (that's LRCAT).

What do the catalog files contain?

When you view the catalog location in your file browser, you'll note there are a variety of different Lightroom files. (Figure 20.1)

*.Ircat is the catalog (SQLite database) which holds all of your settings. This stands for LightRoom CATalog. (Version 1.0 catalogs used *.Irdb and prerelease beta catalogs were *.aglib files.) The catalog contains a note of where the images are stored on the hard drive plus other metadata—that's information about the photos, including the EXIF data from the camera, any IPTC data, keywords and other metadata you add in Lightroom, any Develop changes you make in Lightroom, and any book, print, slideshow and web gallery settings, all of which are stored as text records. (Figure 20.2)

*.Ircat-data contains LUT data from imported profiles, plus any AI based masks (such as *Select Sky*). In other words, it's an essential file that contains some of your

Lightroom Lightroom Lightroom Catalog...ws.lrdata Catalog.ircat Catalog...ws.lrdata Lightroom Lightroom Lightroom Catalog.Ircat-wal Catalog.lrcat.lock Catalog.Ircat-shm DATA Backups Lightroom Mobile Settings Downloads.Irdata

Figure 20.1 Lightroom uses a few different files and folders, in addition to the main catalog file.

edits.

*Previews.Irdata and *Smart Previews. Irdata contain your standard and smart previews. On Windows, the individual previews are contained in a hierarchy of folders and subfolders, and on a Mac, they're wrapped up in a package file. The individual previews inside the Irdata folder/file are *.Irprev files for standard previews, and *.dng files for smart previews.

If Lightroom is open, you may have a couple of additional files:

*.Ircat.lock is a lock file that is created whenever you open the catalog. It protects the database from being corrupted by multiple users attempting to use it at the same time. If Lightroom is closed and the lock file remains, you can safely delete it. It can sometimes get left behind if Lightroom crashes, and may prevent you from opening the catalog again.

*.Ircat-shm and *.Ircat-wal files contain blocks of data that are in the middle of being written to the catalog. They should automatically disappear when you close Lightroom, but if Lightroom quits abnormally, they'll get removed at the next startup.

*Helper.Irdata is a temporary cache which helps to speed up searches, such as filtering

l ^	ld_global		baseName	er	er	exte	nsion	externa/Mo	fol	
	12DC791B-7A0	*	19950402-132230 ♥			dng	٧	381096665	23	
46	C0950B7D-505	*	19950402-132305 ♥	NUL	NUL	dng	*	381096665	23	•
68	EAC9D561-3AE	۳	19950402-132442 ¥	NUL	NUL	dng	W	381096665	23	•
84	602962FD-EF7	۳	19950402-132548 *	NUL	NUL	dng		381096666	23	•
100	D5FA1D00-6DF	٧	19950402-132636 ▼	NUL	NUL	dng	W	381096666	23	•
126	138B78AF-E49	۳	19950402-132726 ▼	NUL	NUL	dng		381096666	23	
142	66210F90-23E4	¥	19950402-132800 V	NUL	NUL	dng	W	381096666	23	
158	50AF120B-844	*	20050801-211058 ▼	NUL	NUL	JPG	*	381097437	23	1
175	6B12EBBB-F1D	۳	20050801-211127 ♥	NUL	NUL	JPG		381097437	23	1
191	9A4D9444-70D	۳	20050801-211153 ▼	NUL	NUL	JPG		381097437	23	1
207	88E6DB99-A0C	w	20050801-211214 ♥	NUL	NUL	JPG	*	381097438	23	1
223	4B5A8DBB-687	V	20050801-211238 ♥	NUL	NUL	JPG		381097438	23	1
239	D96BA0C7-8D	V	20050801-211257 ♥	NUL	NUL	JPG		381097438	23	1
255	AFFA846D-C42	Ψ	20050801-211314 ♥	NUL	NUL	JPG	*	381097438	23	:
271	89147D03-96A	w	20050801-211336 ♥	NUL	NUL	JPG	w	381097438	23	1

Figure 20.2 A Lightroom catalog is a SQLite database.

the Folders panel or Keywords panel. If it gets deleted, it's automatically rebuilt.

*Sync.Irdata is a temporary cache which helps reconcile the Lightroom Classic catalog with the cloud database. If it gets deleted, it's automatically rebuilt, but can take a long time to rebuild if you have a large number of photos synced with the cloud.

Additional temporary files may sometimes appear, such as Temporary Import Data.db-journal. If they're still there after closing Lightroom, and they're more than a few days old, you can safely delete them.

There may also be a few folders created by Lightroom with the catalog:

Images folders may contain some or all of your photos. They're stored on your hard drives as normal image files, so they may be stored anywhere, but the default Destination folder selected in the Import dialog is an Images folder next to the catalog.

Backups folder may contain catalog

backups, if you haven't changed the default backup location.

Lightroom Settings folder may contain some of your presets if you have *Store presets* with this catalog checked in the Preferences dialog.

How much space does Lightroom's catalog take up on my hard drive?

That's a long list of files, so you may wonder how much space they take up on your hard drive. You can check this using the same Catalog Settings dialog. (Figure 20.3)

The catalog file size is listed under the *General* tab. The size depends on the number of photos and the amount of data stored for each photo. For example, masks, spot healing and large numbers of history states increase the catalog size significantly.

Preview and Smart Preview cache sizes are noted under the File Handling tab.

Standard Preview size depends on the image content and your preview size and

Catalog Settin	gs	
General File Handling	Metadata	
Preview Cache		
Total Size:	16 GB	
Standard Preview Size:	1680 pixels	0
Preview Quality:	Medium	
Automatically Discard 1:1 Previews:	After One Day	٥
Smart Previews		
Total Size:	7 GB	
Import Sequence Numbers		
Import Number: 1 Photo	os Imported: 0	

Figure 20.3 In the Catalog Settings dialog, you can check how much space your catalog and previews are using.

quality settings, as well as the presence of any 1:1 previews. Smart Previews also vary depending on the image content, averaging 0.5-1.5 MB each regardless of the original raw file size.

As a guide, a catalog that contains 25000 photos may be:

Catalog-1 GB (with zipped backups of around 250 MB)

Previews (1680px, medium quality, discard 1:1 after 1 day)—16 GB

Smart Previews-25 GB

Original Files-300 GB

How do I rename my catalog?

Lightroom doesn't offer a catalog renaming tool, but you can rename the catalog and its associated files in Explorer (Windows) / Finder (Mac) as if you were renaming any other file. Just make sure you close Lightroom first.

When you rename the catalog file, you should also rename the preview folders/files to match. For example:

Lightroom Catalog.lrcat > New Name.lrcat

Lightroom Catalog Previews.lrdata > New

Name Previews.Irdata

Lightroom Catalog Smart Previews.lrdata > New Name Smart Previews.lrdata

Lightroom Catalog Helper.lrdata > New Name Helper.lrdata

Lightroom Catalog Sync.lrdata > New Name Sync.lrdata

After renaming, double-click on the catalog file (*.Ircat) to open it into Lightroom.

If you don't rename the previews correctly, Lightroom simply recreates them all. There's no harm done except for the time involved. If you have offline files, previews for these photos won't be recreated until they're next online. If this happens, delete the old previews file to regain the drive space once your previews have been recreated.

After opening the renamed catalog, go to Preferences > General > Default Catalog pop-up and ensure the correct catalog is selected.

Do I need to do any regular maintenance?

We've already discussed how important the catalog is, so how do you look after it? Under the *File menu*, the **Optimize Catalog** command checks through your catalog, reorganizing your database to make it run faster and more smoothly. (**Figure 20.4**)

Figure 20.4 Catalog optimization 'tidies up' to make Lightroom run faster.

For the more technically minded, over the course of time, with many imports and deletes, the data can become fragmented and spread across the whole database, making Lightroom jump around to find the information it needs. *Optimize Catalog* runs a SQLite VACUUM command to sort it all back into the correct order, bringing it back up to speed.

It's worth running the catalog optimization whenever you've made significant database changes, such as removing or importing a large number of photos, or any time you feel that Lightroom has slowed down.

There's also a checkbox in the Back Up Catalog dialog to automatically run the optimization each time you back up your catalog.

And most importantly, don't forget to back up regularly!

MOVING LIGHTROOM

The time may come when you run out of space on your hard drive and need to move Lightroom to a new home on a bigger hard drive, or you may need to move to a new computer or reinstall your operating system. Lightroom uses files in so many different locations, the move may look daunting at first, but it's surprisingly straightforward if you follow my step by step instructions carefully.

We'll cover four different scenarios:

- Moving just the catalog to a new location.
- Moving just the photos to a new location.
- Moving the catalog and the photos to a new location.

• Moving to a completely new computer or reinstalling the operating system.

How do I move only my catalog to another hard drive, leaving the photos where they are?

If only your catalog is moving, and the photos are remaining in their existing locations, the process is very simple:

- 1. Quit Lightroom.
- **2.** Move your catalog (and any extra files such as the previews) to the new location using Explorer (Windows) / Finder (Mac). It's usually easiest to move the entire folder containing your catalog and other related files.
- **3.** Double click on the catalog (*.lrcat file) to open it. After opening the catalog at its new location, go to *Preferences > General > Default Catalog pop-up* and ensure the correct catalog is selected.

As none of the photos moved, you can continue working without further issues. When the backup next runs, double check the location of the backups. (Instructions on page 60.)

How do I move only my photos to another hard drive, leaving the catalog where it is?

If you need to move photos to another hard drive, perhaps because you've outgrown your existing hard drive, there are two main options. As a rule of thumb, you can use option two for moving a few photos/folders, but option one is safer when moving larger numbers of photos.

Option One—move in Explorer/Finder and update Lightroom's links

1. Follow the instructions in the Library

chapter (page 117) to show the folder hierarchy. This makes it easy to relink the folders/files that are marked as missing in the process.

2. Close Lightroom and use Explorer (Windows) / Finder (Mac) to copy the folders/files to the new drive.

Most file corruption happens while moving/copying photos between hard drives. To ensure that the files gets to the new drive safely, I prefer to use file synchronization or other software with byte-for-byte/checksum verification. Consider using:

TeraCopy https://www.Lrq.me/teracopy

Vice Versa (Windows) https://www.Lrq.me/viceversa

Chronosync (Mac) https://www.Lrg.me/chronosync

- **3.** When the copy completes, rename the original folder (the one on the old hard drive) using Explorer (Windows) / Finder (Mac), or disconnect the old hard drive. This allows you to check everything is working correctly before deleting the files from the original location.
- **4.** Open Lightroom and right-click on the parent folder. Select *Find Missing Folder* or *Update Folder Location* from the list, depending on which option is available. Navigate to the new location and press *Select Folder* (Windows) / *Choose* (Mac). The folder disappears from the old volume (drive) in the Folders panel and reappears under the new volume bar.

Don't Re-import! Using these instructions to update the location in the catalog is essential. Don't import the photos at the new location, or use *Synchronize Folder* to update the folder references, as you'll lose

all of the work you've done in Lightroom.

- **5.** If you have more than one parent folder, repeat the process for any other parent folders until the question marks have disappeared from all the folders.
- **6.** Once you've confirmed that all the photos are available for editing within Lightroom, you can safely detach the old hard drive or delete the files from their original location using Explorer (Windows) / Finder (Mac).

Option Two—move the photos using Lightroom's Folders panel

- **1.** If you can't see the new folder in the Folders panel, go to *Library menu > New Folder*. Navigate to the new location and create a new folder, or select an existing folder where you plan to place the photos. (Existing folders can only be selected if they're empty, or by importing one of the photos in that folder.)
- **2.** Within the Folders panel, drag the folders to their new location. One warning—don't press the X in the Activity Center to cancel this move. There have been (rare!) reports of problems caused by canceling the transfer, so it's best to let it complete uninterrupted.
- **3.** Check that the entire folder contents have copied correctly before deleting the originals. If you drag individual photos to the new location, rather than whole folders, remember that files that aren't currently in the catalog (e.g. text files) won't be copied as Lightroom doesn't know that they exist.

How do I archive photos to offline hard drives?

As your collection of photos grows, your working hard drives may eventually start

to overflow, but Lightroom can continue to track photos held in offline storage. The easiest solutions for the working copy of your offline archives are external hard drives or NAS units, as they hold large amounts of data. Optical media (DVD/Blu-ray) can be used, but they have a comparatively short lifespan and limited space.

If you move the photos to offline storage using the instructions in the previous question, the archived photos remain referenced in your main catalog. They are marked as missing when the drive is offline, but you can search through those offline photos along with the rest of your current photos, and Lightroom remembers where the photos are stored.

Ensure you have standard previews before you disconnect the hard drive, so you can still browse with the photos offline. To access the original file, perhaps to export a copy, plug that drive back into the computer and carry on working as normal.

How do I move my complete catalog & photos to another hard drive on the same computer?

If you need to move both the catalog and the photos to a new hard drive, use the same steps as moving each individually (instructions on previous pages).

There's another option which has been recommended in the past, which involves using Export as Catalog to create a new catalog and duplicate photos on the other hard drive, and then deleting the existing catalog and photos. There are, however, a few risks in using that option, as not all data is included when using Export as Catalog, so I can no longer recommend it.

Export as Catalog is better suited to exporting work temporarily to another

computer and then importing back into the main catalog later, rather than moving whole catalogs. We'll come back to Export as Catalog in more detail later in the chapter on page 483.

How do I move my catalog, photos and other Lightroom files to a new computer?

Moving Lightroom to a new computer can appear daunting at first, especially if you're moving cross-platform, but rest assured, it's straightforward as long as you follow these simple steps.

Note that these instructions are for a oneway move, for example, moving from an old computer to a new one, or reinstalling the operating system. Working on multiple computers, for example, transferring between a desktop and a laptop, requires a slightly different process that we'll consider in the next section (page 468).

1. Preparation—set up your folder hierarchy

It's a good idea to make sure that Lightroom's Folders panel shows a tidy hierarchy before you back up the catalog. You may need to relink the files if the relative folder location, or the drive letter for an external drive, changes as a result of the move. Doing so using a hierarchy (right) is much easier than a flat list of folders (left) (Figure 20.5). There are instructions on setting up a folder hierarchy starting on page 117. It's especially important if you're moving to a different operating system.

2. Check your backups

Next, you need to make sure that all the essentials are backed up—the catalogs, photos, preferences, presets, profiles, defaults, plug-ins and any other related files. Turn back to the backup chapter for a

Figure 20.5 A flat folder list (left) is much harder to reconnect compared with a folder hierarchy (right).

full list of all the Lightroom files you need to include in your backups (page 67). If you're wiping the hard drive in the process, rather than running both machines at the same time, it's even more important to make sure that you don't miss anything.

3. Install Lightroom on the new machine

Once everything's safely backed up, we're ready to set Lightroom up on the new computer. Turn back to the installation instructions for more details (page 13).

It's possible to upgrade Lightroom at the same time as transferring to a new computer, for example, from Lightroom 6 on the old computer to Lightroom Classic on the new one. I would, however, suggest that you do the upgrade and transfer as separate processes to minimize the risk of mistakes.

For example, either install Lightroom Classic on the old machine, allow it to upgrade the catalog, check everything's working as expected and then move to the new computer, or install Lightroom 6 on the new computer, follow all of the instructions

to move to the new computer and check everything's working, and then install Lightroom Classic and allow it to upgrade the catalog.

4. Transfer the files

Transfer all of the files (the ones you backed up in step 2) to the new computer—the catalog, the photos, the mobile downloads, the preferences and so forth—and if possible, place them in the same locations as they were on the old computer. Most people copy the files to an external hard drive for the transfer, or copy them over a wired network connection.

5. Open the catalog on the new computer

Now it's time to open the catalog, which you've already transferred. Double-click on the *.lrcat catalog file to open it, or hold down Ctrl (Windows) / Opt (Mac) while launching Lightroom to show the Select Catalog dialog and navigate to the catalog.

6. Relink any missing files

You might find that there are question marks all over the folders (Figure 20.6) or there are rectangular icons containing exclamation points in the corners of the thumbnails. These warnings appear if the original photos can no longer be found at the previous known location. STOP! Don't be tempted to remove the missing photos and re-import, or try to synchronize a folder, and don't try to relocate individual files by clicking on a thumbnail icon, as you'll create a bigger job.

Instead, right-click on the parent folder that we created in step 1, and choose *Find Missing Folder* from the context-sensitive menu, and navigate to the new location of that folder.

Figure 20.6 The hard drive or photos may be marked as missing.

Relocate any other top level folders (you should have one for each drive), until all the photos are online. There are more details on reconnecting missing files starting on page 499. If you get stuck at this stage, please ask and I'll be pleased to help.

CROSS-PLATFORM MOVE

The process of moving your catalog cross-platform is exactly the same as moving to a new machine of the same platform. If you're transferring between platforms, it's even more important that you set Lightroom to show the folder hierarchy (step 1) to make it easy to relink missing files, as Windows works with drive letters and macOS works with drive names.

If you're moving from Windows to Mac or vice versa, some of the file locations are different, especially for preferences and presets. The locations of those files on both platforms are listed in the Backup chapter on page 67.

The subscription is cross-platform, so Lightroom will work on both Windows and Mac, although there are separate downloads for the Windows and Mac versions.

There's just one other main thing to look out for if you're moving cross-platform—the Mac OS can read Windows NTFS formatted drives, but can't write to them, and Windows can't read or write to Mac HFS/APFS formatted drives. If you're going to use your external drives with a different operating system, you may need to reformat them at some stage, after having copied the data off safely to another drive, of course.

If you're constantly moving between Mac and Windows, consider formatting transfer drives as exFAT, or using additional software such as NTFS for Mac (https://www.Lrq.me/ntfsmac) that allow either operating system to have read/write access regardless of drive format, but be aware that it may be slower than using a native drive format.

Figure 20.7 Plug-ins are marked with a green circle if they're enabled. Yellow, red or gray circles warn of problems with the plug-in.

7. Check your preferences and presets

Double check that all of your presets and templates appear correctly, for example, all of your Develop presets are available in the Develop module, to confirm that you copied all the files correctly. If they don't show up, you may need to toggle the *Preferences > Presets tab > Store presets with this catalog* checkbox. (See page 489 for more detail.) Graphical watermark presets may need to be recreated, as the path to the graphic file may have changed.

8. Reload any disabled plug-ins

Finally, you might find your plug-ins need reloading as the locations may have changed in the move. Go to *File menu > Plug-in Manager* and check whether all the plug-ins have green circles. **(Figure 20.7)** If any plugins are incorrectly loaded or missing, add them again at their new locations. Turn back to the Before You Start chapter for a refresher (page 5).

That's it! It's as simple as that. The main things to remember are to transfer all the applicable files onto the new computer, don't try importing anything, don't use Synchronize Folder, and ideally don't wipe the old machine until you've checked that everything's up and running.

WORKING WITH MULTIPLE MACHINES

Many photographers today are working between multiple computers, for example, a laptop and a desktop.

You can have Lightroom activated on two computers at a time, for example, your desktop and your laptop. It can be installed on additional machines, but you would need to deactivate and reactivate when switching machines. Using the same catalog on multiple computers is a little trickier, so let's investigate...

Can I use Lightroom over a network?

Lightroom doesn't have network or multiuser capabilities, other than accessing photos that are stored on a network drive. The SQLite database format that Lightroom uses isn't well suited to being accessed across a network; the file would be too easily corrupted beyond repair by something as simple as the network connection dropping at the wrong moment. That's not just an oversight—SQLite was chosen for its other benefits, such as the simplicity for the user, cost, and most importantly, speed of access.

There are some 'solutions' posted on the web, suggesting that it's possible to trick Lightroom's network blocking by using a subst command on Windows or mounting a disc image stored on a network drive on a Mac. Take care! The network blocking is there for good reason. SQLite, which is the database used for Lightroom's catalog, depends on a guarantee from the operating system that what it thinks has been written to disk has actually been written to disk. Network volumes are notorious for lying about that to improve perceived performance. Adobe strongly discourages these workarounds because they can corrupt your catalog beyond repair, so I can't recommend it either. It's a risky hack.

You could, of course, store your catalog on a NAS and copy it to a local drive every time you want to work on it, and then copy it back again. The process can be automated using File Synchronization software, but it's still a lot of data to constantly move around the network. Alternatively, using software like Dropbox to keep the same catalog on multiple machines can work well, and although it's not supported by Adobe, it doesn't attempt to circumvent any of Lightroom's features, so the risks are limited

The photos can be on your NAS or other network drive, but if you're putting the photos on your NAS, be aware that NAS file access can be slower than internal or even external drives, depending on the connection speed, so this may slow Lightroom down too.

If I can't use Lightroom over a network, how can I use it on multiple computers?

There are solutions, however. For example, Lightroom allows you to split and merge catalogs to move parts of catalogs easily between computers, and Lightroom can work with offline photos on the road too.

If you need to work on multiple machines or even with multiple users, there are many different options. We're going on concentrate on six primary options, each with their own variations. Later in the section, on page 489, we'll also look at ways of keeping your presets up to date on each computer.

The simplest option gives you partial access to your catalog via the Lightroom Cloud:

1. Lightroom Cloud Sync—sync your photos from your 'main' computer to the cloud, then

access them using the simpler Lightroom cloud-based apps on other computers or mobile devices or using a web browser.

The next three options give you access to your entire catalog and the full power of Lightroom Classic on each machine, with or without the image files.

- **2. Self-Contained**—place your catalog and photos on an external hard drive, and plug it into whichever machine you're going to use at the time.
- **3. Semi-Portable**—place your catalog and previews on an external drive and plug it into whichever machine you're going to use at the time, but the photos remain on the main computer or on network accessible storage.
- **4. Copy/Sync (e.g. Dropbox)**—copy your catalog back and forth, using synchronization software such as Dropbox to keep both copies updated.

The final two options involve splitting and merging catalogs, so they're a little more complicated.

- **5. Import from a Temporary Catalog**—create a new catalog for the photos on the secondary machine and merge them back into the primary machine.
- **6. Split and Merge**—use one computer as a base (usually the desktop) and export chunks of work out as a smaller catalog out for use on the secondary computer (usually the laptop), then merge it back into the primary catalog on your return.

1. Lightroom Cloud Sync

Summary: Using one of the Lightroom cloud-based apps on your secondary computer or mobile devices, you can view

your photos, flag & star them, add titles and captions, manage collections, search for photos using image-analysis, do a wide range of Develop edits, as well as uploading new photos. (Details are correct at the time of writing but change frequently!) (Figure 20.8)

For whom: You primarily work on a single machine, where you need all of the features that Lightroom Classic offers, but sometimes you need to view/edit your photos or add new photos from another computer or mobile device.

Difficulty Rating: 1/4

Pros:

- Very easy to set up—just select the collections to sync.
- There's nothing to worry about when you get back to your main computer as the changes automatically sync.
- Works well if multiple people need access to the photos, even at the same time.

Cons:

- Requires an internet connection, both for the initial upload and while downloading on the other computer. If new photos are added to the Lightroom (cloud-based) apps, these are uploaded to the cloud as full resolution files, so a fast connection and unlimited bandwidth are beneficial.
- Features in Lightroom (cloud-based) are more limited than Lightroom Classic.
- Keywords, stacks, album folders and a growing list of features don't sync back to Lightroom Classic, although Develop edits are fully compatible. (See the Cloud Sync chapter for full details, starting on page

547.)

- Lightroom (cloud-based) may not have access to full resolution original photos, depending on how they were uploaded, although lower resolution smart previews work fine for most editing.
- Only one Lightroom Classic catalog can be synced with the cloud.

Storage—Catalog: Stays on your main computer, synced to the cloud.

Storage—Photos: Stay on your main computer, synced to the cloud as smart previews.

Storage—Presets: Stay on your main computer, but can also be imported into to the Lightroom (cloud-based) apps (page 553).

Other Considerations:

- Think about what you'll actually need to do on the other computer, and whether Lightroom (cloud-based) has all the features you need. To double check, see https://www.Lrq.me/lightroom-cc-vs-classic-features/ If it doesn't fill your needs yet, check back again regularly, as they're constantly adding new features.
- If you're allowing someone else access to your photos using this method (by giving them your login details), consider how much of a mess they could make of your existing ratings and edits!

Setup Instructions:

- **1.** In Lightroom Classic on the primary machine, enable sync (page 553).
- **2.** Add the photos to Collections (not Smart Collections), and enable Sync for the

Sample "Lightroom Cloud Sync" Workflow

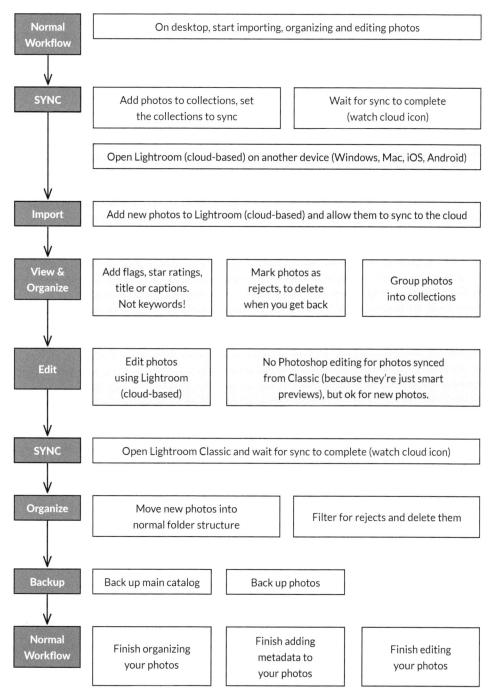

Figure 20.8 Lightroom Sync is an easy way of accessing your photos on other devices and doing limited edits, without having to import and export catalogs.

collections. (You could simply drag them to the All Synced Photographs collection in the Catalog panel, but they're more easily managed when broken down into smaller groups.)

- 3. Wait for the photos to upload, checking the status on the cloud icon.
- 4. Specify a local folder for originals added using Lightroom (cloud-based) (page 556).

Switching Computers:

- 1. Open a cloud-based Lightroom app on another computer or mobile device, and wait for it to sync.
- 2. Work on the photos in Lightroom (cloudbased), and add any new photos. Lightroom uploads changes whenever it has an internet connection.
- 3. When you return to your primary machine, open Lightroom Classic and simply wait for Lightroom to sync the changes and download new photos. Again, you can watch the progress on the cloud icon.
- 4. Filter for rejected photos in Lightroom Classic and delete them if desired. This will also delete them from the cloud sync. whereas photos deleted from the Lightroom (cloud-based) apps may not be deleted from Lightroom Classic.

2. Self-Contained Catalog

Summary: Other than cloud sync, the simplest solution is to place the entire catalog and all of your photos on a portable external hard drive, which you can then plug into whichever computer you want to use at the time

For whom: You regularly work on different

computers and your entire collection of photos is small enough to fit on a portable hard drive. You need the full power of Lightroom Classic on both computers. (Figure 20.9)

Difficulty Rating: 1/4

Pros:

- Your entire catalog is available.
- As the original photos are on the same drive, Lightroom's functionality is not limited.

Cons:

- External hard drive speeds are usually slower than internal drives, so you'd want to choose a fast connection such as a Thunderbolt, eSATA or USB 3.0 connection if possible.
- Slightly greater risk of corruption when the catalog is stored on an external drive, as they're more likely to become disconnected while you're working.
- Small external drives are at a higher risk of being lost, stolen, or dropped.

Storage—Catalog: Portable drive.

Storage-Photos: Portable drive.

Storage—Presets: Store Presets with Catalog or Dropbox Sync.

Other Considerations:

- Think about your backup strategy, as your portable drive may be excluded from your normal backups.
- If you work on multiple platforms, you may need to relink the files each time vou

Sample "Self-Contained Catalog" Workflow

Figure 20.9 Storing the catalogs and photos on an external works well for multiple computers.

switch computers, as Windows uses drive letters whereas macOS uses drive names. You'll also need to use an ExFAT formatted drive or translation software.

Setup Instructions:

- **1.** Turn back to page 463 and follow the instructions for moving the photos to another drive.
- **2.** Turn back to page 463 and follow the instructions for moving the catalog to another drive.
- **3.** Turn to page 489 and follow the instructions for sharing your presets with both computers.

Switch Instructions:

- 1. Quit Lightroom on Computer A.
- **2.** Safely disconnect the portable hard drive.
- **3.** Plug portable the hard drive into Computer B.

4. Open Lightroom on Computer B. If the photos are marked as missing, perhaps because the drive letter has changed or you're moving cross-platform, turn to page 499 to fix the broken links.

3. Semi-Portable Catalog

Summary: Place the entire catalog on a portable external hard drive, which you can then plug into whichever computer you want to use at the time. Store most photos on one computer or network storage. Your current photos may fit on the portable drive with the catalog. (Figure 20.10)

For whom: You regularly work on different computers but your entire collection of photos is too large to fit on an external drive. You need the full power of Lightroom Classic on both computers.

Difficulty Rating: 2/4

Pros:

• Your entire catalog is available.

Cons:

- Access to the original files varies, depending on where they're stored.
- External hard drive speeds are usually slower than internal drives, so you'd want to choose a fast connection such as a Thunderbolt, eSATA or USB 3.0 connection if possible.
- Slightly greater risk of corruption when the catalog is stored on an external drive, as they're more likely to become disconnected while you're working.
- Small external drives are at a higher risk of being lost, stolen, or dropped.

Storage—Catalog: Portable drive.

Storage-Photos:

• Store photos on network storage (i.e. NAS) or shared drive. This allows you to

access the photos from any computer on the network, but the data transfer rate may be slower.

- Store photos on main computer (internal/ external drives). This has the benefit of faster data transfer on the main machine, with more limited edits from other computers.
- A mixture—store specific photos on the portable drive with the catalog (e.g. the ones you're currently working on), and store the rest on the main computer or NAS. This gives access to specific files from any computer, even when you're offline, with more limited access to the rest.

Variations:

When the original files are offline (e.g. you're not connected to the network storage), you can still work on those photos using Lightroom's previews. The kind of work you can do depends on the type of

Sample "Semi-Portable Catalog" or "Copy/Sync" Workflow

Figure 20.10 A semi-portable catalog workflow places the catalog on an external drive or syncs it to other other computer using software like Dropbox, but leaves most files at home.

previews. **Figure 20.11** summarizes the main limitations. For the full list, turn to page 484.

Storage—Presets: Store Presets with Catalog or Dropbox Sync.

Other Considerations:

- Think about your backup strategy, as your portable drive may be excluded from your normal backups.
- If you work on multiple platforms, you may need to relink the files each time you switch computers, as Windows uses drive letters whereas macOS uses drive names.

Setup Instructions:

- **1.** Turn back to page 463 and follow the instructions for moving the catalog to another drive.
- **2.** Turn to page 489 and follow the instructions for sharing your presets with both computers.

Switch Instructions:

- 1. Quit Lightroom on Computer A.
- **2.** Safely disconnect the portable hard drive.
- **3.** Plug the portable hard drive into Computer B.
- 4. Open Lightroom on Computer B.
- **5.** (Optional) If the photos are available on network storage, but marked as missing, turn to page 499 to fix the broken links.

Portable Originals:

If you want to transfer some originals to your portable drive, or you shoot some new photos while you're away from your main storage and need to transfer them into your primary archives, turn back to page 123 and follow the instructions for safely moving those photos between hard drives.

Options	with standard previews	with 1:1 previews	with smart previews	with selected originals
Add new photos	Yes (move later)	Yes (move later)	Yes (move later)	Yes (move later)
View & search	Yes	Yes	Yes	Yes
View 100% (e.g. check focus)	No	Yes	No	Yes (if original)
Edit in Develop	No	No	Yes (if smart)	Yes (if original)
Edit in PS	No	No	No	Yes (if original)
Rename/Delete Files	No	No	No	Yes (if original)
Export	No	No	Yes (up to 2560px)	Yes (if original)

Figure 20.11 If you're using a Semi-Portable Catalog, the available Lightroom features depend on which previews or files you have available at the time.

4. Copy/Sync (e.g. Dropbox)

Summary: The catalog, the previews, smart previews and even the photos themselves can be automatically copied to multiple computers using Dropbox, or file synchronization software such as Vice Versa (Windows) / Chronosync (Mac). You can also copy the files manually, but that introduces more room for user error. (The workflow is the same as Figure 20.10).

For whom: You regularly work on different computers but you don't like the idea of a portable hard drive. You need the full power of Lightroom Classic on both computers.

Difficulty Rating: 3/4

Pros:

- Your entire catalog is available.
- The catalog is stored on internal hard drives, so it's not limited by portable hard drive speeds.
- There's no portable hard drive to drop or lose.

Cons:

- Access to the original files varies, depending on where they're stored.
- You have to be very careful to avoid creating conflicts when switching computers.
- Using Dropbox uses significant bandwidth as the previews are updated when you make Develop changes. File synchronization software uses the local network, but requires a little more tracking.
- Sync services such as Dropbox are not officially supported by Adobe. (I've used

Dropbox for my own personal catalog for years, but I haven't tested other sync services.)

Storage—Catalog: Copied to both computers using Dropbox/file sync software

Storage-Photos:

- Store photos on network storage (i.e. NAS) or shared drive. This allows you to access the photos from any computer on the network, but the data transfer rate may be slower
- Store photos on portable drive. This allows you to access the photos from any computer, but only if the portable drive is plugged in.
- Store photos on main computer (internal/ external drives). This has the benefit of faster data transfer on the main machine. with more limited edits from other computers.
- Sync photos to both computers (e.g. using Dropbox or file sync software). This allows you to access the photos from any computer, but may use lots of bandwidth and storage space.
- A mixture—sync specific photos to both computers (e.g. the ones you're currently working on, using Dropbox or file sync software), and store the rest on the main computer or NAS. This gives access to specific files from any computer, with more limited access to the rest.

Variations:

When the original files are offline (e.g. you're not connected to the network storage), you can still work on those photos using Lightroom's previews. The kind of

Options	with previews	with 1:1 previews	with smart previews	with some/all originals
Add new photos	Yes (move later)	Yes (move later)	Yes (move later)	Yes (move later)
View & search	Yes	Yes	Yes	Yes
View 100% (e.g. check focus)	No	Yes	No	Yes (if original)
Edit in Develop	No	No	Yes (if smart)	Yes (if original)
Edit in PS	No	No	No	Yes (if original)
Rename/Delete Files	No	No	No	Yes (if original)
Export	No	No	Yes (up to 2560px)	Yes (if original)

Figure 20.12 If you're copying your catalog back and forth, the available Lightroom features depend on which previews or files you have available at the time.

work you can do depends on the type of previews. **Figure 20.12** summarizes the main limitations. For the full list, turn to page 484.

Storage—Presets: Store Presets with Catalog or Dropbox Sync.

Other Considerations:

- Make sure that the catalog isn't changed on both computers at once, as one of the catalogs would become a 'conflicted copy' in Dropbox. You must allow time for the catalog to be completely uploaded and downloaded before you open it on the other computer.
- There's more potential for things to go wrong when using File Sync software or services, whether due to bugs or user error, so make more frequent catalog backups (ideally every time you quit Lightroom).
- If you have performance problems with Dropbox running at the same time as Lightroom, pause Dropbox sync while

you're working in Lightroom. If you don't, Dropbox runs constantly, trying to stay up to date with all the preview changes.

Setup Instructions:

- **1.** Turn back to page 463 and follow the instructions for moving the catalog. Move it to your Dropbox folder (or other sync folder).
- **2.** Turn to page 489 and follow the instructions for sharing your presets with both computers.

Switch Instructions:

- 1. Quit Lightroom on Computer A.
- **2.** Wait for the sync to complete on Computer A and Computer B. This is VERY important.
- **3.** Open Lightroom on Computer B.
- **4.** (Optional) If the photos are marked as missing, turn to page 499 to fix the broken

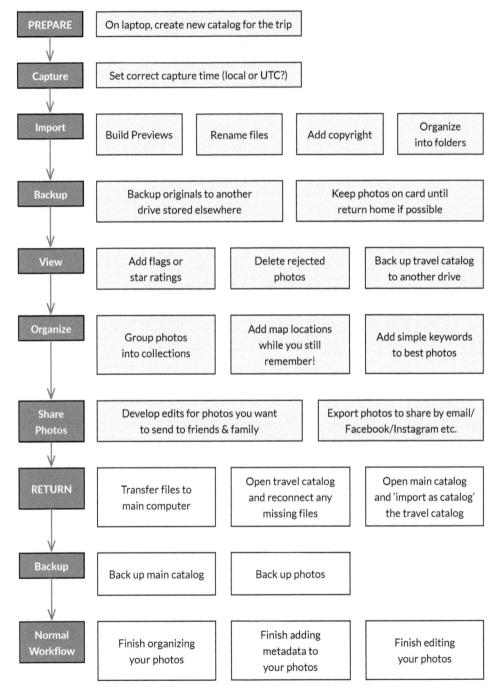

Figure 20.13 If you create a temporary catalog while travelling, you can merge it into your main catalog when you return.

links.

5. Import from a Temporary Catalog

Summary: Create a new catalog for the shoot on the secondary machine (or a portable hard drive) and later merge it into the main catalog on the primary machine. (Figure 20.13)

For whom: You want to keep your new shoot separate (e.g. a location shoot or vacation photos) until you're ready to transfer it back to your main computer. You don't need access to your existing photos on the secondary machine.

Difficulty Rating: 3/4

Pros:

• It's relatively simple, especially if it's a one-off.

Cons:

- No access to existing photos.
- Keyword list isn't available in the new catalog, so you may end up with duplicates or different spellings.
- Face recognition data isn't available in the new catalog.
- Publish Services (e.g. Facebook, Flickr) and Lightroom (cloud-based) sync information isn't transferred between catalogs.

Storage—Catalog: Main catalog on main computer, new catalog on secondary computer.

Storage—Photos: Main photos on main computer, external hard drive or NAS. New photos on secondary computer or portable

hard drive.

Storage—Presets: Leave on main machine or Dropbox Sync.

Other Considerations:

• Think about your backup strategy, as your secondary computer or portable drive may be excluded from your normal backups.

Setup Instructions:

- **1.** On the secondary computer, go to File menu > New Catalog and create a catalog.
- 2. Import your photos as normal.

Switch Instructions:

- **1.** Upon your return, copy the catalog and photos to the main computer, or transfer the portable hard drive.
- **2.** Double-click on the temporary catalog to open it, then relink any files that are marked as missing, using the instructions on page 499.
- **3.** Open the main catalog (File menu > Open Recent) and select File menu > Import from Another Catalog.
- **4.** Navigate to the folder containing the temporary catalog, select the Ircat file and press *Choose*.
- **5.** In the Import from Catalog dialog, check the folders at the top. In the *File Handling* pop-up, decide whether to *Add new photos* to catalog without moving or *Copy new photos* to a new location and import as shown in **Figure 20.14**. Since this was a new catalog, the *Changed Existing Photos* section is unavailable.
- 6. Click Import.

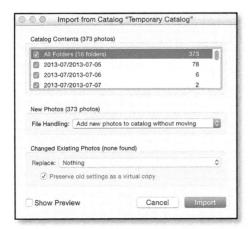

Figure 20.14 Use Import from Another Catalog to merge the travel catalog into your main catalog.

7. When you're happy that everything's transferred correctly and backed up, delete the temporary catalog and photos from the secondary computer or portable drive.

6. Split and Merge

Summary: Use one computer as a base (your main workstation, often a desktop) and export chunks of work out as a smaller catalog out for use on the secondary computer, then merge it back into the primary catalog on your return. (Figure 20.15)

For whom: Someone else needs to work on some of the photos while you're working in the main catalog.

Difficulty Rating: 4/4

Pros:

- Multiple people can work on the photos.
- The photos are still primarily stored in a single searchable catalog.

Cons:

- You must keep track of who is working on each chunk of photos, as the catalog import overwrites existing metadata when merging.
- It can quickly become complicated if you're not careful.
- The exported catalog only has access to the selected photos.
- Face recognition data isn't available in the new catalog.
- Publish Services (e.g. Facebook, Flickr) and Lightroom cloud sync information isn't transferred between catalogs.

Storage—Catalog: Main catalog on main computer, exported chunks on other computers or portable drive.

Storage—Photos: Main photos on main computer, external hard drive or NAS. Selected photos on secondary computer or portable hard drive.

Variations:

When the original files are offline (e.g. you're not connected to the network storage), you can still work on the photos using Lightroom's previews. The kind of work you can do depends on the type of previews. **Figure 20.16** summarizes the main limitations. For the full list, turn to page 484.

Storage—Presets: None or Dropbox Sync.

Other Considerations:

 Think about how you'll track which photos you've exported, for example, add them to a special collection or apply a color label to remind you not to edit the photos in

Sample "Split & Merge" Workflow

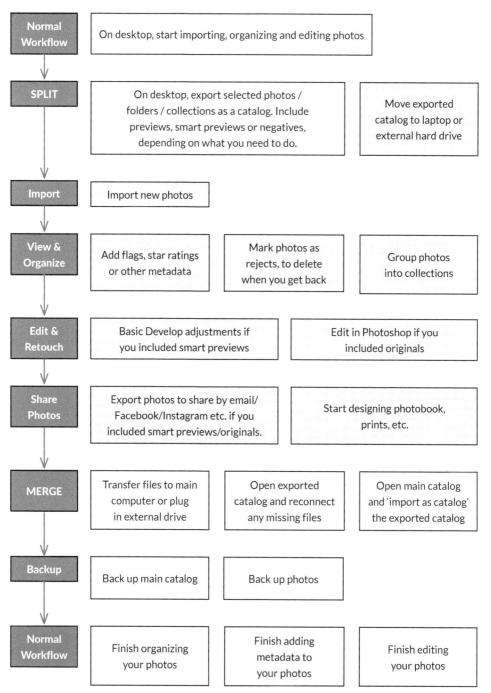

Figure 20.15 Use Export as Catalog and Import from Another Catalog to take part of your catalog offsite.

Options	with selected previews	with selected 1:1 previews	with selected smart previews	with selected originals
Add new photos	Yes (move later)	Yes (move later)	Yes (move later)	Yes (move later)
View & search	Yes (only selected photos)	Yes (only selected photos)	Yes (only selected photos)	Yes (only selected photos)
View 100% (e.g. check focus)	No	Yes (if 1:1)	No	Yes (if original)
Edit in Develop	No	No	Yes (if smart)	Yes (if original)
Edit in PS	No	No	No	Yes (if original)
Rename/Delete Files	No	No	No	Yes (if original)
Export	No	No	Yes (up to 2560px)	Yes (if original)

Figure 20.16 If you're using Export as Catalog to take part of your catalog offsite, the available Lightroom features depend on which previews or files you include when creating the exported catalog.

the main catalog while the exported catalog is 'checked out'.

Setup Instructions:

1. In the main catalog, select the photos, folder or collections that you want to transfer.

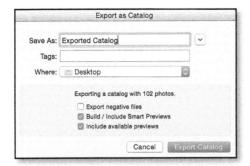

Figure 20.17 Use Export as Catalog to take a chunk of your catalog to another machine (or send it to another person). The checkbox settings depend on what you need to do with the files. See Figure 20.12 to help you choose the right options.

- **2.** Go to File menu > Export as Catalog and navigate to a location for the exported catalog (e.g. a portable hard drive). (Figure 20.17)
- **3.** Depending on the kind of work you need to do, include only the previews and either the smart previews or originals. Check the table above to work out which you checkboxes you need.
- **4.** On the secondary computer, double-click to open the exported catalog, and work as normal.

Switch Instructions:

- 1. When you return to the main computer, connect the portable hard drive or copy the catalog and any new/edited originals from the secondary computer (you don't need to copy the originals if you haven't changed them).
- 2. Select File menu > Import from Another

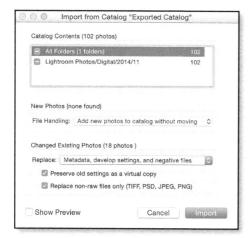

Figure 20.18 Use Import from Another Catalog to merge the exported catalog back into your main catalog.

Catalog. (Figure 20.18)

- **3.** Navigate to the folder containing the exported catalog, select the Ircat file and press *Choose*.
- **4.** As the photos are already in your main working catalog, the Import from Catalog dialog asks how to handle the new settings:

In the Changed Existing Photos section, select Metadata, develop settings and negative files from the pop-up and check the Replace nonraw files only (TIFF, PSD, JPEG, PNG) checkbox below. (For more detail on the available options, turn to page 487.)

If you've accidentally edited the photos in both catalogs, check the *Preserve old settings* as a virtual copy checkbox. To overwrite the main catalog with the settings from the exported catalog, leave it unchecked.

Check the *All Folders* checkbox at the top of the dialog. If you've only edited some of the files, it displays a line instead of a checkmark.

- 5. Click Import.
- **6.** When you're happy that everything's transferred correctly and backed up, delete the temporary catalog and photos from the secondary computer or portable drive.

Can multiple users use a Lightroom catalog?

Lightroom isn't designed for multi-user workflows, but some solutions are available. They include:

- Split and Merge workflow on page 480.
- Write the second user's settings to XMP and read them back into the main catalog (learn about XMP on page 411).
- Use the Lightroom (cloud-based) apps to apply star ratings or flags.

How does Export as Catalog work?

We've used Export as Catalog and Import from Catalog in the last couple of multicomputer examples, but let's take a closer look at the options so you can apply it in a wider range of situations.

Export as Catalog allows you to take a subset of your catalog—perhaps a folder or collection—and create another catalog from these photos, complete with your metadata, the previews and smart previews, and the original files too if you wish. You can then take this catalog to another computer, and merge it back in to your main catalog later.

- **1.** Decide which photos you want to include in the export. You can export any selected photos using *File menu > Export as Catalog*, or right-click on a folder or collection and select *Export Folder/Collection as Catalog*.
- 2. Navigate to a folder that will hold your

newly exported catalog, such as a portable hard drive. (Figure 20.19)

3. Decide which previews or files to include:

Include available previews exports the previews that have already been rendered. This is important if you're exporting a catalog subset to take to another computer and you won't be taking the original files with you, otherwise you'll just have a catalog full of gray thumbnails.

Build/Include Smart Previews exports the smart previews, or builds them if they don't already exist. This allows you to edit your photos in the Develop module without the negative files (full size original images).

Export negative files copies the original photos along with the catalog, you edit the photos in Photoshop or export full resolution photos.

The resulting catalog is a normal catalog, just like any other. If you've chosen to *Export negative files*, there are also one or more subfolders containing copies of your original files, in folders reflecting their original folder structure.

You can transfer this catalog to any computer with the same version of

	Export as Catalog
Save As:	Exported Catalog
Tags:	
Where:	Desktop 😊
	Exporting a catalog with 102 photos.
	Export negative files
	Build / Include Smart Previews
	Include available previews
	Cancel Export Catalog

Figure 20.19 Export as Catalog allows you to take part of your catalog to another computer.

Lightroom Classic installed, and either double-click on it, hold down Ctrl (Windows) / Opt (Mac) on starting Lightroom, or use the *File menu > Open Catalog* command to open it.

Note that some data is excluded when exporting catalogs. This includes Publish Services and Sync, as well as potentially some plug-in metadata.

Having finished working on that catalog, you can later use Import from Catalog to merge it back into your main catalog again. First, though, let's look at the limitations resulting for each checkbox setting in more detail.

What are the limitations of offline files, with standard or smart previews?

When the original files are offline, perhaps because you're working on another machine or the drive containing your original photos is disconnected, you'll still be able to do some work in Lightroom.

As long as you have standard-sized previews, you'll still be able to do Library tasks—labeling, rating, keywording, creating collections, etc. You can also view slideshows, design books, and export web galleries. If you've built 1:1 size previews, you'll also be able to zoom in to check focus in the Library Loupe view.

With Smart Previews, you can go one stage further—editing in the Develop module, and exporting medium resolution photos.

The Smart Previews have been designed to behave as much like the originals as possible, so Develop adjustments applied to the smart previews should look almost identical when applied to the original files. Noise reduction and sharpening know the size of the smart preview compared to the size of the original and scale the settings

appropriately behind the scenes. You may choose to fine tune them later, but this won't be necessary in most cases.

There are exceptional cases where you might see a difference between the Smart Previews and the original files. For example, if you make extreme adjustments, it may be possible to see artifacts in the smart previews, caused by the 8-bit lossy compression. The artifacts disappear when you reconnect the original raw files.

The Smart Previews are only up to 2560px along the long edge, so if you zoom into 100% view when the originals are offline, it won't truly be a 100% view. (There's one exception—if you've created 1:1 standard previews and you have made any Develop changes, the Library Loupe 100% view is true 100%.) They average around 1 MB each.

	Standard Previews	Smart Previews	Original Files
Import			
Import from Catalog			√
File Management			
Move			✓
Rename			✓
Remove from Catalog	✓	√	✓
Delete from Hard Drive			✓
Metadata			
Add Stars, Labels, Flags	✓	✓	√
Add Keywords	✓	✓	✓

Figure 20.20 A quick summary of which previews you can use for each task.

			In the second second
	Standard Previews	Smart Previews	Original Files
Create Faces Index		✓	✓
Add Names to Faces	✓	√	✓
Add Map Locations	✓	✓	✓
Add other Metadata	✓	✓	✓
Create Virtual Copies	✓	✓	✓
Work with Videos			✓
Create & Edit Collections	✓	✓	√
Previews			
Build Standard Sized Previews		√	√
Build 1:1 Sized Previews			√
Build Smart Previews			✓
Export as Catalog			
Export as Catalog with Standard Previews	✓	✓	✓
Export as Catalog with Smart Previews		✓	√
Export as Catalog with Originals			✓
Import from Catalog with Standard Previews	√	√	✓
Import from Catalog with Smart Previews		✓	✓
Import from Catalog with Originals			✓
Develop			
Global Develop Adjustments		√	✓
Local Develop Adjustments		✓	√

	Standard Previews	Smart Previews	Original Files
Merge to Panorama		√	✓
Merge to HDR			✓
Soft-proof photos		✓	✓
Export			
Export best quality full resolution photos	,		✓
Export to any size photos		larger than 2560 px will be upsampled	√
Email photos		✓	✓
Publish Services			
Publish photos (as Export)		✓	√
Book			
Design Book	✓	✓	√
Export Book to PDF			1
Export Book to JPEG			✓
Export Book to Blurb			✓
Slideshow			
Design Slideshow	1	V	1
Preview Slideshow	✓	✓	✓
Play Slideshow on Computer	~	✓	1
Export Slideshow to PDF			√
Export Slideshow to JPEG			~
Export Slideshow to Video	✓	✓	✓

	Standard Previews	Smart Previews	Original Files
Print			
Set up Print	~	✓	✓
Print to JPEG			✓
Print to Printer			✓
Web			
Design Web Gallery	✓	✓	✓
Export Web Gallery to Hard Drive	✓	✓	1
Export Web Gallery to FTP	✓	✓	√

Of course with the originals offline, you can't do anything that requires the original files—moving files between folders, renaming, writing to XMP, deleting files, creating HDR or full size panoramic photos, editing the photos in Photoshop, and other similar tasks—until the original files are available again. (Figure 20.20)

How do I check which photos have previews or smart previews?

Under the Histogram is a file status area. (Figure 20.21)

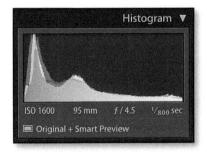

Figure 20.21 File status shows in the Histogram panel.

When a single photo is selected, it says:

Original Photo—the original is available, but there's no smart preview

Original + Smart Preview—the original is available, but a smart preview is available if the originals go offline

Smart Preview—the original is offline, but a smart preview is available

Photo is Missing—the original is offline and there's no smart preview

If multiple photos are selected, it just displays the icons and photo counts. When more than 1000 photos are selected, a + symbol appears next to the photo counts, showing that it stopped counting for performance reasons. (Figure 20.22)

You can also create a Smart Collection for Has Smart Previews is True or False, which makes it easy to keep track of which Smart Previews you need to build.

How do I build or discard smart previews?

You can build smart previews while you're importing photos by checking the Build Smart Previews in the Import dialog's File Handling panel, or later, select all (or none) of the photos in Grid view and choose

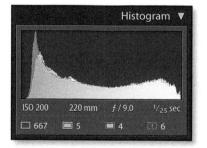

Figure 20.22 When multiple photos are selected, the file status switches to icons.

Library menu > Previews > Build Smart Previews. It skips any photos that already have smart previews. Likewise, you can discard smart previews that you no longer need by selecting the photos and using the Library menu > Previews > Discard Smart Previews command.

How does Import from Catalog work?

The Import from Catalog command is used to merge multiple catalogs into a single catalog, or transfer photos between catalogs without losing all the work you've done.

- **1.** Open the source catalog and reconnect any photos that are marked as missing, using the instructions on page 499. This helps to prevent duplicate records in the merged catalog.
- **2.** Open the target catalog that you want the photos to end up in. If you're merging multiple catalogs into one catalog, you might want to create a new catalog.
- **3.** Select File menu > Import from Another Catalog, and navigate to the source catalog, from which you want to pull the metadata.
- **4.** Lightroom reads the source catalog and checks it against the target catalog, resulting in the Import from Catalog dialog. (Figure 20.23)

If you select an older catalog in the Import from Catalog dialog, Lightroom automatically upgrades the catalog before importing. You can save the upgraded catalog, as if you had opened the catalog normally and run the upgrade, or discard the upgraded catalog. Either way, the original catalog is left untouched.

Depending on the choices you make, new photos are imported into the target catalog

and existing photos are updated. The main options are:

The **Catalog Contents** section lists all of the folders in the source catalog, and allows you to check the folders that you want to include in the import. It's particularly useful when you want to import selected folders.

The **Show Preview** checkbox displays a thumbnail area to the right. Each thumbnail has a checkbox, allowing you to include or exclude specific photos. If you click on a folder in the *Catalog Contents* section, the thumbnail preview area updates to show only the photos in the selected folder. Dimmed photos are unavailable for import as they already exist in the target catalog with the same settings.

New Photos controls how new photos are handled. These are photos that don't exist in the target catalog in a matching folder hierarchy.

File Handling offers a choice of Add new photos to catalog without moving, Copy new photos to a new location and import or Don't import new photos.

Changed Existing Photos controls how photos that already exist in the target catalog are handled. Photos that are identical in both catalogs are skipped, as you won't need to update these.

The **Replace** pop-up offers a choice of *Metadata and develop settings only, Metadata, develop settings and negative files* or *Nothing* from the pop-up. Unless you've edited the files themselves in another program, for example, retouching in Photoshop, then you can usually just copy the metadata and settings.

If you select Metadata, develop settings and

Figure 20.23 Import from Catalog allows you to merge catalogs together. You can select specific folders or photos to copy into the target catalog.

negative files, the **Replace non-raw files only** (**TIFF, PSD, JPEG, PNG**) checkbox becomes available. This saves time by only replacing files that may have been edited, for example, photos edited in Photoshop. Unless you've worked on the files themselves in another program, for example, retouching in Photoshop, then you can usually just copy the settings.

Preserve old settings as a virtual copy is useful if you've accidentally edited the photos in both catalogs. It creates a virtual copy of the target catalog's settings and imports the source catalog's settings as the master photo. Once the import completes, you can check through the photos and determine which version to keep

Are there any limitations when importing and exporting catalogs?

I should give one word of warning about the catalog import/export process: some data is excluded. This includes:

Extra Files—Any files that are stored in the selected folders but aren't referenced in Lightroom's catalog, such as text documents, are not included in the exported catalog/folder.

Keywords—Your keyword list in the exported catalog only includes keywords that have been applied to the selected photos. You can work around this by using *Metadata menu > Export Keywords* in the main catalog, and *Metadata menu > Import Keywords* in the exported catalog to add your full keyword list.

Publish Services—Publish Services settings and collections are tied directly to their original catalog and are not transferred by Export as Catalog. (Although Publish Services data is excluded when using Import/Export Catalogs, it's possible to work around

this limitation using the LRVoyager plug-in. https://www.Lrq.me/alloy-lrvoyager)

Lightroom Cloud Sync—Lightroom only syncs with a single catalog with the cloud.

Plug-ins—Some plug-ins store data in undefined areas of the catalog, which may not be transferred by Export as Catalog.

As with many things, it's simply a case of weighing the pros and cons.

It's also worth noting that Import from Catalog merges complete photo records, so if you've changed a photo's star rating in the source catalog and Develop settings in the target catalog, all of the photo's metadata in the the source catalog overwrites the same photo's metadata in the target catalog. You can choose to create virtual copies, retaining both sets of settings at the expense of additional clutter in your catalog.

Can I share my catalog with multiple users on the same machine?

We've discussed using Lightroom on multiple computers, but what happens if you have multiple user accounts on the same computer and you want to share the same photos? All of the same options apply. Only one user can have the catalog open at a time, so if both users are logged in to the computer at the same time using Fast User Switching, the previous user needs to close Lightroom before the next user can open it.

Should I check 'Store presets with this catalog'?

By default, your presets and templates are stored in your user account on your computer, either in the *Lightroom* or *CameraRaw* folder, depending on the type of preset or template.

Figure 20.24 If you work with a single catalog and use it on multiple computers, perhaps on an external drive or synced via Dropbox, consider checking Store presets with this catalog. Otherwise, it's best left unchecked.

When Preferences dialog > Presets tab > Store presets with this catalog is checked, Lightroom looks for most presets in a Lightroom Settings folder next to your catalog, rather than the standard user account folder. (Figure 20.24)

I'd recommend leaving it unchecked unless you have a specific reason for using it. In most situations, this checkbox causes unnecessary confusion, but it can be useful when using a single catalog on multiple computers or multiple user accounts.

If you do decide to enable *Store presets with this catalog*, there are a few warnings to note:

- Some settings are always stored in the user account, regardless of the *Store presets with this catalog* checkbox state. These include all of the settings shared with Camera Raw, such as default Develop settings, custom point curves, lens and camera profiles, and also email account settings. (There is an alternative way of using Symbolic Links and Dropbox or similar sync software to sync all types of presets and templates between computers, described in the next question.)
- When importing new presets, use the manual installation method described on page 373, as the automatic installation process ignores the *Store presets with this catalog* setting and stores the presets in the Camera Raw location.
- If your presets and templates ever seem

to have 'gone missing' or are out of date, this checkbox is probably to blame, so try toggling it.

- When checked, the presets are only available to that specific catalog, so don't check it if you need to use multiple catalogs (unless you want different presets with each catalog).
- Lightroom doesn't move the presets (except for Develop Presets) to the new location automatically, so you'd need to manually copy them to the Lightroom Settings folder. To do so:
- **1.** Go to *Preferences* > *Presets tab* and uncheck *Store presets with this catalog* and press the *Show All Other Lightroom Presets* button.
- **2.** An Explorer (Windows) / Finder (Mac) window opens, showing the presets/ templates in their user account folder. Keep it open in the background.
- **3.** Check the Store presets with this catalog checkbox and press the Show All Other Lightroom Presets button again.
- **4.** A second Explorer (Windows) / Finder (Mac) window opens, showing the catalog-specific Lightroom Settings folder.
- **5.** Drag (or copy/paste) your presets from the user account folder to the catalog-specific one.

If you have the opposite problem, and the

presets are stored with the catalog, just swap the steps around. If you have multiple catalogs with multiples sets of presets, you can copy and paste them all into the user account folder to make them available to all catalogs.

How do I synchronize my presets using Dropbox?

The more technical (but more flexible) workaround for keeping presets updated on multiple computers involves using Dropbox (https://www.Lrq.me/dropbox) and junctions (Windows) / symlinks (Mac). It works well for shared Camera Raw presets (such as Develop presets) as well as Lightroom-specific presets. The computers can even run different platforms, for example, a Windows machine and a Mac. (Other cloud sync services may also work, but haven't been tested as extensively.)

Having installed Dropbox according to the instructions on their website, you first need to copy the presets and profiles into the Dropbox folder. Personally I keep a *Sync* subfolder in Dropbox, as I use this same principle for many different programs.

For both operating systems:

- **1.** Create a folder in Dropbox to store your presets.
- **2.** In Lightroom, ensure that *Preferences* > *Presets tab* > *Store presets with this catalog* is unchecked
- **3.** Using Explorer (Windows) / Finder (Mac), open the user account application data folders at:

Windows—C: \ Users \ [your username]\ AppData \ Roaming \ Adobe \

Mac-Macintosh HD / Users / [your

username] / Library / Application Support / Adobe /

These are hidden OS folders, but the Show Lightroom Develop Presets and Show All Other Lightroom Presets buttons in Lightroom's Preferences > Presets tab will take you straight there, as long as Store presets with this catalog is unchecked.

- 4. Quit Lightroom.
- **5.** Copy the Lightroom folder and the CameraRaw subfolders (e.g. Defaults, CameraProfiles—but exclude the GPU folder as it may crash Lightroom) to your Dropbox folder.
- **6.** Move, rename or delete the original folders in the Application Support folder.

Having copied the presets and other folders, it's time to create the symbolic links, so the instructions depend on your operating system...

Windows:

- **1.** Download Symlink Creator (https://www.Lrq.me/winsymlink). It's a small free program which creates a symbolic link without needing to understand DOS and the mklink command.
- **2.** There's no installation needed other than unzipping the download (or just selecting the .exe download in the first place). To avoid permissions issues, you'll need to right-click on the Symlink Creator.exe file and select *Run as Administrator*.
- **3.** In the dialog, working from the top, select *Folder symbolic link* as the type of link. (Figure 20.25)
- **4.** In the *Link Folder* section, browse for the C:\Users\[your username]\AppData\

Figure 20.25 Symbolic Link Creator is an easy way to create symbolic links on Windows.

Roaming\Adobe\Lightroom folder (this may be a hidden folder) and call the link *Lightroom*.

- **5.** In the Destination Folder section, browse to the Lightroom folder you created in your Dropbox folder.
- **6.** Select *Symbolic Link* as the type of link, and press *Create Link*.
- **7.** Repeat steps 3-6 using the Camera Raw subfolders instead of the Lightroom folder.
- **8.** Now restart Lightroom and check that it has found your presets and camera raw settings correctly.
- **9.** Switch to the other computer and repeat steps 1-8. If you had different presets on the other computer, you may want to merge them into your Dropbox folders so that they're available on all computers.

Mac:

- **1.** Download SymbolicLinker (https://www.Lrq.me/macsymlink). It's a small free program which creates a symbolic link without needing to visit Terminal.
- **2.** Install it according to the instructions included with the app.
- **3.** Right-click on the Lightroom folder in Dropbox and select *Services > Make Symbolic Link*. (Figure 20.26)
- **4.** The new symbolic link appears next to the Lightroom folder, and is called *Lightroom symlink*.
- **5.** Drag the new Lightroom symlink to the Macintosh HD/Users/[your username]/Library/Application Support/Adobe/ folder, where the original folder was stored.
- **6.** Rename the Lightroom symlink to remove the word symlink—you want to match the original name (Lightroom) so that Lightroom follows your link.
- **7.** Repeat steps 3-6 using the Camera Raw subfolders instead of the Lightroom folder.
- **8.** Now restart Lightroom and check that it has found your presets and camera raw settings correctly.
- **9.** Switch to the other computer and repeat steps 1-8. If you had different presets on the other computer, you may want to merge them into your Dropbox folders so that they're available on all computers.

Figure 20.26 SymbolicLinker is an easy way to create symbolic links on Mac.

Once the setup is complete, Lightroom looks at the presets in the Dropbox folder, which should be updated whenever you add or edit a preset. If Lightroom is open on both computers at the same time, changes may not appear on the other computer until Lightroom is restarted.

SINGLE OR MULTIPLE CATALOGS

Until now, we've been working on the assumption that you have a single master catalog. Since version 1.1, Lightroom has made it easy to create and use multiple catalogs, but the question is, just because you can, should you? We'll consider some of the pros and cons, and how to make it work if you do decide that multiple catalogs are right for you.

Should I use one big catalog, or multiple smaller catalogs?

There's no 'right' number of catalogs. As with the rest of your Lightroom workflow, it depends on how you work. So should you use multiple catalogs for your main working catalog, or should you split your photos into multiple catalogs? We're not referring to temporary catalogs which are created for a purpose, for example, to take a subset of photos to another machine before later merging them back in, but more specifically your main working or master catalog.

The main benefit of keeping all of your photos in a DAM (Digital Asset Management) system is being able to easily search through them and find specific photos, but there are a few other pros and cons to consider:

Pros of Multiple Catalogs

• Smaller catalogs may be slightly faster on very low spec hardware. (Although even

50,000 photos counts as a small catalog!)

- Backups are faster than a single big catalog.
- Multiple catalogs give a clear distinction between types of photography, i.e., work vs home.
- You can't accidentally drag photos into the wrong folder (e.g. wedding photos can't end up with the wrong client).
- If your catalog becomes corrupted, you have less to lose (although frequent backups will avoid this issue).
- If multiple users need to be working on photos at the same time, it's easier to track individual catalogs.

Cons of Multiple Catalogs

- Can't search across multiple catalogs (e.g. to find the best photos from multiple shoots).
- Cloud sync only works with one catalog.
- You can end up with variations in metadata and keyword spellings.
- It's harder to keep track of backups.
- You have to keep switching catalogs.
- You can't switch catalogs while a process is running (e.g. if you're running an export in one catalog, you have to wait for it to complete before switching to another catalog).
- Some photos may be forgotten and not included in any catalog.
- You can end up with duplicate photos in multiple catalogs by accident.

There are few questions to ask yourself:

- How many photos are you working on at any one time? And how many do you have altogether?
- Do you want to be able to search through all of your photos to find a specific photo? Or do you have another DAM system that you prefer to use for cataloging your photos?
- If you decide to work across multiple catalogs, how are you going to make sure your keyword lists are the same in all of your catalogs?
- If you use multiple catalogs, is there going to be any crossover, with the same photos appearing in more than one catalog?
- How would you keep track of which photos are in which catalog?
- Do you want to keep the photos in your catalog indefinitely or just while you're working on them, treating Lightroom more like a basic raw processor?
- How will you keep track of catalogs and their backups?

Your answers likely depend on your reasons for using Lightroom. For some people, using multiple catalogs isn't a problem—they already have another system they use for DAM (digital asset management), and they want to use Lightroom for the other tools it offers. For example, some wedding photographers may decide to have a catalog for each wedding, and if they know that a photo from Mark & Kate's wedding is going to be in Mark & Kate's catalog, finding it really isn't a problem. But then, if you had to find a photo from a specific venue, or to use for publicity, you'd have to search through multiple catalogs.

Many high-volume photographers choose the best of both worlds: a small catalog for working on their current photos, and then transferring them into a large searchable archive catalog for storing completed photos. That's certainly another viable option, and a good compromise for many.

There are some easy distinctions, for example, you may also decide to keep personal photos entirely separate from work photos. These kind of clear-cut distinctions work well, as long as there's never any crossover between the two. Keeping the same photo in multiple catalogs is best avoided, as it becomes very confusing! The more catalogs you have, the harder they become to track.

As a simple rule of thumb, use the fewest catalogs you can and no fewer. For most photographers, that's just one catalog.

Is there a maximum number of photos a catalog can hold?

So you might be wondering, how big is too big? There's no known maximum number of photos you can store in a Lightroom catalog. At the last count, the largest known catalog contained 13 million photos, and it's likely much larger now!

If your catalog's stored on a FAT32 formatted hard drive, 2 GB is the maximum file size allowable on that drive format, so your catalog could hit that limit, but then you could always move the catalog onto a drive formatted as NTFS on Windows or HFS/APFS on Mac.

How do I create a new catalog and open catalogs?

Assuming you've decided to create a new catalog, you'll need to understand some basic catalog management, such as how to

Figure 20.27 If you hold down Ctrl (Windows) / Opt (Mac) while starting Lightroom, it asks which catalog to open.

Figure 20.28 Set your default catalog in Lightroom's Preferences dialog.

create new catalogs and switch between them.

If Lightroom's already running, you can create a new catalog using *File menu > New Catalog*, or open an existing catalog using *File menu > Open Catalog*.

If Lightroom's closed, hold down the Ctrl key (Windows) / Opt key (Mac) while opening Lightroom. In the Select Catalog dialog, it lists your recently used catalogs, or you can open another existing catalog or create a new catalog. (Figure 20.27)

How do I set or change my default catalog?

By default, Lightroom opens your last used catalog when it launches, however you can change this behavior in Lightroom's *Preferences > General tab.* (Figure 20.28) You can choose to open a specific catalog, open the most recent catalog, or be prompted each time Lightroom starts.

How do I set default Catalog Settings to use for all new catalogs?

Certain settings are catalog-specific, for example, anything set in the Catalog Settings dialog, Identity Plates, smart collections and keyword lists. Lightroom doesn't currently provide a way of making these settings available to new catalogs as templates, however there is a workaround. Set up a new empty catalog with the settings of your choice and save it somewhere safe. Whenever you need a new catalog with all of your favorite settings, simply duplicate the template catalog using Explorer (Windows) / Finder (Mac) instead of using File menu > New Catalog.

If you only need to import your smart collections into each new catalog, there's another handy trick. Export the existing smart collections (right-click > Export Smart Collection Settings) and change their file extension from ".Irmscol" to ".Irtemplate"

Then go to Preferences dialog > Presets tab and press the Show All Other Lightroom Presets button. There you'll find a folder call Smart Collection Templates, If you add your renamed smart collections to that folder. they'll automatically be added to any new catalogs.

How do I delete a spare catalog?

If you've ended up with too many catalogs, you may want to delete any unused catalogs. It's probably a good idea to open it before you delete it, to check that you definitely don't want to keep it. To do so, either use File menu > Open Catalog or double-click on the catalog in Explorer (Windows) / Finder (Mac). You can safely delete the spare catalog and its previews files as long as vou're sure there are no settings in it that catalog that you need. If in doubt, delete the previews (*.lrdata), zip the catalog (*.lrcat) and keep it somewhere safe.

How do I merge multiple catalogs into one larger catalog?

To merge your existing separate catalogs into one large catalog, it's simply a case of using Import from Catalog to pull the data into a new combined catalog. If you've accidentally ended up working in a backup catalog or created a new catalog by mistake. this process also allows you to fix your mistake without losing any data.

- 1. Open each individual catalog by doubleclicking on it. If any folders or photos are marked as missing, turn to page 499 and fix the broken links before merging catalogs. You'll save a lot of time later.
- 2. Select File menu > New Catalog and create a clean catalog which will become your new master catalog.
- **3.** Go to File menu > Import from Another

Catalog and select one of the smaller catalogs (the *.lrcat file). Ideally you should work through in date order, from the oldest catalog to the newest. Note that we're importing the metadata from the existing catalog rather than importing the photos using the standard Import dialog. There's a big difference!

Assuming that your photos are remaining in their current location, you'll need to select:

New Photos > File Handling set to Add new photos to catalog without moving.

Changed Existing Photos > Replace set to Metadata and develop settings only.

If photos appear in more than one catalog, and vou're not sure which settings are the most recent, check Preserve old settings as a virtual copy. This creates virtual copies of each of the different sets of settings, so you can go back through later and decide which to keep.

For more information on the available options, turn back to page 487.

- 4. Repeat the Import from Catalog process for each of the other smaller catalogs until you've imported them all.
- 5. Keep the individual catalogs at least until you're sure that everything's transferred correctly and you have a current backup.
- 6. If some photos were duplicated in more than one catalog and you checked Preserve old settings as a virtual copy, sort through the photos and delete any virtual copies you don't need to keep. If the version you want to keep is a virtual copy, promote it to master status using Photo menu > Set Copy As Master and then delete the other version.

If you merge multiple catalogs, especially

from multiple computers, you may end up with duplicate photos. The Duplicate Finder plug-in can help to identify them, although there's still some manual cleanup involved. https://www.Lrg.me/duplicatefinder

How do I split a catalog into multiple catalogs?

To split an existing catalog into smaller catalogs, use the Export as Catalog command discussed on page 483. (There are few occasions when I'd recommend this, as using a single large catalog is usually a better choice. However there are occasions when it's useful, for example, you may need to take part of the catalog to another computer or have someone else work on part of the catalog.)

How do I transfer photos between catalogs?

If you do decide to use a small working catalog and a large archive catalog, you'll need to transfer photos between catalogs. Using Import from Another Catalog is essential when transferring photos between catalogs. Simply importing the photos instead of the catalog would lose all of the work you've previously done in Lightroom.

- **1.** Open your Archive catalog, or create one if you haven't done so already.
- **2.** Select *File menu > Import from Another Catalog*, and navigate to the Working catalog. In the Import from Catalog dialog that follows, select the folders that you want to transfer into your Archive catalog, deselecting the others.

Assuming that your photos are remaining in their current location, you'll need to select:

• New Photos > File Handling set to Add new photos to catalog without moving.

- Changed Existing Photos > Replace set to Metadata and develop settings only if it's available.
- For more information on the available options, turn back to page 487.
- **3.** Import these folders into your Archive catalog and check that they've imported as expected.
- **4.** Close your Archive catalog and reopen your Working catalog.
- **5.** Make sure you have a current backup, before you start removing photos from a catalog, just in case you make a mistake.
- **6.** Select the photos that you've just transferred.
- **7.** Press the Delete key to remove these files from the Working catalog, being careful to choose *Remove from the catalog* rather than *Delete from the hard drive*.
- **8.** Repeat the process whenever you want to transfer more photos into the Archive catalog.

CATALOG SHORTCUTS

		Windows	Mac
Open Catalog		Ctrl O	Cmd Shift O
	Open Specific Catalog when opening Lightroom	Hold down Ctrl while opening Lightroom	Hold down Opt while opening Lightroom

TROUBLESHOOTING 21

It's a computer—they don't always work the way you expect! Hiccups do occur, so let's explore some of the most frequent troubleshooting steps.

First, we'll look at the most frequent problems and their solutions, and then general troubleshooting steps you can try, if none of these fit. The most frequent problems are:

- Missing photos, marked with question marks or exclamation points.
- Missing toolbar.
- Missing panels and dialogs.
- Catalogs that won't open, perhaps due to corruption.
- · Corrupted photos.
- Preview problems, including odd colors, gray thumbnails and corruption.

MISSING FILES

At some stage, most people run into worrying exclamation points or question marks denoting missing files. Those warnings appear when Lightroom can no longer find the photos at their last known location.

Usually, it's because you've used other software such as Explorer (Windows) or Finder (Mac) to:

- Delete the photos or folders.
- Move the photos or folders.
- Rename the photos or folders.

It can also happen when something's happened to the drive, such as:

- The external or network drive holding the photos is unplugged/disconnected.
- The drive letter has changed (Windows) or drive mount point has changed (Mac).
- You've moved to a new computer.

How do I know that Lightroom can't find my photos?

Missing files are identified by a rectangular icon in the corner of the Grid thumbnail, with or without an exclamation point. (Figure 21.1) (In earlier versions, it displayed a question mark icon instead.)

If you've previously built Smart Previews, it says *Smart Preview* under the Histogram, to indicate that the original file is unavailable. You can continue working in Lightroom using those lower quality proxy files even though the original files are offline, with

Figure 21.1 Missing photos have an exclamation point icon.

some limitations that we discussed in the Multi-computer chapter on page 484.

If there are no Smart Previews, the rectangular icon on the thumbnail contains an exclamation point, and when you check the histogram, you'll find it's blank and says *Photo is missing.* (Figure 21.2) When you switch to the Develop module, the sliders are unavailable, as you can't edit a photo that's completely missing.

If the entire folder is missing, the folder name in the Folders panel goes gray with a question mark folder icon. (Figure 21.3)

If an entire drive is offline, the volume name in the Folders panel and the small rectangular icon on the left turn gray.

Figure 21.2 Missing Photo status also shows in the Histogram panel.

What else can cause photos to disappear?

There's a couple of other things that can make it look like your photos have disappeared. They include:

Opening the Wrong Catalog—Go to *File menu > Open Recent* and see if another catalog is listed. If it's not, search your hard drives for *.Ircat files and double click to open.

Collapsed Stacks— Go to Photo menu > Stacking > Expand All Stacks.

Filters—Uncheck Library menu > Enable Filters.

Show Photos in Subfolders— Check Library menu > Show Photos in Subfolders.

STOP!

If you have missing photos or folders, don't be tempted to synchronize the folder or re-import the photos until you've explored every other possibility. If you do so, you may lose the work you've done in Lightroom.

Lightroom thinks my photos are missing—how do I fix it?

If Lightroom tells you that files are missing,

Figure 21.3 Missing folders have question mark icons. If the whole volume's offline, the drive goes gray.

don't panic. First, stop and work out the extent of the problem, and if you can, why it's happened. Then fix it as soon as you can, using the instructions below, as problems tend to snowball if you ignore them.

The quickest way to fix the missing files is to follow these instructions in order. If you start relinking missing photos before you relink missing folders and drives, you can create a bigger job.

1. First, you must **find the files on your hard drive**. Lightroom can't tell you where you've put the files, if you've moved/renamed/deleted them using other software, so you first need to locate the missing files on your hard drives.

Once you've found them on your hard drive using Explorer (Windows) / Finder (Mac), you can move on to step 2. If you get stuck, try using Windows Search or Mac Spotlight to search for one of the filenames.

2. Look in the Folders panel. **Is the whole drive offline**, shown by dark gray text and a gray rectangle on the left?

If the answer's no, skip on to step 3.

If the answer's yes, why is the drive offline? Is it disconnected? If you're on Windows, has the drive letter changed? If you're on a Mac, has the drive name changed?

If the drive is disconnected, plug it back in or reconnect to the network storage.

If the drive letter/name has changed, you can change it back (page 503), or you can move on to step 3 and reconnect the individual folders.

3. Look in the Folders panel. **Are some of the folders marked as missing**, with gray text and a question mark on the folder icon?

If the answer's no, skip on to step 4.

If the answer's yes, why are the folders missing? Did you delete, rename or move a folder?

If you deleted the folders, restore from the Recycle Bin/Trash or from a backup.

If you renamed or moved the folder, you could move/rename it back and then redo the move/rename within Lightroom.

If you can't put them back as they were, you can link Lightroom to the new name/location. That's the next step...

4. If you set up the folders as a hierarchy using the instructions earlier in the book (page 117), is a **whole folder hierarchy of parent/child folders** marked as missing? Or is it a single folder (or a few folders) that's marked as missing?

If it's a whole folder hierarchy that's missing, right-click on the parent folder (rather than the individual subfolders) and select **Find Missing Folder** from the context-sensitive menu, then navigate to the new location of that parent folder. As long as the names and structure of the subfolders hasn't changed, all of the subfolders are fixed at the same time.

If it's a single missing folder, right-click on the missing folder and select *Find Missing Folder* from the context-sensitive menu, then navigate to the new location of that single folder. Lightroom then updates its records to the new location and the question marks disappear.

If there are multiple missing folders, that aren't in a folder hierarchy, do the same for each of these folders.

5. Are individual photos still marked as

missing, with an exclamation point inside a rectangle on each of the thumbnail borders?

If the answer's no, your work is done. Go to *Library menu > Find Missing Photos*, just to double-check you haven't missed any photos.

If the answer's yes, why are those photos missing? Do you remember moving or renaming them? Or deleting them?

If you deleted them, you'll need to restore the photos to their previous location from the Recycle Bin/Trash or from a recent backup. Remember, the photos are never IN Lightroom, and most of Lightroom's tools won't work without the original photos. (We'll come back to worst case scenarios in a moment).

If you moved the photos without renaming, you can either move them back, or you can link Lightroom's records to the new location of the photos.

To link Lightroom to the new name/location, click on the rectangle in the corner of the thumbnail. Lightroom displays the last known location of the photo. Click *Locate* and navigate to the new location of that photo. (Figure 21.4) Check the *Find nearby missing photos* checkbox to allow Lightroom to try to automatically relink other files in

the same folder. Lightroom updates its records to the new location and the rectangular icons disappear.

If you renamed the photos outside of Lightroom, the quickest solution is to restore the photos with the old names from your backups and then redo the rename within Lightroom. If there are only a few photos, you can link Lightroom to the new name/location (using the previous instructions), however every renamed photo must be relinked individually.

How do I prevent missing files?

Prevention is better than cure, and preventing missing files will save you some additional work, so there are a few things to look out for...

- Don't delete the original files from your hard drive. Photos are not stored IN Lightroom.
- Move any files or folders within Lightroom's own interface, simply by dragging and dropping around the Folders panel. Don't "tidy up" using other software or the operating system (or if you do, fix Lightroom's links immediately).
- Rename any files before importing into Lightroom, or use Lightroom to rename

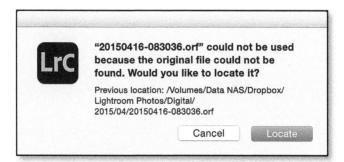

Figure 21.4 Click on the exclamation point and navigate to the new location of the photo. Lightroom doesn't find them automatically, but it does display the last known location.

them. Whatever you do, don't rename in other software once they're imported.

• Don't use *Synchronize Folder* to remove missing files and import them again at their new location as you'll lose all of your Lightroom settings.

Set Lightroom's Folders panel to show the full folder hierarchy to a single root level folder. If a folder is moved from its previous location, or the drive letter changes, it can be fixed more easily than individual folders.

How do I change drive letters on Windows?

When using external drives, Lightroom doesn't change the drive letters, but Windows often does. That can confuse Lightroom, requiring you to relink missing files on a regular basis. Leaving the drives plugged in to your computer, or always reattaching them in the same order can help avoid the drive letter changing.

To set the drive letter a little more permanently, or reset them if they change, you can go into Windows Disk Management and assign a specific drive letter. You'll need to be logged in as an Administrator. Go to Start menu > Control Panel > Administrative Tools > Computer Management. Disk Management is listed in the left-hand panel under Storage. Selecting this connects to the Virtual Disk Service and displays the drives seen in the main panel.

Find the relevant drive in the list, right-click and there's an option to *Change Drive Letter and Paths*. Be careful to ensure you have the correct drive! Selecting Change displays a list of available letters to select from. Selecting a letter outside the range Windows would usually assign automatically helps to reduce the possibility of it changing, so a letter from the latter

half of the alphabet is a good choice. When you've finished, press *OK*, and select *Yes* when prompted to confirm the drive letter change.

It says The selected folder or one of its subfolders is already in Lightroom. Do you want to combine these folders? Do I say yes or no?

If a folder has been marked as missing for a while, and you've since imported photos from the new location, when you select Find Missing Folder, it might say The selected folder or one of its subfolders is already in Lightroom. Do you want to combine these folders? If you're sure you've selected the correct folder, press the Merge button to combine them.

It says The file is associated with another photo in the catalog. How do I fix it?

There's another problem that can arise if you reimport the photos at their new location instead of fixing the broken links. This creates duplicate records, and prevents you from fixing the links.

How might you get into this state? Imagine your photos hard drive is originally called Drive D, and you import your photos and edit them. Then, at some point, Windows changes the drive letter to Drive F (or you rename a Mac drive). Later, you want to edit one of these old photos but it's marked as missing, so you import it again (big mistake!). Time passes, and you're reading this chapter, so you decide to relink all of the missing files. When you try to relink some of the files, Lightroom says "The file is associated with another photo in the catalog" and won't let you continue.

So how do you fix it? Let's work through it step by step:

- **1.** Back up your catalog, just in case you make a mistake.
- **2.** First, you have to determine which of the duplicates to keep. The original one that's marked as missing? Or the newer one? In most cases, you'll choose to keep the version that you've edited.
- **3.** When you've decided which record you're going to remove from the catalog, make sure you have a folder selected (not a collection) then select the photo and press the Delete key. When Lightroom asks whether to *Remove* or *Delete*, make sure you select *Remove*.
- **4.** Once that duplicate record has been removed from the catalog, check the photo you've decided to keep. If it was marked as missing, click the rectangle in the corner and navigate to the new location. Lightroom now allows you to select the photo.
- **5.** Repeat for each of the photos with the same problem. If you have the same problem on a large number of photos, you may be able to check and delete a whole folder at a time, rather than fixing each photo individually.

It can be a time consuming job, so it's yet another good reason to fix missing photos at the earliest opportunity.

How do I check my catalog for missing files?

If you go to Library menu > Find Missing Photos, Lightroom creates a temporary collection of the missing photos so that you can relink them. It doesn't update live, so even after you've located the missing photo, it still appears in that collection. To remove

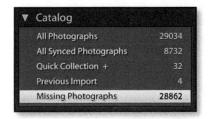

Figure 21.5 If you go to Library menu > Find Missing Photos, Lightroom creates a collection in the Catalog panel.

this temporary collection from the Catalog panel, right-click on it and select *Delete this Temporary Collection*. (Figure 21.5)

I accidentally deleted my photos from my hard drive and I don't have backups! Can I recover them using Lightroom's previews or smart previews?

If you've deleted your original files, you don't have backups, and they're not in the Recycle Bin (Windows) / Trash (Mac), the next thing to check is whether the photos are still on the memory card. If you haven't reshot the entire card, it may be possible to rescue some of the original photos using recovery software. You could also try recovery software on the hard drive, to see if they can be rescued from there.

If that's not possible, before you do anything else, close Lightroom, find the catalog on the hard drive, and duplicate the catalog and previews, just in case you make a mistake.

It's possible to convert Lightroom's previews into files. It's not ideal as the quality isn't as high as the original files, but they're not bad as a last-ditch rescue attempt.

First, check under the Histogram in the Library module to see whether you have Smart Previews for the missing photos. You're looking for the words *Smart Preview*. If there are Smart Previews, select the

photos and go to File menu > Export. Choose DNG as the File Format (leave the checkboxes unchecked) and export them to a folder on the hard drive. They're only 2560px along the longest edge and they're lossy compressed, but they're better than nothing. (Turn back to the Export chapter starting on page 415 for more information on exporting).

Next, we'll save your standard previews as JPEGs. If you don't have smart previews, these standard previews are the only files you have left. Even if you did have smart previews, the standard previews may be larger (i.e. 1:1 size) so it's worth trying both options.

Adobe released a script that retrieves Lightroom's previews and saves them as image files, however there are also a couple of free plug-ins which make the process easier. The resulting JPEGs are only the size and quality of the previews, but they're better than nothing. In these instructions, we'll use a plug-in by Jeffrey Friedl.

1. Download Jeffrey's plug-in from

https://www.Lrg.me/friedl-extractpreviews

- 2. Double click to unzip the plug-in.
- **3.** Go to File menu > Plug-in Manager and press the Add button. Navigate to the plug-in you've just unzipped.
- **4.** Back in Lightroom's Grid view, select the photos you need to rescue.
- **5.** Go to File menu > Plugin Extras > Extract Preview Images to show the dialog.
- **6.** Select the location for the extracted previews and press *Begin Extraction*.
- **7.** In the results dialog, the plug-in reports on the size and quality of the extracted previews. (Figure 21.6)

Finally, import the new DNG files and/or JPEG files into your Lightroom catalog. You may need to reorganize them into folders while importing, and then sort them into collections again and reapply flags, but they're better than nothing. Once you're happy that your replacement files are

		in Lightroom			Extracted Preview				
	Master Original	Size	Last Edit		Size	Est. Crea	te Date	Status / Quality	
	1. 20140822-134310.cr2	1146 x 1146	2015-Mar-19 9:56am	Visit	1146 x 1146	2015-Mar-19	1:47pm	Best: "Final Render"	
	2. 20140822-134439.cr2	1307 x 1961	2015-Mar-19 9:57am	Visit	1307 x 1961	2015-Apr-04	12:24pm	Best: "Final Render"	
	3. 20140822-134439.cr2	1307 x 1961	2015-Mar-19 9:57am	Visit	420 x 280	2015-Mar-31	8:04pm	smallRender	
walls.	4. 20140822-134441.cr2	4426 x 2951	2015-Mar-19 9:57am	Visit	1680 x 1120	2015-Apr-04	12:25pm	standard	

Figure 21.6 Jeffrey's Extract Previews plug-in turns Lightroom's previews into normal JPEGs, if you've lost the originals.

sorted out, you can remove the old missing files from the catalog.

THE CAT WALKED OVER THE KEYBOARD

There are some other problems that frequently crop up on the forums, so here are the quick fixes for your reference...

My Toolbar's disappeared—where's it gone?

The Toolbar usually appears between the photos in the Preview Area and the Filmstrip. It holds buttons such as view options and star rating buttons. Flip back to the Workspace chapter on page 77 for more detail. If your Toolbar disappears, press T—you've hidden it!

Where's the Done button gone?

For many years, whenever someone's complained the *Done* button's gone missing, everyone would cry in unison, "press the T key" but no more! As of version 12.0, the *Done* button really is completely gone. Now, to finish using a tool such as the Crop or Masking tool, click its icon again in the Toolstrip under the Histogram, or click the Sliders button to their left. (Figure 21.7)

Where have my panels gone?

If a panel goes missing, for example, the Folders panel in the Library module, go to Window menu > Panels and click on the name

Figure 29.2 The Done button in the toolbar has been replaced by a Sliders button in the Toolstrip under the Histogram.

of the panel to enable it. You can also rightclick on a panel header (in the gray space next to the panel name) to show the contextsensitive menu and put a checkmark against the name of the missing panel. (Figure 21.8)

How do I show missing dialogs?

If you've hidden some of the dialogs by checking a *Don't Show Again* checkbox, you can bring them all back by pressing the *Reset all warning dialogs* button in the *Preferences dialog* > *General tab*.

Dialogs can also go missing if you use dual monitors. Lightroom remembers which monitor you last used to display each dialog. If you then unplug one of those monitors, Lightroom may still try to show the dialog on the detached monitor, resulting in an error beep when you try to press anything else. To solve it, press the Escape key to close the imaginary dialog, and either plug the second monitor back so you can see the dialog to move it back, or reset Lightroom's Preferences file. We'll come to these instructions a little later in the chapter on page 515.

CATALOG CORRUPTION

Lightroom's catalogs are basic databases, so

Figure 21.8 If a panel goes missing, right-click on one of the other panel headers and reselect it from the menu.

it's possible for them to become corrupted, even though it's relatively rare. Don't worry, you have nothing to fear from keeping all of your work in a single catalog, as long as you take regular backups. But what do you do if you have problems with your catalog? Let's investigate.

Why can't I open my catalog?

If you can't open your catalog, there are a few possible reasons, and the error message offers a few clues.

Lightroom may say: The Lightroom catalog cannot be opened because another application already has it open. Quit the other copy of Lightroom before trying to relaunch. If so, check the catalog's folder for a *.lrcat.lock file. If Lightroom's closed, it shouldn't be there, so you can safely delete it. They sometimes get left behind if Lightroom crashes. Remember, if there's a *.lrcat-journal file, don't delete this journal as it contains data that hasn't been written back to the catalog yet.

Lightroom requires read and write access to the catalog file, so it may show an error message that says: The Lightroom catalog cannot be used because the parent folder ... does not allow files to be created within it or Lightroom cannot launch with this catalog. It is either on a network volume or on a volume on which Lightroom cannot save changes.

If you see either of these errors, check your operating system's folder and file permissions as they're probably set to readonly. It may not be the catalog folder itself that has the wrong permissions, but perhaps a parent folder. On Windows, there are additional security layers which can cause similar issues. (You might need to Google how to do that, as these are operating system settings.)

Also check your catalog location—it can't stored be on a network drive, or on read-only media such as a DVD, or on an incorrectly formatted drive (e.g. an NTFS drive on a Mac).

Finally, Lightroom might give a warning about the catalog being corrupted. This can be more serious, so we'll cover it in more detail.

How do catalogs become corrupted?

In almost all cases, corruption results from a hardware problem. This can include the computer crashing due to a hardware fault, kernel panics, or power outages, any of which can prevent Lightroom from finishing writing to the catalog safely.

Catalogs also become corrupted if the connection to the drive cuts out while Lightroom is writing to the catalog, for example, as a result of an external drive being accidentally disconnected or the catalog being stored on a network drive (via an unsupported hack). Some external drives drop their connection intermittently for no known reason, so it's safest to keep your catalog on an internal drive if possible.

Lightroom says that my catalog is corrupted—can I fix it?

If Lightroom warns you that your catalog is corrupted, it also offers to try to repair it for you. (Figure 21.9)

Figure 21.9 If Lightroom can't open the catalog, it warns you before quitting.

In many cases, the corruption can be repaired automatically, but it depends on how it's happened. (Figure 21.10)

If the catalog repair fails, restoring a backup is your next step, which we covered in detail in the Backup chapter on page 64. (Figure 21.11) You can also try moving the catalog to a different drive, which can solve some false corruption warnings.

If you don't have a current backup catalog, there may be another way of rescuing your data. It involves using Import from Catalog to transfer the uncorrupted data into a new catalog. Usually the corruption is confined to one or two folders that were being accessed when the catalog became corrupted, so working through methodically can sometimes rescue almost all of your data. It's worth a shot!

To attempt recovery:

1. Close Lightroom and duplicate the corrupted catalog using Explorer (Windows) / Finder (Mac) before you proceed with rescue attempts, just in case you make it

worse.

- **2.** Create a new catalog (by going to *File menu > New Catalog*) and then go to the Catalog Settings dialog and set the backup interval to *Every time Lightroom exits*. You can change this back again later, but it saves you starting this process again from the beginning if you pull some corrupted data into the new catalog.
- **3.** Go to File menu > Import from Another Catalog and navigate to the corrupted catalog. If it gets as far as the Import from Catalog dialog box, select just a few folders in the Catalog Contents section. In the popups below, select File Handling > Add new photos to catalog without moving.
- **4.** Repeat the Import from Catalog, each time selecting a few folders to transfer. Between imports, close and reopen Lightroom, so that a new backup is created, and the integrity check runs to ensure that your new catalog hasn't become corrupted.
- **5.** Keep repeating the process until all of the folders are imported from the corrupted

Figure 21.10 If Lightroom confirms that the catalog is corrupted, it offers to repair it.

	Ci	annot Repair Corrupt	Catalog	
1 40	Unfortunately, the catalog	named "Fix Catalog"	cannot be	repaired.
LrC	Please use a recent backup c	opy of this catalog or see	the TechNote	e for other possible options.
	See Adobe TechNote	Show in Finder	Quit	Choose a Different Catalog

Figure 21.11 If the catalog can't be repaired, you'll need to restore a backup.

catalog. If you hit another corruption warning, go back a step, restore the previous backup, and make a note of the folders you had just imported, skipping them. In the process, you may be able to narrow the corruption down to a single folder or even specific photos.

- **6.** Once you've finished, and you have a working catalog again, select all the photos and go to *File menu > Export as Catalog*. Give the exported catalog a new name, and uncheck the checkboxes at the bottom. This extra step helps to remove any orphaned data.
- **7.** Open the newly exported catalog. This now becomes your main working catalog.
- **8.** After a significant corruption, it's also worth rebuilding the previews. To do so, select all the photos and go to *Library menu* > *Previews* > *Render Standard-Sized Previews*. This process takes a long time if you have a large number of photos, so you might choose to leave it running overnight.
- **9.** Finally, if everything's working as expected, you can archive or delete the backups created in step 4, the temporary catalog created in step 2, and the corrupted catalog.

Of course, having current backups would have prevented all of this work, so you'll want to make sure that your backups are current in future!

How do I prevent catalog corruption?

A little bit of common sense goes a long way in protecting your work.

- Back up regularly, and keep older catalog backups.
- Always shut your computer down

properly.

- Don't disconnect an external drive while Lightroom is open.
- Keep the catalog on an internal drive if possible.
- Turn on *Test integrity* and *Optimize catalog* in the Backup dialog to run each time you back up. If they have trouble running, it'll give you a clue that something's going wrong.

IMAGE & PREVIEW PROBLEMS

Viewing accurate previews of your photos is essential. Problems do sometimes occur, so you'll need to know how to fix them, even if they're not Lightroom's fault.

Why do I just get gray boxes instead of previews?

If Lightroom's showing gray thumbnails (Figure 21.12) instead of image previews in the Grid view, there are a few possibilities...

Previews don't exist—If there's an exclamation point in the corner of the thumbnail in Grid view as well as gray thumbnails, Lightroom simply hasn't been

Figure 21.12 Gray thumbnails may be caused by a corrupted monitor profile, graphics card drivers, or missing files.

able to build the previews yet. The original file may have been renamed or moved outside of Lightroom, or the drive was disconnected before Lightroom was able to create the previews. If you reconnect the drive or find the missing files, the previews can be created. (Turn back to the Missing Files section starting on page 499 for more information.)

Previews can't display—If there are no exclamation points in the corner of the thumbnails in Grid view, a corrupted monitor profile is the most likely cause, or the graphics card driver may need updating. We'll discuss corrupted monitor profiles in more detail in the next question.

Corrupted preview cache—It's also possible that the preview cache is corrupted, particularly if your catalog has been upgraded from an earlier version. We'll come back to that on page 510.

Everything in Lightroom is a funny color, but the original photos look perfect in other programs, and the exported photos don't look like they do in Lightroom either. What could be wrong?

In addition to previews that are completely missing, your previews may be displayed in the wrong color.

Strange colored previews that don't match the exported photos in color managed programs are usually caused by a corrupted monitor profile. Lightroom uses the profile differently to other programs (perceptual rendering rather than relative colorimetric), so corruption in that part of the profile shows up in Lightroom even though it appears correct in other programs. It often happens with the manufacturer's profiles that come with most monitors.

To confirm that the corrupted monitor

profile is the mostly likely cause, select a B&W photo (or turn a photo B&W by pressing the V key). The B&W photo and its histogram should be neutral shades of gray, but you may see a color cast (likely brown) if your profile's corrupted. (Figure 21.13)

Ideally you should recalibrate your monitor using a hardware calibration device, such as a Spyder, i1Display Pro or ColorMunki. If you don't have such a tool, put it on your shopping list, and in the meantime, remove the corrupted monitor profile as a temporary solution.

How do I remove my monitor profile to check whether it's corrupted?

Windows

- 1. Close Lightroom.
- **2.** Go to Start menu > Control Panel > Color Management or type color management in the Start menu search box. Click the Devices tab if it's not already selected. (Figure 21.14)
- **3.** From the *Device* pop-up, select your monitor. If you have more than 1 monitor connected, pressing the Identify monitors button displays a large number on screen for identification.
- **4.** Check the Use my settings for this device

Figure 21.13 A color cast on the Histogram panel is a clear indication that the monitor profile is corrupted.

checkbox.

- **5.** Make a note of the currently selected profile, which is marked as (default). If there isn't an existing profile, you can skip this step.
- 6. Click the Add button.
- **7.** In the Associate Color Profile dialog, select *sRGB IE61966-2.1* (sRGB Color Space Profile.icm) and press *OK*.

8. Back in the Color Management dialog, select the sRGB profile and click *Set as Default Profile*, and then close the dialog.

macOS

- 1. Close Lightroom.
- **2.** Go to System Preferences > Displays > Display Settings.
- **3.** Click the *Color Profile* pop-up menu, then

Figure 21.14 Setting the monitor profile to sRGB using the Windows Color Management dialog confirms or rules out a corrupted monitor profile.

Figure 21.15 The basic Mac Calibration tool is ok for testing, but it's only as good as your eyes, so you'll still need calibration hardware.

choose *Customize*. A list of color profiles for your display and other color profiles appears.

4. Click the + button to open Display Calibrator Assistant, and follow the instructions. (Figure 21.15)

Finally, restart Lightroom and check whether everything looks correct. If it does, you've confirmed that the previous monitor profile was the cause of the problem. You can temporarily leave sRGB as the monitor profile, as it's better than a corrupted one, but it would then be wise to calibrate your monitor accurately using a hardware calibration device.

The only real way of calibrating a monitor is with a hardware calibration device. Software calibration is only ever as good as your eyes, and everyone sees color differently, but calibration hardware, such as the ColorMunki, i1 Display Pro or Spyder devices are now inexpensive, and an essential part of every keen digital photographer's toolkit.

Most calibration software offers an advanced setting, so if it gives you a choice, go for a brightness of around 100-120 cd/m2, 6500K or native white point for LCD monitor, and most importantly, an ICC2 Matrix profile rather than an ICC4 or LUT-based profile, as these more recent profiles aren't compatible with many programs yet.

Why is Lightroom changing the colors of my photos?

If Lightroom starts changing the appearance of the newly imported photos automatically, there are a few settings that you might have changed.

Are the photos raw? If so, the changes are likely just a difference in rendering, because

raw data is just that—raw—and each raw processor has its own default style. Turn back to the Develop chapter on page 222 for a detailed discussion.

There are a few other possibilities, however, which would also apply to JPEG and other rendered formats:

Develop Preset—You may have selected a Develop preset in the Import dialog. Set the *Develop Settings* pop-up to *None* in the Apply During Import panel and see if the problem recurs on future imports.

Default Settings—You may have changed the Default settings. To check, open a newly imported photo in the Develop module and press the *Reset* button. If the photo doesn't change, hold down the Shift key to change the button to *Reset* (*Adobe*) and click again. If the photo now changes, go to *Preferences dialog* > *Presets tab* and press the *Reset all default Develop settings* button to reset the defaults back to Adobe's own settings.

Existing Edits—Have the photos been edited in Lightroom or ACR previously? If so, they may have Develop settings recorded in the metadata.

For photos that are already imported, select them in Grid view and press the *Reset All* button in the Quick Develop panel to reset them all back to the default settings.

Why doesn't the Library module preview match the Develop module preview?

The Library module uses pre-rendered Adobe RGB JPEGs. At 100% view, it's fairly accurate, but the color space is smaller than Develop, so some highly saturated colors may appear slightly desaturated.

The Develop module uses the original data in a large color space, and downsizes the image data on-the-fly. This means that Develop's 100% view is the most accurate, but high sharpening and noise reduction values can be wildly inaccurate at Fit or Fill view.

Lightroom says my preview cache is corrupted—how do I fix it?

There's one more problem that can occur with previews—a corrupted preview cache.

The most obvious clue is Lightroom showing an error message telling you that the preview cache is corrupted and then resets the preview cache automatically.

Alternatively you might find that Lightroom displays the wrong preview for some of your photos, some previews or thumbnails disappear when the photo is deselected, or the photo only shows in the Develop module.

If so, you can fix it by manually rebuilding the preview cache:

- **1.** Find your catalog on the hard drive. If you can open Lightroom, go to *Edit menu* (Windows) / *Lightroom menu* (Mac) > *Catalog Settings* > *General tab* and press the Show button to open an Explorer (Windows) / Finder (Mac) window, then quit Lightroom. If you can't open Lightroom, and you don't know where to find your catalog, you'll need to search for *LRCAT files.
- **2.** Using Explorer (Windows) / Finder (Mac), move or rename the previews folder (*Previews.Irdata) and restart Lightroom.
- **3.** Lightroom can now rebuild the previews from the original files. Select all the photos and go to *Library menu > Previews > Build Standard-Sized Previews* and leave it to work, perhaps overnight as it takes a long time. If any of the photos are offline (e.g. stored)

on disconnected external hard drives), these previews will remain blank until you reconnect the drive.

4. Once you're happy they've all rebuilt, you can delete the previous previews folder (*Previews.Irdata) if you haven't already done so. I don't usually recommend deleting the old previews before building new ones, just in case there are any missing original files, and the previews are the only copy you have left. If you're comfortable that you still have all of your original files available, then you can delete the old previews before building the new ones.

Lightroom appears to be corrupting my photos—how do I stop it?

In the Import chapter error messages starting on page 52, we briefly discussed the problem of images becoming corrupted, especially during import. It can happen to anyone.

Severe file corruption is often picked up at the Import stage, resulting in a file is unsupported or damaged error message (Figure 21.16), but less serious corruption might not be discovered until you look at Lightroom's standard size previews.

Initially, Lightroom displays the embedded JPEG preview, which often escapes corruption because it's confined to a small area of the file. Lightroom then reads the whole file to create an accurate preview, at which point the corruption appears. That may lead you to believe that Lightroom's

The file appears to be unsupported or damaged.

Figure 21.16 When entering the Develop module, Lightroom may warn that a photo is unsupported or damaged, which usually indicates corruption.

corrupting the files, but it's not.

If a file is corrupted (Figure 21.17), Lightroom's unable turn the leftover data into an accurate image, which results in a distorted view and *There was an error working with the photo* error message in the Loupe view and Develop module.

Because most other image browsers only display the uncorrupted embedded JPEG, they often fail to detect the problem. It's therefore important to build standard or 1:1 previews and visually check them for corruption in Lightroom (or another full raw processor) before wiping your memory cards.

But if it's not Lightroom's fault, what causes corruption? Unfortunately the files are usually corrupted before they reach Lightroom, and it's almost always due to hardware problems.

Corrupted files are most frequently caused by a damaged card reader or cable. The good news is the file on the memory card is often uncorrupted, and can be safely imported without corruption by using another card reader.

Other regular suspects include damaged

Figure 21.17 A corrupted file may not import at all, may show a low resolution thumbnail with a black border, or may show very visible corruption.

memory cards or problems with the camera initially writing the file, such as the battery dying or the card being removed while writing.

If a photo gets corrupted some time after the original import, your computer likely has a hardware problem. A dying hard drive or damaged connection (e.g. cable) or damaged RAM are frequent causes, but a variety of other hardware issues can also cause problems.

Whatever the cause, you'll need to redownload the file from the memory card or replace it with an uncorrupted backup.

STANDARD TROUBLESHOOTING

If your issue isn't covered by the previous sections, or in the specific topic area of the book, there are some general troubleshooting steps you can try.

As always, make sure you have backups before you try any troubleshooting steps.

1. The Magic Reboot

If you're having odd problems with any computer program, the age-old wisdom "turn it off and turn it on again" still works wonders. First, try restarting the program, and if that doesn't solve it, reboot the computer.

2. Optimize the Catalog

Go to File menu > Optimize Catalog and wait for it to tell you it's completed before moving on.

3. Check for Updates

Next, check for updates, as the issue you're running into could be a bug that's been fixed

in a later release. Make sure you're running the latest updates, both for Lightroom (by going to *Help menu > Check for Updates*) and also for your operating system. Also update drivers on your machine, particularly the graphics card drivers and any mouse or tablet drivers

4. Check the GPU

Buggy graphics card drivers can cause no end of trouble, including crashes, strange artifacts on the screen and performance problems. Go to *Preferences > Performance* tab and set *Use Graphics Processor* to *Off.*

If this solves the problem, check the graphics card manufacturer's website for an updated driver (Windows) / check Software Update for an updated operating system version (Mac). Once the driver has been updated, set *Use Graphics Processor* back to *Auto*. If the issue recurs, visit https://www.Lrq.me/gpufix for further GPU troubleshooting tips.

5. Reset Preferences

If you're still having problems, resetting Lightroom's Preferences file can solve all sorts of 'weirdness,' so it's a good early step in troubleshooting. See page 517 for detailed instructions.

6. Try a new catalog

If resetting the preferences doesn't help, create a new catalog to rule out minor catalog corruption. To do so:

- **1.** Go to File menu > New Catalog.
- **2.** If you can't open Lightroom to access the menu, hold down Ctrl (Windows) / Opt (Mac) while restarting Lightroom, then click the *Create New Catalog* button.

- **3.** Choose a location for the temporary catalog such as the desktop. (Note that this is only a test to check whether the problem is catalog-specific. Don't delete your working catalog or start working in this temporary catalog!)
- **4.** Import some photos into this new catalog to check everything is working as expected.
- **5.** If this works, the problem is likely specific to your catalog. Don't panic, that can usually be fixed! Turn back to the Catalog Corruption section on page 506.

7. Rule out corrupted presets

The next thing to check for is corrupted presets, as they can cause strange problems like module hanging and performance problems. To do so:

- **1.** Go to Edit menu (Windows) / Lightroom menu (Mac) > Preferences > Presets tab.
- **2.** Press the Show Lightroom Develop Presets and Show All Other Lightroom Presets buttons. This will open two Explorer (Windows) / Finder (Mac) windows to the Lightroom and CameraRaw presets folders.
- 3. Quit Lightroom.
- **4.** Select the contents of the Lightroom folder, with the exception of the Preferences folder (as we've already ruled out preferences problems). Move these subfolders (e.g. Develop Presets, Print Templates, etc.) to another location, such as the desktop.
- **5.** Select the contents of the CameraRaw folder and move it to another location such as the desktop.
- **6.** On macOS, you'll need to reboot the computer as macOS caches some files.

7. Restart Lightroom.

If it does solve the problem, copy the presets back a few at a time, to narrow down which specific preset (or group of presets) is causing the problem.

If the problem isn't solved, you can copy the preset folders back, overwriting the default preset folders that have been automatically created, and we'll try something else.

8. Rule out corrupted fonts

Corrupted fonts have also been known to cause problems, particularly in the Print and Book modules. Fonts aren't specific to Lightroom. If you're not familiar with managing your operating system's fonts, Google "uninstall font" and the name of your operating system for instructions on removing fonts.

9. Try a clean user account

Sometimes issues are specific to your computer's user account. Testing a clean user account can rule out a lot of potential problems in one go. If you're not sure how to create a clean user account, here are the official instructions:

Windows-https://www.Lrg.me/winuser

Mac-https://www.Lrg.me/macuser

10. Check for hardware and operating system problems

Lightroom taxes your computers hardware more than most of the programs you use, so it often finds hardware and operating system problems that don't show up in other software.

Damaged RAM can also cause some odd problems-Lightroom finds dodgy memory quicker than almost any other program. You can easily check that by running software such as Memtest.

Depending on the issues you're having, check other hardware for issues, for example, if Lightroom's running slowly, check the hard drives, particularly if it's an intermittent problem. They could be dying or just running low on space. If the screen is behaving oddly, check your graphics card, monitor and calibration. If you're having problems importing, check your card reader, USB ports and the destination hard drive.

Also check your boot drive to ensure it has plenty of space available, as a lack of space for operating system temp files can cause all sorts of problems.

DEFAULT FILE & MENU LOCATIONS

If you need to find Lightroom's files at any time, you'll need to know where to look, so here are the most popular Lightroom file locations.

By default, the boot drive is C:\ on Windows and Macintosh HD on Mac. If your operating system is installed on a different drive, you may need to replace the drive letter/name on the file paths that are listed below.

[your username] refers to the name of your user account, for example, mine is called Vic.

The default location of the Lightroom catalog is...

Windows—C: \ Users \ [your username] \ My Pictures \ Lightroom \ Lightroom Catalog.lrcat

Mac-Macintosh HD / Users / [your username] / Pictures / Lightroom / Lightroom Catalog.lrcat

The default location of the Preferences is...

Windows—C: \ Users \ [your username] \ AppData \ Roaming \ Adobe \ Lightroom \ Preferences \ Lightroom Classic CC 7 Preferences.agprefs

Mac—Macintosh HD / Users / [your username] / Library / Preferences / com. adobe.LightroomClassicCC7.plist

Preference files aren't cross-platform. By default, Preferences are a hidden file on Windows and macOS.

There are also separate startup preferences. These include the last used catalog path, the recent catalog list, which catalog to load on startup and the catalog upgrade history.

Windows—C: \ Users \ [your username] \ AppData \ Roaming \ Adobe \ Lightroom \ Preferences \ Lightroom Classic CC 7 Startup Preferences.agprefs

Mac—Macintosh HD / Users / [your username] / Library / Application Support / Adobe / Lightroom / Preferences / Lightroom Classic CC 7 Startup Preferences.agprefs

How do I reset Lightroom's Preferences?

There's a simple automated way of resetting preferences—just hold down Alt and Shift (Windows) / Opt and Shift (Mac) while

opening Lightroom and it'll ask whether to reset the preferences. The timing is crucial—hold them down while clicking/double-clicking on the app/shortcut. (Figure 21.18)

If Lightroom is already open, you can go to Lightroom's *Preferences dialog > General tab* and hold down the Alt (Windows) / Opt (Mac) key. The **Reset all preferences and relaunch** button appears, and when you press it, Lightroom asks for confirmation before automatically relaunching with clean preferences.

Alternatively, you can reset the preferences manually. Moving or renaming the preferences file, rather than deleting it, means that you can put it back if it doesn't solve the problem, to save you manually recreating your preferences again.

Windows

- **1.** Go to Edit menu > Preferences > Presets tab
- **2.** If Store presets with this catalog is unchecked, press the Show All Other Lightroom Presets button.

If Store presets with this catalog is checked, uncheck it, and then press the Show All Other Lightroom Presets button. Don't forget to check the checkbox again after step 4, otherwise you'll wonder why some of your

Figure 21.18 Hold down Alt and Shift (Windows) / Opt and Shift (Mac) while opening Lightroom to reset the preferences.

presets disappeared.

Alternatively, you can navigate directly to C:\Users\[your username]\AppData\ Roaming\Adobe\Lightroom\Preferences Note that this is a hidden folder, so the easiest way to do so is to open the Start menu search box and type %appdata%\ Adobe\Lightroom\Preferences

- **3.** Whichever way you choose to find the folder, close Lightroom before going any further.
- **4.** Rename, move or delete the Lightroom Classic CC 7 Preferences.agprefs and any earlier versions (but leave the Lightroom Classic CC 7 Startup Preferences there), then restart Lightroom.

Mac

- 1. Quit Lightroom.
- 2. Open Finder and select the Go menu.
- **3.** Hold down the Opt key so *Library* appears in the menu, then click on *Library*.
- **4.** In the Finder window, open the Preferences folder and scroll down to com. adobe.LightroomClassicCC7.plist
- **5.** Move this file, plus any other Lightroom preference files (e.g. com.adobe. LightroomClassicCC7.LSSharedFileList. plist or older versions), to another folder or delete them.
- **6.** Reboot your computer (because macOS caches some preference files), then restart Lightroom.
- **7.** If your presets are missing, go to Lightroom menu > Preferences > Presets tab, check Store presets with this catalog and they should reappear.

Some people like to keep screenshots of the Preferences and View Options dialogs, as well as a backup of the preferences file, so they can easily be restored.

What's stored in Preferences?

If you reset your Preferences file, the obvious settings that you lose are those in the Preferences dialog, but it also includes other details such as your View Options settings, last used settings, FTP server details, some plug-in settings, your country, etc.

Your original photos, Develop settings, Develop defaults, collections, presets and other important settings aren't affected by deleting the Preferences file.

The Store presets with this catalog setting also reverts to default (unchecked) if you reset the preferences file, but the presets themselves are perfectly safe, and checking the checkbox in Preferences causes the presets to reappear.

There are also separate startup preferences which don't usually need resetting. These include the last used catalog path, the recent catalog list, which catalog to load on startup and the catalog upgrade history.

How do I show hidden files to find my preferences and presets?

On Windows, you can open the Start menu search box and type <code>%appdata%\Adobe\Lightroom</code>, and you'll be taken directly to the Lightroom user folder.

On macOS, the user Library folder is hidden by default. If you go to Finder, select the Go menu, and hold down the Opt key, you'll see Library appear in the menu, and then you can navigate to the Preferences or Application Support folder. Personally, I

Figure 21.19 Press the Show Presets buttons in Preferences to easily find the presets and templates.

drag that Library folder to the sidebar so that it's always easily accessible.

Develop Presets and Default Settings are shared with Camera Raw, so they're stored at...

Windows—C: \ Users \ [your username] \ AppData \ Roaming \ Adobe \ CameraRaw \

Mac—Macintosh HD / Users / [your username] / Library / Application Support / Adobe / CameraRaw /

To find them easily on either platform, go to Edit menu (Windows) / Lightroom menu (Mac) > Preferences > Presets tab and press the Show Lightroom Develop Presets button. (Figure 21.19)

Most of Lightroom's Presets and Templates are stored at...

Windows—C: \ Users \ [your username] \ AppData \ Roaming \ Adobe \ Lightroom \

Mac—Macintosh HD / Users / [your username] / Library / Application Support / Adobe / Lightroom /

If you've checked the *Store presets with this catalog* checkbox in Preferences, many (but not all) will be stored next to your catalog file instead.

To find them easily on either platform, go to *Edit menu* (Windows) / *Lightroom menu* (Mac) > *Preferences* > *Presets tab* and press the *Show All Other Lightroom Presets* button.

Each type of preset has its own folder, for

Auto Layout Presets	Local Adjustment Presets
Color Profiles	Locations
Develop Presets	Metadata Presets
Device Icons	Panel End Marks
Email Accounts	Plugin Develop Presets
Email Address Book	Preferences
Export Actions	Print Templates
Export Presets	Scripts
External Editor Presets	Slideshow Templates
Filename Templates	Smart ColleTemplates
Filter Presets	Splash Screen
FTP Presets	Text Style Presets
Import Presets	Text Templates
Keyword Sets	Watermarks
Label Sets	Web Galleries
Layout Templates	Web Templates

Figure 21.20 Presets are sorted into folders according to their type.

example Local Adjustment Presets, Filename Templates and Metadata Presets. (Figure 21.20)

If you have a folder called Develop Presets, these are the old .Irtemplate format Develop presets, and are automatically converted to the newer .xmp format when opening Lightroom. (See page 374 for further details.)

The default location of the Camera Raw Cache is...

Windows—C: \ Users \ [your username] \ AppData \ Local \ Adobe \ CameraRaw \ Cache \

Mac-Macintosh HD / Users / [your username] / Library / Caches / Adobe Camera Raw /

Your custom Camera & Lens Profiles should be installed to the User folders...

Lightroom no longer uses the shared

ProgramData (Windows) / Application Support (Mac) folders for Camera or Lens Profiles. Instead, it stores the built-in profiles with its program files.

When you create camera or lens profiles, they must be stored in the user locations listed below. If you previously stored custom profiles in other locations, you'll need to move them to these user folders, otherwise Lightroom won't be able to find them.

Windows—C: \ Users \ [your username] \ AppData \ Roaming \ Adobe \ CameraRaw \ CameraProfiles \

Mac—Macintosh HD / Users / [your username] / Library / Application Support / Adobe / CameraRaw / CameraProfiles /

For the lens profiles, substitute the *LensProfiles* folder for the *CameraProfiles* folder in these paths.

The camera and lens profile file extensions are:

.dcpr—camera profile recipe file used for creating/editing a profile in the DNG Profile Editor

.dcp-camera profile

.lcp-lens profile

Preferences & Settings Menu Locations

A few of the menu commands are in different locations on Windows and Mac, depending on the operating system standard. Rather than repeating them every time I refer to Preferences or Catalog Settings, here's a quick reference:

Lightroom Preferences & Catalog Settings are...

Windows-under the Edit menu

Mac-under the Lightroom menu

Photoshop Preferences are...

Windows-under the Edit menu

Mac-under the Photoshop menu

TROUBLESHOOTING SHORTCUTS

	Windows	Mac
Reset Preferences	Hold Alt Shift while starting Lightroom	Hold Opt Shift while starting Lightroom

IMPROVING PERFORMANCE

22

The speed of Lightroom or the lack thereof—is one of the most popular topics among photographers. You

may have asked questions such as "why is Lightroom so painfully slow?" and "how do I speed up Lightroom?" or "how do I make Lightroom run faster?"

Browsing the web, you'll find thousands of suggestions on ways to speed Lightroom up. Some of the suggestions work. Others are complete myths. Some suggestions can even make Lightroom slower.

Simply saying, "Lightroom is slow" doesn't help, because different areas of the program benefit from different optimizations. For example, if you're finding it slow in the Develop module, rendering 1:1 previews won't help.

In future, Adobe's main focus is on improving Lightroom's performance, but it's a complex program, and there are many things you can do to help yourself.

To fine-tune performance, you need to understand what Lightroom's doing under the hood, so in this chapter, we're going to take a close look at the different factors that affect Lightroom's performance.

NON-DESTRUCTIVE EDITING

Before we start optimizing Lightroom, let's set some expectations. I frequently hear people say, "But my computer runs fine with everything else," only to then discover that they're only running web browsers and office software, which use minimal resources. Others complain that Photoshop runs fine, but when they try to do the same tasks in Lightroom, it crawls.

Why is Lightroom slower at some tasks than Photoshop?

It's important to understand the nature of Lightroom's non-destructive editing, compared to most other program's pixel-based photo editing. We'll use Photoshop as an example of a pixel editor. (In this context, we're referring to Photoshop itself, as an example of a pixel based editor. Photoshop can also use the Camera Raw plug-in, which works as a non-destructive editor like Lightroom.

Imagine a conversation between you and your computer:

You: "Computer, increase Exposure to +1.0"

Photoshop: "Ok, Exposure +1.0"

Lightroom: "Ok, Exposure +1.0"

You: "Computer, add Clarity +20"

Photoshop: "Ok, Clarity +20"

Lightroom: "Ok, Exposure +1.0, Clarity +20"

Now carry on working for a while, and we'll catch up towards the end of the edit...

You: "Computer, remove that dust spot"

Photoshop: "Ok, dust spot removed"

Lightroom: "Ok, Exposure +1.0, Clarity +20, Contrast +24, Temperature 5600, Tint 23, Highlights -40, Shadows +34, Vibrance +13, Tone Curve Strong Contrast, Lens Corrections on, Chromatic Aberration Removal on, Noise Reduction +20, Sharpening Amount +20, Vignette -10, HSL Blue Luminance -23, Upright Auto, Linear Gradient mask top to bottom with X settings, Brush mask with long list of coordinates, another brush mask with long list of coordinates, another brush mask with long list of coordinates, first brush spot, second brush spot, third brush spot, fourth brush spot... ok, that new dust spot removed now too."

Did you spot the difference? Pixel editors such as Photoshop run a task once, applying the changes to the pixels of the image itself. Each time you make another adjustment, it carries on from the current set of pixels. (That's a generalization as you can use smart objects or adjustment layers, but let's keep things simple for now, as these would also have performance implications.)

Lightroom, on the other hand, is a parametric editor. This means that every time you make an adjustment, it runs a series of text instructions. The more adjustments you make to the image, the more text instructions it has to run each time you make a change. The more complex the instructions, the longer they take to run. (Lightroom silently caches some editing stages to ease this issue, but again, let's keep

things simple.)

What are Lightroom's strengths and weaknesses?

There are pros and cons to both options:

File Size—Lightroom's text instructions are tiny, and since it doesn't touch the original image pixels, you only have to store the text instructions in the catalog and the original image file (plus backups, of course). In Photoshop, the edits are applied to the pixels, so you need to work on a copy of the photo, and if you start saving additional layers, the file size can balloon even further. Winner—Lightroom.

Changing Edits—If you make an edit one day in Lightroom, and change your mind the next day, you can simply move the slider back. No pixels were harmed in the process. In Photoshop, on the other hand, you either have to start all over again from the original, or if the change isn't too huge, you may be able to tweak the edited file, albeit with a lower quality result. (Or if you were really sensible, you may have used layers in Photoshop, at the cost of a larger file.) Winner—Lightroom.

Quality—Photoshop applies adjustments in the order you make them. If you lighten a photo and then darken some areas of it, you can't pull back the detail you've lost in that earlier step (without layers, etc.). Lightroom has the advantage of working on the raw data and silently applies the edits in the optimum order when exporting, with a higher quality result. Winner—Lightroom.

Speed—As we've seen, Lightroom has to constantly re-run text instructions, whereas Photoshop applies them immediately and directly to the pixels. For global edits, that's not too noticeable, but Lightroom can start to drag when using multiple masks

and retouching multiple spots. For this reason, pixel editors such as Photoshop and Elements are still better suited to more detailed retouching. On the other hand, when you're doing global edits to a large number of photos, Lightroom is far quicker than opening each of the photos in Photoshop. Winner—for editing lots of photos, Lightroom wins, but for detailed local edits, Photoshop wins.

It's simply a case of understanding their strengths and weaknesses. For editing most of your photos, Lightroom wins hands-down. For building complex masks, doing detailed retouching or even removing numerous dust spots from scans, Photoshop is still the better tool for the job.

DEBUNKING MYTHS

I've read much of the information already published online on the topic of Lightroom's performance. Some of the suggestions work. Others are complete myths. Some of the advice (including advice found in my older blog posts and books) is simply outdated. Some suggestions can even make Lightroom slower. These are the main myths to avoid...

Myth #1: GPU—Everyone should turn it off (or on)

I've seen many posts saying that the *Use Graphics Processor* pop-up in *Preferences > Performance tab* should be turned off. I've seen almost as many saying it should be turned on. The reality is, there isn't a blanket 'best setting' that applies to everyone.

The correct setting for your computer depends on your graphics card, the driver version, your screen resolution and how you actually use Lightroom. We'll discuss how to select the best setting for you on page 539.

Myth #2: Render 1:1 previews to speed up Develop

Bloggers frequently recommend that you render 1:1 previews in order to speed up loading in the Develop module... however pre-rendered 1:1 previews aren't used AT ALL in the Develop module. There are some good reasons to render 1:1 previews, such as quickly zooming in the Library module, but they won't help in the Develop module. We'll come back to where different types of previews are used on page 524 and page 527.

Myth #3: Make the Camera Raw Cache huge

A long time ago, I recommended enlarging the Camera Raw Cache size in Preferences > Performance tab to its maximum, saying "Bigger is better!" Then, in Lightroom 3.6 and later, the cache format was changed and compression applied, meaning the cached files shrunk to a few hundred KB per image, instead of multiple MB, so you could fit a lot more cached images into the same amount of space.

In Lightroom Classic, the rules change again. Now the size of the cached images is linked to the standard preview size set in Catalog Settings, so if you use a high resolution monitor, they may be big.

For most people, it IS worth enlarging the cache from its 5GB default. On the other hand, 200GB is overkill for most people. You'd be better off with a medium sized cache on a fast drive (e.g. SSD) than a much larger cache on a slower drive. We'll look at some rough calculations on page 527.

Myth #4: Use loads of little catalogs

Another frequent "solution" for performance problems is breaking the

library up into multiple small catalogs. To be fair, a few things are slightly slower on a big catalog—most notably, opening the catalog and backing it up. But let's just define big catalogs: 1 million photos is a big catalog, 50,000 photos is a small catalog.

These slight delays in opening and backing up are easily offset by the lack of hassle trying to search and maintain multiple catalogs, and the confusion that can result.

We discussed the pros and cons of multiple catalogs on page 493. For the majority of photographers, multiple catalogs create far more problems than they solve. Just optimize the catalog regularly, and keep it on a fast drive.

Myth #5: Delete all of your previews

The final suggestion I frequently see is to empty Lightroom's caches and delete previews regularly. But stop and think about this suggestion for a moment. Lightroom has to display previews, otherwise you're looking at a blank screen. So which is quicker? Loading a small JPEG preview file from the hard drive, or loading a full size raw file and applying complex calculations to it? If you're unsure of the answer, trust me, loading a small JPEG preview is much faster! So why would you want to throw away all of the previews you've already rendered, and force Lightroom to do all these complex calculations again?

PREVIEWS IN THE LIBRARY MODULE

Lightroom is a powerful program, offering far more than just basic raw processing, but it can also tax the most powerful of computer systems. Lightroom uses numerous kinds of previews and caches for different purposes, both in the Library and Develop modules. Having a basic idea of their usage can help you pick the right ones for your needs.

Before Lightroom does anything, it checks to see if the photo is already cached in RAM (random access memory). This is the fastest data to access. This happens automatically so you don't need to do anything to benefit.

If the photo's not already held in RAM, then Lightroom must load a pre-rendered preview, or build one from the original image data. You can see the full decision tree in **Figure 22.1** on page 525. The Library module uses three main kinds of pre-rendered preview—Embedded Previews, Standard Previews and 1:1 Previews.

What are Embedded Previews?

When most cameras write a raw file, they embed a JPEG preview too, although the size varies depending on the manufacturer. During import, you can extract these embedded previews for temporary use in the Library module, so you can start viewing and selecting your photos almost as soon as they've finished importing. We discussed this workflow in more detail on page 89. They don't have any Lightroom adjustments applied, so they look like the camera JPEGs.

What are Standard Rendered Previews?

Standard rendered previews are the most frequently used previews. They're used to display the photo in every module except Develop (where they're shown briefly and then replaced with cached raw data). For speed, Lightroom stores a range of different size AdobeRGB JPEGs as previews, from thumbnails right up to your chosen preview size.

Preview Loading Logic in the Library module

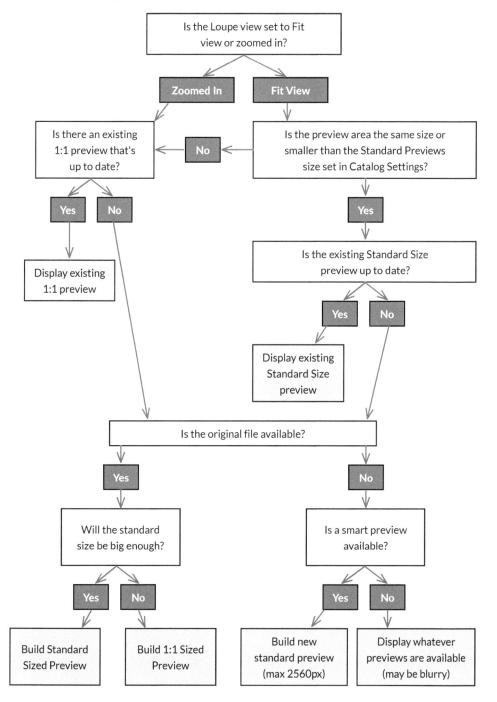

Figure 22.1 The decision tree Lightroom uses when deciding which preview to load in the Library module.

The size and quality of the standard-sized previews is set in the Catalog Settings dialog, which we'll come back to on page 534. The default *Auto* setting is ideal for most photographers.

What are 1:1 Rendered Previews?

1:1 rendered previews are full resolution AdobeRGB JPEGs, so they take up more space. If you want to zoom in on your photos in the Library module (e.g. checking focus), building them in advance avoids Lightroom having to build 1:1 previews on the fly, which would slow your browsing experience.

Where are Library module's rendered previews stored?

The previews are stored in a *.Irdata folder (Windows) / package file (Mac) next to your catalog. The standard previews have *.Irprev extensions and the folder/filename ends in Previews.Irdata.

The previews folders/files can grow very large, especially if you're creating 1:1 previews. You can delete any of the previews without permanent damage, but Lightroom will have to rebuild the previews when you next view the photos. If the files are offline, it will just show gray boxes until the files are next online and the previews can be rebuilt, so deleting the *.Irdata files can be a false economy.

If you find your previews are taking up too much space, consider discarding specific 1:1 or smart previews rather than deleting the entire preview cache.

How do I build standard or 1:1 previews?

While embedded previews can only be extracted during import, there are multiple ways of building standard and 1:1 sized previews.

On Demand—The standard sized preview is automatically built when you view a photo in the Library module and 1:1 preview is rendered when you zoom in. The problem with waiting for them to build on demand is you're sat staring at a Loading overlay while Lightroom builds the preview, which slows down your browsing. To avoid this delay, you can build the previews in advance.

On Import—In the File Handling panel of the Import dialog, you can choose to build *Standard* or 1:1 *Previews* immediately after import. (Figure 22.2)

Menu Command—If you select the photos in the Library module, you can select Library menu > Previews > Build Standard-Sized Previews or Build 1:1 Previews. This is particularly valuable, as you can leave Lightroom building these previews at a time when you're not using the computer. It can also be used to update existing rendered previews when you've made Develop changes. It automatically skips any previews that are already up to date. (Figure 22.3)

If you have no photos selected, or all photos selected, Lightroom builds previews for all the photos in the current view, whether that's a collection, a folder, a filtered view, etc. If you have more than 1 photo selected in Grid mode, it assumes you just want to

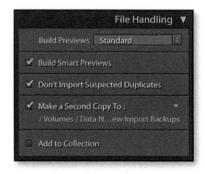

Figure 22.2 You can build Standard or 1:1 while importing photos.

Figure 22.3 When one photo is selected, Lightroom asks whether to build previews for all the photos or just the selected photo.

build previews for all of the selected photos. If you have just 1 photo selected, it asks whether you want to build just that one preview, or previews for all photos in the current view.

Automatic Preloading—when you're stepping through photos in the Library module in 100% view, Lightroom intelligently creates 1:1 previews for other photos surrounding the selected photo, so when you move on, it loads much quicker.

How do I delete previews?

If you're concerned about the disk space that the 1:1 previews take up, you can discard 1:1 previews on demand by selecting the photos and choosing *Library menu > Previews > Discard 1:1 Previews*.

You can automatically delete 1:1 previews on a regular basis by selecting **Automatically Discard 1:1 Previews** After One Day / After One Week / After 30 Days or Never in the Catalog Settings dialog.

Lightroom only deletes 1:1 previews that are more than twice the size of your Standard-Sized Previews preference. For example, if your Standard-Sized Previews preference is set to 2048 and your 1:1 preview is 3036, Lightroom will keep the 1:1 preview, whereas if your Standard-Sized Previews preference is set to 1024, the 1:1 preview will be deleted.

The previews are also automatically deleted if you remove or delete a photo from within Lightroom. There's a slight delay in deleting the preview, just in case you press Undo, but they usually disappear at the next relaunch, if not before.

PREVIEWS & CACHES IN THE DEVELOP MODULE

Whereas the Library module displays lower quality rendered previews from the previews cache, the Develop module assumes you need an accurate, rapidly changing view. It first displays the normal preview from Lightroom's main preview cache (if GPU is disabled), then it reads any existing cached data, makes the Basic sliders available for adjustment, and then finishes loading and processing the full resolution data. You can see the full decision process in Figure 22.4 on page 528. Lightroom mainly uses three main types of data in Develop—a temporary RAM cache, partially processed raw data stored on disk, and the original files.

RAM Cache—Before Lightroom does anything, it checks to see if the photo is already cached in RAM. This is the fastest data to access. When you're working in the Develop module, Lightroom intelligently preloads some photos either side of your current photo, so when you move on to the next photo, it loads quickly. This happens

Preview Loading Logic in the Develop Module

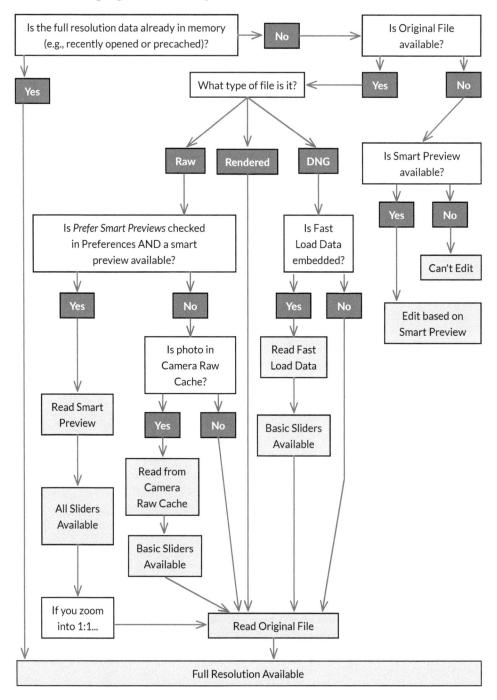

Figure 22.4 The decision tree Lightroom uses when deciding which preview to load in the Develop module.

automatically so you don't need to do anything to benefit, other than having enough RAM in your computer.

Partially Processed Raw Data—Raw files have to go through some initial processing (such as the demosaic process) before they can be displayed on screen. To save constantly repeating this initial processing, Lightroom caches this low resolution partially processed data in a few different locations. These caches aren't used for rendered files (JPEG/TIFF/PSD) as they don't need this early stage processing.

There are two main caches that hold partially processed raw data: the Camera Raw Cache and Smart Previews. We'll look at each of these caches in more detail shortly.

Originals—Finally, depending on your preference setting, Lightroom may load the original file.

What is the Camera Raw Cache?

The Camera Raw Cache, also known as the ACR Cache, is a folder on your computer that temporarily holds partially processed data (Cache*.dat files) for the most recently accessed raw files, and is used in the Develop module to speed up loading times.

Photos are loaded into the Camera Raw Cache whenever the original raw file is read, for example, when building previews or loading photos into the Develop module. It's a temporary cache, so first in, first out.

Once this data's cached, it's a bit faster doing the initial load in the Develop module and the sliders free up so you can start working, although the Loading overlay may still show on screen while it does further processing. You'd mainly notice the difference on very large files when you're not working through them consecutively, or when you're moving through them quickly.

The pixel dimensions of the cached image very depending on your selected *Catalog Settings > File Handling tab > Standard Preview Size* setting, essentially making the cached data slightly larger than your screen resolution. This means that the file size also varies, depending on your screen resolution, so if you have a large monitor, you'll need a bigger camera raw cache. We'll come back to figuring out the best size for you on page 532.

What are Smart Previews?

Smart Previews contain the same type of partially processed raw data, and they're always 2560px along the longest edge, regardless of the original file resolution or your screen resolution.

Smart previews can be used as proxy files, in place of the original files, when the original files are offline. They also help with performance when indexing photos for face recognition, when uploading photos to the Lightroom cloud, and when editing photos.

They're stored with the catalog, and unlike the Camera Raw Cache, you're in control of building and discarding smart previews. To build smart previews, check the *Build Smart Previews* checkbox in the File Handling panel of the Import dialog, or after import, select the photos in the Library module and go to *Library menu > Previews > Build Smart Previews*. If you decide to delete them later, perhaps because you require the disk space, you'll find *Discard Smart Previews* under the same menu.

If smart previews exist, they're used to speed up loading in the Develop module, and they can also be used to improve interactive performance, simply because there are fewer pixels for Lightroom to compute. We'll come back to the related Preferences checkbox on page 533.

How do I decide whether I'd be better to use the Camera Raw Cache or Smart Previews?

It can all sound very confusing, but as a rule of thumb:

- If you work sequentially through the photos slowly, leave Lightroom to figure it out.
- If you work quickly, mainly in Fit view, and need interactive speed, build smart previews and enable the *Use Smart Previews instead of Originals for Image Editing* checkbox in *Preferences > Performance tab*.
- If you work quickly and often zoom into 100% view, keep your originals on fast storage, make your Camera Raw Cache bigger in *Preferences > Performance tab*, and build Standard-Sized Previews if you haven't done so recently, to preload the Camera Raw cache.

How do I solve Develop loading bottlenecks?

As you look through the loading diagram on page 528, you'll note a few potential bottlenecks that you may be able to fix:

RAM—Temporary caches are limited by the amount of RAM available on your system. If you don't have enough RAM, photos are cleared quicker, so you may want to add more RAM to your computer.

Hard drive speed—The speed of the hard drives containing the catalog, the previews, the smart previews, the Camera Raw Cache and the originals all affect performance. Especially in the case of spinning hard

drives, splitting these various caches across multiple hard drives can help, as can upgrading the catalog/previews/cache drive to an SSD.

Computer processing power—Once the data's been read from the disk, it still has to be processed, and this is primarily reliant on the speed of your CPU. That's a more expensive upgrade!

GPU Setting—Enabling the Graphics Processor in Preferences slows down the initial load time, as the data has to be passed from the CPU to GPU, although once it's there, the interactive performance is smoother. Your checkbox setting will depend on your workflow and screen resolution.

PREFERENCES & CATALOG SETTINGS

In addition to selecting the right preview for your workflow, you can optimize your Lightroom Preferences and Catalog Settings for best performance. They're found under the *Edit menu* (Windows) / *Lightroom menu* (Mac).

Lightroom Updates

Lightroom is usually updated every 2 months, and these updates frequently include performance improvements as well, so it's worth staying up to date. (See page 16.)

Occasionally, an update introduces new bugs that aren't spotted before release. If you're not completely comfortable with this process, you may be safer to wait until the update has been available for a few days, just in case any serious new bugs surface. Keep an eye on my What's New blog posts at https://www.Lrq.me/whatsnew/classic/forthe-latest news.

Use Graphics Processor

Your computer's CPU is designed to do a wide range of different tasks, a few at a time. On the other hand, graphics processors, or GPUs, are more specialized. They're optimized to do thousands of calculations at once, but only for specific tasks.

Lightroom can use the GPU to speed up certain calculations, especially on high resolution (4K/5K) screens.

In an ideal world, these optimizations would be applied automatically, however there are many possible combinations of GPUs, drivers and driver settings, especially on Windows. A bad combination can cause slower performance, strange artifacts on the screen, or even crash the entire system. (We covered some GPU troubleshooting tips on page 516.)

As a result, there are a couple of preference settings to give you control over how Lightroom accesses the GPU, so you can optimize your own system. The *Use Graphics Processor* pop-up is found in the *Preferences > Performance tab.* (Figure 22.5)

Auto is the default, and is the best choice for most people. It only enables GPU performance enhancements that are expected to work well, and leaves potentially buggy options disabled. The information line below tells you which enhancements you're benefiting from, for

example, Your system automatically supports basic acceleration means you're using the GPU for display visualization but not image processing or export.

Custom gives you control, so you can try your graphics card / driver combination and select that options that work best on your system. There are two custom options:

Use GPU for display visualization is the same as the *Enable Graphics Processor* checkbox in earlier Lightroom versions. It uses the GPU to accelerate the drawing of pixels on the screen.

Use GPU for image processing uses the GPU to speed up image calculations in the Develop module, so when you move a slider, the preview is much faster to update. This does require a more powerful graphics card than the display visualization option, but also has greater performance benefits.

Use GPU for Export uses the GPU to export your photos faster. You'll need at least 8GB of VRAM to benefit, or at least 16GB of shared memory. If you enable it on a computer with less memory, performance is likely to be negatively affected.

Off disables these optimizations. You might select *Off* if your graphics card is underpowered, or continues to have issues (performance degradation, crashes or artifacts) after you've updated the driver.

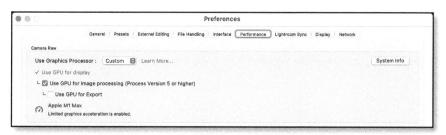

Figure 22.5 The Graphics Processor acceleration settings can be optimized for your computer.

To use the GPU, you need a single mid-range graphics card that meets the requirements listed at https://www.Lrq.me/gpufaq, and isn't on the blacklist of cards known to cause conflicts.

On Windows, you also need to keep the graphics card driver updated from the manufacturer's website rather than relying on Windows Update, as buggy drivers can cause significant performance issues and crashes. On macOS, updating the operating system to the latest version updates the graphics card drivers.

How much of a benefit you'll see depends on a multitude of factors, including the preference settings, your graphics card and driver version, your screen resolution, the size of the photo, if you're zoomed in, the kind of adjustments you're applying, the number of adjustments you're applying, and more.

Camera Raw Cache Settings

By default, the Camera Raw cache is only 5 GB in size, and when new data is added, the oldest data is removed.

You can set the **Maximum Size** of the cache in *Preferences* > *Performance tab*, up to a maximum of 200 GB. So how big should you make your cache? (Figure 22.6)

The format and size of the individual cache files has changed over the years. In Lightroom Classic, the size varies, based on

your standard preview size, which is based on on your screen resolution. Essentially this means you need a larger Camera Raw Cache if you have a high resolution screen. But let's be a little more scientific...

I've done some rough calculations in **Figure 22.7**, to give you an idea of how many photos can be cached in each 5GB of cache space.

Next, you need to ask yourself roughly how many photos you're likely to be working on at any one time. For example, if I'm going to be working on a 4 weddings over a course of a month, at 1500 photos each, I'm probably going to want space for at least 6000 photos cached at any one time. At 2880px preview size, those previews will average approximately 2.2MB each, so I'll need at least 13.2GB space. (That's 6000 x 2.2 = 13200, then 13200 / 1000 = 13.2)

Standard Preview Size	Average Size of Cached File	Approx. Number of Photos per 5GB Cache
1024px	0.2 MB	25,000
1440px	0.45 MB	11,100
1680px / 2048px	0.8 MB	6,250
2880рх	2.2 MB	2,275

Figure 22.7 This chart shows average Camera Raw Cache file sizes, to help you figure out the optimal size for your workflow.

Location: /Users/Vic/Library/Caches/Adobe Ca	imera Raw	Choose	
Maximum Size: 5.0 GB		Purge Cache	
ideo Cache Settings			
Limit video cache size	Maximum Size: 3.0 GB	Purge Cache	

Figure 22.6 The Camera Raw Cache and Video Cache settings are in the Performance tab.

You can also change the location of this cache, but make sure it's on a fast hard drive or SSD. The Camera Raw cache settings that you change in Lightroom also apply to ACR in Bridge/Photoshop, and can be changed in the ACR Preferences dialog too.

If you start to run low on disk space, or the Develop previews appear to be corrupted, you can purge this cache using the **Purge Cache** button, but it's not something you'd need to do on a regular basis.

Video Cache Settings

Like the Camera Raw cache, the video cache stores recently viewed video data for faster previews. If you regularly work with video, you can enlarge the *Limit Video Cache Size*, so that more of your video footage is cached.

Enable Hover Preview of Presets in Loupe

By default, when you hover over a preset in the Develop module's Presets panel, the main preview is updated to show the effect of the preset. This can affect performance, so if you don't need the large preview, you can disable **Enable hover preview of presets in Loupe** in Preferences > Performance tab.

Use Smart Previews Instead of Originals For Image Editing

When it comes to improving Develop performance, Smart Previews are one of

Lightroom's best hidden gems. They're much smaller than raw files, so they load much quicker and are a lot less taxing on the computer's processor, so the interactive performance is smoother too. They're not perfectly accurate for adjusting sharpening and noise reduction, however that tradeoff is very worthwhile for the smoother performance.

To use the Smart Previews for editing, you need to build the smart previews in advance (page 529), then go to *Preferences* > *Performance tab* and check *Use Smart Previews instead of Originals for Image Editing.* When you zoom into 100% or export the photos, it's smart enough to automatically switch to the full resolution original, to give the most accurate preview for judging noise reduction and sharpening, although there's a slight delay at this point while it loads the full file. (Figure 22.8)

Optimize the Catalog

Over the course of time, with many imports and deletions, the data in Lightroom's catalog can become fragmented and spread across the whole database, making Lightroom jump around to find the information it needs. The *Preferences* > *Performance tab* > *Optimize Catalog* button "tidies up" and sorts it all back into the right order, bringing it back up to speed.

It's worth running the catalog optimization

Enable hover preview of presets in Loupe		
Use Smart Previews instead of Originals for image editing		
This will allow increased performance, but may display decreased quality while editing. Final output	t will remain full size (quality	
the miles county, may be perfectly as property of the county, may be perfectly	t matternout full state quality.	
Catalog Settings		
Catalog Settings Some settings are catalog-specific and are changed in Catalog Settings.	Optimize Catalog	Go to Catalog Settings
	Optimize Catalog	Go to Catalog Settings
Some settlings are catalog-specific and are changed in Catalog Settlings.	Optimize Catalog	Go to Catalog Settings
	Optimize Catalog	Go to Catalog Settings

Figure 22.8 The Camera Raw Cache and Video Cache settings are in the Performance tab.

whenever you've made significant database changes, such as removing or importing a large number of photos, or any time you feel that Lightroom has slowed down. You'll also find it under the File menu, and there's a checkbox in the Back Up Catalog dialog to automatically run the optimization each time you back up your catalog, which saves you having to remember.

Standard Preview Size & Quality

In Catalog Settings > File Handling tab, you can set the **Standard Preview Size** and **Preview Quality**. (Figure 22.9) (This is a percatalog setting, so if you use multiple catalogs, you'll need to check each catalog.)

The best size setting depends on your general browsing habits and on your screen resolution. Choosing a size about the width of your screen is a good starting point, and the default *Auto* setting does this automatically. If you always leave the panels open and your hard drive space is very limited, you may prefer a slightly smaller size.

The quality setting is, as with most things, a trade-off. Low quality previews take up less space on disk as they're more compressed, but higher quality previews look better. The default. Medium, is a good compromise.

Auto-write XMP checkbox

By default, all of the work you do in Lightroom, such as adding keywords or Develop edits, is stored as text instructions in the Lightroom catalog. If you need to make the metadata available to other programs, such as Bridge or Camera Raw, you need to store it in/with the files using a metadata format called XMP. Some users also use XMP as an additional (but incomplete) backup of edits. (For a full understanding of XMP, see page 411.)

If you frequently edit your photos in other software such as Bridge, writing changes automatically saves you having to remember to do so. However, it can have a notable impact on performance, especially if the photos are stored on a slower drive. To check and change your auto write preference, go to Catalog Settings > Metadata tab > Automatically Write Changes Into XMP. (Figure 22.10) If you choose to turn autowrite off, you can manually write to XMP at any time by selecting the photos in Grid view and selecting Metadata menu > Write Metadata to Files.

View Options Loading Overlay

You don't have to wait for the Loading overlay (Figure 22.11) to disappear before

	General	File Hand	lling	Metadata	
Preview Cache					
Total Size	e: 50 GE	3			
Standard Preview Size	e: 2048	3 pixels	0		
Preview Qualit	y: Medi	um	0		
Automatically Discard 1:1 Preview	s: After	30 Days	0		
Smart Previews					
Total Siz	e: 0 byt	es			

Figure 22.9 Select your preview size in the Catalog Settings dialog.

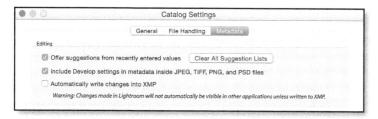

Figure 22.10 The "Automatically write changes into XMP" setting can have performance implications, so it's worth weighing the pros and cons.

Figure 22.11 The Loading overlay can be very frustrating when you're in a hurry!

starting work on the photo. If you find the overlay distracting, you can turn it off by going to the *View menu > View Options > Loupe tab* and turning off the **Show message when loading or rendering photos** checkbox.

WORKFLOW TWEAKS

Besides optimizing your computer and Lightroom settings, you can also save yourself a lot of frustration by thinking ahead and allowing your computer to do many of its processor-intensive activities at a time when you're not using the computer.

Use embedded previews

Most cameras embed a JPEG preview inside a raw file at the time of capture. To view the photos without having to wait for Lightroom to build its own previews, extract the readymade previews while importing, by selecting Import dialog > File Handling panel > Build Previews > Embedded & Sidecar. They can be replaced later, when you're not using the computer.

Build previews overnight

Earlier in the chapter, we learned about the different kinds of previews and caches that can be used to speed up Lightroom. You're going to need rendered previews, but you don't have to sit there waiting for them! Decide which size rendered previews you'll need, then set the standard sized or 1:1 previews building overnight, or at least while you go and make a drink. The same goes for smart previews, if you want to use them to speed up the Develop module. While Lightroom's rendering previews, it's using a lot of the computer's processing power, so you're better off doing something else while it works.

Apply presets before building previews

While we're on the subject of previews, think about Develop settings you apply to all or most of your photos. There's no point building the standard or 1:1 previews and THEN applying a preset, because the previews will need to be updated again. Apply your presets or sync your most-frequently used settings first, and then build your previews to save wasted effort.

Reduce the Window size

The size of your preview area makes a significant difference to the interactive performance, especially in the Develop module. The lower resolution the preview,

the fewer pixels Lightroom has to compute, and the quicker it runs. If you don't mind a smaller preview, you can reduce the size of the Lightroom window, enlarge the panels to make the preview area smaller, use Reference View (page 381), or simply select a smaller zoom ratio (e.g. 1:4 / 25%) in the Navigator panel. (Figure 22.12)

Pause background tasks

Lightroom runs a series of background tasks, including Sync, Face Recognition and Reverse Geocoding. These use additional processing power, especially for Sync and Face Recognition, so if you're struggling for speed, it can be useful to pause these tasks

Figure 22.12 Selecting a smaller zoom ratio means Lightroom has fewer pixels to calculate each time you make an adjustment.

Figure 22.13 Click on the Identity Plate to view the Activity Center and pause background tasks that are slowing you down.

while you're working in Lightroom. To do so, click on the Identity Plate in the top left corner and press the *Pause* buttons in the Activity Center. (Figure 22.13) Don't forget to start them again when you've finished.

Use optimum slider order

In the Develop module, regardless of the order in which you move the sliders, the end result is always the same (with the exception of spot healing which can be affected slightly by lens corrections and also by overlapping spots). There is, however, a slight performance advantage to using the tools in the following order:

- **1.** Tonal Adjustments (e.g. Basic panel, etc.) can be done at any stage, but are often done first
- 2. Spot Healing
- **3.** Lens Corrections (Profile, Manual Transform sliders, Upright, etc.)
- 4. Masking
- **5.** Detail Corrections (Noise Reduction, Sharpening)

If you apply some of these settings (e.g. the lens profile or noise reduction) on import using a preset or default settings, but you're struggling for speed, you can temporarily disable the panel using the panel switch on the left, and then re-enable it when you're finished. (Figure 22.14)

Figure 22.14 You can temporarily turn off adjustments such as Noise Reduction if it's slowing you down.

Clear history

If the History panel becomes extremely long, particularly with local brush adjustments or spot healing, it can slow down Lightroom's performance. The history is compressed in the database, to improve performance, but it does still make a difference.

You can clear the History for individual photos by clicking the X button on the panel, or you can clear the History for a large number of photos by selecting them and navigating to *Develop menu > Clear History*. (Figure 22.15)

Clearing the History doesn't remove your current settings. It only clears the list of the slider movements/adjustments you made to get to the current state. Even if you clear the

•	History		×
	Temperature	-50	5.3K
	Black Clipping	+10	-10
	Temperature	-200	5.3K
	White Balance: Custom		
	Tint	+45	4
	Tint	-65	-41
	Tint	+20	24
	Temperature	-1.8K	5.1K
	Temperature	+1.8K	6.9K
	Post-Crop Vignette Hig	+100	100
	Post-Crop Vignette Am	-15	-15
	Clarity	-40	10
	Contrast	+20	90
	Shadows	0	40
	Shadows	+20	40
	Contrast	+20	70
	Exposure	-0,10	0.43
	Exposure	+0.40	0.53
	Exposure	-0.20	0.13
	Shadows	+20	20
	Contrast	+20	50
	Highlights	-20	-40

Figure 22.15 A large number of History states can slow Lightroom down slightly.

History, your current settings remain, and if you want to change them, you simply move the sliders.

Use a pixel editor for intensive local edits

At the beginning of the chapter, we learned the difference between non-destructive parametric editing (Lightroom) and pixel based editing (Photoshop). Extensive local adjustments, such as detailed brush masks or large/numerous spot heals, are better suited to Photoshop. While it may be possible to do them in Lightroom, they won't be fast.

Close extra panels

If you're really struggling for speed, you can also help by minimizing the work Lightroom has to do.

This includes closing panels such as the Histogram panel, the Navigator panel, the Develop Detail panel 100% preview, the Keywording & Keyword List panels, the Metadata panel and the Filmstrip. Closing the Collections panel and then restarting Lightroom also saves having to count the smart collection contents, which can slow down metadata entry on large catalogs.

When you're moving photos to a new folder, start the move and then switch to an empty folder or collection, such as the Quick Collection, so that Lightroom's not having to constantly redraw the Grid view while it's working. You can also turn off the thumbnail badges in *View menu > View Options*.

Leave exports & merges for when you're not using the computer

Finally, leave large exports for times when you're not using the computer. It's a processor-intensive task that can slow down the fastest of computers, due to the

complex calculations involved.

HARDWARE CHOICES

Every single day, I receive emails asking how to choose a new computer for Lightroom. We're not going to go into specific hardware recommendations, because they'd be out of date almost immediately. What we will do is talk about which hardware benefits different Lightroom tasks, so you can make your own decisions based on your needs and budget.

Adobe publishes minimum system requirements for Lightroom at https://www.Lrg.me/classic-sysreg. but we should be clear... these are MINIMUM system requirements. They allow Lightroom to run... well, it'll walk. If you want to enjoy using Lightroom, you'll definitely want to exceed these minimum requirements. Your hardware requirements depend on how many photos you're editing each week, your budget, the size of the images you're shooting, the amount of time you have available and let's be honest, your tolerance for slow computers.

CPU

There are two primary factors to weigh up when selecting a new CPU: the number of cores on the single CPU (two physical CPU's don't help much) and its clock speed.

Lightroom makes good use of multiple cores for image processing tasks such as building previews, working in the Develop module, and exporting photos, so it's worth selecting a quad-core processor if possible, even though other areas of the program are only lightly threaded.

A high clock speed (measured in GHz) is equally important, as it determines how

quickly computations are made, not only for image processing tasks, but also all of the other tasks Lightroom has to perform.

The release date of the processor also affects performance. The clock speed isn't a perfect comparison, because the manufacturers have been working hard on efficiency, so a recent 3.0GHz processor is much faster than a 3.0GHz processor released 10 years ago.

So if you can't trust the clock speed for comparison, how do you figure out which CPU is faster? One easy way to compare is to check other people's Geekbench scores for your chosen processor at http://browser.primatelabs.com/—you're looking for the 64-bit Single and Multi-Core scores.

Need a rule of thumb? If you're looking for a new CPU, a recent generation Intel quad-core desktop processor with a fast clock speed is a great choice. For a high end machine focused primarily on editing, a six-core CPU is also a good choice, although they're a little more expensive and often have a slightly slower clock speed.

Memory (RAM)

The operating system, open programs and their data are held in RAM. The more data you're working with, the more RAM you need. If you don't have enough RAM, some of the data has to be written to the hard drive, which is much slower.

Like most image-editing programs, Lightroom works with large amounts of data, so it needs more RAM than, for example, a word processor. The amount of RAM available affects how many photos can be cached, which can affect image loading time. Some tasks, such as merging panoramas and HDR files, are particularly memory hungry.

Although Adobe lists 8GB of RAM minimum, you don't really want any less than 16GB. 32GB is a much better choice for most users, especially if you're buying a quadcore processor. The more CPU cores you have, the more RAM you need.

If you're running other programs at the same time, perhaps switching to Photoshop to do further editing, you may need additional RAM.

A tip—if you're buying a desktop Mac (not a laptop), it's much cheaper to buy the extra RAM from companies such as OWC (US) or Crucial (International) and install it yourself, rather than paying the Apple premium. Minimal computer knowledge needed!

Hard drives

The speed of the drive that holds the catalog and previews makes a fairly substantial difference, especially in the Library module and also for startup times. This is where an SSD really helps, and therefore it's the first thing I'd put on my shopping list. This is an upgrade that can be beneficial on existing systems, as well as new builds.

Bear in mind that the catalog and its previews—especially if you're building 1:1 and/or smart previews—can grow quite large. For example, my 50k catalog is currently 1.6GB, the previews are 70GB and the smart previews take up another 50GB.

Next, think about where the images will be stored. The access speed primarily affects the loading speed in the Develop module, although Lightroom's smart enough to cache files in advance if you're stepping through images in order. In an ideal world, you'd put the original photos on an incredibly fast drive such as an SSD, but the cost per MB is

still quite high. For most users, a 7200rpm internal or fast external drive is adequate for storing photos, but if you need greater speed, a striped RAID is a cost-effective solution.

Also, if your photo storage drive is external, think about connection speed. Even the fastest SSD would be horribly slow in a USB1 external enclosure! If you need to use external drives, look for USB3 or Thunderbolt connections if your computer supports them. The photos can be stored on a NAS (network accessed storage), but the connection speed can be painfully slow, so NAS units are better suited to backups.

Don't forget your backup drives. You need a minimum of one backup drive kept onsite, plus some kind of offsite backup, whether that's an additional drive held at a different location or an online backup such as Crashplan (Small Business edition), Carbonite or Backblaze.

As an example configuration, you could choose a good-sized SSD for the operating system and Lightroom catalog/previews, and then a second reasonably fast drive to hold the photos (plus additional backup drives, of course).

While we're thinking about hard drives, remember to leave the operating system and Lightroom space to work. Aim to keep at least 20% free space on your boot and catalog hard drives.

GPU

When deciding on the GPU or graphics card, think about the resolution of the monitor you'll be using. A standard HD screen (1920×1080) is 2 megapixels (MP), a MacBook Retina Pro 15" is 5 MP, a 4K display is 8 MP, and a 5K display is a whopping 15 MP. This means that Lightroom

has to calculate and display 4 times as many pixels on a 4K display, compared to a standard HD screen, and nearly 8 times as many on a 5K display. This is why Lightroom slows down on big screens!

Lightroom can use the GPU in place of the CPU to accelerate Develop rendering, especially on high resolution screens/retina screens. To take advantage of this, you need a mid-range graphics card. The recommended specifications for graphics cards are found at https://www.Lrq.me/gpudriver. Lightroom will still work with an underpowered or unsupported graphics card, but it can't benefit from the additional performance acceleration.

For a high resolution display (4K and beyond), it's worth getting a graphics card with more video RAM (e.g., at least, 8GB preferably more). Lightroom caches a lot of data on the video card when doing interactive edits, and the bigger the screen, the more data it has to hold.

If you're using integrated graphics, such as the GPU in many laptops, bear in mind that they share the computer's RAM, so the more RAM, the better. For example, if you're buying a 13" MacBook Pro, which isn't available with a separate graphics card, then it's worth getting at least 16GB of RAM, as the graphics card will borrow a chunk of it.

It's also important to keep the graphics card driver up to date. To do so, check the graphics card manufacturer's website (Windows) or Software Update (Mac). Check page 541 for instructions.

Monitor & Calibration

Monitor choices are also largely dependent on budget, but IPS screens are generally considered a good choice for photographers. For accurate color, NEC and EIZO are among the best.

4K/5K screens are wonderful for text, but it's a lot more pixels to compute, so bear in mind that the screen resolution will impact performance.

Finally, don't forget you'll need monitor calibration hardware too. This helps to ensure that you're seeing an accurate preview on the screen.

Desktop vs. Laptop

Unless portability is essential, a desktop computer is usually a better choice for Lightroom. There's only a limited amount of space in a laptop, so everything has to be smaller. This means most laptops have slower mobile CPU's, less RAM, and are reliant on slower external hard drives for storage. They're also much more difficult to keep cool due to the lack of space, and when components get hot, they slow down. There are, of course, exceptions: performance laptops are available, but they come at a premium price.

Interaction & Budget

The final thing to remember is that all of these hardware components interact. The fastest CPU in the world won't help if your hard drives can't transfer the data quickly enough. Having 32GB of RAM won't help if your CPU is incredibly slow.

There are also budgetary considerations to weigh up. If you're buying a new machine with a limited budget, \$400 for a minor clock speed upgrade on a CPU would be better spent on an SSD, or on 16GB of RAM instead of 8GB, because you'll get a bigger performance boost for the money.

Upgrading Existing Computers

If you're considering upgrading components of your existing computer, take a look at the next section (page 543) and think about what specifically is slow. Slow catalog loading and Library updates may benefit from installing an SSD, but the SSD will have less of an impact in the Develop module. Replacing the GPU will mainly help in the Develop module if you're running a high resolution screen.

Also check Resource Monitor (Windows) / Activity Monitor (Mac) to see where you're hitting your computer's limits. For example, if you're running out of RAM and using virtual memory, then adding additional memory may help. (Figure 22.16)

GENERAL SYSTEM MAINTENANCE

Lightroom can't perform well if the operating system is struggling. While not specific to Lightroom, it's worth running

regular computer maintenance and optimizing other software running on your computer. This includes operating system and driver updates, keeping hard drives in good condition, and minimizing the number of other programs running in the background.

Operating System Updates

Updates to the Windows or macOS operating systems not only fix bugs and add security fixes, but also improve its performance and compatibility with applications. Windows service packs and other updates are available from the Microsoft Windows Update website and macOS updates are downloaded from the App Store.

Driver Updates

Windows Update includes some drivers, however these are rarely the latest, so you'll need to visit the component manufacturer's website, or for laptops, the laptop

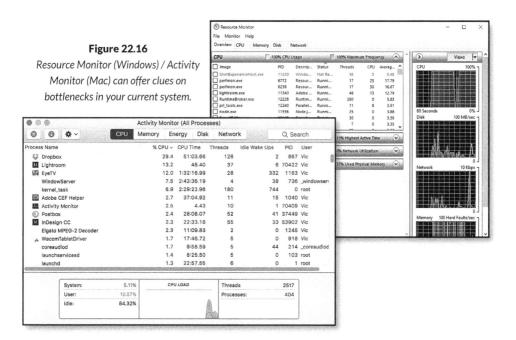

manufacturer's website to get the latest drivers. It's important to keep drivers up to date, especially for the graphics card and input devices such as Wacom tablets and other mice, as older or buggy drivers can cause crashes as well as performance issues. Occasionally you may need to roll back one of the drivers, when an updated driver triggers new bugs.

Most macOS driver updates are downloaded from the App Store, but you'll need to check manufacturer's websites for third-party hardware drivers, such as Wacom tablets.

Care of Hard Drives

Both the operating system and Lightroom need room to work, and processes can slow down significantly when they're constrained. Therefore it's important to keep enough space available on your hard drives, especially for the boot drive and the drive containing your catalog.

You can clear space on your hard drive by emptying the Recycle Bin/Trash, deleting files (be careful!) or moving them to another drive. You can also clear out temporary files and caches to help to free up additional space. Windows and macOS both include tools to make this easier.

If you're working with spinning drives on Windows (not SSD's), you also need to defragment/optimize the hard drive from time to time. This moves the data back into contiguous blocks, making it faster to read/write.

macOS automatically defragments small files, so it doesn't require user intervention unless you're working with large numbers of huge files (e.g. 1GB videos).

Power Saving Settings

Performance can be affected by the powersaving settings, especially when a laptop is running on battery power. For example, where there are onboard graphics as well as a dedicated graphics card, the computer may default to the less powerful onboard graphics and dim the screen when running on battery.

On Windows, these settings are found in *Settings > System and Security > Power Options*, or by right-clicking on the battery icon in the system tray on a laptop. On macOS laptop with a dedicated graphics card, turn off *System Preferences > Energy Saver > Automatic Graphics Switching* to improve performance when running on battery power.

Other system tasks and software

Other programs running in the background also reduce the resources available to Lightroom. To make these resources available to Lightroom, quit other open applications, including those running in the system tray (Windows) / menubar (Mac), and prevent unnecessary programs running on startup.

Anti-virus/security software running real-time scans also use your computer's resources, so it may be useful to pause the scan while you're working in Lightroom, and exclude specific files such as the catalog and previews.

The same goes for other software that runs automated tasks in the background, such as backup software or cloud sync such as Dropbox. If you're struggling with performance issues, temporarily pausing these tasks can help.

Reboot occasionally

Finally, it's worth rebooting from time to time... yes, even on a Mac!

WHAT'S SLOW?

Throughout this chapter, we've learned the pros and cons of non-destructive editing, how different computer components affect different areas of the program, and the ways you can adjust your Lightroom workflow to get the best performance.

At the beginning of the chapter, we said simply saying "Lightroom is slow" doesn't help, because different areas of the program benefit from different optimizations. In this section, we'll summarize the main places to look for improvement, based on what specifically is slow.

Opening Lightroom

Loading the Lightroom program is primarily dependent on your drive speeds, for both the OS/program files and also for the catalog. If you're finding it slow to load, replacing your spinning drive with an SSD can help, and is a relatively inexpensive upgrade.

Load time is also affected by the size of the catalog, however I wouldn't recommend breaking the catalog up into smaller catalogs to solve this, as this causes more problems than it solves for most people.

Importing Photos

Importing photos is also primarily limited by file transfer rates. This includes the speed of the source—whether that's a camera cable, card reader or hard drive—and the speed of the destination drive(s).

For the source, card readers are usually more reliable than direct camera connections, and faster USB card readers (e.g. USB 3) are available to help improve the import speed.

For the destination, there are potentially two drives in play: the main Destination folder and also the Second Copy location. If these are on external drives, the connection speed (USB2 vs USB3, etc.) is usually the main issue. Many photographers send their second copies to a NAS, which can reduce the speed further.

If you choose to add the photos at their current location, this is a lot quicker than moving/copying the files, however take care that the photos are on a hard drive, not a memory card.

Finally, the additional work you ask Lightroom to do immediately after import can prolong the import time, especially conversion to DNG format or building previews.

Building Previews

The time it takes to build previews is largely dependent on your computer's processing power, but also the drive speed for the catalog and original images.

Improving preview build times frequently requires a newer CPU, so it's not an easy fix. If you're running low on RAM and having to use temp files, this may slow you down further, so it's worth keeping an eye on Resource Monitor (Windows) / Activity Monitor (Mac) to see which computer components are reaching their limits.

The simplest solution for building previews is simply to let them build overnight, or at another time when you don't need the computer. Also, you only need to build the

previews you actually use, so if you rarely zoom in the Library module, there's no need to build 1:1 previews.

Viewing In Library

You can speed up viewing in the Library module by building the right size previews in advance. If you need to zoom in, you'll need 1:1 previews. Otherwise, standard sized previews (set to Auto in Catalog Settings) will be plenty. If you've made Develop edits since building the previews, don't forget to rebuild them, otherwise they'll have to update when you select the photo.

Once the previews are built, the drive speed for the catalog/previews is next in line. Putting the catalog/previews on an SSD can make Library browsing smoother.

Applying Metadata

Applying metadata is mainly limited by the speed of the drive containing the catalog, so again, putting the catalog/previews on an SSD makes a notable difference.

It also helps to minimize the amount of work Lightroom has to do, especially closing the Collections, Metadata and Keyword panels if you're not using them.

Don't forget to optimize the catalog regularly, as this saves Lightroom skipping around the catalog to find the information it needs.

Moving/deleting photos

Moving or deleting photos is also affected by drive speeds—both for the original images as they're moved, and also the catalog as the image records are updated.

Lightroom also has to redraw the grid view as photos disappear, so switching to

a different folder or collection (e.g. Quick Collection) can speed the process up slightly.

Finally, rather than trying to delete one photo at a time, consider marking them as rejects and then deleting the rejects when you've finished sorting through the photos.

Loading in Develop

Moving over to the Develop module, let's talk about loading speed. This is primarily dependent on any data that is already cached, then on a mix of processing power (CPU/GPU), screen resolution, drive speeds, and of course, the size and complexity of the image files too.

If you're moving through photos sequentially (and not too quickly!) in the Develop module, Lightroom automatically caches the photos either side in the background to improve loading speed. Once the image data is loaded from the cache (held in RAM), the CPU/GPU is responsible for additional image processing. At this point, buying a computer with a faster CPU/GPU is your main upgrade potential.

If you're not moving sequentially, additional factors come into play. The full resolution image data has to be read from the hard drive, so hard drive speed is a major factor. Once the image data is read from hard drive, then initial processing has to be applied, which is dependent on the CPU or GPU processing power.

The higher the resolution of the image, the more data there is to process, so 50MP images will naturally take longer than 5MP. Some sensors (I'm looking at you, Fuji!) also require more complex calculations.

Whether you're moving sequentially or skipping around, building Smart Previews in advance and checking the *Preferences* >

Performance tab > Use Smart Previews for Editing checkbox is the greatest potential improvement, simply because there's less data to read and process. If you're struggling for loading times in Develop, this is your first place to start.

Editing in Develop

Once the photo is loaded into the Develop module, as long as you have enough RAM, then you're primarily limited by your processing power—the CPU or GPU, depending on your *Use Graphics Processor* setting.

If you're using a 4K/5K monitor, it's worth enabling the GPU for smoother interactive performance, but on standard resolution monitors or when using an under-powered graphics card, you may be better to leave it disabled and let the CPU do the image processing. Try it both ways and see which you prefer.

The more image data to process, the longer it takes, so you can reduce the preview size to limit the number of pixels Lightroom has to crunch. You can do this by resizing the Lightroom window, enlarging the panels or selecting a smaller zoom ratio (e.g. 1:4 / 25%).

We also learned that the slider order can make a slight performance difference. Some tasks are more processor intensive than others, so using a pixel editor such as Photoshop for more complex local adjustments can be a good choice. Temporarily disabling complex calculations such as Lens Corrections can also help with interactive performance.

And finally, like the Develop Loading time, utilizing Smart Previews has the biggest potential gain.

Exporting

Like building previews and working in the Develop module, exporting photos is largely limited by the CPU, where multiple cores can help, and also the speed of the hard drive containing your original photos and the export destination. Alternatively, you could just leave the exports to run when you're not using the computer.

Syncing to Lightroom Cloud

Finally, sync speed is largely dependent on the speed of your internet connection, especially the upload speed, which is often around 1/10 of the download speed.

PERFORMANCE CHECKLIST	
System Maintenance	☐ Set the Camera Raw Cache size
☐ Install operating system updates	Workflow
☐ Check for driver updates	■ Build previews in advance
☐ Clear hard drive space	☐ Apply presets before building previews
■ Defragment hard drive	☐ Use a smaller preview area or lower
☐ Check power saving settings	zoom ratio
Quit OS background tasks	■ Pause background tasks
☐ Exclude files from live virus scan	☐ Use the optimum slider order
☐ Reboot the computer	☐ Clear the History panel
Lightroom Settings	☐ Use a pixel editor for detailed retouching
☐ Check for Lightroom updates	☐ Close unused panels
Optimize the catalog	☐ Export when you're not using the
☐ Select the best <i>Use Graphics Processor</i> setting for your graphics card	computer Upgrade the Computer
☐ Deselect Automatically Write Settings	opgrade the computer
into XMP	☐ SSD (Solid State Drive)
Previews & Caches	□ RAM (Memory)
■ Build Standard-Sized Previews	☐ CPU (Processor)
	☐ GPU (Graphics Card) especially if 4K/5K monitor
■ Build 1:1 Previews if zooming in	4K/3K monitor
■ Build Smart Previews and check Use Smart Previews instead of Originals for Image Editing checkbox	

PERFORMANCE SHORTCUTS

	Windows	Mac
Preferences	Ctrl,	Cmd,
Catalog Settings	Ctrl Alt,	Cmd Opt ,

CLOUD SYNC

23

When Lightroom was first introduced to the world in 2006, editing your photos meant sitting down at a desk

at a "proper" computer. Mobile phones were used for phoning people, and in most cases, sending text messages involved pressing the same button 3 or 4 times to spell out a single letter. How times have changed.

In May 2013, we were given a sneak preview of the future—Lightroom on an iPad. When it was released nearly a year later, it synced with the subscription version of Lightroom 5, and the iPhone and Android apps followed shortly thereafter.

The mobile apps went from strength to strength, but in October 2017, Adobe announced that the Lightroom family was growing and being reorganized. Like a human family, the Lightroom family of apps all share the same foundation, called the Camera Raw engine. But like the members of a human family, the individual apps have different interests, different strengths and weaknesses, different appearances—and they occasionally argue! (Figure 23.1)

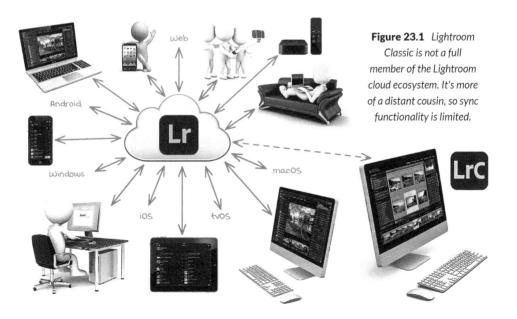

What's the difference between Lightroom Classic and the Lightroom cloud ecosystem?

The traditional folder-based version of Lightroom, now known as Lightroom Classic, has been refocused on its greatest strength: being a really advanced desktop app. It's had many years of development, so it has a lot of advanced features, and a steep learning curve to match.

The Lightroom ecosystem apps—with the catchy names Lightroom Desktop, Lightroom Mobile & Lightroom Web—are all cloud clients. Their strength is in making your photos available everywhere, in a simple interface that lets you focus on improving your photography skills instead of file management.

They're different tools for different audiences, but it's possible to use them together to benefit from the best of both worlds, with some limitations.

I use Lightroom Classic, so why might I want to use the Lightroom cloud ecosystem too?

Imagine, you shoot an event with your DSLR, upload it to Lightroom Classic, set it syncing and walk away. Later, you're sat on the train and decide to start sorting through the photos using your tablet. You rate them, organize them into albums/collections and even do some initial edits.

While traveling, you capture a photo with your phone, edit it using Lightroom right there on your phone, and post it to social media.

While you're out, you run into a friend or potential client, and want to share some photos from your portfolio, so you open Lightroom on your tablet, navigate to the collection and start a slideshow. They want to see more, so you email them a link to view the entire album/collection in their web browser later.

When you return home, the photos taken with your phone have automatically been downloaded to your desktop, complete with your non-destructive edits and all of the other changes you made while you were out.

There are many possible workflows, so we'll just cover the basic principles in this chapter, so you can build a workflow that suits you.

We'll also explore the most popular "best of both worlds" workflow, where Lightroom Classic remains your primary photo archive, but photos can be accessed on your phone/ tablet and new photos captured using your phone are automatically added to your Lightroom Classic catalog.

LIGHTROOM MOBILE BASICS

Most photographers start dabbling in cloud sync as a way to easily transfer the photos they capture with their phone, so let's start there. You'll find detailed information about all of the Lightroom cloud ecosystem apps in my book, **Adobe Lightroom—Edit Like a Pro**.

How do I import photos on mobile?

There are multiple ways to get photos into Lightroom Mobile, including:

- Shoot using Lightroom's own camera.
- Automatically add photos captured using other camera apps.
- Manually add photos from the Photos/ Gallery app.

LIGHTROOM—EDIT LIKE A PRO

The Lightroom cloud ecosystem apps for Windows, macOS, iOS, iPadOS, Android, Apple TV and Web are simple to use, but there are loads of hidden features. Allow me to save you some time and share some of the insider secrets and power user tips with you. Our book on the Lightroom cloud ecosystem is called **Adobe Lightroom—Edit Like a Pro.** It's available from https://www.lightroomqueen.com/shop as well as many online bookshops.

- Direct import from a memory card or camera.
- Sync from other Lightroom apps on Windows, Mac, iOS, Android or Web, as well as smaller smart previews from Lightroom Classic.

How do I use Lightroom's camera?

The iOS app and Android phone app include a built-in camera which has some specific advantages over other camera apps including:

- Raw capture, so you have full editing flexibility.
- Manual camera controls, such as shutter speed and ISO.
- Shoot-through presets that can be cleared later.
- Zoom recorded as non-destructive crop.
- HDR capture for scenes that have too much contrast.
- Hand-held long exposure up to 5 seconds without camera-shake.
- Depth mask capture for easy selections.

Figure 23.2 The camera included in the Lightroom mobile apps offers advantages over the standard camera apps. (iOS app shown)

(Some tools are only available on more powerful devices due to the complexity of the image processing involved, or the limitations of the operating system.) (Figure 23.2)

To open Lightroom's camera, tap the

Figure 23.3 Click the camera icon (right) to open Lightroom's Camera.

camera icon in Organize/Grid view. (Figure 23.3)

The Lightroom camera is also available as a widget to add to the Notifications view (iOS) / Home Screen (Android) for easy access.

How do I add photos captured using other camera apps?

To automatically add new photos captured using other camera apps, go to Lightroom's *Settings* menu (which is the cog icon on iOS or hamburger icon on Android).

On iOS, select *Import* and toggle the *Photos* and *Videos* switches to the right. On Android, select *Preferences* > *Enable Auto Add* and toggle the *Auto Add New Photos* switch, along with the *JPGs/PNGs*, *Videos* and *Raws* switches. **(Figure 23.4)**

Adding photos automatically saves you having to remember to upload your photos. On iOS, you must open the Lightroom app occasionally to allow the photos to import and upload, whereas on Android, the import happens in the background.

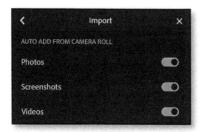

Figure 23.4 Toggle the Auto Import switches. (iOS app shown)

How do I import photos from my camera?

If you've used a separate camera, you can import the photos into Lightroom using your phone or tablet. This is particularly useful when traveling, as long as you have enough space on your device or fast internet. The instructions are slightly different, depending on your operating system:

iOS

iOS/iPadOS 13.2 and later allow you to browse files stored on a memory card and import them directly into Lightroom, without needing to go through the Photos app. You'll need a Lightning to USB adapter and a cable to connect your camera, a Lightning to SD card reader, or the USB-C equivalent for newer devices.

- **1.** Insert the memory card into the SD card reader, or connect the camera and turn it on. The first time, Lightroom asks permission to access the connected device.
- **2.** On the Device Connected screen, tap *Continue*. (Figure 23.5)
- **3.** Lightroom reads the card and presents an import dialog, where you can select specific photos. Tap the checkmarks on individual photos, date segments, or tap the ... menu to *Select All*. The ... menu also allows you to filter specific types.
- **4.** At the top of the dialog, choose whether

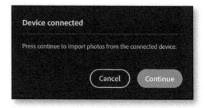

Figure 23.5 Import photos from a connected device such as memory card. (iOS app shown)

Figure 23.6 Wait patiently while the photos copy to the device. (iOS app shown)

to add the photos to All Photos or a new album.

- **5.** Tap *Import* to begin the import process. Don't remove the card/camera or switch to another app until the import completes. (Figure 23.6)
- **6.** Tap the X to close the Direct Import dialog and return to Lightroom. I'd recommend keeping the photos on the card until you return home as an additional backup..

One word of warning: at the time of writing, direct import on iOS does not copy videos. Check that you have all of the photos and videos before you format the card.

Android

You'll need a supported OTG cable or adapter, and you may need a cable to connect to your camera.

- **1.** Connect the camera to the mobile device using a supported OTG cable/adapter. Ensure the camera is turned on and is in PTP or MTP mode.
- **2.** In the app picker, select Lightroom. If your device automatically opens another

Figure 23.7 Select Lightroom when your device asks what to do with the USB device. (Android app shown)

Figure 23.8 Select the photos to import. (Android app shown)

app, you'll need to check your device manufacturer's documentation to clear the default setting. (Figure 23.7)

- **3.** Tap specific photos to select them (shown by a blue border), or tap the ... icon to *Select All, Select None* or filter by file type. Once you've selected the photos, tap *Add*. (Figure 23.8)
- **4.** Lightroom asks whether to add the photos to *All Photos*, to a specific album or to create a new album. By default, *All Photos* is selected. Once you've made your choice, tap *Add* again.
- **5.** Lightroom displays a progress dialog while it copies the photos to your Android device. When it's finished importing the photos, you can disconnect the camera.

How do my photos sync up to the cloud from the mobile app?

Once you've added photos, Lightroom Mobile automatically uploads them to the Lightroom cloud whenever you have an internet connection.

Syncing photos, especially full size originals, can quickly use up your cellular data allowance, so you may want to limit Lightroom to WiFi only. To do so, go to Settings > Cloud Storage & Sync (iOS) / Settings > Preferences (Android) and toggle Use Cellular Data to the left to disable it.

How do I check sync status on mobile?

You can check the overall sync status by tapping the sync icon in the top right corner. Initially it tells you how many photos are still syncing, and when it's done, it changes to **Synced and Backed Up**.

How do I pause sync on mobile?

If you're on a limited bandwidth connection (such as tethering or a hotel WiFi), you can temporarily pause sync, tap the sync icon in the top right corner and then tap the **Pause Syncing** button. Later, when you're back on

Figure 23.9 Tap the cloud icon to view sync activity and pause sync.

good WiFi, repeat to resume syncing. (Figure 23.9)

What happens if I fill up my 20GB cloud space?

If your Lightroom subscription only includes 20GB of cloud space, the simplest solution is to upgrade your subscription to 1TB of storage. However, if you're traveling and hitting the limit is a one-off and you have plenty of storage space to keep them in Lightroom until you get home, then you can transfer the photos from mobile to Lightroom Classic in 20GB chunks.

Allow the mobile device to upload until it hits the 20GB then open Lightroom Classic, allow the 20GB of photos to safely download, and then follow the instructions on page 557 to remove them from the cloud. That'll free up your 20GB of cloud space, which the mobile device can then refill. Repeat the process until all of the photos have safely downloaded into your Lightroom Classic catalog.

How much organizing can I do using the Lightroom Mobile apps?

You can sort through and organize your photos using the mobile apps, including:

- Group photos into albums, which become Collections in Lightroom Classic.
- Rate photos with flags and stars in the Review view.
- Add Titles, Captions & Copyright in the Info view.

However you may not want to waste your time on the following mobile features, as they don't sync back to Lightroom Classic:

• Group albums into album folders. These

don't become Classic collection sets.

- Add keywords, as they only sync between the cloud apps.
- Identify people, as they only sync between the cloud apps.
- Create "versions" with different edits, as they only sync between the cloud apps.

We'll look at these limitations in further detail on page 558.

How much editing can I do using the Lightroom Mobile apps?

All of your editing syncs non-destructively back to Lightroom, so your efforts aren't wasted. Of course, mobile device screens can't be calibrated, so you may want to tweak the settings when you get back to your desktop.

The mobile apps have most of Lightroom Classic's sliders and tools, but they're grouped slightly differently.

Lightroom Classic's Basic panel sliders are split between the Light panel, the Color panel and the Effects panel.

More advanced sliders, for example, HSL, B&W Mix and Tone Curve, are hidden behind buttons in the main panels.

There are additional buttons to access the Healing Brush, Masking tools and Crop.

You can also copy and paste settings across multiple photos.

If you use profiles and presets in your editing, they can be synced to the mobile apps via the Lightroom Desktop app. We covered this in a blog post: https://www.Lrq.me/cloud-import-profiles-presets/

Can I share photos from the mobile apps?

Finally, you can share your finished photos via email, social media, web galleries or by saving them to the device's Photos/Gallery app or cloud services.

SYNCING LIGHTROOM CLASSIC

Lightroom Classic isn't a full cloud client, but it automatically downloads any photos and videos it finds in the cloud, and can selectively upload small versions of your photos.

How do I enable sync?

To enable sync for the first time, click on the cloud icon to show the Sync Activity, then click **Start Syncing**. (Figure 23.10)

Lightroom automatically starts to download any photos and videos it finds in the cloud, for example, photos you've imported into a mobile app.

How do I choose which photos to sync to the cloud?

Once you've activated sync, you can choose which photos to sync to the cloud

Figure 23.10 Start syncing a new catalog with the cloud.

from Lightroom Classic. It only uploads lower resolution smart previews, not full resolution originals, and these don't count towards your 20GB cloud quota, so you can add as many as you like.

To start syncing photos, drag the photos from Grid view directly to the **All Synced Photographs** collection in the Catalog panel. (Figure 23.11)

Lightroom Classic can't sync videos up to the cloud. To add videos to cloud albums, for example, to share in a web gallery, they must be uploaded using one of the Lightroom cloud apps.

Figure 23.11 The All Synced Photographs collection appears in the Catalog panel.

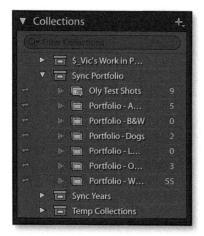

Figure 23.12 Toggle the Sync icons on the left of the Collections panel to sync the collections.

How do I sync collections?

Rather than just syncing a mass of individual photos, you can enable sync for collections. These collections become albums in the Lightroom cloud apps.

To sync existing collections, toggle the checkboxes on the left in the Collections panel. (Figure 23.12)

When you're creating a new collection, check the *Sync with Lightroom* checkbox in the New Collection dialog. (Figure 23.13)

You can't sync smart collections or collection sets, only standard collections.

If you need a refresher on collections, turn back to page 109 for more details on creating and managing collections.

Can I sync folders?

Only collections sync to the cloud, not folders. If you've previously used folders to organize your photos by topic, and you start to use cloud sync extensively, you may want to convert the folders into collections so you can access that organization in that cloud apps (page 112).

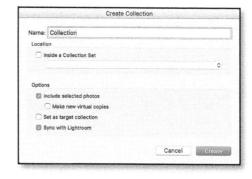

Figure 23.13 If Sync is enabled, the Sync with Lightroom checkbox displays in the Create/Edit Collection dialog.

Once you've converted your organization to use collections, you may then want to change to a date-based folder structure (page 130) to avoid confusion.

It's not ideal, as collection sets don't sync to the cloud app, but the collections themselves sync, and it doesn't take long to reproduce collection grouping in the Lightroom cloud.

How do I check the sync status?

The cloud icon changes depending on the current status. These are the main ones:

Paused

Click on the cloud icon to view further details. (Figure 23.14)

Additional icons also appear in the top right corner of the thumbnails in Grid view, to show the sync status of individual photos. The sync icon simply shows that it's synced

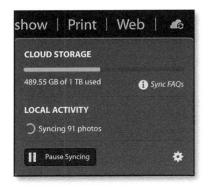

Figure 23.14 Sync status is displayed on the cloud icon. Click on it to view additional information.

Figure 23.15 The Sync icon appears in the top right corner of the thumbnail if the photo's included in Sync.

to the cloud. Three dots below the sync icon means that something's happening to that photo—it's being synced, the metadata's being read or updated, or previews are being rendered. (Figure 23.15)

How do I pause sync?

If you need to pause the sync, perhaps because you need the bandwidth for a higher priority upload, click on the cloud icon and then click the *Pause* button. When you later click again to turn it back on, Lightroom Classic continues uploading from where it left off.

If you close Lightroom Classic while it's syncing, it automatically continues when you next relaunch it. It asks for confirmation before it quits, just in case you're unaware that the sync hasn't completed.

Where does Lightroom Classic put the photos I added to the Lightroom cloud?

When you add photos to one of the Lightroom cloud apps, for example your phone, they're uploaded to the Lightroom cloud and then downloaded to your Lightroom Classic catalog. These are the full size originals, not a smaller version.

By default, Lightroom puts them in a special folder (Windows) / package file (Mac) on your computer. The full folder path is:

Windows—C:\Users\[your username]\My Pictures \ Lightroom \ Mobile Downloads.

Mac—Macintosh HD / Users / [your username] / Pictures / Lightroom / Mobile Downloads.lrdata

This is a fixed location, regardless of where you store your catalog. They show up in the Folders panel as an additional drive. (Figure 23.16)

This isn't a great place to leave the files, because they may not be included in your regular backups, and since they're not with the rest of your photos, they can get left behind when you move to a different computer. Since the default location is the boot drive, you might also find yourself running out of space.

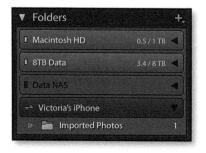

Figure 23.16 By default, Lightroom cloud devices show in the Folders panel as additional drives.

If you select the photos in the Grid view, you can drag and drop them onto a normal folder of your choice. There's more detail on page 129.

How do I change the default download location?

Rather than having to manually move the photos into your normal photo storage, you can change the default location and select a dated folder structure for future downloads by going to *Lightroom's Preferences dialog > Lightroom Sync tab.* (Figure 23.17)

Where do I find my albums/collections created using the Lightroom cloud apps?

Any albums you create in the Lightroom cloud apps are placed inside a *From Lightroom Sync* collection set in Lightroom Classic's Collections panel.

How do I share collections as web galleries?

If you right-click on a synced collection in the Collections panel and choose *Lightroom Links*, you can select *Make Collection Public*. This makes the collection accessible to other people, but only if they have the secret link. The link is displayed at the top of the Grid view, or you can select *Copy Public Link* in the same right-click menu to copy it to the clipboard.

When someone visits on the secret link, they can view the photos in Grid or Loupe view, although they have much more limited access than your own gallery view. If they sign in using an Adobe ID or social login

Location		
Specify location for Lightroom's Synced images:	/Users/Vic/Dropbox/Lightroom Catalog/Mobile Photos	Choose
Use subfolders formatted by capture date:	2022/09	8

Figure 23.17 The location and folder structure for mobile/web uploads can be selected in Preferences.

(Google, Facebook or Apple), they can also leave *Likes* and *Comments* on the photos.

If you visit the web interface at https://lightroom.adobe.com, there are additional sharing options for each collection/album, for example, you can allow your viewers to download photos, view additional metadata, or even turn the gallery into a personalized web page including additional text describing the photos. New features are being added all the time.

How do I see my friends comments?

When someone comments on your photos, a little yellow icon appears on the collection in the Collections panel. The quickest way to find the latest comments is to select the *Last Comment Time* sort order from the *Sort By* pop-up on the Toolbar. The thumbnails themselves display a yellow comment badge, which turns gray when you've

Figure 23.18 The collection icon adds a small speech bubble when there are comments, and it turns orange when the comments are new.

Figure 23.19 Comments made on the web interface are synced back to the Comments panel on the desktop.

selected the photo. (Figure 23.18)

The comments are displayed in the Comments panel, at the bottom of the right panel group, and if you click in the field at the top, you can reply to the comments too. (Figure 23.19)

How do I stop syncing a collection?

You can stop syncing a collection by toggling the checkbox on the left of the Collections panel, but this only stops the collection syncing. It doesn't remove the photos from the cloud or *All Synced Photographs*, because you may have intentionally uploaded original photos as a cloud backup, or the photos may be in another collection.

How do I remove photos from the cloud?

To remove photos from the cloud, they must be removed from the *All Synced Photographs* collection, or deleted using one of the Lightroom cloud apps.

Most of the time, it's simpler to just leave the photos in the cloud. If they're synced from Lightroom Classic, they don't count towards your cloud storage quota. However, if you do need to remove them, it's a multistep process.

First, if the photos are in an album/collection, uncheck the sync checkboxes on the left in the Collections panel of Lightroom Classic to stop the affected collections syncing. You could skip this step, but the photos will be removed from all synced collections when they're removed from the cloud.

Select the photos you wish to remove, then switch to the **All Synced Photographs** collection in the Catalog panel.

Right-click on one of the selected photos and select Remove from All Synced

Photographs and allow sync to complete. The photos remain on your local hard drive and in your Lightroom Classic catalog, but are just removed from the cloud.

How do I remove videos from the cloud?

Because videos don't show in *All Synced Photographs*, removing them is a little more tricky. If you delete them from Lightroom Classic, they get deleted from the cloud too. However, if you just want to remove them from the cloud, but leave them in your Classic catalog, you must visit the web interface to delete the videos directly from the cloud.

ENDS HERE

SYNC LIMITATIONS

Because Lightroom Classic is not a full member of the Lightroom cloud ecosystem, there are some limitations to be aware of.

What are the limitations of syncing Lightroom Classic with the cloud?

If you decide to sync Lightroom Classic with the cloud, these are the main issues to look out for:

Lightroom Classic is a hoarder—When you open Lightroom Classic and enable sync, it downloads anything it finds in the cloud to your local hard drive. Even if you then delete a photo from the Lightroom cloud, it stays in Lightroom Classic, and if you delete an album in the Lightroom cloud, the collection just becomes unsynced in Lightroom Classic. Lightroom Classic wants to be in charge of your photos.

Some Features Don't Sync—Lightroom Classic has many features that aren't

available in the Lightroom cloud apps, and other features are available in both apps but work differently. This list is likely to grow further as new features are added to Lightroom cloud apps. (Figure 23.20) Right now, most notably:

- Keywords don't sync between Classic and the Lightroom cloud.
- Stacks don't sync between Classic and the Lightroom cloud.
- Location metadata (except GPS coordinates) doesn't sync between Classic and the Lightroom cloud.
- Album/Collection hierarchy doesn't sync between Classic and the Lightroom cloud.
- Virtual copies created in Classic upload as smart previews, even if the original's already in the cloud. And real copies created in the Lightroom cloud apps become virtual copies in Classic.

Features Have Different Names—Collections in Lightroom Classic become albums in the Lightroom cloud, but Album Folders in the Lightroom cloud don't become Collection Sets. Also, some of the editing features are grouped differently, for example, the White Balance sliders are in the Basic panel in Lightroom Classic but in the Color panel in the Lightroom cloud apps. And the Lightroom cloud apps don't have a user interface for all of Classic's Develop sliders, although it understands them all.

Videos Don't Sync—Videos download to Lightroom Classic, but Classic can't upload videos or some metadata changes to the cloud.

Selective Sync—Lightroom Classic only syncs photos you specifically choose to sync. It's easy to miss uploading photos, such as

Task	Sync Up from Classic	Sync Down from LR Cloud	
Import			
Add Photos	Originals not uploaded— uploads as a smart preview, and only if marked to sync	Classic downloads all originals from the cloud (as long as you haven't already deleted them from the cloud)	
Add Videos	No	Classic downloads all videos, but sync link is then broken.	
Organizing Photos			
Collection / Album Membership	Yes, if collection marked to sync	Yes, if album created in Lightroom cloud app or marked to sync in Classic	
Collection Set / Album Folder Hierarchy	No	No	
Collection Custom Sort Order	Yes	Yes	
Stack Membership	No	No	
Create Copies	Virtual copies upload as smart previews even if originals are already in the cloud	Real duplicates created in cloud apps become virtual copies in Classic	
Delete Photos/Videos	If you delete or unsync, photos are deleted from the cloud	No, just unsynced if already downloaded	
Adding / Editing Metadata			
Files Renamed	Yes	N/A	
Capture Date Changed	Yes	Yes	
Flags & Star Ratings	Yes	Yes	
Title & Caption	Yes	Yes	
Copyright	Yes	Yes	
Keywords / People	Keywords only on first sync, if metadata was written to the files	No	
Location (GPS)	Yes, co-ordinates only	Yes, co-ordinates only	
Develop Edits			
All Edits	Yes (even if there isn't a user interface for the slider/tool)	Yes	
Snapshots / Versions	No	No	

Figure 23.20 Some features exist in both the Lightroom cloud apps and Lightroom Classic, but don't sync, or only sync in one direction. This list is likely to grow over time, as new features are added to the Lightroom cloud ecosystem.

those created by Edit in Photoshop or HDR/ Panorama merge. This can be a good thing or a bad thing, depending on whether you want access to all of your photos from other devices or not.

Single Catalog—Lightroom Classic only syncs a single catalog, so if you have more than one catalog, you'll need to decide which one you're going to use or merge them into a single catalog using the instructions on page 496.

Only Smart Previews Upload—Lightroom Classic only syncs smart previews to the cloud, so even if you remember to sync all of the photos, it can't send the originals to the cloud. However, if you have a slow internet connection or only 20GB of cloud space, only uploading smart previews may be an advantage, as you'll still be able to view, flag, rate and edit photos on other devices, and they don't count towards your 20GB guota.

Can I upload originals from Lightroom Classic?

If you still need the power of Lightroom Classic on your main computer, but you want your originals in the cloud, it is possible. However, it's not an officially recommended or sanctioned workflow, so it won't undergo official testing.

The safest option is to use the Lightroom cloud apps to import your photos and upload to the cloud, then let them download into Lightroom Classic. This works reliably, but if your internet connection is slow, you may have to wait a long time before you can start working on the photos in Lightroom Classic.

The alternative is to add all of your photos to the All Synced Photographs collection in Lightroom Classic's Catalog panel, wait for the smart previews to upload to the

cloud, wait for all of the photos to sync to Lightroom Desktop on the same machine, and then add the same original photos into Lightroom Desktop. It should be smart enough to recognize that these are originals of existing synced photos, and just upload the originals to the cloud, without duplicating the photos. It gets messy with videos!

TROUBLESHOOTING SYNC

Sync is notoriously complex, and as we said earlier in the chapter, Lightroom Classic isn't a full cloud sync client. You may need to intervene from time to time, so it's useful to have a few troubleshooting tools up your sleeve.

Why doesn't the All Synced Photographs count match the count in the Lightroom ecosystem apps?

The Lightroom cloud apps and web interface include videos in their All Synced Photos count, whereas Lightroom Classic only includes synced photographs. Counts could also differ if the devices haven't finished syncing.

How do I solve sync errors?

If Lightroom Classic runs into problems syncing photos up to the cloud, it creates a temporary collection in the Catalog panel called *All Sync Errors*. In many cases, there's a logical reason for the error, for example, if the original photos are offline and smart previews don't currently exist, Lightroom can't sync these photos. The errors usually clear automatically, when the photos are next available.

For more detailed feedback, go to Preferences > Lightroom Sync tab and check the **Sync Activity** section. This shows the current sync processes and the names of photos that are stuck. However, it doesn't show every single sync activity, for example, collection updates aren't listed. As a result, sync may still churn or appear to be stuck at times, without any sync activity being listed here. (Figure 23.21)

If there's nothing obvious in Lightroom Classic, you can also log into your account at https://lightroom.adobe.com and see the current cloud status. This can offer clues on what's stuck, for example, if a thumbnail is gray with a cloud icon, it hasn't finished uploading to the cloud. Float over the thumbnail to show additional information, then reopen Lightroom on the device in question and let it finish uploading. If that device is no longer available, click the checkmark then select *Delete* in the menu above to delete the partially uploaded photo

Figure 23.22 If a photo seems to be stuck syncing, check the web interface to see whether it's safely uploaded to the cloud.

from the cloud. (Figure 23.22)

How do I reset Lightroom Classic's local sync cache?

If the web interface and mobile devices appear to be in sync, but Lightroom Classic's

Figure 23.21 The Pending Sync Activity section shows the current sync activity which is useful for troubleshooting sync errors.

sync is stuck for a long time, clearing the local sync cache can help.

To do so, go to Preferences > Lightroom Sync tab. Hold down Alt (Windows) / Opt (Mac) and click the Rebuild Sync Data button. Lightroom automatically guits and deletes the *Sync.Irdata folder (Windows) / file (Mac), which is stored next to the catalog. Alternatively, you can delete it manually.

Restart Lightroom, click the cloud icon and resume the sync. Lightroom will then attempt to reconcile your local synced data and the cloud synced data. This can take a long time if you have a large number of photos in the cloud, and the sync count may go up and down repeatedly before it finally completes.

How do I get help from Adobe?

More unusual sync issues may require a little help from Adobe. This also allows them to investigate and figure out the cause of the problem, so they can avoid it in future releases

To request support from Adobe, it's best to post at https://feedback.photoshop.com/ as the engineers themselves watch this forum.

When posting, don't forget to include your Lightroom version and operating system. The easiest way to find the information is to go to Help menu > System Info and just copy the first block of text. And of course, don't forget to include a detailed description of what's wrong!

Adobe support staff may ask you to create a diagnostic log. Go to Preferences > Lightroom Sync tab and hold down the Alt key (Windows) / Opt key (Mac) to display the Generate Diagnostic Log button. Lightroom generates the log and offers to open it in your web browser or show it in Explorer

(Windows) / Finder (Mac) ready to email to the support staff.

How do I completely disable sync and remove everything from the cloud?

If you're having significant sync problems that Adobe can't solve, and Lightroom Classic is your primary photo manager, sometimes the "nuclear" option is the simplest solution. Obviously you'll need to ensure that all originals loaded into the cloud from other devices have finished syncing down to your Lightroom Classic catalog, or you can manually download them from Lightroom Web.

To delete everything from the cloud so you can start syncing afresh, go to https://lightroom.adobe.com and sign in. Click your avatar in the top right corner. select Account Info from the menu and then click the Delete Lightroom Library button. Restart Lightroom to complete the process. (There's a Delete All Synced Data button in Preferences, but it just tells you to do the same thing.)

Your Lightroom Classic catalog remains safely on your desktop, but all of the data is

Figure 23.23 To clear the cloud, log into the Lightroom website.

removed from the cloud and the Lightroom cloud apps, so triple check that everything has safely downloaded to Lightroom Classic before taking this nuclear option. (Figure 23.23)

What happens if the same photo changes on the desktop and mobile device while they're offline, creating a conflict?

With many syncing situations, it's possible to end up with conflicts, where the same photo has changed in both locations at the same time, or while they're both offline.

Lightroom resolves these conflicts automatically. If a setting's changed in both Lightroom Classic and a Lightroom cloud client while they're both offline, the latest change wins. For example, if you change the flag status on one device, and Develop settings on the other device, both changes will be updated. If you change the flag status on both devices, whichever change was made last is the setting that sticks.

When Lightroom updates the Develop settings from sync, it adds a *From Lr mobile* history state to the History panel.

What happens if I want to sync a different catalog or I need to restore a backup catalog?

You can only have one Lightroom Classic catalog syncing at a time. If you enable sync in a different catalog or an outdated backup

Figure 23.24 Lightroom can only sync one catalog.

catalog, Lightroom asks whether you want to switch to syncing this new catalog.

If you select **Yes, sync this catalog instead**, Lightroom downloads all of the photos from the cloud into the new catalog. It attempts to match up the cloud photos against existing photos, but this only works if the photos are still in their original location, so you may end up with duplicates. **(Figure 23.24)**

While there's nothing to stop you repeatedly switching catalogs, repeatedly wiping data from the cloud and reuploading everything, it takes a lot of time and bandwidth. Sticking to a single catalog is much, much simpler.

ADVANCED WORKFLOWS

In this chapter, we've focused on the principles that will allow you to build a sync workflow that suits you. Every photographer has slightly different requirements. Whatever your sync workflow, there's one essential decision you must make...

What is the Single Source of Truth?

IT guys have a concept called the Single Source of Truth. In plain English, that just means, don't store the same data in more than one place. Why not? Because if there's a conflict, how do you know which is right?

You may have used the same principle in your own life. Let's illustrate. Imagine you have two appointment diaries. Every time you book a new appointment, or change a time or location, you must update the information in both diaries. But what happens if you forget, or you write down the wrong time in one of the diaries. A few months later, the memory of what you did has faded, and you no longer have any idea which is correct. Should you go to the

dentist at 1:30 on Thursday, as diary one tells you to, or 12:30 on Friday, as diary two suggests? Now start duplicating that information on the calendar hung in the kitchen and the digital calendar on your phone, and the problems multiply further.

Lightroom Classic's entire foundation is designed to be the single source of truth. It wants to be in charge, but the same is true of the Lightroom cloud database. It also thinks it should be in charge, especially if you've entrusted it with your original photos. And what happens when two different people—or in this case, programs—want to be in charge? Arguments! Conflicts! Chaos!

As we've seen in this chapter, it is possible to use both together, to get the best of both worlds, however you must decide which version will be the primary photo archive, or single source of truth, and which you'd be willing to wipe in the event of irreconcilable sync conflicts.

How do I decide which Lightroom version should be my single source of truth?

Throughout this chapter, we've assumed that Lightroom Classic, along with your local file system, is your primary photo archive or single source of truth.

Lightroom Classic is probably your single source of truth if you mainly use sync to:

- Import mobile photos into your Lightroom Classic catalog without having to plug in your phone.
- Upload photos to your tablet to view/ edit while traveling, and have those edits seamlessly transfer back to your Lightroom Classic catalog on your return.
- View or edit existing photos while traveling or even just sat on the sofa with

your phone or tablet.

- Use the cloud-based app to view and edit photos on your laptop using the Lightroom Desktop app, rather than having to worry about copying Lightroom Classic catalogs between devices (such as the workflow described on page 471).
- Use the Lightroom cloud ecosystem for features that aren't available using Lightroom Classic, such as Al-based search and best photo selection.
- Share web galleries with friends, family or clients, and even allow them to add their own photos to your Lightroom catalog.
- Trialling the Lightroom cloud ecosystem before migrating permanently.

The Lightroom cloud ecosystem is probably your single source of truth if you mainly use the Lightroom cloud apps or you want your originals in the cloud. You might still want to sync back to Lightroom Classic to:

- Use Lightroom Classic for features that aren't yet available in the cloud apps, for example, adding map locations or printing. (For one-off prints, it's easier to export from Lightroom Desktop as *Original+Settings* and import the photos into a clean Lightroom Classic catalog instead.)
- Migrate from the Lightroom cloud ecosystem to Lightroom Classic, perhaps because your internet is too slow, you have too many photos, or you want Lightroom Classic's more advanced features.
- Keep a local backup of photo metadata, which isn't currently possible with the cloud ecosystem.

Which will be your Single Source of Truth?

REGISTER YOUR BOOK FOR ADDITIONAL BENEFITS

With your book purchase, you also get a year's access* to our **Lightroom Classic Premium Members Area**.

The benefits include:

- Multiple eBook formats of this book.
- **Updates** as Adobe add new features and other changes to Lightroom Classic, so you always have the latest information.
- **Email Support** from Victoria and Paul, if you can't find the answer in the book. Use the Lightroom Classic Premium Email Support form in the Members Area at https://www.lightroomqueen.com/contact/

To register your book, we need:

- **Proof of Purchase**, for example, your confirmation email, shipping confirmation, a scan/photograph of the packing slip, or a screenshot of the order confirmation on Amazon's website—we need to be able to read the order number and order/delivery date.
- The book reference code: CL122022LS

If you purchased the book direct from $\underline{\text{https://www.lightroomqueen.com}},$ you'll already be registered.

Send us the details using either:

- The book registration form: https://www.lightroomqueen.com/register
- Email: registration@lightroomqueen.com

What happens next?

We'll upgrade your Members Area account and confirm by email. This can take up to 48 hours, as it requires a real human to press the buttons.

You can then log into your Members Area account at https://www.lightroomqueen.com/members to access the bonus downloads and email support form.

* Members Area access is valid for 365 days (from date of book purchase if new, or from date of publication if purchased used). When your Members Area access expires, you're welcome to extend it at a low cost, so you always have the most up to date information about Lightroom Classic.

Symbols

Α

1:1 previews See previews: 1:1 previews	Auto Straighten 338
8-bit or 16-bit 398	Auto Sync 87, 97, 136
16-bit printing C17	
32-bit HDR 403	В
	backup catalog 59-62
	deleting old backups 62
activation 14, 468	file location 60
Activity Center 49, 70, 72, 73, 156, 158, 176,	frequency 61
177, 178, 464, A28, D13, E8	optimizing catalog 60
adjustment brushes See editing, local	photos not included 60
adjustments	postponing 61
Adobe Bridge See Bridge	restoring 64
Adobe Camera Raw	restoring part of catalog 65
compatibility with Photoshop 405	testing integrity 60
Adobe Photoshop See External Editors	unable to backup 62
Adobe Photoshop Elements 395, 401-405	backup checklist 67
Adobe RGB 387	backup extra files 64
soft proofing 389	backup photos 62
analyzing photos 197-214	restoring 66
artistic intent 204-211	synchronization software 63, 476
Photo Analysis Checklist 212, 213	backup presets 68
Photo Analysis Worksheet example 214	Basic panel (Develop) 215
technical faults 197-211	Beardsworth, John
Aperture, import from 21, E26	Big Note plug-in 140
Apple Photos app, import from E25	CaptureTime to Exif plug-in 142
Apply During Import panel (import) 40-42	Open Directly plug-in 257, 409
Armes, Tim	Search Replace Transfer plug-in 129
Keyword Master plug-in 147	Syncomatic plug-in 385
LR/Mogrify2 plug-in 431, C14	Workflow Smart Collections 194
LR/Transporter plug-in 191	Before / After Preview 380
LR/TreeExporter plug-in 418	bit depth 398
LR/Voyager plug-in 442	Blacks slider 244, 246
Aspect slider 349	black & white 320-325
attribute filter 186	changes to color 11
Auto Import 55	convert to 224, 225, 321

Auto Mask 292

photo shot in 11-13	photos, zooming in A12
blue overlay in Develop See clipping warnings	photos, zoom to fit A11
Blurb A26-A29	previewing 447, A2
Book module 445-448, A1-A32	saving A24
Auto Layout panel 447, A2, A8, A10	saving as PDF or JPEG A28
Background panel A15, A16, A17	shortcuts A30-A31
Book Settings panel 447, A3, A4, A26,	snapshot A25
A27, A28	spine A17, A21
Cell panel A9, A16, A20	spine text A21
Collections panel 447, A2, A24, A25, A26	templates, creating A8
Guides panel A9, A13, A17, A20	text A17-A21
Page panel 447, 448, A3, A4, A5, A6, A20	text, alignment A23
Preview panel 446, A2, A18	text, columns A23
Text panel 448, A4, A18, A19, A20	text, formatting A21
Type panel A20, A21, A22, A23, A24	text, positioning A20
books 445-458, A1-A32	text, red square marker A20
Blurb A26-A29	text, spell check A21
Blurb cost A27	text, style A23
Blurb logo page A27	text, TAT tool A22
Blurb maximum pages A6	text, types A18
Blurb, sending to A28	text, using metadata A19
Blurb vs PDF A29	view modes 446, A2
ebooks A29	borders
export & print A26	export 431
pages, adding A5	printing C14
pages, auto layout 447, A2, A10	slideshows B5
pages, background A15	breadcrumb bar 70, 76
pages, bleed A13	Bridge 105, 126, 229, 405, 411, 533, 534
pages, clear layout 447, A2	brush <i>See Masking</i>
pages, copy layout A10	Brush tool See Masking
pages, deleting A7	B&W See black & white
pages, drag and drop A7	B&W conversion
pages, duplicating A10	tinted 328
pages, inserting A7	
pages, numbering A20	С
pages, order A7	calibration See monitor calibration; See also So
pages, selecting A6	Proofing
pages, style A15	Calibration panel (Develop) 234, 255
pages, templates A4-A10, A25	camera profile 10, 225, 520
photos A12-A32	camera raw cache See performance: camera
photos, adding A25	raw cache
photos, adding borders A16	camera raw file format 9
photos, captions A12	Canon
photos, editing A25	Auto Lighting Optimizer 12-13
photos, exclamation point on A14	Highlight Tone Priority 11
photos, removing A14	caption
photos, used in book A14	add in Lightroom (cloud-based) 470, 471

book, adding to A12	479
ITPC 133, 190	multiple users on same machine 489
capture time	NAS 468
editing 140-142	offline file limitations 484
sort by 183	opening 495
Catalog panel	optimizing 462
Find Missing Photos 504	preferences, contents of 518
Previous Import 27	renaming 462
Quick Collection 113	searching for 459
catalogs	sharing between computers See catalogs:
contents 460	multiple machines
corruption See troubleshooting: catalog	single or multiple 493–497
corruption	space used 461
creating new 494	splitting 497
default 495	switching 494
default settings 495	unzip backup, Mac 64
definition of 5-20, 459	catalog settings
deleting 496	delete all synced data 562
Dropbox, synchronize catalog 476	Catalog Settings
exporting as catalog 483	choose secondary monitor 96
first catalog 15	Delete all synced data 562
importing from catalog 487	external editor preferences 396
importing from catalog, limitations 489	File Handling
location of 459	Import Sequence Numbers 39
maintenance 462, 463	Standard Preview Size & Quality 534
maximum number of photos 494	General
merging 496	Backup Frequency 61
moving 463-468	Catalog Name & Location 459
moving catalog & photos to new computer	Metadata
465	Automatically detect faces in all
moving catalog & photos to new drive 465	photos 158
moving catalog to new drive 463	Automatically write changes into
moving, data verification 464	XMP 412, 534
moving photos to archive 464	Clear All Suggestion Lists 139
moving photos to new drive 463	Export address suggestions whenever
multiple catalogs, merging 496	address fields are empty 177
multiple catalogs, pros & cons 493	Include Develop settings in metadata
multiple catalogs, transfer photos between	inside 413
497	Look up city, state and country of GPS
multiple machines 468-493	coordinates to provide address
multiple machines, self-contained catalog	suggestions 176
472	Offer suggestions from recently
multiple machines, semi-portable catalog	entered values 139
473	Write date or time changes into
multiple machines, split & merge catalog	proprietary raw files 413
480	chromatic aberration 203 See: chromatic
multiple machines, use temporary catalog	aberration

Clarity slider 237, 248-251	copying / pasting
clipping 200	Develop settings 367-370
clone & heal tools 268-274	metadata 135-140
delete spot 273	copyright See importing photos: copyright data
differences 269	adding metadata
straight lines 272	corruption
cloud sync 469, 553-565	cache 513
limitations 558	catalog 506-509
troubleshooting 560-565	presets 515
CMYK 50, 53	preview cache 513
collections 109-116	CPU 538
adding photos to 110	Creative Cloud app 13
deleting 111	cropping photos 261-268
icons 109	aspect ratio 263
Quick Collection 113	Constrain to Image 267
removing photos from 111	custom size 264
sets 111-113	default ratio 264
Smart Collections 193	overlay 266
target collection 113	ratio 263
color cast 319	reset 268
ColorChecker chart E19	resize 263
Color Grading 325	rotating 85, 262
cinematic 329	Straighten tool 262
color combinations 328-364	cross-processing effects 330
Color Grading panel 326	custom sort order 184
Colorize slider 307–309	20,
color labels 106	D
color management 386-393	Dawson, Matt
colors look different in external editor 403	Snapshotter plug-in 385
color space 386, 397	Defaults on Import 376-393
color space when exporting 422	defringing 345
Perceptual or Relative Colorimetric 389	Dehaze 251
printer output C17	deleting
Color Picker 307, A15, A21, B5, B8, B12, B13,	folders 124
C13, C14, C15, D6, D7	previews 527
Color Range tool 295	Destination panel (import) 42-48
Comments panel 442, 557	Detail panel (Develop) 333-338
Compare view 93-95	Develop advanced 365
comparing photos	Develop introduction to editing 197-214
before / after view 380	Develop module See editing photos; See
Compare view 93-95	also editing, Masking
Grid view 81-85	Basic panel 215–260
Loupe view 87-92	Camera Calibration panel 234, 255
Survey view 92-93	Detail panel 333-338
composition 206-211	Effects panel 350–354
contact sheet See photos: contact sheet	Histogram panel 254
Contrast slider 237, 238, 239, 240	History panel 254, 378, 379, 382, 383
,,,	

HSL panel 331-332	adjustment brushes, erase strokes 290
Lens Corrections panel 338-350	adjustment brushes, flow & density 291
Navigator panel 333, 371, 390	adjustment brushes, size & feathering 291
Panel Order 75	dodge & burn 305
Presets panel 228, 302, 333, 371, 372,	graduated filters 293
373, 375	graduated filters, edit existing 293
Snapshots panel 383	graduated filters, sharpen 307
Split Toning panel 326	moire 308-309
Tone Curve panel 313-320, 332, 381	radial filter 295
digital asset management 43, 493	radial filters, edit existing 293
discard 1:1 previews 462, 487	Range Mask 295-309
Display P3 387, 398, 422	editing photos
DNG format 420, E1-E13	adjust for mood 232
ACR compatibility E4	adjust from the top 215-216
converting to E8, E9	Analysis Checklist 212
convert non-raw files E11	analysis example 214
defaults E8	analyze the image first 197-214
extracting embedded proprietary files	auto adjustments 216
from E12	basic how to 219
Fast Load Data E2	Basic Panel Workflow 217
hash validation E3	blacks 244, 246
lossy DNG E5	black & white 224, 225, 320-325
preferences E6	book examples to download 4, 220
pro and cons E1-E4	camera settings 11-13
quality E4	clarity 238, 248
Recover Edges plug-in 12, 264, E13	contrast 237, 238
sRAW/mRAW files E6	Contrast vs Clarity 239
DNG Profile Editor E15-E19	copying / pasting settings 367-370
ColorChecker Passport plug-in E19	cropping 261–268 See also cropping photos
dodge & burn See Masking: dodge & burn	default photo settings 376
DPI vs PPI 426	dodge and burn 305
drag and drop	examples 219-222
sort order 184	exposure 235
Dropbox	file type (raw, sRAW, JPEG) 9, 12
presets, synchronizing 491	grain 353 See also noise reduction
sharing catalog, photos, previews 476	highlights 237, 242
duplicates	history step states 380
don't import 36	individual style 210-211
Duplicate Finder plug-in 497	infrared photos 234, 325
dynamic range 199	matching exposures 370
	moire 308
	noise reduction 333-338
Edit Capture Time dialog 140-142	preview changes, before / after 380
editing, local adjustments See also cropping	profiles 10
photos; See also red eye & pet eye correction	red eye & pet eye 274
adjustment brushes 279-282	saturation 252
adjustment brushes, Auto Mask 292	shadow detail 237, 243

E

sharpening 333-338	file settings, color space 422
sharpening, selective 337	hierarchies 418
sliders, working with 218	image size 415, 423-426
snapshots & virtual copies 382-385	image size, don't enlarge 426
split toning See split toning	image size, resize to fit 423
sync settings 86, 367	JPEG quality 421
sync settings, Auto Sync 138	location 417
sync settings, white balance won't sync	metadata to include 427
369	metadata to strip 428
vibrance 252	naming, change names 419
vignette, adding 351	naming, names already exist 418
vignette, adding off-center 352	presets 432
virtual copies, rename 384	reimport 418
white balance 229	resize photos 423
whites 244, 245	resolution See export: image size
editing, retouching See also External Editors	save as a copy 415
clone & heal tools 268	sharpening based on paper types 427
clone & heal tools, differences 269	slideshow See slideshows: exporting
spot removal 268	specific file size 421
Effect presets 304	TIFF, save transparency 421
Effects panel (Develop) 350-354	upsize, best program to use 426
Elements, import from 21, E30	videos 422
Ellis, John	watermarking See watermarking
Any Filter plug-in 192	web See : exporting
email address (author) 566	Export as Catalog dialog 483
emailing photos 434-439	Exposure slider 235
attachment size 437	external drives 465, 468, 469, 472, 474, 476
copy, retain 438	External Editors
Lightroom address book 438	8-bit or 16-bit depth 398
mail clients supported 434	auto stack images 401
multiple email accounts 437	color space to use 397
presets 437	Edit Original, Copy, Copy with Adjustment
SMTP settings 435	402
embedded previews See previews: embedded	editor, specific filenames 400
previews	Elements 395, 401-405
Enhance Details 354	Elements, import from E30
export	file formats 397
adjustments not applied problem 433	file naming & location 400
after export actions 431	open as layers in Photoshop 403
book See : export & print	opening raw files in 408
CD/DVD 417	Photoshop 395-396, 401-405
compression 420	Photoshop, ACR compatibility 405
DPI vs PPI 426	Photoshop, ACR mismatch 407
export as catalog 442, 483	Photoshop, ACR older version 405
export error 434	Photoshop, file not opening as TIFF / PSD
file settings 420-423	401
file settings, bit depth 421	Photoshop Lightroom can't find 404

Photoshop, merge to HDR Pro 403	editing, Healing 268
Photoshop, merge to Panorama 403	editing, Histogram 198
Photoshop, photos look different 403	editing in other programs 395
Photoshop, smart objects 402	editing, introduction to 219
preferences 396-401	editing, lens & perspective corrections
presets 407	338
resolution choice 399	editing, red eye 274
setting up 407-409	editing, sharpening & noise reduction 333
sort order 401	emailing photos 434
when to use 396	exporting (saving) 415
why use 396	face recognition 155
eyedropper	finding and filtering 183
defringing 345	getting photos and videos into Lightroom
white balance E17	21
white balance, averaging 233	gradients & brushes 279
white balance, disappears 232	grouping using stacks 107
eyes, enhancing 309	history & reset 378
	introduction 2
	keywording photos 142
face recognition 155-165	managing individual photos 126
adding names 162, 165	managing photos (moving, renaming,
birthdays 165	deleting) 117
deleting 165	map locations 166
draw face tool 165	performance 521-546
filtering by date 163	photo merging 356
indexing whole catalog 158	presets 371
keywords 159	printing 450
keywords, keeping private 165	publish services 439
keywords, use existing 160	rating photos 101
missing 164	selecting photos 81
navigate people view 160	sliders 218
People Support plug-in 165	slideshows 448
single person 163	smart collections 193
sort order 161	snapshots & virtual copies 382
spelling mistake 163	troubleshooting 499
tagging people 155	viewing in Compare view 93
unrecognized people 163	viewing in Grid view 81
Fast Track	viewing in Loupe view 87
adding metadata 133	viewing in Survey view 92
backing up 59	workspace 69
before you start 5	file formats 9, 50, 222
book, designing 445	File Handling panel (import) 34–36
capture time fixing 133	file locations 516-520
collections of photos 107	camera & lens profiles 519
editing, adjust from the top 215	camera raw cache 519
editing, black & white 320	catalog 67, 459, 516
editing, copying settings 367	catalog backups 67

develop settings 519	parent folders 120
hidden files, show 518	renaming 124
mobile uploads 68	reorganize into dated 130
photos 67	Show Photos in Subfolders 108, 120
plug-ins 68	views 120
preferences 68, 517	Folders panel (Library) 117-123
preferences & settings menu locations	Friedl, Jeffrey
520	Collection Manager plug-in 418
presets 68,519	Collection Publisher plug-in 443
presets default location 519	color management article 386
preview files 526	Configuration Manager plug-in E22
previews 67	Data Explorer plug-in 192
Startup Preferences 68	Extract Previews plug-in 505
File Renaming panel (import) 36–40	Facebook & Flickr plug-ins 442
fill light 253	Folder Manager plug-in 418
film emulation 222	
filmstrip 71, 76	Geocoding plug-in 175, 442, E22 Metadata Editor Preset Builder 135
filtering	
attributes 186	Metadata Wrangler Export plug-in 428
combining filters 191	People Support plug-in E22
criteria to filter on 184	Fringe Color Selector tool 342
custom sort order 184	FTP See web galleries
locking 192	G
metadata 187	
metadata, hierarchical vs flat 187	Gadgets E20
	gamut clipping See color management: color
multiple filters 188	space
saving presets 192 Smart Collections 193–196	geotagging See Map module: address lookup
	GPS data See mapping photo locations
specific filename 191	GPU 515, 531, 539 See also Preferences:
text 190	Performance: Use Graphics Processor
text AND OR searches 190	grain, adding 353 See also noise reduction
text file plug-in LR/Transporter 191	graphics processor See GPU
user sort order 184	Grid view 81-85
flags 78, 101–106	grouping photos 109-113
Flat Field Correction E14	
Flickr See Publish Services: Flickr	Н
flip photo 267	H.264 video format 422
folders 117-126	HDR 357
changing structure 123	auto align 363
deleting 124	deghost 363
disclosure triangles 121	edit after merge 363
don't import 117	editing options 362
favorites 122	merge using Photoshop 403
move or copy photos between 129	photos to use 362
moving 123	HDR Pano 359
new folder 123	Healing 268-278
new photos not showing in 125	hide parent folder 120

hierarchy, folders 117	hanging on import 51
High Dynamic Range 199	iPhoto, from 21, E26
Highlights slider 237, 242	Make a Second Copy 25
Histogram panel 198-199, 254	memory card 22-23, 24
History panel (Develop) 378-380	multiple sources 29
clear 537	navigation 30
HSL panel (Develop) See Develop module: HSL	new folder, creating 45
panel	organizing by date 43
HSL sliders 306-309	organizing by topic 43
	organizing into folders 42
	photos not appearing 51-58
ICC profiles 422, C22, E17	pixel limit 50
Identity Plate 70, 72, 73, 156, 158, 178, 430,	presets 48
B7, B8, B9, B10, B12, B13, C14, C15	preview building 34
Import dialog	preview size 34
Apply During Import panel 26, 40, 42	Raw+JPEG pairs 52
Destination panel 42-48	saving settings 49
File Handling panel 25, 31, 34-36	second copy, make 36
File Renaming panel 36-40	selecting photos 30-33
Source panel 23, 24, 28, 28–30, 29, 30,	selecting photos, filter selection 32
44, 48	selecting photos, select certain ones 31
Import from Catalog dialog 487	selecting photos, some dimmed 31
mporting photos	selecting photos, sort order 31
add / copy / move 22-23, 33	source options 28-30
Aperture, from E26	troubleshooting 49-54
Apple Photos app, from E25	Info Overlay 88
apply develop settings 41	infrared 234, 325, E18
apply keywords during import 41	installing Lightroom 13-16
basic how to 23-27	internet connection
collection, add to on import 36	mobile, WiFi only 552
compact dialog 48	interpolation methods 426
copy or move, using 45	iPad/iPhone B20
copyright data, adding metadata 41	iPhoto, import from E26
destination folder, italic 46	iris enhance effects preset 304
destination folders, date based 43, 44,	
45, 46	J
destination folder, selecting 44	JPEG
destination folders, shoot based 47	format 397, 420
destination for images 42-48	quality 9
duplicates, don't import 36	
Elements, import from E30	K
error messages 52	keyboard shortcuts See shortcuts
file formats 50	keystoning 204
file handling 34	Keyword panel (Library) 142-155
file renaming 36-40	keywords 139, 142-151
file types, import by 32	adding 145
folder structure 26-58	applying during import 41

	cleanup 150	activation 14, 468
	controlled vocabularies 143	dot releases 16-17
	editing or removing 148	installing 13-16
	finding 154	licensing 468
	hierarchy 149	minimum system requirements 13
	in multiple catalogs 145	multiple computers, license 15
	merge 148	opening 14
	number applied 147	plug-ins, installing 409-410
	Painter tool, add using 147	splash screen when opening 14
	people keywords 159	subscription expires 17
	photos not keyworded 154	uninstalling 17
	symbols 152	updates 530
	synonyms 150	upgrading from previous versions 17-19
		version, checking which 16
L		Lightroom (cloud-based ecosystem) 1, 469,
	labels See color labels	547-566
	L*a*b* values 386	Lightroom mobile 443 See also sync, mobile
	language 14	basics 548-565
	Layout Overlay 91	Lights Out mode 90, 262
	Lens Corrections panel (Develop) 338-350	limits
	lens & perspective corrections 338-350	images in catalog 494
	chromatic aberration 342	image size 50
	chromatic aberration, localized fringing	Linear Gradient tool See Masking
	345	Link Focus 95
	default on import 340	local adjustments See editing, local adjustments
	grid 350	lossy DNG See deleting: lossy DNG
	Guided Upright 347	Loupe view 87-92
	lens profiles 10, 340	Low Dynamic Range 199, 247
	lens profiles, default 339	Ircat, Irdata, Irprev 459
	manual transform lens sliders 348	Luminance Range tool 296
	Library module	LUT's 229
	Catalog panel 81	
	Collections panel 110, 111, 112, 113, 154,	M
	184, 193, 194, 195	MakerNotes E3
	Folders panel 81	Map module 166-178
	Histogram panel 486	Navigator panel 87, 88, 163, 333, 371,
	Keywording panel 145, 146, 148, 150,	390, 447, A2, C12
	152, 165	Saved Locations panel 171, 172
	Keyword List panel 145, 146, 147, 148,	mapping photo locations
	149, 150, 154, 156, 162, 163, 165, 188	adding & editing location metadata 172
	Metadata panel 105, 128, 133, 133-140,	adding photos to map 172
	136, 139, 167, 172, 177, 178	address lookup 176
	Navigator panel 87,88	address lookup, make permanent 178
	Publish Services panel 439-443	address lookup not working 178
	Quick Develop panel 106	basic how to 166
	licensing Lightroom 14, 468	filter bar 170
	Lightroom	Geocoding plug-in 178

limitations 178	sliders, setting 303
locations 166	Subject selection tool 287-290
locations dimmed 177	teeth 309
navigation 167	Match Total Exposures 370
offline 167	Members Area 566
overlays 169	memory 538
photos by location 168	merge to HDR See HDR
photos not tagged 173	merge to panorama See panoramic images
saved locations 170	merging catalogs 496
second window 172	metadata
tracklogs See tracklogs	adding 133-140
Masking 279-312	autofilling 139
AI-Based Selections 286	best performance 137
Background selection tool 287-290	Big Note plug-in 140
Brush tool 290	birthdays 165
Color Range tool 295	CaptureTime to Exif plug-in 142
combining mask types 299	conflicts 414
copying masks to other photos 302	definition of 133
creating 282	export 427
Depth Range tool 297-299	map See mapping photo locations
dodge and burn 305	presets 138
dots or speckles after use 292	reading from files 413
duplicating 283	removing 137
editing 283	saving to files 411–414 See also XMP
Effect presets 304	saving to JPEG, TIFF, PNG, PSD files 413
erase strokes 290	status 84
eyes 309	sync 135-140
fading the effect 304	Metadata panel 133-140
flow & density 291	missing files See troubleshooting
HSL sliders 306	Mobile Downloads.Irdata 556
intersect 301	Module Picker 69
Linear Gradient tool 293-309	moire 202 See editing, local adjustments: moire
Luminance Range tool 296	moiré patterning 202
Object selection tool 287-290	monitor calibration 19, 512, C21
organizing 282	how to 19
overlays 284	profile, remove 510
People selection tool 287-290, 309	moving
pin icons 286	catalogs 463-468
Radial Gradient tool 294	folders 123
Range Masks 295-309	photos to new drive 463
renaming 283	to a new computer 465
save masks as presets 302	multiple catalogs
selective sharpening 307	merging 496
shortcuts 310-312	pros & cons 493
size & feathering 291	transfer photos between 497
skin selection 288-290, 309	multiple machines 463-468
Sky selection tool 287-290	

N	export print as C22
negatives, inverting 320	export slideshow as B20
negatives scanned, reversal 320	people See face recognition
network storage 15, 473, 474, 476, 480, 501	performance
Nik software 395	camera raw cache See Preferences:
noise reduction 202, 333-338	Performance: Camera Raw Cache Settings
selective 337	catalog optimizing 462, 463, 509
slider interaction 336	checklist 546
Noise Reduction sliders 308	choose secondary monitor 96
non-destructive editing 34, 215, 396, 415,	general maintenance 541
419, 423, 521, 537	hardware choices 538
notes, adding 140	improving 521-546
	moving / deleting photos 544
0	myths 523
OnOne software 395	preferences and catalog settings 530
Optimize catalog 462, 509	previews, building 543
Organizing Masks 282	previews & cache - Develop 527
organizing photos	previews - Library module 524
metadata 133-140	previews size 534
naming characters 43	shortcut 546
rating 101-106	slider order 536
using folders 42	pet eye & red eye correction 274
Original format 420	photo merge 356-364 See also HDR; See
overlays	also panoramic images
Embedded Previews to Avoid 89	file types to use 359
info 88	Lightroom vs Photoshop 359
layout 91	merged file format 360
loading 89, 534	when to edit 360
map 169	photos
status 89-97	backup See Backup, Photos
	capture time 140
P	capture time, sync cameras 141
Painter tool 147	corrupted See troubleshooting: photos,
PaintShop Pro 395	corrupted
panels	dark, appear 11–13
by module See specific modules	faces See face recognition
missing 506	flip 267
solo mode 74	importing See also importing photos
turn off settings 381	keywords applied to 152 See also keywords
panoramic images 357	location on hard drive 129
auto crop 361	managing individual photos 126
merge using Photoshop 403	mirror 267
projection modes 361	moving to a new computer 465
white edges 361	moving to new drive 463
parametric curve 315	photos not keyworded 154
PDF format	picks and rejects 102
export book as A28	rating 101

rating, color labels 105	LR/Mogrify2 431, C14
rating, refining 105	LR/Transporter 191
renaming 127, 129	LR/TreeExporter 418
reorganize into dated 130	LR/Voyager 442
stacking 107	Metadata Editor Preset Builder 135
stacking, auto stack 108	Metadata Wrangler Export 428
where are 21	Open Directly 257, 409
where to store 22	People Support 165
Photos (app) 21	Publish Services 439-443
Photoshop 395-396, 401-405 See	Search Replace Transfer 129
also External Editors	Snapshotter 385
ACR compatibility 405	Syncomatic 385
ACR mismatch 407	Timelapse B22
ACR older version 405	Timelapse Develop B22
actions via droplets E23-E25	using 410
edit in, logic tree 406	Voyager 442
file not opening as TIFF / PSD 401	point curve 315
Lightroom can't find 404	Preferences
merge to HDR Pro 403	External Editing
merge to Panorama 403	File Naming 400
photos look different 403	Stack With Original 401
resize 426	File Handling
smart objects 402	DNG files E6
Photoshop Elements, import from E30	General
pick and reject photos 102	Automatically check for updates 16
pixelation 423-426	Default Catalog 495
pixel limit 50	Language 14
Pixelmator 395	Replace embedded previews with
plug-ins	standard previews during idle
Any Filter 192	time 90
Big Note 140	Reset all warning dialogs 506
CaptureTime to Exif 142	Select the 'Current/Previous Import'
Collection Manager 418	collection during import 49
Collection Publisher 443	Show Import dialog when a memory
ColorChecker Passport E19	card is detected 28
Configuration Manager E22	Show splash screen during startup 14
Data Explorer 192	Treat JPEG files next to raw files as
Duplicate Finder 497	separate photos 51, 52
Extract Previews 505	Interface
Facebook & Flickr 442	Fill Color 77
Folder Manager 418	Filmstrip 76
Geocoding 175, 178	Font Size 75
installing 409–410	Keyword Entry 146
Keyword Master 147	Lights Out 91
Lightroom Statistics 192	Panel End Marks 76
List View 87	Swipe between images using mouse/
location 68, 409	trackpad 82
iocation oo, T o /	Compad of

Lightroom Sync	detail preview 333
Specify Location & Folder Structure	Develop module 527
556	embedded previews 34, 89, 524, 535
Sync Activity 560	Library module 524
menu location 520	loading logic, Develop 528
Performance	loading logic, Library 525
Camera Raw Cache Settings 519,	location 526
523, 529, 532	minimal 34
Limit Video Cache Size 533	problems See Troubleshooting, Image 8
Optimize Catalog See Optimize catalog	Preview problems
Use Graphics Processor 523, 531,	size and quality 534
539	size to build 34, 526
Use Smart Previews instead of	smart previews 35, 529-545
Originals for Image Editing 533	standard 34, 524
Presets	Previous button 368
Show All Other Lightroom Presets	printing
374	16-bit output C17
Show Lightroom Develop Presets	adding text C15
Folder 228	background color C13
Store presets with this catalog 68	basic how to 450-456, C1-C7
reset 515	border C14
reset, what's lost 518	borderless 451, C2
presets 371-393	color management C17
backing up See backup presets	contact sheet 450, 454, C2
corrupted 515	contact sheet, adjusting layout C9
develop 371-376	contact sheet, creating 453, C4
develop, applying multiple 374	contact sheet, sort order C10
develop, organizing 375	custom printer profile C20
different to profiles 229-257	deleting saved layout C23
Dropbox synchronizing 491	deleting saved print C23
email 437	designing print C13-C16
export 432	draft mode C16
import 48	exporting C16-C23
installing 227, 373	JPEG output C21
ISO adaptive 373	layout C7-C13
metadata 138	layout guides C8
restoring See Backup presets, restore	layout ideas C12
updating 375	logo, adding C14
use on two computers 489	margins C8
when to use 208	page numbers & crop marks C16
Presets panel (Develop) 371-376	Page Setup & Print Settings C20
previews	PDF output C22
1:1 previews 35, 462, 514, 526	picture package 450, C2, C10
before / after (Develop) 380	picture package, creating 454, C5
building 487, 543	picture package, creating a custom
cache corruption 513	package 455, C6
deleting 527	noints & nicas C8

printer drivers C19	Flickr 439
prints not match preview C21	hard drive 443
resolution C17	Lightroom mobile 443
roll paper C7	marking as published 441
saving design C23	multiple catalogs 442
saving layout C23-C25	publishing my photos 441
sharpening C17	revoked authorization on website 442
shortcuts C26	third party plug-ins 442
single image 450, C2	
standard lab prints C1	Q
steps to print 452, C3	Quick Collection 113
templates See printing: saving layout	Quick Develop panel (Library) 106, 369
text C14, C15	
units of measurement C8	R
watermark, adding C15	Radial Gradient tool See Masking
zoom to fill C10	RAM requirements 13
Print module 450-456, C1-C26	Range Mask See editing, local adjustments:
Collections panel C23, C24	Range Mask
Guides panel 454, C6, C8, C9, C11, C14,	Range Masks 295-309
C17	rating photos 78, 101-106
Image Settings panel 451, 454, 455, C3,	workflows 104
C5, C6, C10, C12, C14	raw+jpeg 52
Layout panel 451, 452, 454, C3, C5, C8,	raw file format 9
C9, C10, C14	raw files
Layout Style panel 450, 451, 454, 455, C1,	converting to DNG E8, E9
C2, C3, C5, C6, C7	read metadata from files 413
Page panel 454, C5, C13, C14, C15, C16	red eye & pet eye correction 274
Preview panel C24	red overlay See clipping warnings
Print Job panel 452, C3, C4, C8, C16, C17,	Reference view 381
C22	refine photos 105 See also flags
Template Browser panel C24	registering this book 566
Process Version (PV) 253	re-index folder or collection 159
profiles	removing See deleting
creating using SDK 229	renaming
different to presets 229-257	catalogs 462
how to filter 227	custom text and start numbers 40
types of 224, 229-257	during import 37
when to use 208, 222, 223-257	filename template 37
proofing See Soft Proofing	folders 124
ProPhoto RGB color space 386, 387, 389,	Import#, Image#, Sequence#, Total#
398, 403, 404, 415, 416, 422	options 39
soft proofing 389	Import vs Library 128
PSD format 397, 420	naming conventions 37
Publish Services 439-443	numbering 40
automatically publish 440	original filename 128
Comments panel 442	padding with zeros 39
deleted photo in error 441	photos 129

	Search Replace Transfer plug-in 129	Export 444
	resetting preferences 515	filtering 196
	resetting settings (Develop) 378	help 20
	resizing photos 423	Import module 58
	resolution 423-426	managing photos and folders 131–132
	restoring	metadata 179-182
	catalog 64	performance 545, 546
	photos 66	Print C26
	retouching photos See editing, local	selecting photos 114-116
	adjustments; See also External Editors	Slideshow B23-B24
	reverse geocoding See mapping photo	troubleshooting 520
	locations: address lookup	viewing photos 98-100
	RGB values 385	Web D13-D14
	rotating photos 85, 262	Workspace 79-80
		Show Parent Folder 118
S		Show Photos in Subfolders 108, 120
	Saturation slider 252, 307	skin softening 250, 309
	saving edited photos See export	Sliders, working with 218
	searching See filtering	Slideshow module 448-450, B1-B24
	secondary display 95-100	Backdrop panel B4, B5, B6
	choose monitor for secondary wondow 96	Collections panel 449, B2, B16, B17, B18
	slideshow playback B16	Layout panel B2, B3
	use in Map Module 172	Music panel 449, B2, B14
	Second Copy 25, 36	Options panel B4, B5, B6, B7, B12
	selecting photos 86-87	Overlays panel B7, B8, B10, B12
	selective editing See editing, local adjustments	Playback panel 449, B2, B14, B15, B16
	sepia tint 328	Preview panel B18
	sequence numbers 415, 419	Template Browser panel 449, B2, B18
	sets	Titles panel B13
	collection 111	slideshows
	keywords 146	adding photos to B18
	shadows 243	advancing slides manually B16
	Shadows slider 237, 243	anchor points B8
	sharpening	aspect ratios B3
	Develop module 248, 333-338	background color B4
	output 426	background gradients B6
	selective 307	background image B6
	sharpening photos 307	basic how to B1
	shortcuts	blank slides at start and end B13
	Book A30-A32	borders B5
	Catalog 498	branding (Identity Plate) B7
	custom E19	creating a saved slideshow B17
	Develop basic 259	custom text captions B10
	Develop selective 277-278, 310-312	deleting text captions B10
	Develop tools 393-394	editing or deleting saved slideshow B18
	downloadable list 3	exporting B19-B22
	Edit In 414	formats when exporting B19

impromptu slideshow B19	Dropbox sync 476
JPEG export B21	export as catalog option 483
layout & design B2-B7	limitations 484
missing photos B21	not for merge 359
monitor to play on B16	use for multi-computers 482
music, adding track B14	where held 460
music copyright B14	snapshots 382-385 See also virtual copies
music exclamation warning B14	convert to virtual copies 384
music fading B14	when to use 383
music, multiple tracks B14	Snapshots panel (Develop) 383
music, removing B14	soften skin effects preset 304
opening saved show B18	Soft Proofing 386-393
PDF export B20	Blurb A26
photo borders B5	gamut warnings 390
photo size not fitting photo cell B4	Perceptual or Relative Colorimetric 389
photo sizes B2	simulate paper & ink 390
playback settings B13-B17	why use it 388
playback timings B15	solo mode 74
play slideshow B16	sort order 183, 183-184
rating photos while playing B12	Source panel (import) 28-30
saving B17-B22	specifications of hardware 13
saving settings B18	speed See performance
shadows B5, B12	splash screen 14
shortcuts B23	splitting catalog 480
slide order B16	Split Toning See Color Grading
star ratings, display B12	spot color 324
subset, playing B16	sRAW file format 9
text caption in quotes B11	sRGB 386, 387
text captions B7-B12	soft proofing 388
text captions, adding B10	stacking photos 107, 108
text captions different for each photo B10	standard previews See previews: standard
text captions, empty displayed B11	star rating 78, 101-106
text captions font B11	Status Overlay 89
text captions presets, metadata based B10	Embedded Previews to Avoid 89
text captions, shadows behind B12	Straighten tool 262
timelapse photography B22	subscription See Creative Cloud
transition styles B15	Survey view 92-93
video export B20	symlinks See presets: Dropbox synchronizing
watermark, adding B10	sync
smart collections See collections; See	bandwidth 412
also filtering	cloud sync 469, 545, 547-563
complex criteria 194	limitations 558
duplicating 194	troubleshooting 560
transfer between catalogs 195	develop settings 367-370
Smart Previews 158 See previews: smart	metadata settings 135
previews	snapshots 385
build or discard 487	virtual copies 385

Sy	nchronize Folder	add in Lightroom (cloud-based) 470, 471
	125	book, adding to A12, A17, A19
sy	stem requirements 13	Facebook 439
		ITPC 133, 190
T		title bar 70,73
Ta	rget Collection 113	Web gallery D6-D13
Ta	rgeted Adjustment Tool	Tone Curve panel (Develop) 313-320
	how to use 317	tone curves 313-320
	HSL & color 332	point curve 318
	point curve 318	Targeted Adjustment Tool 317
	text in Book module A22	types - parametric & point curve 315
	tone curve 317	Tone & Presence 234
	use of 317	tracklogs 173-178
TA	AT (targeted adjustment tool) 324	camera time difference 175
te	eth whitening 309	formats 174
te	eth whitening effects preset 304	Geocoding plug-in 175
te	mplates	importing 174
	book A4	smartphone apps 173
	filename 37	time zone offset 175
	metadata based (Slideshow) B10	won't import 175
	print C23-C25	TranslatedStrings.txt E19-E23
	slideshow B18	Jeffrey's configuration manager E22
	web D9-D11	troubleshooting 499-520, 521-546
Te	est integrity 509	catalog corruption 506-509
te	thered shooting 54-58	catalog corruption, can't open 507
	auto import 55	catalog corruption, causes 507
	cameras supported 55	catalog corruption, fixing 507
	watched folder 57	catalog corruption, prevention 509
te	ext	clean user account 516
	books A17-A21	dialogs missing 506
	filtering 190	file associated with another photo 503
	printing C15	files missing fix 499-506
	slideshows B7-B12	fixing missing photos 500
te	ext filters 189	folder already in Lightroom 503
	AND OR searches 190	gray boxes instead of previews 509
Te	exture slider 248-251	hardware & operating system problems
th	numbnail options 82	516
	Quick Collection marker 84	image & preview problems 509-514
	rotating 85	import errors 49-54
	stacking 85	missing files, check catalog for 504
	video 85	missing files prevention 502
	virtual copies 85	monitor profiles 510
Т	IFF format 397, 415, 420	new catalog 515
	Save Transparency 421	panels gone 506
	imelapse plug-in B22	photos, can't find 499
	imestamp See Edit Capture Time dialog	photos changing color 512
ti	tle	photos, color mismatch 510

photos, corrupted 513	Edit Only view 136
photos, deleted with no backup 504	Lights Out 90
photos, Lightroom thinks missing 500	View Options 76, 82, 84, 85, 89, 92, 95, 267,
Preferences, reset 515	384, 518, 535
presets, corrupted 515	reference view 381
preview cache corruption 513	Show message when loading or rendering
salvaging corrupt raw files 50	photos 535
steps to troubleshoot 514-516	vignetting 350
sync 560-565	adding 351
toolbar disappeared 506	fixing 341-350
Windows drive letters 503	virtual copies 382–385 See also snapshots
	convert to snapshots 384
	promoting to master 385
undo command 378	renaming 384
unsharp mask 334	when to use 383
upgrading Lightroom See Lightroom: upgrading	Visualize Spots 272
from previous versions	visual mass 206
upright adjustments See cropping photos	
USB drive See external drives	W
	watched folder 54-58
	watermarking
Vibrance slider 252, 307-309	adding 428
video	complex & metadata-based 431
slideshow export B20	graphical 429
videos 255	printing C15
cache 257	saving 431
capture frame, set poster frame 255	size & placement 429, 430
color & exposure 256	slideshow B10
editing 255	text 429
editing software 257	web galleries
exporting 422	adding photos to saved gallery D10
export sizes 423	basic how to D4
importing See also importing photos	colors, how to change D6
joining 255	editing or deleting D10
metadata 256	exporting D11-D13
music fade in slideshow B14	file naming D11
playing 92	FTP Settings D11
trimming 255	hosting options D2
viewing photos	layout & design D5-D9
Compare view 93	metadata display D7
Grid view 81	multiple galleries D13
Lights Out mode 90	personalizing D6
Link Focus 95	photo quality D8
Loupe view 87	saving D9-D11
Survey view 92	saving settings D9
thumbnail options 82	saving template D10
View modes	share Collections 556
	The state of the s

U

speed tip D9
styles D5
thumbnails D7
uploading using FTP software D11
uploading using Lightroom D12
web hosting D1
website not changed D13
Web module 456-458, D1-D14
Appearance panel D7
Collections panel 456, D4, D9, D10
Color Palette panel D6
Image Info panel D7
Layout Style panel D5, D6
Output Settings panel D8
Preview panel A56, D4, D10
Site Info panel D6, D7
Template Browser panel 456, D4, D5, D6, D7, D10
Upload Settings panel 457, D5, D12
white balance 306–309
White Balance 10, 229–234
Whites slider 245, 244–257
workflow 6-9
Basic Lightroom Workflow 7
Basic Panel 217
Develop 258
Import from a temporary catalog 478
Lightroom cloud sync 471
my personal workflow diagram 8, 471,
473, 474
rating photos 103, 104
self-contained catalog 473
semi-portable catalog 474
Smart Collections 194
split and merge catalog 481
workspace
breadcrumb bar 70,76
filmstrip 71,76
filter bar 71, 77
font size 75
main interface 70
module picker 69,71
panel preferences 75
panels 70, 74
preview area 71, 77
title bar 70,73
toolbar 71,77

write metadata to files using XMP sidecar files 411

Χ XMP 135-140 metadata 411

Z zoom

how to 87

Lock Zoom position 88